ART HISTORY
PORTABLE EDITION THIRD EDITION

Ancient Art

MARILYN STOKSTAD

Judith Harris Murphy Distinguished Professor of Art History Emerita
The University of Kansas

PEARSON

Prentice
Hall

Upper Saddle River, NJ 07458

Editor-in-Chief: Sarah Touborg
Sponsoring Editor: Helen Ronan
Editorial Assistant: Christina DeCesare
Editor in Chief, Development: Rochelle Diogenes
Development Editors: Jeannine Ciliotta, Margaret Manos,
　Teresa Nemeth, and Carol Peters
Media Editor: Alison Lorber
Director of Marketing: Brandy Dawson
Executive Marketing Manager: Marissa Feliberty
AVP, Director of Production and Manufacturing: Barbara Kittle
Senior Managing Editor: Lisa Iarkowski
Production Editor: Barbara Taylor-Laino
Production Assistant: Marlene Gassler
Senior Operations Specialist: Brian K. Mackey
Operations Specialist: Cathleen Peterson
Creative Design Director: Leslie Osher
Art Director: Amy Rosen
Interior and Cover Design: Anne DeMarinis
Layout Artist: Gail Cocker-Bogusz
Line Art and Map Program Management: Gail Cocker-Bogusz,
　Maria Piper

Line Art Studio: Peter Bull Art Studio
Cartographer: DK Education, a division of Dorling Kindersley, Ltd.
Pearson Imaging Center: Corin Skidds, Greg Harrison, Robert
　Uibelhoer, Ron Walko, Shayle Keating, and Dennis Sheehan
Site Supervisor, Pearson Imaging Center: Joe Conti
Photo Research: Laurie Platt Winfrey, Fay Torres-Yap, Mary Teresa
　Giancoli, and Christian Peña, Carousel Research, Inc.
Director, Image Resource Center: Melinda Patelli
Manager, Rights and Permissions: Zina Arabia
Manager, Visual Research: Beth Brenzel
Manager, Cover Visual Research and Permissions: Karen Sanatar
Image Permission Coordinator: Debbie Latronica
Manager, Cover Research and Permissions: Gladys Soto
Copy Editor: Stephen Hopkins
Proofreaders: Faye Gemmellaro, Margaret Pinette, Nancy Stevenson,
　and Victoria Waters
Composition: Prepare, Inc.
Portable Edition Composition: Black Dot
Cover Printer: Phoenix Color Corporation
Printer/Binder: R. R. Donnelley

Maps designed and produced by DK Education, a division of Dorling Kindersley, Limited, 80 Strand London WC2R 0RL.
DK and the DK logo are registered trademarks of Dorling Kindersley Limited.

Credits and acknowledgements borrowed from other sources and reproduced, with permission, in this textbook appear on the appropriate page within text or on the credit pages in the back of this book.

Cover Photo:
Constantine the Great
　Basilica of Maxentius and Constantine, Rome, 325–26 CE. Marble, Height of head 8′6″ (2.6 m). Palazzo dei Conservatori, Rome.
　Photo: Peter Adams / JSI / Corbis

Pearson Education LTD.
Pearson Education Australia PTY, Limited
Pearson Education Singapore, Pte. Ltd
Pearson Education North Asia Ltd

Pearson Education, Canada, Ltd
Pearson Educación de Mexico, S.A. de C.V
Pearson Education—Japan
Pearson Education Malaysia, Pte. Ltd

10 9 8 7 6 5 4 3 2

ISBN 0-13-604097-7
ISBN 978-0-13-604097-2

CONTENTS

1 PREHISTORIC ART IN EUROPE 1

2 ART OF THE ANCIENT NEAR EAST 24

3 ART OF ANCIENT EGYPT 48

PREFACE

As I expressed in the Revised Second Edition of *Art History*, I believe that the first goal of an introductory art history course is to create an educated, enthusiastic public for the inspired, tangible creations of human skill and imagination that make up the visual arts—and I remain convinced that every student can and should enjoy her or his introduction to this broad field of study.

Like its predecessors, this book balances formalist analysis with contextual art history to support the needs of a diverse and fast-changing student population. Throughout the text, the visual arts are treated within the real-world contexts of history, geography, politics, religion, economics, and the broad social and personal aspects of human culture.

So . . . What's New in This Edition?

A Major Revision

I strongly believe that an established text should continually respond to the changing needs of its audience. With this in mind, the Third Edition has been revised in several major ways.

Significant Restructuring and Rewriting: In response to the evolving requirements of the text's audience—both students and educators—the changes implemented in this edition result in greater depth of discussion, and for some specific cultures and time periods, a broader scope. I also revamped a number of chapters and sections in a continuing effort to better utilize chapter organization as a foundation for understanding historic periods and to help explain key concepts.

Improved Student Accessibility: New pedagogical features make this book even more readable and accessible than its previous incarnations. Revised maps and chronologies, for example, anchor the reader in time and place, while the redesigned box program provides greater detail about key contextual and technical topics. At the same time, I have worked to maintain an animated and clear narrative to engage the reader. Incorporating feedback from our many users and reviewers, I believe we have succeeded in making this edition the most student-accessible art history survey available.

Enhanced Image Program: Every image that could be obtained in color has been acquired. Older reproductions of uncleaned or unrestored works also have been updated when new and improved images were available. In some instances, details have also been added to allow for closer inspection. (See, for example, figs. 18-21 and 19-37.) The line art program has been enhanced with color for better readability, and there is a new series of color reconstructions and cutaway architectural images. To further assist both students and teachers, we have sought permission for electronic educational use so that instructors who adopt *Art History* will have access to an extraordinary archive of high quality digital images for classroom use. (SEE P. XV FOR MORE DETAILS ABOUT THE PRENTICE HALL DIGITAL ART LIBRARY)

WHAT'S NEW

Chapter by Chapter Revisions

Chapter 1 includes a focus on the arts and daily life in prehistoric Europe with enhanced coverage of Neolithic paintings and the village of Skara Brae.

Chapter 2 is reorganized to follow a chronological sequence, and the focus on the arts and daily life in this chapter incorporates the sites of Jericho and Catal Huyuk.

Chapter 3 features an aerial view and reconstruction drawing of Karnak, as well as expanded coverage of Abu Simbel.

Chapter 4 now offers aerial views combined with reconstruction drawings for the sites of Knossos and Mycenae, and the "Object Speaks" highlights the Lions Gate at Mycenae.

Chapter 5 is enhanced by the addition of Exekias' vase, *Achilles and Ajax Playing a Game*. There also is a clarification of the ownership status of the *Death of Sarpedon* vase by Euphronios.

Chapter 6 is reorganized to follow a chronological sequence rather an organization by medium. The addition of more "natural" busts such as *Pompey* and a *Middle-aged Flavian Woman* broadens the discussion of Roman portrait. A colorized reproduction of the *Augustus of Primaporta* is included in a discussion of the use of color in ancient sculpture.

Chapter 7 includes new images of the Old St. Peter's interior and the Hosios Lukas exterior. New examples of Early Christian sculpture are a sarcophagus with Christian themes, and the carved doors of the church of Santa Sabina.

Chapter 8 heightens its emphasis on the exchanges within the Islamic world and between Islam and its neighbors. A new section on the "Five Pillars" of Islamic religious observance is incorporated. Coverage is extended into the modern period.

Chapter 9 features new material on Southeast Asia, including Thailand, Cambodia, Indonesia, and Sri Lanka.

Chapter 10 has an extensive new section on Korean art, including painting, ceramics, and metalwork. Korean Buddhist works now complement the coverage of Buddhist art in China.

Chapter 11 has updated text and improved illustrations.

Chapter 12 includes a greater emphasis on North America as well as an expanded section on Mayan sculpture.

Chapter 13 now features a discussion of the earliest evidence of art-making in Africa, an expansion of the rock art section, and an added exploration of Igbo-Ukwu culture. A discussion of Kongo art from central Africa is also added. Textiles are introduced as a high art form.

Chapter 14 is reorganized to clarify the complex styles of migrating peoples in the fifth through seventh centuries as well as the contributions of the Vikings in sculpture and architecture. To allow for a more cohesive discussion, eleventh-and twelfth-century work in wood has been moved to this chapter.

Chapter 15 is reorganized chronologically rather than regionally or by medium. It includes a new focus on secular architecture and Dover Castle. In sculpture, there is enhanced coverage of cloister reliefs, historiated capitals, and bronze work.

Chapter 16 is reorganized in several significant ways. The chapter incorporates early and high Gothic art and ends at about 1300. The origins and development of Gothic art in France have been reworked, the "hall" church has been reinstated, and the coverage of secular architecture continues with Stokesay Castle in England.

Chapter 17 is a new chapter that permits a discussion of the fourteenth century as it unfolded across Europe. An aerial view and illustrated drawing of the Cathedral in Florence have been added. A new section on Bohemian art is included.

Chapters 18–21 are a result of a major restructuring. The two chapters formerly devoted to the fifteenth and sixteenth centuries each have been divided into four chapters.

Chapter 18 continues some of the themes and traditions of Gothic and fourteenth-century art outside Italy. The *Ghent Altarpiece* has been reinstated with open and closed views. A closed view of Rogier van der Weyden's *Last Judgment Altarpiece* also is added.

Chapter 19 is devoted to Italian fifteenth-century art. Donatello's *St. George* is now incorporated, as is the *Triumph of Federico and Battista da Montefeltro*. The art and architecture of Venice are given greater emphasis.

Chapter 20 features sixteenth-century Italian art. The sculpture discussion is broadened. Illustrations from *The Farnese Hours* emphasize the continuing tradition of the illuminated manuscript.

Chapter 21 deals with the sixteenth century outside Italy. The "Object Speaks" focuses on Portuguese sculpture and the great Window at Tomar. Secular architecture is expanded to include the Château of Chenonceau and Tudor Hardwick Hall.

Chapter 22 remains regionally organized, but is slightly reordered for better clarity. Spanish colonial sculpture and architecture are moved to chapter 29.

Chapter 23 has new Nepalese and Tibetan material as well as an added segment on Southeast Asia (including Burma, Thailand, and Vietnam). There is enhanced coverage of modern and contemporary India.

Chapter 24 now features a survey of the later art of Korea, including ceramics and painting, with coverage up to the twentieth century.

Chapter 25 includes a Japanese print once owned by Frank Lloyd Wright. Also added are a Nihonga style work by Yokoyama Taikan and a contemporary painting by Takashi Murakami.

Chapter 26 now includes Aztec featherwork and a discussion of the National Museum of the American Indian.

Chapter 27 incorporates a discussion of the importance of the ocean in the culture and art of Oceania. There is an emphasis on shared materials and the commonalities of this vast region.

Chapter 28 now features masquerade, Kuba elite costuming and architectural decoration, and Fon memorial iron sculpture. The contemporary art section is expanded to include artists working on the continent and in the Diaspora.

Chapter 29 includes more historical context in the discussion of artists and works. Colonial Latin American objects are moved to this chapter.

Chapter 30 features a section on Orientalism. The interaction of French political history and art is explored in greater detail, and the discussion relating to the definition and causes of Modern art is rewritten and expanded.

Chapter 31 includes an increased exploration of Primitivism in relation to several movements. There is a key new section on Latin American early Modern art, and the segments relating to Kandinsky's abstract art, Dada, and Surrealism are rewritten.

Chapter 32 has a new discussion of cultural factors such as existentialism, John Cage, and the influence of mass media. There is increased coverage of postwar European art and Latin American art. An expanded discussion of the end of Modernism and the beginnings of Postmodernism is incorporated, as well as new sections relating to some dominant trends in Postmodernism.

Tools for Understanding *Art History*

Art History offers the most student-friendly, contextual, and inclusive survey of art history.

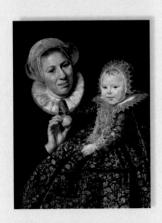

The text provides students with essential historical, social, geographical, political, and religious contexts. It anchors works of art and architecture in time and place to foster a better understanding of their creation and influence. Marilyn Stokstad takes students on a unique journey through the history of art, illustrating the rich diversity of artists, media, and objects.

Key Features of Every Chapter

Art History has always been known for superb pedagogical features in every chapter, many of which have been enhanced for this new edition. These include:

Chapter openers quickly immerse the reader in time and place and set the stage for the chapter. **Clear, engaging prose** throughout the text is geared to student comprehension.

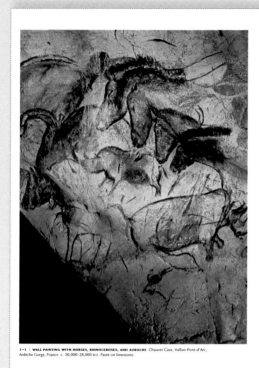

C H A P T E R O N E

PREHISTORIC ART IN EUROPE

Prehistory includes all of human existence before the emergence of writing, but long before that defining moment, people were carving objects, painting images, and creating shelters and other structures. In fact, much of what we know about prehistoric people is based on the art they produced. These works are fascinating because they are supremely beautiful and because of what they tell us about those who made them. The sheer artistry and immediacy of the images left by our early ancestors connect us to them as surely as written records link us to those who came later.

The first contemporary people to explore the painted caves of France and Spain entered an almost unimaginably ancient world. Hundreds of yards from the entrances and accessed through long, narrow underground passages, what they found astounded them and still fascinates us. In the Chauvet Cave, located in a gorge in the Ardèche region of southeastern France (FIG. 1–1) images of horses, deer, mammoths, aurochs (extinct ancestors of oxen), and other animals that lived 30,000 years ago cover the walls and ceilings. Their forms bulge and seem to shift and move. The images are easily identifiable, for the painters have transformed their memories of active, three-dimensional figures into two dimensions by capturing the essence of well-observed animals—meat-bearing flanks, powerful legs, and dangerous horns or tusks. Using only the formal language of line and color, shading, and contour, these prehistoric painters seem to communicate with us.

Archaeologists and anthropologists study every aspect of material culture, while art historians usually focus on those things that to twenty-first-century eyes seem superior in craft and beauty. But 30,000 years ago our ancestors were not making "works of art." They were flaking, chipping, and polishing flints into spear points, knives, and scrapers, not into sculptures, however beautiful the forms of these tools appear to us. The creation of the images we see today on the walls of the Chauvet Cave must have seemed a vitally important activity to their makers in terms of everyday survival. They were often painted in areas far from the cave entrance, without access to natural daylight, and which were visited over many years. The walls were not flat canvases but irregular natural rock forms. What we perceive as "art" may have been a matter of necessity to these ancient image makers.

For art historians, archaeologists, and anthropologists, prehistoric art provides a significant clue—along with fossils, pollen, and artifacts—to understanding early human life and culture. Although specialists continue to discover more about when and how these works were created, they may never be able to tell us why they were made. The sculpture, paintings, and structures that survive are only a tiny fraction of what must have been created over a very long span of time. The conclusions and interpretations drawn from them are only hypotheses, making prehistoric art one of the most speculative areas of art history.

1–1 | **WALL PAINTING WITH HORSES, RHINOCEROSES, AND AUROCHS** Chauvet Cave, Vallon-Pont-d'Arc, Ardèche Gorge, France. c. 30,000–28,000 BCE. Paint on limestone.

1

Chapter-at-a-glance feature allows students to see how the chapter will unfold.

as the spiritual capital of Islam. After his triumph, he went to the Kaaba (FIG. 8–1), a cubical shrine said to have been built for God by the biblical patriarch Abraham and long the focus of pilgrimage and polytheistic worship. He emptied the shrine, repudiating its accumulated pagan idols, while preserving the enigmatic cubical structure itself and dedicating it to God.

The Kaaba is the symbolic center of the Islamic world, the place to which all Muslim prayer is directed and the ultimate destination of Islam's obligatory pilgrimage, the Hajj. Each year, huge numbers of Muslims from all over the world travel to Mecca to circumambulate the Kaaba during the month of pilgrimage. The exchange of ideas that occurs during the intermingling of these diverse groups of pilgrims has been a primary source of Islamic art's cultural eclecticism.

CHAPTER-AT-A-GLANCE

■ ISLAM AND EARLY ISLAMIC SOCIETY

■ ART DURING THE EARLY CALIPHATES | Architecture | Calligraphy | Ceramics and Textiles

■ LATER ISLAMIC ART | Architecture | Portable Arts | Manuscripts and Painting

■ THE OTTOMAN EMPIRE | Architecture | Illuminated Manuscripts and *Tugras*

■ THE MODERN ERA

■ IN PERSPECTIVE

ISLAM AND EARLY ISLAMIC SOCIETY

Seemingly out of nowhere, Islam arose in seventh-century Arabia, a land of desert oases with no cities of great size, sparsely inhabited by tribal nomads. Yet, under the leadership of its founder, the Prophet Muhammad (c. 570–632 CE), and his successors, Islam spread rapidly throughout northern Africa, southern and eastern Europe, and much of Asia, gaining territory and converts with astonishing speed. Because Islam encompassed geographical areas with a variety of long-established cultural traditions, and because it admitted diverse peoples among its converts, it absorbed and combined many different techniques and ideas about art and architecture. The result was a remarkable eclecticism and artistic sophistication.

Muslims date their history as beginning with the hijira ("emigration"), the flight of the Prophet Muhammad in 622 from Mecca to Medina. In less than a decade Muhammad had succeeded in uniting the warring clans of Arabia under the banner of Islam. Following his death in 632, four of his closest associates in turn assumed the title of caliph ("successor").

Muhammad's act of emptying the Kaaba of its pagan idols confirmed the fundamental concept of aniconis (avoidance of figural imagery) in Islamic art. Following his example, the Muslim faith discourages the representation of figures, particularly in religious contexts. Instead, Islamic artists elaborated a rich vocabulary of nonfigural ornament, including complex geometric designs and scrolling vines

sometimes known as **arabesques**. Islamic art revels in surface decoration, in manipulating line, color, and especially pattern, often highlighting the interplay of pure abstraction, organic form, and script.

According to tradition, the Qur'an assumed its final form during the time of the third caliph, Uthman (ruled 644–56). As the language of the Qur'an, the Arabic language and script have been a powerful unifying force within Islam. From the eighth through the eleventh centuries, Arabic was the universal language among scholars in the Islamic world and in some Christian lands as well. Inscriptions frequently ornament works of art, sometimes written clearly to provide a readable message, but in other cases written as complex patterns simply to delight the eye.

The accession of Ali as the fourth caliph (ruled 656–61) provoked a power struggle that led to his assassination and resulted in enduring divisions within Islam. Followers of Ali, known as Shi'ites (referring to the party or *shi'a* of Ali), regard him alone as the Prophet's rightful successor. Sunni Muslims, in contrast, recognize all of the first four caliphs as "rightly guided." Ali was succeeded by his rival Muawiya (ruled 661–80), a close relative of Uthman and the founder of the Umayyad dynasty (661–750).

Islam expanded dramatically. In just two decades, seemingly unstoppable Muslim armies conquered the Sasanian Persian Empire, Egypt, and the Byzantine provinces of Syria and Palestine. By the early eighth century, under the Umayyads, they had reached India, conquered northern

Africa and Spain, and penetrated France to within 100 miles of Paris before being turned back (MAP 8–1). In these newly conquered lands, the treatment of Christians and Jews who did not convert to Islam was not consistent, but in general, as "People of the Book"—followers of a monotheistic religion based on a revealed scripture—they enjoyed a protected status. However, they were also subject to a special tax and restrictions on dress and employment.

Muslims participate in congregational worship at a osque (*masjid*, "place of prostration"). The Prophet Muhammad himself lived simply and instructed his followers in prayer at a mud-brick house, now known as the Mosque of the Prophet, where he resided in Medina. This was a square enclosure that framed a large courtyard. Facing the courtyard along the east wall were small rooms where Muhammad and his family lived. Along the south wall, a thatched portico supported by palm-tree trunks sheltered both the faithful as they prayed and Muhammad as he spoke from a low platform. This simple arrangement inspired the design of later mosques.

Lacking an architectural focus such as an altar, nave, or dome, the space of this prototypical mosque reflected the founding spirit of Islam in which the faithful pray directly to God without the intermediary of a priesthood.

ART DURING THE EARLY CALIPHATES

The caliphs of the Umayyad dynasty (661–750), which ruled from Damascus in Syria, built mosques and palaces throughout the Islamic Empire. These buildings projected the authority of the new rulers and reflected the growing acceptance of Islam. In 750 the caliphs of the Abbasid dynasty replaced the Umayyads in a coup d'etat, ruling until 1258 in the grand manner of the ancient Persian emperors. Their capital was Baghdad in Iraq, and their art patronage reflected Persian and Turkic traditions. Their long and cosmopolitan reign saw achievements in medicine, mathematics, the natural sciences, philosophy, literature, music, and art. They were generally

MAP 8–1 | **THE ISLAMIC WORLD**

Within 200 years after 622 CE, the Islamic world expanded from Mecca to India in the east, and to Morocco and Spain in the west.

Easy-to-read color maps use modern country names for ease of reference and point to the sites and locations mentioned in the chapter.



...tion and that of her customer tell a different reflection, which Manet has curiously... as if the mirror were placed at an angle,... ward the patron, whose intent gaze the... physical and psychological distance... nished. Exactly what Manet meant to... position has been much debated. One... wanted to contrast the longing for hap-... reflected miragelike in the mirror, with... ality of ordinary existence that directly... of the painting.

OF MODERN ART

...ressionists are generally regarded as the... art, a many-faceted movement that... the 1860s and lasted for just over a hun-... than a cohesive movement with specific... ics (such as the Rococo, for example),... guished primarily by a rejection of the... hat had been handed down since the... traditional legacy came to artists in the... hniques, conventions, and rules. *Custom*... *le*, that artists paint with oil on canvas,... in certain ways, or that they cast public... *re. Techniques* formed the principal sub-... in, such as one-point perspective and fig-... nude. *Conventions* are the often impo-... tween artists and viewers, which, for... n viewers to see three-dimensional space... surface or to regard large works as more... l ones. *Rules* are more stringent prohibi-... ity laws, which can invoke penalties. Far... ive, this network of traditions defined... ut 400 years, giving artists a scope in... d a set of values by which viewers could... s. Before Modern art, most innovation... e tradition.

...nd half of the nineteenth century, artists... systematically to question that traditional... for various reasons, which some artists... others acted on unconsciously. Some... dition was simply used up and that noth-... aid with it. Others regarded the tradition... fiscat-changing world of urbanization and... that period. Claude Monet, for example,... emic teacher when he urged the class to... pture every time they saw a nude. Monet... about the relevance of Greek sculpture to... artists (probably a minority) were natural... believed in opposing authority. The rise... another important impetus to experi-... Thy perfect ancient methods of rendering

a subject when a machine could do it almost as well? Whatever the reason, Modern artists rejected not only the tradition but also the superstructure that came with it in the form of academic training, Salon exhibitions, and the taste of most of the art-viewing public. This choice was a costly one for many of them, who could have had much more lucrative careers if they had created their art in more acceptable modes.

A deeper cause of Modern art was the modernization of society. The Industrial Revolution created a new public for art in the urban middle classes who flocked to the Salons in search of culture. As we have seen, their taste was cautious and conservative, favoring Academic artists such as Bouguereau, Carpeaux, and Cabanel. Modern artists had little interest in catering to this clientele, and preferred to carry out and exhibit their experiments in realms outside the norm.

In place of the "official" art culture, Modern artists created what has been called an **avant-garde**. The term was initially used in a military context, designating the forward units of an advancing army that scouted territory which the rest of the troops would soon occupy. This term thus captures the forward-looking aspect of Modern art, and the belief that Modernists are working ahead of the public's ability to comprehend. As an art-world social group, the avant-garde consisted of Modern artists, along with a few collectors, art critics, and art dealers who followed the latest developments and found them stimulating. These two concepts, the rejection of tradition and the avant-garde, are most important for understanding Modern art.

Despite the angry protestations of conservative critics, the rejection of tradition did not happen all at once. In fact, the Modern art movement unfolded in a gradual and even logical way, as artists questioned and threw out one rule after another in succeeding decades. Modernism was not revolutionary but rather evolutionary. The Realists shunned traditional narrative content and properly "dignified" subject matter. The Impressionists also did that, and in addition they broke the convention that separated sketch from finished work. Although they seemed radical to some at the time, both of these movements left large parts of the tradition perfectly intact. After Impressionism began to run its course in the middle 1880s, other movements came along to challenge other aspects of the tradition. To these artists and movements we turn next.

Post-Impressionism

The English critic Roger Fry coined the term *Post-Impressionism* in 1910 to identify a broad reaction against Impressionism in avant-garde painting of the late nineteenth and early twentieth centuries. Art historians recognize Paul Cézanne (1839–1906), Georges Seurat (1859–1891), Vincent van Gogh (1853–1890), and Paul Gauguin (1848–1903) as the principal Post-Impressionist painters. Each of these painters moved through an Impressionist phase, and each continued to use in his mature work the bright Impressionist palette. But each came also to reject

Impressionism's emphasis on the spontaneous recording of light and color. Some sought to create art with a greater degree of formal order and structure; others moved further from Impressionism and developed more abstract styles that would prove highly influential for the development of Modern painting in the early twentieth century.

CÉZANNE. No artist had a greater impact on the next generation of Modern painters than Cézanne, who enjoyed little professional success until the last few years of his life, when younger artists and critics began to recognize the innovative qualities of his art. The son of a prosperous banker in the southern French city of Aix-en-Provence, Cézanne studied art first in Aix and then in Paris, where he participated in the circle of Realist artists around Manet. Cézanne's early pictures, somber in color and coarsely painted, often depicted Romantic themes of drama and violence, and were consistently rejected by the Salon.

In the early 1870s Cézanne changed his style under the influence of Pisarro and adopted the bright palette, broken brushwork, and everyday subject matter of Impressionism. Like the Impressionists, with whom he exhibited in 1874 and 1877, Cézanne now dedicated himself to the objective transcription of what he called his "sensations" of nature. Unlike the Impressionists, however, he did not seek to capture transi-

tory effects of light and atmosphere but rather to create a sense of order in nature through a methodical application of color that merged drawing and modeling into a single process. His professed aim was to "make of Impressionism something solid and durable, like the art of the museums."

Cézanne's tireless pursuit of this goal is exemplified in his paintings of Mont Sainte-Victoire, a prominent mountain near his home in Aix that he depicted about thirty times in oil from the mid-1880s to his death. The version here (FIG. 30-62) shows the mountain rising above the Arc Valley, which is dotted with houses and trees and is traversed at the far right by an aqueduct. Framing the scene at the left is an

Sequencing Works of Art		
1884	Homer, *The Life Line*	
1884–86	Seurat, *A Sunday Afternoon on the Island of La Grande Jatte*	
1884–89	Rodin, *Burghers of Calais*	
1885–87	Cézanne, *Mont Sainte-Victoire*	
1887–89	Eiffel, Eiffel Tower, Paris	
1889	van Gogh, *The Starry Night*	

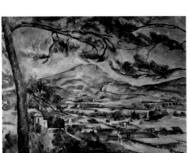

30–62 · Paul Cézanne **MONT SAINTE-VICTOIRE**
c. 1885–87. Oil on canvas, 25½ × 32″ (64.8 × 92.3 cm). Courtauld Institute of Art Gallery, London.
(P 1934 SC 55)

R THIRTY NINETEENTH-CENTURY ART IN EUROPE AND THE UNITED STATES

THE BIRTH OF MODERN ART 1039

Annotation (right margin):

Mini chronologies provide small in-text sequencing charts related to historic events and works of art.

Second spread (The Object Speaks box):

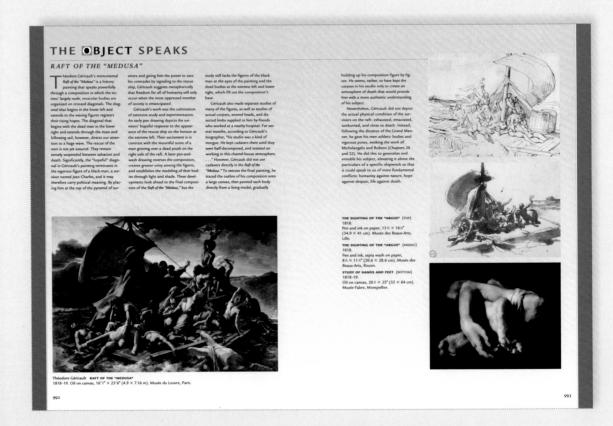

THE ◉BJECT SPEAKS

RAFT OF THE "MEDUSA"

Théodore Géricault's monumental *Raft of the "Medusa"* is a history painting that speaks powerfully through a composition in which the victims' largely nude, muscular bodies are organized on crossed diagonals. The diagonal that begins in the lower left and extends to the waving figures registers their rising hopes. The diagonal that begins with the dead man in the lower right and extends through the mast and billowing sail, however, directs our attention to a huge wave. The rescue of the men is not yet assured. They remain tensely suspended between salvation and death. Significantly, the "hopeful" diagonal in Géricault's painting terminates in the vigorous figure of a black man, a survivor named Jean Charles, and it may therefore carry political meaning. By placing him at the top of the pyramid of survivors and giving him the power to save his comrades by signaling to the rescue ship, Géricault suggests metaphorically that freedom for all of humanity will only occur when the most oppressed member of society is emancipated.

Géricault's work was the culmination of extensive study and experimentation. An early pen drawing depicts the survivors' hopeful response to the appearance of the rescue ship on the horizon at the extreme left. This excitement is in contrast with the mournful scene of a man grieving over a dead youth on the right side of the raft. A later pen-and-wash drawing reverses the composition, creates greater unity among the figures, and establishes the modeling of their bodies through light and shade. These developments look ahead to the final composition of the *Raft of the "Medusa,"* but the

study still lacks the figures of the black man at the apex of the painting and the dead bodies at the extreme left and lower right, which fill out the composition's base.

Géricault also made separate studies of many of the figures, as well as studies of actual corpses, severed heads, and dissected limbs supplied to him by friends who worked at a nearby hospital. For several months, according to Géricault's biographer, "his studio was a kind of morgue. He kept cadavers there until they were half-decomposed, and insisted on working in this charnel-house atmosphere. . . ." However, Géricault did not use cadavers directly in the *Raft of the "Medusa."* To execute the final painting, he traced the outline of his composition onto a large canvas, then painted each body directly from a living model, gradually

building up his composition figure by figure. He seems, rather, to have kept the corpses in his studio only to create an atmosphere of death that would provide him with a more authentic understanding of his subject.

Nevertheless, Géricault did not depict the actual physical condition of the survivors on the raft: exhausted, emaciated, sunburned, and close to death. Instead, following the dictates of the Grand Manner, he gave his men athletic bodies and vigorous poses, evoking the work of Michelangelo and Rubens (Chapters 20 and 22). He did this to generalize and ennoble his subject, elevating it above the particulars of a specific shipwreck so that it could speak to us of more fundamental conflicts: humanity against nature, hope against despair, life against death.

THE SIGHTING OF THE "ARGUS" (TOP)
1818.
Pen and ink on paper, 13¾ × 16½″
(34.9 × 41 cm). Musée des Beaux-Arts, Lille.

THE SIGHTING OF THE "ARGUS" (MIDDLE)
1818.
Pen and ink, sepia wash on paper,
8⅛ × 11¼″ (20.6 × 28.6 cm). Musée des Beaux-Arts, Rouen.

STUDY OF HANDS AND FEET (BOTTOM)
1818–19.
Oil on canvas, 20½ × 25″ (52 × 64 cm).
Musée Fabre, Montpellier.

Théodore Géricault, **RAFT OF THE "MEDUSA"**
1818–19. Oil on canvas, 16′1″ × 23′6″ (4.9 × 7.16 m). Musée du Louvre, Paris.

992

993

Annotation:

The Object Speaks boxes provide in-depth insights on topics such as authenticity, patronage, and artistic intention.

X

Box program brings an added layer of understanding to the contextual and technical aspects of the discipline:

- The Object Speaks
- Elements of Architecture
- Technique
- Defining Art
- Science and Technology
- Religion and Mythology
- Art and Its Context

or woman began in Paris, moved on to southern France to visit a number of well-preserved Roman buildings and monuments there, then headed to Venice, Florence, Naples, and Rome. As repository of the classical and the Renaissance past, Italy was the focus of the Grand Tour and provided inspiration for the most characteristic style to prevail during the Enlightenment, Neoclassicism. Neoclassicism (*neo* means "new") presents classical subject matter—mythological or historical—in a style derived from classical Greek and Roman sources. While some Neoclassical art was conceived to please the senses, most of it was intended to teach moral lessons. In its didactic manifestations—usually history paintings—Neoclassicism was an important means for conveying Enlightenment ideals such as courage and patriotism. It arose, in part, in reaction to the perceived frivolity and excess of the Rococo. Most Enlightenment thinkers held Greece and Rome in high regard as fonts of democracy and secular government, and the Neoclassical artists likewise revived classical stories and styles in an effort to instill those virtues.

Beginning in 1738, extraordinary archaeological discoveries made at two sites near Naples also excited renewed interest in classical art and artifacts. Herculaneum and Pompeii, two prosperous Roman towns buried in 79 CE by the sudden volcanic eruption of Mount Vesuvius, offered sensational new material for study and speculation. Numerous illustrated books on these discoveries circulated throughout Europe and America, fueling public fascination with the ancient world and contributing to a taste for the Neoclassical style.

Italian Portraits and Views

Most educated Europeans regarded Italy as the wellspring of Western culture, where Roman and Renaissance art flourished in the past and a great many artists still practiced. The studios of important Italian artists were required stops on the Grand Tour, and collectors avidly bought portraits and landscapes that could boast an Italian connection.

CARRIERA. Wealthy northern European visitors to Italy often sat for portraits by Italian artists. Rosalba Carriera (1675–1757), the leading portraitist in Venice during the first half of the eighteenth century, began her career designing lace patterns and painting miniature portraits on the ivory lids of snuffboxes. By the early eighteenth century she was making portraits with **pastels**, crayons of pulverized pigment bound to a chalk base by weak gum water. A versatile medium, pastel can be employed in a sketchy manner to create a vivacious and fleeting effect or can be blended through rubbing to produce a highly finished image. Carriera's pastels earned her honorary membership in Rome's Academy of Saint Luke in 1705, and she later was admitted to the academies in Bologna and Florence. In 1720 she traveled to Paris, where she made a pastel portrait of the young Louis XV and was elected to the Royal Academy of Painting and Sculpture,

29–13 | Rosalba Carriera **CHARLES SACKVILLE, 2ND DUKE OF DORSET**
c. 1730. Pastel on paper, 25 × 19" (63.5 × 48.3 cm). Private collection.

despite the f women (see to Italy in 17 in Venice, an guished sitter (FIG. 29–13).

CANALETTO. tors to Italy co city views, w their travels. ("caprice;" pi features, espe sitions; and t rendering of took the for detailed, top of contempo Venetian sitt (1697–1768). *vedute* that hi 1755 in Engl London and a school of E In 1762 Canaletto's s **TO BARTOLO** in 1735–38. century eques

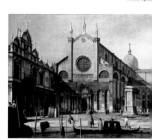

29–14 | Canaletto **SANTI GIOVANNI E PAOLO AND THE MONUMENT TO BART**
c. 1735–38. Oil on canvas, 18½ × 30½" (46 × 78.4 cm). The Royal Collection, W

In Perspective is a concluding synthesis of essential ideas in the chapter.

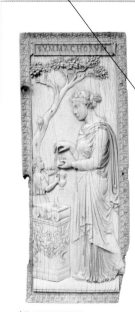

6–79 **PRIESTESS OF BACCHUS (?)**
Right panel of the diptych of Symmachus. c. 390–401 CE. Ivory, 11⅞ × 4¾" (29.9 × 12 cm). Victoria & Albert Museum, London.

pagan practices. As a result, stories of the ancient gods and heroes entered the secular realm as lively, visually delightful, and even erotic decorative elements.

The style and subject matter of the art reflect a society in transition, for even as Roman authority gave way to local rule by powerful "barbarian" tribes in much of the West, many people continued to appreciate classical learning and to treasure Greek and Roman art. In the East, classical traditions and styles endured to become an important element of Byzantine art.

IN PERSPECTIVE

The Romans, who supplanted the Etruscans and the Greeks, appreciated the earlier art of these peoples and adapted it to their own uses, but they also had their own strengths, such as efficiency and a practical genius for organization. As sophisticated visual propaganda, Roman art served the state and the empire. Creating both official images and representations of private individuals, Roman sculptors enriched and developed the art of portraiture. They also recorded contemporary historical events on commemorative arches, columns, and mausoleums.

Roman artists covered the walls of private homes with paintings, too. Sometimes fantastic urban panoramas surround a room, or painted columns and cornices, swinging garlands, and niches make a wall seem to dissolve. Some artists created the illusion of being on a porch or in a pavilion looking out into an extensive landscape. Such painted surfaces are often like backdrops for a theatrical set.

Roman architects relied heavily on the round arch and masonry vaulting. Beginning in the second century BCE, they also relied increasingly on a new building material: concrete. In contrast to stone, the components of concrete are cheap, light, and easily transported. Imposing and lasting concrete structures could be built by a larger, semiskilled work force directed by one or two trained and experienced supervisors.

Drawing artistic inspiration from their Etruscan and Greek predecessors and combining this with their own traditions, Roman artists made a distinctive contribution to the history of art, creating works that formed an enduring ideal of excellence in the West. And as Roman authority gave way to local rule, the newly powerful "barbarian" tribes continued to appreciate and even treasure the Classical learning and art the Romans left behind.

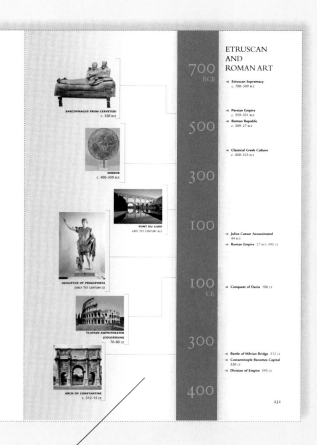

ETRUSCAN AND ROMAN ART

700 BCE
- Etruscan Supremacy c. 700–509 BCE

- Persian Empire c. 559–331 BCE
- Roman Republic c. 509–27 BCE

500

- Classical Greek Culture c. 450–323 BCE

300

100

- Julius Caesar Assassinated 44 BCE
- Roman Empire 27 BCE–395 CE

100 CE

- Conquest of Dacia 106 CE

300

- Battle of Milvian Bridge 312 CE
- Constantinople Becomes Capital 330 CE
- Division of Empire 395 CE

400

SARCOPHAGUS FROM CERVETERI c. 520 BCE

MIRROR c. 400–350 BCE

PONT DU GARD LATE 1ST CENTURY BCE

AUGUSTUS OF PRIMAPORTA EARLY 1ST CENTURY CE

FLAVIAN AMPHITHEATER (COLOSSEUM) 70–80 CE

ARCH OF CONSTANTINE c. 312–15 CE

231

Timelines provide an overview of the chapter time frame.

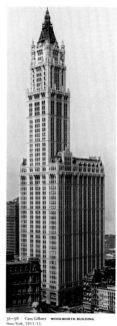

Elements of Architecture
THE SKYSCRAPER

The evolution of the skyscraper depended on the development of these essentials: metal beams and girders for the structural-support skeleton; the separation of the building-support structure from the enclosing layer (the cladding); fireproofing materials and measures; elevators; and plumbing, central heating, artificial lighting, and ventilation systems. First-generation skyscrapers, built between about 1880 and 1900, were concentrated in the Midwest, especially in Chicago and St. Louis (SEE FIG. 30–86). Second-generation skyscrapers, with more than twenty stories, date from 1895. At first the tall buildings were freestanding towers, sometimes with a base, like the Woolworth Building of 1911–13 (SEE FIG. 31–56). New York City's Building Zone Resolution of 1916 introduced mandatory setbacks—recessions from the ground-level building line—to ensure light and ventilation of adjacent sites. Built in 1931, the 1,250-foot setback form of the Empire State Building, diagrammed here, is thoroughly modern in having a streamlined exterior—its cladding is in Art Deco style (SEE FIG. 31–25, caption)—that conceals the great complexity of the internal structure and mechanisms that make its height possible. The Empire State Building is still one of the tallest buildings in the world.

which is intended to facilitate contemplation of the spectacular view across the canyon. The roofline of the structure is also irregular, like the surrounding canyon wall. Inside, she used huge bare logs for most of the structural supports, between raw stone walls. All of these features can also be found in Hopi architecture. The sole concessions to modernity are in the liberal use of glass and a flat cement floor over the stone foundation. Her work on hotels and railroad stations throughout the Southwest helped to establish a distinctive identity for architecture of that region.

THE AMERICAN SKYSCRAPER. After 1900, New York City assumed leadership in the development of the skyscraper, whose soaring height was made possible by the use of the steel-frame skeleton for structural support and other advances in engineering and technology (see "The Skyscraper," above).

New York clients rejected the innovative style of Louis Sullivan and other Chicago architects for the historicist approach still in favor in the East, as seen in the **WOOLWORTH BUILDING** (FIG. 31–56), designed by the Minnesota-based Cass Gilbert (1859–1934). When completed, at 792 feet and 55 floors, it was the world's tallest building. Its Gothic-style external details, inspired by the soaring towers of late-medieval churches, resonated well with the United States' increasing worship of business. Gilbert explained that he wished to make something "spiritual" of what others called his "Cathedral of Commerce."

ART BETWEEN THE WARS

World War I had a profound effect on Europe's artists and architects. While the Dadaists responded sarcastically to the unprecedented destruction, some sought in the war's ashes the basis for a new, more secure civilization. The onset of the Great Depression in 1929 also motivated many artists to try to find ways to serve society. In general, a great deal of art produced between 1919 and 1939 in Europe and North America is connected in some way with the hope for a better and more just world, rather than primarily serving self-expression or the investigation of aesthetics.

Utilitarian Art Forms in Russia

In the 1917 Russian Revolution, the radical socialist Bolsheviks overthrew the czar, took Russia out of the world war, and turned to winning an internal civil war that lasted until 1920. Most of the Russian avant-garde enthusiastically supported the Bolsheviks, who in turn supported them.

CONSTRUCTIVISM. The case of Aleksandr Rodchenko (1891–1956) is fairly representative. An early associate of Malevich and Popova (SEE FIGS. 31–29, 31–31), Rodchenko initially used drafting tools to make abstract drawings. The Suprematist phase of his career culminated in a 1921 exhibition where he showed three large flat, monochromatic panels painted in red, yellow, and blue, which he titled *Last Painting* (they are unfortunately lost). After making this work, he renounced painting as a basically selfish activity and condemned self-expression as socially irresponsible.

In the same year he helped launch a group known as the Constructivists, who were committed to quitting the studio and going "into the factory, where the real body of life is made." In place of artists dedicated to expressing themselves or exploring aesthetic issues, politically committed artists would create useful objects and promote the aims of society. Rodchenko came to believe that painting and sculpture did not contribute enough to practical needs, so after 1921 he began to make photographs, posters, books, textiles, and theater sets that would promote the egalitarian ends of the new Soviet society.

31–56 | Cass Gilbert **WOOLWORTH BUILDING**
New York. 1911–13.
© Collection of the New York Historical Society, New York

Diagrams make difficult concepts related to architecture and materials and techniques accessible to students.

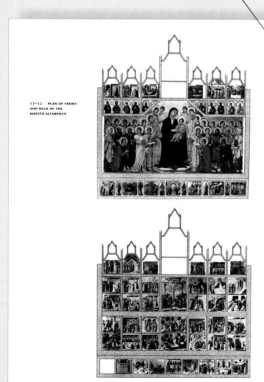

17–12 | **PLAN OF FRONT AND BACK OF THE MAESTÀ ALTARPIECE**

Creating this altarpiece was an arduous undertaking. The central panel alone was 7 by 13 ½ feet, and it had to be painted on both front and back, because it was meant to be seen from both sides. The main altar for which it was designed stood beneath the dome in the center of the sanctuary. Inscribed on Mary's throne are the words, "Holy Mother of God be thou the cause of peace for Siena and, because he painted thee thus, of life for Duccio" (cited in Hartt and Wilkins 4.2, page 104).

Mary and Christ, adored by angels and the four patron saints of Siena—Ansanus, Savinus, Crescentius, and Victor—kneeling in front, fill the large central panel. This *Virgin and Child in Majesty* represents both the Church and its specific embodiment, Siena Cathedral. Narrative scenes from the early life of the Virgin and the infancy of the Christ Child appear below the central image. The **predella** (the lower zone of the altarpiece) was entirely painted with the events in the childhood of Jesus. The back of this immense work was dedicated to scenes of his adult life and the miracles. The entire composition was topped by pinnacles—on the front, angels and the later life of the Virgin, and on the back, events after the Passion.

Duccio created a personal style that combines a softened Italo-Byzantine figure style with the linear grace and the easy relationship between figures and their settings characteristic of French Gothic. This subtle blending of northern and southern elements can be seen in the haloed ranks of angels around Mary's architectonic throne. The central, most holy figures retain a solemnity and immobility while more realistic touches, such as the weighty figure of the child, the adoring saints reflect a more naturalistic, courtly Gothic style that became the hallmark of the Sienese school for years to come. The brilliant palette, which mingles pastels with primary hues, the delicately patterned textiles that shimmer with gold, and the ornate **punchwork**—tooled designs in gold leaf on the haloes—are characteristically Sienese.

In 1771 the altarpiece was broken up, and individual panels were sold. One panel—the **NATIVITY WITH PROPHETS ISAIAH AND EZEKIEL**—is now in Washington, D.C. Duccio represented the Nativity in the tradition of Byzantine icons. Mary lies on a fat mattress within a cave hollowed out of a jagged, stylized mountain (FIG. 17–13). Jesus appears twice: first lying in the manger and then with the midwife below. However, Duccio followed Western tradition by placing the scene in a shed. Rejoicing angels fill the sky, and the shepherds and sheep add a realistic touch in the lower right corner. The light, intense colors, the calligraphic linear quality, even the meticulously rendered details recall Gothic manuscripts (see Chapter 16). The tentative move toward a defined space in the shed as well as the subtle modeling of the figures point the way toward future development in representing people and their world. Duccio's graceful, courtly art contrasts with Giotto's austere monumentality.

Technique
BUON FRESCO

The two techniques used in mural painting are **buon** ("true") *fresco* ("fresh"), in which paint is applied with water-based paints on wet plaster, and *fresco secco* ("dry"), in which paint is applied to a dry plastered wall. The two methods can be used on the same wall painting.

The advantage of *buon fresco* is its durability. A chemical reaction occurs as the painted plaster dries, which bonds the pigments into the wall surface. In *fresco secco*, by contrast, the color does not become part of the wall and tends to flake off over time. The chief disadvantage of *buon fresco* is that it must be done quickly without mistakes. The painter plasters and paints only as much as can be completed in a day. In Italy, each section is called a *giornata*, or day's work. The size of a giornata varies according to the complexity of the painting within it. A face, for instance, can occupy an entire day, whereas large areas of sky can be painted quite rapidly.

In medieval and Renaissance Italy, a wall to be frescoed was first prepared with a rough, thick undercoat of plaster. When this was dry, assistants copied the master painter's composition onto it with charcoal. The artist made any necessary adjustments. These drawings, known as *sinopia*, have an immediacy and freshness lost in the finished painting. Work proceeded in irregularly shaped sections conforming to the contours of major figures and objects. Assistants covered one section at a time with a fresh, thin coat of very fine plaster over the sinopia, and when this was "set" but not dry, the artist worked with pigments mixed with water. Painters worked from the top down so that drips fell on unfinished portions. Some areas requiring pigments such as ultramarine blue (which was unstable in *buon fresco*), as well as areas requiring gilding, would be added after the wall was dry using the *fresco secco* method.

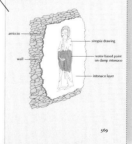

arriccio
sinopia drawing
wall
water-based paint on damp intonaco
intonaco layer

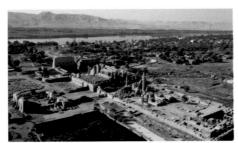

3-22 | THE RUINS OF THE GREAT TEMPLE OF AMUN AT KARNAK, EGYPT

hall and sanctuary. The design was symmetrical and axial—that is, all of its separate elements were symmetrically arranged along a dominant center line, creating a processional path.

The rooms became smaller, darker, and more exclusive as they neared the sanctuary. Only the pharaoh and the priests entered these inner rooms.

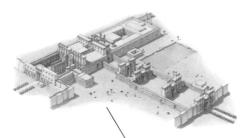

3-23 | RECONSTRUCTION DRAWING OF THE GREAT TEMPLE OF AMUN AT KARNAK, EGYPT
New Kingdom, c. 1579–1075 BCE.

Two temple districts consecrated primarily to the worship of Amun, Mut, and Khons arose near Thebes—a huge complex at Karnak to the north and, joined to it by an avenue of sphinxes, a more compact temple at Luxor to the south.

KARNAK. At Karnak, temples were built and rebuilt for over 1,500 years, and the remains of the New Kingdom additions to the Great Temple of Amun still dominate the landscape (FIG. 3–22). Over the nearly 500 years of the New Kingdom, successive kings renovated and expanded the Amun temple until the complex covered about 60 acres, an area as large as a dozen football fields (FIG. 3–23).

Access to the heart of the temple, a sanctuary containing the statue of Amun, was from the west (on the left side of the reconstruction drawing) through a principal courtyard, a hypostyle hall, and a number of smaller halls and courts. Pylons set off each of these separate elements. Between the Eighteenth and Nineteenth dynasty reigns of Thutmose I (ruled c. 1493–? BCE), and Rameses II (ruled c. 1279–1213 BCE), this area of the complex underwent a great deal of construction and renewal. The greater part of Pylons II through VI leading to the sanctuary (modern archaeologists have given the pylons numbers) and the halls and courts behind them were renovated or newly built and embellished with colorful wall reliefs. A sacred lake to the south of the temple, where the king and priests might undergo ritual purification before entering, was also added. In the Eighteenth Dynasty, Thutmose III erected a court and festival temple to his own glory behind the sanctuary of Amun. His great-grandson Amenhotep III (ruled 1390–1353 BCE) placed a large stone statue of the god Khepri, the scarab (beetle) symbolic of the rising sun, rebirth, and everlasting life, next to the sacred lake.

In the sanctuary, the priests washed the god's statue every morning and clothed it in a new garment. Because the god was thought to derive nourishment from the spirit of food, it was provided with tempting meals twice a day, which the priests then removed and ate themselves. Ordinary people entered the temple precinct only as far as the forecourts of the hypostyle halls, where they found themselves surrounded by inscriptions and images of kings and the god on columns and walls. During religious festivals, however, they lined the waterways, along which statues of the gods were carried in ceremonial boats, and were permitted to submit petitions to the priests for requests they wished the gods to grant.

THE GREAT HALL AT KARNAK. Between Pylons II and III at Karnak stands the enormous hypostyle hall erected in the reigns of the Nineteenth Dynasty rulers Sety I (ruled c. 1290–1279 BCE) and his son Rameses II (ruled c. 1279–1213 BCE). Called the "Temple of the Spirit of Sety, Beloved of Ptah in the House of Amun," it may have been used for royal coronation ceremonies. Rameses II referred to it as "the place where the common people extol the name of

his majesty." The hall was 340 feet wide and 170 feet long. Its 134 closely spaced columns supported a stepped roof of flat stones, the center section of which rose some 30 feet higher than the rest of the roof (FIGS. 3–24, 3–25). The columns supporting this higher part of the roof are 66 feet tall and 12 feet in diameter, with massive lotus flower capitals. On each side, smaller columns with lotus bud capitals seem to march off forever into the darkness. In each of the side walls of the higher

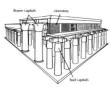

3-24 | RECONSTRUCTION DRAWING OF THE HYPOSTYLE HALL, GREAT TEMPLE OF AMUN AT KARNAK
Nineteenth Dynasty, c. 1292–1190 BCE.

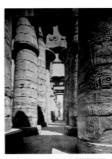

3-25 | FLOWER AND BUD COLUMNS, HYPOSTYLE HALL, GREAT TEMPLE OF AMUN AT KARNAK

Reconstructions bring partially destroyed and no longer extant sites to life.

THE CATHEDRAL. In Florence, the cathedral (duomo) (FIGS. 17–3, 17–4) has a long and complex history. The original plan, by Arnolfo di Cambio (c. 1245–1302), was approved in 1294, but political unrest in the 1330s brought construction to a halt until 1357. Several modifications of the design were made, and the cathedral we see today was built between 1357 and 1378. (The façade was given its veneer of white and green marble in the nineteenth century to coordinate it with the rest of the building and the nearby Baptistry of San Giovanni.)

Sculptors and painters rather than masons were often responsible for designing Italian architecture, and as the Florence Cathedral reflects, they tended to be more concerned with pure design than with engineering. The long, square-bayed nave ends in an octagonal domed crossing, as wide as

the nave and side aisles. Three polygonal apses, each with five radiating chapels, surround the central space. This symbolic Dome of Heaven, where the main altar is located, stands apart from the worldly realm of the congregation in the nave. But the great ribbed dome, so fundamental to the planners' conception, was not begun until 1420, when the architect Filippo Brunelleschi (1377–1446) solved the engineering problems involved in its construction (see Chapter 19).

THE BAPTISTRY DOORS. In 1330, Andrea Pisano (c. 1290–1348) was awarded the prestigious commission for a pair of gilded bronze doors for the Florentine Baptistry of San Giovanni. (Although his name means "from Pisa," Andrea was not related to Nicola and Giovanni Pisano.) The Baptistry doors were completed within six years and display

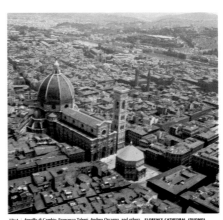

17-4 | Arnolfo di Cambio, Francesco Talenti, Andrea Orcagna, and others FLORENCE CATHEDRAL (DUOMO)
1296–1378; drum and dome by Brunelleschi, 1420–36; bell tower (Campanile) by Giotto, Andrea Pisano, and Francesco Talenti, c. 1334–50.

The Romanesque Baptistry of San Giovanni stands in front of the Duomo.

twenty scenes from the life of John the Baptist (San Giovanni) set above eight personifications of the Virtues (FIG. 17–5). The reliefs are framed by quatrefoils, the four-lobed decorative frames introduced at the Cathedral of Amiens in France (SEE FIG. 16–21). The figures within the quatrefoils are in the monumental, classicizing style inspired by Giotto then current in Florentine painting, but they also reveal the soft curves of northern Gothic forms in their gestures and draperies, and a quiet dignity of pose particular to Andrea. The individual scenes are elegantly natural. The figures' placement, on shelflike stages, and their modeling create a remarkable illusion of three-dimensionality, but the overall effect created by the repeated barbed quatrefoils is two-

dimensional and decorative, and emphasizes the solidity of the doors. The bronze vine scrolls filled with flowers, fruits, and birds on the lintel and jambs framing the door were added in the mid-fifteenth century.

Florentine Painting

Florence and Siena, rivals in so many ways, each supported a flourishing school of painting in the fourteenth century. Both grew out of the Italo-Byzantine style of the thirteenth century, modified by local traditions and by the presence of individual artists of genius. The Byzantine influence, also referred to as the maniera greca ("Greek manner"), was characterized by dramatic pathos and complex iconography and showed

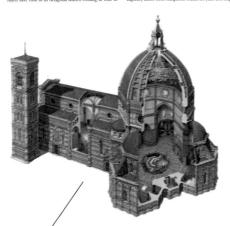

17-3 | FLORENCE CATHEDRAL (DUOMO)
Plan 1294, construction begun 1296, redesigned 1357 and 1366, drum and dome 1420–36.
Illustration by Philippe Biard in Guide Gallimard Florence © Gallimard Loisirs.

Cutaways assist students in understanding the design and engineering of major buildings.

FACULTY AND STUDENT RESOURCES FOR *ART HISTORY*

Prentice Hall is pleased to present an outstanding array of high quality resources for teaching and learning with Stokstad's *Art History*.

DIGITAL & VISUAL RESOURCES

The Prentice Hall Digital Art Library: Instructors who adopt Stokstad's *Art History* are eligible to receive this unparalleled resource. Available in a two-DVD set (ISBN 0-13-232211-0) or a 16-CD set (ISBN 0-13-156321-1), the Prentice Hall Digital Art Library contains every image in *Art History* in the highest resolution (300–400 dpi) and pixellation (up to 3000 pixels) possible for optimal projection and one-click download. Developed with input from a panel of instructors and visual resource curators, this resource features over 1,200 illustrations in jpeg and in PowerPoint, an instant download function for easy import into any presentation software, along with a zoom feature, and a compare/contrast function, both of which are unique and were developed exclusively for Prentice Hall.

 VangoNotes: Students can study on the go with VangoNotes—chapter reviews from the text in downloadable mp3 format. Each chapter review contains: Big Ideas—your "need to know" for each chapter; Key Terms: audio "flashcards" to help you review key concepts and terms; and Rapid Review: a quick drill session—use it right before your test. Visit **www.vango.com.**

 OneKey is Prentice Hall's exclusive course management system that delivers all student and instructor resources in one place. Powered by WebCT and Blackboard, OneKey offers an abundance of online study and research tools for students and a variety of teaching and presentation resources for instructors, including an easy-to-use gradebook and access to many of the images from the book.

 Art History Interactive CD-ROM: 1,000 Images for Study & Presentation is a powerful study tool for students. Images are viewable by title, by period, or by artist. Students can quiz themselves in flashcard mode or by answering any number of short answer and compare/contrast questions.

Classroom Response System (CRS) In Class Questions: Get instant, class-wide responses to beautifully illustrated chapter-specific questions during a lecture to gauge student comprehension—and keep them engaged. Visit www.prenhall.com/art.

 Companion Website: Visit www.prenhall.com/stokstad for a comprehensive online resource featuring a variety of learning and teaching modules, all correlated to the chapters of *Art History*.

Prentice Hall Test Generator is a commercial-quality computerized test management program available for both Microsoft Windows and Macintosh environments.

PRINT RESOURCES

 TIME Special Edition, Art: Featuring stories such as "The Mighty Medici," "When Henri Met Pablo," and "Redesigning America," Prentice Hall's TIME Special Edition contains thirty articles and exhibition reviews on a wide range of subjects, all illustrated in full color. This is the perfect complement for discussion groups, in-class debates, or writing assignments. With TIME Special Edition, students also receive a three-month pass to the TIME archive, a unique reference and research tool.

***Understanding the Art Museum* by Barbara Beall-Fofana:** This handbook gives students essential museum-going guidance to help them make the most of their experience seeing art outside of the classroom. Case studies are incorporated into the text, and a list of major museums in the United States and key cities across the world is included. (0-13-195070-3)

 OneSearch with Research Navigator helps students with finding the right articles and journals in art history. Students get exclusive access to three research databases: The New York Times Search by Subject Archive, ContentSelect Academic Journal Database, and Link Library.

Instructor's Manual & Test Item File is an invaluable professional resource and reference for new and experienced faculty, containing sample syllabi, hundreds of sample test questions, and guidance on incorporating media technology into your course. (0-13-232214-5)

To find your Prentice Hall representative, use our rep locator at **www.prenhall.com.**

ACKNOWLEDGEMENTS
AND GRATITUDE

Dedicated to my sister, Karen L. S. Leider, and to my niece, Anna J. Leider

A preface gives the author yet another opportunity to thank the many readers, faculty members, and students who have contributed to the development of a book. To all of you who have called, written, e-mailed, and just dropped by my office in the Art History Department or my study in the Spencer Research Library at the University of Kansas, I want to express my heartfelt thanks. Some of you worried about pointing out defects, omissions, or possible errors in the text or picture program of the previous edition. I want to assure you that I am truly grateful for your input and that I have made all the corrections and changes that seemed right and possible. (I swear the Weston photograph in the Introduction is correctly positioned in this edition, and that, no, I was not just being witty by showing only the Gallic trumpeter's back side in Chapter 5—that slip has been corrected!)

Art History represents the cumulative efforts of a distinguished group of scholars and educators. Single authorship of a work such as this is no longer viable, especially because of its global coverage. The work done by Stephen Addiss, Chu-tsing Li, Marylin M. Rhie, and Christopher D. Roy for the original edition has been updated and expanded by David Binkley and Patricia Darish (Africa), and Claudia Brown (Asia). Patrick Frank has reworked the modern material previously contributed by David Cateforis and Bradford R. Collins. Dede Ruggles (Islamic) and Sara Orel (Pacific Cultures) also have contributed to the third edition.

As ever, this edition has benefited from the assistance and advice of scores of other teachers and scholars who have generously answered my questions, given recommendations on organization and priorities, and provided specialized critiques. I want to especially thank the anonymous reviewers for their advice about reorganizing and revising individual chapters.

In addition, I want to thank University of Kansas colleagues Sally Cornelison, Amy McNair, Marsha Haufler, Charles Eldredge, Marni Kessler, Susan Earle, John Pulz, Linda Stone Ferrier, Stephen Goddard, and Susan Craig for their insightful suggestions and intelligent reactions to revised material. I want to mention, gratefully, graduate students who also helped: Stephanie Fox Knappe, Kate Meyer, and Emily Stamey.

I am additionally grateful for the detailed critiques that the following readers across the country prepared for this third edition: Charles M. Adelman, University of Northern Iowa; Fred C. Albertson, University of Memphis; Frances Altvater, College of William and Mary; Michael Amy, Rochester Institute of Technology; Jennifer L. Ball, Brooklyn College, CUNY; Samantha Baskind, Cleveland State University; Tracey Boswell, Johnson County Community College; Jane H. Brown, University of Arkansas at Little Rock; Roger J. Crum, University of Dayton; Brian A. Curran, Penn State University; Michael T. Davis, Mount Holyoke College; Juilee Decker, Georgetown College; Laurinda Dixon, Syracuse University; Laura Dufresne, Winthrop University; Dan Ewing, Barry University; Arne Flaten, Coastal Carolina University; John Garton, Cleveland Institute of Art; Rosi Gilday, University of Wisconsin, Oshkosh; Eunice D. Howe, University of Southern California; Phillip Jacks, George Washington University; William R. Levin, Centre College; Susan Libby, Rollins College; Henry Luttikhuizen, Calvin College; Lynn Mackenzie, College of DuPage; Dennis McNamara, Triton College; Gustav Medicus, Kent State University; Lynn Metcalf, St. Cloud State University; Jo-Ann Morgan, Coastal Carolina University; Beth A. Mulvaney, Meredith College; Dorothy Munger, Delaware Community College; Bonnie Noble, University of North Carolina at Charlotte; Leisha O'Quinn, Oklahoma State University; Willow Partington, Hudson Valley Community College; Martin Patrick, Illinois State University; Albert Reischuck, Kent State University; Jeffrey Ruda, University of California, Davis; Diane Scillia, Kent State University; Stephanie Smith, Youngstown State University; Janet Snyder, West Virginia University; James Terry, Stephens College; Michael Tinkler, Hobart and William Smith Colleges; Reid Wood, Lorain County Community College. I hope that these readers will recognize the important part they have played in this new edition of *Art History* and that they will enjoy the fruits of all our labors. Please continue to share your thoughts and suggestions with me.

Many people reviewed the original edition of *Art History* and have continued to assist with its revision. Every chapter was read by one or more specialists. For work on the original book and assistance with subsequent editions my thanks go to: Barbara Abou-el-Haj, SUNY Binghamton; Roger Aiken, Creighton University; Molly Aitken; Anthony Alofsin, University of Texas, Austin; Christiane Andersson, Bucknell University; Kathryn Arnold; Julie Aronson, Cincinnati Art Museum; Michael Auerbach, Vanderbilt University; Larry Beck; Evelyn Bell, San Jose State University; Janetta Rebold Benton, Pace University; Janet Berlo, University of Rochester; Sarah Blick, Kenyon College; Jonathan Bloom, Boston College; Suzaan Boettger; Judith Bookbinder, Boston College; Marta Braun, Ryerson University; Elizabeth Broun, Smithsonian American Art Museum; Glen R. Brown, Kansas State University; Maria Elena Buszek, Kansas City Art Institute; Robert G. Calkins; Annmarie Weyl Carr, Southern Methodist University; April Clagget, Keene State College;

William W. Clark, Queens College, CUNY; John Clarke, University of Texas, Austin; Jaqueline Clipsham; Ralph T. Coe; Robert Cohon, The Nelson-Atkins Museum of Art; Bradford Collins, University of South Carolina; Alessandra Comini; Charles Cuttler; James D'Emilio, University of South Florida; Walter Denny, University of Massachusetts, Amherst; Jerrilyn Dodds, City College, CUNY; Lois Drewer, Index of Christian Art; Joseph Dye, Virginia Museum of Art; James Farmer, Virginia Commonwealth University; Grace Flam, Salt Lake City Community College; Mary D. Garrard; Paula Gerson, Florida State University; Walter S. Gibson; Dorothy Glass; Oleg Grabar; Randall Griffey, The Nelson-Atkins Museum of Art; Cynthia Hahn, Florida State University; Sharon Hill, Virginia Commonwealth University; John Hoopes, University of Kansas; Carol Ivory, Washington State University; Reinhild Janzen, Washburn University; Alison Kettering, Carleton College; Wendy Kindred, University of Maine at Fort Kent; Alan T. Kohl, Minneapolis College of Art; Ruth Kolarik, Colorado College; Carol H. Krinski, New York University; Aileen Laing, Sweet Briar College; Janet Le Blanc, Clemson University; Charles Little, The Metropolitan Museum of Art; Laureen Reu Liu, McHenry County College; Loretta Lorance; Brian Madigan, Wayne State University; Janice Mann, Bucknell University; Judith Mann, St. Louis Art Museum; Richard Mann, San Francisco State University; James Martin; Elizabeth Parker McLachlan, Rutgers University; Tamara Mikailova, St. Petersburg, Russia, and Macalester College; Anta Montet-White; Anne E. Morganstern, Ohio State University; Winslow Myers, Bancroft School; Lawrence Nees, University of Delaware; Amy Ogata, Cleveland Institute of Art; Judith Oliver, Colgate University; Edward Olszewski, Case Western Reserve University; Sara Jane Pearman; John G. Pedley, University of Michigan; Michael Plante, Tulane University; Eloise Quiñones-Keber, Baruch College and the Graduate Center, CUNY; Virginia Raguin, College of the Holy Cross; Nancy H. Ramage, Ithaca College; Ann M. Roberts, Lake Forest College; Lisa Robertson, The Cleveland Museum of Art; Barry Rubin; Charles Sack, Parsons, Kansas; Jan Schall, The Nelson-Atkins Museum of Art; Tom Shaw, Kean College; Pamela Sheingorn, Baruch College, CUNY; Raechell Smith, Kansas City Art Institute; Lauren Soth; Anne R. Stanton, University of Missouri, Columbia; Michael Stoughton; Thomas Sullivan, OSB, Benedictine College (Conception Abbey); Pamela Trimpe, University of Iowa; Richard Turnbull, Fashion Institute of Technology; Elizabeth Valdez del Alamo, Montclair State College; Lisa Vergara; Monica Visoná, University of Kentucky; Roger Ward, Norton Museum of Art; Mark Weil, Washington University, St. Louis; David Wilkins; Marcilene Wittmer, University of Miami.

My thanks also to additional expert readers for this new edition including Susan Cahan, University of Missouri-St. Louis; David Craven, University of New Mexico; Marian Feldman, University of California, Berkeley; Dorothy Johnson, University of Iowa; Genevra Kornbluth, University of Maryland; Patricia Mainardi, City University of New York; Clemente Marconi, Columbia University, Tod Marder, Rutgers University; Mary Miller, Yale University; Elizabeth Penton, Durham Technical Community College; Catherine B. Scallen, Case Western University; Kim Shelton, University of California, Berkeley.

I also want to thank Saralyn Reese Hardy, William J. Crowe, Richard W. Clement, and the Kenneth Spencer Research Library and the Helen F. Spencer Museum of Art of the University od Kansas.

Again I worked with my editors at Prentice Hall, Sarah Touborg and Helen Ronan, to create a book that would incorporate effective pedagogical features into a narrative that explores fundamental art historical ideas. Helen Ronan, Barbara Taylor-Laino, Assunta Petrone, and Lisa Iarkowski managed the project. I am grateful for the editing of Jeannine Ciliotta, Margaret Manos, Teresa Nemeth, and Carol Peters. Peter Bull's drawings have brought new information and clarity to the discussions of architecture. Designer Anne Demarinis created the intelligent, approachable design of this book; she was supported by the masterful talents of Amy Rosen and Gail Cocker-Bogusz. Much appreciation goes to Brandy Dawson, Marissa Feliberty, and Sasha Anderson-Smith in marketing and Sherry Lewis the manufacturing buyer, as well as the entire Humanities and Social Sciences team at Prentice Hall.

I hope you will enjoy this third edition of *Art History* and, as you have done so generously and graciously over the past years, will continue to share your responses and suggestions with me.

—Marilyn Stokstad
Lawrence, Kansas

USE NOTES

The various features of this book reinforce each other, helping the reader to become comfortable with terminology and concepts that are specific to art history.

Starter Kit and Introduction The Starter Kit is a highly concise primer of basic concepts and tools. The Introduction is an invitation to the many pleasures of art history.

Captions There are two kinds of captions in this book: short and long. Short captions identify information specific to the work of art or architecture illustrated:

> artist (when known)
> title or descriptive name of work
> date
> original location (if moved to a museum or other site)
> material or materials a work is made of
> size (height before width) in feet and inches, with meters and centimeters in parentheses
> present location

The order of these elements varies, depending on the type of work illustrated. Dimensions are not given for architecture, for most wall paintings, or for most architectural sculpture. Some captions have one or more lines of small print below the identification section of the caption that gives museum or collection information. This is rarely required reading.

Long captions contain information that complements the narrative of the main text.

Definitions of Terms You will encounter the basic terms of art history in three places:

> IN THE TEXT, where words appearing in boldface type are defined, or glossed, at their first use. Some terms are boldfaced and explained more than once, especially those that experience shows are hard to remember.

> IN BOXED FEATURES, on technique and other subjects, where labeled drawings and diagrams visually reinforce the use of terms.

> IN THE GLOSSARY, at the end of the volume, which contains all the words in boldface type in the text and boxes. The Glossary begins on page G1, and the outer margins are tinted to make it easy to find.

Maps and Timelines At the beginning of each chapter you will find a map with all the places mentioned in the chapter. At the end of each chapter, a timeline runs from the earliest through the latest years covered in that chapter.

Boxes Special material that complements, enhances, explains, or extends the text is set off in three types of tinted boxes. Elements of Architecture boxes clarify specifically architectural features, such as "Space-Spanning Construction Devices" in the Starter Kit (page xx). Technique boxes (see "Lost-Wax Casting," page xxiv) amplify the methodology by which a type of artwork is created. Other boxes treat special-interest material related to the text.

Bibliography The bibliography at the end of this book beginning on page B1 contains books in English, organized by general works and by chapter, that are basic to the study of art history today, as well as works cited in the text.

Dates, Abbreviations, and Other Conventions This book uses the designations BCE and CE, abbreviations for "Before the Common Era" and "Common Era," instead of BC ("Before Christ") and AD ("Anno Domini," "the year of our Lord"). The first century BCE is the period from 99 BCE to 1 BCE; the first century CE is from the year 1 CE to 99 CE. Similarly, the second century CE is the period from 199 BCE to 100 BCE; the second century CE extends from 100 CE to 199 CE.

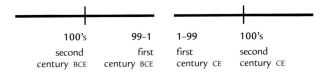

100's	99–1	1–99	100's
second	first	first	second
century BCE	century BCE	century CE	century CE

Circa ("about" or "approximately") is used with dates, spelled out in the text and abbreviated to "c." in the captions, when an exact date is not yet verified.

An illustration is called a "figure," or "fig." Thus, figure 6–7 is the seventh numbered illustration in Chapter 6. Figures 1 through 24 are in the Introduction. There are two types of figures: photographs of artworks or of models, and line drawings. Drawings are used when a work cannot be photographed or when a diagram or simple drawing is the clearest way to illustrate an object or a place.

When introducing artists, we use the words *active* and *documented* with dates, in addition to "b." (for "born") and "d." (for "died"). "Active" means that an artist worked during the years given. "Documented" means that documents link the person to that date.

Accents are used for words in French, German, Italian, and Spanish only.

With few exceptions, names of museums and other cultural bodies in Western European countries are given in the form used in that country.

Titles of Works of Art Most paintings and works of sculpture created in Europe and North America in the past 500 years have been given formal titles, either by the artist or by critics and art historians. Such formal titles are printed in italics. In other traditions and cultures, a single title is not important or even recognized. In this book we use formal descriptive titles of artworks where titles are not established. If a work is best known by its non-English title, such as Manet's *Le Déjeuner sur l'Herbe (The Luncheon on the Grass)*, the original language precedes the translation.

STARTER KIT

A rt history focuses on the visual arts—painting, drawing, sculpture, graphic arts, photography, decorative arts, and architecture. This Starter Kit contains basic information and addresses concepts that underlie and support the study of art history. It provides a quick reference guide to the vocabulary used to classify and describe art objects. Understanding these terms is indispensable since you will encounter them again and again in reading, talking, and writing about art, and when experiencing works of art directly.

Let us begin with the basic properties of art. A work of art is a material object having both form and content. It is also described and categorized according to its style and medium.

FORM

Referring to purely visual aspects of art and architecture, the term form encompasses qualities of *line, shape, color, texture, space, mass* and *volume,* and *composition.* These qualities all are known as *formal elements.* When art historians use the term formal, they mean "relating to form."

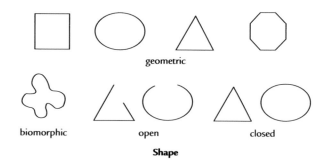

geometric

biomorphic open closed

Shape

Line and **shape** are attributes of form. Line is a form—usually drawn or painted—the length of which is so much greater than the width that we perceive it as having only length. Line can be actual, as when the line is visible, or it can be implied, as when the movement of the viewer's eyes over the surface of a work follows a path determined by the artist. Shape, on the other hand, is the two-dimensional, or flat, area defined by the borders of an enclosing *outline,* or *contour.* Shape can be *geometric, biomorphic* (suggesting living things; sometimes called organic), *closed,* or *open.* The *outline,* or *contour,* of a three-dimensional object can also be perceived as line.

Color has several attributes. These include *hue, value,* and *saturation.*

Hue is what we think of when we hear the word color, and the terms are interchangeable. We perceive hues as the result of differing wavelengths of electromagnetic energy. The visible spectrum, which can be seen in a rainbow, runs from red through violet. When the ends of the spectrum are connected through the hue red-violet, the result may be diagrammed as a color wheel. The *primary hues* (numbered 1) are red, yellow, and blue. They are known as primaries because all other colors are

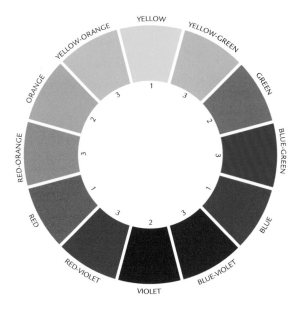

made of a combination of these hues. Orange, green, and violet result from the mixture of two primaries and are known as secondary hues (numbered 2). *Intermediate hues,* or *tertiaries* (numbered 3), result from the mixture of a primary and a secondary. *Complementary colors* are the two colors directly opposite one another on the color wheel, such as red and green. Red, orange, and yellow are regarded as warm colors and appear to advance toward us. Blue, green, and violet, which seem to recede, are called cool colors. Black and white are not considered colors but neutrals; in terms of light, black is understood as the absence of color and white as the mixture of all colors.

Value is the relative degree of lightness or darkness of a given color and is created by the amount of light reflected from an object's surface. A dark green has a deeper value than a light green, for example. In black-and-white reproductions of colored objects, you see only value, and some artworks—for example, a drawing made with black ink—possesses only value, not hue or saturation.

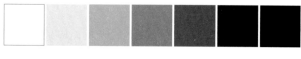

Value scale from white to black.

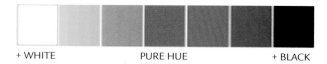

+ WHITE PURE HUE + BLACK

Value variation in red.

Saturation, also sometimes referred to as intensity, is a color's quality of brightness or dullness. A color described as highly saturated looks vivid and pure; a hue of low saturation may look a little muddy or dark.

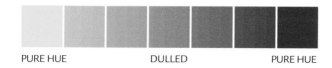

PURE HUE DULLED PURE HUE

Intensity scale from bright to dull.

Texture, another attribute of form, is the tactile (or touch-perceived) quality of a surface. It is described by words such as *smooth, polished, rough, grainy,* or *oily*. Texture takes two forms: the texture of the actual surface of the work of art and the implied (illusionistically depicted) surface of the object that the work represents.

Space is what contains objects. It may be actual and three-dimensional, as it is with sculpture and architecture, or it may be represented illusionistically in two dimensions, as when artists represent recession into the distance on a wall or canvas.

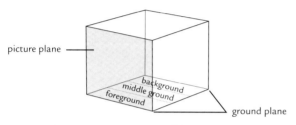

picture plane
background
middle ground
foreground
ground plane

Mass and **volume** are properties of three-dimensional things. Mass is matter—whether sculpture or architecture—that takes up space. Volume is enclosed or defined space, and may be either solid or hollow. Like space, mass and volume may be illusionistically represented in two dimensions.

Composition is the organization, or arrangement, of form in a work of art. Shapes and colors may be repeated or varied, balanced symmetrically or asymmetrically; they may be static or dynamic. The possibilities are nearly endless and depend on the time and place where the work was created as well as the personal sensibility of the artist. *Pictorial depth* (spatial recession) is a specialized aspect of composition in which the three-dimensional world is represented in two dimensions on a flat surface, or *picture plane*. The area "behind" the picture plane is called the *picture space* and conventionally contains three "zones": *foreground, middle ground,* and *background*.

Various techniques for conveying a sense of pictorial depth have been devised by artists in different cultures and at different times. A number of them are diagrammed below. In Western art, the use of various systems of *perspective* has created highly convincing illusions of recession into space. In other cultures, perspective is not the most favored way to treat objects in space.

CONTENT

Content includes *subject matter*, which is what a work of art represents. Not all works of art have subject matter; many buildings, paintings, sculptures, and other art objects include no recognizable imagery but feature only lines, colors, masses, volumes, and other formal elements. However, all works of art—even those

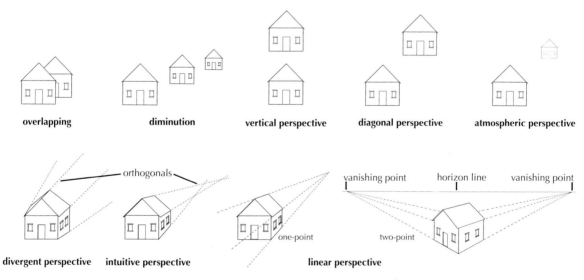

overlapping diminution vertical perspective diagonal perspective atmospheric perspective

orthogonals

divergent perspective intuitive perspective one-point linear perspective

vanishing point horizon line vanishing point

two-point

PICTORIAL DEVICES FOR DEPICTING RECESSION IN SPACE

The top row shows several comparatively simple devices, including *overlapping*, in which partially covered elements are meant to be seen as located behind those covering them, and *diminution*, in which smaller elements are to be perceived as being farther away than larger ones. In *vertical* and *diagonal perspective*, elements are stacked vertically or diagonally, with the higher elements intended to be perceived as deeper in space. Another way of suggesting depth is through *atmospheric perspective*, which depicts objects in the far distance, often in bluish gray hues, with less clarity than nearer objects and treats sky as paler near the horizon than higher up. In the lower row, *divergent perspective*, in which forms widen slightly and lines diverge as they recede in space, was used by East Asian artists. *Intuitive perspective*, used in some late medieval European art, takes the opposite approach: forms become narrower and converge the farther they are from the viewer, approximating the optical experience of spatial recession. *Linear perspective*, also called *scientific, mathematical, one-point,* and *renaissance perspective*, is an elaboration and standardization of intuitive perspective and was developed in fifteenth-century Italy. It uses mathematical formulas to construct illusionistic images in which all elements are shaped by imaginary lines called *orthogonals* that converge in one or more vanishing points on a *horizon line*. Linear perspective is the system that most people living in Western cultures think of as perspective. Because it is the visual code they are accustomed to reading, they accept as "truth" the distortions it imposes. One of these distortions is *foreshortening*, in which, for instance, the soles of the feet in the foreground are the largest elements of a figure lying on the ground.

without recognizable subject matter—have content, or meaning, insofar as they seek to convey feelings, communicate ideas, or affirm the beliefs and values of their makers and, often, the people who view or use them.

Content may comprise the social, political, religious, and economic *contexts* in which a work was created, the *intention* of the artist, the *reception* of the work by the beholder (the audience), and ultimately the meanings of the work to both artist and audience. Art historians applying different methods of interpretation often arrive at different conclusions regarding the content of a work of art.

The study of subject matter is *iconography* (literally, "the writing of images"). The iconographer asks, What is the meaning of this image? Iconography includes the study of *symbols* and *symbolism*—the process of representing one thing by another through association, resemblance, or convention.

STYLE

Expressed very broadly, *style* is the combination of form and composition that makes a work distinctive. *Stylistic analysis* is one of art history's most developed practices, because it is how art historians recognize the work of an individual artist or the characteristic manner of several artists working in a particular time or place. Some of the most commonly used terms to discuss *artistic styles* include *period style, regional style, representational style, abstract style, linear style*, and *painterly style*.

Period style refers to the common traits detectable in works of art and architecture from a particular historical era. For instance, Roman portrait sculpture created at the height of the Empire is different from sculpture made during the late imperial period, but it is recognizably Roman. It is good practice not to use the words style and period interchangeably. Style is the sum of many influences and characteristics, including the period of its creation. An example of proper usage is "an American house from the Colonial period built in the Georgian style."

Regional style refers to stylistic traits that persist in a geographic region. An art historian whose specialty is medieval art can recognize French style through many successive medieval periods and can distinguish individual objects created in medieval France from other medieval objects that were created in, for example, the Low Countries.

Representational styles are those that create recognizable subject matter. *Realism, naturalism*, and *illusionism* are representational styles.

> REALISM AND NATURALISM are terms often used interchangeably, and both describe the artist's attempt to describe the observable world. *Realism* is the attempt to depict objects accurately and objectively. *Naturalism* is closely linked to realism but often implies a grim or sordid subject matter.

> IDEAL STYLES strive to create images of physical perfection according to the prevailing values of a culture. The artist may work in a representational style or may try to capture an underlying or expressive reality. Both the *Medici Venus* and Utamaro's *Woman at the Height of Her Beauty* (see Introduction, figs. 7 and 9) can be considered *idealized*.

> ILLUSIONISM refers to a highly detailed style that seeks to create a convincing illusion of reality. *Flower Piece with Curtain* is a good example of this trick-the-eye form of realism (see Introduction, fig. 2).

> IDEALIZATION strives to realize an image of physical perfection according to the prevailing values of a culture. The *Medici Venus* is idealized, as is Utamaro's *Woman at the Height of Her Beauty* (see Introduction, figs. 7 and 9).

Abstract styles depart from literal realism to capture the essence of a form. An abstract artist may work from nature or from a memory image of nature's forms and colors, which are simplified, stylized, distorted, or otherwise transformed to achieve a desired expressive effect. Georgia O'Keeffe's *Red Canna* is an abstract representation of nature (see Introduction, fig. 5). *Nonrepresentational art* and *expressionism* are particular kinds of abstract styles.

> NONREPRESENTATIONAL (OR NONOBJECTIVE) ART is a form that does not produce recognizable imagery. *Cubi XIX* is nonrepresentational (see Introduction, fig. 6).

> EXPRESSIONISM refers to styles in which the artist uses exaggeration of form to appeal to the beholder's subjective response or to project the artist's own subjective feelings. Munch's *The Scream* is expressionistic (see fig 30–71).

Linear describes both style and techniques. In the linear style the artist uses line as the primary means of definition, and modeling—the creation of an illusion of three-dimensional substance, through shading. It is so subtle that brushstrokes nearly disappear. Such a technique is also called "sculptural." Raphael's *The Small Cowper Madonna* is linear and sculptural (fig. 20–5)

Painterly describes a style of painting in which vigorous, evident brushstrokes dominate and shadows and highlights are brushed in freely. Sculpture in which complex surfaces emphasize moving light and shade is called "painterly." Claudel's *The Waltz* is painterly sculpture (see fig. 30–75).

MEDIUM

What is meant by medium or mediums (the plural we use in this book to distinguish the word from print and electronic news media) refers to the material or materials from which a work of art is made.

Technique is the process used to make the work. Today, literally anything can be used to make a work of art, including not only traditional materials like paint, ink, and stone, but also rubbish, food, and the earth itself. Various techniques are explained throughout this book in Technique boxes. When several mediums are used in a single work of art, we employ the term *mixed mediums*. Two-dimensional mediums include painting, drawing, prints, and photography. Three-

dimensional mediums are sculpture, architecture, and many so-called decorative arts.

Painting includes wall painting and fresco, illumination (the decoration of books with paintings), panel painting (painting on wood panels) and painting on canvas, miniature painting (small-scale painting), and handscroll and hanging scroll painting. Paint is pigment mixed with a liquid vehicle, or binder.

Graphic arts are those that involve the application of lines and strokes to a two-dimensional surface or support, most often paper. Drawing is a graphic art, as are the various forms of printmaking. Drawings may be sketches (quick visual notes made in preparation for larger drawings or paintings); studies (more carefully drawn analyses of details or entire compositions); cartoons (full-scale drawings made in preparation for work in another medium, such as fresco); or complete artworks in themselves. Drawings are made with such materials as ink, charcoal, crayon, and pencil. Prints, unlike drawings, are reproducible. The various forms of printmaking include woodcut, the intaglio processes (engraving, etching, drypoint), and lithography.

Photography (literally "light writing") is a medium that involves the rendering of optical images on light-sensitive surfaces. Photographic images are typically recorded by a camera.

Sculpture is three-dimensional art that is *carved, modeled, cast,* or *assembled*. Carved sculpture is subtractive in the sense that the image is created by taking away material. Wood, stone, and ivory are common materials used to create carved sculptures. Modeled sculpture is considered additive, meaning that the object is built up from a material, such as clay, that is soft enough to be molded and shaped. Metal sculpture is usually cast (see "Lost-Wax Casting," page xxiv) or is assembled by welding or a similar means of permanent joining.

Sculpture is either freestanding (that is, not attached) or in relief. Relief sculpture projects from the background surface of which it is a part. High relief sculpture projects far from its background; low relief sculpture is only slightly raised; and sunken relief, found mainly in Egyptian art, is carved into the surface, with the highest part of the relief being the flat surface.

Ephemeral arts include processions and festival decorations and costumes, performance art, earthworks, cinema, video art, and some forms of digital and computer art. All have a central temporal aspect in that the artwork is viewable for a finite period of time and then disappears forever, is in a constant state of change, or must be replayed to be experienced again.

Architecture is three-dimensional, highly spatial, functional, and closely bound with developments in technology and materials. An example of the relationship among technology, materials, and function can be seen in "Space-Spanning Construction Devices" (page xxv). Several types of two-dimensional schematic drawings are commonly used to enable the visualization of a building. These architectural graphic devices include plans, elevations, sections, and cutaways.

PLANS depict a structure's masses and voids, presenting a view from above—as if the building had been sliced horizontally at about waist height.

plan

ELEVATIONS show exterior sides of a building as if seen from a moderate distance without any perspective distortion.

elevation

SECTIONS reveal a building as if it had been cut vertically by an imaginary slicer from top to bottom.

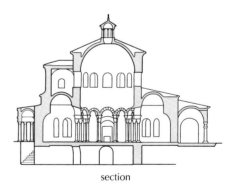

section

CUTAWAYS show both inside and outside elements from an oblique angle.

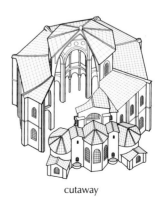

cutaway

Technique
LOST-WAX CASTING

The lost-wax process consists of a core on which the sculptor models the image in wax. A heat-resistant mold is formed over the wax. The wax is melted and replaced with metal, usually bronze or brass. The mold is broken away and the piece finished and polished by hand.

The usual metal for this casting process was bronze, an alloy of copper and tin, although sometimes brass, an alloy of copper and zinc, was used. The progression of drawings here shows the steps used by the Benin sculptors of Africa. A heat-resistant "core" of clay approximating the shape of the sculpture-to-be (and eventually becoming the hollow inside the sculpture) was covered by a layer of wax having the thickness of the final sculpture. The sculptor carved or modeled the details in the wax. Rods and a pouring cup made of wax were attached to the model. A thin layer of fine, damp sand was pressed very firmly into the surface of the wax model, and then model, rods, and cup were encased in thick layers of clay. When the clay was completely dry, the mold was heated to melt out the wax. The mold was then turned upside down to receive the molten metal, which is heated to the point of liquification. The cast was placed in the ground. When the metal was completely cool, the outside clay cast and the inside core were broken up and removed, leaving the cast brass sculpture. Details were polished to finish the piece of sculpture, which could not be duplicated because the mold had been destroyed in the process.

In lost-wax casting the mold had to be broken and only one sculpture could be made. In the eighteenth century a second process came into use—the piece mold. As its name implies, the piece mold could be removed without breaking allowing sculptors to make several copies (editions) of their work.

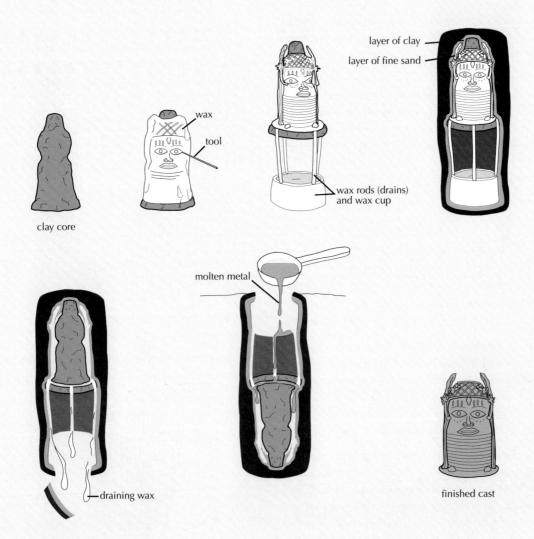

clay core

wax

tool

layer of clay

layer of fine sand

wax rods (drains) and wax cup

draining wax

molten metal

finished cast

Elements of Architecture
SPACE-SPANNING CONSTRUCTION DEVICES

Gravity pulls on everything, presenting great challenges to architects and sculptors. Spanning elements must transfer weight to the ground. The simplest space-spanning device is **post-and-lintel** construction, in which uprights are spanned by a horizontal element. However, if not flexible, a horizontal element over a wide span may break under the pressure of its own weight and the weight it carries.

Corbeling, the building up of overlapping stones, is another simple method for transferring weight to the ground. Arches, round or pointed, span space. **Vaults**, which are essentially extended arches, move weight out from the center of the covered space and down through the corners. The cantilever is a variant of post-and-lintel construction. **Suspension** works to counter the effect of gravity by lifting the spanning element upward. **Trusses** of wood or metal are relatively lightweight spanners but cannot bear heavy loads. Large-scale modern construction is chiefly steel frame and relies on steel's properties of strength and flexibility to bear great loads. When **concrete** is **reinforced** with steel or iron rods, the inherent brittleness of cement and stone is overcome because of metal's flexible qualities. The concrete can then span much more space and bear heavier loads. The **balloon frame**, an American innovation, is based on **post-and-lintel** principles and exploits the lightweight, flexible properties of wood.

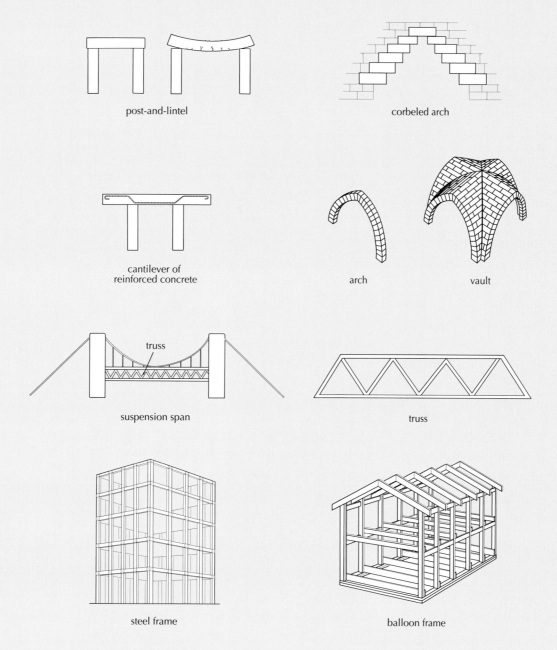

post-and-lintel

corbeled arch

cantilever of reinforced concrete

arch

vault

suspension span

truss

truss

steel frame

balloon frame

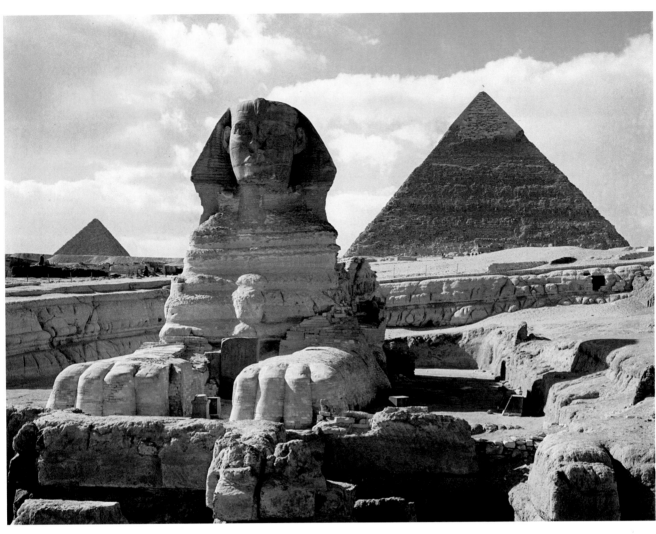

1 THE GREAT SPHINX, Giza, Egypt
Dynasty 4, c. 2613–2494 BCE. Sandstone, height approx. 65′ (19.8 m).

INTRODUCTION

Crouching in front of the pyramids of Egypt and carved from the living rock of the Giza plateau, the **GREAT SPHINX** is one of the world's best-known monuments (FIG. 1). By placing the head of the ancient Egyptian king Khafre on the body of a huge lion, the sculptors merged human intelligence and animal strength in a single image to evoke the superhuman power of the ruler. For some 4,600 years, the Sphinx has defied the desert sands; today it also must withstand the sprawl of greater Cairo and the impact of air pollution. In its majesty, the Sphinx symbolizes mysterious wisdom and dreams of permanence, of immortality. But is such a monument a work of art? Does it matter that the people who carved the Sphinx—unlike today's independent, individualistic artists—obeyed formulaic conventions and followed the orders of priests? No matter what the ancient Egyptians may have called it, today most people would say, "Certainly, it is art." Human imagination conceived this creature, and human skill gave it material form. Combining imagination and skill, the creators have conceived an idea of awesome grandeur and created a work of art. But we seldom stop to ask: What is art?

WHAT IS ART?

At one time the answer to the question "What is art?" would have been simpler than it is today. The creators of the *Great Sphinx* demonstrate a combination of imagination, skill, training, and observation that appeal to our desire for order and harmony—perhaps to an innate aesthetic sense. Yet, today some people question the existence of an aesthetic faculty, and we realize that our tastes are products of our education and our experience, dependent on time and place. Whether acquired at home, in schools, in museums, or in other public places, our responses are learned—not innate. Ideas of truth and falsehood, of good and evil, of beauty and ugliness are influenced as well by class, gender, race, and economic status. Some historians and critics even go so far as to argue that works of art are mere reflections of power and privilege.

Even the idea of "beauty" is questioned and debated today. Some commentators find discussions of aesthetics (the branch of philosophy concerned with The Beautiful) too subjective and too personal, and they dismiss the search for objective criteria that preoccupied scholars in the eighteenth and nineteenth centuries. As traditional aesthetics come under challenge, we can resort to discussing the authenticity of expression in a work of art, even as we continue to analyze its formal qualities. We can realize that people at different times and in different places have held different values. The words "art history" can be our touchstone. Like the twofold term itself, this scholarly discipline considers both art and history—the work of art as a tangible object and as part of its historical context. Ultimately, because so-called objective evaluations of beauty seem to be an impossibility, beauty again seems to lie in the eye of the beholder.

Today's definition of art encompasses the intention of the creator as well as the intentions of those who commissioned the work. It relies, too, on the reception of the artwork by society—both today and at the time when the work was made. The role of art history is to answer complex questions: Who are these artists and patrons? What is this thing they have created? When and how was the work done? Only after we have found answers to practical questions like these can we acquire an understanding and appreciation of the artwork and, answering our earlier question, we can say, yes, this is a work of art.

ART AND NATURE

The ancient Greeks enjoyed the work of skillful artists. They especially admired the illusionistic treatment of reality in which the object represented appears to actually be present. The Greek penchant for realism is illustrated in a story from the late fifth century BCE about a rivalry between two painters named Zeuxis and Parrhasios as to whom was the better painter. First, Zeuxis painted a picture of grapes so accurately that birds flew down to peck at them. But, when Parrhasios

2 Adriaen van der Spelt and Frans van Mieris
FLOWER PIECE WITH CURTAIN
1658. Oil on panel, 18¼ × 25¼" (46.5 × 64 cm). The Art Institute of Chicago.

took his turn, and Zeuxis asked his rival to remove the curtain hanging over his rival's picture, Parrhasios pointed out with glee that the "curtain" was his painting. Zeuxis had to admit that Parrhasios had won the competition since he himself had fooled only birds, while Parrhasios had deceived a fellow artist.

In the seventeenth century, the painters Adriaen van der Spelt (1630–73) and Frans van Mieris (1635–81) paid homage to the story of Parrhasios's curtain in a painting of blue satin drapery drawn aside to show a garland of flowers. We call the painting simply **FLOWER PIECE WITH CURTAIN** (FIG. 2). The artists not only re-created Parrhasios's curtain illusion but also included a reference to another popular story from ancient Greece, Pliny's anecdote of Pausias and Glykera. In his youth, Pausias had been enamored of the lovely flower-seller Glykera, and he learned his art by persistently painting the exquisite floral garlands that she made, thereby becoming the most famously skilled painter of his age. The seventeenth-century people who bought such popular still-life paintings appreciated their classical allusions as much as the artists' skill in drawing and painting and their ability to manipulate colors on canvas. But, the reference to Pausias and Glykera also raised the conundrum inherent in all art that seeks to make an unblemished reproduction of reality: Which has the greater beauty, the flower or the painting of the flower? And which is the greater work of art, the garland or the painting of the garland? So then, who is the greater artist, the garland maker or the garland painter?

MODES OF REPRESENTATION

Many people think that the manner of Zeuxis and Parrhasios, and of van der Spelt and van Mieris—the manner of representation that we call **naturalism**, or **realism**—the mode of

3 CORINTHIAN CAPITAL FROM THE THOLOS AT EPIDAURUS
c. 350 BCE. Archaeological Museum, Epidaurus, Greece.

interpretation that seeks to record the visible world—represents the highest accomplishment in art, but not everyone agrees. Even the ancient Greek philosophers Aristotle (384–322 BCE) and Plato (428–348/7 BCE), who both considered the nature of art and beauty in purely intellectual terms, arrived at divergent conclusions. Aristotle believed that works of art should be evaluated on the basis of mimesis ("imitation"), that is, on how well they copy definable or particular

aspects of the natural world. This approach to defining "What is art?" is a realistic or naturalistic one. But, of course, while artists may work in a naturalistic style, they also can render lifelike such fictions as a unicorn, a dragon, or a sphinx by incorporating features from actual creatures.

In contrast to Aristotle, Plato looked beyond nature for a definition of art. In his view even the most naturalistic painting or sculpture was only an approximation of an eternal ideal world in which no variations or flaws were present. Rather than focus on a copy of the particular details that one saw in any particular object, Plato focused on an unchangeable ideal—for artists, this would be the representation of a subject that exhibited perfect symmetry and proportion. This mode of interpretation is known as **idealism**. In a triumph of human reason over nature, idealism wishes to eliminate all irregularities, ensuring a balanced and harmonious work of art.

Let us consider a simple example of Greek idealism from architecture: the carved top, or capital, of a Corinthian column, a type that first appeared in ancient Greece during the fourth century BCE. The Corinthian capital has an inverted bell shape surrounded by acanthus leaves (**FIG. 3**). Although the acanthus foliage was inspired by the appearance of natural vegetation, the sculptors who carved the leaves eliminated blemishes and irregularities in order to create the Platonic ideal of the acanthus plant's foliage. To achieve Plato's ideal images and represent things "as they ought to be" rather than as they are, classical sculpture and painting established ideals that have inspired Western art ever since.

4 Edward Weston
SUCCULENT
1930. Gelatin silver print,
7½ × 9½″ (19.1 × 24 cm).
Center for Creative Photography, The University of Arizona, Tucson.

Like ancient Greek sculptors, Edward Weston (1886–1958) and Georgia O'Keeffe (1887–1986) studied living plants. In his photograph **SUCCULENT**, Weston used straightforward camera work without manipulating the film in the darkroom in order to portray his subject (**FIG. 4**). He argued that although the camera sees more than the human eye, the quality of the image depends not on the camera, but on the choices made by the photographer-artist.

When Georgia O'Keeffe painted **RED CANNA**, she, too, sought to capture the plant's essence, not its appearance—although we can still recognize the flower's form and color (**FIG. 5**). By painting the canna lily's organic energy rather than the way it actually looked, she created a new abstract beauty, conveying in paint the pure vigor of the flower's life force. This **abstraction**—in which the artist appears to transform a visible or recognizable subject from nature in a way that suggests the original but purposefully does not record the subject in an entirely realistic or naturalistic way—is another manner of representation.

Furthest of all from naturalism are pure geometric creations such as the polished stainless steel sculpture of David Smith (1906–65). His Cubi works are usually called **nonrepresentational** art—art that does not depict a recognizable subject. With works such as **CUBI XIX** (**FIG. 6**), it is important to distinguish between subject matter and content. Abstract art like O'Keeffe's has both subject matter and content, or meaning. Nonrepresentational art does not have subject matter but it does have content, which is a product of the interaction between the artist's

6 David Smith **CUBI XIX**
1964. Stainless steel, 9′5⅝″ × 1′9¾″ × 1′8″ (2.88 x .55 × .51 m).
Tate Gallery, London.
© Estate of David Smith/Licensed by VAGA, New York, NY

intention and the viewer's interpretation. Some viewers may see the Cubi works as robotic plants sprung from the core of an unyielding earth, a reflection of today's mechanistic society that challenges the natural forms of trees and hills.

At the turn of the fifteenth century, the Italian master Leonardo da Vinci (1452–1519) argued that observation alone produced "mere likeness" and that the painter who copied the external forms of nature was acting only as a mirror. He believed that the true artist should engage in intellectual activity of a higher order and attempt to render the inner life—the energy and power—of a subject. In this book we will see that artists have always tried to create more than a superficial likeness in order to engage their audience and express the cultural contexts of their particular time and place.

5 Georgia O'Keeffe **RED CANNA**
1924. Oil on canvas mounted on Masonite, 36 × 29⅞″
(91.44 × 75.88 cm). Collection of the University of Arizona
Museum of Art, Tucson.
© 2007 The Georgia O'Keeffe Foundation/Artists Rights Society (ARS), New York

Beauty and the Idealization of the Human Figure

Ever since people first made what we call art, they have been fascinated with their own image and have used the human body to express ideas and ideals. Popular culture in the twenty-first century continues to be obsessed with beautiful people—with Miss Universe pageants and lists of the Ten

8 Leone Leoni **CHARLES V TRIUMPHING OVER FURY, WITHOUT ARMOR**
c. 1549–55. Bronze, height to top of head 5′8″ (1.74 m).
Museo Nacional del Prado, Madrid.

7 **THE MEDICI VENUS**
Roman copy of a 1st-century BCE Greek statue.
Marble, height 5′ (1.53 m) without base. Villa
Medici, Florence, Italy.

Best-Dressed Women and the Fifty Sexiest Men, just to name a few examples. Today the **MEDICI VENUS**, with her plump arms and legs and sturdy body, would surely be expected to slim down, yet for generations such a figure represented the peak of female beauty (**FIG. 7**).

This image of the goddess of love inspired artists and those who commissioned their work from the fifteenth through the nineteenth century. Clearly, the artist had the skill to represent a woman as she actually appeared, but instead he chose to generalize her form and adhere to the classical canon (rule) of proportions. In so doing, the sculptor created a universal image, an ideal rather than a specific woman.

The *Medici Venus* represents a goddess, but artists also represented living people as idealized figures, creating symbolic portraits rather than accurate likenesses. The sculptor Leone Leoni (1509–90), commissioned to create a monumental bronze statue of the emperor Charles V (ruled 1519–56), expressed the power of this ruler of the Holy Roman Empire just as vividly as did the sculptors of the

Egyptian king Khafre, the subject of the *Great Sphinx* (SEE FIG. 1). Whereas in the Sphinx, Khafre took on the body of a vigilant lion, in CHARLES V TRIUMPHING OVER FURY, the emperor has been endowed with the muscular torso and proportions of the classical ideal male athlete or god (FIG. 8). Charles does not inhabit a fragile human body; rather, in his muscular nakedness, he embodies the idea of triumphant authoritarian rule. (Not everyone approved. In fact, a full suit of armor was made for the statue, and today museum officials usually exhibit the sculpture clad in armor rather than nude.)

Another example of ideal beauty is the abstract vision of a woman depicted in a woodblock print by Japanese artist Kitagawa Utamaro (1753–1806). In its stylization, WOMAN AT THE HEIGHT OF HER BEAUTY (FIG. 9), reflects a social context regulated by convention and ritual. Simplified shapes depict the woman's garments and suggest the underlying human forms. The treatment of the rich textiles turn the body into an abstract pattern, and pins turn the hair into another elaborate shape. Utamaro rendered the decorative silks and carved pins meticulously, but he depicted the woman's face and hands with a few sweeping lines. The attention to surface detail combined with an effort to capture the essence of form is characteristic of abstract art in Utamaro's time and place, and images of men were equally elegant.

Today, when images—including those of great physical and spiritual beauty—can be captured with a camera, why should an artist draw, paint, or chip away at a knob of stone? Does beauty even play a significant role in our world? Attempting to answer these and other questions that consider the role of art is a branch of philosophy called *aesthetics*, which considers the nature of beauty, art, and taste as well as the creation of art.

Laocoön: A Meditation on Aesthetics

Historically, the story of Laocoön has focused attention on the different ways in which the arts communicate. In the *Iliad*, Homer's epic poem about the Trojan War, Laocoön was the priest who forewarned the Trojans of an invasion by the Greeks. Although Laocoön spoke the truth, the goddess Athena, who took the Greeks' side in the war, dispatched serpents to strangle him and his sons. His prophecy scorned, Laocoön represents the virtuous man tragically destroyed by unjust fate. In a renowned ancient sculpture, his features twist in agony, and the muscles of his and his sons' torsos and arms extend and knot as they struggle (FIG. 10). When this sculpture was discovered in Rome in 1506, Michelangelo rushed to watch it being excavated, an astonishing validation of his own ideal, heroic style coming straight out of the earth. The pope acquired it for the papal collection, and it can be seen today in the Vatican Museum.

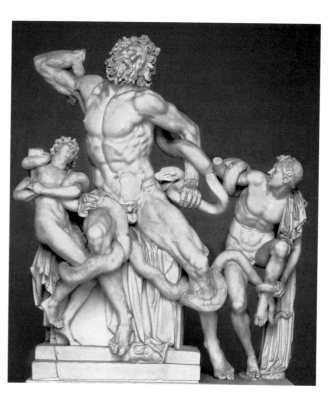

9 Kitagawa Utamaro **WOMAN AT THE HEIGHT OF HER BEAUTY**
Mid-1790s. Color woodblock print, 15⅛ × 10″ (38.5 × 25.5 cm). Spencer Museum of Art, The University of Kansas, Lawrence.
William Bridges Thayer Memorial, (1928.7879)

10 Hagesandros, Polydoros, and Athanadoros of Rhodes
LAOCOÖN AND HIS SONS
As restored today. Probably the original of 1st century CE or a Roman copy of the 1st century CE. Marble, height 8′ (2.44 m). Musei Vaticani, Museo Pio Clementino, Cortile Ottagono, Rome, Italy.

Like other learned people in the eighteenth century, the German philosopher Lessing knew the story of Laocoön and admired the sculpture as well. In fact, he titled his study of the relationship between words and images "Laocoon: An Essay upon the Limits of Painting and Poetry" (1766). Lessing saw literary pursuits such as poetry and history as arts of time, whereas painting and sculpture played out in a single moment in space. Using words, writers can present a sequence of events, while sculptors and painters must present a single critical moment. Seen in this light, the interpretation of visual art depends upon the viewer who must bring additional knowledge in order to reconstitute the narrative, including events both before and after the depicted moment. For this reason, Lessing argued for the primacy of literature over the visual arts. The debate over the comparative virtues of the arts has been a source of excited argument and even outrage among critics, artists, philosophers, and academics ever since.

Underlying all our assumptions about works of art—whether in the past or the present—is the idea that art has meaning, and that its message can educate and move us, that it can influence and improve our lives. But what gives art its meaning and expressive power? Why do images fascinate and inspire us? Why do we treasure some things but not others? These are difficult questions, and even specialists disagree about the answers. Sometimes even the most informed people must conclude, "I just don't know."

Studying art history, therefore, cannot provide us with definitive answers, but it can help us recognize the value of asking questions as well as the value of exploring possible answers. Art history is grounded in the study of material objects that are the tangible expression of the ideas—and ideals—of a culture. For example, when we become captivated by a striking creation, art history can help us interpret its particular imagery and meaning. Art history can also illuminate the cultural context of the work—that is, the social, economic, and political situation of the historical period in which it was produced, as well as its evolving significance through the passage of time.

Exceptional works of art speak to us. However, only if we know something about the **iconography** (the meaning and interpretation) of an image can its larger meaning become clear. For example, let's look again at *Flower Piece with Curtain* (SEE FIG. 2). The brilliant red and white tulip just to the left of the blue curtain was the most desirable and expensive flower in the seventeenth century; thus, it symbolizes wealth and power. Yet insects creep out of it, and a butterfly—fragile and transitory—hovers above it. Consequently, here flowers also symbolize the passage of time and the fleeting quality of human riches. Informed about its iconography and cultural context, we begin to fathom that this painting is more than a simple still life.

WHY DO WE NEED ART?

Before we turn to Chapter 1—before we begin to look at, read about, and think about works of art and architecture historically, let us consider a few general questions that studying art history can help us answer and that we should keep in mind as we proceed: Why do we need art? Who are artists? What role do patrons play? What is art history? and What is a viewer's role and responsibility? By grappling with such questions, our experience of art can be greatly enhanced.

Biologists account for the human desire for art by explaining that human beings have very large brains that demand stimulation. Curious, active, and inventive, we humans constantly explore, and in so doing we invent things that appeal to our senses—fine art, fine food, fine scents, fine fabrics, and fine music. Ever since our prehistoric ancestors developed their ability to draw and speak, we have visually and verbally been communicating with each other. We speculate on the nature of things and the meaning of life. In fulfilling our need to understand and our need to communicate, the arts serve a vital function. Through art we become fully alive.

Self-Expression: Art and the Search for Meaning

Throughout history art has played an important part in our search for the meaning of the human experience. In an effort to understand the world and our place in it, we turn both to introspective personal art and to communal public art. Following a personal vision, James Hampton (1909–64) created profoundly stirring religious art. Hampton worked as a janitor to support himself while, in a rented garage, he built THRONE OF THE THIRD HEAVEN OF THE NATIONS' MILLENNIUM GENERAL ASSEMBLY (FIG. 11), his monument to his faith. In rising tiers, thrones and altars have been prepared for Jesus and Moses. Placing New Testament imagery on the right and Old Testament imagery on the left, Hampton labeled and described everything. He even invented his own language to express his visions. On one of many placards he wrote his credo: "Where there is no vision, the people perish" (Proverbs 29:18). Hampton made this fabulous assemblage out of discarded furniture, flashbulbs, and all sorts of refuse tacked together and wrapped in gold and silver aluminum foil and purple tissue paper. How can such worthless materials turn into an exalted work of art? Art's genius transcends material.

In contrast to James Hampton, whose life's work was compiled in private and only came to public attention after his death, most artists and viewers participate in more public expressions of art and belief. Nevertheless, when people employ special objects in their rituals, such as statues, masks, and vessels, these pieces may be seen as works of art by others who do not know about their intended use and original significance.

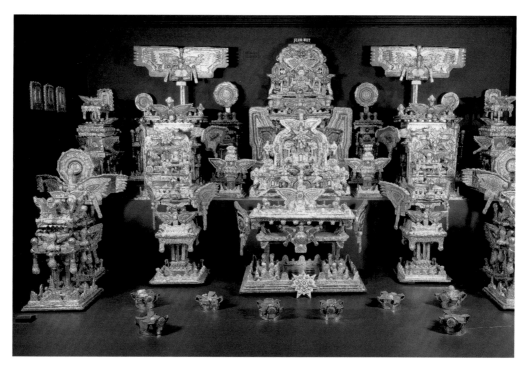

11 James Hampton **THRONE OF THE THIRD HEAVEN OF THE NATIONS'**
MILLENNIUM GENERAL ASSEMBLY
c. 1950–64. Gold and silver aluminum foil, colored Kraft paper, and plastic sheets over wood, paper-
board, and glass, 10'6" × 27' × 14'6" (3.2 × 8.23 × 4.42 m). Smithsonian American Art Museum,
Smithsonian Institution, Washington, D.C.
Gift of Anonymous Donors, 1970.353.1

Social Expression: Art and Social Context

The visual arts are among the most sophisticated forms of
human communication, at once shaping and being shaped by
their social context. Artists may unconsciously interpret their
times, but they also may be enlisted to consciously serve
social ends in ways that range from heavy-handed propa-
ganda (as seen earlier in the portrait of Charles V, for example)
to subtle suggestion. From ancient Egyptian priests to elected
officials today, religious and political leaders have understood
the educational and motivational value of the visual arts.

Governments and civic leaders use the power of art to
strengthen the unity that nourishes society. In sixteenth-cen-
tury Venice, for example, city officials ordered Veronese (Paolo
Caliari, 1528–88) to fill the ceiling in the Great Council Hall
with a huge and colorful painting, THE TRIUMPH OF VENICE
(FIG. 12). Their contract with the artist survives as evidence of
their intentions. They wanted a painting that showed their
beloved Venice surrounded by peace, abundance, fame, happi-
ness, honor, security, and freedom—all in vivid colors and ide-
alized forms. Veronese and his assistants complied by painting
the city personified as a mature, beautiful, and splendidly robed

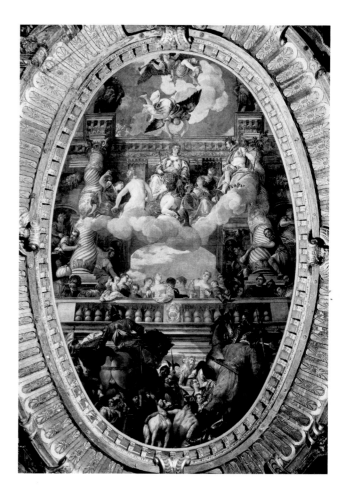

12 Veronese **THE TRIUMPH OF VENICE**
Ceiling painting in the Council Chamber, Palazzo Ducale, Venice,
Italy. c. 1585. Oil on canvas, 29'8" × 19' (9.04 × 5.79 m).

woman enthroned between the towers of the Arsenal, a building where ships were built for worldwide trade, the source of the city's wealth and power. Veronese painted enthusiastic crowds of cheering citizens, together with personifications of Fame blowing trumpets and of Victory crowning Venice with a wreath. Supporting this happy throng, bound prisoners and trophies of armor attest to Venetian military prowess. The Lion of Venice—the symbol of the city and its patron, Saint Mark—oversees the triumph. Although Veronese created this splendid propaganda piece to serve the purposes of his patrons, his artistic vision was as individualistic as that of James Hampton, whose art was purely self-expression.

Social Criticism: Uncovering Sociopolitical Intentions

Although powerful patrons have used artworks throughout history to promote their political interests, modern artists are often independent-minded and astute critics of the powers that be. For example, among Honoré Daumier's most trenchant comments on the French government is his print **RUE TRANSON-AIN, LE 15 AVRIL 1834** (FIG. 13). During a period of urban unrest, the French National Guard fired on unarmed citizens, killing fourteen people. For his depiction of the massacre, Daumier used lithography—a cheap new means of illustration. He was not thinking in terms of an enduring historical record, but rather of a medium that would enable him to spread his message as widely as possible. Daumier's political commentary created such horror and revulsion among the public that the government reacted by buying and destroying all the newspapers in which the lithograph appeared. As this example shows, art historians sometimes need to consider not just the historical context of a work of art but also its political content and medium to have a fuller understanding of it.

Another, more recent, work with a critical message recalls how American citizens of Japanese ancestry were removed from their homes and confined in internment camps during World War II. In 1978, Roger Shimomura (b. 1939) painted **DIARY**, which illustrates his grandmother's account of the family's experience in one such camp in Idaho (FIG. 14). Shimomura has painted his grandmother writing in her diary, while he (the toddler) and his mother stand by an open door—a door that does not signify freedom but opens on to a field bounded by barbed wire. In this commentary on discrimination and injustice, Shimomura combines two stylistic traditions—the Japanese art of the color woodblock print and American Pop art of the 1960s—to create a personal style that expresses his own dual culture.

WHO ARE THE ARTISTS?

We have focused so far mostly on works of art. But what of the artists who make them? How artists have viewed themselves and have been viewed by their contemporaries has

13 Honoré Daumier **RUE TRANSONAIN, LE 15 AVRIL 1834**
Lithograph, 11″ × 17⅜″ (28 × 44 cm). Bibliothèque Nationale, Paris.

changed over time. In Western art, painters and sculptors were at first considered artisans or craftspeople. The ancient Greeks and Romans ranked painters and sculptors among the skilled workers; they admired the creations, but not the creators. The Greek word for art, *tekne*, is the source for the English word "technique," and the English words *art* and *artist* come from the Latin word *ars*, which means "skill." In the Middle Ages, people sometimes went to the opposite extreme and attributed especially fine works of art not to human artisans, but to supernatural forces, to angels, or to Saint Luke. Artists continued to be seen as craftspeople—admired, often prosperous, but not particularly special—until the Renaissance, when artists such as Leonardo da Vinci proclaimed themselves to be geniuses with "divine" abilities.

14 Roger Shimomura
DIARY (MINIDOKA SERIES #3)
1978. Acrylic on canvas, 4′11⅞″ x 6′ (1.52 × 1.83 m). Spencer Museum of Art, The University of Kansas, Lawrence.
Museum purchase, (1979.51)

Soon after the Renaissance, the Italian painter Guercino (Giovanni Francesco Barbieri, 1591–1666) combined the idea that saints and angels have miraculously made works of art with the concept that human painters have special, divinely inspired gifts. In his painting **SAINT LUKE DISPLAYING A PAINTING OF THE VIRGIN** (FIG. 15), Guercino portrays the Evangelist who was regarded as the patron saint of artists. Christians widely believed that Luke had painted a portrait of the Virgin Mary holding the Christ Child. In Guercino's painting, Luke, seated before just such a painting and assisted by an angel, holds his palette and brushes. A book, a quill pen, and an inkpot decorated with a statue of an ox (Saint Luke's symbol) rest on a table, reminders of his status as the author of a gospel. Guercino seems to say that if Saint Luke is a divinely endowed artist, then surely all other artists share in this special power and status. This image of the artist as an inspired genius has persisted.

Even after the idea of "specially endowed" creators emerged, numerous artists continued to conduct their work as craftspeople leading workshops, and oftentimes artwork continued to be a team effort. Nevertheless, as the one who conceives the work and controls its execution—the artist is the "creator," whose name is associated with the final product.

This approach is evident today in the glassworks of American artist Dale Chihuly (b. 1941). His team of artist-craftspeople is skilled in the ancient art of glass-making, but Chihuly remains the controlling mind and imagination behind the works. Once created, his multipart pieces may be transformed when they are assembled for display; they can take on a new life in accordance with the will of a new owner, who may arrange the pieces to suit his or her own preferences. The viewer/owner thus becomes part of the creative team. Originally fabricated in 1990, **VIOLET PERSIAN SET WITH RED LIP WRAPS** (FIG. 16) has twenty separate pieces, but the person who assembles them determines the composition.

How Does One Become an Artist?

Whether working individually or communally, even the most brilliant artists spend years in study and apprenticeship and continue to educate themselves throughout their lives. In his painting **THE DRAWING LESSON**, Dutch artist Jan Steen (1626–79) takes us into a well-lit artist's studio. Surrounded by the props of his art—a tapestry backdrop, an easel, a stretched canvas, a portfolio, musical instruments, and decorative *objets d'art*—a painter instructs two youngsters—a boy apprentice at a drawing board, and a young woman in an elegant armchair (FIG. 17). The artist's pupil has been drawing from sculpture and plaster casts because women were not permitted to work from nude models. *The Drawing Lesson* records contemporary educational practice and is a valuable record of an artist's workplace in the seventeenth century.

Even the most mature artists learn from each other. In the seventeenth century, Rembrandt van Rijn carefully studied

15 Guercino **SAINT LUKE DISPLAYING A PAINTING OF THE VIRGIN**
1652–53. Oil on canvas, 7'3" × 5'11" (2.21 × 1.81 m).
The Nelson-Atkins Museum of Art, Kansas City, Missouri.
Purchase (F83-55)

16 Dale Chihuly **VIOLET PERSIAN SET WITH RED LIP WRAPS**
1990. Glass, 26 x 30 × 25" (66 x 76.2 × 63.5 cm). Spencer Museum of Art, The University of Kansas, Lawrence.
Museum Purchase: Peter T. Bohan Art Acquisition Fund, 1992.2

Leonardo's painting of **THE LAST SUPPER** (FIG. 18). Leonardo had turned this traditional theme into a powerful drama by portraying the moment when Christ announces that one of the assembled apostles will betray him. Even though the men react with surprise and horror to this news, Leonardo depicted the scene in a balanced symmetrical composition typical of the Italian Renaissance of the fifteenth and early sixteenth centuries, with the apostles in groups of three on each side of Christ. The regularly spaced tapestries and ceiling panels lead the viewers' eyes to Christ, who is silhouetted in front of an open window (the door seen in the photograph was cut through the painting at a later date).

Rembrandt, working 130 years later in the Netherlands—a very different time and place—knew the Italian master's painting from a print, since he never went to Italy. Rembrandt copied **THE LAST SUPPER** in hard red chalk (**FIG. 19**). Then he reworked the drawing in a softer chalk, assimilating Leonardo's lessons but revising the composition and changing the mood of the original. With heavy overdrawing he recreated the scene, shifting Jesus's position to the left, giving Judas more emphasis. Gone are the wall hangings and ceiling, replaced by a huge canopy. The space is undetermined and expansive rather than focused. Rembrandt's drawing is more than an academic exercise; it is also a sincere tribute from one

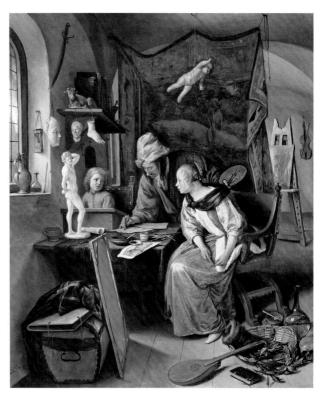

17 Jan Steen **THE DRAWING LESSON**
1665. Oil on wood, 19⅜ × 16¼″ (49.3 × 41 cm). The J. Paul Getty Museum, Los Angeles, California.

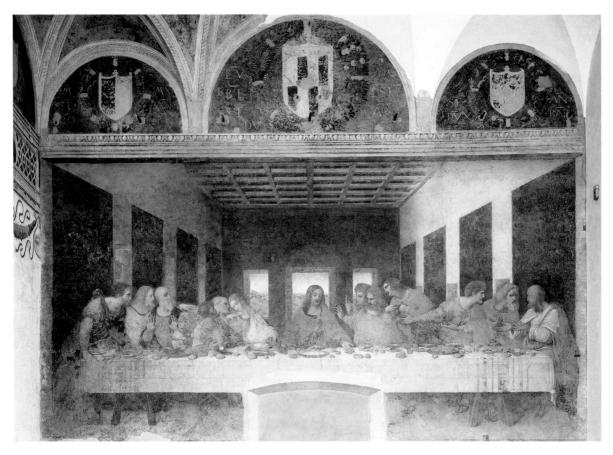

18 Leonardo da Vinci **THE LAST SUPPER**
Wall painting in the refectory, Monastery of Santa Maria delle Grazie, Milan, Italy. 1495–98. Tempera and oil on plaster, 15′2″ × 28′10″ (4.6 × 8.8 m).

great master to another. The artist must have been pleased with his version of Leonardo's masterpiece because he signed his drawing boldly in the lower right-hand corner.

WHAT ROLE DO PATRONS AND COLLECTORS PLAY?

As we have seen, the person or group who commissions or supports a work of art—the patron—can have significant impact on it. The *Great Sphinx* (SEE FIG. 1) was "designed" following the conventions of priests in ancient Egypt; the monumental statue of Charles V was cast to glorify absolutist rule (SEE FIG. 8); the content of Veronese's *Triumph of Venice* (SEE FIG. 12) was determined by that city's government officials; and Chihuly's glassworks (SEE FIG. 16) may be reassembled according to the collector's wishes or whims.

The civic sponsorship of art is epitomized by fifth-century BCE Athens, a Greek city-state whose citizens practiced an early form of democracy. Led by the statesman and general Perikles, the Athenians defeated the Persians, and then rebuilt Athens's civic and religious center, the Acropolis, as a tribute to the goddess Athena and a testament to the glory of Athens. In FIGURE 20, a nineteenth-century British artist, Sir Lawrence Alma-Tadema, conveys the accomplishment of the

20 Lawrence Alma-Tadema **PHEIDIAS AND THE FRIEZE OF THE PARTHENON**, Athens 1868. Oil on canvas, 29⅗ × 42⅓″ (75.3 × 108 cm). Birmingham City Museum and Art Gallery, England.

Athenian architects, sculptors, and painters, who were led by the artist Pheidias. Alma-Tadema imagines the moment when Pheidias showed the carved and painted frieze at the top of the wall of the Temple of Athena (the Parthenon) to Perikles and a group of Athenian citizens—his civic sponsors.

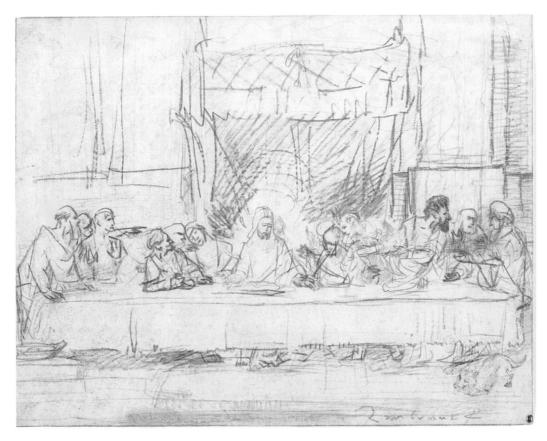

19 Rembrandt van Rijn **THE LAST SUPPER**
After Leonardo da Vinci's fresco. Mid-1630s. Drawing in red chalk, 14⅜ × 18¾″ (36.5 × 47.5 cm).
The Metropolitan Museum of Art, New York.
Robert Lehman Collection, 1975 (1975.1.794)

THE ◉BJECT SPEAKS

THE VIETNAM VETERANS MEMORIAL

"Cattle die. Kinfolk die. We all die. Only fame lasts," said the Vikings. Names remain. Flat, polished stone walls inscribed with thousands of names reflect back the images of the living as they contemplate the memorial to the Vietnam War's (1964–75) dead and missing veterans. The idea is brilliant in its simplicity. The artist Maya Ying Lin (b. 1959) combined two basic ideas: the minimal grandeur of long, black granite walls and row upon row of engraved names—the abstract and the intimate conjoined. The power of Lin's monument lies in its understatement. The wall is a statement of loss, sorrow, and the futility of war, and the names are so numerous that they lose individuality and become a surface texture. It is a timeless monument to suffering humanity, faceless in sacrifice. Maya Lin said, "The point is to see yourself reflected in the names."

The VIETNAM VETERANS MEMORIAL, now widely admired as a fitting testament to the Americans who died in that conflict, was the subject of public controversy when it was first proposed due to its severely Minimalist style. In its request for proposals for the design of the monument, the Vietnam Veterans Memor-ial Fund—composed primarily of veterans themselves—stipulated that the memorial be without political or military content, that it be reflective in character, that it harmonize with its surroundings, and that it include the names of the more than 58,000 dead and missing. They awarded the commission to Maya Lin, then an undergraduate studying in the architecture department at Yale University. Her design called for two 200-foot long walls (later expanded to 246 feet) of polished black granite to be set into a gradual rise in Constitution Gardens on the Mall in Washington, D.C., meeting at a 136 degree angle at the point where the walls and slope would be at their full 10-foot height. The names of the dead were to be incised in the stone in the order in which they died, with only the dates of the first and last deaths to be recorded.

The walls also reflect more than visitors. One wall faces and reflects the George Washington Monument (constructed 1848–84). Robert Mills, the architect of many public buildings at the beginning of the nineteenth century, chose the obelisk, a time-honored Egyptian sun symbol, for his memorial to the nation's founder. The other wall leads the eye to the Neoclassical-style Lincoln Memorial. By subtly incorporating the Washington and Lincoln monuments into the design, Lin's *Vietnam Veterans Memorial* reminds the viewer of sacrifices made in defense of liberty throughout the history of the United States.

Until the modern era, most public art celebrated political and social leaders and glorified aspects of war in large, free-standing monuments. The motives of those who commissioned public art have ranged from civic pride and the wish to honor heroes to political propaganda and social intimidation. Art in public places may engage our intellect, educating or reminding us of significant events in history. Yet the most effective memorials also appeal to our emotions. Public memorials can provide both a universal and intimate experience, addressing subjects that have entered our collective conscious as a nation, yet remain highly personal. Lin's memorial in Washington, D.C., to the American men and women who died in or never returned from the Vietnam War is among the most visited works of public art of the twenty-first century and certainly among the most affecting war monuments ever conceived.

Maya Ying Lin **VIETNAM VETERANS MEMORIAL**
1982. Black Granite, length 500' (152 m). The Mall, Washington, D.C.

Although artists sometimes work speculatively, hoping afterwards to sell their work on the open market, throughout history interested individuals and institutions have acted as patrons of the arts. During periods of great artistic vigor, enlightened patronage has been an essential factor. Today, museums and other institutions, such as governmental agencies (for example, in the United States, the National Endowment for the Arts), also provide financial grants and support for the arts.

Individual Patrons

People who are not artists often want to be involved with art, and patrons of art constitute a very special audience for artists. Many collectors truly love works of art, but some collect art only to enhance their own prestige, to give themselves an aura of power and importance. Patrons can vicariously participate in the creation of a work by providing economic support to an artist. Such individual patronage can spring from a cordial relationship between a patron and an artist, as is evident in an early fifteenth-century manuscript illustration in which the author, Christine de Pizan, presents her work to her patron Isabeau, the Queen of France (FIG. 21). Christine—a widow who supported her family by writing—hired painters and scribes to copy, illustrate, and decorate her books. She especially admired the painting of a woman named Anastaise, whose work she considered unsurpassed in the city of Paris. While Queen Isabeau was Christine's patron, Christine in turn was Anastaise's patron; and all the women seen in the painting were patrons of the brilliant textile workers who supplied the brocades for their gowns, the tapestries for the wall, and the embroideries for the bed. Such networks of patronage shape a culture.

Relations between artists and patrons are not always necessarily congenial. Patrons may change their minds or fail to pay their bills. Artists may ignore their patron's wishes, or exceed the scope of their commission. In the late nineteenth century, for example, the Liverpool shipping magnate Frederick Leyland asked James McNeill Whistler (1834–1903), an American painter living in London, what color to paint the shutters in the dining room where he planned to hang Whistler's painting *The Princess from The Land of Porcelain* (FIG. 22).

The room had been designed by Thomas Jeckyll with embossed and gilded leather on the walls and finely crafted shelves to show off Leyland's collection of blue and white Chinese porcelain. While Leyland was away, Whistler, inspired by the Japanese theme of his own painting as well as by the porcelain, painted the window shutters with splendid turquoise and gold peacocks, the walls and ceiling with peacock feathers, and then he gilded the walnut shelves. When Leyland, shocked and angry at what seemed to him to be wanton destuction of the room, paid him less than half the agreed on price, Whistler added a painting of himself and Leyland as fighting peacocks. Whistler called the room **HARMONY IN BLUE AND GOLD: THE PEACOCK ROOM.**

21 CHRISTINE DE PIZAN PRESENTING HER BOOK TO THE QUEEN OF FRANCE 1410-15. Tempera and gold on vellum, image approx. 5½ × 6¾″ (14 × 17 cm). The British Library, London.
MS. Harley 4431, folio 3

22 James McNeill Whistler **HARMONY IN BLUE AND GOLD: THE PEACOCK ROOM** northeast corner, from a house owned by Frederick Leyland, London. 1876-77. Oil paint and metal leaf on canvas, leather, and wood, 13′11⅞″ × 33′2″ × 19′11½″ (4.26 × 10.11 × 6.83 m). Over the fireplace, Whistler's *The Princess from The Land of Porcelain.* Freer Gallery of Art, Smithsonian Institution, Washington, D.C.
Gift of Charles Lang Freer, (F1904.61)

Luckily, Leyland did not destroy the Peacock Room. After Leyland's death, Charles Lang Freer (1854–1919) purchased the room and the painting of *The Princess.* Freer reinstalled the room in his home in Detroit, Michican, and filled the delicate gold shelves with his own collection of porcelain. When Freer died in 1919, the Peacock Room was moved to the Freer

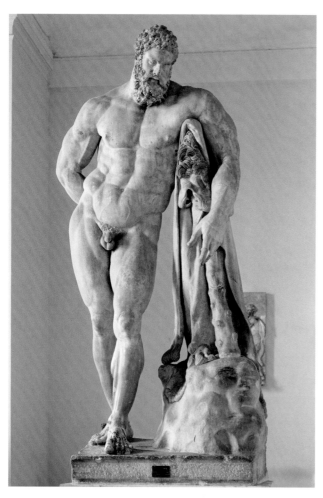

23 THE FARNESE HERCULES
3rd century BCE. Copy of *The Weary Hercules* by Lysippos. Found in the Baths of Caracalla in 1546; exhibited in the Farnese Palace until 1787. Marble, 10½' (3.17 m). Signed "Glykon" on the rock under the club. Left arm restored.

Gallery of Art, which he had founded in Washington D.C., where it remains as an extraordinary example of interior design and late nineteenth-century patronage.

Collectors and Museums

From the earliest times, people have collected and kept precious objects that convey the idea of power and prestige. Today both private and public museums are major patrons, collectors, and preservers of art. Curators of such collections acquire works of art for their museums and often assist patrons in obtaining especially desirable pieces, although the idea of what is best and what is worth collecting and preserving often changes from one generation to another.

Charles Lang Freer, mentioned on the previous page, is another kind of patron—one who was a sponsor of artists, a collector, and the founder of the museum that bears his name. Freer was an industrialist in Detroit—the manufacturer of railway cars—who was inspired by the nineteenth-century ideal of art as a means of achieving universal harmony and of the philosophy "Art for Art's Sake." The leading American exponent of

this philosophy was James McNeill Whistler. On a trip to Europe in 1890, Freer met Whistler, who inspired him to collect Asian art as well as the art of his own time. Freer became an avid collector and supporter of Whistler, whom he saw as a person who combined the aesthetic ideals of both East and West. Freer assembled a large and distinguished collection of American and Asian art, including the *Peacock Room*. (SEE FIG. 22). In his letter written at the founding the Freer Gallery, donating his collection to the Smithsonian Institution and thus to the American people, he wrote of his desire to "elevate the human mind."

WHAT IS ART HISTORY?

Art history became an academic field of study relatively recently. Many art historians consider the first art history book to be the 1550 publication *Lives of the Most Excellent Italian Architects, Painters, and Sculptors*, by the Italian artist and writer Giorgio Vasari. As the name suggests, art history combines two studies—the study of individual works of art outside time and place (**formal analysis** and **theory**) and the study of art in its historical and cultural context (**contextualism**), the primary approach taken in this book. The scope of art history is immense. As a result, art history today draws on many other disciplines and diverse methodologies.

Studying Art Formally and Contextually

The intense study of individual art objects is known as **connoisseurship**. Through years of close contact with artworks and through the study of the formal qualities that compose style in art (such as the design, the composition, and the way materials are manipulated)—an approach known as formalism—the connoisseur learns to categorize an unknown work through comparison with related pieces, in the hope of attributing it to a period, a place, and sometimes even a specific artist. Today such experts also make use of the many scientific tests—such as x-ray radiography, electron microscopy, infrared spectroscopy, and x-ray diffraction—but ultimately connoisseurs depend on their visual memory and their skills in formal analysis.

As a humanistic discipline, art history adds theoretical and contextual studies to the formal and technical analyses of connoisseurship. Art historians draw on biography to learn about artists' lives; on social history to understand the economic and political forces shaping artists, their patrons, and their public; and on the history of ideas to gain an understanding of the intellectual currents influencing artists' works. Some art historians are steeped in the work of Sigmund Freud (1856–1939), whose psychoanalytic theory addresses creativity, the unconscious mind, and art as an expression of repressed feelings. Others have turned to the political philosopher Karl Marx (1818–83) who saw human beings as the products of their economic environment and art as a reflection of humanity's excessive concern with material val-

ues. Some social historians see the work of art as a status symbol for the elite in a highly stratified society.

Art historians also study the history of other arts—including music, drama, and literature—to gain a fuller sense of the context of visual art. Their work results in an understanding of the iconography (the narrative and allegorical significance) and the context (social history) of the artwork. Anthropology and linguistics have added yet another theoretical dimension to the study of art. The Swiss linguist Ferdinand de Saussure (1857–1913) developed structuralist theory, which defines language as a system of arbitrary signs. Works of art can be treated as a language in which the marks of the artist replace words as signs. In the 1960s and 1970s structuralism evolved into other critical positions, the most important of which are semiotics (the theory of signs and symbols) and deconstruction. To the semiologist, a work of art is an arrangement of marks or "signs" to be decoded, and the artist's meaning or intention holds little interest. Similarly the deconstructionism of the French philosopher Jacques Derrida (1930–2004) questions all assumptions including the idea that there can be any single correct interpretation of a work of art. So many interpretations emerge from the creative interaction between the viewer and the work of art that in the end the artwork is "deconstructed."

The existence of so many approaches to a work of art may lead us to the conclusion that any idea or opinion is equally valid. But art historians, regardless of their theoretical stance, would argue that the informed mind and eye are absolutely necessary.

As art historians study a wider range of artworks than ever before, many have come to reject the idea of a fixed canon of superior pieces. The distinction between elite fine arts and popular utilitarian arts has become blurred, and the notion that some mediums, techniques, or subjects are better than others has almost disappeared. This is one of the most telling characteristics of art history today, along with the breadth of studies it now encompasses and its changing attitude to challenges such as preservation and restoration.

WHAT IS A VIEWER'S ROLE AND RESPONSIBILITY?

As viewers we enter into an agreement with artists, who in turn make special demands on us. We re-create the works of art for ourselves as we bring to them our own experiences, our intelligence, our knowledge, and even our prejudices. Without our participation, artworks are merely chunks of stone or flecks of paint. But remember, all is change. From extreme realism at one end of the spectrum to entirely nonrepresentational art at the other, artists have worked with varying degrees of naturalism, idealism, and abstraction. For students of art history, the challenge is to discover not only how those styles evolved, but also why they changed, and

ultimately what significance these changes hold for us, for our humanity, and for our future.

Our involvement with art can be casual or intense, naive or sophisticated. At first we may simply react instinctively to a painting or a building or a sculpture (FIG. 23), but this level of "feeling" about art—"I know what I like"—can never be fully satisfying. Like the sixteenth-century Dutch visitors to Rome (FIG. 24), we too can admire and ponder the ancient marble FARNESE HERCULES, and we can also ponder Hendrick Goltzius's engraving that depicts his Dutch friends as they ponder, and we can perhaps imagine an artist depicting us as our glance leaps backwards and forwards pondering art history. Because as viewers we participate in the re-creation of a work of art, its meaning changes from individual to individual, from era to era.

Once we welcome the arts into our lives, we have a ready source of sustenance and challenge that grows, changes, mellows, and enriches our daily experience. This book introduces us to works of art in their historical context, but no matter how much we study or read about art and artists, eventually we return to the contemplation of an original work itself, for art is the tangible evidence of the ever-questing human spirit.

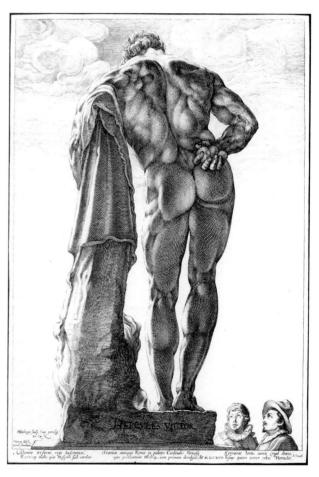

24 Hendrick Goltzius **DUTCH VISITORS TO ROME LOOKING AT THE FARNESE HERCULES** c. 1592. Engraving, 16 × 11½″ (40.5 x 29.4 cm). After Goltzius returned from a trip to Rome in 1591–1592, he made engravings based on his drawings. The awe-struck viewers have been identified as two of his Dutch friends.

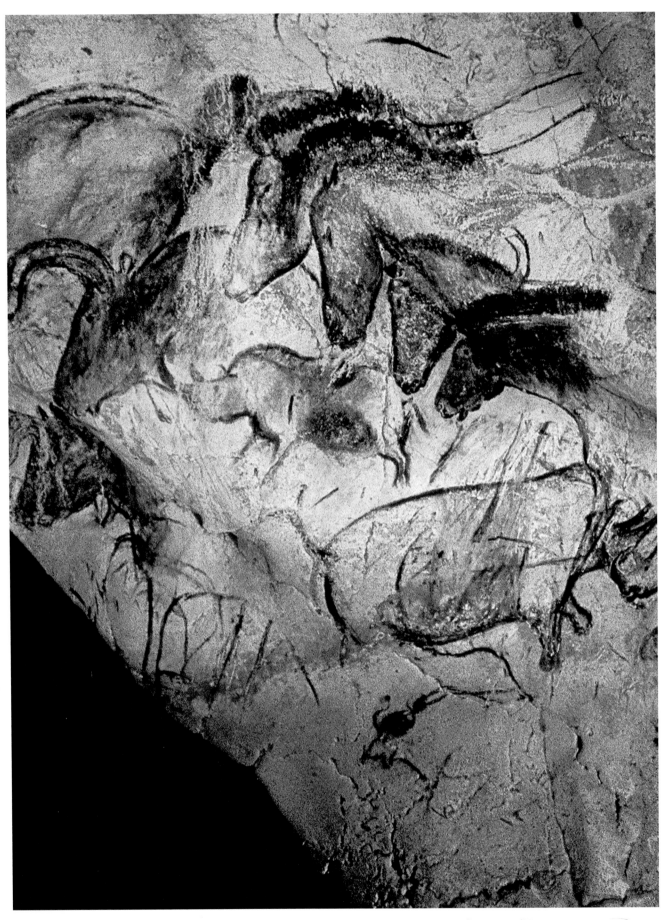

I–I | **WALL PAINTING WITH HORSES, RHINOCEROSES, AND AUROCHS** Chauvet Cave, Vallon-Pont-d'Arc, Ardèche Gorge, France. c. 30,000–28,000 BCE. Paint on limestone.

PREHISTORIC ART IN EUROPE

Prehistory includes all of human existence before the emergence of writing, but long before that defining moment, people were carving objects, painting images, and creating shelters and other structures. In fact, much of what we know about prehistoric people is based on the art they produced. These works are fascinating because they are supremely beautiful and because of what they tell us about those who made them. The sheer artistry and immediacy of the images left by our early ancestors connect us to them as surely as written records link us to those who came later.

The first contemporary people to explore the painted caves of France and Spain entered an almost unimaginably ancient world. Hundreds of yards from the entrances and accessed through long, narrow underground passages, what they found astounded them and still fascinates us. In the Chauvet Cave, located in a gorge in the Ardèche region of southeastern France (FIG. 1–1) images of horses, deer, mammoths, aurochs (extinct ancestors of oxen), and other animals that lived 30,000 years ago cover the walls and ceilings. Their forms bulge and seem to shift and move. The images are easily identifiable, for the painters have transformed their memories of active, three-dimensional figures into two dimensions by capturing the essence of well-observed animals—meat-bearing flanks, powerful legs, and dangerous horns or tusks. Using only the formal language of line and color, shading, and contour, these prehistoric painters seem to communicate with us.

Archaeologists and anthropologists study every aspect of material culture, while art historians usually focus on those things that to twenty-first–century eyes seem superior in craft and beauty. But 30,000 years ago our ancestors were not making "works of art." They were flaking, chipping, and polishing flints into spear points, knives, and scrapers, not into sculptures, however beautiful the forms of these tools appear to us. The creation of the images we see today on the walls of the Chauvet Cave must have seemed a vitally important activity to their makers in terms of everyday survival. They were often painted in areas far from the cave entrance, without access to natural daylight, and which were visited over many years. The walls were not flat canvasses but irregular natural rock forms. What we perceive as "art" may have been a matter of necessity to these ancient image makers.

For art historians, archaeologists, and anthropologists, prehistoric art provides a significant clue—along with fossils, pollen, and artifacts—to understanding early human life and culture. Although specialists continue to discover more about when and how these works were created, they may never be able to tell us why they were made. The sculpture, paintings, and structures that survive are only a tiny fraction of what must have been created over a very long span of time. The conclusions and interpretations drawn from them are only hypotheses, making prehistoric art one of the most speculative areas of art history.

THE STONE AGE

How and when modern humans evolved is the subject of ongoing lively debate, but anthropologists now agree that the species called *Homo sapiens* appeared about 200,000 years ago, and that the subspecies to which we belong, *Homo sapiens sapiens*, evolved about 120,000 to 100,000 years ago. Based on anthropological and archaeological findings, many scientists now contend that modern humans spread from Africa across Asia, into Europe, and finally to Australia and the Americas. Current evidence suggests that this vast movement of people took place between 100,000 and 35,000 years ago.

Scholars began the systematic study of prehistory only about 200 years ago. Nineteenth-century archaeologists, struck by the wealth of stone tools, weapons, and figures found at ancient sites, named the whole period of early human development the Stone Age. Today, researchers divide the Stone Age into the Paleolithic (from the Greek *paleo-*, "old," and *lithos*, "stone"), and the Neolithic (from the Greek *neo-*, "new") periods. The Paleolithic period itself is divided into three phases: Lower, Middle, and Upper, reflecting the relative position of objects found in the layers of excavation. (Upper is the most recent, lower the earliest.) In some places a transitional, or Paleolithic–Neolithic period—formerly called the Mesolithic (from the Greek *meso-*, "middle")—can also be identified.

Because the glaciers retreated gradually about 11,000 to 8,000 years ago, the dates for the transition from Paleolithic to Neolithic vary with geography. For some of the places discussed in this chapter, the Neolithic period arrived later and lasted until just 2,800 years ago. Archaeologists mark time in so many years ago, or BP ("before present"). However, to ensure consistent style throughout the book, which reflects the usage of art historians, we will use BCE ("before the Common Era") and CE (the Common Era) to mark time.

Much is yet to be discovered in prehistoric art. In Australia, some of the world's very oldest images have been dated to between 50,000 and 40,000 years ago. Africa, as well, is home to ancient rock art in both its northern and southern regions. In all cases, archaeologists associate the arrival of *Homo sapiens sapiens* in these regions with the advent of image making. This chapter explores the rich traditions of prehistoric European art from the Paleolithic and Neolithic periods into the Bronze and Iron ages (MAP 1–1). Later chap-

ters will consider the prehistoric art of other continents and cultures, such as the Near East (Chapter 2), the Americas (Chapter 12), and sub-Saharan Africa (Chapter 13).

THE PALEOLITHIC PERIOD

Researchers found that human beings made tools long before they made what today we call "art." *Art*, or image making, is the hallmark of the Upper Paleolithic period. Representational images are seen in the archaeological record beginning around 40,000 years ago in Australia, Africa, and Europe. Before that time, as far back as 2 million years ago during the Lower Paleolithic period in Africa, early humans made tools by flaking and chipping (knapping) flint pebbles into blades and scrapers with sharp edges.

Evolutionary changes took place over time and by 100,000 years ago, during the late Middle Paleolithic period, a well-developed type of *Homo sapiens* called Neanderthal inhabited Europe. They used many different stone tools and may have carefully buried their dead with funerary offerings. Although Neanderthals survived for thousands of years, Cro-Magnons—fully modern humans like us—overlapped and probably interbred with the Neanderthals and eventually replaced them, probably between 40,000 to 35,000 years ago. Called "Cro-Magnon" after the French site where their bones were first discovered, these modern humans made many different kinds of tools out of reindeer antler and bone, as well as very fine chipped-stone implements. Clearly social beings, Cro-Magnons must have had social organization, rituals, and beliefs that led them to create art. They engraved, carved, drew, and painted with colored ochers, earthy iron ores that could be ground into pigments. These people are our ancestors, and with their sculpture and painting we begin our history of art.

Shelter or Architecture?

The term **architecture** has been applied to the enclosure of spaces with at least some aesthetic intent. Some people object to its use in connection with prehistoric improvisations, but building even a simple shelter requires a degree of imagination and planning deserving of the name "architecture." In the Upper Paleolithic period, humans in some regions used great ingenuity to build shelters that were far from simple. In

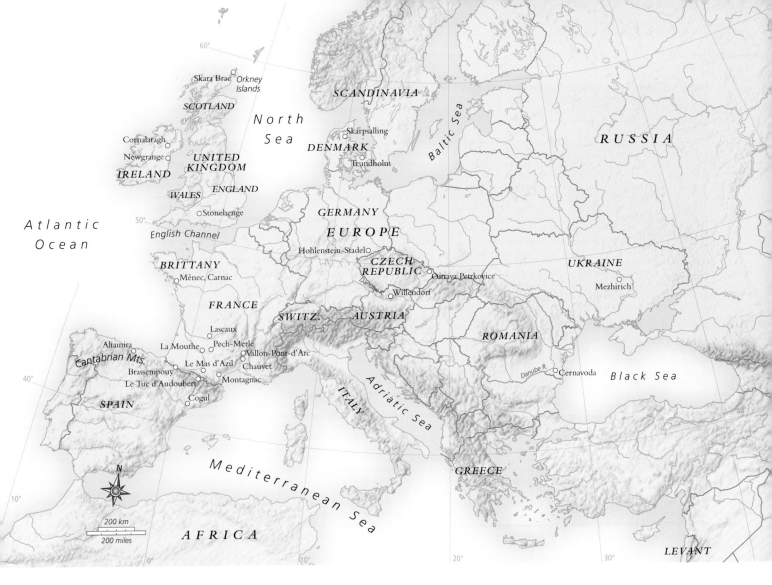

MAP 1–1 | **PREHISTORIC EUROPE**

As the Ice Age glaciers receded, Paleolithic, Neolithic, Bronze Age, and Iron Age settlements increased from south to north.

woodlands, evidence of floors indicates that circular or oval huts of light branches and hides were built. These measured as much as 15 to 20 feet in diameter. (Modern tents to accommodate six people vary from 10 by 11-foot ovals to 14 by 7-foot rooms.)

In the treeless grasslands of Upper Paleolithic Russia and Ukraine, builders created settlements of up to ten houses using the bones of the now extinct woolly mammoth, whose long, curving tusks made excellent roof supports and arched door openings (**FIG. 1–2**). This bone framework was probably

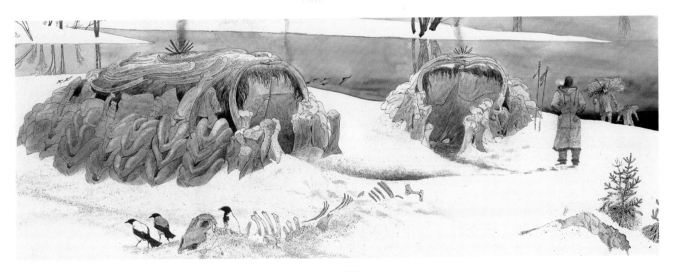

1–2 | **RECONSTRUCTION DRAWING OF MAMMOTH-BONE HOUSES**
Ukraine. c. 16,000–10,000 BCE.

Artifacts or Works of Art?

As early as 30,000 BCE small figures, or figurines, of people and animals made of bone, ivory, stone, and clay appeared in Europe and Asia. Today we interpret such self-contained, three-dimensional pieces as examples of sculpture in the round. Prehistoric carvers also produced **relief sculpture** in stone, bone, and ivory. In relief sculpture, the surrounding material is carved away, forming a background that sets off the figure.

THE LION-HUMAN. An early and puzzling example of a sculpture in the round is a human figure—probably male—with a feline head (**FIG. 1–3**), made about 30,000–26,000 BCE. Archaeologists excavating at Hohlenstein-Stadel, Germany, found broken pieces of ivory (from a mammoth tusk) that they realized were parts of an entire figure. Nearly a foot tall, this remarkable statue surpasses most early figurines in size and complexity. Instead of copying what he or she saw in nature, the carver created a unique creature, part human and part beast. Was the figure intended to represent a person wearing a ritual lion mask? Or has the man taken on the appearance of an animal? One of the few things that can be

1–3 | **LION-HUMAN**
Hohlenstein-Stadel, Germany. c. 30,000–26,000 BCE.
Mammoth ivory, height 11⅜″ (29.6 cm).
Ulmer Museum, Ulm, Germany.

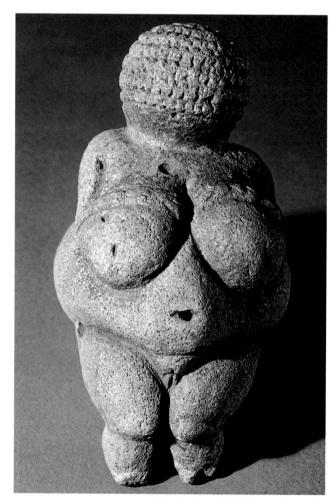

1–4 | **WOMAN FROM WILLENDORF**
Austria. c. 24,000 BCE. Limestone, height 4⅜″ (11 cm).
Naturhistorisches Museum, Vienna.

covered with animal hides and turf. Most activities centered around the inside fire pit, or hearth, where food was prepared and tools were fashioned. Larger dwellings might have had more than one hearth and spaces set aside for specific uses—working stone, making clothing, sleeping, and dumping refuse. In Mezhirich, Ukraine, archaeologists found fifteen small hearths inside the largest dwelling that still contained ashes and charred bones left by the last occupants. Some people also colored their floors with powdered ocher ranging in color from yellow to red to brown.

Art and Its Context
THE POWER OF NAMING

Words are only symbols for ideas. But the very words we invent—or our ancestors invented—reveal a certain view of the world and can shape our thinking. Early people recognized clearly the power of words. In the Old Testament, God gave Adam dominion over the animals and allowed him to name them (Genesis 2:19-20). Today, we still exert the power of naming when we select a name for a baby or call a friend by a nickname. Our ideas about art can also be affected by names, even the ones used for captions in a book. Before the twentieth century, artists usually did not name, or title, their works. Names were eventually supplied by the works' owners or by scholars writing about them and thus may express the cultural prejudices of the labelers or of the times in which they live.

An excellent example of such distortion is provided by the names early scholars gave to the hundreds of small prehistoric statues of women they found. They called them by the Roman name "Venus." For example, the sculpture in Figure 1-4 was once called the Venus of Willendorf after the place where it had been found. Using the name of the Roman goddess of love and beauty sent a message that this figure was associated with religious belief, that it represented an ideal of womanhood, and that it was one of a long line of images of "classical" feminine beauty. In a short time, most similar works of sculpture from the Upper Paleolithic period came to be known as Venus figures. The name was repeated so often that even scholars began to assume that these had to be fertility figures and mother goddesses, although there is no proof that this was so.

Our ability to understand and interpret works of art creatively is easily compromised by distracting labels. Calling a prehistoric figure a "woman" instead of "Venus" encourages us to think about the sculpture in new and different ways.

said about the **LION-HUMAN** is that it shows highly complex thinking and creative imagination: the ability to conceive and represent a creature never seen in nature.

FEMALE FIGURES. While a number of figurines representing men have been found recently, most human figures from the Upper Paleolithic period are female. The most famous female figure, the **WOMAN FROM WILLENDORF** (FIG. 1–4), from Austria, dates from about 22,000–21,000 BCE (see "The Power of Naming," above). Carved from limestone and originally colored with red ocher, the statuette's swelling, rounded forms make it seem much larger than its actual 4⅜-inch height. The sculptor exaggerated the figure's female attributes by giving it pendulous breasts, a big belly with deep navel (a natural indentation in the stone), wide hips, dimpled knees and buttocks, and solid thighs. By carving a woman with a well-nourished body, the artist may be expressing health and fertility, which could ensure the ability to produce strong children, thus guaranteeing the survival of the clan.

Another carved figure, found in the Czech Republic, the **WOMAN FROM OSTRAVA PETRKOVICE** (FIG. 1–5), presents an entirely different conception of the female form. It is less than 2 inches tall and dates from about 23,000 BCE. Archaeologists excavating an oval house stockpiled with flint stone and rough chunks of hematite (iron oxide) discovered the figure next to the hearth. The torso and thighs of a youthful, athletic figure of a woman suggest an animated pose, with one angular hip slightly raised and a knee bent as if she were walking. The marks left by the artist's carving tool are visible.

Another remarkable female image, discovered in the Grotte du Pape in Brassempouy, France, is the tiny ivory head

1–5 | **WOMAN FROM OSTRAVA PETRKOVICE**
Czech Republic. c. 23,000 BCE. Hematite, height 1¾″ (4.6 cm). Archaeological Institute, Brno, Czech Republic.
© Institute of Archaeology, Academy of Sciences of the Czech Republic, Brno

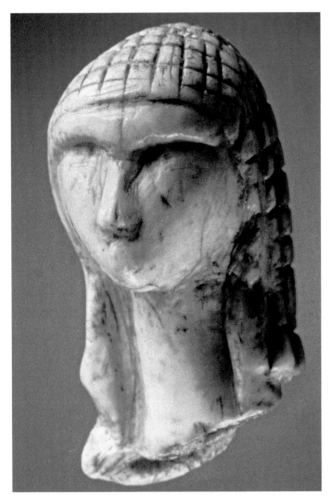

1–6 | **WOMAN FROM BRASSEMPOUY**
Grotte du Pape, Brassempouy, Landes, France. Probably
c. 30,000 BCE. Ivory, height 1¼″ (3.6 cm). Musée des Antiquités
Nationales, St.-Germain-en-Laye, France.

known as the **WOMAN FROM BRASSEMPOUY** (FIG. 1–6). The
finders did not record its archaeological context; however,
recent studies declare it to be authentic and date it as early as
30,000 BCE. The carver captured the essence of a head or what
psychologists call the *memory image*—those generalized ele-
ments that reside in our standard memory of a human head.
An egg shape rests atop a long neck, a wide nose and a strongly
defined browline suggest deep-set eyes, and an engraved square
patterning may be hair or a headdress. The image is an abstrac-
tion (what has come to be known as **abstract art**): the reduc-
tion of shapes and appearances to basic yet recognizable forms
that are not intended to be exact replications of nature. The
result in this case looks uncannily modern to the contempo-
rary viewer. Today when such a piece is isolated in a museum
case or as a book illlustration, we enjoy it as an aesthetic object,
but we lose its original cultural context.

Cave Painting

Art in Europe entered a rich and sophisticated phase between
about 30,000 and 10,000 BCE, when images were painted on
the walls of caves in central and southern France and
northern Spain.

No one knew of the existence of prehistoric cave paint-
ings until one day in 1879, when a young girl, exploring with
her father in Altamira in northern Spain, crawled through a
small opening in the ground and found herself in a chamber
whose ceiling was covered with painted animals (see page 9).
Her father, a lawyer and amateur archaeologist, searched the
rest of the cave, told authorities about the remarkable find,
and published his discovery the following year. Few people
believed that these amazing works could have been done by
"primitive" people, and the scientific community declared
the paintings a hoax. They were accepted as authentic only in
1902, after many other cave paintings, drawings, and engrav-
ings had been discovered at other places in northern Spain
and in France.

What caused people to paint such dramatic imagery on
the walls of caves? The idea that human beings have an inher-
ent desire to decorate themselves and their surroundings—
that an aesthetic sense is somehow innate to the human
species—found ready acceptance in the nineteenth century.
Many believed that people create art for the sheer love of
beauty. Scientists now agree that human beings have an aes-
thetic impulse, but the effort required to accomplish the great
cave paintings suggests their creators were motivated by more
than simple pleasure. Since the discovery at Altamira, anthro-
pologists and art historians have devised several hypotheses to
explain the existence of cave art. Like the search for the
meaning of prehistoric female figurines, these explanations
depend on the cultural views of those who advance them.

THE MEANING OF CAVE PAINTINGS. Early twentieth-century
scholars believed that art fulfills a social function and that aes-
thetics are culturally relative. They proposed that the cave
paintings might be products both of *totemistic* rites to
strengthen clan bonds and *increase ceremonies* to enhance the
fertility of animals used for food. In 1903, French scholar
Salomon Reinach suggested that cave paintings were expres-
sions of *sympathetic magic* (the idea, for instance, that a picture
of a reclining bison would insure that hunters found their
prey asleep). Abbé Henri Breuil took these ideas further and
concluded that caves were used as places of worship and the
settings for initiation rites. In the second half of the twentieth
century, scholars rejected these ideas and based their interpre-
tations on rigorous scientific methods and current social the-
ory. Andre Leroi-Gourhan and Annette Laming-Emperaire,
for example, dismissed the sympathetic magic theory because
statistical analysis of debris from human settlements revealed
that the animals used most frequently for food were not the
ones traditionally portrayed in caves. Their analysis also
showed a systematic organization of images.

Researchers continue to discover new cave images and to
correct earlier errors of fact or interpretation. A study of the

Altamira cave in the 1980s led Leslie G. Freeman to conclude that these artists faithfully represented a herd of bison during the mating season. Instead of being dead, asleep, or disabled—as earlier observers had thought—the bison were dust-wallowing, common behavior during the mating season.

Although hypotheses that seek to explain cave art have changed and evolved over time, scholars have always agreed that decorated caves must have had a special meaning, because people returned to them time after time over many generations, in some cases over thousands of years. Perhaps Upper Paleolithic cave art was the product of rituals intended to gain the favor of the supernatural. Perhaps because much of the art was made deep inside the caves and nearly inaccessible, its significance may have had less to do with the finished painting than with the very act of creation. Artifacts and footprints (such as those found at Chauvet, below, and Le Tuc d'Audoubert, page 10) suggest that the subterranean galleries, which were far from living quarters, had a religious or magical function. Perhaps the experience of exploring the cave may have been significant to the image makers. Musical instruments, such as bone flutes, have been found in the caves, implying that even acoustical properties may have played a role.

CHAUVET. The earliest known site of prehistoric cave paintings today, discovered in December 1994, is the Chauvet Cave (so called after one of the persons who found it) near Vallon-Pont-d'Arc in southeastern France—a tantalizing trove of hundreds of paintings (SEE FIG. 1–1). The most dramatic of the Chauvet Cave images depict grazing, running, or resting animals. Among the animals depicted are wild horses, bison, mammoths, bears, panthers, owls, deer, aurochs, woolly-haired rhinos, and wild goats (or ibex). Also included are occasional humans, both male and female, many hand-

Sequencing Events
PREHISTORIC PERIODS

c. 40,000–8000 BCE	Upper Paleolithic period; modern man arrives in Europe
c. 10,000 BCE	Present interglacial period begins
c. 9000–4000 BCE	Paleolithic-Neolithic overlap (formerly called the Mesolithic period)
c. 6500–1200 BCE	Neolithic period; farming in Europe
c. 2300–c.800 BCE	Bronze Age in Europe; trade with Near East increases
c. 1000–50 BCE	Proto-historic Iron Age in Europe

prints, and hundreds of geometric markings such as grids, circles, and dots. Footprints in the Chauvet Cave, left in soft clay by a child, go to a "room" containing bear skulls. The charcoal used to draw the rhinos has been radiocarbon dated to 32,410 plus or minus 720 years before the present.

PECH-MERLE. A cave site at Pech-Merle, also in southern France, appears to have been used and abandoned several times over a period of 5,000 years. Images of animals, handprints, and nearly 600 geometric symbols have been found in thirty different parts of the underground complex. The earliest artists to work in the cave, some 24,000–25,000 years ago, painted horses (FIG. 1–7) with small, finely detailed heads, heavy bodies, massive extended necks, and legs tapering to almost nothing at the hooves. The right-hand horse's head follows the

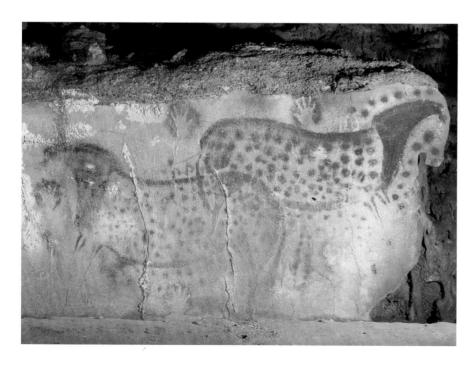

1–7 SPOTTED HORSES AND HUMAN HANDS
Pech-Merle Cave, Dordogne, France. Horses 25,000–24,000 BCE; hands c. 15,000 BCE. Paint on limestone, individual horses are over 5′ (1.5 m) in length.

Technique
PREHISTORIC WALL PAINTING

In a dark cave, working by the light of an animal-fat lamp, an artist chews a piece of charcoal to dilute it with saliva and water. Then he blows out the mixture on the surface of a wall, using his hand as a stencil. In the drawing, cave archaeologist Michel Lorblanchet is showing us how the original makers of a cave painting at Pech-Merle in France created a complex design of spotted horses.

By turning himself into a human spray can, Lorblanchet can produce clear lines on the rough stone surface much more easily than he could with a brush. To create the line of a horse's back, with its clean upper edge and blurry lower one, he blows pigment below his hand. To capture its angular rump, he places his hand vertically against the wall, holding it slightly curved. To produce, the sharpest lines, such as those of the upper hind leg and tail, he places his hands side by side and blows between them. To create the forelegs and the hair on the horses' bellies, he finger paints. A hole punched in a piece of leather serves as a stencil for the horses' spots. It takes Lorblanchet only 32 hours to reproduce the Pech-Merle painting of spotted horses, his speed suggesting that a single artist created the original (perhaps with the help of an assistant to mix pigments and tend the lamp).

Cro-Magnon artists used three painting techniques—the spraying demonstrated by Lorblanchet, drawing with fingers or blocks of ocher, and daubing with a paintbrush made of hair or moss. In some places in prehistoric caves three stages of image creation can be seen—engraved lines using flakes of flint, followed by a color wash of ocher and manganese, and a final engraving to emphasize shapes and details.

shape of the rock. The horse images were then overlaid with bright red dots. Some interpreters see these circles as ordinary spots on the animals' coats, but others see them as representations of rock weapons ritually hurled at the painted horses.

The handprints on the walls at Pech-Merle and other cave sites were almost certainly not idle graffiti or accidental smudges. Some are positive images made by simply coating the hand with color pigment and pressing it against the wall. Others are negative images: The surrounding space rather than the hand shape itself is painted. Negative images were made by placing the hand with fingers spread apart against the wall, then spitting or spraying paint around it with a reed blowpipe or daubing with a paint-covered pad or brush—artist's tools that have been found in such caves (see "Prehistoric Wall Painting," left). In other places, artists drew or incised (scratched) figures onto the cave walls.

LASCAUX. The best-known cave paintings are those found in 1940 at Lascaux, in the Dordogne region of southern France. They have been dated to about 15,000 BCE (FIG. 1–8). Opened to the public after World War II, the prehistoric "museum" at Lascaux soon became one of the most popular tourist sites in France. Too popular, because the visitors brought heat, humidity, exhaled carbon dioxide, and other contaminants. The cave was closed to the public in 1963 so that conservators could battle an aggressive fungus. Eventually they won, but instead of reopening the site, authorities created a facsimile of it. Visitors at what is called Lascaux II may now view copies of the painted scenes without harming the precious originals.

The scenes they view are truly remarkable. The Lascaux artists painted cows, bulls, horses, and deer along the natural ledges of the rock, where the smooth white limestone of the ceiling and upper wall meets a rougher surface below. They also utilized the curving wall to suggest space. Lascaux has about 600 paintings and 1,500 engravings. Ibex and a bear, engraved felines, and a woolly rhinoceros, but no mammoths, have also been found. The animals appear singly, in rows, face to face, tail to tail, and even painted on top of one another. Their most characteristic features have been emphasized. Horns, eyes, and hooves are shown as seen from the front, yet heads and bodies are rendered in profile in a system known as **twisted perspective**. Even when their poses are exaggerated or distorted, the animals are full of life and energy, and the accuracy in the drawing of their silhouettes, or outlines, is remarkable.

Painters worked not only in large caverns, but also far back in the smallest chambers and recesses, many of which are almost inaccessible today. Small stone lamps found in such caves—over 100 lamps have been found at Lascaux—indicate that they worked in flickering light from burning animal fat (SEE FIG. 1–12). (Although 500 grams of fat would burn for 24 hours and animal fat produces no soot, the light created is not as strong as a candle.)

One scene at Lascaux was discovered in a remote setting on a wall at the bottom of a 16-foot shaft that contained a stone

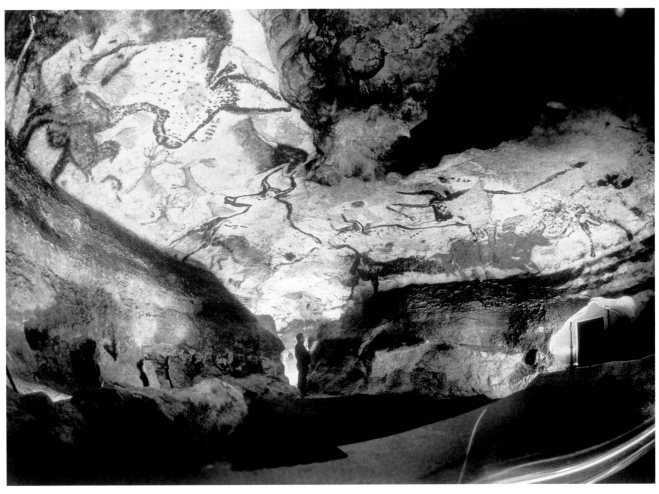

I–8 | **HALL OF BULLS**
Lascaux Cave, Dordogne, France. c. 15,000 BCE. Paint on limestone, length of the largest auroch (bull) 18′ (5.50 m).

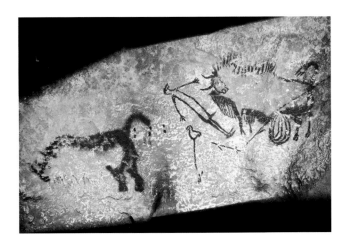

I–9 | **BIRD-HEADED MAN WITH BISON**
Shaft scene in Lascaux Cave. c. 15,000 BCE. Paint on limestone, length approx. 9′ (2.75 m).

lamp and spears. The scene is unusual because it is the only painting in the cave complex that seems to tell a story **(FIG. I–9)**, and it is stylistically different from the other paintings at Lascaux. A figure who could be a hunter, greatly simplified in form but recognizably male and with the head of a bird or wearing a bird's-head mask, appears to be lying on the ground. A great bison looms above him. Below him lie a staff, or baton, and a spear thrower *(atlatl)*—a device that allowed hunters to throw farther and with greater force—the outer end of which has been carved in the shape of a bird. The long, diagonal line slanting across the bison's hindquarters may be a spear. The bison has been disemboweled and will soon die. To the left of the cleft in the wall a woolly rhinoceros seems to run off.

Why did the artist portray the man as only a sticklike figure when the bison was rendered with such accurate detail? Does the painting illustrate a story or a myth regarding the death of a hero? Is it a record of an actual event? The painting may depict the vision of a *shaman*. Shamans are thought to have special powers, an ability to contact spirits in the form of animals or birds. In a trance they leave their bodies and communicate through spirit guides. The images they use to record their visions tend to be abstract, incorporating geometric

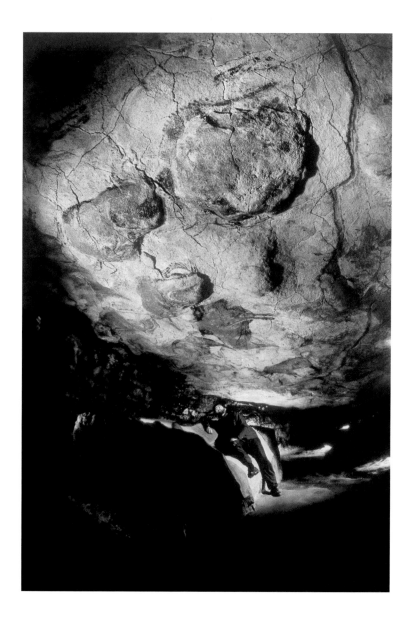

I–10 | **BISON**
Ceiling of a cave at Altamira, Spain. c. 12,500 BCE.
Paint on limestone, length approx. 8′3″ (2.5 m).

figures and combinations of human and animal forms, such as the bird-headed man in this scene from Lascaux or the lion-headed figure discussed earlier (SEE FIG. 1–3).

ALTAMIRA. The cave paintings at Altamira, near Santander in the Cantabrian Mountains in Spain—the first to be discovered and attributed to the Upper Paleolithic period—have been recently dated to about 12,500 BCE. The Altamira artists created sculptural effects by painting over and around natural irregularities in the cave walls and ceilings. To produce the herd of bison on the ceiling of the main cavern (FIG. 1–10), they used rich red and brown ochers to paint the large areas of the animals' shoulders, backs, and flanks, then sharpened the contours of the rocks and added the details of the legs, tails, heads, and horns in black and brown. They mixed yellow and brown from ochers with iron to make the red tones and derived black from manganese or charcoal.

Cave Sculptures

Caves were sometimes adorned with relief sculpture as well as paintings. At Altamira, an artist simply heightened the resemblance of a natural projecting rock to a similar and familiar animal form. Other reliefs were created by **modeling**, or shaping, the damp clay of the cave's floor. An excellent example of such work in clay from about 13,000 BCE is preserved at Le Tuc d'Audoubert, south of the Dordogne region of France. Here the sculptor created two bison leaning against a ridge of rock (FIG. 1–11). Although these beasts are modeled in very **high relief** (they extend well forward from the background), they display the same conventions as in earlier painted ones, with emphasis on the broad masses of the meat-bearing flanks and shoulders. To make the animals even more lifelike, their creator engraved short parallel lines below their necks to represent their shaggy coats. Numerous small footprints found in the clay floor of this cave suggest that important group rites took place here.

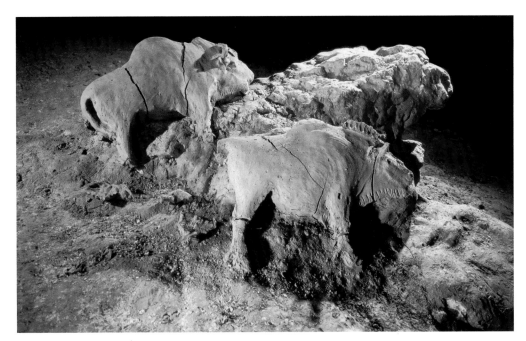

1—11 | **BISON**
Le Tuc d'Audoubert,
France. c. 13,000 BCE.
Unbaked clay, length 25″
(63.5 cm) and 24″
(60.9 cm).

1—12 | **LAMP WITH IBEX DESIGN**
La Mouthe Cave, Dordogne, France. c. 15,000–13,000 BCE.
Engraved stone.

An aesthetic sense and the ability to express it in a variety of ways are among the characteristics unique to our subspecies, *Homo sapiens sapiens*. Lamps found in caves provide an example of objects that were both functional and aesthetically pleasing. Some were carved in simple abstract shapes; others were adorned with engraved images, like one found at La Mouthe, France (FIG. 1—12). The maker decorated the underside of this lamp with an ibex. The animal's distinctive head is shown in profile, its sweeping horns reflecting the curved outline of the lamp itself. Objects such as the ibex lamp were made by people whose survival depended upon their skill at hunting animals and gathering wild grains and other edible plants. But a change was already under way that would completely alter human existence.

THE NEOLITHIC PERIOD

Today, advances in technology, medicine, transportation, and electronic communication change human experience in a generation. Many thousands of years ago, change took place much more slowly. In the tenth millennium BCE the world had already entered the present interglacial period, and our modern climate was taking shape. However, the Ice Age ended so gradually and unevenly among regions that people could not have known it was occurring.

To determine the onset of the Neolithic period in a specific region, archaeologists look for evidence of three conditions: an organized system of agriculture, the maintenance of herds of domesticated animals, and permanent, year-round settlements. The cumulative effects of warming temperatures were challenging to a settled way of life. Europe underwent a long and varied intermediary period not only of climate change, but also of cultural development.

At the end of the Ice Age in Europe, rising ocean levels dramatically altered the shorelines of the continent, making islands in some places. About 6000 BCE, the land bridge connecting England with the rest of Europe disappeared beneath the waters of what are now known as the North Sea and the English Channel. Most significantly, the retreating glaciers exposed large temperate regions. The heavily forested Mediterranean basin gave way to grassy plains supporting new, edible plants. Great herds of smaller and quicker animals, such as deer, were lured farther and farther west and north into the open areas and forests of central and northern Europe.

At the same time, people responded to these new conditions by inventing new hunting technologies or improving older ones. Hunters now used the bow and arrow much

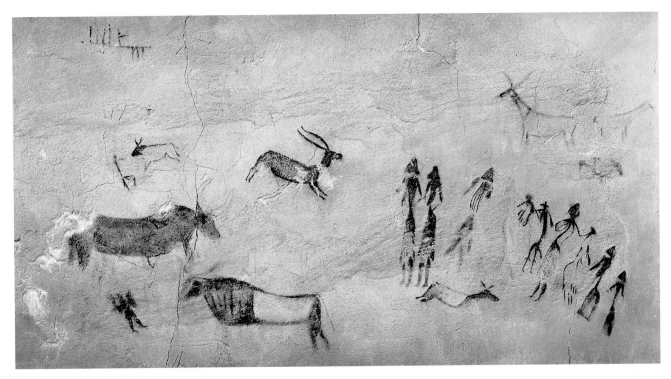

I–13 | **PEOPLE AND ANIMALS**
Detail of rock-shelter painting, Cogul, Lérida, Spain. c. 4000–2000 BCE.

more frequently than they did in Paleolithic times. Bows were easier to carry, much more accurate at longer range than spears, and much more effective against the new type of game. The use of dugout boats opened up rich new areas formed by the rising waters of the North Sea for fishing and hunting. Stone tools were now polished to a high gloss instead of being chipped and flaked as in the Paleolithic period. With each advance, the standard of living improved.

The new environment led to a new, more sedentary way of life. Europeans began domesticating animals and cultivating plants. Dogs first joined hunters in Europe more than 10,000 years ago; cattle, sheep, and other animals were domesticated later. Between 10,000 and 5,000 years ago, people along the eastern shore of the Mediterranean began cultivating wild wheat and barley, developing these grasses into productive grains such as bread wheat.

The new farming culture gradually spread across Europe, reaching Spain and France by 5000 BCE. Farmers in the Paris region were using plows by 4000 BCE. As larger numbers of people became farmers, they began to live in villages and produce more than enough food to support themselves—thus freeing some people to attend to other communal needs such as political and military affairs, or ceremonial practices. Over time these early societies became increasingly complex. By the end of the period, villages were larger, trading had developed among distant regions, and advanced building technology had produced awe-inspiring architecture.

Rock-Shelter Art

The period of transition between Paleolithic and Neolithic culture (sometimes called Mesolithic) saw the rise of a distinctive art combining geometric forms and schematic images—simplified, diagrammatic renderings—with depictions of people and animals engaged in everyday activities. Artists of the time preferred to paint and engrave such works on the walls of easily accessible, shallow rock shelters. In style, technique, and subject matter, these rock-shelter images are quite different from those found in Upper Paleolithic cave art. The style is abstract, and the technique is often simple line drawing, with no addition of color. Beginning about 6000 BCE, rock-shelter art appeared in many places near the Mediterranean coast.

At Cogul, in the province of Lérida in Catalonia, the broad surfaces of a rock shelter are decorated with elaborate scenes involving dozens of small figures. The artists now represent men, women, children, animals, even insects, going about daily activities (FIG. I–13). The paintings date from between 4000 and 2000 BCE (see "How Early Art Is Dated," right). No specific landscape features are indicated, but occasional painted patterns of animal tracks give the sense of a rocky terrain, like that of the surrounding barren hillsides.

In the detail shown here, a number of women are seen strolling or standing about, some in pairs holding hands. The women's small waists are emphasized by skirts with scalloped hemlines revealing large calves and sturdy ankles. All of them have shoulder-length hair. The women stand near several large animals, some of which are shown leaping forward with

legs fully extended. This pose, called a *flying gallop*, has been used to indicate speed in a running animal from prehistory to the present. The paintings are more than a record of daily life: People continued to visit these sites long after their original purpose had been forgotten. Inscriptions in Latin and an early form of Spanish scratched by Roman-era visitors—2,000-year-old graffiti—share the rock wall surfaces with the prehistoric paintings.

Architecture

As humans adopted a settled, agricultural way of life, they began to build large structures to serve as dwellings, storage spaces, and shelters for their animals. After the disappearance of the glaciers in Europe, timber became abundant, and Neolithic people, like their Paleolithic predecessors, continued to construct buildings out of wood and other plant materials. They clustered their dwellings in villages, and built large tombs and ritual centers outside settlements.

DWELLINGS AND VILLAGES. A northern European village of this period typically consisted of three or four long timber buildings, each up to 150 feet long, housing forty-five to fifty people. The structures were rectangular, with a row of posts down the center supporting a **ridgepole,** a long horizontal beam against which the slanting roof poles were braced (see example 4 in "Post-and-Lintel and Corbel Construction," page 14). The walls were probably made of what is known as **wattle and daub,** branches woven in a basketlike pattern, then covered with mud or clay. They were probably roofed with **thatch,** plant material such as reeds or straw tied over a framework of poles. These houses also included large granaries, or storage spaces for the harvest. Similar structures serving as animal shelters or even dwellings can still be seen today. Around 4000 BCE, Neolithic settlers began to locate their communities at defensible sites—near rivers, on plateaus, or in swamps. For additional protection, they also frequently surrounded them with wooden walls, earth embankments, and ditches.

SKARA BRAE. A Neolithic settlement has been wonderfully preserved at Skara Brae in the Orkney Islands off the northern coast of Scotland. It was constructed of stone, which was an abundant building material in this bleak, treeless region. A long-ago storm buried this seaside village under a layer of sand, and another storm brought it to light again in 1850.

Skara Brae presents a vivid picture of Neolithic life in the far north. In the houses, archaeologists found beds, shelves, stone cooking pots, basins, stone mortars for grinding, and pottery with incised decoration. Comparison of these artifacts with objects from sites farther south and laboratory analysis of the village's organic refuse date the settlement to between 3100 and 2600 BCE.

Science and Technology
HOW EARLY ART IS DATED

Since the first discoveries at Altamira, archaeologists have developed increasingly sophisticated ways of dating cave paintings and other objects. Today, archaeologists primarily use two approaches to determine an artifact's age. **Relative dating** relies on the chronological relationships among objects in a single excavation or among several sites. If archaeologists have determined, for example, that pottery types A, B, and C follow each other chronologically at one site, they can apply that knowledge to another site. Even if "type B" is the only pottery present, it can still be assigned a relative date. **Absolute dating** aims to determine a precise span of calendar years in which an artifact was created.

The most accurate method of absolute dating is **radiometric dating**, which measures the degree to which radioactive materials have disintegrated over time. Used for dating organic (plant or animal) materials—including some pigments used in cave paintings—one radiometric method measures a carbon isotope called radiocarbon, or carbon-14, which is constantly replenished in a living organism. When an organism dies, it stops absorbing carbon-14 and starts to lose its store of the isotope at a predictable rate. Under the right circumstances, the amount of carbon-14 remaining in organic material can tell us how long ago an organism died.

This method has serious drawbacks for dating works of art. Using carbon-14 dating on a carved antler or wood sculpture shows only when the animal died or when the tree was cut down, not when the artist created the work using those materials. Also, some part of the object must be destroyed in order to conduct this kind of test—something that is never a desirable procedure to conduct on a work of art. For this reason, researchers frequently test organic materials found in the same context as the work of art rather than in the work itself.

Radiocarbon dating is most accurate for materials no more than 30,000 to 40,000 years old. **Potassium-argon dating**, which measures the decay of a radioactive potassium isotope into a stable isotope of argon, an inert gas, is most reliable with materials more than a million years old. Two newer techniques have been used since the mid-1980s. **Thermo-luminescence dating** measures the irradiation of the crystal structure of a material subjected to fire, such as pottery, and the soil in which it is found, determined by the luminescence produced when a sample is heated. **Electron spin resonance** techniques involve using a magnetic field and microwave irradiation to date a material such as tooth enamel and the soil surrounding it.

Recent experiments have helped to date cave paintings with increasing precision. Radiocarbon analysis has determined, for example, that the animal images at Lascaux are 17,000 years old—to be more precise, 17,070 years plus or minus 130 years.

Elements of Architecture
POST-AND-LINTEL AND CORBEL CONSTRUCTION

Of all the methods for spanning space, post-and-lintel construction is the simplest. At its most basic, two uprights (posts) support a horizontal element (lintel). There are countless variations, from the wood structures, dolmens, and other underground burial chambers of prehistory, to Egyptian and Greek stone construction, to medieval timber-frame buildings, and even to cast-iron and steel construction. Its limitation as a space spanner is the degree of tensile strength of the lintel material: the more flexible, the greater the span possible. Another early method for creating openings in walls and covering space is **corbeling**, in which rows or layers of stone are laid with the end of each row projecting beyond the row beneath, progressing until opposing layers almost meet and can then be capped with a stone that rests across the tops of both layers.

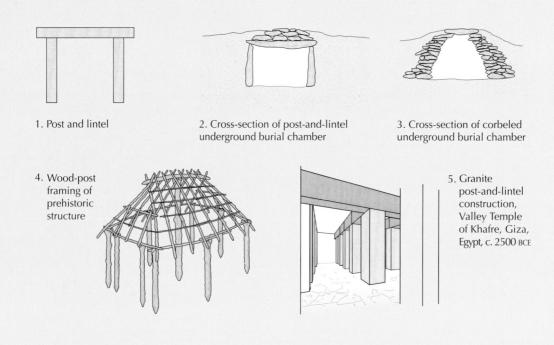

1. Post and lintel

2. Cross-section of post-and-lintel underground burial chamber

3. Cross-section of corbeled underground burial chamber

4. Wood-post framing of prehistoric structure

5. Granite post-and-lintel construction, Valley Temple of Khafre, Giza, Egypt, c. 2500 BCE

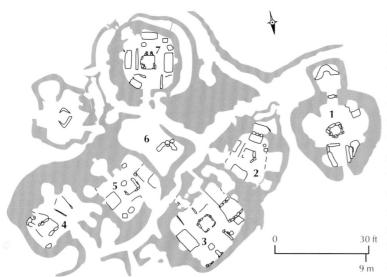

I–I4 | PLAN, VILLAGE OF SKARA BRAE
Orkney Islands, Scotland. c. 3100–2600 BCE. (Numbers refer to individual houses.)

0 _____ 30 ft
9 m

The village consists of a compact cluster of dwellings linked by covered passageways (**FIG. I–I4**). Each of the houses has a square plan with rounded corners. The largest one measures 20 by 21 feet, the smallest, 13 by 14 feet. Layers of flat stones without mortar form walls, with each layer, or course, projecting slightly inward over the one below. This type of construction is called **corbeling** (see example 3 in "Post–and–Lintel and Corbel Construction," above). In some structures, inward-sloping walls come together at the top in what is known as a **corbel vault**, but at Skara Brae the walls stopped short of meeting, and the remaining open space was covered with hides or turf. There are smaller corbel-vaulted rooms within the main walls of some of the houses that may have been used for storage. One room, possibly a latrine, has a drain leading out under its wall.

The houses of Skara Brae were equipped with space-saving built-in furniture. In the room shown (**FIG. I–I5**), a large rectangular hearth with a stone seat at one end occupies the center of the space. Rectangular stone beds, some engraved with simple designs, stand against the walls on two sides of the

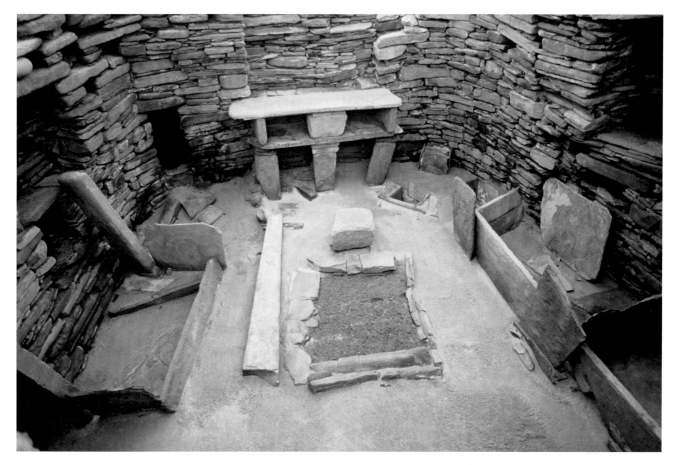

I–15 | **HOUSE INTERIOR, SKARA BRAE**
(House 7 in Fig. 1-14).

hearth. These boxlike beds would probably have been filled with heather "mattresses" and covered with warm furs. In the left corner, a sizable storage room is built into the thick outside wall. Smaller storage niches were provided over each of the beds. A stone tank lined with clay to make it watertight is partly sunk into the floor. This container was probably used for live bait, for it is clear that the people at Skara Brae were skilled fisherfolk. On the back wall is a two-shelf cabinet that is a clear example of what is known as post-and-lintel construction (see "Post-and-Lintel and Corbel Construction," left).

CEREMONIAL AND TOMB ARCHITECTURE. In western and northern Europe, people used huge stones to erect ceremonial structures and tombs. In some cases, they had to transport these great stones over long distances. The monuments thus created are examples of what is known as **megalithic architecture**, the descriptive term derived from the Greek word roots for "large" (*mega-*) and "stone" (*lithos*).

Architecture formed of such massive elements testifies to a complex, stratified society. Powerful religious or political

figures and beliefs were needed to identify the society's need for such structures and dictate their design. Skilled "engineers" were needed to devise methods for shaping, transporting, and aligning the stones. Finally, only strong leaders could have assembled and maintained the labor force required to move the stones long distances.

Elaborate megalithic tombs first appeared in the Neolithic period. Some were built for single burials; others consisted of multiple burial chambers. The simplest type of megalithic tomb was the **dolmen**, built on the post-and-lintel principle. The tomb chamber was formed of huge upright stones supporting one or more tablelike rocks, or *capstones*. The structure was then mounded over with smaller rocks and dirt to form a **cairn** or artificial hill. A more imposing structure was the *passage grave*, which was entered by one or more narrow, stone-lined passageways into a large room at the center.

At Newgrange, in Ireland, the mound of an elaborate passage grave (**FIG. 1–16**) originally stood 44 feet tall and measured about 280 feet in diameter. The mound was built

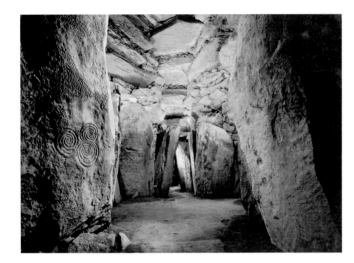

I–16 | TOMB INTERIOR WITH CORBELING AND ENGRAVED STONES
New Grange, Ireland. c. 3000–2500 BCE.

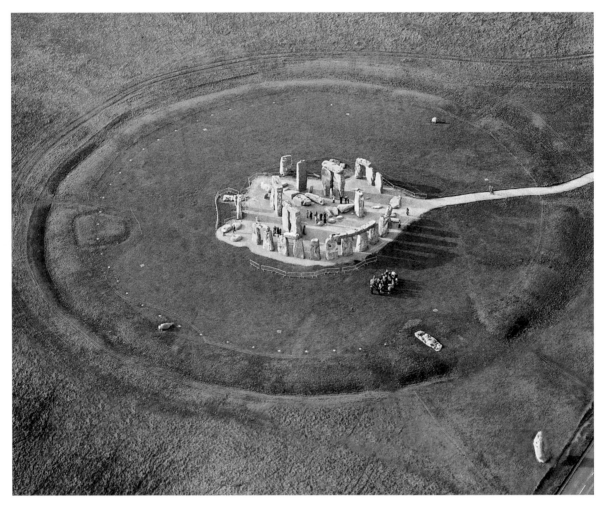

I–17 | STONEHENGE
Salisbury Plain, Wiltshire England. c. 2750–1500 BCE.

of sod and river pebbles and was set off by a circle of engraved standing stones around its perimeter. Its passage-way, 62 feet long and lined with standing stones, leads into a three-part chamber with a corbel vault rising to a height of 19 feet. Some of the stones are engraved with linear designs, mainly rings, spirals, and diamond shapes. These patterns may have been marked out using strings or com-passes, then carved by picking at the rock surface with tools made of antlers.

Such large and richly decorated structures did more than honor the distinguished dead; they were truly public archi-tecture that must have fostered communal pride and a group identity. As is the case with elaborate funerary monuments built today, their function was both practical and symbolic.

FIBER ARTS

People began working with plant fibers very early. They made ropes, fishing lines, nets, baskets, and even garments using techniques resembling modern macramé and crochet. The actual strings, ropes, and cloth are perishable, but fragments of dried or fired clay impressed with fibers, and even cloth, have been found and dated as early as 25,000 BCE. Fibers were twisted into cording for ropes and strings; netting for traps, fish nets, and perhaps hair nets; knotting for macramé; *sprang* (a looping technique similar to making a cat's cradle); and single-hook work or crocheting (knitting with two needles is a relatively modern technique). Work with fibers may have been women's work since women, with primary responsibility for child care, could work with string no matter how frequently they were interrupted by the needs of their families. The creation of strings and nets suggests that women as well as men could hunt for meat; net and trap hunting is common among hunter-gatherers.

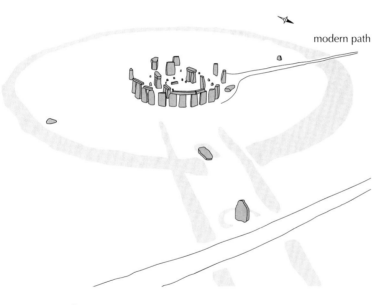

modern path

1–18 | DIAGRAM OF STONEHENGE

STONEHENGE. Of all the megalithic monuments in Europe, the one that has stirred the imagination of the public most strongly is Stonehenge, on Salisbury Plain in southern England (FIGS. 1–17, 1–18). A **henge** is a circle of stones or posts, often surrounded by a ditch with built-up embankments. Laying out such circles with accuracy would have posed no particular problem. Architects likely relied on the human compass, a simple but effective surveying method that persisted well into modern times. All that is required is a length of cord either cut or knotted to mark the desired radius of the circle. A person holding one end of the cord is stationed in the center; a co-worker, holding the other end and keeping the cord taut, steps off the circle's circumference. By the time of Stonehenge's construction, cords and ropes were readily available.

Stonehenge is not the largest such circle from the Neolithic period, but it is one of the most complex. Stones were brought from great distances during at least four major building phases between about 2750 and 1500 BCE. In the earliest stage, its builders dug a deep, circular ditch, placing the excavated material on the inside rim to form an embankment more than 6 feet high. They dug through the turf to expose the chalk substratum characteristic of this part of England, thus creating a brilliant white circle about 330 feet in diameter. An "avenue" from the henge toward the northeast led well outside the embankment to a pointed sarsen megalith—*sarsen* is a gray sandstone—brought from 23 miles away. Today, this so-called heel stone, tapered toward the top and weighing about 35 tons, stands about 16 feet high. Whoever stood at the exact center of Stonehenge on the morning of the summer solstice 3,260 years ago would have seen the sun rise directly over the heel stone.

By about 2100 BCE, Stonehenge included all of the internal elements reflected in the drawing shown here (SEE FIG. 1–18). Dominating the center was a horseshoe-shaped arrangement of five sandstone *trilithons*, or pairs of upright stones topped by lintels. The one at the middle stood considerably taller than the rest, rising to a height of 24 feet, and its lintel was more than 15 feet long and 3 feet thick. This group was surrounded by the so-called sarsen circle, a ring of sandstone uprights weighing up to 26 tons each and averaging 13 feet 6 inches tall. This circle, 106 feet in diameter, was capped by a continuous lintel. The uprights were tapered slightly toward the top, and the gently curved lintel

THE **O**BJECT SPEAKS

PREHISTORIC WOMAN AND MAN

For all we know, the artist who created these figures almost 5,500 years ago had nothing particular in mind—people had been modeling clay figures in southeastern Europe for a long time. Perhaps a woman who was making cooking and storage pots out of clay amused herself by fashioning images of the people she saw around her. But because these figures were found in a grave in Cernavoda, Romania, they suggest to us an otherworldly message.

The woman, spread-hipped and big-bellied, sits directly on the ground, expressive of the mundane world. She exudes stability and fecundity. Her ample hips and thighs seem to ensure the continuity of her family. But in a lively, even elegant, gesture, she joins her hands coquettishly on one raised knee, curls up her toes, and tilts her head upward. Though earthbound, is she a spiritual figure communing with heaven? Her upwardly tilted head could suggest that she is watching the smoke rising from the hearth, or worrying about holes in the roof, or admiring hanging containers of laboriously gathered drying berries, or gazing adoringly at her partner. The man is rather slim, with massive legs and shoulders. He rests his head on his hands in a brooding, pensive pose, evoking thoughtfulness, even weariness or sorrow.

We can interpret the Cernavoda woman and man in many ways, but we cannot know what they meant to their makers or owners. Depending on how they are displayed, we spin out different stories about them. When set facing each other, side by side as they are in the photograph, we tend to see them as a couple—a woman and man in a relationship. In fact, we do not know whether the artist conceived of them in this way, or even made them at the same time. For all their visual eloquence, their secrets remain hidden from us.

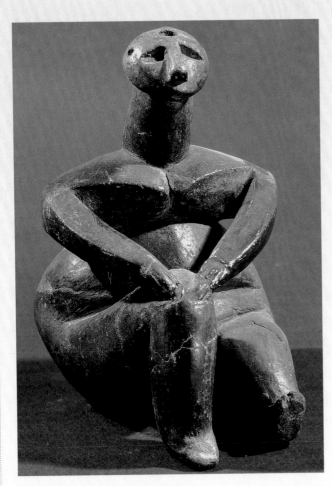
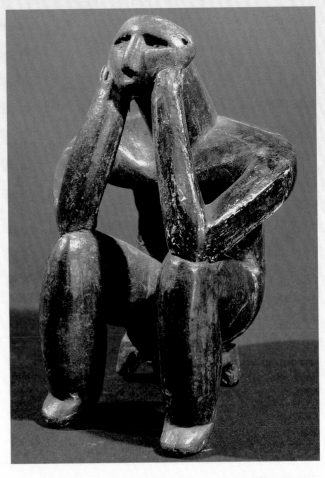

FIGURES OF A WOMAN AND A MAN
Cernavoda, Romania. c. 3500 BCE. Ceramic, height 4½″ (11.5 cm). National Historical Museum, Bucharest.

sections were secured by **mortise-and-tenon** joints, that is, joints made by a conical projection at the top of each upright that fits like a peg into a hole in the lintel.

Just inside the sarsen circle was once a ring of bluestones—worked blocks of a bluish stone found only in the mountains of southern Wales, 150 miles away. Why the builders used this type of stone is one of many mysteries about Stonehenge. Clearly the stones were highly prized, for centuries later, about 1500 BCE, they were reused to form a smaller horseshoe (inside the trilithons) that encloses the so-called altar stone. Calling the horizontal stone an altar is yet another example of misnaming (see "The Power of Naming," page 5).

Through the ages, many theories have been advanced to explain Stonehenge. In the Middle Ages, people thought that Merlin, the magician of the King Arthur legend, had built Stonehenge. Later, the site was incorrectly associated with the rituals of the Celtic Druids (priests). Because its orientation is related to the movement of the sun, some people believe it may have been a kind of observatory. The structure must have been an important site for major public ceremonies. Whatever its role may have been, Stonehenge continues to fascinate visitors. Crowds of people still gather there at midsummer to thrill to its mystery. Even if we never learn the original purpose of megalithic structures, we can understand that the technology developed for building them made possible a new kind of architecture.

Sculpture and Ceramics

Besides working in stone, Neolithic artists also commonly used clay. Their **ceramics**—wares made of baked clay—display a high degree of technical skill and aesthetic imagination. This art required a remarkable conceptual leap. Sculptors created their work out of an existing substance, such as stone, bone, or wood. To produce ceramics, artists had to combine certain substances with clay—bone ash was a common addition—then subject the objects formed of that mixture to high heat for a period of time, hardening them and creating an entirely new material. Among the ceramic figures discovered at a pottery-production center in the Danube River valley at Cernavoda, Romania, are a seated man and woman who form a most engaging pair (see "Prehistoric Woman and Man," left). The artist who made them shaped their bodies out of simple cylinders of clay but managed to pose them in ways that make them seem very true to life.

One unresolved puzzle of prehistory is why people in Europe did not produce pottery vessels much earlier. Although they understood how to harden clay figures by firing them in an oven at high temperatures as early as 32,000 BCE, it was not until about 7000 BCE that they began making vessels using the same technique. Some anthropolo-

gists argue that clay is a medium of last resort for vessels. Compared with hollow gourds, wooden bowls, or woven baskets, clay vessels are heavy and quite fragile, and firing them requires considerable skill. The earliest pots were round and pouchlike and had built-in loops so that they could be suspended on cords.

Excellence in ceramics depends upon the degree to which a given vessel combines domestic utility, visual beauty, and fine execution (see "Pottery and Ceramics," page 20). A group of bowls from Denmark, made in the third millennium BCE, provides only a hint of the extraordinary achievements of Neolithic artists working in clay (FIG. 1–19).

The earliest pieces in the illustration are the globular bottle with a collar around its neck (bottom center), a form perhaps inspired by eggs or gourd containers, and the flask with loops (top). Even when potters began making pots with flat bottoms that could stand without tipping, they often added hanging loops as part of the design. Some of the ornamentation of these pots, including hatched engraving and stitchlike patterns, seems to reproduce the texture of the baskets and bags that preceded them as containers. It was also possible to decorate clay vessels by impressing stamps into the surface or scratching them with sticks, shells, or toothed implements. Many of these techniques appear to have been used to decorate the flat-bottomed vase with the wide, flaring top (bottom left), a popular type of container that came to be known as a funnel beaker.

The large engraved bowl in FIGURE 1–19, found at Skarpsalling, is considered to be the finest piece of northern Neolithic pottery yet discovered. The potter lightly incised its

Technique
POTTERY AND CERAMICS

The terms *pottery* and *ceramics* may be used interchangeably—and often are. Because it covers all baked-clay wares, **ceramics** is technically a more inclusive term than pottery. **Pottery** includes all baked-clay wares except porcelain, which is the most refined product of ceramic technology.

Pottery vessels can be formed in several ways. It is possible, though difficult, to raise up the sides from a ball of raw clay. Another method is to coil long rolls of soft, raw clay, stack them on top of each other to form a container, and then smooth them by hand. A third possibility is to simply press the clay over an existing form, a dried gourd for example. By about 4000 BCE, Egyptian potters had developed the potter's wheel, a round, spinning platform on which a lump of clay is placed and then formed with the fingers, making it relatively simple to produce a uniformly shaped vessel in a very short time. The potter's wheel appeared in the ancient Near East about 3250 BCE and in China about 3000 BCE.

After a pot is formed, it is allowed to dry completely before it is fired. Special ovens for firing ceramics, called **kilns**, have been discovered at prehistoric sites in Europe dating from as early as 32,000 BCE. For proper firing, the temperature must be maintained at a relatively uniform level. Raw clay becomes porous pottery when heated to at least 500° centigrade. It then holds its shape permanently and will not disintegrate in water. Fired at 800° centigrade, pottery is technically known as earthenware. When subjected to temperatures between 1,200° and 1,400° centigrade, certain stone elements in the clay vitrify, or become glassy, and the result is a stronger type of ceramic called stoneware.

Pottery is relatively fragile, and new vessels were constantly in demand to replace broken ones, so fragments of low-fired ceramics—fired at the hearth, rather than the higher temperature kiln—are the most common artifacts found in excavations of prehistoric settlements. Pottery fragments, or **potsherds**, serve as a major key in dating sites and reconstructing human living and trading patterns.

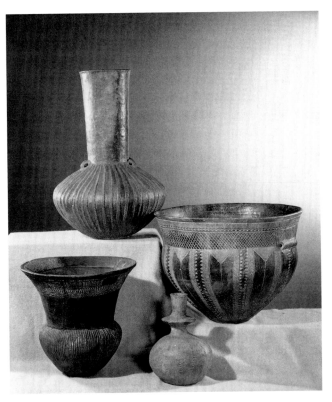

I–19 | VESSELS
Denmark. c. 3000–2000 BCE. Ceramic, heights range 5¾" to 12¼" (14.5 to 31 cm). National Museum of Denmark, Copenhagen.

sides with delicate linear patterns, then rubbed white chalk into the engraved lines so that they would stand out against the dark body of the bowl.

FROM STONE TO METAL

The technology of metallurgy is closely allied to that of ceramics. Although Neolithic culture persisted in northern Europe until about 2000 BCE, the age of metals made its appearance in Europe about 2300 BCE. In central and southern Europe, and in the Aegean region, copper, gold, and tin had been mined, worked, and traded even earlier. Smelted and cast copper beads and ornaments dated to 4000 BCE have been discovered in Poland. (Contemporary art from the Mediterranean and ancient Near East and Egypt is discussed in Chapters 2, 3, and 4.)

The Bronze Age

The period that followed the introduction of metalworking is commonly called the Bronze Age. Although copper is relatively abundant in central Europe and in Spain, objects fashioned from it are too soft to be functional. However, bronze—an **alloy**, or mixture, of tin and copper—is a stronger, harder substance with a wide variety of uses. The introduction of bronze, especially for weapons, changed the peoples of Europe in fundamental ways. Societies dominated

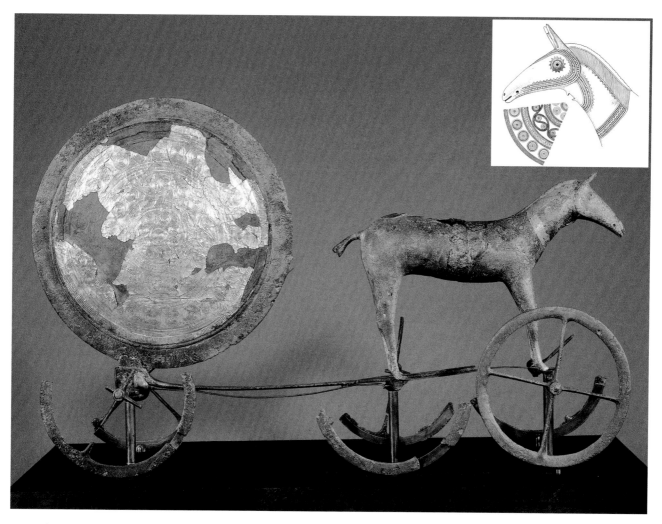

I–20 ┊ **HORSE AND SUN CHARIOT AND SCHEMATIC DRAWING OF INCISED DESIGN**
Trundholm, Denmark. c. 1800–1600 BCE. Bronze, length 23¼″ (59.2 cm).National Museum, Copenhagen.

by a strong elite came into existence, and trade and inter-group contacts across the continent and into the Near East increased. Exquisite objects made of bronze are frequently found in the settlements and graves of early northern farming communities.

A remarkable bronze sculpture from between 1500 and 1300 BCE was discovered at what is now Trundholm, in Denmark. It depicts a wheeled horse pulling a cart laden with a large, upright disk commonly thought to represent the sun (FIG. I–20). Horses had been domesticated in Ukraine by about 4000 BCE, but the first evidence of wheeled chariots and wagons designed to exploit the horse's strength dates from about 2000 BCE. Rock engravings in northern Europe show the sun being drawn through the sky by either an animal or a bird—possibly an indication of a widespread sun cult. This horse and sun cart sculpture could have been rolled from place to place in a ritual reenactment of the sun's passage across the sky.

The valuable materials from which the sculpture was made and the great attention devoted to its details attest to its importance. The horse, cart, and sun were cast in bronze.

After two faults in the casting had been repaired, the horse was given its surface finish, and its head and neck were incised with ornamentation. Its eyes were represented as tiny suns. Elaborate and very delicate designs were engraved on its body to suggest a collar and harness. The bronze sun was cast as two disks, both of which were engraved with concentric rings filled with zigzags, circles, spirals, and loops. A thin sheet of beaten gold was then applied to one of the bronze disks and pressed into the incised patterns. Finally, the two disks were joined together by an encircling metal band. The patterns on the horse tend to be geometric and rectilinear, but those on the sun disks are continuous and curvilinear, suggestive of the movement of the sun itself.

The Proto-Historic Iron Age

Although bronze remained the preferred material for luxury items, iron was commonly used for practical items because it was cheaper and more readily available. By 1000 BCE, iron technology had spread across Europe. A hierarchy of metals emerged based on the materials' resistance to corrosion. Gold, as the most permanent and precious metal, ranked first,

I–21 | **OPENWORK BOX LID**
Cornalaragh County Monaghan, Ireland. La Tène period,
c. 1st century BCE. Bronze, diameter 3″ (7.5 cm).
National Museum of Ireland, Dublin.

followed by silver, bronze, and, finally, practical but rusty iron. The blacksmiths who forged the warriors' swords and the farmers' plowshares held a privileged position among artisans, for they practiced a craft that seemed akin to magic as they transformed iron by heat and hammer work into tools and weapons.

During the Iron Age of the first millennium BCE, proto-historic Celtic peoples inhabited most of central and western Europe. The term *proto-historic* implies that they left no written records but that others wrote about them. Most of their wooden buildings and sculptures and their colorful woven textiles have disintegrated, but their protective earthworks, such as embankments fortifying cities, and funerary goods such as jewelry, weapons, and tableware, have survived.

An openwork box lid, in which space is worked into the pattern, illustrates the characteristic Celtic style and the continuing use of bronze during this period (FIG. I–21). The pattern consists of a pair of expanding, diagonally symmetrical trumpet-shaped spirals surrounded by lattice. The openwork trumpets—the forms defined by the absence of material—catch the viewer's attention, yet at the same time the delicate tendrils of solid metal are equally compelling. Shapes inspired by compass-drawn spirals, stylized vines, and serpentine dragons seem to change at the blink of an eye, for the

artist has eliminated any distinction between figure and background. In Celtic hands, pattern becomes an integral part of the object itself, not an applied decoration.

The Celtic art of the second and first centuries BCE survived well into the Christian era (see Chapter 14) in Ireland, to be reused in the Middle Ages, in folk art, and as a source for Art Nouveau in the nineteenth century.

IN PERSPECTIVE

The paintings and objects that composed the first art made in Europe held great meaning for the people who made them, but without the aid of writing, we cannot know what that meaning was.

Art emerged about 35,000 years ago during the Upper Paleolithic period with the appearance of Cro-Magnon people. These first modern humans constructed houses made of available materials—branches, hides, even mammoth bones. They carved small figures—many of them depicting women—in bone, ivory, and stone. In the caves of southern France and northern Spain, artists painted images of animals and geometric figures with the aid of animal-fat lamps, using a variety of techniques. They took advantage of natural irregularities of the cave walls to create lifelike effects for their figures, and even modeled clay animals in high relief.

In the transition to the Neolithic period, cave art based on observation was replaced by schematic rock-shelter paintings of people engaged in activities that indicated a more settled way of life. Where timber was plentiful, people built long timber houses. In the northern islands they built in stone with stone furniture. This period in northern Europe is also distinguished by the introduction of a wide variety of ceramics, and of dramatic megalithic architecture. Great tomb and ritual centers built on the post-and-lintel system took the efforts of entire communities. At Stonehenge in England, builders overcame great logistical obstacles to move special stones long distances.

Around 2300 BCE, metalworking was introduced into Europe from the Near East. The period that followed is commonly called the Bronze Age and is a time of fundamental change in technology and trade for the peoples of Europe.

The prehistoric period in European art ends with the Celts. Some of what we know about them was recorded by the Greeks and Romans. Fortunately, their art, like that of other prehistoric people, survives as direct evidence of their culture. In later chapters we will study prehistoric and proto-historic art in other areas of the world.

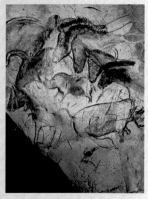

WALL, PAINTING,
CHAUVET
C. 30,000–20,000 BCE

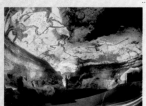

WALL PAINTING,
LASCAUX
C. 15,000 BCE

WOMAN FROM WILLENDORF,
C. 24,000 BCE

STONEHENGE,
C. 2750–1500 BCE

HORSE AND SUN CHARIOT,
C. 1800–1600 BCE

40000 BCE

20000

5000

1000 BCE

PREHISTORIC
ART IN EUROPE

◀ **Upper Paleolithic** 40,000–8000 BCE

◀ **Last Ice Age** 18,000–15,000 BCE

◀ **Paleolithic-Neolithic Overlap**
9000–4000 BCE

◀ **Neolithic** 6500–1200 BCE

◀ **Farming in Europe** c. 5000 BCE
◀ **Metallurgy** c. 5000 BCE

◀ **Domestication of Horses** c. 4000 BCE
◀ **Plow in Use** c. 4000 BCE

◀ **Potter's Wheel in Use** c. 3250 BCE
◀ **Invention of Writing** c. 3100 BCE

◀ **Bronze Age** c. 2300–800 BCE

◀ **Iron Age** c. 1000 BCE

23

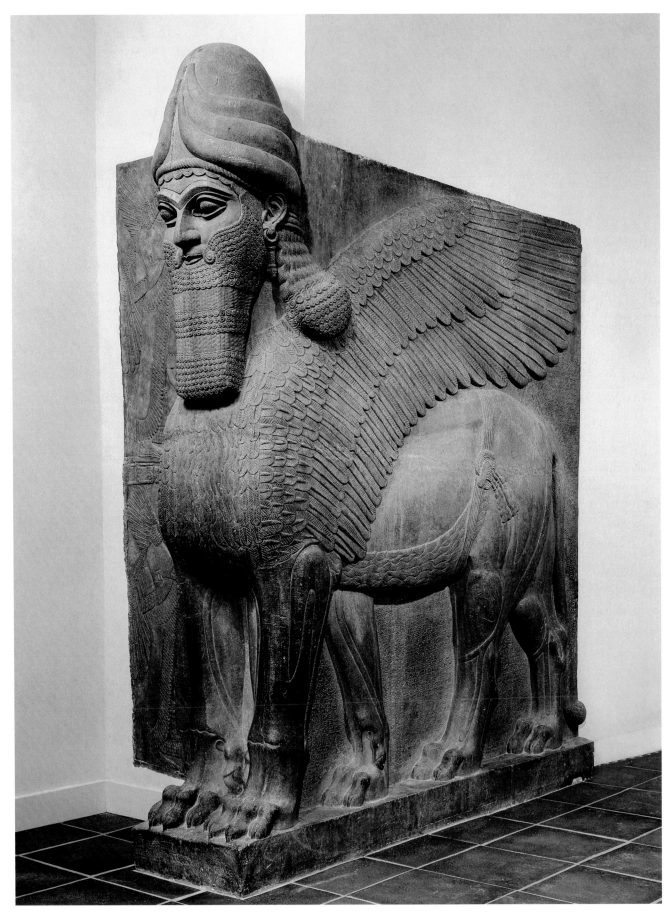

2-1 | **HUMAN-HEADED WINGED LION (LAMASSU)** Colossal gateway figure, the palace of Assurnasirpal II, Mesopotamia, Assyria, Kalhu (present-day Nimrud, Iraq). 883–859 BCE. Alabaster, height 10′3½″ (3.11 m).
The Metropolitan Museum of Art, New York.
Gift of John D. Rockefeller, Jr., 1932 (32.143.1.-2)

ART OF THE ANCIENT NEAR EAST

Visitors to capital cities like Washington, Paris, and Rome today stroll along broad avenues among huge buildings, dominating gateways, and imposing sculpture. They are experiencing a kind of civic design that rulers—consciously or not—have used since the third millennium. In the ninth century BCE, the Assyrians, one of the many groups that rose and fell in the ancient Near East, were masters of the art of impressing and intimidating visitors. Emissaries to the city of Kalhu (later called Nimrud), for example, would have encountered breathtaking examples of this ceremonial urbanism, in which the city itself is a stage for the ritual dramas that reinforce and confirm the ruler's absolute power.

Even from a distance, strangers approaching the city would have seen the high walls and imposing gates and temple platforms where the priest-king acted as intermediary between the people and the gods. Important visitors and ambassadors on the way to an audience with the ruler would have passed sculpture extolling the power of the Assyrian armies and then come face-to-face with **lamassus**, the extraordinary guardian-protectors of the palaces and throne rooms. These colossal gateway figures combined the bearded head of a man, the powerful body of a lion or bull, the wings of an eagle, and the horned headdress of a god **(FIG. 2–1)** Because they were designed to be viewed frontally and from the side, lamassus seem to have five legs. When seen from the front, two forelegs are placed together and the creatures appear immobile. But when viewed from the side, the legs are shown as vigorously striding (hence the fifth leg). The sheer size of the lamassus—often twice a person's height—symbolizes the strength of the ruler they defend. Their forceful forms and prominent placement contribute to an architecture of domination. On the other hand, the exquisite detailing of their beards, feathers, and jewels testifies to boundless wealth, which also signifies power. These fantastic composite beasts inspired both civic pride and fear. They are works of art with an unmistakable political mission. In the ancient Near East, the arts played an important political role.

THE FERTILE CRESCENT AND MESOPOTAMIA

Well before farming communities appeared in Europe, people in Asia Minor and the ancient Near East domesticated grains. This first occurred in an area known today as the *Fertile Crescent* (MAP 2–1), the outline of which stretches along the Lebanese mountain range on the Mediterranean and then circles the northern reaches of the Tigris and Euphrates rivers (near the present-day borders of Turkey, Syria, and Iraq), down through the Zagros Mountains. A little later, in the sixth or fifth millennium BCE, agriculture developed in the alluvial plains between the Tigris and Euphrates rivers, which the Greeks called *Mesopotamia*, meaning the "land between the rivers," now in present-day Iraq. Because of problems with periodic flooding, there was a need for large-scale systems to control the water supply. In a land prone to both drought and flood, this need for a system of water management may have contributed to the development of the first cities.

Between 4000 and 3000 BCE, a major cultural shift seems to have taken place. Agricultural villages evolved into cities simultaneously and independently in both northern and southern Mesopotamia. These prosperous cities joined with their surrounding territories to create what are known as *city-states*, each with its own gods and government. Social hierarchies—rulers and workers—emerged with the development of specialized skills beyond those needed for agricultural work. To grain mills and ovens were added brick and pottery kilns and textile and metal workshops. With extra goods and even modest affluence came increased trade and contact with other cultures.

Builders and artists labored to construct huge temples and government buildings. Organized religion played an important role, and the people who controlled rituals and the sacred sites eventually became priests. The people of the ancient Near East worshiped numerous gods and goddesses. Each city had a special protective deity, and people believed the fate of the city depended on the power of that deity. (The names of comparable deities varied over time and place—for example, Inanna, the Sumerian goddess of fertility, love, and war, was equivalent to the Babylonians' Ishtar.) Large architectural complexes—clusters of religious, administrative, and service buildings—developed in each city as centers of ritual and worship and also of government.

Mesopotamia's wealth and agricultural resources, as well as its few natural defenses, made it vulnerable to political upheaval. Over the centuries, the balance of power shifted between north and south and between local powers and outside invaders. First the Sumerians controlled the south. Then they were eclipsed by the Akkadians, their neighbors to the north. When invaders from farther north in turn conquered the Akkadians, the Sumerians regained power locally. The Babylonians were next to dominate the south. Later, the center of power shifted to the Assyrians in the north, then back again to the Babylonians (Neo-Babylonian period). Throughout this time, important cultural centers arose outside Mesopotamia, such as Elam on the plain between the Tigris River and the Zagros Mountains to the east, the Hittite kingdom in Anatolia (present-day Turkey), and beginning in the sixth century BCE, the land of the Achaemenid Persians in present-day Iran. The Persians eventually forged an empire that included the entire ancient Near East.

The First Cities

Agriculture made possible the development of large, sustainable communities that required permanent housing for their residents, means of defense from outsiders, and the development of new technologies to sustain everyday life. The earliest of these settlements, in the Fertile Crescent and southeastern Anatolia, reveal architectural solutions impressive for their variety and use of local materials, sculpture that shows well-developed religious practices, sophisticated decorated pottery, and evidence of crafts based on extensive trade.

JERICHO. Jericho (located in today's West Bank territory)—whose walls and towers became part of folklore when the biblical Joshua fought the battle of Jericho and the walls "came a tumblin' down"—has the earliest stone fortifications discovered to date (FIG. 2–2). People had been living there beside an ever-flowing spring in the ninth millennium, and by about 8000 BCE this agricultural village had grown into a town of mud-brick houses (mud bricks are shaped from clay and dried in the sun). The town covered six to ten acres, and by 7500 BCE it may have had a population of 2,000.

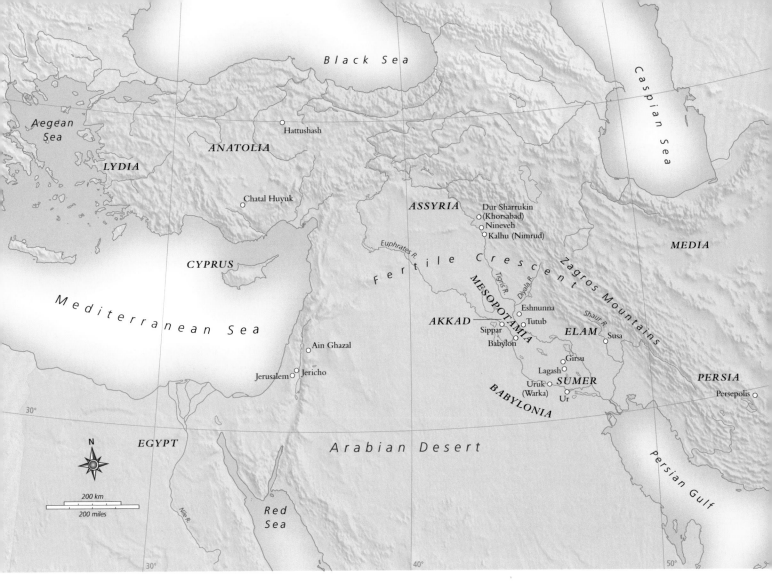

MAP 2—1 | **THE ANCIENT NEAR EAST**

Ancient Mesopotamia (present-day Iraq). The Tigris and Euphrates rivers.

2—2 | WALLS AND TOWER, JERICHO
c. 8000–7000 BCE. Mud brick, rubble, stone.

The people of Jericho found they needed protection from their neighbors, or perhaps they were establishing a boundary. For whatever reason, they built a huge brick wall 5 feet thick and nearly 20 feet high, made even higher by a ditch. They also constructed a circular stone tower 28 feet high with a diameter of 33 feet and an inner stair, which required quite sophisticated masonry skills on the part of the builders. Whether this tower was unique or one of several we do not know, but whether one or many, the tower and fortifications of Jericho are a remarkable achievement.

AIN GHAZAL. Another early site, Ain Ghazal ("Spring of Gazelle"), just outside present-day Amman, Jordan, was even larger than Jericho. That settlement, inhabited from about 7200 to 5000 BCE, occupied 30 acres at its maximum extent on terraces stabilized by stone retaining walls. (Its houses, made of stones mortared together with mud, show signs of long occupation, and may have resembled the adobe pueblos built by native peoples in the American Southwest.) The concentration of people and resources in cities such as these was an early step toward the formation of the larger city-states in the ancient Near East.

CHATAL HUYUK. Although agriculture appears to have been the economic mainstay of these new permanent communities, other specialized activities, such as crafts and trade, were also important by about 6500 to 5500 BCE. Chatal Huyuk, a city in Anatolia (present-day Turkey) with a population of about 5,000, developed a thriving trade in obsidian, a rare black volcanic glass that was used from Paleolithic into modern times for sharp blades. The inhabitants of Chatal Huyuk lived in single-story buildings clustered around shared courtyards, used as garbage dumps. Chatal Huyuk's design, with no streets or open plazas and protected with continuous, unbroken exterior walls, made it easy to defend. Yet the residents could move around freely by crossing from rooftop to rooftop, entering houses through openings in the roofs (FIG. 2–3).

SUSA. The strip of fertile plain between the Tigris River and the Zagros Mountains to the east (in present-day Iran), was a flourishing farming region by 7000 BCE. By about 4200 BCE, the city of Susa, later the capital of an Elamite kingdom, was established on the Shaur River. This area, later known as Elam, had close cultural ties to Mesopotamia, but the two regions were often in conflict. For example, in the twelfth century BCE, Elamite invaders did something with which we are all too familiar: They looted art treasures from Mesopotamia and carried them back to Susa (see "Art as Spoils of War—Protection or Theft?" page 31).

The Arts

Among the arts that flourished in these early cities were sculpture, painting, textiles, and pottery.

As in prehistoric art, the sculptures found in these early cities give us hints about the technology and the culture of those who made them. Among the most imposing objects recovered from Ain Ghazal are more than thirty painted plaster figures. Fragments suggest that some figures were nearly life-size (FIG. 2–4). Sculptors molded the figures by applying wet plaster to reed-and-cord frames in human shape. The eyes were inset cowrie shells, and small dots of the black, tarlike substance bitumen—which Near Eastern artists used

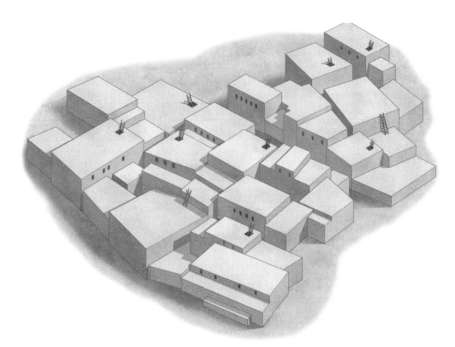

2–3 | **COMPOSITE RECONSTRUCTION DRAWING OF CHATAL HUYUK**
Anatolia (present-day Turkey).
c. 6500–5500 BCE.

frequently—formed the pupils. The figures probably wore wigs and clothing and stood upright.

At Chatal Huyuk, the elaborately decorated buildings are assumed to have been shrines. Bold geometric designs, painted animal scenes, actual animal skulls and horns, and three-dimensional shapes resembling breasts and horned animals adorned the walls. In one chamber, a leopard-headed woman—portrayed in a high-arched wall area above three large, projecting bulls' heads—braces herself as she gives birth to a ram.

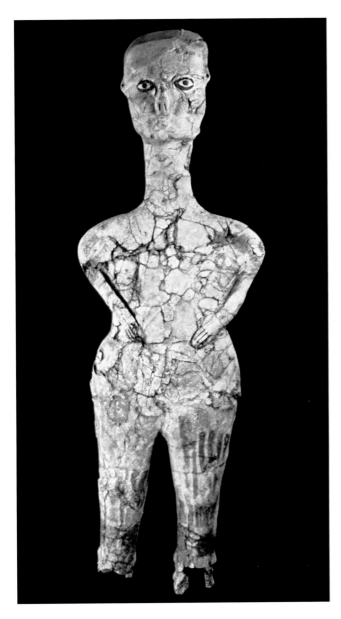

2—4 | HUMAN FIGURE
Ain Ghazal, Jordan. c. 7000-6000 BCE. Fired lime plaster with cowrie shell, bitumen, and paint, height approx. 35″ (90 cm). National Museum, Amman, Jordan.

Although this dramatic image suggests worship of a fertility goddess, any such interpretation is risky because so little is known about the culture. Like other early Near Eastern settlements, Chatal Huyuk seems to have been abandoned suddenly, for unknown reasons, and never reoccupied.

SOUTHERN MESOPOTAMIA

Although the stone-free, alluvial plain of southern Mesopotamia was prone to floods and droughts, it served as a fertile bed for agriculture and successive, interlinked societies. The Sumerians, a people about whose origins little is known, first developed this area. They filled their independent city-states with the fruits of new technology, literacy, and impressive art and architecture. The Sumerian states, marked by constant feuds, were eventually unified by another people, the Akkadians, who united Mesopotamia. The Akkadians embraced Sumerian culture, but the unification they accomplished was, in turn, broken by invaders from the northeast. Only one city-state, Lagash, survived and was revived under the ruler Gudea. Mesopotamia remained in turmoil for several more centuries until order was restored by the Amorites, who had migrated to Mesopotamia from the Syrian desert. Under them and their king, Hammurabi, a new, unified society arose with its capital in the city of Babylon.

Sumer

The cities and city-states that developed along the rivers of southern Mesopotamia between about 3500 and 2340 BCE are known collectively as Sumer. The inhabitants, who had migrated from the north but whose origins are otherwise obscure, are credited with important "firsts." Sumerians may have invented the wagon wheel and the plow, and they created a system of writing—perhaps their greatest contribution to later civilizations. (Recent discoveries indicate that writing developed simultaneously in Egypt; see Chapter 3.)

WRITING. Sumerians pressed **cuneiform** ("wedge-shaped") symbols into clay tablets with a **stylus**, a pointed writing instrument, to keep business records (see "Cuneiform Writing," page 32). Thousands of Sumerian tablets document the gradual evolution of writing and arithmetic, another tool of commerce, as well as an organized system of justice and the world's first and best-known literary epic. The origins of the *Epic of Gilgamesh* are Sumerian, but the fullest version, written in Akkadian, was found in the library of the Assyrian king Assurbanipal (ruled 669–c. 627 BCE) in Nineveh (present-day Kuyunjik, Iraq). It records the adventures of Gilgamesh, legendary Sumerian king of Uruk, and his companion Enkidu. When Enkidu dies, a despondent Gilgamesh sets out to find the secret of eternal life from a man

and his wife who are the sole survivors of a great flood sent by the gods to destroy the world, and the only people to whom the gods had granted immortality. Gilgamesh ultimately accepts his mortality, abandons his quest, and returns to Uruk, recognizing the majestic city as his lasting accomplishment.

THE ZIGGURAT. The Sumerians' most impressive surviving archaeological remains are their **ziggurats**, huge stepped structures with a temple or shrine on top. The first ziggurats may have developed from the practice of repeated rebuilding at a sacred site, with rubble from one structure serving as the foundation for the next. Elevating the buildings also protected the shrines from flooding.

Whatever the origin of their design, ziggurats towering above the flat plain proclaimed the wealth, prestige, and stability of a city's rulers and glorified its gods. Ziggurats functioned symbolically too, as lofty bridges between the earth and the heavens—a meeting place for humans and their gods. They were given names such as "House of the Mountain" and "Bond between Heaven and Earth."

URUK. Uruk (present-day Warka, Iraq), the first independent Sumerian city-state, had two large architectural complexes in the 1,000-acre city. One was dedicated to

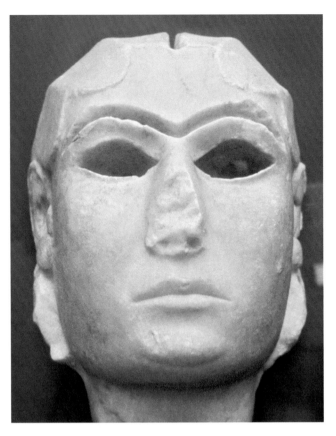

2–6 | **FACE OF A WOMAN, KNOWN AS THE WARKA HEAD**
Uruk (present-day Warka, Iraq). c. 3300–3000 BCE. Marble, height approx. 8″ (20.3 cm). Iraq Museum, Baghdad (stolen and recovered in 2003).

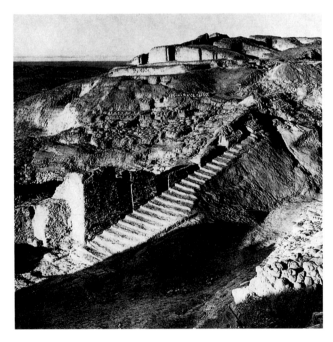

2–5 | **RUINS OF THE WHITE TEMPLE**
Uruk (present-day Warka, Iraq) c. 3300–3000 BCE.

Many Ancient Near Eastern cities still lie undiscovered. In most cases an archaeological site in a region is signaled by a large mound—known locally as a *tell, tepe,* or *huyuk*—that represents the accumulated debris of generations of human habitation. When properly excavated, such mounds yield evidence about the people who inhabited the site.

Inanna, the goddess of love and war. The Inanna buildings seem to have been an administrative complex as well as serving as temples. The other complex belonged to the sky god Anu. The temple platform of Anu, built up in stages over the centuries, ultimately rose to a height of about 40 feet. Around 3100 BCE, a whitewashed brick temple that modern archaeologists refer to as the White Temple (**FIG. 2–5**) was erected on top. This now-ruined structure was a simple rectangle oriented to the points of the compass. An off-center doorway on one of the long sides led into a large chamber containing a raised platform and altar; smaller spaces opened off this main chamber.

Statues of gods and donors were placed in the temples. A striking life-size marble face from Uruk may represent a goddess (**FIG. 2–6**). It could have been attached to a wooden head on a full-size wooden body. Now stripped of its original paint, wig, and **inlaid** (set-in) brows and eyes, it appears as a stark white mask. Shells may have been used for the whites of the eyes and lapis lazuli for the pupils, and the hair may have been gold. Even without these accessories, the compelling stare and sensitively rendered features attest to the skill of Sumerian sculptors.

Art and Its Context

ART AS SPOILS OF WAR—PROTECTION OR THEFT?

Art has always been a casualty in times of social unrest. One of the most recent examples is the looting of the head of a woman from Warka, when an angry mob broke into the unguarded Iraq National Museum in April 2003. The delicate marble sculpture was later found, but not without significant damage (compare with FIG. 2-6).

Some of the most bitter resentment spawned by war—whether in Mesopotamia in the twelfth century BCE or in our own time—has involved the "liberation" by the victors of art objects of great value to the people from whom they were taken. Museums around the world hold works either snatched by invading armies or acquired as a result of conquest. Two historically priceless objects unearthed in Elamite Susa, for example—the Akkadian Stele of Naram-Sin (see FIG. 2-14) and the Babylonian Stele of Hammurabi (see "The Code of Hammurabi," page 38)—were not Elamite at all, but Mesopotamian. Both had been brought there as military trophies by an Elamite king, who added an inscription to the Stele of Naram-Sin explaining that he had merely "protected" it. The stele came originally from Sippar, an Akkadian city on the Euphrates River, in what is now Iraq. Raiders from Elam took it there as booty in the twelfth century BCE.

The same rationale has been used in modern times. The Rosetta Stone, the key to deciphering Egyptian hieroglyphics, was discovered in Egypt by French troops in 1799, fell into British hands when they forced the French from Egypt, and ultimately ended up in the British Museum in London (see page 78). In the early nineteenth century, the British Lord Elgin purchased and removed classical Greek reliefs from the Parthenon in Athens with the permission of the Ottoman authorities who governed Greece at the time (see pages 138–139). Although his actions may indeed have protected the reliefs from neglect and damage in later wars, they have remained installed, like the Rosetta Stone, in the British Museum, despite continuing protests from Greece.

The Ishtar Gate from Babylon (see FIG. 2-21) is now reconstructed in Berlin, Germany. Many German collections include works that were similarly "protected" at the end of World War II and are surfacing now. In the United States, Native Americans are increasingly vocal in their demands that artifacts and human remains collected by anthropologists and archaeologists be returned to them. "To the victor," it is said, "belong the spoils." It continues to be a matter of passionate debate whether this notion is appropriate in the case of revered cultural artifacts.

PHOTO OF FACE OF A WOMAN KNOWN AS THE WARKA HEAD, Displayed by Iraqi authorities on its recovery.

A tall, carved alabaster vase found near the temple complex of Inanna at Uruk (FIG. 2–7) shows how Near Eastern sculptors of the time—and for the next 2,500 years—told their stories with great economy and clarity. They organized the picture space into **registers**, or horizontal bands, and condensed the narrative, much as modern comic-strip artists do. The stylized figures are shown simultaneously with profile heads and legs and with three-quarter-view torsos, making both shoulders visible and increasing each figure's breadth. The lower register of the vase shows the natural world, beginning with water and plants identified as the date palm and barley or the now extinct silphium (identified by medical historians as a plant used by early people to control fertility). Above the plants, alternating rams

and ewes stand on a solid groundline. In the middle register nude men carry baskets of foodstuffs. In the top register, Inanna stands in front of her shrine and storehouse accepting an offering from the priest-king. Through the doorway we see a display of her wealth as well as two devotees.

The scene is usually interpreted as the ritual marriage between the goddess and a human priest-king during the New Year's festival, a ritual meant to ensure the fertility of crops, animals, and people. The riches of the natural—world the date palms, the rams and ewes, the silphium—placed around the base of the vase literally and visually support the human activity in honor of the goddess. The imagery of the alabaster vase attests to the continued survival Uruk.

Technique
CUNEIFORM WRITING

Sumerians invented writing around 3100 BCE, apparently as an accounting system for goods traded at Uruk. The symbols were pictographs, simple pictures cut into moist clay slabs with a pointed tool. Between 2900 and 2400 BCE, the symbols evolved from pictures into *phonograms*—representations of syllable sounds—thus becoming a true writing system. During the same centuries, scribes adopted a stylus, or writing tool, with one triangular end and one pointed end. The stylus could be pressed easily and rapidly into a wet clay tablet to create the increasingly abstract symbols, or characters, of cuneiform writing.

This illustration shows examples of the shift from pictograph to cuneiform writing. The drawing of a bowl, which means "bread" or "food" and dates from about 3100 BCE, was reduced to a four-stroke sign by about 2400 BCE, and by about 700 BCE to a highly abstract arrangement of vertical marks. By combining the pictographs and, later, cuneiform signs, writers created composite signs; for example, a combination of the signs for "head" and "food" meant "to eat."

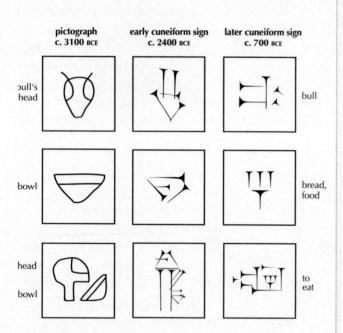

	pictograph c. 3100 BCE	early cuneiform sign c. 2400 BCE	later cuneiform sign c. 700 BCE	
bull's head				bull
bowl				bread, food
head bowl				to eat

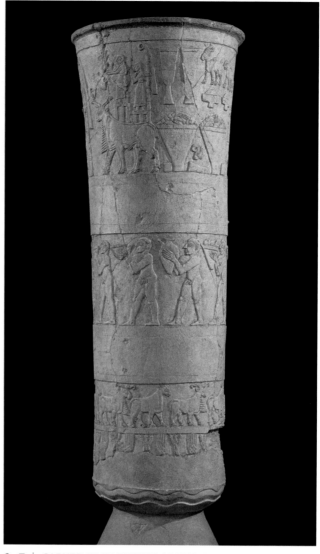

2–7 | **CARVED VASE KNOWN AS THE URUK VASE**
Uruk (present-day Warka, Iraq). c. 3300–3000 BCE. Alabaster, height 36″ (91 cm). Iraq Museum, Baghdad (stolen and recovered in 2003).

VOTIVE FIGURES. Limestone statues dated to about 2900–2600 BCE from the Diyala River Valley, Iraq, excavated in 1932–33, reveal another aspect of Sumerian religious art (FIG. 2–8). These **votive figures**—images dedicated to the gods—are an early example of an ancient Near Eastern religious practice: the placement in a shrine of statues of individual worshipers before a larger, more elaborate image of a god. Anyone who was a donor to the temple might commission a representation of him- or herself and dedicate it in the shrine. Many are figures of women. A simple inscription might identify the figure as "One who offers prayers." Longer inscriptions might recount in detail all the things the donor had accomplished in the god's honor. Each sculpture served as a stand-in, at perpetual attention, making eye contact with the god, and chanting its donor's praises.

The sculptors of the votive figures followed the conventions of Sumerian art—that is, the traditional way of repre-

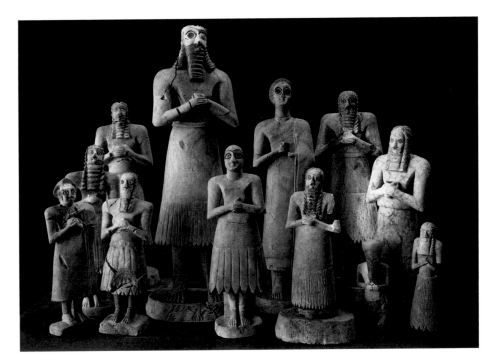

2–8 | **VOTIVE FIGURES**
The Square Temple, Eshnunna
(present-day Tell Asmar, Iraq).
c. 2900–2600 BCE. Limestone,
alabaster, and gypsum, height
of largest figure approx. 30″
(76.3 cm).
The Oriental Institute of the University
of Chicago.

senting forms with simplified faces and bodies, and with clothing that emphasized the cylindrical shape. The figures stand solemnly, hands clasped in respect. The wide-open eyes may be explained by cuneiform texts that reveal the importance of approaching a god with an attentive gaze. As with the face of the woman from Uruk, arched brows are inlaid with dark shell, stone, or bitumen that once emphasized the huge, staring eyes. The male figures, bare-chested and dressed in what appear to be sheepskin skirts, are stocky and muscular, with heavy legs, large feet, big shoulders, and cylindrical bodies. The female figures are as massive as the men. One wears a long sheepskin skirt and the other a calf-length skirt that reveals sturdy legs and feet.

South of Uruk lay the city of Ur (present-day Muqaiyir, Iraq). About a thousand years after the completion of the temples at Uruk, the people of Ur built a ziggurat dedicated to the moon god Nanna, also called Sin (FIG. 2–9). Although located on the site of an earlier temple, this imposing mud-brick structure was not the accidental result of successive rebuildings. Its base is a rectangle 205 by 141 feet, with three sets of stairs converging at an imposing entrance gate atop the first of what were three platforms. Each platform's walls slope outward from top to base, probably to prevent rainwater from forming puddles and eroding the mud-brick pavement below. The first two levels of the ziggurat and their retaining walls have been reconstructed in recent years.

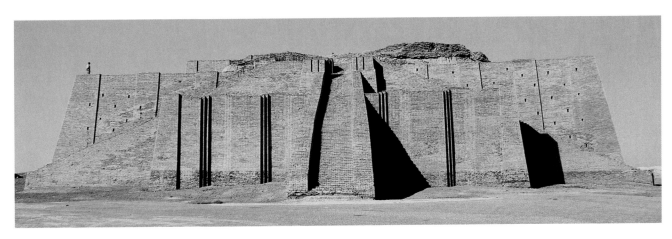

2–9 | **NANNA ZIGGURAT**
Ur (present-day Muqaiyir, Iraq). c. 2100–2050 BCE.

Scene 1
showing power

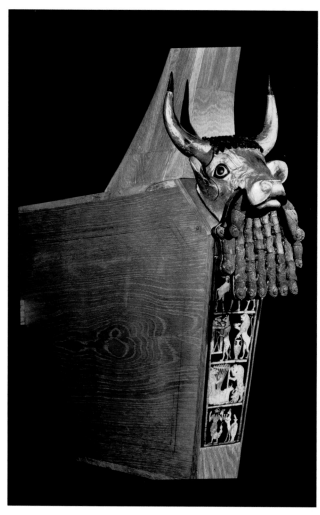

2–10 | **THE GREAT LYRE WITH BULL'S HEAD**
Royal Tomb, Ur (present-day Muqaiyir, Iraq). c. 2550–2400
BCE. Wood with gold, silver, lapis lazuli, bitumen, and shell,
reassembled in modern wood support; height of head 14″
(35.6 cm); height of front panel 13″ (33 cm); maximum length
of lyre 55½″ (140 cm), height of upright back arm 46½″ (117
cm).University of Pennsylvania Museum of Archaeology and
Anthropology, Philadelphia.

From about 3000 BCE on, Sumerian artisans worked in
various precious metals, and in bronze, often combining them
with other materials. Many of these creations were decorated
with—or were in the shape of—animals or composite
animal-human-bird creatures. A superb example of their skill
is a lyre—a kind of harp—from a royal tomb (identified as
PG789). The harp combines wood, gold, lapis lazuli, and shell
(FIG. 2–10). Projecting from the base of the lyre is a sculp-
tured head of a bearded bull, intensely lifelike despite the
decoratively patterned blue lapis lazuli beard. (Lapis lazuli,
which had to be imported from Afghanistan, is evidence of
widespread trade in the region.)

On the front panel of the sound box, four horizontal
registers present scenes executed in shell inlaid in bitumen
(FIG. 2–11). In the bottom register a scorpion man holds a
cylindrical object in his left hand. Scorpion men are associ-

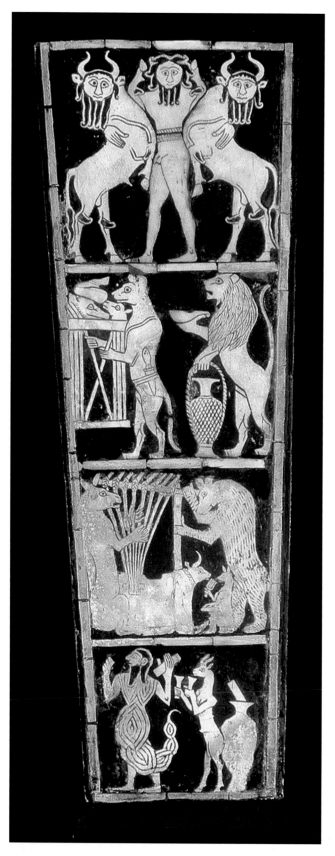

2–11 | **FRONT PANEL, THE SOUND BOX
OF THE GREAT LYRE**
Ur (present-day Muqaiyir, Iraq). Wood with shell inlaid in
bitumen, height 12¼ × 4½″ (31.1 × 11cm). University of
Pennsylvania Museum of Archaeology and Anthropology,
Philadelphia.
(T4-29C)

34 **CHAPTER TWO** ART OF THE ANCIENT NEAR EAST

ated with the land of demons, the mountains of sunrise and sunset, which are part of the journey made by the dead. The scorpion man is attended by a gazelle standing on its hind legs and holding out two tall cups, perhaps filled from the large container from which a ladle protrudes. The scene above this one depicts a trio of animal musicians. A seated donkey plucks the strings of a bull lyre—showing how such instruments were played—while a standing bear braces the instrument's frame and a seated animal, perhaps a fox, plays a *sistrum* (a kind of rattle).

The next register shows animal attendants, also walking erect, bringing food and drink for the feast. On the left a hyena, assuming the role of a butcher with a knife in its belt, carries a table piled high with meat. A lion follows with a large jar and pouring vessel. In the top panel, striding but facing forward, is an athletic man, probably meant to represent the deceased. His long hair and a full beard denote a semi-divine status. He is naked except for a wide belt, and he clasps two rearing human-headed bulls. The imagery on the harp may have been inspired in part by the *Epic of Gilgamesh*, with its descriptions of heroic feats and fabulous creatures like the scorpion man, whom Gilgamesh met as he searched for his friend Enkidu. With the invention of writing we are no longer dealing only with speculation as we did with prehistoric art, and we can begin to study the **iconography** (the narrative and allegorical meaning) of images.

Because the lyre and others like it were found in royal tombs chambers and were used in funeral rites, the imagery we see here probably depicts a funeral banquet in the realm of the dead. The animals shown are the traditional guardians of the gateway through which the newly dead person had to pass. Cuneiform tablets preserve songs of mourning, which may have been chanted by priests to lyre music at funerals. One begins: "Oh, lady, the harp of mourning is placed on the ground."

Retainers of the deceased ruler seem to have followed them to the tomb, where they committed suicide. In tomb PG789, six soldiers and fifty-seven retainers, mostly women, accompanied the king to the Netherworld. At his death, the legendary Gilgamesh took his wife, child, concubine, minstrel, cup bearer, barber, and courtiers with him into the tomb.

CYLINDER SEALS. People in the area of present-day Syria and Turkey first employed simple clay stamps with designs incised (cut) into one surface to stamp textiles or bread. About the time written records appeared, Sumerians developed seals for identifying documents and establishing property ownership. By 3300–3100 BCE, record keepers redesigned the stamp seal as a cylinder. Rolled across soft clay applied to the closure that was to be sealed—a jar lid, the knot securing a bundle, or the door to a room—the cylinder left a raised image of the design. No unauthorized person could then gain access secretly. Sumerian **cylinder seals**, usually less than 2 inches high, were made of a hard stone, such as marble or lapis lazuli, so that the tiny, elaborate scenes carved into them would not wear away.

The scene in a seal from Ur (FIG. 2–12) includes a human hero protecting rampant bulls from lions in the upper register and five fighting figures in the lower register. Ancient Near Eastern leaders were expected to protect their people from both human and animal enemies, as well as exert control over the natural world. This seal belonged to a queen of Ur named Ninbanda.

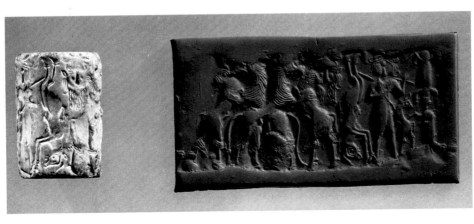

2–12 | **CYLINDER SEAL AND ITS IMPRESSION**
Ur (present-day Muqaiyir, Iraq). c. 2550–2400 BCE. Lapis lazuli, height, 1⅝" (4.1 cm). University of Pennsylvania Museum of Archaeology and Anthropology, Philadelphia.
B16852

Akkad

During the Sumerian period, a people known as the Akkadians had settled north of Uruk. They adopted Sumerian culture, but unlike the Sumerians, the Akkadians spoke a Semitic language (the same family of languages that includes Arabic and Hebrew). Under the powerful military and political figure Sargon I (ruled c. 2332–2279 BCE), they conquered most of Mesopotamia. For more than half a century, Sargon, "King of the Four Quarters of the World," ruled this empire from his capital at Akkad, the actual site of which is yet to be discovered.

HEAD OF A RULER. Few artifacts can be identified with Akkad, making a life-size bronze head thought to date from the time of Sargon especially precious (FIG. 2–13). The head is the earliest major work of hollow-cast copper sculpture known in the Ancient Near East.

The facial features and hairstyle probably reflect a generalized male ideal rather than the appearance of a specific individual, although the sculpture was once identified as Sargon. The enormous curling beard and elaborately braided hair (circling the head and ending in a knot at the back) indicate both royalty and the ideal male appearance. This head was found in the northern city of Nineveh. The deliberate damage to the left side of the face and eye suggests that the head was symbolically mutilated to destroy its power. The ears and the inlaid eyes appear to have been deliberately removed; thus the statue could neither hear nor see.

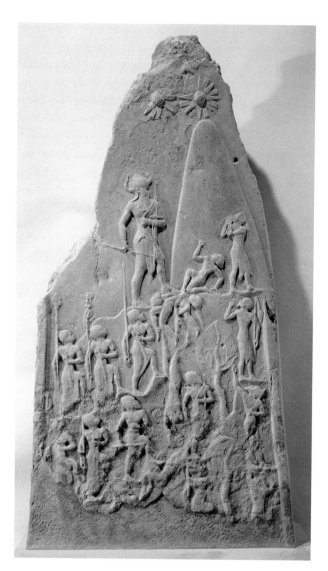

2–14 | **STELE OF NARAM-SIN**
Sippar. Found at Susa. c. 2220–2184 BCE. Limestone, height 6'6" (1.98 m). Musée du Louvre, Paris.

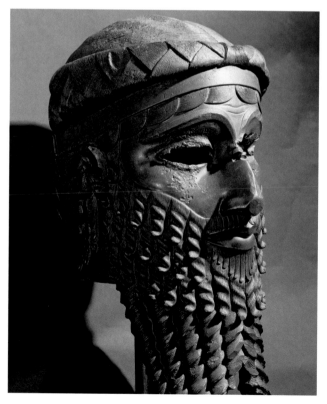

2–13 | **HEAD OF A MAN (KNOWN AS AKKADIAN RULER)**
Nineveh (present-day Kuyunjik, Iraq). c. 2300–2200 BCE. Copper alloy, height 14⅜" (36.5 cm). Iraq Museum, Baghdad.

THE STELE OF NARAM-SIN. The concept of imperial authority was literally carved in stone by Sargon's grandson Naram-Sin (FIG. 2–14). A 6½-foot-high **stele** (an upright stone slab) memorializes one of Naram-Sin's military victories, and is one of the first works of art created to celebrate a specific achievement of an individual ruler. The inscription states that the stele commemorates the king's victory over the people of the Zagros Mountains. Naram-Sin made himself divine during his lifetime—a new concept requiring new iconography. As god-king, Naram-Sin is immediately recognizable by his size. Size was associated with importance in ancient art, a convention known as **hieratic scale**. Watched over by three solar deities, symbolized by the rayed suns in the sky, he ascends a mountain wearing the horned helmet-crown associated with deities, which he is now entitled to wear. Naram-Sin's importance is magnified by his position at the dramatic center of the scene, closest to the mountaintop and silhouetted against the sky.

The sculptors used the stele's pointed shape to underscore the dynamic role of the carved mountain in the composition. In a sharp break with visual tradition, they replaced the horizontal registers of Mesopotamian and Egyptian art (see Chapter 3) with wavy groundlines. Soldiers (smaller than the king, as dictated by the convention of hieratic scale) follow their leader at regular intervals, passing conquered enemy forces sprawled in death or begging for mercy. Both the king and his warriors hold their weapons triumphantly upright. (Ironically, although this stele depicts Akkadians as conquerers, they would dominate the region for only about another half century.)

Lagash and Gudea

About 2180 BCE, the Guti, a mountain people from the northeast, conquered the Akkadian Empire. The Guti controlled most of the Mesopotamian plain for a brief time before the Sumerian people regained control of the region. However, one large Sumerian city-state remained independent throughout the period: Lagash, whose capital was Girsu (present-day Telloh, Iraq), on the Tigris River. Gudea, the ruler, built and restored many temples, in which he placed votive statues representing himself as governor and embodiment of just rule. The statues are made of diorite, a very hard imported stone. Perhaps the difficulty of carving diorite prompted sculptors to use compact, simplified forms for the portraits. Twenty of these figures survive, making Gudea's face a familiar one in ancient Near Eastern art.

Images of Gudea present him as a strong, peaceful, pious ruler worthy of divine favor (FIG. 2–15). Whether he is shown sitting or standing, he wears a long garment (which provides ample space for long cuneiform inscriptions). His right shoulder is bare, and he is barefooted. He wears a cap with a wide brim carved with a pattern to represent fleece. In one image, Gudea holds a vessel from which life-giving water flows in two streams, each filled with leaping fish. The text says that he dedicated himself, the statue, and its temple to the goddess Geshtinanna, the divine poet and interpreter of dreams. This imposing statue is only 2½ feet tall. The sculptor emphasizes the power centers of the human body: the eyes, head, and smoothly muscled chest and arms. Gudea's face, below the sheepskin hat, is youthful and serene, and his eyes—oversized and wide open, the better to return the gaze of the deity—express intense concentration.

Babylon: Hammurabi's Code

For more than 300 years, periods of political turmoil alternated with periods of stable government in Mesopotamia, until the Amorites (a Semitic-speaking people from the Syrian Desert, to the west) reunited the region under Hammurabi (ruled 1792–1750 BCE). Hammurabi's capital city was Babylon and his subjects were called Babylonians. Among Hammurabi's achievements was a written legal code that listed the laws of his realm and the penalties for breaking them (see "The Code of Hammurabi," page 38).

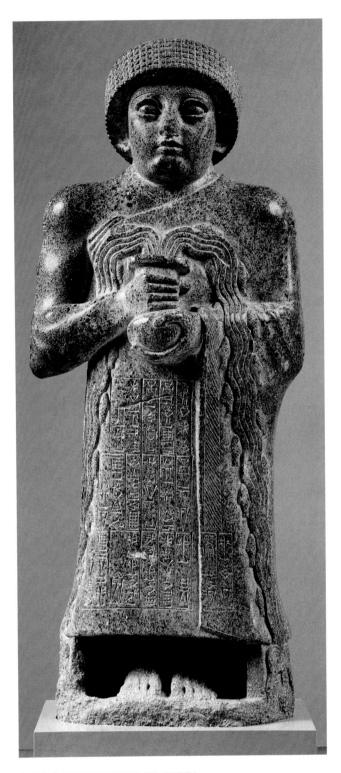

2–15 VOTIVE STATUE OF GUDEA
Girsu (present-day Telloh, Iraq). c. 2090 BCE. Diorite, height 29″ (73.7 cm). Musée du Louvre, Paris.

THE HITTITES OF ANATOLIA

Outside of Mesopotamia, other cultures developed and flourished in the ancient Near East. Each had an impact on Mesopotamia. Finally one of them, Persia, overwhelmed them all, but the Hittites of Anatolia were among the most influential.

Anatolia (present-day Turkey) had been home to several independent cultures that resisted Mesopotamian domination.

THE ⬤BJECT SPEAKS

THE CODE OF HAMMURABI

One of Hammurabi's greatest accomplishments was the systematic codification of his people's rights, duties, and punishments for wrongdoing. This code was engraved on the Stele of Hammurabi, and this black diorite stele speaks to us both as a work of art that depicts a legendary event and as a historical document that records a conversation about justice between god and man.

At the top of the stele, we see Hammurabi standing before a mountain where Shamash, the sun god and god of justice, is seated. The mountain is indicated by three flat tiers on which Shamash rests his feet. Hammurabi, standing in an attitude of prayer, listens respectfully. Shamash sits on a backless throne, dressed in a long flounced robe and crowned by a conical horned cap. Rays rise from his shoulders, and he holds additional symbols of his power—the measuring rod and the rope circle—as he gives the law to the king, his intermediary. From there, the laws themselves flow forth in horizontal bands of exquisitely engraved cuneiform signs. (The idea of god-given laws engraved on stone tablets is a long-standing tradition in the ancient Near East: Moses, the Lawgiver of Israel, received two stone tablets containing the Ten Commandments from God on Mount Sinai [Exodus 32:19].)

A prologue on the front of the stele lists the temples Hammurabi has restored, and an epilogue on the back glorifies him as a peacemaker, but most of the stele was clearly intended to publish the law guaranteeing uniform treatment of people throughout his kingdom. In the long cuneiform inscription, Hammurabi declared that with this code of law he intended "to cause justice to prevail in the land and to destroy the wicked and the evil, that the strong might not oppress the weak nor the weak the strong." Most of the 300 or so entries that follow deal with commercial and property matters. Only sixty-eight relate to domestic problems, and a mere twenty deal with physical assault.

Punishments are based on the wealth, class, and gender of the parties—the rights of the wealthy are favored over the poor, citizens over slaves, men over women. The death penalty is frequently decreed for crimes such as stealing from a temple or palace, helping a slave to escape, or insubordination in the army. Trial by water and fire could also be imposed, as when an adulterous woman and her lover were to be thrown into the water (those who did not drown were deemed innocent) or when a woman who committed incest with her son was to be burned (an incestuous man was only banished). Although some of the punishments may seem excessive today, we recognize that Hammurabi was breaking new ground in his attempt to create a society regulated by laws rather than the whims of rulers or officials.

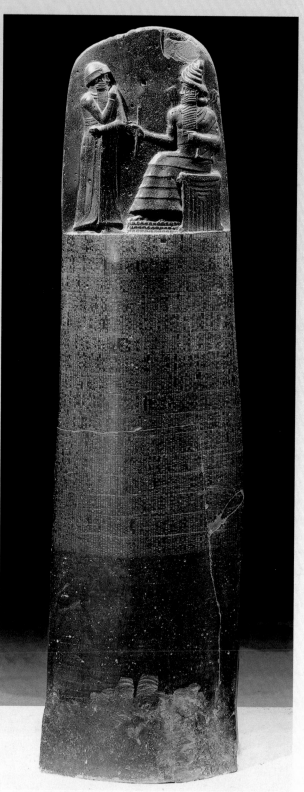

STELE OF HAMMURABI
Susa (present-day Shush, Iran). c. 1792–1750 BCE. Diorite, height of stele approx. 7′ (2.13 m); height of relief 28″ (71.1 cm). Musée du Louvre, Paris.

The most powerful of them was the Hittite civilization, whose founders had moved into the mountains and plateaus of central Anatolia from the east.

They established their capital at Hattusha (near present-day Boghazkoy, Turkey) about 1600 BCE. (The city was destroyed about 1200 BCE.) Through trade and conquest, the Hittites created an empire that stretched along the coast of the Mediterranean Sea in the area of present-day Syria and Lebanon, bringing them into conflict with the Egyptian Empire, which was expanding into the same region from the south (Chapter 3). They also made incursions into Mesopotamia.

The Hittites may have been the first people to work in iron, which they used for war chariot fittings, weapons, chisels, and hammers for sculptors and masons (see also Chapter 1, page 21). They are noted for the artistry of their fine metalwork and for their imposing palace citadels with double walls and fortified gateways. One of the most monumental of these sites consists of the foundations and base walls of the Hittite stronghold at Hattusha, which date to about 1400–1300 BCE. The lower walls were constructed of stone supplied from local quarries, and the upper walls, stairways, and walkways were finished in brick.

The blocks of stone used to frame doorways at Hattusha were decorated in high relief with a variety of guardian figures—some of them seven feet tall. Some were half-human–half-animal creatures; others were more naturalistically rendered animals like the lions at the Lion Gate (FIG. 2–16). Carved from the building stones, the lions seem

to emerge from the gigantic boulders that form the gate, unlike the later Assyrian guardians (SEE FIG. 2-1) who, while clearly part of the building, seem to stride or stand as independent creatures. The Hittite Lion Gate harmonizes with the colossal scale of the wall. Despite extreme weathering, the lions have endured over the millennia and still possess a sense of both vigor and permanence.

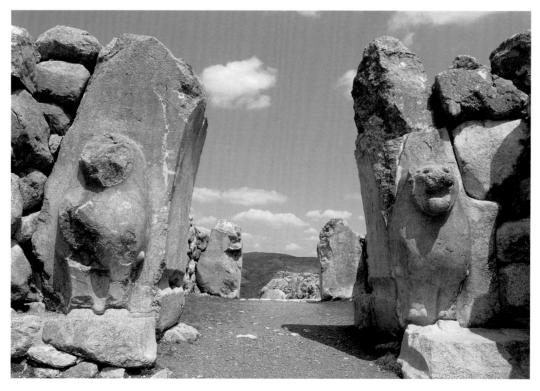

2–16 | **LION GATE**
Hattusha (near present-day Boghazkoy, Turkey). c. 1400 BCE. Limestone.

LATER MESOPOTAMIAN ART

Assyria

After centuries of struggle among Sumer, Akkad, and Lagash, in southern Mesopotamia, a people called the Assyrians rose to dominance in northern Mesopotamia. They began to extend their power by about 1400 BCE, and after about 1000 BCE started to conquer neighboring regions. By the end of the ninth century BCE, the Assyrians controlled most of Mesopotamia, and by the early seventh century they had extended their influence as far west as Egypt. Soon afterward they succumbed to internal weakness and external enemies, and by 600 BCE their empire had collapsed.

Assyrian rulers built huge palaces atop high platforms inside the different fortified cities that served at one time or another as Assyrian capitals. They decorated these palaces with scenes of battles, Assyrian victories with presentations of tribute to the king, combat between men and beasts, and religious imagery.

KALHU (NIMRUD). During his reign (883–859 BCE), Assurnasirpal II established his capital at Kalhu (present-day Nimrud, Iraq), on the east bank of the Tigris River, and undertook an ambitious building program. His architects fortified the city with mud-brick walls 5 miles long and 42 feet high, and his engineers constructed a canal that irrigated fields and provided water for the expanded population of the city. According to an inscription commemorating the event, Assurnasirpal gave a banquet for 69,574 people to celebrate the dedication of the new capital in 863 BCE.

Most of the buildings in Nimrud were made from mud bricks, but limestone and alabaster—more impressive and durable—were used to veneer walls for architectural decorations. Colossal guardian figures, lamassus, flanked the major portals (SEE FIG. 2-1), and panels covered the walls with scenes carved in low relief of the king participating in religious rituals, war campaigns, and hunting expeditions.

THE LION HUNT. In a vivid lion-hunting scene (FIG. 2–17), Assurnasirpal II stands in a chariot pulled by galloping horses and draws his bow against an attacking lion that already has four arrows protruding from its body. Another beast, pierced by arrows, lies on the ground. This was probably a ceremonial hunt, in which the king, protected by men with swords and shields, rode back and forth killing animals as they were released one by one into an enclosed area. The immediacy of this image marks a shift in Mesopotamian art away from a sense of timelessness and toward visual narrative.

DUR SHARRUKIN (KHORSABAD). Sargon II (ruled 721–706 BCE) built a new Assyrian capital (FIG. 2–18) at Dur Sharrukin (present-day Khorsabad, Iraq). On the northwest side of the capital, a walled **citadel**, or fortress, containing several palaces and temples, straddled the city wall. Sargon's **palace complex** (the group of buildings where the ruler governed and resided) at the rear of the citadel on a raised, fortified platform about 40 feet high, demonstrates the use of art as propaganda to support political power.

Guarded by two towers, it was accessible only by a wide ramp leading up from an open square, around which the residences of important government and religious officials were clustered. Beyond the ramp was the main courtyard, with service buildings on the right and temples on the left. The heart of the palace, protected by a reinforced wall with only two small, off-center doors, lay past the main courtyard. Within the inner compound was a second courtyard lined with narrative relief panels showing tribute bearers that functioned as an audience hall. Visitors would have entered the king's throne room from this courtyard through a stone gate flanked by colossal guardian figures even larger than those of Assurnasirpal (SEE FIG. 2-1).

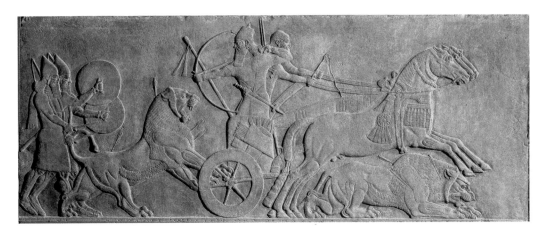

2–17 | **ASSURNASIRPAL II KILLING LIONS**
Palace complex of Assurnasirpal II, Kalhu (present-day Nimrud, Iraq). c. 850 BCE. Alabaster, height approx. 39″ (99.1 cm). The British Museum, London.

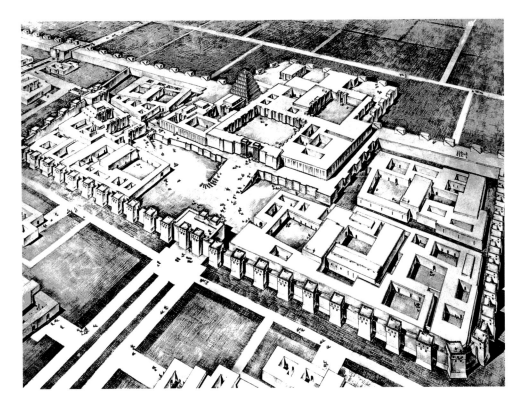

The ziggurat at Dur Sharrukin towered in an open space between the temple complex and the palace, declaring the might of Assyria's kings and symbolizing their claim to empire. It probably had seven levels, each about 18 feet high and painted a different color. The four levels still remaining were once white, black, blue, and red. Instead of separate flights of stairs between the levels, a single, squared-off spiral ramp rose continuously along the exterior from the base.

NINEVEH (KUYUNJIK). Assurbanipal (ruled 669–c. 627 BCE), king of the Assyrians three generations after Sargon II, maintained his capital at Nineveh (present-day Kuyunjik, Iraq).

His palace was decorated with alabaster panels carved with pictorial narratives in low relief. Most show the king and his subjects in battle and hunting, but there are occasional scenes of palace life. An unusually peaceful scene shows the king and queen in a pleasure garden (FIG. 2–19). The king reclines on a couch, and the queen sits in a chair at his feet. Servants arrive with trays of food, while others wave whisks to protect the royal couple from insects.

This apparently tranquil domestic scene is actually a victory celebration. The king's weapons (sword, bow, and quiver of arrows) are on the table behind him, and the severed head of his vanquished enemy hangs upside down from a tree at the far left.

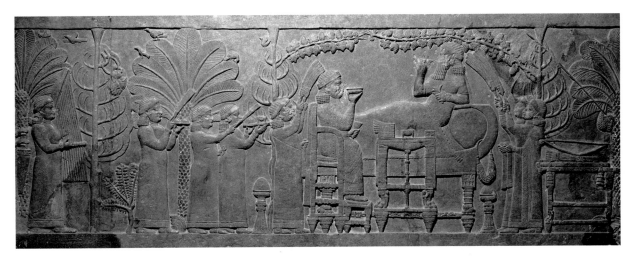

2–19 │ **ASSURBANIPAL AND HIS QUEEN IN THE GARDEN**
The Palace at Nineveh (present-day Kuyunjik, Iraq). c. 647 BCE. Alabaster, height approx. 21″ (53.3 cm). The British Museum, London.

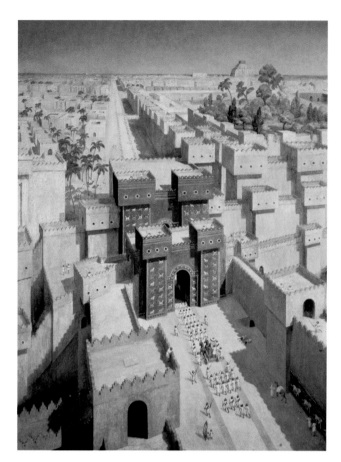

2–20 **RECONSTRUCTION DRAWING OF BABYLON IN THE 6TH CENTURY BCE**
Courtesy the Oriental Institute of the University of Chicago.

The palace of Nebuchadnezzar II, with its famous Hanging Gardens, can be seen just behind and to the right of the Ishtar Gate, west of the Processional Way. The Marduk Ziggurat looms in the far distance on the east bank of the Euphrates.

Neo-Babylonia

At the end of the seventh century BCE, the Medes, a people from western Iran, allied with the Babylonians and the Scythians, a nomadic people from northern Asia (present-day Russia and Ukraine) invaded Assyria. In 612 BCE, this army captured Nineveh. When the dust settled, Assyria was no more and the Neo-Babylonians controlled a region that stretched from modern Turkey to northern Arabia and from Mesopotamia to the Mediterranean Sea.

NEBUCHADNEZZAR. The most famous Neo-Babylonian ruler was Nebuchadnezzar II (ruled 605–562 BCE), notorious today for his suppression of the Jews, as recorded in the Hebrew (Old Testament) Book of Daniel, where he may have been confused with the final Neo-Babylonian ruler, Nabonidus. A great patron of architecture, he built temples dedicated to the Babylonian gods throughout his realm and transformed Babylon—the cultural, political, and economic

hub of his empire—into one of the most splendid cities of its day. Babylon straddled the Euphrates River, its two sections joined by a bridge.

The older, eastern sector was traversed by the Processional Way, the route taken by religious processions honoring the city's patron god, Marduk (FIG. 2–20). This street, paved with large stone slabs set in a bed of bitumen, was up to 66 feet wide at some points. It ran from the Euphrates bridge, through the temple district and palaces, and finally through the Ishtar Gate, the ceremonial entrance to the city. Beyond the Ishtar Gate, walls on either side of the route were faced with dark blue **glazed** bricks. The glazed bricks consisted of a film of colored glass placed over the surface of the bricks and fired, a process used since about 1600 BCE. Against that blue background, specially molded turquoise, blue, and gold-colored bricks formed images of striding lions, symbols of the goddess Ishtar.

THE ISHTAR GATE. The double-arched Ishtar Gate, a symbol of Babylonian power, was guarded by four crenellated towers. (**Crenellations** are notched walls—the notches are called *crenels*—built as a part of military defenses.) It is decorated with tiers of *mushhushshu* (horned dragons with the head and body of a snake, the forelegs of a lion, and the hind legs of a bird of prey) that were sacred to Marduk, and with bulls with blue horns and tails that were associated with Adad, the storm god.

Now reconstructed inside a Berlin Museum, the Ishtar Gate is installed next to a panel from the throne room in Nebuchadnezzar's nearby palace (FIG. 2–21). In the fragment seen here, lions walk beneath stylized palm trees. Among Babylon's other marvels—none of which have survived—were its fabled terraced and irrigated Hanging Gardens (one of the so-called Seven Wonders of the World), and the Marduk Ziggurat. All that remains of this ziggurat, which ancient documents describe as painted white, black, crimson, blue, orange, silver, and gold, is the outline of its base and traces of the lower stairs.

PERSIA

In the sixth century BCE, the Persians, a formerly nomadic, Indo-European–speaking people, began to seize power in Mesopotamia. From the region of Parsa, or Persis (present-day Fars, Iran), they eventually overwhelmed all of the ancient Near East and established a vast empire. The rulers of this new empire traced their ancestry to a semilegendary Persian king named Achaemenes, and consequently they are known as the Achaemenids.

Empire

The dramatic expansion of the Achaemenids began in 559 BCE with the ascension of a remarkable leader, Cyrus II the Great

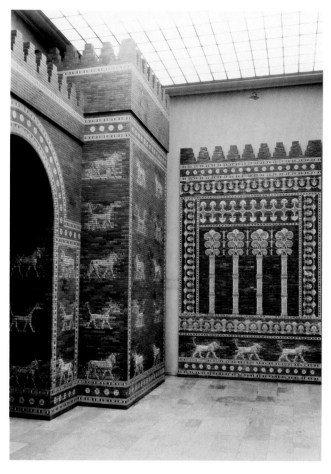

2–21 | ISHTAR GATE AND THRONE ROOM WALL
Reconstructed in a Berlin museum, originally from Babylon (present-day Iraq) c. 575 BCE. Glazed brick, height of gate originally 40 feet (12.2 m) with towers rising 100 feet (30.5 m). Vorderasiatisches Museum, Staatliche Museen zu Berlin, Preussischer Kulturbesitz.

(ruled 559–530 BCE). By the time of his death, the Persian Empire included Babylonia, Media (which stretched across present-day northern Iran through Anatolia), and some of the Aegean islands far to the west. Only the Greeks stood fast against them (see Chapter 5). When Darius I (ruled 521–486 BCE) took the throne, he could proclaim: "I am Darius, great King, King of Kings, King of countries, King of this earth."

An able administrator, Darius organized the Persian lands into twenty tribute-paying areas under Persian governors. He often left local rulers in place beneath the governors. This practice, along with a tolerance for diverse native customs and religions, won the Persians the loyalty of many of their subjects. Darius also developed a system of fair taxation, issued a standardized currency (SEE FIG. 2-25), and improved communication throughout the empire. Like many powerful rulers, Darius created palaces and citadels as visible symbols of his authority. He made Susa his first capital and commissioned a 32-acre administrative compound to be built there.

Persepolis

In about 515 BCE, Darius began construction of Parsa, a new capital in the Persian homeland in the Zagros highlands. Today this city, known as Persepolis, the name the Greeks gave it, is one of the best-preserved and most impressive ancient sites in the Near East (FIG. 2–22). Darius imported materials, workers, and artists from all over his empire for his building projects. He even ordered work to be executed in Egypt and transported to his capital. The result was a new style of art that combined many different cultural traditions, including Persian, Mede, Mesopotamian, Egyptian, and Greek.

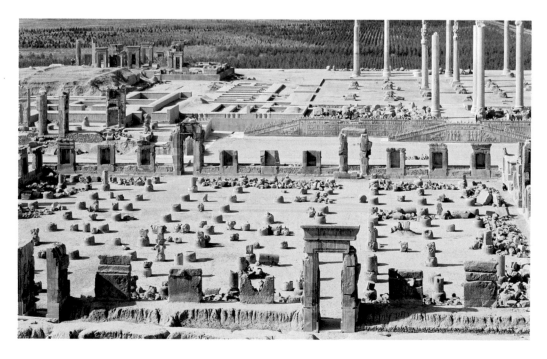

2–22 | AIR VIEW OF THE CEREMONIAL COMPLEX, PERSEPOLIS
Iran. 518–c. 460 BCE.

Technique
TEXTILES

Textiles are usually a woman's art although men, as shepherds and farmers, often produced the raw materials (wool, flax, and other fibers). And as traveling merchants, men sold or bartered the extra fabrics not needed by the family. Early Assyrian cuneiform tablets preserve correspondence between merchants traveling by caravan and their wives. These astute business women ran the production end of the business back home and often complained to their husbands about late payments and changed orders. The woman shown spinning in the fragment from Susa is important-looking, wearing an elegant hairstyle, many ornaments, and a garment with a patterned border. She sits barefoot and cross-legged on a lion-footed stool covered with sheepskin, spinning thread with a large spindle. A servant stands behind the woman, fanning her, while a fish and six round objects (perhaps fruit) lie on an offering stand in front of her.

The production of textiles is complex. First, fibers gathered from plants (such as flax for linen cloth or hemp for rope) or from animals (wool from sheep, goats, and camels or hair from humans and horses) are cleaned, combed, and sorted. Only then can the fibers be twisted and drawn out under tension—that is, spun—into the long, strong, flexible thread needed for textiles. Spinning tools include a long, sticklike spindle to gather the spun fibers, a whorl (weight) to help rotate the spindle, and a distaff (a word still used to describe women and their work) to hold the raw materials. Because textiles are fragile and decompose rapidly, the indestructible stone or fired-clay spindle whorls are usually the only surviving evidence of thread making.

Weaving is done on a loom. Warp threads are laid out at right angles to weft threads, which are passed over and under the warp. In the earliest vertical looms, warp threads hung from a beam, their tension created either by wrapping them around a lower beam (a tapestry loom) or by tying them to heavy stones. Although weaving was usually a home industry, in palaces and temples slave women staffed large shops, and specialized as spinners, warpers, weavers, and finishers.

Early fiber artists depended on the natural colors of their materials and on natural dyes from the earth (ochers), plants (madder for red, woad and indigo for blue, safflower and saffron crocus for yellow), and animals (royal purple—known as Tyrian purple after the city of its origin—from marine mollusks). They combined color and techniques to create a great variety of fiber arts: Egyptians seem to have preferred white linen, elaborately folded and pleated, for their garments. The Minoans of Crete created multicolored patterned fabrics with fancy borders. Greeks excelled in the art of pictorial tapestries. The people of the ancient Near East used woven and dyed patterns and also developed knotted pile (the so-called Persian carpet) and felt (a cloth made of fibers bound by heat and pressure, not by spinning, weaving, or knitting).

WOMAN SPINNING
Susa (present-day Shush, Iran). c. 8th–7th century BCE. Bitumen compound, 3⅜ × 5⅛″ (9.2 × 13 cm). Musée du Louvre, Paris.

In Assyrian fashion, the imperial complex at Persepolis was set on a raised platform and laid out on a rectangular **grid**, or system of crossed lines. The platform was 40 feet high and measured 1,500 by 900 feet. It was accessible only from a single approach made of wide, shallow steps that allowed horsemen to ride up on horseback. Darius lived to see the completion of a treasury, the Apadana (audience hall), and a very small palace for himself on the platform. The Apadana, set above the rest of the complex on a second terrace (FIG. 2–23), had open porches on three sides and a square hall large enough to hold several thousand people. Darius's son Xerxes I (ruled 485–465 BCE) added a sprawling palace complex for himself, enlarged the treasury building, and began a vast new public reception space, the Hall of 100 Columns.

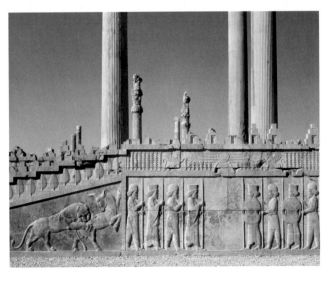

2–23 | **APADANA (AUDIENCE HALL) OF DARIUS AND XERXES**
Ceremonial Complex, Persepolis Iran. 518–c. 460 BCE.

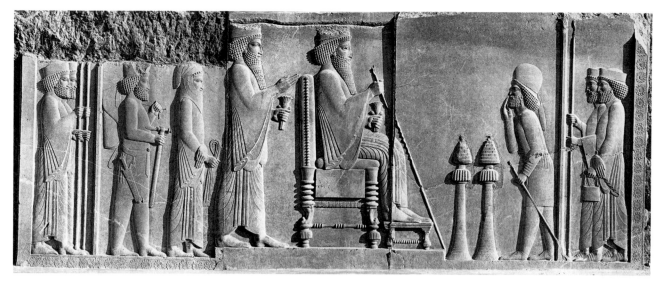

2–24 | **DARIUS AND XERXES RECEIVING TRIBUTE**
Detail of a relief from the stairway leading to the Apadana (ceremonial complex), Persepolis, Iran. 491–486 BCE. Limestone, height 8′4″ (2.54 m). Courtesy the Oriental Institute of the University of Chicago.

Persian sculpture emphasizes the extent of the empire and its economic prosperity under Persian rule. The central stair of Darius's Apadana displays reliefs of animal combat, tiered ranks of royal guards (the "10,000 Immortals"), and delegations of tribute bearers. Here, lions attack bulls at each side of the Persian generals. These animal combats (a theme found throughout the Near East) emphasize the ferocity of the leaders and their men. Ranks of warriors cover the walls with repeated patterns and seem ready to defend the palace. The elegant drawing, balanced composition, and sleek modeling of figures reflect the Persians' knowledge of Greek art and perhaps the use of Greek artists. Other reliefs throughout Persepolis depict displays of allegiance or economic prosperity. In one example, once the centerpiece, Darius holds an audience while his son and heir, Xerxes, listens from behind the throne (FIG. 2–24). Such panels would have looked quite different when they were freshly painted in rich tones of deep blue, scarlet, green, purple, and turquoise, with metal objects such as Darius's crown and necklace covered in gold leaf (sheets of hammered gold).

Persian Coinage

The Persians' decorative arts—including ornamented weapons, domestic wares, horse trappings, and jewelry—demonstrate high levels of technical and artistic sophistication. The Persians also created a refined coinage, with miniature low-relief portraits of rulers, so that coins, in addition to their function as economic standards, served as propaganda. Persians had learned to mint standard coinage from the Lydi-

ans of western Anatolia after Cyrus the Great defeated Lydia's fabulously wealthy King Croesus in 546 BCE (see "Coining Money," page 46). Croesus's wealth—the source of the lasting expression "rich as Croesus"—had made Lydia an attractive target for an aggressive empire builder like Cyrus.

A Persian coin, the gold daric, named for Darius and first minted during his regime (FIG. 2–25), is among the most valuable coins in the world today. Commonly called an "archer," it shows the well-armed emperor wearing his crown and carrying a lance in his right hand. He lunges forward as if he had just let fly an arrow from his bow.

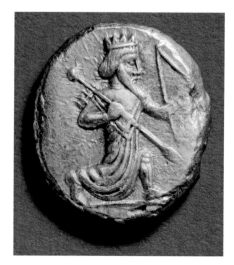

2–25 | **DARIC**
A coin first minted under Darius I of Persia. 4th century BCE. Gold. Heberden Coin Room, Ashmolean Museum, Oxford.

Technique
COINING MONEY

Ancient people had long used gold, silver, bronze, and copper as mediums of exchange, but each piece had to be weighed to establish its exact value. In the seventh century BCE, the Lydians of western Anatolia began to produce metal coins in standard weights, adapting the seal—a Sumerian invention—to designate their value. Until about 525 BCE, coins bore an image on one side only. The beautiful early coin shown here, minted during the reign of the Lydian king Croesus (ruled 560–546 BCE), is stamped with the heads and forelegs of a bull and a lion in low relief. The reverse has only a squarish depression left by the punch used to force the metal into the mold.

To make two-faced coins, the ancients used a punch and anvil, each of which held a die, or mold, with the design to be impressed in the coin. A metal blank weighing the exact amount of the denomination was placed over the anvil die, containing the design for the "head" (obverse) of the coin. The punch, with the die of the "tail" (reverse) design, was placed on top of the metal blank and struck with a mallet. Beginning in the reign of Darius I, representations of kings appeared on coins, proclaiming the ruler's control of the coin of the realm—a custom that has continued throughout the world in coins. Because we often know approximately when ancient monarchs ruled, coins discovered in an archaeological excavation help to date the objects around them.

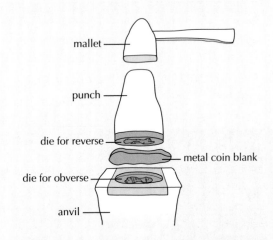

FRONT AND BACK OF A GOLD COIN
First minted under Croesus, king of Lydia. 560–546 BCE.
Heberden Coin Room, Ashmolean Museum, Oxford.

At its height, the Persian Empire extended from Africa to India. From the Persians' spectacular capital, Darius in 490 BCE and Xerxes in 480 BCE sent their armies west to conquer Greece. Mainland Greeks successfully resisted the armies of the Achaemenids, however, preventing them from advancing into Europe (Chapter 5). And it was a Greek who ultimately put an end to their empire. In 334 BCE, Alexander the Great of Macedonia (d. 323) crossed into Anatolia and swept through Mesopotamia, defeating Darius III and nearly laying waste the magnificent Persepolis in 330. Although the Achaemenid Empire was at an end, Persia eventually revived and the Persian style in art continued to influence Greek artists (Chapter 5) and ultimately Islamic art (Chapter 8).

IN PERSPECTIVE

In the ancient Near East, people developed systems of recordkeeping and written communication. Thousands of clay tablets covered with cuneiform writing document the gradual evolution of writing in Mesopotamia, as well as an organized system of justice and the world's first epic literature. We know a great deal about this ancient society—both from its records and from modern archaeological exploration and excavation. In Sumer, Akkad, Lagash, and Babylonia, agriculture, including the control of the rivers, was improved. Increased food production then made urban life possible. Population density gave rise to the development of specialized skills. Social hierarchies evolved. Priests communicated with the gods; rulers led and governed; warriors defended the greater community and its fields and villages; and artisans and farmers supplied basic material needs.

Art itself became a means of communication. A distinctive architecture arose as people built colorful stepped ziggurats. Sculptors represented these people as compact cylindrical figures animated only by wide staring eyes. By the ninth century, the Assyrians in northern Mesopotamia had built enormous city palaces and fortresses and placed guardian figures at the gates. The walls of corridors and courtyards were covered with low-relief sculptured narratives that told in vivid detail of the Assyrians' daring exploits in nearly constant warfare. Later, Babylon in the south became a luxurious city, whose hanging gardens were considered one of the wonders of the ancient world, and whose temples and ziggurats, palaces and ceremonial avenues, were lined with brilliantly colored images made of glazed bricks.

Finally, the Achaemenid Persians formed a spectacularly rich and powerful empire. Kings Darius and Xerxes built a huge palace at Persepolis (in present-day Iran) where sculptures extolled their wealth and power. Rulers in western Anatolia (present-day Turkey) invented coinage. These lumps of precious metal, stamped with portraits of rulers and symbols of cities or territories, are in fact miniature works of art.

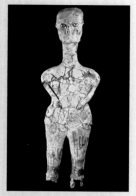

HUMAN FIGURE,
AIN GHIZAL
C. 7000–6000 BCE

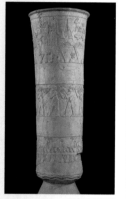

URUK VASE
C. 3300–3000 BCE

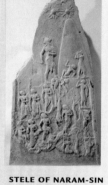

STELE OF NARAM-SIN
C. 2220–2184 BCE

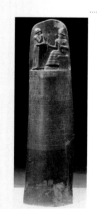

STELE OF HAMMURABI
C. 1792–1750 BCE

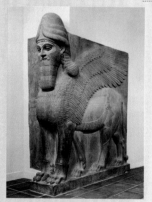

ASSYRIAN GUARDIAN FIGURE
C. 883–859 BCE

**DARIUS AND XERXES
RECEIVING TRIBUTE**
491-486 BCE

9000 BCE

5000

3000

1000

300 BCE

ART OF THE
ANCIENT
NEAR EAST

◀ **Paleolithic-Neolithic Overlap**
 c. 9000–4000 BCE

◀ **Growth of Jericho**
 c. 8000–7500 BCE

◀ **Earliest Pottery** c. 7000 BCE

◀ **Neolithic** 6500–1200 BCE

◀ **Sumer** c. 3500–2340 BCE
◀ **Potter's Wheel in Use** c. 3250 BCE
◀ **Invention of Writing** c. 3100 BCE

◀ **Akkad** c. 2340–2180 BCE
◀ **Lagash** c. 2150 BCE

◀ **Babylonia, Mari, Hammurabi Ruled**
 c. 1792–1750 BCE
◀ **Hittite (Anatolia)** c. 1600–1200 BCE

◀ **Assyrian Empire** c. 1000–612 BCE

◀ **Neo-Babylonia** c. 612–539 BCE

◀ **Persia** c. 559–331 BCE

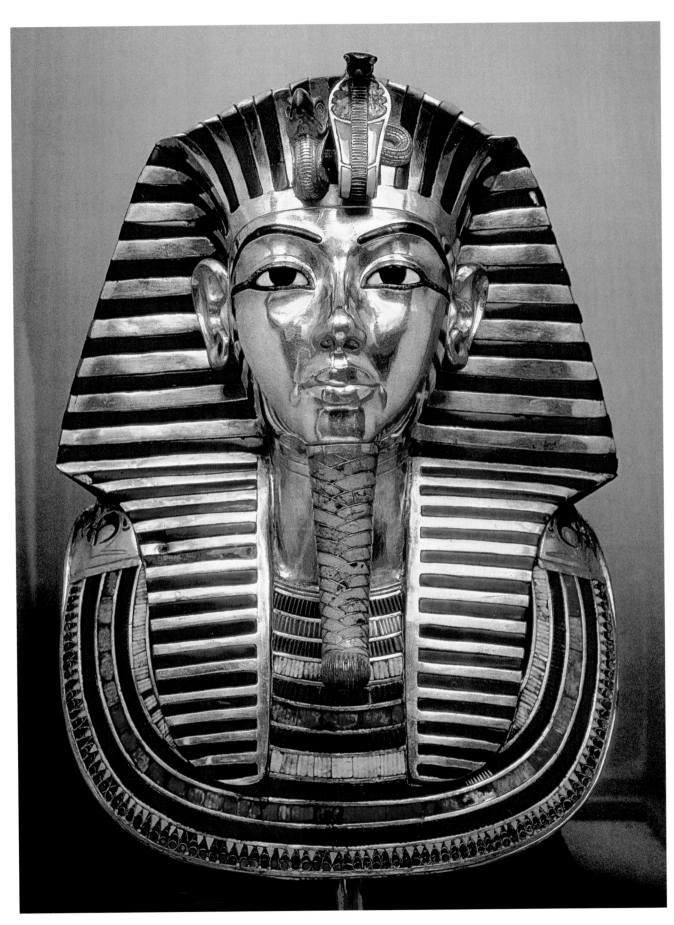

3–1 | FUNERARY MASK OF TUTANKHAMUN Eighteenth Dynasty (Tutankhamun, ruled 1332–1322 BCE), c. 1327 BCE. Gold inlaid with glass and semiprecious stones. Height 21¼″ (54.5 cm). Weight 24 pounds (11 kg). Egyptian Museum, Cairo.

ART OF ANCIENT EGYPT

On February 16, 1923, the *Times* of London cabled the *New York Times* with dramatic news of a discovery: "This has been, perhaps, the most extraordinary day in the whole history of Egyptian excavation. Whatever one may have guessed or imagined of the secret of Tut-ankh-Amen's tomb, they [sic] surely cannot have dreamed the truth as now revealed. The entrance today was made into the sealed chamber of the tomb . . . and yet another door opened beyond that. No eyes have seen the King, but to practical certainty we know that he lies there close at hand in all his original state, undisturbed." And indeed he did. A collar of dried flowers and beads covered the chest, and a linen scarf was draped around the head. A gold funerary mask (FIG. 3–1) had been placed over the head and shoulders of his mummified body, which was enclosed in three nested coffins, the innermost made of gold (SEE FIG. 3–33, and page 75). The coffins were placed in a yellow quartzite box that was itself encased within gilt wooden shrines nested inside one another.

The discoverer of this treasure, the English archaeologist Howard Carter, had worked in Egypt for more than twenty years before he undertook a last expedition, sponsored by the wealthy British amateur Egyptologist Lord Carnarvon, after World War I. Carter, a former chief inspector of Upper Egypt and draftsman for the Egypt Exploration Fund, had a detailed knowledge of the area to be excavated. He was convinced that the tomb of Tutankhamun, the only Eighteenth Dynasty royal burial place then still unidentified,

lay still hidden in the Valley of the Kings. After fifteen years of digging, on November 4, 1922, Carter unearthed the entrance to Tutankhamun's tomb. His workers cleared the way to the antechamber, which was found to contain unbelievable treasures: jewelry, textiles, gold-covered furniture, a carved and inlaid throne, four gold chariots. In February 1923, they pierced the wall separating the anteroom from the actual burial chamber. Tutankhamun's tomb had been entered, resealed, and hidden, but the burial chamber had not been disturbed.

Since ancient times, tombs have tempted looters; more recently, they also have attracted archaeologists and historians. The first large-scale "archaeological" expedition in history landed in Egypt with the armies of Napoleon in 1798. The French commander, who went to investigate digging a canal between the Mediterranean and Red seas, must have realized that he might find great riches there, for he took with him some 200 French scholars to study ancient sites. The military adventure ended in failure, but the scholars eventually published thirty-six richly illustrated volumes of their findings, unleashing a craze for all things Egyptian that has not dimmed since.

In 1976, the first blockbuster museum exhibition was born when treasures from the tomb of Tutankhamun began a tour of the United States and attracted over 8 million visitors. Major archaeological finds still make newspaper headlines around the world. In 1987, Kent R. Weeks reopened a huge

burial complex in the Valley of the Kings. Excavations beginning in 1995 revealed the tomb of Rameses II's fifty-two sons. In September 2000, Egyptian archaeologists again made the front pages when they announced the spectacular discovery of more than a hundred mummies—some from about 500 BCE and most from the time of the Roman occupation of Egypt—in a huge burial site called the Valley of the Golden Mummies, about 230 miles southwest of Cairo. The director of excavations for the government of Egypt, Dr. Zahi Hawass, believes that as many as 10,000 mummies will eventually come to light from the Valley. Meanwhile, in 2006, Dr. Hawass announced the discovery of a tomb containing five sarcophagi in the Valley of the Kings, the first tomb to be found there since Tutankhamun's in 1922.

THE GIFT OF THE NILE

The Greek traveler and historian Herodotus, writing in the fifth century BCE, remarked: "Egypt is the gift of the Nile." This great river, the longest in the world, winds northward from equatorial Africa and flows through Egypt in a relatively straight line to the Mediterranean (MAP 3–1). There it forms a broad delta before emptying into the sea. Before it was dammed in 1970 by the Aswan High Dam, the lower (northern) Nile, swollen with the runoff of heavy seasonal rains in the south, overflowed its banks for several months each year. Every time the floodwaters receded, they left behind a new layer of rich silt, making the valley and delta a fertile and attractive habitat.

By about 8000 BCE, the valley's inhabitants had become relatively sedentary, living off the abundant fish, game, and wild plants. Not until about 5000 BCE did they adopt the agricultural village life associated with Neolithic culture (see Chapter 1). At that time, the climate of North Africa grew increasingly dry. To ensure adequate resources for agriculture, the farmers along the Nile cooperated to control the river's flow. As in Mesopotamia (see Chapter 2), this common challenge led riverside settlements to form alliances. Over time, these rudimentary federations expanded by conquering and absorbing weaker communities. By about 3500 BCE, there were several larger states, or chiefdoms, in the lower Nile Valley.

The Predynastic period, from roughly 5000 to 2950 BCE, was a time of significant social and political transition that preceded the unification of Egypt under a single ruler. (Egyptian history is divided into dynasties—periods in which members of the same family inherited Egypt's throne.) According to later legend, the earliest Kings of Egypt were gods who ruled on earth. By the last centuries of the Predynastic period, after about 3500 BCE, a centralized form of leadership had emerged in which the rulers were considered to be divine. Their subjects expected their leaders to protect them not only from outside aggression, but also from natural catastrophes such as droughts and insect plagues.

The surviving art of the Predynastic period consists chiefly of ceramic figurines, decorated pottery, and reliefs carved on stone plaques and pieces of ivory. A few examples of Predynastic wall painting—lively scenes filled with small figures of people and animals—were found in a tomb at Hierakonpolis, in Upper Egypt, a Predynastic town of mud-brick houses that was once home to as many as 10,000 people.

We begin our discussion with the art of the early dynastic period, from c. 2950 to c. 2575 BCE, and with Manetho's list, the chronology of Egypt's rulers.

EARLY DYNASTIC EGYPT

Sometime about 3000 BCE, Egypt became a consolidated state. According to legend, the country had previously evolved into two major kingdoms—the Two Lands—Upper

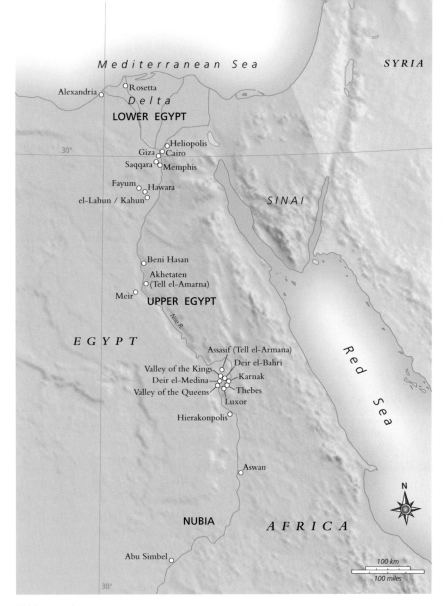

MAP 3–1 | **ANCIENT EGYPT**

Upper (southern) Egypt and Lower (northern) Egypt were united about 3100 BCE.

Egypt in the south (upstream on the Nile) and Lower Egypt in the north. But then a powerful ruler from Upper Egypt, referred to in an ancient document as "Menes king–Menes god," finally conquered Lower Egypt.

Manetho's List

In the third century BCE, an Egyptian priest and historian named Manetho used temple records to compile a chronological list of Egypt's rulers since ancient times. He grouped the kings into dynasties and included the length of each king's reign. Although scholars do not agree on all the dates, his chronology is still the accepted guide to ancient Egypt's long history. Manetho listed thirty dynasties that ruled the country between about 3000 and 332 BCE, when Egypt was conquered by Alexander the Great of Macedonia and the Greeks. Egyptologists have grouped these dynasties into larger periods reflecting broad historical developments. The dating system used in this book is that followed by the *Atlas of Ancient Egypt*.

Religion and the State

The Greek historian Herodotus thought the Egyptians the most religious people he had ever encountered. Religious beliefs permeate Egyptian art of all periods. Many of the earliest and most important deities in Egypt's pantheon are introduced in its creation myths.

CREATION MYTHS. One version of the creation myth relates that the sun god Ra—or Ra-Atum—shaped himself out of the waters of chaos, or unformed matter, and emerged sealed atop a mound of sand hardened by his own rays. By spitting—or ejaculating—he then created the gods of wetness and dryness, Tefnut and Shu, who in turn begat the male Geb (earth) and the female Nut (sky). Geb and Nut produced two sons, Osiris and Seth, and two daughters, the goddesses Isis and Nephthys.

Taking Isis as his wife, Osiris became king of Egypt. His envious brother, Seth, promptly killed Osiris, hacked his body to pieces, and snatched the throne for himself. Isis and her sister, Nephthys, gathered up the scattered remains of Osiris

Art and Its Context
EGYPTIAN SYMBOLS

Four crowns symbolize kingship: the tall clublike white crown of Upper Egypt (sometimes adorned with two plumes); the flat red cap with rising spiral of Lower Egypt; the double crown representing unified Egypt; and, in the New Kingdom, the blue oval crown, which evolved from a helmet.

A striped gold and blue linen head cloth, known as the **nemes headdress**, having the cobra and vulture at the center front, was commonly used as a royal headdress. The cobra goddess, Meretseger of Lower Egypt ("she who rears up"), was equated with the sun and with royalty and was often included in headdresses. The queen's crown included the feathered skin of the vulture goddess Nekhbet of Upper Egypt.

The god Horus, king of the earth and a force for good, is represented as a falcon or falcon-headed man. His eyes symbolize the sun and moon; the solar eye is called the *wedjat*. The looped cross, called the **ankh,** is symbolic of everlasting life. The **scarab beetle** (*khepri*, meaning "he who created himself") was associated with creation, resurrection, and the rising sun.

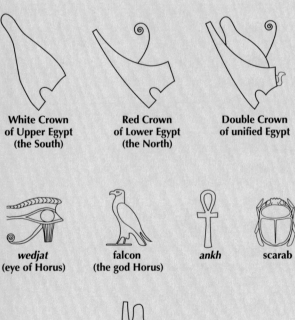

White Crown of Upper Egypt (the South)	Red Crown of Lower Egypt (the North)	Double Crown of unified Egypt

wedjat (eye of Horus)	falcon (the god Horus)	*ankh*	scarab

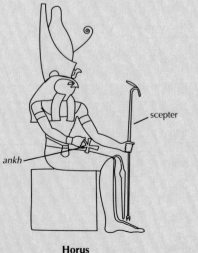

scepter

ankh

Horus

and, with the help of the god Anubis (represented by a jackal), they patched him back together. Despite her husband's mutilated condition, Isis conceived a son—Horus, another power for good, capable of guarding the interests of Egypt. Horus defeated Seth and became king of the earth, while Osiris retired to the underworld as overseer of the realm of the dead (SEE FIG. 3–35).

The myths give different explanations of the creation of human beings. In one, Ra lost an eye but, unperturbed, replaced it with a new one. When the old eye was found, it began to cry, angered that it was no longer of any use. Ra created human beings from its tears. In another myth, the god Khnum created humankind on his potter's wheel.

THE GOD-KINGS. By the Early Dynastic period (2950–2575 BCE), Egypt's kings were revered as gods in human form. A royal jubilee, the *heb sed* or *sed* festival, held in the thirtieth year of the living king's reign, renewed and reaffirmed his power. Kings rejoined their father the sun god Ra at death and rode with him in the solar boat as it made its daily journey across the sky.

To please the gods and ensure their continuing goodwill toward the state, the kings built splendid temples and provided priests to maintain them. The priests saw to it that statues of the gods, placed deep in the innermost rooms of the temples, were never without fresh food and clothing. The many gods and goddesses were depicted in various forms, some as human beings, others as animals, and still others as humans with animal heads. Osiris, for example, regularly appears in human form wrapped in linen as a mummy. His sister-wife, Isis, has a human form, but their son, the sky god Horus, is often depicted as a falcon or falcon-headed man (see "Egyptian Symbols," left).

By the New Kingdom (c. 1539–1075 BCE), Amun (chief god of Thebes, represented as blue and wearing a plumed crown), Ra (of Heliopolis), and Ptah (of Memphis) had become the primary national gods. Other gods and their manifestations included Hathor (cow), goddess of love and fertility; Thoth (ibis), god of writing, science, and law; Maat (feather), god of truth, order, and justice; Anubis (jackal), god of embalming and cemeteries; and Bastet (cat), daughter of Ra.

Egyptian religious beliefs reflect an ordered cosmos. The movements of heavenly bodies, the workings of gods, and the humblest of human activities all were thought to be part of a balanced and harmonious grand design. Death was to be feared only by those who lived in such a way as to disrupt that harmony: Upright souls could be confident that their spirits would live on eternally.

Artistic Conventions

Conventions in art are the customary ways of representing people and the world, generally accepted by artists and patrons. Egyptian artists followed certain well-established

conventions: Images are based on memory images and characteristic viewpoints; mathematical formulas determine proportions; importance determines size (hieratic scale); space is represented in horizontal registers; drawing and contours are simplified; and colors are clear and flat. The conventions that govern Egyptian art appear early and continue to be followed, with subtle variations, through its long history.

THE NARMER PALETTE. Being one of the most historically and artistically significant works of ancient Egyptian art, the **NARMER PALETTE** (FIG. 3–2) was created at the dawn of its history. It is commonly interpreted to announce the unification of Egypt and the beginning of the country's growth as a powerful nation-state. It also exhibits many visual conventions that characterize the art of Egyptian civilization from this point on.

The first king, named Narmer, who may be Menes, is known from this ceremonial palette of green schist found at Hierakonpolis. The ruler's name appears in an early form of **hieroglyphic** writing at the center top of both sides within a small square representing a palace façade—a horizontal fish (*nar*) above a vertical chisel (*mer*). Narmer and his palace are protected by Hathor, depicted as a human face with cow ears and horns and shown on each side of his name.

Palettes, flat stones with a circular depression on one side, were used for grinding eye paint. (Both men and women

Sequencing Events
KEY EGYPTIAN PERIODS

c. 5000–2950 BCE	Predynastic Period
c. 2950–2575 BCE	Early Dynastic Period
c. 2575–2150 BCE	Old Kingdom
c. 2125–1975 BCE	First Intermediate Period
c. 1975–c. 1640 BCE	Middle Kingdom
c. 1630–1520 BCE	Second Intermediate Period
c. 1630–1520 BCE	New Kingdom
c. 715–332 BCE	Late Period

painted their eyelids to help prevent infections in the eyes and to reduce the glare of the sun.) The *Narmer Palette,* carved in low relief on both sides, is much larger than most. It was found in the temple of Horus, so it may have had a ceremonial function or been a votive offering.

Narmer dominates the scenes on the palette: Images of conquest proclaim him to be the great unifier, protector, and leader of the Egyptian people. Hieratic scale signals the status of individuals and groups in this highly stratified society; so, as in the *Stele of Naram-Sin* (SEE FIG. 2–14), the ruler is larger than the other human figures. Narmer wears the White

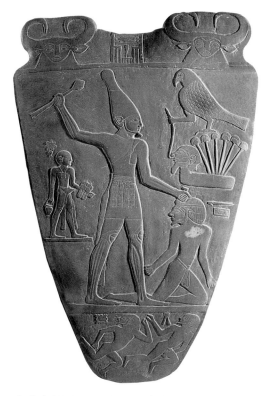
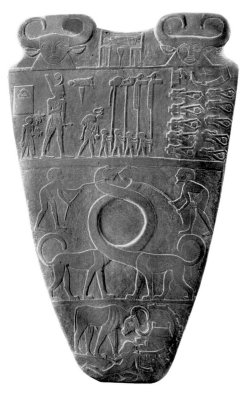

3–2 | **THE NARMER PALETTE**
Hierakonpolis. Early Dynastic period, c. 2950–2775 BCE. Green schist, height 25″ (64 cm).
Egyptian Museum, Cairo.

Crown of Upper Egypt; a ceremonial bull's tail, signifying strength, hangs from his waistband. He is barefoot, and an attendant standing behind him holds his sandals.

He bashes the enemy with a club, and above his kneeling foe, the god Horus—depicted as a falcon with a human hand—holds a rope tied around the neck of a man whose head is attached to a block sprouting stylized papyrus, a plant that grew in profusion along the Nile and was used symbolically to represent Lower Egypt. This combination of symbols makes clear that Narmer has tamed Lower Egypt. At the bottom, below Narmer's feet, two more defeated enemies appear sprawled on the ground.

In the top register on the other side of the palette (FIG. 3–2, right), Narmer wears the Red Crown of Lower Egypt, possibly to indicate he now rules both lands (see "Egyptian Symbols," page 52). With his attendant sandal-bearer, he marches behind his minister of state and four men carrying standards that may symbolize different regions of the country. Before them, under the watchful eye of Horus, decapitated bodies of the enemy are arranged in two neat rows. In the center register, the elongated necks of two feline creatures, each held on a leash by an attendant, curve gracefully around the rim of the cup of the palette. The intertwining of their necks may be another reference to the union of the Two Lands. At the bottom, the king, symbolized as a bull (an animal known for its strength and virility), menaces a fallen foe outside the walls of a fortress.

The images carved on the palette are strong and direct, and although scholars disagree about some of their specific meanings, their overall message is clear: A king named Narmer rules over the unified land of Egypt with a strong hand. For the next 3,000 years, much of Egyptian art was created to meet the demand of royal patrons for similarly graphic and indestructible testimonies to their glory.

TWISTED PERSPECTIVE. Narmer's palette is a very early example of the way Egyptian artists solved the problem of depicting the human form in the two-dimensional arts of relief sculpture and painting. Many of the figures on the palette are shown in poses that would be impossible in real life. By Narmer's time, Egyptian artists, composing their art from **memory images** (the generic form that suggests a specific object), had arrived at a unique way of drawing the human figure with the aim of representing each part of the body from its most characteristic angle. Heads are shown in profile, to best capture the nose, forehead, and chin. Eyes were rendered frontally. As for the body, a profile head and neck are joined to profile hips and legs by a fully frontal torso. The figure is usually striding to reveal both legs. The result is a formalized version of the twisted perspective we have seen in cave paintings (Chapter 1) and in ancient Near Eastern art (Chapter 2).

This artistic convention was followed especially in the depiction of royalty and other dignitaries. Persons of lesser social rank engaged in active tasks tend to be represented more naturally (compare the figure of Narmer with those of his standard-bearers).

Similar long-standing conventions governed the depiction of animals, insects, inanimate objects, landscape, and architecture. **Groundlines** establish space as a series of horizontal registers in which the uppermost register is the most distant. A landscape combines the bird's-eye view of a map with the depiction of elements such as trees from the side.

THE CANON OF PROPORTIONS. Egyptian artists also established an ideal image of the human form, following a **canon of proportions**. The ratios between a figure's height and all of its component parts were clearly prescribed. They were calculated as multiples of a specific unit of measure, such as the width of the closed fist. This unit became the basis of a square grid, the **OLD KINGDOM STANDARD GRID** (FIG. 3–3). Every body part had its designated place on the grid: Knowing the knee should appear a prescribed number of squares above the groundline, the waist was then x number of squares above the knee, and so on. The whole process was thereby simplified. Since size depended not on the object, but on the amount of space it occupied, even the smallest image possesses the quality of a monumental figure.

3–3 | **OLD KINGDOM STANDARD GRID—AN EGYPTIAN CANON OF PROPORTIONS FOR REPRESENTING THE HUMAN BODY**

This canon sets the height of the male body from heel to hairline at 18 times the width of the fist, which is 1 unit wide. Thus, there are 18 units between the heels and the hairline. The knees align with the fifth unit up, the elbows with the twelfth, and the junction of the neck and shoulders with the sixteenth.

Technique
PRESERVING THE DEAD

Egyptians developed mummification techniques to ensure that the *ka*, or life force, could live on in the body in the afterlife. No recipes for preserving the dead have been found, but the basic process seems clear enough from images found in tombs, the descriptions of later Greek writers such as Herodotus and Plutarch, scientific analysis of mummies, and modern experiments.

By the time of the New Kingdom, the routine was roughly as follows: The body was taken to a mortuary, a special structure used exclusively for embalming. Under the supervision of a priest, workers removed the brains, generally through the nose, and emptied the body cavity through an incision in the left side. They then placed the body and major internal organs in a vat of natron, a naturally occurring salt, to steep for a month or more.

This preservative caused the skin to blacken, so workers often dyed it later to restore some color, using red ocher for a man, yellow ocher for a woman. They then packed the body cavity with clean linen, soaked in various herbs and ointments, provided by the family of the deceased. They wrapped the major organs in separate packets, putting them in special containers called **canopic jars,** to be placed in the tomb chamber.

Workers next wound the trunk and each of the limbs separately with cloth strips, then wrapped the whole body. They wound it in additional layers of cloth to produce the familiar mummy shape. The linen winders often inserted charms and other smaller objects among the wrappings. If the family supplied a copy of the Book of the Dead, it was tucked between the mummy's legs.

Funerary Architecture

Ancient Egyptians believed that an essential part of every human personality is its life force, or spirit, called the *ka*, which lived on after the death of the body, forever engaged in the activities it had enjoyed in its former existence. The *ka* needed a body to live in, and a sculpted likeness was adequate. It was especially important to provide a comfortable home for the *ka* of a departed king, so that even in the afterlife he would continue to ensure the well-being of Egypt.

The Egyptians developed elaborate funerary practices to ensure that their deceased moved safely and effectively into the afterlife. They preserved the bodies of the royal dead with care and placed them in burial chambers filled with all the supplies and furnishings the *ka* might require throughout eternity (see "Preserving the Dead," above). The quantity and value of these grave goods were so great that even in ancient times looters routinely plundered tombs.

THE MASTABA. In Early Dynastic Egypt, the most common tomb structure—used by the upper level of society, the King's family and relatives—was the **mastaba,** a flat-topped, one-story building with slanted walls erected above an underground burial chamber (see "Mastaba to Pyramid," page 56). Mastabas were at first constructed of mud brick, but toward the end of the Third Dynasty (c. 2650–2575 BCE), many incorporated cut stone, at least as an exterior facing.

In its simplest form, the mastaba contained a **serdab,** a small, sealed room housing the *ka* statue of the deceased, and a chapel designed to receive mourning relatives and offerings. A vertical shaft dropped from the top of the mastaba down to the actual burial chamber, where the remains of the deceased reposed in a **sarcophagus** (a coffin), surrounded by appropriate grave goods. This chamber was sealed off after interment. Mastabas might have numerous underground burial chambers to accommodate whole families, and mastaba burial remained the standard for Egyptian elites for centuries.

THE NECROPOLIS. The kings of the Third Dynasty, such as Djoser, devoted huge sums to the design, construction, and decoration of extensive funerary complexes. These structures tended to be grouped together in a **necropolis**—literally, a "city of the dead"—at the edge of the desert on the west bank of the Nile, for the land of the dead was believed to be in the direction of the setting sun. Two of the most extensive of these early necropolises are at Saqqara and Giza, just outside modern Cairo.

DJOSER'S COMPLEX AT SAQQARA. For his tomb complex at Saqqara, the Third Dynasty King Djoser (c. 2650–2631 BCE) commissioned the earliest known monumental architecture in Egypt (FIG. 3–4). The designer of the complex was Imhotep, the highly educated prime minister who served as one of Djoser's chief advisers. Imhotep is the first architect in history known by name. His name, together with the king's, is inscribed on the base of a statue of Djoser found near the step pyramid.

Elements of Architecture
MASTABA TO PYRAMID

As the gateway to the afterlife for Egyptian kings and members of the royal court, the Egyptian burial structure began as a low rectangular mastaba with an internal *serdab* (the room where the *ka* statue was placed) and chapel. Then a mastaba with attached chapel and *serdab* (not shown) was the custom. Later, mastaba forms of decreasing size were stacked over an underground burial chamber to form the step pyramid. The culmination of the Egyptian burial chamber is the pyramid, in which the actual burial site may be within the pyramid—not below ground—with false chambers, false doors, and confusing passageways to foil potential tomb robbers.

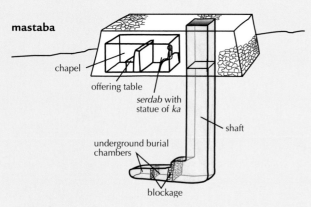

mastaba

chapel
offering table
serdab with statue of *ka*
shaft
underground burial chambers
blockage

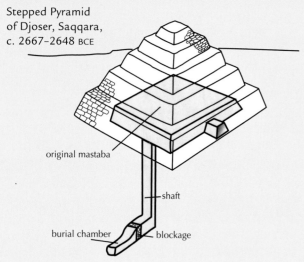

stepped pyramid

Stepped Pyramid of Djoser, Saqqara, c. 2667-2648 BCE

original mastaba
shaft
burial chamber
blockage

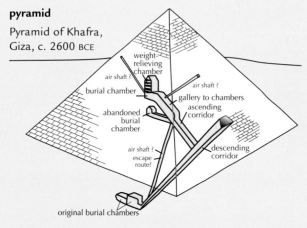

pyramid

Pyramid of Khafra, Giza, c. 2600 BCE

weight-relieving chamber
air shaft ?
burial chamber
air shaft ?
gallery to chambers
abandoned burial chamber
ascending corridor
air shaft ?
escape route?
descending corridor
original burial chambers

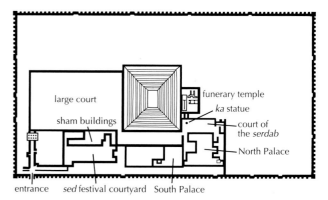

large court
sham buildings
funerary temple
ka statue
court of the *serdab*
North Palace
entrance
sed festival courtyard
South Palace

3–4 PLAN OF DJOSER'S FUNERARY COMPLEX, SAQQARA
Third Dynasty, c. 2630-2575 BCE.

Situated on a level terrace, this huge commemorative complex—some 1,800 feet (544 m) long by 900 feet (277 m) wide—was designed as a replica in stone of the wood, brick, and reed buildings of Djoser's actual palace compound. Inside the wall, the step pyramid dominated the complex. Underground apartments copied the layout and appearance of rooms in the royal palace.

It appears that Imhotep first planned Djoser's tomb as a single-story mastaba, then later decided to enlarge upon the concept (FIG. 3–5). In the end, what he produced was a step pyramid formed by six mastaba-like elements of decreasing size placed on top of each other. Although the final structure resembles the ziggurats of Mesopotamia, it differs in both its intention (as a stairway to the sun god Ra) and its purpose (protecting a tomb). A 92-foot shaft descended from the original mastaba enclosed within the pyramid. A descending corridor at the base of the pyramid provided an entrance from outside to a granite-lined burial vault.

The adjacent funerary temple, where priests performed their final rituals before placing the king's mummified body in its tomb, was used for continuing worship of the dead king. In the form of his *ka* statue, Djoser intended to observe these devotions through two peepholes in the wall between the *serdab* and the funerary chapel. To the east of the pyramid, buildings filled with debris represent actual structures in which the dead king could continue to observe the *sed* rituals that had ensured his long reign. In a pavilion near the entrance to the complex in the southeast corner, his spirit could await the start of ceremonies he had performed in life, such as the running trials of the *sed* festival. These would take place in a long outdoor courtyard within the complex. After proving himself, the king would proceed first to the South Palace and then to the North Palace, to be symbolically crowned once again as ruler of Egypt's Two Lands.

THE OLD KINGDOM, c. 2575–2150 BCE

The Old Kingdom was a time of social and political stability despite increasingly common military excursions to defend the borders. The growing wealth of ruling families of the period is reflected in the size and complexity of the tomb structures they commissioned for themselves. Court sculptors

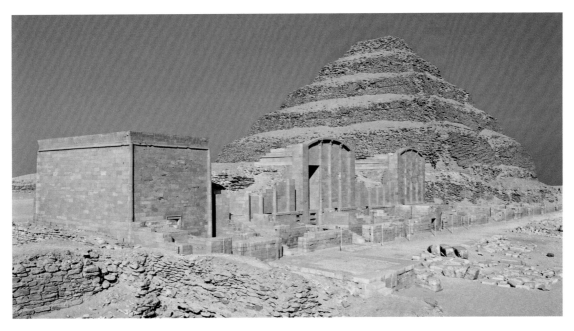

3–5 | **THE STEP PYRAMID, AND SHAM BUILDINGS. FUNERARY COMPLEX OF DJOSER, SAQQARA**
Limestone, height of pyramid 204' (62 m).

were regularly called on to create life-size, even colossal royal portraits in stone. Kings were not the only patrons of the arts, however. Upper-level government officials also could afford to have tombs decorated with elaborate carvings.

Architecture: The Pyramids at Giza

The architectural form most closely identified with Egypt is the true pyramid with a square base and four sloping triangular faces. The first such structures were erected in the Fourth

Dynasty (2575–2450 BCE). The angled sides of the pyramids may have been meant to represent the slanting rays of the sun, for inscriptions on the walls of pyramid tombs built in the Fifth and Sixth dynasties tell of deceased kings climbing up the rays to join the sun god Ra.

Egypt's most famous funerary structures are the three great pyramid tombs at Giza (see Introduction, Fig. 1,; and FIG. 3–6). These were built by the Fourth Dynasty kings Khufu (ruled c. 2551–2528 BCE), Khafre (ruled 2520–2494 BCE), and

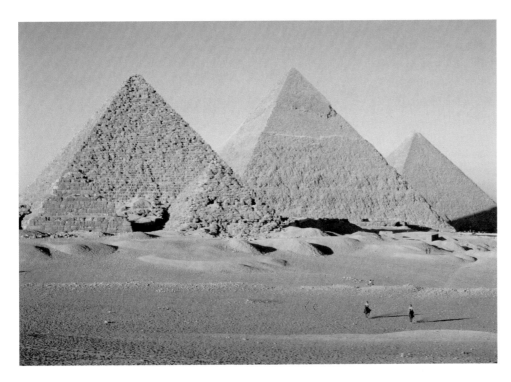

3–6 | **GREAT PYRAMIDS, GIZA**
Fourth Dynasty, c. 2575–2450 BCE. Erected by (from the left) Menkaure, Khafre, and Khufu. Granite and limestone, height of pyramid of Khufu, 450' (137 m).

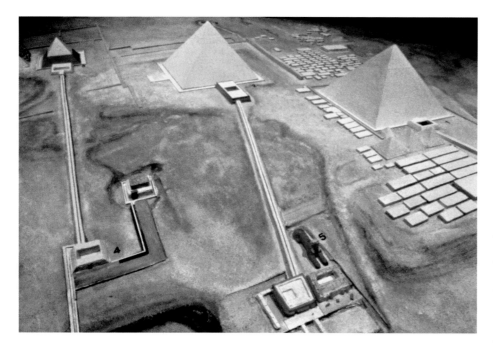

3–7 | MODEL OF THE GIZA PLATEAU
From left to right: the temples and pyramids of Menkaure, Khafre, and Khufu. (Number 4 is the Valley Temple of Menkaure; number 5 is the Valley Temple and Sphinx of Khafre.)

Prepared for the exhibition "The Sphinx and the Pyramids: One Hundred Years of American Archaeology at Giza," held in 1998 at the Harvard University Semitic Museum. Harvard University Semitic Museum, Cambridge, Massachusetts.

Menkaure (ruled c. 2490–2472 BCE). The Greeks were so impressed by these monuments—*pyramid* is a Greek term—that they numbered them among the world's architectural marvels. The early Egyptians referred to the Giza pyramids as" Horizon of Khufu," "Great is Khafre," and "Divine is Menkaure," thus acknowledging the desire of these rulers to commemorate themselves as divine beings.

KHUFU AND KHAFRE. The oldest and largest pyramid is that of Khufu, which covers thirteen acres at its base. It was originally finished with a thick veneer of polished limestone that lifted its apex to almost 481 feet, some 30 feet above the present summit. The pyramid of Khafre, the only one of the three that still has a little of its veneer at the top, is slightly smaller than Khufu's. Menkaure's pyramid is considerably smaller than the other two and had a polished red granite base.

The site was carefully planned to follow the sun's east–west path. Next to each of the pyramids was a funerary temple connected by a causeway, or elevated road, to a valley temple on the bank of the Nile (FIG. 3–7). When a king died, his body was embalmed and ferried west across the Nile from the royal palace to his valley temple, where it was received with elaborate ceremonies. It was then carried up the causeway to his funerary temple and placed in its chapel, where family members presented offerings of food and drink, and priests performed rites in which the deceased's spirit consumed a meal. Finally, the body was entombed in a vault deep inside the pyramid.

The designers of the pyramids tried to ensure that the king and his tomb would never be disturbed. Khufu's builders placed his tomb chamber in the very heart of the mountain of masonry, at the end of a long, narrow, steeply rising passageway, sealed off after the burial with a 50-ton stone block. Three false passageways further obscured the location of the tomb.

Khafre's funerary complex is the best preserved. In the valley temple, massive blocks of red granite form walls and piers supporting a flat roof (FIG. 3–8). Tall, narrow windows act as a clerestory in the upper walls, letting in light which reflects off the polished alabaster floor (see "Post-and-Lintel and Corbel Construction," page 14).

CONSTRUCTING THE PYRAMIDS. The pyramid was a triumph of engineering and design. Constructing one was a formidable undertaking. A large workers' burial ground discovered at Giza attests to the huge labor force that had to be assembled, housed, and fed. Most of the cut stone blocks—each weighing an average of 2.5 tons—used in building the Giza complex were quarried either on the site or nearby. Teams of workers transported them by sheer muscle power, employing small logs as rollers or pouring water on sand to create a slippery surface over which they could drag the blocks on sleds.

Scholars and engineers have various theories about how the pyramids were raised. Some ideas have been tested in computerized projections and a few models on a small but representative scale have been constructed. The most efficient means of getting the stones into position might have been to build a temporary, gently sloping ramp around the body of the pyramid as it grew higher. The ramp could then be dismantled as the stones were smoothed out or slabs of veneer were laid.

and blocklike—express a feeling of strength and permanence, and address the practical difficulties of carving hard stone such as diorite.

PORTRAIT OF KHAFRE. As was the custom, Khafre commissioned many portraits of himself. His most famous image is the Great Sphinx, just behind his valley temple: a colossal monument some 65 feet tall that combines his head with the long body of a crouching lion (SEE FIG. 1, Introduction). In an over–life-size statue, one of several discovered inside his valley temple, Khafre was portrayed as an enthroned king (FIG. 3–9). sitting erect on a elegant but simple throne. The falcon god Horus perches on the back of the throne, protectively enfolding the king's head with his wings (FIG. 3–10).

3–8 ⋮ **VALLEY TEMPLE OF KHAFRE**
Giza. Old Kingdom, c. 2570–2544 BCE. Limestone and red granite. Commissioned by Khafre.

The architects who oversaw the building of such massive structures were capable of the most sophisticated mathematical calculations. They oriented the pyramids to the points of the compass and may have incorporated other symbolic astronomical calculations as well. There was no room for trial and error. The huge foundation layer had to be absolutely level and the angle of each of the slanting sides had to remain constant so that the stones would meet precisely in the center at the top.

Sculpture

Egyptian artists were adept at creating lifelike three-dimensional figures. In contrast to the cylindrical images of early Mesopotamian sculpture, their forms—compact, solid,

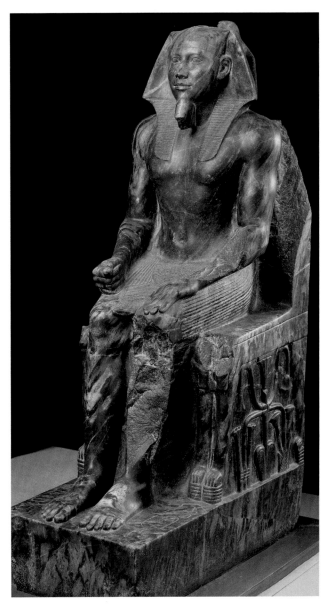

3–9 ⋮ **KHAFRE**
Giza, Valley Temple of Khafre. Fourth Dynasty (ruled c. 2520–2494 BCE). Anorthosite gneiss, height 5′ 6⅛″ (1.68 m).Egyptian Museum, Cairo.

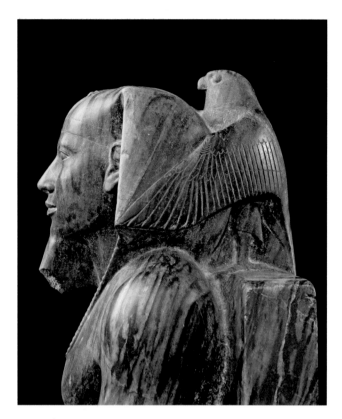

Lions—symbols of regal authority—form the throne's legs, and the intertwined lotus and papyrus plants beneath the seat symbolize the king's power over Upper (lotus) and Lower (papyrus) Egypt.

Khafre wears the traditional royal costume: a short, pleated kilt, a linen headdress with the cobra symbol of Ra, and a false beard symbolic of royalty (see "Egyptian Symbols," page 52). He holds a cylinder, probably a rolled piece of cloth. The figure conveys a strong sense of dignity, calm, and above all permanence. The arms are pressed tight to the body, and the body is firmly anchored in the block. The statue was carved in an unusual stone: anorthosite gneiss (related to diorite), imported from Nubia. This stone produces a rare optical effect: In sunlight, it glows a deep blue, the celestial color of Horus. Through skylights in the valley temple, the sun would have illuminated the alabaster floor and the figure, creating a blue radiance.

MENKAURE. Dignity, calm, and permanence also characterize the beautiful double portrait of Khafre's heir King Menkaure and a queen, probably Khamerernebty II, discovered in Menkaure's valley temple (FIG. 3–11). The sculptor's handling of the composition of this work, however, makes it far less austere than Khafre's statue. The couple's separate figures, close in size, are joined by the stone out of which they emerge, forming a single unit. They are further united by the queen's symbolic gesture of embrace. Her right hand comes from behind to lie gently against his ribs, and her left hand rests on his upper arm.

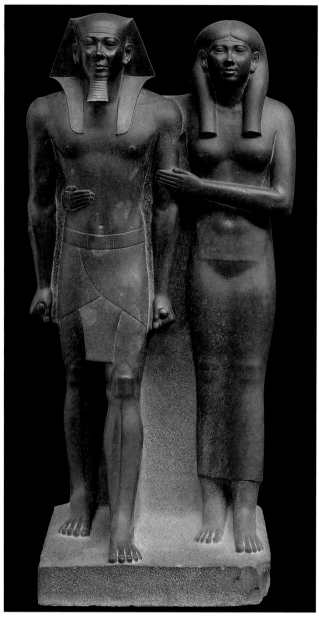

3–11 | MENKAURE AND A QUEEN
Perhaps his wife Khamerernebty, from Giza. Fourth Dynasty (ruled 2490-2472 BCE). Graywacke with traces of red and black paint, height 54½″ (142.3 cm). Museum of Fine Arts, Boston.
Harvard University-MFA Expedition

The king, depicted in accordance with the Egyptian ideal as an athletic, youthful figure nude to the waist and wearing the royal kilt and headcloth, stands in a typically Egyptian balanced pose, striding with the left foot forward, his arms straight at his sides, and his fists clenched over cylindrical objects. His equally youthful queen, taking a smaller step forward, echoes his pose. The sculptor exercised remarkable skill in rendering her sheer, close-fitting garment, which clearly reveals the curves of her body. The time-consuming task of polishing this double statue was never completed, indicating that the work may have been undertaken only a few years before Menkaure's death in about 2472 BCE. Traces

of red paint remain on the king's face, ears, and neck (male figures were traditionally painted red), as do traces of black on the queen's hair.

PEPY II AND HIS MOTHER. In the Fifth and Sixth dynasties more generic figures appear, and inscriptions personalize the images. In a statue representing Pepy II (ruled c. 2246–2152 BCE), the king wears the royal kilt and headdress but is reduced to the size of a child seated on his mother's lap (FIG. 3–12). The work pays homage to Queen Ankhnes-meryre, who wears a vulture-skin headdress linking her to the goddess Nekhbet and proclaiming her royal blood. The queen is inscribed "Mother of the King of Upper and Lower Egypt, the god's daughter, the revered one, beloved of Khnum Ankhnesmeryra."

If Pepy II inherited the throne at the age of six, as the Egyptian priest and historian Manetho claimed, then the queen may have acted as regent until he was old enough to rule alone. The sculptor placed the king at a right angle to his mother, thus providing two "frontal" views—the queen facing forward, the king to the side. In another break with convention, he freed the queen's arms and legs from the stone block of the throne, giving her figure greater independence.

THE SEATED SCRIBE. Old Kingdom sculptors produced figures not only of kings but also of less prominent people. Such works—for example, the *Seated Scribe* from early in the Fifth Dynasty (FIG. 3–13)—are often more lively and less formal than royal portraits. Other early Fifth Dynasty statues found at Saqqara have a similar round head and face, alert expression, and cap of close-cropped hair. This statue was discovered near the tomb of a government official named Kai, and there is some evidence that it may be a portrait of Kai himself.

The scribe's sedentary vocation has made his body a little flabby, a condition that advertised a life freed from hard physical labor. A comment found in a tablet, probably copied from a book of instruction, emphasizes this interpretation: "Become a scribe so that your limbs remain smooth and your hands soft and you can wear white and walk like a man of

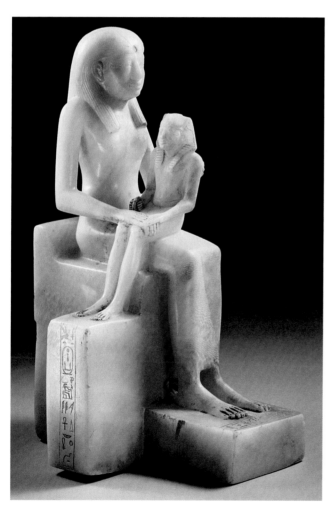

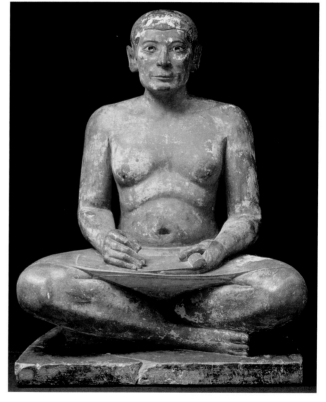

3–13 | **SEATED SCRIBE**
found near the tomb of Kai, Saqqara. Fifth Dynasty, c. 2450–2325 BCE. Painted limestone with inlaid eyes of rock crystal, calcite, and magnesite mounted in copper, height 21″ (53 cm). Musée du Louvre, Paris.

3–12 | **PEPY II AND HIS MOTHER, QUEEN ANKHNES-MERYRE**
Sixth Dynasty, c. 2323–2152 BCE (ruled. c. 2246–2152 BCE). Egyptian alabaster, height 15¼ × 9¹³⁄₁₆″ (39.2 × 24.9 cm). The Brooklyn Museum of Art, New York.
Charles Edwin Wilbour Fund (39.119)

standing whom [even] courtiers will greet" (cited in Strouhal, page 216). He sits holding a papyrus scroll partially unrolled on his lap, his right hand clasping a now-lost reed pen, and his face reveals a lively intelligence. Because the pupils are slightly off-center in the irises, the eyes give the illusion of being in motion, as if they were seeking contact.

A high-ranking scribe with a reputation as a great scholar could hope to be appointed to one of several "houses of life," where lay and priestly scribes copied, compiled, studied, and repaired valuable sacred and scientific texts. Completed texts were placed in related institutions, some of the earliest known libraries.

Tomb Decoration

To provide the *ka* with the most pleasant possible living quarters for eternity, wealthy families often had the interior walls and ceilings of their tombs decorated with paintings and reliefs. Much of this decoration was symbolic or religious, especially in royal tombs, but it could also include a wide variety of everyday events or scenes recounting momentous events in the life of the deceased. Tombs therefore provide a wealth of information about ancient Egyptian culture.

TI AND THE HIPPOPOTAMUS HUNT. A scene in the large mastaba of a Fifth Dynasty government official named Ti—a commoner who had achieved great power at court and amassed sufficient wealth to build an elaborate home for his immortal spirit—shows him watching a hippopotamus hunt, an official duty of members of the court (FIG. 3–14). It was believed that Seth, the god of darkness, disguised himself as a hippo. Hippos were thought to be destructive: They wandered into fields, damaging crops. Tomb depictions of such hunts therefore illustrated the valor of the deceased and the triumph of good over evil.

The artists who created this painted limestone relief employed a number of established conventions. They depicted the river as if seen from above, rendering it as a band of parallel wavy lines below the boats. The creatures in the river, however—fish, a crocodile, and hippopotami—are shown in profile for easy identification. The shallow boats carrying Ti and his men skim along the surface of the water unhampered by the papyrus stalks, shown as parallel vertical lines, which choke the marshy edges of the river. At the top of the panel, where Egyptian convention placed background scenes, several animals, perhaps foxes, are seen stalking birds among the papyrus leaves and flowers. The erect figure of Ti, rendered in the traditional twisted pose, looms over all. The actual hunters, being of lesser rank and engaged in more strenuous activities, are rendered more realistically (see "Egyptian Painting and Sculpture," page 64).

3–14 | TI WATCHING A HIPPOPOTAMUS HUNT
Tomb of Ti, Saqqara. Fifth Dynasty, c. 2450–2325 BCE. Painted limestone relief, height approx. 45″ (114.3 cm).

THE MIDDLE KINGDOM, c. 1975–c. 1640 BCE

The collapse of the Old Kingdom, with its long succession of powerful kings, was followed by roughly 150 years of political turmoil traditionally referred to as the First Intermediate Period. The provinces grew in power, essentially establishing independent rule, and political and military battles dominated the period. About 2010 BCE, three successive kings named Mentuhotep (Eleventh Dynasty, c. 2010–c. 1938? BCE), gained power from Thebes, and the country was reunited under Nebhepetre Menthutop. He reasserted royal power and founded the centralized Twelfth Dynasty.

The Middle Kingdom was another high point in Egyptian history, a period with a powerful, unified government. Arts and writing flourished, and literary and artistic efforts reflect a burgeoning awareness of the political upheaval the country had undergone. During the Middle Kingdom, Egypt's kings also strengthened the military: They expanded the borders and maintained standing armies to patrol these borders, especially in lower Nubia, south of present-day Aswan. By the Thirteenth Dynasty, however, political authority once again became less centralized. A series of short-lived kings succeeded the strong rulers of the Twelfth Dynasty, and an influx of foreigners, especially in the Delta, weakened the King's control over the nation.

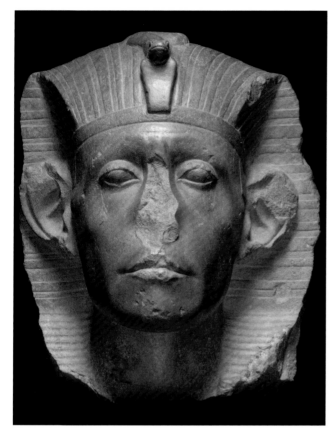

3–15 | **HEAD OF SENUSRET III**
Twelfth Dynasty, c. 1938–1755 BCE (ruled c. 1836–1818 BCE). Yellow quartzite, height 17¾ × 13½ × 17″ (45.1 × 34.3 × 43.2 cm). The Nelson-Atkins Museum of Art, Kansas City, Missouri.
Purchase: Nelson Trust (62-11)

Sculpture: Royal Portraits

Some royal portraits from the Middle Kingdom express a special awareness of the hardship and fragility of human existence. The statue of **SENUSRET III** (**FIG. 3–15**), a king of the Twelfth Dynasty, who ruled from c. 1836 to 1818 BCE, reflects this new sensibility. Senusret was a dynamic king and successful general who led four military expeditions into Nubia, overhauled the central administration at home, and did much toward regaining control over the country's increasingly independent nobles. His portrait statue seems to reflect not only his achievements, but also something of his personality and even his inner thoughts. He appears to be a man wise in the ways of the world but lonely, saddened, and burdened by the weight of his responsibilities.

Old Kingdom figures such as *Khafre* (SEE FIG. 3–9) gaze into eternity confident and serene, whereas *Senusret III* shows a monarch preoccupied and emotionally drained. Deep creases line his sagging cheeks, his eyes are sunken, his eyelids droop, and his jaw is sternly set. Intended or not, this image betrays a pessimistic view of life, a degree of distrust similar to that reflected in the advice given by Amenemhat I, Senusret

III's great-great-grandfather and the founder of the Twelfth Dynasty, to his son Senusret I (cited in Breasted, page 231):

> Fill not thy heart with a brother,
> Know not a friend,
> Nor make for thyself intimates, . . .
> When thou sleepest, guard for thyself thine own heart;
> For a man has no people [supporters],
> In the day of evil.

Tomb Architecture and Funerary Objects

During the Eleventh and Twelfth dynasties, members of the royal family and high-level officials commissioned a new form of tomb. Rock-cut tombs were excavated in the faces of cliffs, such as those in the necropolis at Beni Hasan on the east bank of the Nile. The chambers and their ornamental columns, lintels, false doors, and niches were all carved out of solid rock (**FIG. 3–16**). Each one was like a single, complex piece of sculpture that was also usually painted. A typical Beni Hasan tomb included an entrance portico, a main hall, and a shrine with a burial chamber under the offering chapel. Rock-cut tombs at other places along the Nile exhibit variations on this simple plan.

Because the afterlife was always open to danger, ancient Egyptian tombs were equipped with a variety of objects meant to meet not only practical needs—such as actual food, clothing, and furniture—but also reliefs, paintings, and other objects designed to insure the safety and well-being of the individual in perpetuity. Jewelry or amulets with protective or magical functions, figures of deities, and miniature models of buildings, servants, and soldiers all insured that the deceased would experience a life of pleasure and security.

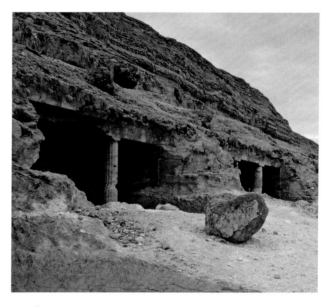

3–16 | **ROCK-CUT TOMBS, BENI HASAN**
Twelfth Dynasty, c. 1938–1755 BCE. At the left is the entrance to the tomb of a provincial governor and the commander-in-chief Amenemhat.

Technique
EGYPTIAN PAINTING AND SCULPTURE

Painting usually relies on color and line for its effect, and relief sculpture usually depends on the play of light and shadow alone, but in Egypt, relief sculpture was also painted. Nearly every inch of the walls and closely spaced columns of Egyptian tombs and temples was adorned with colorful scenes and hieroglyphic texts. Until the Eighteenth Dynasty (c.1539–1292 BCE), the only colors used were black, white, red, yellow, blue, and green. Later, colors were mixed and thinned to produce a wide variety of shades. Modeling might be indicated by overpainting lines in a contrasting color. As more colors were added, the primacy of line was never challenged.

With very few exceptions, figures, scenes, and texts were composed in bands, or registers. Usually the base line at the bottom of each register represented the ground, but determining the sequence of images can be a problem because the registers can run horizontally or vertically.

Surfaces to be painted had to be smooth, so in some cases a coat of plaster was applied. The next step was to lay out the registers with painted lines and draw the appropriate grid (SEE FIG. 3-5). In the unfinished Eighteenth Dynasty tomb of Horemheb in the Valley of the Kings, the red base lines and horizontals of the grid are clearly visible. The general shapes of the hieroglyphs have also been sketched in red. The preparatory drawings from which carvers worked were black. Egyptian artists worked in teams, and each member had a particular skill. The sculptor who executed the carving seen here was following someone else's drawing. Had there been time to finish the tomb, other hands would have smoothed the surface of this limestone relief, and still others would have made fresh drawings to guide the artists assigned to paint it.

When carving a freestanding statue, sculptors approached each face of the block as though they were simply carving a relief. A master drew the image full face on the front of the block and in profile on the side. Sculptors cut straight back from each drawing, removing the superfluous stone and literally "blocking out" the figure. Then the three-dimensional shapes were refined, surface details were added, and finally the statue was polished and details were painted.

UNFINISHED RELIEF
Tomb of Horemheb, 18th Dynasty, Valley of the Kings, west bank of the Nile, Egypt.

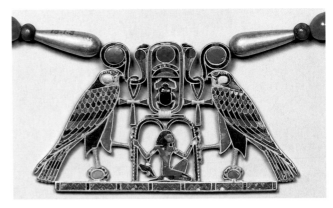

3–17 | PECTORAL OF SENUSRET II
Tomb of Princess Sithathoryunet, el-Lahun. Twelfth Dynasty, c. 1938–1755 (ruled c. 1842–1837 BCE). Gold and semiprecious stones, length 3¼" (8.2 cm).
The Metropolitan Museum of Art, New York.
Purchase, Rogers Fund and Henry Walters Gift, 1916 (16.1.3)

THE SENUSRET PECTORAL. Royal dress, especially jewelry, was very splendid, as shown by a pectoral, or chest ornament (FIG. 3-17) found in the funerary complex of Senusret II at el-Lahun, in the tomb of the king's daughter Sithathoryunet. The design, executed in gold and inlaid with semiprecious stones, incorporates the name of Senusret II and a number of familiar symbols. Two Horus falcons perch on its base, and above their heads is a pair of coiled cobras, symbols of Ra, wearing the **ankh,** the symbol of life. Between the two cobras, a **cartouche**—an oval formed by a loop of rope—contains the hieroglyphs of the king's name. The sun disk of Ra appears at the top, and a **scarab** beetle, the hieroglyph *khepri* (a symbol of Ra and rebirth), is at the bottom. Below the cartouche, a kneeling male figure helps the falcons support a double arch of notched palm ribs, a hieroglyphic symbol meaning "millions of years." Decoded, the pectoral's combination of images yields the message: "May the sun god give eternal life to Senusret II."

THE FAIENCE HIPPO. Middle Kingdom art of all kinds and in all mediums, from official portrait statues to delicate bits of jewelry, exhibits the artists' talent for well-observed, accurate detail. A hippopotamus figurine discovered in the Twelfth Dynasty tomb of a governor named Senbi, for example, has all the characteristics of the beast itself: the rotund body on stubby legs, the massive head with protruding eyes, the tiny ears and characteristic nostrils (FIG. 3-18). The figurine is an example of Egyptian **faience**, with its distinctive lustrous glaze (see "Glassmaking and Egyptian Faience," page 70).

The artist made the hippo the watery blue of its river habitat, then painted lotus blossoms on its flanks, jaws, and head, giving the impression that the creature is standing in a tangle of aquatic plants. Such figures were often placed in tombs, especially of women, since the goddess Taweret, protector of female fertility and childbirth, was a composite fig-

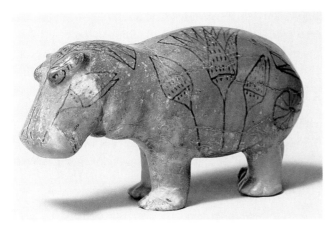

3–18 | **HIPPOPOTAMUS**
Tomb of Senbi (Tomb B.3), Meir. Twelfth Dynasty,
c. 1938-1755 BCE. Faience, length 7⅞″ (20 cm).
The Metropolitan Museum of Art, New York.
Gift of Edward S. Harkness, 1917 (17.9.1)

ure, with the head of a hippo. However, the hippo could also be a symbol of evil, especially in men's tombs (see the discussion of *Ti Watching a Hippotamus Hunt*, FIG. 3–14).

REPRESENTATIONS OF DAILY LIFE. Funeral offerings represented in statues and paintings would be available for the deceased's use through eternity. On a funeral stele of a man named Amenemhat I (FIG. 3–19), a table heaped with food is watched over by a young woman named Hapi. The family sits together on a lion-legged bench. Everyone wears green jewelry and white linen garments, produced by the women in

the household. Amenemhat (at the right) and his son Antef link arms and clasp hands while Iyi holds her son's arm and shoulder with a firm but tender gesture. The hieroglyphs identify everyone and preserve their prayers to the god Osiris.

Tomb art reveals much about domestic life in the Middle Kingdom. Wall paintings, reliefs, and small models of houses and farm buildings—complete with figurines of workers and animals—reproduce everyday scenes. Many of these models survive because they were made of inexpensive materials of no interest to early grave robbers. One from Thebes, made of

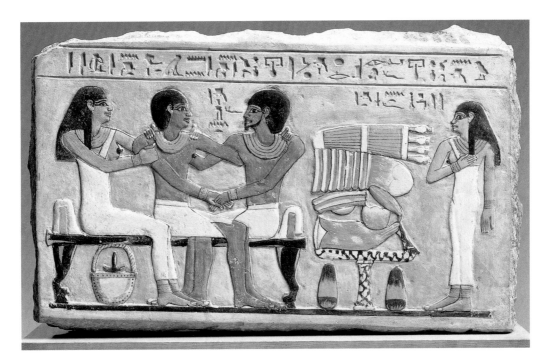

3–19 | **STELE OF AMENEMHAT I**
Assasif. Twelfth Dynasty, c. 1938-1755 (ruled c. 1938-1908 BCE). Painted limestone,
11 × 15″ (30 × 50 cm). Egyptian Museum, Cairo. The Metropolitan Museum of Art, New York.
Excavation 1915-16.

wood, plaster, and copper, from about 1975 to 1940 BCE, depicts the home of Meketre, the owner of the tomb (FIG. 3–20). Colorful columns carved to resemble bundles of papyrus support the flat roof of a portico that opens onto a garden. Trees surround a central pool such as only the wealthy could afford. The shade and water provided natural cooling and the pool was probably stocked with fish.

Town Planning

Although Egyptians used durable materials in the construction of tombs, they built their own dwellings with simple mud bricks, which have either disintegrated over time or been carried away for fertilizer by farmers. Only the foundations of these dwellings now remain.

Archaeologists have unearthed the remains of Kahun, a town built by Senusret II (SEE FIG. 3–17) for the many officials, priests, and workers in his court (FIG. 3–21). The plan offers a unique view of the Middle Kingdom's social structure. Parallel streets laid out with rectangular blocks divided into lots for

homes and other buildings reflect three distinct economic and social levels. The houses of priests, court officials, and their families were large and comfortable, with private living quarters and public rooms grouped around central courtyards. The largest had as many as seventy rooms spread out over half an acre. Workers and their families made do with small, five-room row houses built back to back along narrow streets.

A New Kingdom workers' village which was discovered at Deir el-Medina on the west bank of the Nile near the Valley of the Kings, has provided us with detailed information about the lives of the people who created the royal tombs. Workers lived together here under the rule of the king's chief minister. At the height of activity there were forty-eight teams of builders and artists. During a ten-day week, they worked for eight days and had two days off, and also participated in many religious festivals. They lived a good life with their families, were given clothing, sandals, grain, and firewood by the king, and had permission to raise livestock and birds and to tend a garden. The residents had an elected council, and the

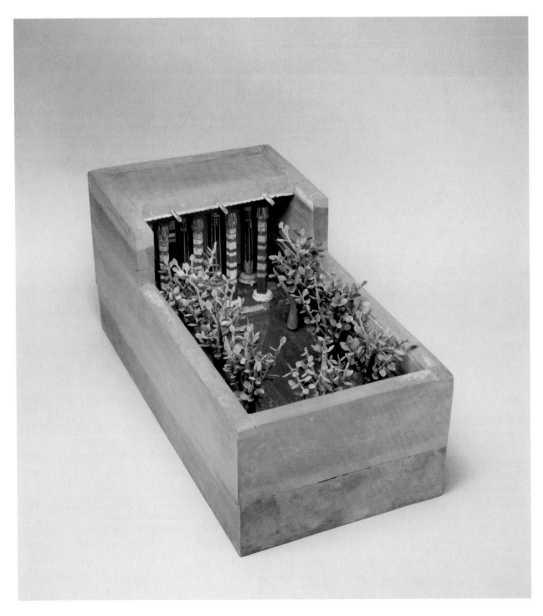

3–20 | **MODEL OF A HOUSE AND GARDEN** Tomb of Meketre, Deir el-Bahi. Eleventh Dynasty, c. 2125-2055 BCE. Painted and plastered wood and copper, length 33″ (87 cm). The Metropolitan Museum of Art, New York.

Purchase, Rogers Fund and Edward S. Harkness Gift, 1920 (20.3.13)

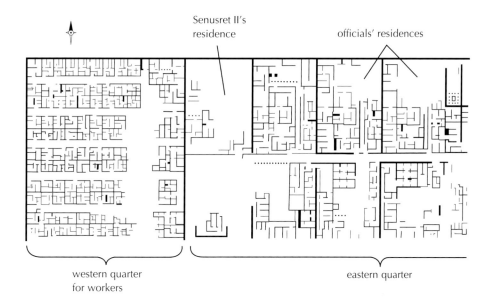

western quarter for workers

eastern quarter

Senusret II's residence

officials' residences

3–21 | **PLAN OF THE NORTHERN SECTION OF KAHUN**
Built during the reign of Senusret II near Modern el-Lahun. Dynasty 12, c. 1880–1874 BCE.

many written records that survive suggest a literate and litigious society that required many lawyers and scribes. Because the men were away for most of the week working on the tombs, women had a prominent role in the town. The remaining letters, many of which were between women, suggest the women may have been able to read and write.

THE NEW KINGDOM, c. 1539–1075 BCE

During the Second Intermediate period—another turbulent interruption in the succession of dynasties ruling a unified country—an eastern Mediterranean people called the Hyksos invaded Egypt's northernmost regions. Finally, the kings of the Eighteenth Dynasty (c. 1539–1292 BCE) regained control of the entire Nile region from Nubia in the south to the Mediterranean Sea in the north, restoring the country's political and economic strength. Roughly a century later, one of the same dynasty's most dynamic kings, Thutmose III (ruled 1479–1425 BCE), extended Egypt's influence along the eastern Mediterranean coast as far as the region of present-day Syria. His accomplishment was the result of fifteen or more military campaigns and his own skill at diplomacy.

Thutmose III was the first ruler to refer to himself as "pharaoh," a term that literally meant "great house." Egyptians used it in the same way that Americans say "the White House" to mean the current U. S. president and his staff. The successors of Thutmose III continued to use the term, and it ultimately found its way into the Hebrew Bible—and modern usage—as the name for the kings of Egypt.

By the beginning of the fourteenth century BCE, the most powerful Near Eastern kings acknowledged the rulers of Egypt as their equals. Marriages contracted between Egypt's ruling families and Near Eastern royalty helped to forge a generally cooperative network of kingdoms in the region, stimulating trade and securing mutual aid at times of natural disaster and outside threats to established borders. Over time, however, Egyptian influence beyond the Nile diminished, and the power of Egypt's kings began to wane.

The Great Temple Complexes

At the height of the New Kingdom, rulers undertook extensive building programs along the entire length of the Nile. Their palaces, forts, and administrative centers disappeared long ago, but remnants of temples and tombs of this great age have endured. Even as ruins, Egyptian architecture and sculpture attest to the expanded powers and political triumphs of the builders (FIG. 3–22). Early in this period, the priests of the god Amun at Thebes, Egypt's capital city throughout most of the New Kingdom, had gained such dominance that worship of the Theban triad of deities—Amun, his wife Mut, and their son Khons—had spread throughout the country. Temples to these and other gods were a major focus of royal patronage, as were tombs and temples erected to glorify the kings themselves.

THE NEW KINGDOM TEMPLE PLAN. As the home of the god, an Egyptian temple originally had the form of a house—a simple, rectangular, flat-roofed building preceded by a courtyard and gateway. The temples and builders of the New Kingdom enlarged and multiplied these elements. The gateway became a massive **pylon** with tapering walls; the semipublic courtyard was surrounded by columns (a **peristyle court**); the temple itself included an outer **hypostyle hall** (a vast hall filled with columns), and finally inner rooms—the offering

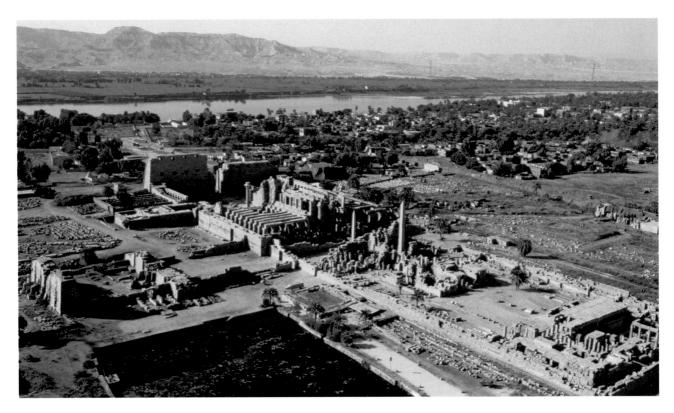

3–22 | **THE RUINS OF THE GREAT TEMPLE OF AMUN AT KARNAK, EGYPT**

hall and sanctuary. The design was symmetrical and axial—that is, all of its separate elements are symmetrically arranged along a dominant center line, creating a processional path.

The rooms became smaller, darker, and more exclusive as they neared the sanctuary. Only the pharaoh and the priests entered these inner rooms.

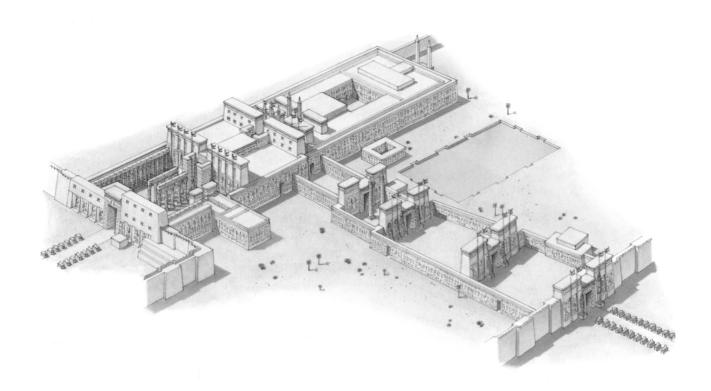

3–23 | **RECONSTRUCTION DRAWING OF THE GREAT TEMPLE OF AMUN AT KARNAK, EGYPT**
New Kingdom, c. 1579–1075 BCE.

Two temple districts consecrated primarily to the worship of Amun, Mut, and Khons arose near Thebes—a huge complex at Karnak to the north and, joined to it by an avenue of sphinxes, a more compact temple at Luxor to the south.

KARNAK. At Karnak, temples were built and rebuilt for over 1,500 years, and the remains of the New Kingdom additions to the Great Temple of Amun still dominate the landscape (FIG. 3–22). Over the nearly 500 years of the New Kingdom, successive kings renovated and expanded the Amun temple until the complex covered about 60 acres, an area as large as a dozen modern American football fields (FIG. 3–23).

Access to the heart of the temple, a sanctuary containing the statue of Amun, was from the west (on the left side of the reconstruction drawing) through a principal courtyard, a hypostyle hall, and a number of smaller halls and courts. Pylons set off each of these separate elements. Between the Eighteenth and Nineteenth dynasty reigns of Thutmose I (ruled c. 1493–? BCE), and Rameses II (ruled c. 1279–1213 BCE), this area of the complex underwent a great deal of construction and renewal. The greater part of Pylons II through VI leading to the sanctuary (modern archaeologists have given the pylons numbers) and the halls and courts behind them were renovated or newly built and embellished with colorful wall reliefs. A sacred lake to the south of the temple, where the king and priests might undergo ritual purification before entering, was also added. In the Eighteenth Dynasty, Thutmose III erected a court and festival temple to his own glory behind the sanctuary of Amun. His great-grandson Amenhotep III (ruled 1390–1353 BCE) placed a large stone statue of the god Khepri, the scarab (beetle) symbolic of the rising sun, rebirth, and everlasting life, next to the sacred lake.

In the sanctuary, the priests washed the god's statue every morning and clothed it in a new garment. Because the god was thought to derive nourishment from the spirit of food, it was provided with tempting meals twice a day, which the priests then removed and ate themselves. Ordinary people entered the temple precinct only as far as the forecourts of the hypostyle halls, where they found themselves surrounded by inscriptions and images of kings and the god on columns and walls. During religious festivals, however, they lined the waterways, along which statues of the gods were carried in ceremonial boats, and were permitted to submit petitions to the priests for requests they wished the gods to grant.

THE GREAT HALL AT KARNAK. Between Pylons II and III at Karnak stands the enormous hypostyle hall erected in the reigns of the Nineteenth Dynasty rulers Sety I (ruled c. 1290–1279 BCE) and his son Rameses II (ruled c. 1279–1213 BCE). Called the "Temple of the Spirit of Sety, Beloved of Ptah in the House of Amun," it may have been used for royal coronation ceremonies. Rameses II referred to it as "the place where the common people extol the name of

his majesty." The hall was 340 feet wide and 170 feet long. Its 134 closely spaced columns supported a stepped roof of flat stones, the center section of which rose some 30 feet higher than the rest of the roof (FIGS. 3–24, 3–25). The columns supporting this higher part of the roof are 66 feet tall and 12 feet in diameter, with massive lotus flower capitals. On each side, smaller columns with lotus bud capitals seem to march off forever into the darkness. In each of the side walls of the higher

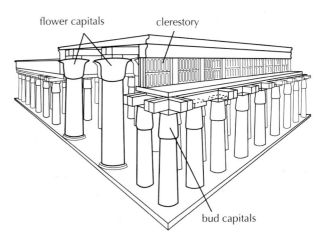

3–24 **RECONSTRUCTION DRAWING OF THE HYPOSTYLE HALL, GREAT TEMPLE OF AMUN AT KARNAK**
Nineteenth Dynasty, c. 1292–1190 BCE.

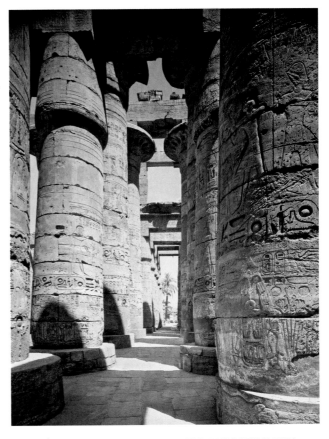

3–25 **FLOWER AND BUD COLUMNS, HYPOSTYLE HALL, GREAT TEMPLE OF AMUN AT KARNAK**

Technique

GLASSMAKING AND EGYPTIAN FAIENCE

Heating a mixture of sand, lime, and sodium carbonate or sodium sulfate to a very high temperature produces glass. The addition of other substances can make the glass transparent, translucent, or opaque and create a vast range of colors.

No one knows precisely when or where the technique of glassmaking first developed.

By the Predynastic period, Egyptians were experimenting with **faience,** a technique in which glass paste, when fired, produces a smooth and shiny opaque finish. It was used first to form small objects—mainly beads, charms, and color inlays—but later it was used as a colored glaze to ornament pottery wares and clay figurines. The first evidence of all-glass vessels and other hollow objects dates from the early New Kingdom. The first objects to be made entirely of glass in Egypt were produced with the technique known as **core glass** (see Hippopotamus, FIG. 3-18, on page 65).

A lump of sandy clay molded into the desired shape of the finished vessel was wrapped in strips of cloth, then skewered on a fireproof rod. It was then briefly dipped into a pot of molten glass. When the resulting coating of glass had cooled, the clay core was removed through the opening left by the skewer. To decorate the vessel, glassmakers frequently heated thin rods of colored glass and fused them to the surface in elegant wavy patterns, zigzags, and swirls. In the fish-shaped bottle shown here, an example of core glass from the New Kingdom, the body was created from glass tinted with cobalt, and the surface was then decorated with swags resembling fish scales using small rods of white and orange glass.

FISH-SHAPED BOTTLE
Akhetaten (present-day Tell el-Amarna). Eighteenth Dynasty, c. 1353–1336 BCE. Core glass, length 5⅛″ (13 cm). The British Museum, London.

center section, a long row of window openings created what is known as a **clerestory.** These openings were filled with stone grillwork, so they cannot have provided much light, but they did permit a cooling flow of air through the hall. Despite the dimness of the interior, artists covered nearly every inch of the columns, walls, and cross-beams with reliefs.

The Valley of the Kings and Queens

Across the Nile from Karnak and Luxor lay Deir el-Bahri and the Valleys of the Kings and Queens. These valleys on the west bank of the Nile held the royal necropolis, and it was near the Valley of the Kings that the pharaoh Hatshepsut built her funerary temple. The dynamic Hatshepsut (Eighteenth Dynasty, ruled c. 1473–1458 BCE) is a notable figure in a

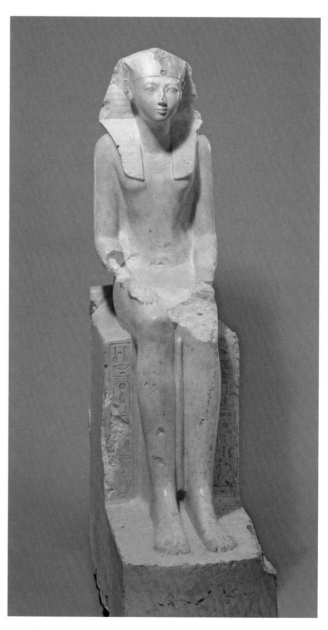

3–26 | HATSHEPSUT ENTHRONED
Deir el-Bahri. Eighteenth Dynasty
(ruled c. 1473–1458 BCE).
The Metropolitan Museum of Art, New York.

period otherwise dominated by male warrior-kings. Besides Hatshepsut, very few women ruled Egypt—they included the little-known Sobekneferu, Tausret, and much later, the notorious Cleopatra VII.

HATSHEPSUT. Of the women rulers who went down in history as "living gods" themselves and not merely "wives of gods," Hatshepsut left the greatest legacy of monuments. Among the reliefs in her funerary temple at Deir el-Bahri, she placed a depiction of her divine birth, just as a male ruler might have done. There she is portrayed as the daughter of her earthly mother, Queen Ahmose, and the god Amun.

The daughter of Thutmose I, Hatshepsut married her half brother, who then reigned for fourteen years as Thutmose II. When he died, she became regent for his underage son—Thutmose III—born to one of his concubines. Hatshepsut had herself declared "king" by the priests of Amun, a maneuver that prevented Thutmose III from assuming the

throne for twenty years. In art, she was represented in all the ways a male ruler would have been, even as a human-headed sphinx, and she was called "His Majesty." Portraits often show her in the full royal trappings; in FIG. 3–26 she wears a kilt, linen headdress, and has a bull's tail hanging from her waist (visible between her legs). In some portraits Hatshepsut even wears the false beard of a king.

HATSHEPSUT'S TEMPLE AT DEIR EL-BAHRI. The most innovative undertaking in Hatshepsut's ambitious building program was her own funerary temple at Deir el-Bahri (FIG. 3–27). The structure was not intended to be her tomb; Hatshepsut was to be buried, like other New Kingdom rulers, in the Valley of the Kings, about half a mile to the northwest. Her funerary temple was magnificently positioned against high cliffs and oriented toward the Great Temple of Amun at Karnak, some miles away on the east bank of the Nile. The complex follows an axial plan (FIG. 3–28).

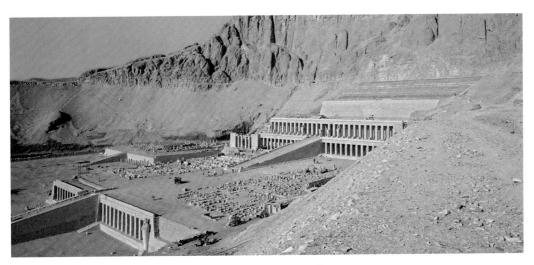

3–27 | **FUNERARY TEMPLE OF HATSHEPSUT, DEIR EL-BAHRI**
Eighteenth Dynasty, c. 1473–1458 BCE. (At the far left, ramp and base of the funerary temple of Mentuhotep III. Eleventh Dynasty, c. 2009–1997 BCE.)

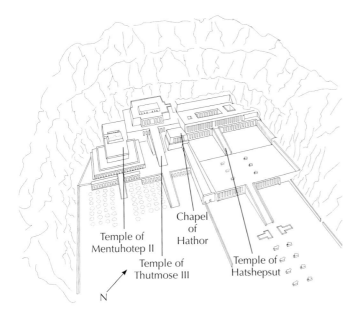

Temple of Mentuhotep II

Chapel of Hathor

Temple of Thutmose III

Temple of Hatshepsut

N

3–28 | **PLAN OF THE FUNERARY TEMPLE OF HATSHEPSUT**
Deir el-Bahri

A raised causeway lined with sphinxes once ran from a valley temple on the Nile to the huge open space of the first court. From there, visitors ascended a long, straight ramp flanked by pools of water to a second court where shrines to Anubis and Hathor occupy the ends of the columned porticos. Relief scenes and inscriptions in the south portico depict Hatshepsut's expedition to the exotic, half-legendary kingdom of Punt (probably located on the Red Sea or the Gulf of Aden), from which rare myrrh trees were obtained for the temple's garden terraces. On the temple's uppermost court, colossal royal statues fronted another colonnade, and behind this lay a large hypostyle hall with chapels dedicated to Hatshepsut, her father, and the gods Amun and Ra-Horakhty—a powerful form of the sun god Ra combined with Horus. Centered in the hall's back wall was the entrance to the innermost sanctuary, a small chamber cut deep into the cliff.

Hatshepsut's funerary temple, with its lively alternating of open garden spaces and grandiose architectural forms, projects an imposing image of authority. Its remarkable union of nature and architecture, with many different levels and contrasting textures—water, stone columns, trees, and cliffs—made it even more impressive in antiquity.

Akhenaten and the Art of the Amarna Period

The most unusual ruler in the history of ancient Egypt was Amenhotep IV, a king of the Eighteenth Dynasty who came to the throne about 1353 BCE. In his 17-year reign (c. 1353–1336 BCE), he radically transformed the political, spiritual, and cultural life of the country. He founded a new religion honoring a single supreme god, the life-giving sun deity Aten (represented by a disk), and changed his own name about 1348 BCE to Akhenaten ("One Who Is Effective on Behalf of Aten"). Abandoning Thebes, the capital of Egypt since the beginning of his dynasty and a city firmly in the grip of the priests of Amun, Akhenaten built a new capital much farther north, calling it Akhetaten ("Horizon of the Aten"). Using the modern name for this site, Tell el-Amarna, historians refer to his reign as the Amarna period.

PORTRAITS OF AKHENATEN. A colossal statue of Akhenaten about 16 feet tall was placed in front of pillars in the new temple to Aten that he built at Karnak when he openly challenged the state gods (FIG. 3–29). He built a huge courtyard (c. 426 by 394 feet) surrounded by porticos, oriented to the movement of the sun. It was here he placed his portraits. The sculpture's strange, softly swelling forms suggest an almost boneless, androgynous figure with long, thin arms and legs, a protruding stomach, swelling thighs, and a thin neck supporting an elongated skull. All the facial features are elongated to the point of distortion. Eyes are slits and slightly down-turned, while the nearly smiling and very full lips add to our discomfort. He holds the traditional royal insignia, the flail

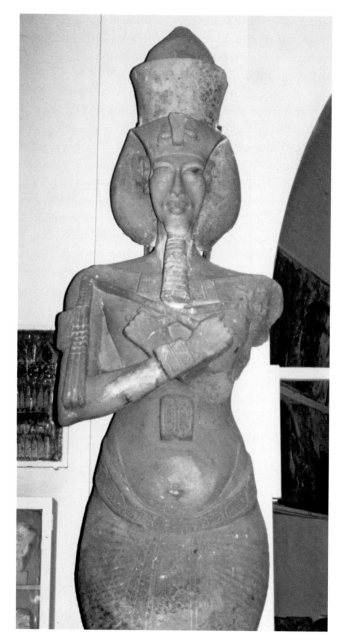

3–29 | **AKHENATEN, COLOSSAL FIGURE**

(symbolizing protection) and the shepherd's crook (the scepter of absolute sovereignty).

THE NEW AMARNA STYLE. The king saw himself as Aten's son, and at his new capital he presided over the worship of Aten as a divine priest. His principal queen, Nefertiti, served as the divine priestess. Temples to Aten were open courtyards, where altars could be bathed in the direct rays of the sun. In art, Aten is depicted as a sun disk sending down long thin rays ending in human hands, some of which hold the *ankh*.

Akhenaten emphasized the philosophical principle of *maat*, or divine truth, and one of his kingly titles was "Living in Maat." Such concern for truth found expression in new artistic conventions. In portraits of the king, artists emphasized his unusual physical characteristics. Unlike his predecessors, and in keeping with his penchant for candor, Akhenaten commanded his artists to portray the royal family in informal situations. Even private houses in the capital city were adorned with reliefs of the king and his family, an indication that he managed to substitute veneration of the royal household for the traditional worship of families of gods, such as Amun, Mut, and Khons.

A painted relief of Akhenaten, Queen Nefertiti, and three of their daughters exemplifies the new openness and a new figural style (**FIG. 3–30**). In this **sunken relief**—where the outlines of the figures have been carved into the surface of the stone, instead of being formed by cutting away the background—the king and queen sit on cushioned thrones playing with their children. The base of the queen's throne is adorned with the stylized plant symbol of a unified Egypt (see the throne of Khafre, FIG. 3–9), which has led some historians to conclude that Nefertiti acted as co-ruler with her husband. The royal couple is receiving the blessings of Aten, whose rays end in hands that penetrate the open pavilion and hold *ankhs* to their nostrils, giving them the "breath of life." Other ray-hands caress the hieroglyphic inscriptions in the center.

The king holds one child and lovingly pats her head. The youngest of the three perches on Nefertiti's shoulder and tries to attract her attention by stroking her cheek. The oldest sits on the queen's lap, tugging at her mother's hand and pointing to her father. The children are nude, and the younger two have shaved heads, a custom of the time. The oldest wears the side-lock of youth, a patch of hair left to grow and hang at one side of the head in a braid. The artist has conveyed the engaging behavior of the children and the loving concern of their parents in a way not even hinted at in earlier royal portraiture in Egypt (compare FIG. 3–30 with Pepy II, FIG. 3–12.)

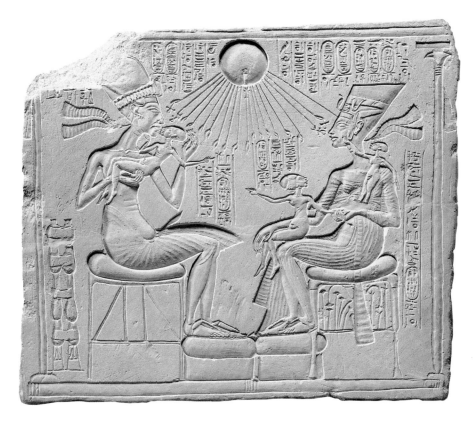

3–30 | **AKHENATEN AND HIS FAMILY**
Akhetaten (present-day Tell el-Amarna). Eighteenth Dynasty, c. 1353–1336 BCE. Painted limestone relief, 12¼ × 15¼" (31.1 × 38.7 cm). Staatliche Museen zu Berlin, Preussischer Kulturbesitz, Ägyptisches Museum.

THE PORTRAIT OF TIY. Akhenaten's goals were actively supported not only by Nefertiti but also by his mother, Queen Tiy (FIG. 3–31). She had been the chief wife of the king's father, Amenhotep III (Eighteenth Dynasty, ruled c. 1390–1353 BCE), and had played a significant role in affairs of state during his reign. Queen Tiy's personality emerges from a miniature portrait head that reveals the exquisite bone structure of her dark-skinned face, with its arched brows, uptilted eyes, and slightly pouting lips.

This portrait of Tiy has existed in two versions. In the original, which may been made for the cult of her dead husband, the queen was identified with the funerary goddesses Isis and Nephthys, the sisters of Osiris. She wore a silver headdress covered with gold cobras and gold jewelry. Later, when her son had come to power and established his new religion, the portrait was altered. A brown cap covered with blue glass beads was placed over the funeral headdress. (Blue was the color of Horus, but for Tiy perhaps it was simply royal and a symbol of the sunlit sky.) A plumed crown, perhaps similar to the one worn by Nefertari (SEE FIG. 3–34), rose above the cap (the attachment is still visible). The entire sculpture would have been about one-third lifesize.

THE HEAD OF NEFERTITI. Tiy's commanding portrait contrasts sharply with a head of Nefertiti. The proportions of Nefertiti's refined, regular features, long neck, and heavy-lidded eyes appear almost too ideal to be human (FIG. 3–32). Part of the beauty of this head is the result of the artist's dra-

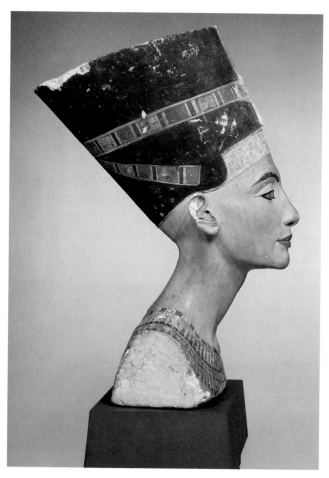

3–32 | **NEFERTITI**
Akhetaten (modern Tell el-Amarna). Eighteenth Dynasty, c. 1353–1336 BCE. Painted limestone, height 20″ (51 cm). Staatliche Museen zu Berlin, Preussischer Kulturbesitz, Ägyptisches Museum.

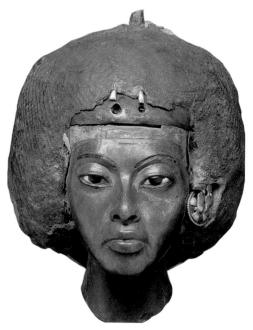

3–31 | **QUEEN TIY**
Kom Medinet el-Ghurab (near el-Lahun). Eighteenth Dynasty, c. 1352 BCE. Boxwood, ebony, glass, silver, gold, lapis lazuli, cloth, clay, and wax; height 3 ¾″ (9.4 cm). Staatliche Museen zu Berlin, Preussischer Kulturbesitz, Ägyptisches Museum.

matic use of color. The hues of the blue headdress and its colorful band are repeated in the rich red, blue, green, and gold of the jewelry. The queen's brows, eyelids, cheeks, and lips are heightened with color, as they no doubt were heightened with cosmetics in real life. Whether or not Nefertiti's beauty is exaggerated, phrases used by her subjects when referring to her—"Beautiful of Face," "Mistress of Happiness," "Great of Love," or "Endowed with Favors"—tend to support the artist's vision. This famous head was discovered in the studio of the sculptor Thutmose in Akhetaten, the capital city. Because bust portraits were rare in New Kingdom art, scholars believe Thutmose may have made this one as a model for sculptures or paintings of the queen.

AMARNA CRAFTS. The crafts also flourished in the Amarna period. Glassmaking, for example, could only be practiced by artists working for the king, and Akhenaten's new capital had its own glassmaking workshops (see "Glassmaking and Egyptian Faience," page 70). A bottle produced there and

meant to hold scented oil was fashioned in the shape of a fish that has been identified as a bolti, a species that carries its eggs in its mouth and spits out its offspring when they hatch. The bolti was a common symbol for birth and regeneration, complementing the self-generation that Akhenaten attributed to the sun disk Aten.

The Return to Tradition: Tutankhamun and Rameses II

Akhenaten's new religion and revolutionary ideas regarding the conduct and the art appropriate for royalty outlived him by only a few years. His successors had brief and troubled reigns, and the priesthood of Amun quickly regained its former power. His son Tutankhaten (Eighteenth Dynasty, ruled c. 1332–1322 BCE) returned to traditional religious beliefs, changing his name to Tutankhamun. He also turned his back on Akhenaten's new city and moved his court back to Thebes.

TUTANKHAMUN. The sealed inner chamber of Tutankhamun's tomb in the Valley of the Kings was never plundered, and when it was found in 1922 its incredible riches were just as they had been left since his interment. His body lay inside three nested coffins that identified him with Osiris, the god of the dead. The innermost coffin, in the shape of a mummy, is the richest of the three, for it is made of over 240 pounds (110.4 kg) of gold (FIG. 3–33). Its surface is decorated with colored glass and semiprecious gemstones, as well as finely incised linear designs and hieroglyphic inscriptions. The king holds a crook and a flail, symbols that were associated with Osiris and had become a traditional part of the royal regalia. A *nemes* headcloth with cobra and vulture on his forehead covers his head. A blue braided beard is attached to his chin. His necklace indicates military valor. Nekhbet and Wadjyt, vulture and cobra gods of Upper and Lower Egypt, spread their wings across his body. The king's features as reproduced on the coffin and masks are those of a very young man (FIG. 3–1). Even though they may

not reflect Tutankhamun's actual appearance, the unusually full lips and thin-bridged nose suggest the continued influence of the Amarna style and its realistic portraiture.

RAMESES II AND ABU SIMBEL. By Egyptian standards Tutankhamun was a rather minor king. Rameses II, on the other hand, was both powerful and long-lived. Under Rameses II (Nineteenth Dynasty, ruled c. 1279–1213 BCE), Egypt became a mighty empire. Rameses was a bold military commander and an effective political strategist. He also triumphed diplomatically by securing a peace agreement with the Hittites, a rival power centered in Anatolia (Chapter 2) that had tried to expand to the west and south at Egypt's expense. Rameses twice reaffirmed that agreement later in his reign by marrying Hittite princesses.

In the course of a long and prosperous reign, Rameses II initiated building projects on a scale rivaling the Old Kingdom Pyramids at Giza. Today, the most awe-inspiring of his many architectural monuments are found at Karnak and Luxor and at Abu Simbel in Egypt's southernmost region (see "The Temples of Rameses II at Abu Simbel," pages 76–77). At Abu Simbel, Rameses ordered two large temples to be carved in the living rock.

The temples at Abu Simbel were not funerary monuments. Rameses' and his queen Nefertari's tombs are in the Valleys of the Kings and Queens near Deir el-Bahri. The walls of Nefertari's tomb are covered with some of the most beautiful paintings discovered so far. In one of the many wall paintings, Nefertari offers jars of perfumed ointment to the goddess Isis (FIG. 3–34). The queen wears the vulture-skin headdress indicating her position, a royal collar, and a long, semitransparent white linen gown. Isis, seated on her throne behind a table heaped with offerings, holds a long scepter in her left hand, the *ankh* in her right. She wears a headdress surmounted by the horns of Hathor framing a sun disk, clear indications of her divinity.

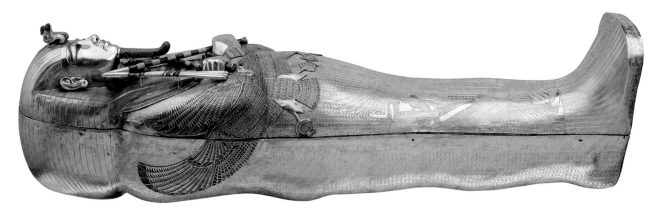

3–33 | INNER COFFIN OF TUTANKHAMUN'S SARCOPHAGUS
Tomb of Tutankhamun, Valley of the Kings, near Deir el-Bahri. Eighteenth Dynasty, 1332–1322 BCE.
Gold inlaid with glass and semiprecious stones, height 6'⅞" (1.85 m), weight nearly 243 pounds (110.4 kg).
Egyptian Museum, Cairo.

THE TEMPLES OF RAMESES II AT ABU SIMBEL

Many art objects speak to us subtly, through their beauty or mystery. Monuments such as Rameses II's temples at Abu Simbel, his colossal statues, and his association with the gods also speak across the ages about the religious and political power of this ruler: the king-god of Egypt, the conqueror of the Hittites, the ruler of a vast empire, a virile man with nearly a hundred children. As an inscription he had carved into an obelisk now standing in the heart of Paris says: "Son of Ra: Rameses-Meryamun ['Beloved of Amun']. As long as the skies exist, your monuments shall exist, your name shall exist, firm as the skies."

Rameses built numerous monuments in Egypt, but his choice of Abu Simbel for his temples proclaims his military and diplomatic success: Abu Simbel is north of the second cataract of the Nile, in Nubia, the ancient land of Kush, which Rameses ruled and which was the source of his gold, ivory, and exotic animal skins. He asserted his divinity in two temples he had carved out of the sacred hills there. The larger temple, carved out of the mountain called Meha, is dedicated to Rameses and the Egyptian gods Amun, Ra, and Ptah. The dominant feature of Rameses' temple is a row of four colossal seated statues of the king himself. At its entrance, four awe-inspiring 65-foot statues of Rameses are flanked by relatively small statues of family members, including his principal wife Nefertari, who reaches as high as his leg,

which she affectionately caresses. Inside the temple, eight 33-foot statues of the god Osiris with the face of the god-king Rameses further proclaim his divinity. The corridor they form leads to the seated figures of Ptah, Amun, Rameses II, and Ra. The corridor was oriented in such a way that twice a year the first rays of the rising sun shot through its entire depth to illuminate statues of the king and the four gods placed against the back wall.

About 500 feet away, Rameses ordered a smaller temple to be carved into the mountain called Ibshek, sacred to Hathor, goddess of fertility, love, joy, and music, and to be dedicated to Hathor and to Nefertari. Six statues, 33 feet tall, include two of the queen wearing the headdress

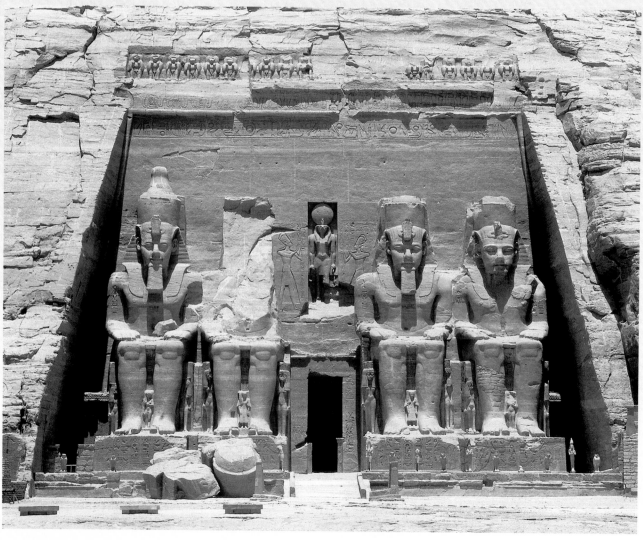

TEMPLE OF RAMESES II
Abu Simbel. Nineteenth Dynasty, c. 1279–1213 BCE.

of Hathor and four of her husband Rameses II. The two temples, together honoring the official gods of Egypt and his dynasty, were oriented so that their axes crossed in the middle of the Nile, suggesting that they may have been associated with the annual life-giving flood.

Ironically, flooding nearly destroyed Rameses' temples at Abu Simbel. Half-buried in the sand over the ages, they were discovered and opened early in the nineteenth century. But in the 1960s, construction of the Aswan High Dam flooded the Abu Simbel site. Only an international effort and modern technology saved the complex. It was relocated high above the flood levels so that it could continue to speak to us.

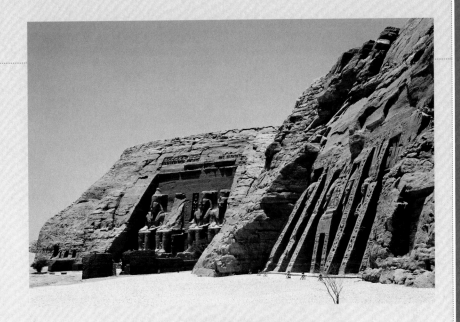

TEMPLES OF RAMESES II (left) and **NEFERTARI** (right) at Abu Simbel. Nineteenth Dynasty, 1279–1213 BCE. (TOP)

DETAIL OF NEFERTARI AND RAMSES'S LEG from Temple of Ramses II. (MIDDLE)

TEMPLE OF RAMESES II, INTERIOR Abu Simbel. Nineteenth Dynasty, c. 1279–1213 BCE. (BOTTOM)

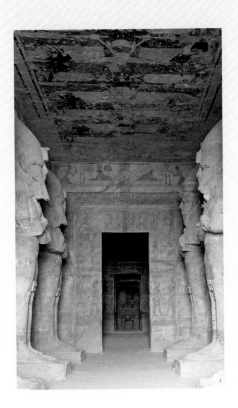

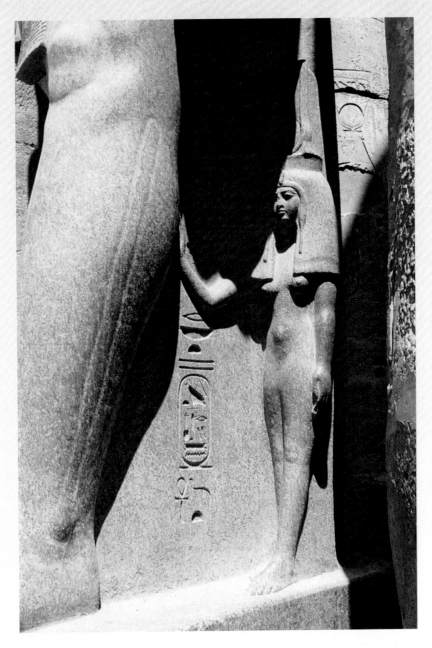

Art and Its Context
HIEROGLYPHIC, HIERATIC, AND DEMOTIC WRITING

Ancient Egyptians developed four types of writing that are known today by the names the Greeks gave them. The earliest system employed a large number of symbols called **hieroglyphs** (from the Greek *hieros,* "sacred," and *glyphein,* "to carve"). As their name suggests, the Greeks believed they had religious significance. Some of these symbols were simple pictures of creatures or objects, or *pictographs,* similar to those used by the Sumerians (Chapter 2). Others were *phonograms,* or signs representing spoken sounds.

The earliest scribes must also have used this system of signs for record keeping, correspondence, and manuscripts of all sorts. In time, however, they developed simplified hieroglyphs that could be written more quickly in lines of script on papyrus scrolls. This type of writing is called **hieratic,** again derived from the Greek word *hieros,* meaning "sacred." Even after this script was perfected, inscriptions in reliefs or paintings and on ceremonial objects continued to be written in hieroglyph.

The third type of writing came into use only in the eighth century BCE, as written communication ceased to be restricted to priests and scribes. It was a simplified, cursive form of hieratic writing that was less formal and easier to master; the Greeks referred to it as **demotic** writing (from *demos,* "the people"). From this time on, all three systems were in use, each for its own specific purpose: religious documents were written in hieratic, inscriptions on monuments in hieroglyph, and all other texts in demotic script. Once the Greeks began to rule over Egypt, the Egyptians adapted their language to be written with Greek characters in a script known as *Coptic.*

After centuries of foreign rule, beginning with the arrival of the Greeks in 332 BCE, the ancient Egyptian language gradually died out. Modern scholars therefore had to decipher four types

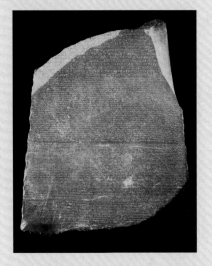

ROSETTA STONE
With its three tiers of writing, from top to bottom: hieroglyphic, demotic, and Greek. 196 BCE. The British Museum, London.

of writing in a long-forgotten language. The key was a fragment of a stone stele, dated 196 BCE, which was called the Rosetta Stone (for the area of the Delta where one of Napoleon's officers discovered it in 1799). On it, a decree issued by the priests at Memphis honoring Ptolemy V (ruled c. 205–180 BCE) had been carved in hieroglyphs, demotic, and Greek.

Even with the Greek translation, the two Egyptian texts were incomprehensible until 1818, when Thomas Young, an English physician interested in ancient Egypt, linked some of the hieroglyphs to specific names in the Greek version. A short time later, French scholar Jean-François Champollion located the names Ptolemy and Cleopatra in both of the Egyptian scripts. With the phonetic symbols for P, T, O, and L in demotic, he was able to build up an "alphabet" of hieroglyphs, and by 1822 he had deciphered the two Egyptian texts.

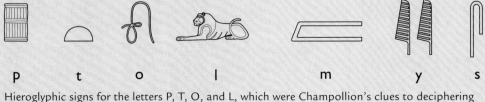

Hieroglyphic signs for the letters P, T, O, and L, which were Champollion's clues to deciphering the Rosetta Stone, plus M, Y, and S: Ptolmys.

The artists responsible for decorating the tomb worked in a new style diverging very subtly but distinctively from earlier conventions. The outline drawing and use of clear colors reflect traditional practices, but quite new is the slight modeling of the body forms by small changes of hue to increase their appearance of three-dimensionality. The skin color of these women is much darker than that conventionally used for females in earlier periods, and lightly brushed-in shading emphasizes their eyes and lips. The tomb's artists used particular care in placing the hieroglyphic inscriptions in order to create a harmonious overall design.

Noble families also had richly painted tombs. Their paintings give us an insight into daily life, much like the models found in earlier tombs (SEE FIG. 3–20).

The Books of the Dead

By the time of the New Kingdom, the Egyptians had come to believe that only a person free from wrongdoing could enjoy an afterlife. The dead were thought to undergo a last judgment consisting of two tests presided over by Osiris, the god of the underworld, and supervised by the jackal-headed god of embalming and cemeteries, Anubis. After the deceased were questioned about their behavior in life, their hearts—

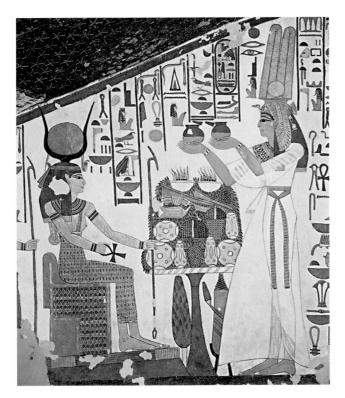

dead survive the tests. Early collectors of Egyptian artifacts referred to such scrolls, often beautifully illustrated, as "Books of the Dead." The books varied considerably in content. A scene created for a man named Hunefer (Nineteenth Dynasty) shows three successive stages in his induction into the afterlife (FIG. 3–35). At the left, Anubis leads him by the hand to the spot where he will weigh his heart, contained in a tiny jar, against the "feather of Truth." Maat herself appears atop the balancing arm of the scales wearing the feather as a headdress. To the right of the scales, Ammit, the dreaded "Eater of the Dead"—part crocodile, part lion, and part hippopotamus—watches eagerly for a sign from the ibis-headed god Thoth, who prepares to record the result of the weighing

But the "Eater" goes hungry. Hunefer passes the test, and Horus, on the right, presents him to the enthroned Osiris, who floats on a lake of natron (see "Preserving the Dead," page 55). Behind the throne, the goddesses Nephthys and Isis support the god's left arm with a tender gesture, while in front of him his four sons, each entrusted with the care of one of the deceased's vital organs, stand atop a huge lotus blossom rising up out of the lake. In the top register, Hunefer, finally accepted into the afterlife, kneels before the nine gods of Heliopolis—the sacred city of the sun god Ra—and the five personifications of life-sustaining principles.

3–34 QUEEN NEFERTARI MAKING AN OFFERING TO ISIS
Wall painting in the tomb of Nefertari, Valley of the Queens, near Deir el-Bahri. Nineteenth Dynasty, 1290–1224 BCE.

which the Egyptians believed to be the seat of the soul— were weighed on a scale against an ostrich feather, the symbol of Maat, goddess of truth, order, and justice.

Family members commissioned papyrus scrolls containing magical texts or spells, which the embalmers placed among the wrappings of the mummified bodies to help the

LATE EGYPTIAN ART, c. 715–332 BCE

The Late Period in Egypt saw the country and its art in the hands and service of foreigners. Nubians, Persians, Macedonians, Greeks, and Romans were all attracted to Egypt's riches and seduced by its art. The Nubians conquered Egypt and

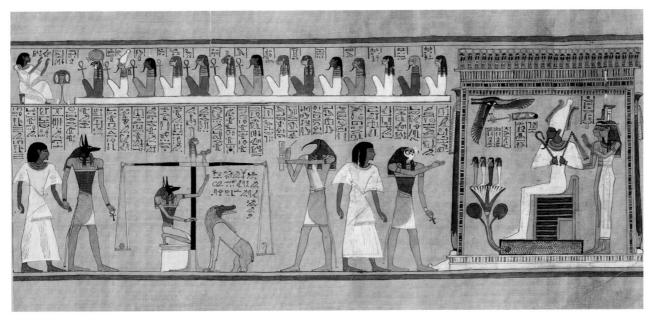

3–35 JUDGMENT OF HUNEFER BEFORE OSIRIS
Illustration from a Book of the Dead. Nineteenth Dynasty, c. 1285 BCE.
Painted papyrus, height 15⅝" (39.8 cm). The British Museum, London.

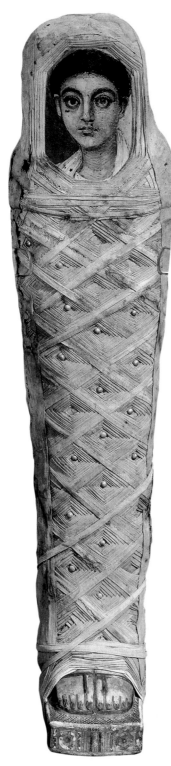

3–36 | **MUMMY WRAPPING OF A YOUNG BOY**
Hawara. Roman period, c. 100–120 CE. Linen wrappings with gilded stucco buttons and inserted portrait in encaustic on wood, height of mummy 53⅜" (133 cm); portrait 9½ × 6½" (24 × 16.5 cm). The British Museum, London.

re-established capitals at Memphis and Thebes (712–657 BCE). They continued the traditional religious practices and architectural forms, including pyramids.

In 332 BCE the Macedonian Greeks led by Alexander the Great conquered Egypt, and after Alexander's death in 323 BCE, his generals divided up the empire. Ptolemy, a Greek, took Egypt, declaring himself king in 305. The Ptolemaic dynasty ended with the death of Cleopatra VII (ruled 51–30 BCE), when the Romans succeeded as Egypt's rulers and made it the breadbasket of Europe.

Not surprisingly, painting from this period reflects the conventions of Greek and Roman, not Egyptian, art. The most representative examples of this very late Egyptian art are the so-called Fayum portraits. The tradition of mummifying the dead continued well into Egypt's Roman period. Hundreds of mummies and mummy portraits from that time have been found in the Fayum region of Lower Egypt. The mummy becomes a "soft sculpture" with a Roman-style portrait (FIG. 3–36) painted on a wood panel in **encaustic** (hot colored wax), inserted over the face in the tradition of the gold mask of Tutankhamun. Although great staring eyes invariably dominate the images, the artists recorded individual features of the deceased. The Fayum portraits link Egyptian art with ancient Roman art (see Chapter 6).

IN PERSPECTIVE

Like the Mesopotamians, the Egyptians brought the prehistoric period to an end when they created hieroglyphic writing (the use of pictures of objects and other signs to represent spoken sounds). They too developed a rich tradition of written history and literature known to us today, thanks to the many surviving texts carved in stone, written on papyrus, and painted on walls.

Egyptian culture included elaborate funerary practices. Rulers devoted huge sums to the design, construction, and decoration of extensive funerary complexes, including the famous pyramids and subterranean tombs. The recovery of this art through the diligent work of archaeologists continues to enlighten and fascinate us.

All cultures have rules for representing both things and ideas, but Egyptian conventions are among the most distinctive in art history. All objects and individual elements are represented from their most characteristic viewpoint, so profile heads are seen on frontal shoulders and stare out at the viewer with eyes drawn in frontal view. Egyptian art is simplified, even geometric, in appearance and often abstract in style.

Egyptian art and history is divided into three principal periods known as the Old, Middle, and New kingdoms. The Old Kingdom was a heroic age of funerary art and architecture whose most famous works—the pyramids and the Great Sphinx—encompass the essence of Egypt to most people. The Middle Kingdom was a slightly decentralized reinstatement of the monarchy with an increase in sensitive and more personal art. In the New Kingdom, rulers devoted extraordinary resources to building temples and expanding the Egyptian empire. During the Eighteenth Dynasty, Akhenaten attempted to change the course of history, religion, and art by introducing a monotheistic religion centered on Aten, the sun. The discovery of the tomb of his successor Tutankhamun ignited an enthusiasm for Egyptian art lasting to this day.

PALETTE OF NARMER
c. 2950–2775 BCE

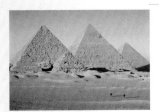

GREAT PYRAMIDS
c. 2575–2450 BCE

STELE OF AMENEMHAT I
c. 1938–1755 BCE

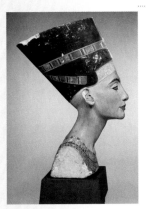

NEFERTITI
c. 1353–1336 BCE

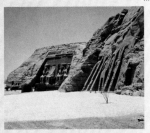

TEMPLE OF RAMESES II
c. 1279–1213 BCE

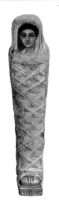

**MUMMY WRAPPING
OF A YOUNG BOY**
c. 100–120 CE

5500 BCE

3000

2500

2000

1500

1000

500

I CE

500

ART OF ANCIENT EGYPT

◀ **Predynastic (Neolithic)**
c. 5000–2950 BCE

◀ **Early Dynastic** c. 2950–2575 BCE

◀ **Old Kingdom** c. 2575–2150 BCE

◀ **First Intermediate** c. 2125–1975 BCE

◀ **Middle Kingdom** c. 1975–1640 BCE

◀ **Second Intermediate** c. 1630–1520 BCE

◀ **New Kingdom** c. 1539–1075 BCE

◀ **Amarna** c. 1353–1336 BCE

◀ **Third Intermediate** c. 1075–715 BCE

◀ **Late Period** c. 715–332 BCE
◀ **Nubian** c. 712–657 BCE

◀ **Ptolemaic** c. 323–30 BCE

◀ **Roman** c. 30 BCE–395 CE

81

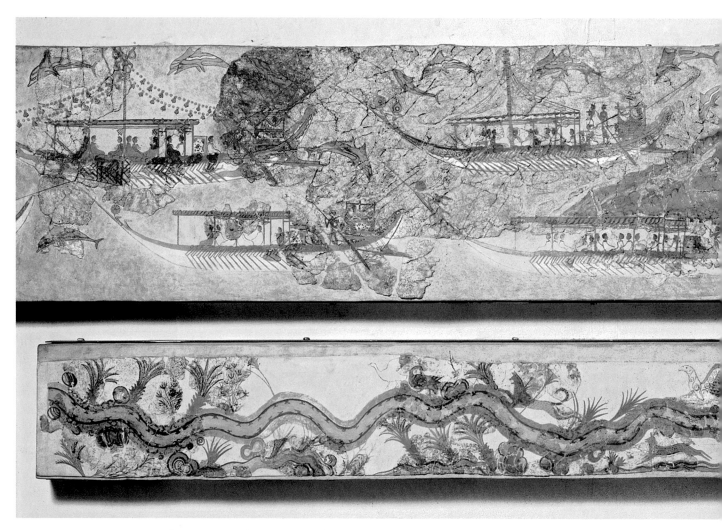

4–1 | **"FLOTILLA" FRESCO** from Room 5 of West House, Akrotiri, Thera. New Palace Period, c. 1650 BCE. National Archaeological Museum, Athens.

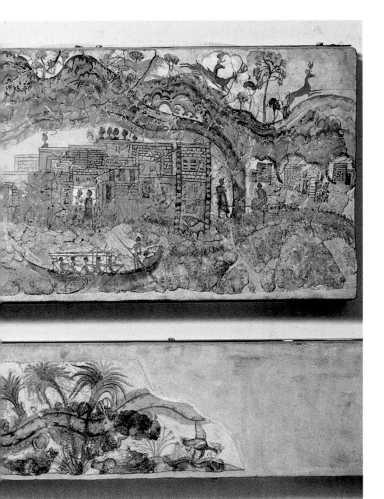

AEGEAN ART

Glorious pink, blue, and gold mountains flicker in the brilliant sunlight. Graceful boats glide on calm seas past islands and leaping dolphins. Picturesque villages line the shore, with people lounging on terraces and rooftops. These words describe the very old painting you see here (FIG. 4–1): the port of Akrotiri on the island of Thera, one of the Cycladic Islands in the southern Aegean Sea. Today, Thera is a romantic and popular tourist destination called Santorini. Akrotiri and the paradise depicted in this painting ended suddenly more than 3,500 years ago, when the volcano that formed the island erupted and blew the top of the mountain off, spewing pumice that filled and sealed every crevice of Akrotiri—fortunately, after the residents had fled.

The discovery of the lost town of Akrotiri in 1967 was among the most significant archaeological events of the second half of the twentieth century, and excavation of the city is still under way. We have much to learn about the cultures that took root on the Cycladic Islands and elsewhere in the Aegean. Every clue helps, especially because only one of the three written languages used there has been decoded. For now, we depend mainly on works of art and architecture like this painting for our knowledge of life in the ancient Aegean world.

Before 3000 BCE until about 1100 BCE, three early European cultures flourished simultaneously in the Aegean region: on a cluster of small islands called the Cyclades, on Crete and

other islands in the eastern Mediterranean, and on the mainland (MAP 4–1). To learn about them, scholars of these cultures have studied shipwrecks, homes and grave sites, and the ruins of architectural complexes. In recent years, archaeologists and art historians have collaborated with researchers in such areas of study as the history of trade and the history of climate change to provide an ever-clearer picture of Aegean society at that time.

THE BRONZE AGE IN THE AEGEAN

One of the hallmarks of Aegean society during this period was the use of bronze. Bronze, an alloy of copper and tin superior to pure copper for making weapons and tools, gave its name to the period known as the Aegean Bronze Age. (See Chapter 1 for the Bronze Age in Northern Europe.) Using metal ores imported from Europe, Arabia, and Anatolia, Aegean peoples created exquisite objects of bronze that became prized for export.

For the Aegean peoples, the sea provided an important link not only between the mainland and the islands, but also to the world beyond. In contrast to the landlocked civilizations of the Near East, and to the Egyptians, who used river transportation, the peoples of the Aegean were seafarers. So shipwrecks offer vast amounts of information about the material culture of these ancient societies. For example, the wreck of a trading vessel thought to have sunk between 1400 and 1350 BCE and discovered in the vicinity of Ulu Burun, off the southern coast of modern Turkey, carried an extremely varied cargo: metals, bronze weapons and tools, aromatic resins, fruits and spices, jewelry and beads, African ebony, ivory tusks, ostrich eggs, raw blocks of blue glass used for faience, and ceramics from the Near East, mainland Greece, and Cyprus. Among the many gold objects was a *scarab* associated with Nefertiti, wife of the Egyptian ruler Akhenaten (see Chapter 3). The cargo suggests this vessel cruised from port to port, loading and unloading goods as it went. It also suggests that Egypt and the people of the ancient Near East were especially important trading partners.

The great epics of Homer, the *Iliad* and the *Odyssey*, were both centered on sea voyages, and the places and characters they described roused the interests of two groundbreaking archaeologists of the nineteenth and early twentieth centuries: Heinrich Schliemann located and excavated Homeric Troy in modern western Turkey; Sir Arthur Evans unearthed one of the great palaces on Crete, and named the civilization Minoan after the mythical king Minos. What archaeologists have since found both substantiates and contradicts Homer.

Probably the thorniest problem in Aegean archaeology is that of dating the finds. Archaeologists have developed a relative dating system for the Aegean Bronze Age, but assigning absolute dates to specific sites and objects continues to be difficult and controversial. One cataclysmic event has helped: A huge volcanic explosion on the Cycladic island of Thera thoroughly devastated Minoan civilization there and on Crete, only 70 miles to the south. Evidence from tree rings from Ireland and California and traces of volcanic ash in ice cores from Greenland put the date of the eruption about 1650–1625 BCE. Outside Thera, archaeologists rely on relative dating, based largely on pottery. Sometimes in this book you will find periods cited without attached dates and in other books you may encounter different dates from those given for objects shown here. You should expect dating to change in the future as our knowledge grows and techniques of dating improve.

THE CYCLADIC ISLANDS

On the Cycladic Islands, late Neolithic and early Bronze Age people had a thriving culture. They engaged in agriculture, herding, some crafts, and trade. They used local stone to build and fortify towns and hillside burial chambers. Because they left no written records and their origins remain obscure, their art is a major source of information about them. From about 6000 BCE on, Cycladic artists used a coarse, poor-quality local clay to make a variety of ceramic objects. Some 3,000 years later, they continued to produce relatively crude but often engaging ceramic figurines of humans and animals, as well as domestic and ceremonial wares. They also produced marble sculptures.

The Cyclades, especially the islands of Naxos and Paros, had ample supplies of a fine and durable white marble. Out of it, sculptors created a unique type of nude figure ranging

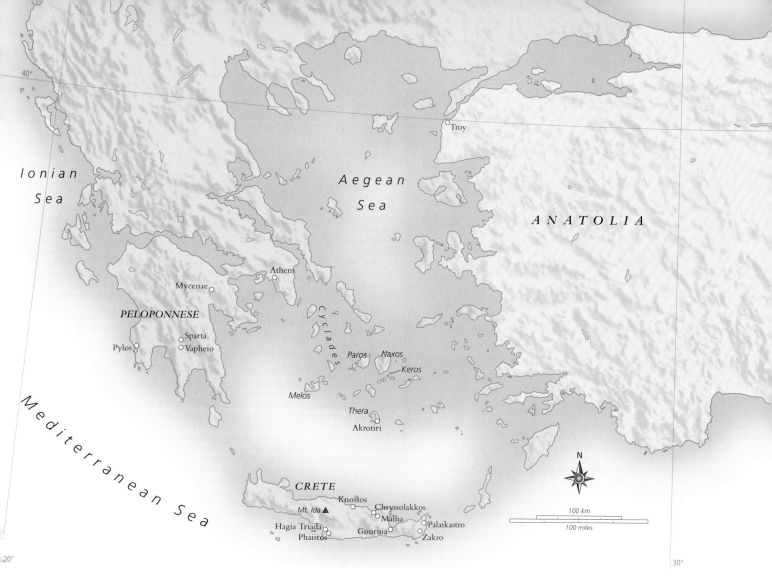

MAP 4–1 | **THE AEGEAN WORLD**

The three main cultures in the ancient Aegean were the Cycladic, in the Cyclades; the Minoan, on Thera and Crete; and the Helladic, including the Mycenaean, on the mainland.

from a few inches to about 5 feet tall. The figures are often found lying on graves. To shape the stone, sculptors used scrapers and chisels made of obsidian from the island of Melos and polishing stones of emery from Naxos. The introduction of metal tools may have made it possible for them to carve on a larger scale, but they continued to limit themselves to simple forms, perhaps because the stone fractured easily.

A few male figurines have been found, including depictions of musicians and acrobats, but they are greatly outnumbered by representations of women. The earliest female figures had simple, violinlike shapes. By 2500 BCE a more familiar type had evolved, and it has become the best-known type of Cycladic art (FIG. 4–2). The figures appear as pared-down, elegant renderings of the body. With their simple contours, the female statuettes seem not far removed from the marble slabs out of which they were carved. Tilted-back heads, folded arms, and down-pointed toes suggest that the

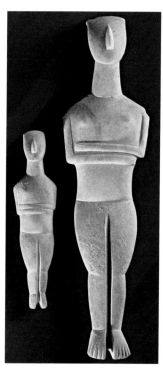

4–2 | **TWO FIGURES OF WOMEN**
Cyclades. c. 2500–2200 BCE. Marble, heights 13″ (33 cm) and 25″ (63.4 cm). Museum of Cycladic Art, Athens.
Courtesy of the N. P. Goulandris Foundation.

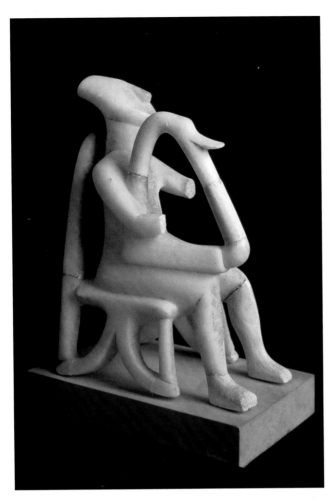

4–3 | **SEATED HARP PLAYER**
Keros, Cyclades. c. 2700–2500 BCE. Marble, height 11½″ (29.2 cm). Museum of Cycladic Art, Athens.

figures were intended to lie on their backs, as if asleep or dead. Anatomical detail has been kept to a minimum; the body's natural articulations at the hips, knees, and ankles are indicated by lines, and the pubic area is marked with a lightly incised triangle. These statues originally had painted facial features, hair, and ornaments in black, red, and blue.

The **SEATED HARP PLAYER** is a fully developed sculpture in the round (**FIG. 4–3**), yet its body shape is just as simplified as that of the female figurines. The figure has been reduced to its geometric essentials, yet with careful attention to elements that characterize an actual musician. The harpist sits on a high-backed chair with a splayed base, head tilted back as if singing, knees and feet apart for stability, and arms raised, bracing the instrument with one hand while plucking its strings with the other. So expressive is the pose that we can almost hear the song.

Although some Cycladic islands retained their distinctive artistic traditions, by the Middle and Later Bronze Age, the art and culture of the Cyclades as a whole was subsumed by Minoan and, later, Mycenean culture.

THE MINOAN CIVILIZATION ON CRETE

By 3000 BCE, Bronze Age people were living on Crete, the largest of the Aegean islands, 155 miles long and 36 miles wide. Crete was economically self-sufficient, producing its own grains, olives and other fruits, and cattle and sheep. But because it lacked the ores necessary for bronze production, its people were forced to look outward. With many safe harbors and a convenient location, Crete became a wealthy sea power, trading with mainland Greece, Egypt, the Near East, and Anatolia.

Between about 1900 BCE and 1375 BCE, a distinctive culture flourished on Crete. Its discoverer, the British archaeologist Sir Arthur Evans, named it Minoan from the legend of Minos, a king who had ruled from the capital, Knossos. According to the legend, a half-man, half-bull monster called the Minotaur was the son of the wife of King Minos and a bull belonging to the sea god Poseidon. It lived at Knossos in a maze called the Labyrinth. To satisfy the Minotaur's appetite for human flesh, King Minos ordered the mainland kingdom of Athens to send a yearly tribute of fourteen young men and women. Theseus, son of King Aegeus of Athens, vowed to free his people from this burden by slaying the monster.

Theseus set out for Crete with the doomed young Athenians, promising his father that on the return he would change the ship's black sails to white ones as a signal if he was victorious. With the help of Crete's princess Ariadne, who gave him a sword and a thread to mark his path through the Labyrinth, Theseus defeated the Minotaur. On his way home with Ariadne and the fourteen Athenians, he stopped at the island of Naxos, where he abandoned Ariadne. As he continued on, he forgot to raise the white sails. When King Aegeus saw the black-sailed ship, he threw himself off a cliff and into the sea that now bears his name, Aegean.

Although a number of written records from the period are preserved, the two earliest forms of Minoan writing, called hieroglyphic and Linear A, continue to defy translation. The surviving documents in a third later script, called Linear B (a very early form of Greek imported from the mainland), have proved to be valuable administrative records and inventories that give an insight into Minoan material culture.

Minoan chronology is divided into two main periods, the Old Palace Period, from about 1900 to 1700 BCE, and the New Palace Period, from around 1700 to 1450 BCE.

The Old Palace Period, c. 1900–1700 BCE

Minoan civilization remained very much a mystery until Sir Arthur Evans discovered the buried ruins of the architectural complex at Knossos, on Crete's north coast, in 1900 CE (**FIGS. 4–4, 4–5**). The site had been occupied in the Neolithic period, then built over with a succession of Bronze Age buildings.

Evans spent the rest of his life excavating and reconstructing the buildings he had found (see "Pioneers of Aegean

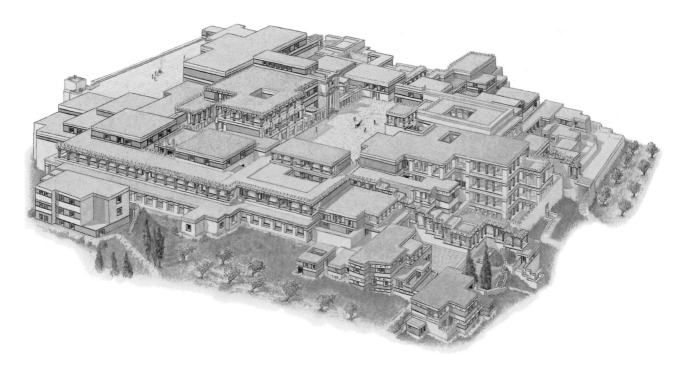

4—4 | RECONSTRUCTION OF THE PALACE COMPLEX, KNOSSOS, CRETE
As it would have appeared during the New Palace Period. Site occupied 2000–1375 BCE; complex begun in Old Palace Period (C. 1900–1700 BCE); complex rebuilt after earthquakes and fires during New Palace Period (c. 1700–1450 BCE); final destruction c. 1375 BCE.

Archaeology," page 88). Like nineteenth-century excavators before him, Evans called these great architectural complexes "palaces." But palaces imply kings, and we do not know the sociopolitical structure of the society.

PALACE LAYOUTS. The walls of early Minoan buildings were made of rubble and mud bricks faced with cut and finished local stone (**dressed stone**). This was the first use of dressed stone as a building material in the Aegean. Columns and other interior elements were made of wood. Both in palaces and in buildings in the surrounding towns, timber appears to have been used for framing and bracing walls. Its strength and flexibility would have minimized damage from the earthquakes common to the area. Nevertheless, the earthquake at

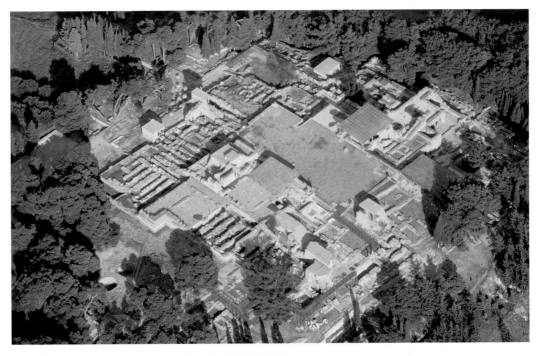

4—5 | KNOSSOS, AERIAL PHOTOGRAPH OF THE SITE

PIONEERS OF AEGEAN ARCHAEOLOGY

The pioneering figure in the modern study of Aegean civilization was Heinrich Schliemann (1822–90), who was inspired by Homer's epic tales, the *Iliad* and the *Odyssey*. The son of an impoverished German minister and largely self-educated, he worked hard in America, grew rich, and retired in 1863 to pursue his lifelong dream of becoming an archaeologist. In 1869, he began conducting fieldwork in Greece and Turkey. Scholars of that time considered Homer's stories pure fiction, but by studying the descriptions of geography in the *Iliad*, Schliemann located a multilayered site at Hissarlik, in present-day Turkey, whose sixth level up from the bedrock is now generally accepted as being Homer's Troy.

After this success, Schliemann pursued his hunch that the grave sites of Homer's Greek royal family would be found inside the citadel at Mycenae. But the graves he found were too early to contain the bodies of Atreus, Agamemnon, and their relatives. The discovery of the palace of the legendary King Minos fell to a British archaeologist, Sir Arthur Evans (1851–1941), who led the excavation of the palace at Knossos between 1900 and 1905. Evans gave the name *Minoan* to Bronze Age culture on Crete. He also made a first attempt to establish an absolute chronology for Minoan art, basing his conjectures on datable Egyptian artifacts found in the ruins on Crete and on Minoan artifacts found in Egypt. Later scholars have revised and refined his dating.

the time of the Thera eruption damaged several building sites, including Knossos and Phaistos. The structures were then repaired and enlarged, and the resulting new complexes shared a number of features. Multistoried, flat-roofed, and with many columns, they were designed to maximize light and air, as well as to define access and circulation patterns. Daylight and fresh air entered through staggered levels, open stairwells, and strategically placed air shafts and light wells (FIG. 4–6).

Suites of rooms lay around a spacious rectangular courtyard from which corridors and staircases led to other courtyards, private rooms and apartments, administrative and ritual areas, storerooms, and baths. Walls were coated with plaster, and some were painted with murals. Floors were plaster, plaster mixed with pebbles, stone, wood, or beaten earth. The residential quarters had many luxuries: sunlit courtyards, richly colored murals, and sophisticated plumbing systems.

Clusters of workshops in and around the palace complexes formed commercial centers. Storeroom walls were lined with enormous clay jars for oil and wine, and in their floors stone-lined pits from earlier structures had been designed for the storage of grain. The huge scale of the centralized management of foodstuffs became apparent when excavators at Knossos found in a single (although more recent) storeroom enough ceramic jars to hold 20,000 gallons of olive oil. There were also workshops that attest to the centralization of manufacturing.

The palace complex itself had a squarish plan and a large central courtyard. Causeways and corridors led from outside to the central courtyard or to special areas such as granaries or storage pits. The complex had a theater or performance area. Around the central court, independent units were made up of eight or nine suites of rooms. Each suite consisted of a forecourt with light well, a hall with a stepped lustral (purification) basin, a room with a hearth, and a series of service rooms. Such suites might belong to a family or serve a special business or government function.

CERAMIC ARTS. During the Old Palace Period, Minoans developed extraordinarily sophisticated metalwork and elegant new types of ceramics, spurred in part by the introduction of the potter's wheel early in the second millennium BCE. One type of ceramic is called Kamares ware, after the cave on Mount Ida overlooking the palace complex at Phaistos, in southern Crete, where it was first discovered. The hallmarks of this select ceramic ware—so sought-after that it was exported as far away as Egypt and Syria—were its extremely

4–6 | KNOSSOS INTERIOR
Reconstruction of palace interior staircase.

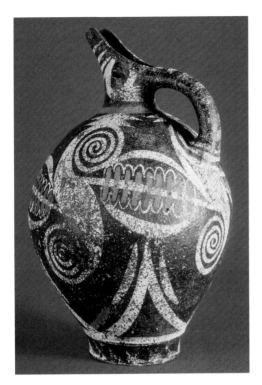

4—7 | KAMARES WARE JUG
Phaistos, Crete. Old Palace Period, c. 2000–1900 BCE.
Ceramic, height 10⅞″ (27 cm). Archaeological Museum,
Iraklion, Crete.

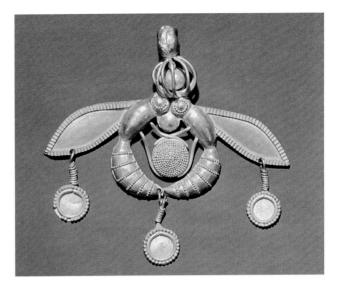

4—8 | PENDANT OF GOLD BEES
Chryssolakkos, near Mallia, Crete. Old Palace Period,
c. 1700–1550 BCE. Gold, height approx. 1¹³⁄₁₆″ (4.6 cm).
Archaeological Museum, Iraklion, Crete.

thin walls, its use of color, and its graceful, stylized, painted decoration. An example from about 2000–1900 BCE has a globular body and a "beaked" pouring spout (FIG. 4–7). Decorated with brown, red, and creamy white pigments on a black body, the jug has rounded contours complemented by bold, curving forms derived from plant life.

METALWORK. Matching Kamares ware in sophistication is early Minoan goldwork (see "Aegean Metalwork," page 93). By about 1700 BCE, Aegean metalworkers were producing objects rivaling those of Near Eastern and Egyptian jewelers, whose techniques they may have adopted. For a pendant in gold found at Chryssolakkos (FIG. 4–8), the artist arched a pair of bees (or perhaps wasps) around a honeycomb of gold granules, providing their sleek bodies with a single pair of outspread wings. The pendant hangs from a spiderlike form, with what appear to be long legs encircling a tiny gold ball. Small disks dangle from the ends of the wings and the point where the insects' bodies meet. The simplified geometric patterns and shapes convey the insects' actual appearance.

Cultural and artistic tradition continued unbroken into the New Palace Period when Minoan civilization reached its highest point.

The New Palace Period, c. 1700–1450 BCE

The "old palace" at Knossos, erected about 1900 BCE, formed the core of an elaborate new one built after the Thera eruption in c. 1650–1625 BCE. The Minoans rebuilt at Knossos and elsewhere, inaugurating the New Palace Period and the

flowering of Minoan art. In its heyday, the palace complex covered six acres (SEE FIG. 4–5).

THE LABYRINTH AT KNOSSOS. Because double-ax motifs were used in its architectural decoration, the Knossos palace was referred to in later Greek legends as the Labyrinth, meaning the "House of the Double Axes" (Greek *labrys*, "double ax"). The layout of the complex seemed so complicated that the word *labyrinth* eventually came to mean "maze" and became part of the Minotaur legend.

The layout provided the complex with its own internal security system: a baffling array of doors leading to unfamiliar rooms, stairs, and yet more corridors. Admittance could be denied by blocking corridors, and some rooms were accessible only from upper terraces. The building was a warren of halls, stairs, dead ends, and suites. Close analysis, however, shows that the builders had laid out a square grid following predetermined principles, and that the apparently confusing layout was caused in part by earthquake destruction and rebuilding over the centuries.

In typical Minoan fashion, the rebuilt Knossos complex was organized around a large central courtyard. A few steps led from the central courtyard down into the so-called Throne Room to the west, and a great staircase on the east side descended to the Hall of the Double Axes, an unusually grand example of a Minoan hall (Evans gave the rooms their misleading but romantic names; see, for example, FIG. 4–6). This hall and others were supported by the uniquely Minoan-type wood columns that became standard in Aegean palace architecture. The tree trunks from which the columns were made were inverted so that they tapered toward the bottom. The top, supporting massive roof beams and a broad flattened capital, was wider than the bottom.

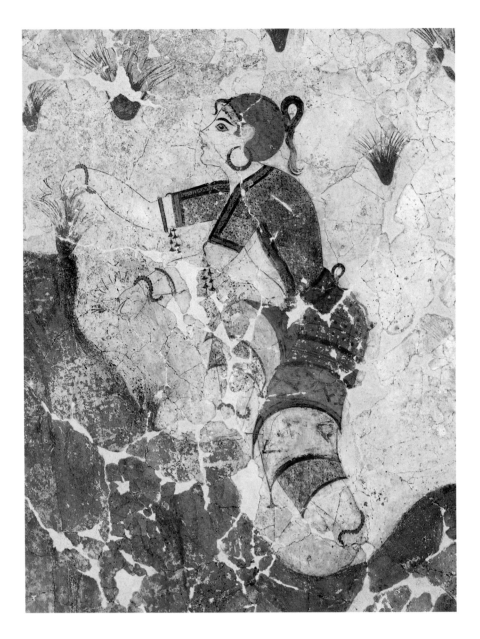

4–9 | **YOUNG GIRL GATHERING SAFFRON CROCUS FLOWERS**
Detail of wall painting, Room 3 of House Xeste 3, Akrotiri, Thera. Cyclades before 1630 BCE. Thera Foundation, Petros M. Nomikos, Greece.

Rooms, following Old Palace tradition, were arranged around a central space rather than along a long axis, as we have seen in Egypt and will see on the mainland. During the New Palace Period, suites functioned as archives, business centers, and residences. Some must also have had a religious function, though the temples, shrines, and elaborate tombs seen in Egypt are not found in Minoan architecture.

WALL PAINTING AT AKROTIRI. Minoan painters worked on a large scale, covering the walls of palace rooms with geometric borders, views of nature, and scenes of human activity. Murals can be painted on a still-wet plaster surface (**buon fresco**) or a dry one (**fresco secco**). The wet technique binds pigments to the wall, but forces the painter to work very quickly. On a dry wall, the painter need not hurry, but the pigments tend to flake off in time. Minoans used both techniques. Their preferred colors were red, yellow, black, white, green, and blue. Like Egyptian painters, Minoan artists filled in the outlines of their figures and objects with unshaded areas of pure color.

Minoan wall painting displays elegant drawing, linear contours filled with bright colors, a preference for profile or full-faced views, and a stylization that turns natural forms into decorative patterns. Those conventions can be seen in the vivid murals at Akrotiri, on the Cycladic island of Thera (SEE FIG. 4–1). Along with other Minoan cultural influences, the art of wall painting seems to have spread to both the Cyclades and mainland Greece. Thera, for example, was so heavily under Crete's influence at this time that it was virtually an outpost of Minoan culture.

The paintings in residences at Akrotiri demonstrate a sophisticated decorative sense, both in color selection and in surface detail. Some of the subjects at Akrotiri also occur in the art of Crete, but others are new. One of the houses, for example, has rooms dedicated to young women's initiation ceremonies. In the detail shown here, a young woman picks saffron crocus, valuable for its use as a yellow dye, as a flavoring for food, and as a medicinal plant to alleviate menstrual cramps (FIG. 4–9). The girl wears the typically colorful

Minoan flounced skirt with a short-sleeved, open-breasted bodice, large earrings, and bracelets. She still has the shaved head, fringe of hair, and long ponytail of a child, but the light blue color of her scalp indicates that the hair is beginning to grow out.

In another house, an artist has created a landscape of hills, rocks, and flowers (FIG. 4–10). This mural is unlike anything previously encountered in ancient art, the first pure landscape painting. A viewer standing in the center of the room is surrounded by orange, rose, and blue rocky hillocks sprouting oversized deep red lilies. Swallows, represented by a few deft lines, swoop above and around the flowers. The artist unifies the rhythmic flow of the undulating landscape, the stylized patterning imposed on the natural forms, and the

decorative use of bright colors alternating with darker neutral tones, which were perhaps meant to represent areas of shadow. The colors—pinks, blues, yellows—may seem fanciful to us, but sailors today who know the area well attest to their accuracy: The artist recorded the actual colors of Thera's wet rocks in the sunshine. The impression is one of a celebration of the natural world. How different is this art—which captures a zestful joy of life—from the cool, static elegance of Egyptian painting!

BULL LEAPING AT KNOSSOS. One of the most famous and best-preserved paintings at Knossos depicts bull leaping. The restored panel is one of a group of paintings with bulls as subjects from a room in the palace's east wing (the painting is later

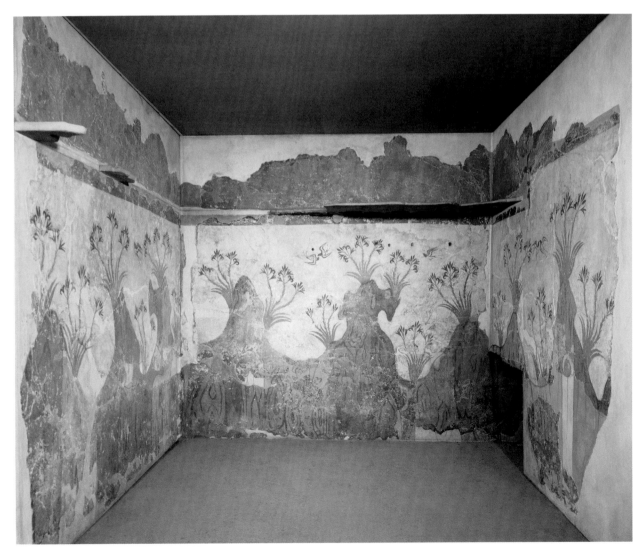

4–10 | *LANDSCAPE (SPRING FRESCO)*
Wall painting with areas of modern reconstruction, from Akrotiri, Thera Cyclades. Before 1630 BCE.
National Archaeological Museum, Athens.

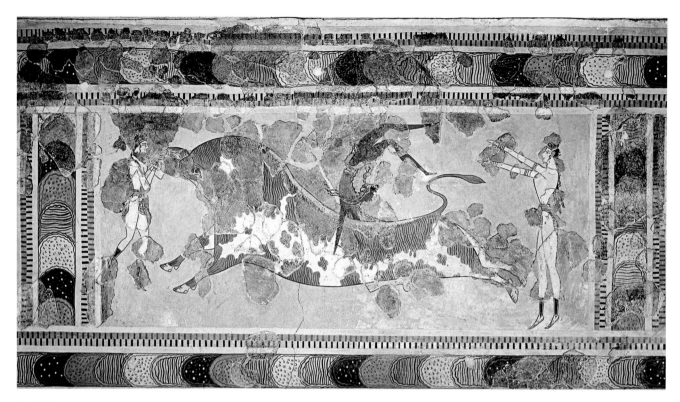

4–11 | **BULL LEAPING**
Wall painting with areas of modern reconstruction, from the palace complex, Knossos, Crete. Late Minoan period, c. 1550–1450 BCE. Height approx. 24½" (62.3 cm). Archaeological Museum, Iraklion, Crete.

than the Akrotiri paintings). The action may represent an initiation or fertility ritual. **BULL LEAPING** (**FIG. 4–11**) shows three scantily clad youthful figures around a gigantic dappled bull, which is charging in the "flying-gallop" pose. The pale-skinned person at the right—probably a woman—is prepared to catch the dark-skinned man in the midst of his leap, and the pale-skinned woman at the left grasps the bull by its horns, perhaps to begin her own vault. The bull's power and grace are masterfully rendered, although the flying-gallop pose is not true to life. Framing the action are overlapping ovals (the so-called chariot-wheel motif) set within striped bands.

SCULPTURE: THE WOMAN WITH SNAKES. Surviving Minoan sculpture consists mainly of small, finely executed work in wood, ivory, precious metals, stone, and faience. Female figurines holding serpents are among the most characteristic images and may have been associated with water, regenerative power, and protection of the home.

The **WOMAN OR GODDESS WITH SNAKES** from the palace at Knossos is intriguing both as a ritual object and as a work of art (**FIG. 4–12**). This faience figurine was found with other

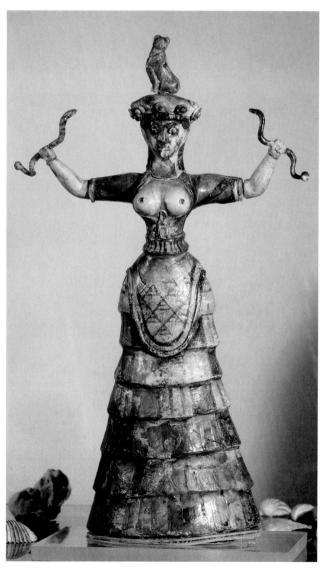

4–12 | **WOMAN OR GODDESS WITH SNAKES**
As restored, from the palace complex, Knossos, Crete. New Palace period, c. 1700–1550 BCE. Faience, height 11⅜" (29.5 cm). Archaeological Museum, Iraklion, Crete.

Technique
AEGEAN METALWORK

Aegean artists created exquisite luxury goods from imported gold. Their techniques included **lost-wax casting** (see "Lost-Wax Casting," PAGE XXV), **inlay**, **filigree**, *repoussé* (embossing), **niello**, and **gilding**. The *Vapheio Cup* (SEE FIG. 4-16) and the funerary mask (SEE FIG. 4-24) are examples of *repoussé*, in which the artist gently hammered out relief forms from the back of a thin sheet of gold. Experienced goldsmiths may have done simple designs freehand or used standard wood forms or punches. For more elaborate decorations they would first have sculpted the entire design in wood or clay and then used this form as a mold for the gold sheet.

The artists who created the Mycenaean dagger blade (SEE FIG. 4-25) not only inlaid one metal into another but also employed a special technique called niello, still a common method of metal decoration. Powdered nigellum—a black alloy of lead, silver, and copper with sulfur—was rubbed into very fine engraved lines in the object being decorated, then fused to the surrounding metal with heat. The lines appear to be black drawings.

Gilding, the application of gold to an object made of some other material, was a technically demanding process by which paper-thin sheets of hammered gold called **gold leaf** (or, if very thin, **gold foil**) were meticulously affixed to the surface to be gilded. This was done with amazing delicacy for the now-bare stone surface of the Harvester Vase (SEE FIG. 4-13) and the wooden horns of the bull's-head rhyton (SEE FIG. 4-14).

ceremonial objects in a pit in one of Knossos's storerooms. Bare-breasted, arms extended, and brandishing a snake in each hand, the woman is a commanding presence. A leopard or a cat (perhaps a symbol of royalty, perhaps protective) is poised on her crown, which is ornamented with circles. This shapely figure is dressed in a fitted, open bodice with an apron over a typically Minoan flounced skirt. A wide belt cinches the waist. The red, blue, and green geometric patterning on her clothing reflects the Minoan weavers' preference for bright colors, patterns, and fancy borders. Realistic elements combine with formal stylization to create a figure that is both lively and dauntingly, almost hypnotically, powerful—a combination that has led scholars to disagree whether statues such as this one represent deities or their human attendants.

STONE RHYTONS. Almost certainly of ritual significance are the stone vases and **rhytons**—vessels used for pouring liquids—that Minoans carved from steatite (a greenish or brown soapstone). These pieces were all found in fragments. The **HARVESTER VASE** is an egg-shaped rhyton barely 4½ inches in diameter (FIG. 4–13). It may have been covered with **gold leaf**, sheets of hammered gold (see "Aegean Metalwork," above).

A rowdy procession of twenty-seven men has been crowded onto its curving surface. The piece is exceptional for the freedom with which the figures occupy three-dimensional space, overlapping and jostling one another instead of marching in orderly single file across the surface in the manner of Near Eastern or Egyptian art. Also new is the exuberance of this scene, especially the emotions shown on the men's faces. They march and chant to the beat of a *sistrum*—a rattlelike percussion instrument—played by a man who seems to sing at the top of his lungs. The men have large,

4–13 HARVESTER VASE
Hagia Triada, Crete. New Palace Period, c. 1650–1450 BCE. Steatite, diameter 4½" (11.3 cm). Lower part of vase is reconstructed. Archaeological Museum, Iraklion, Crete.

coarse features and sinewy bodies so thin that their ribs stick out. Archaeologists have interpreted the scene in many ways—as a spring planting or fall harvest festival, a religious procession, a dance, a crowd of warriors, or a gang of forced laborers.

Rhytons were also made in the form of a bull's head (FIG. 4–14). Bulls often appear in Minoan art, rendered with an intensity not seen since the prehistoric cave paintings at Altamira and Lascaux (Chapter 1). Although many early cultures associated their gods with powerful animals, neither their images nor later myths offer any proof that the Minoans worshiped a bull god. According to later Greek legend, the Minotaur in King Minos's palace was not an object of religious veneration.

The sculptor of a bull's head rhyton found at Knossos used a block of greenish-black steatite to create an image that approaches animal portraiture. Lightly engraved lines, filled with white powder to make them visible, indicate the animal's coat: short, curly hair on top of the head; longer, shaggy strands on the sides; and circular patterns along the neck suggest its dappled coloring. White bands of shell outline the nostrils, and painted rock crystal and red jasper form the eyes. The horns (restored) were made of wood covered with gold leaf. Additionally, liquid could be poured into a hole in the neck and flowed out from the mouth.

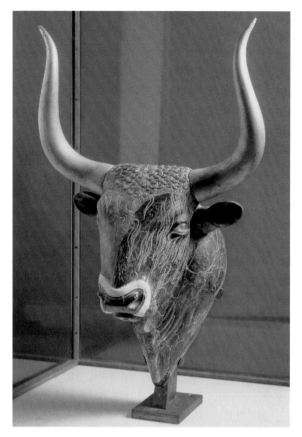

4–14 | BULL'S-HEAD RHYTON
Palace complex, Knossos, Crete. New Palace Period, c.1550–1450 BCE. Steatite with shell, rock crystal, and red jasper, the gilt-wood horns restored, height 12″ (30.5 cm). Archaeological Museum, Iraklion, Crete.

CERAMIC ARTS. Minoan potters also created more modest vessels. The ceramic arts, so splendidly demonstrated in Old Palace Kamares ware, continued throughout the New Palace Period. Some of the most striking ceramics were done in what is called the "Marine style," because of the depictions of sea life on their surfaces. In a stoppered bottle of this style known as the **OCTOPUS FLASK,** made about 1500–1450 BCE (FIG. 4–15), the painter celebrates the sea. Like microscopic life teeming in a drop of pond water, sea creatures float around an octopus's tangled tentacles. The decoration on the Kamares ware jug (SEE FIG. 4–7) reinforces the solidity of its surface, but here the pottery skin seems to dissolve. The painter captured the grace and energy of natural forms while presenting them as a stylized design in harmony with the vessel's spherical shape.

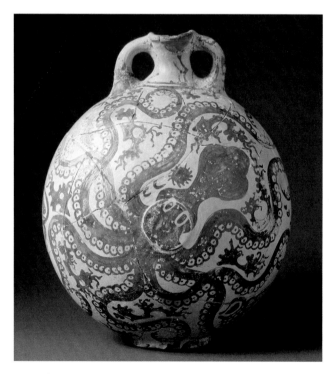

4–15 | OCTOPUS FLASK
Palaikastro, Crete. New Palace Period, c. 1500–1450 BCE. Marine style ceramic, height 11″ (28 cm). Archaeological Museum, Iraklion, Crete.

METALWORK. About 1450 BCE, a conquering people from mainland Greece, known as Mycenaeans, arrived in Crete. They occupied the buildings at Knossos and elsewhere until a final catastrophe and the destruction of Knossos about 1375 BCE caused them to abandon the site. But by 1400 BCE, the center of political and cultural power in the Aegean had shifted to mainland Greece.

The skills of Minoan artists, particularly metalsmiths, made them highly sought after in mainland Greece. A pair of magnificent gold cups found in a large tomb at Vapheio, on

the Greek mainland south of Sparta, were made sometime between 1650 and 1450 BCE, either by Minoan artists or by locals trained in Minoan style and techniques. One cup is shown here (FIG. 4–16). The relief designs were executed in **repoussé**—the technique of hammering from the back of the sheet. The handles were attached with rivets, and the cup was then lined with sheet gold. In the scene that circles the cup, men are depicted trying to capture bulls in various ways. Here, a half-nude man has roped a bull's hind leg. The figures dominate the landscape, which literally bulges with a muscular vitality that belies the cup's small size—it is only 3⅛ inches tall. The depiction of olive trees could indicate that the scene is a sacred grove, and that these may be illustrations of exploits in some long-lost heroic tale rather than commonplace herding scenes.

THE MYCENAEAN (HELLADIC) CULTURE

Archaeologists use the term *Helladic* (from *Hellas*, the Greek name for Greece) to designate the Aegean Bronze Age on mainland Greece. The Helladic period extends from about 3000 to 1000 BCE, concurrent with the Cycladic and Minoan periods. In the early part of the Aegean Bronze Age, Greek-speaking peoples, probably from the northwest, moved into the mainland. They brought with them advanced techniques for metalworking, ceramicware, and architectural design, and they displaced the local Neolithic culture. When Minoan culture declined after about 1450 BCE, people of a late Helladic mainland culture known as Mycenaean, after the city of

Mycenae, occupied Crete as well as Greece, and rose to dominance in the Aegean region.

Helladic Architecture

Mycenaean architecture was distinct from that of the Minoans. Mycenaeans built strongholds of megaliths called citadels to protect the palaces of their rulers. These palaces contained a characteristic structure called a *megaron* that was axial in plan. The Mycenaeans also buried their dead in magnificent vaulted tombs, round in shape and crafted of cut stone.

Sequencing Events
EGYPTIAN, MYCENAEAN, AND MINOAN CULTURES

c. 3000 BCE	Early Bronze Age in the Cyclades
c. 2200 BCE	First Palaces at Knossos, Crete
c. 2000 BCE	First pictographic script, Crete
c. 1900 BCE	Old Palace Period
c. 1650–25 BCE	Destruction of Thera, earthquakes and volcanic eruption
c. 1600 BCE	Mycenaeans rise to power
c. 1450 BCE	Destruction of Minoan palaces; Knossos occupied by Mycenaeans
c. 1400 BCE	Knossos burned and not rebuilt
c. 1300 BCE	Mycenaean walls on acropolis in Athens
c. 1100 BCE	End of Mycenaean dominance

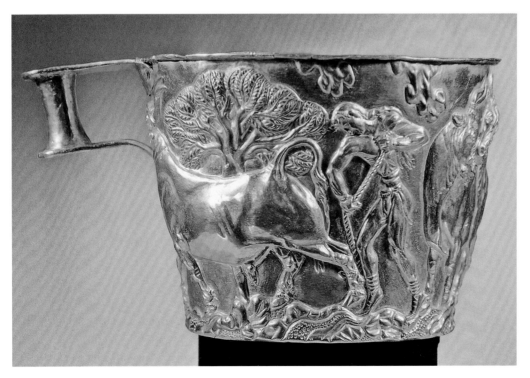

4–16 VAPHEIO CUP Found near Sparta, Greece. c. 1650–1450 BCE. Gold, height 3½" (3.9 cm). Archaeological Museum, Iraklion, Crete.

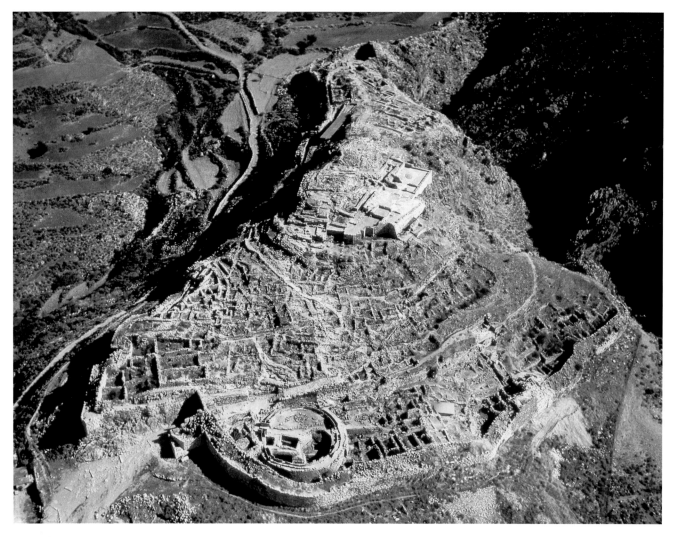

4-17 | CITADEL AT MYCENAE
Greece. Aerial view. Site occupied c. 1600-1200 BCE; walls built c. 1340, 1250, 1200 BCE.

The citadel's hilltop position, the grave circle at the bottom center of the photograph, and the circuit walls are clearly visible. The Lion Gate (see "The Lion Gate," pages 100-101) is at the lower left. The megaron floor and bases of columns and walls are at the top of the hill, at the upper center.

THE CITADEL AT MYCENAE. Later Greek writers called the walled city of Mycenae (FIGS. 4-17, 4-18), located near the east coast of the Peloponnese peninsula in southern Greece, the home of Agamemnon, the leader of the Greek army that conquered the great city of Troy (see "Homeric Greece," page 98). The site has been occupied from the Neolithic period to around 1050 BCE. Even today, the monumental gateway to the citadel at Mycenae is an impressive reminder of the importance of the city. The walls were rebuilt three times—c. 1340 BCE, c. 1250 BCE, and c. 1200 BCE—each time stronger than the last and enclosing more space. The second wall of c. 1250 BCE enclosed the grave circle and was pierced by two gates, the monumental Lion Gate (see "The Lion Gate," pages 100–101) on the west and a small postern gate on the northeast side. The final walls were extended about 1200 BCE to protect the water supply, an underground cis-

tern. These walls were about 25 feet thick and nearly 30 feet high. The drywall masonry is known as **cyclopean**, because it was believed that only the giant Cyclops could have moved such massive stones.

As in Near Eastern citadels, the Lion Gate was provided with guardian figures, which stand above the door rather than in the door jambs. From this gate, the formal entranceway into the citadel, known as the Great Ramp, led up the hillside, past the grave circle, to the king's residence and council room.

The ruler's residence was built on the highest point in the center of the city. Its distinctive feature was a large audience hall called a **megaron**, or "great room." The main courtyard led to a large rectangular building with a porch, a vestibule, and finally the great room—a much more direct approach to the principal room than the complex corridors of a Minoan palace. A typical megaron had a central hearth surrounded by

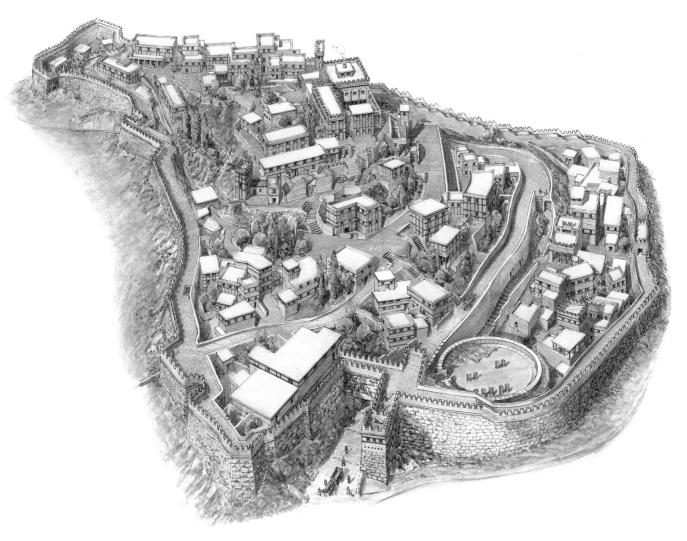

4–18 | **RECONSTRUCTION OF CITADEL AT MYCENAE**

four large columns that supported the ceiling. The roof above the hearth was raised to admit light and air and permit smoke to escape (FIG. 4–19). Some architectural historians think that the megaron eventually came to be associated with royalty. The later Greeks adapted its form when building temples, which they saw as earthly palaces for their gods.

THE PALACE AT PYLOS. The rulers of Mycenae fortified their city, but the people of Pylos, in the extreme southwest of the Peloponnese, perhaps felt that their more remote and defensible location made them less vulnerable to attack. It may be that the people of Pylos should have taken greater care to protect themselves. Within a century of its construction, the palace at Pylos (c. 1300–1200 BCE) was destroyed by fires, apparently set during the violent upheavals that brought about the collapse of Mycenae.

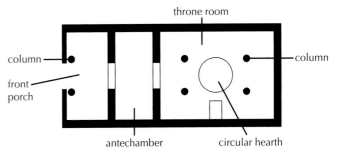

4–19 | **PYLOS PALACE PLAN**
c. 1300–1200 BCE.

The palace at Pylos was built on a raised site without fortifications, and it was focused on the ruler's residence and megaron. Set behind a porch and vestibule facing the court-yard, the Pylos megaron was a magnificent display of archi-tectural and decorative skill. The reconstructed view provided

Art and Its Context
HOMERIC GREECE

The legend of the Trojan War and its aftermath held a central place in the imagination of ancient people. Sometime before 700 BCE, it inspired the great epics of the Greek poet Homer—the *Iliad* and the *Odyssey*—and provided later poets and artists with rich subject matter.

According to the legend, a woman's infidelity caused the war. While on a visit to the city of Sparta in the Peloponnese, in southern Greece, young Paris, son of King Priam of Troy, fell in love with Helen, a human daughter of Zeus who was the wife of the Spartan king Menelaus. With the help of Aphrodite, the goddess of love, Helen and Paris fled to Troy, a rich city in northwestern Asia Minor. The angry Greeks dispatched ships and a huge army to bring Helen back. Led by Agamemnon, king of Mycenae and the brother of Menelaus, the Greek forces laid siege to Troy. The two sides were deadlocked for ten years, until a ruse devised by the Greek warrior Odysseus enabled the Greeks to win: The Greeks pretended to give up the siege and built a huge wooden horse to leave behind as a parting gift to the god-

dess Athena. In fact, Greek warriors were hidden inside the wooden horse. After the Trojans pulled the horse inside the gates of Troy, the Greeks slipped out and opened the gates to their comrades, who slaughtered the Trojans and burned the city.

This legend probably originated with a real attack on a coastal city of Asia Minor by mainland Greeks during the late Bronze Age. Tales of the conflict, modified over the centuries, endured in a tradition of oral poetry until finally written down and attributed to Homer.

Archaeologists, including Schliemann, concluded that the remains of the legendary city might be found at the Hissarlik Mound in northwestern Turkey. Excavated first in 1872–90 and again beginning in the 1930s, this relatively small mound—less than 700 feet across—contained the "stacked" remains of at least nine successive cities, the earliest of which dates to at least 3000 BCE. The most recent hypothesis is that so-called Troy 6 (the sixth-level city), which flourished between about 1800 and 1300 BCE, was the Troy of Homeric legend.

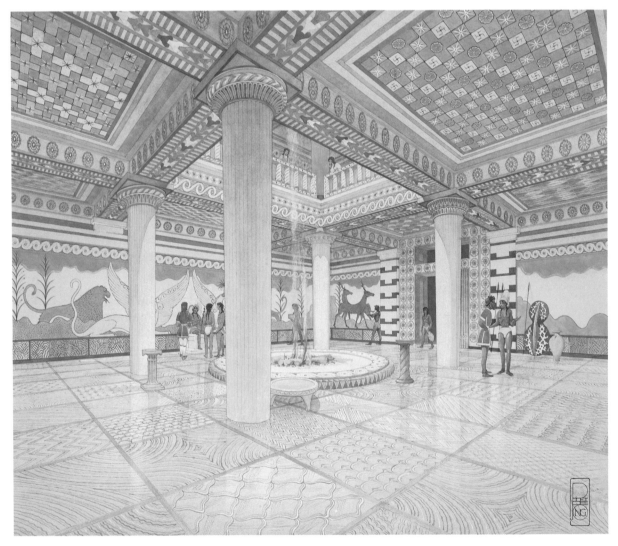

4–20 | **RECONSTRUCTION DRAWING OF THE MEGARON IN THE PALACE AT PYLOS**
Greece. c. 1300–1200 BCE. Drawing in Antonopouleion Archaeological Museum, Pylos.

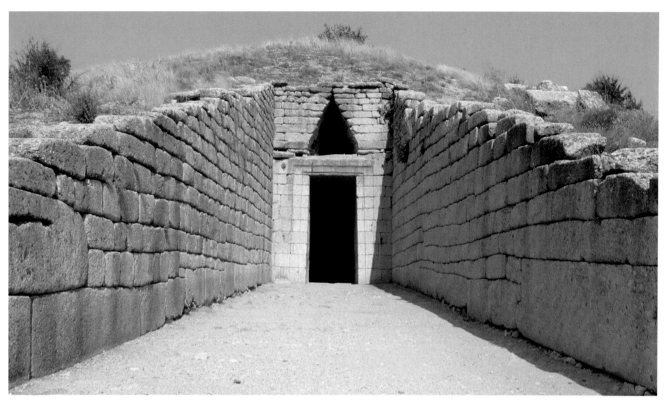

4-21 | THOLOS, THE SO-CALLED TREASURY OF ATREUS
Mycenae, Greece. c. 1300–1200 BCE.

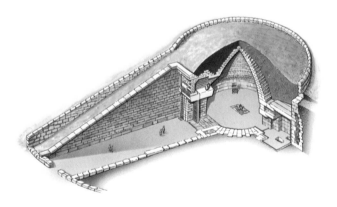

4-22 | CUTAWAY DRAWING OF THOLOS

here (FIG. 4–20) shows how the combined throne room and audience hall might have looked. Fluted, upward-swelling Minoan-type columns support heavy ceiling beams. Every inch was painted—floors, ceilings, beams, and door frames were covered with brightly colored abstract designs, and the walls were covered with paintings of large mythical animals and highly stylized plant and landscape forms. The floor was finished with painted plaster.

Clay tablets in Linear B found in the ruins of the palace include an inventory of furnishings that indicates they were as elegant as the architecture. The listing on one tablet reads: "One ebony chair with golden back decorated with birds; and a footstool decorated with ivory pomegranates. One ebony chair with ivory back carved with a pair of finials and

with a man's figure and heifers; one footstool, ebony inlaid with ivory and pomegranates."

MYCENAEAN TOMBS. Tombs were given much greater prominence in the Helladic culture of the mainland than they were by the Minoans, and ultimately they became the most architecturally sophisticated monuments of the entire Aegean period. The earliest burials were in **shaft graves**, vertical pits 20 to 25 feet deep. In Mycenae, the royal graves were enclosed in a circle of standing stone slabs. In these graves, the ruling families laid out their dead in opulent dress and jewelry and surrounded them with ceremonial weapons (SEE FIG. 4–25), gold and silver wares, and other articles indicative of their status, wealth, and power. It was in shaft grave V that the so-called mask of Agamemnon was found (SEE FIG. 4–24).

By about 1600 BCE, kings and princes on the mainland had begun building large above-ground burial places commonly referred to as **tholos tombs** (popularly known as **beehive tombs** because of their rounded, conical shape). More than a hundred such tombs have been found, nine of them in the vicinity of Mycenae. Possibly the most impressive is the so-called **TREASURY OF ATREUS** (FIGS. 4–21, 4–22) which dates from about 1300 to 1200 BCE.

A walled passageway through the earthen mound covering the tomb, about 114 feet long and 20 feet wide and open to the sky, led to the entrance. The original entrance was 34 feet high and the door was 16½ feet high, faced with bronze plaques. It was flanked by engaged, upward-tapering columns

THE OBJECT SPEAKS

THE LION GATE

One of the most imposing survivals from the Helladic Age is the gate to the city of Mycenae. The gate is today a simple opening, but its importance is indicated not only by the monumental sculptures of guardian beasts, but by the very material of the flanking walls, a conglomerate stone that can be polished to glistening multicolors. Additionally, a corbelled relieving arch above the lintel forms a triangle filled with a limestone panel bearing a grand heraldic composition—a single Minoan column that tapers upward to a large bulbous capital and abbreviated entablature.

An archival photograph shows a group posing jauntily beside, and in, the gate. Visible is Heinrich Schliemann (standing at the left of the gate) and his wife and partner in archeology, Sophia (sitting at the right). Schliemann had already "discovered" Troy, and when he turned his attention to Mycenae, he unearthed graves with rich grave goods, including gold masks (see Fig. 4–24). The grave circle he excavated lay just beyond the Lion Gate.

The Lion Gate has been the subject of much speculation in recent years. What are the animals? What does the architectural feature mean? How is the imagery to be interpreted? The beasts supporting and defending the column are magnificent supple creatures rearing up on hind legs. They once must have faced the visitor, but today only the attachment holes indicate the presence of their heads.

What were they—lions or lionesses? One scholar points out that since the beasts have neither teats nor penises, it is impossible to say. The beasts do not even have to be felines. They could have had eagle heads, which would make them griffins, in which case should they not also have wings? They could have had human heads, and that would turn them into sphinxes. Pausanias, a Greek traveler who visited Mycenae in the second century CE, described a gate guarded by lions. Did he see the now missing heads? Did the "object" not only speak, but roar?

Mixed-media sculpture—ivory and gold, marble and wood—was common. One could imagine that if the creatures had the heads of lions, the heads might have resembled the gold cup in the form of a lion that still survives. Such heads would have gleamed and glowered out at the visitor. And if the sculpture were painted, as most sculpture was, the gold would not have seemed out of place.

A metaphor for power, the lions rest their feet on Mycenaean altars. Between them stands the mysterious column, also on an altar base. What does it mean? Scholars do not agree. Is it a temple? A palace? The entire city? Or the god of the place? The column and capital support a lintel or architrave, which in turn supports the butt ends of logs forming rafters of the horizontal roof, so the most likely theory is that the structure is the symbol of a palace or a temple. But some scholars suggest that by extension it becomes the symbol of a king or a deity (just as we say the "White House" when we mean the government of the United States), and that the imagery of the Lion Gate, with its combination of the guardian beasts and divine or royal palace, serves to legitimize the power of the ruler.

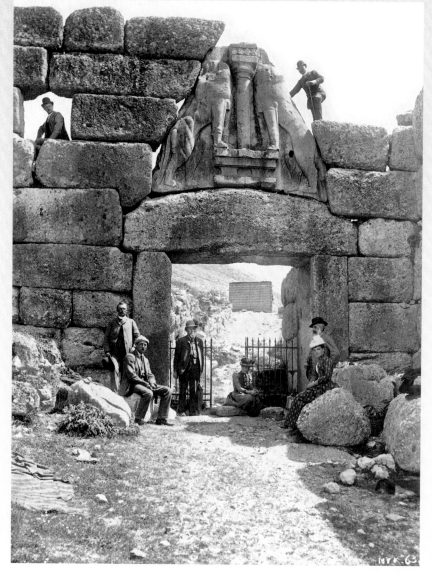

LION GATE, MYCENAE
c. 1250 BCE. Historic photo.

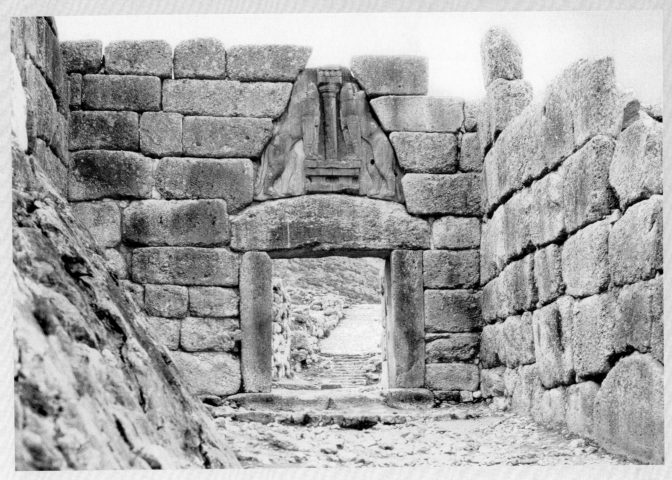

LION GATE, MYCENAE
c. 1250 BCE. Limestone relief, height of sculpture approx. 9'6" (2.9 m).

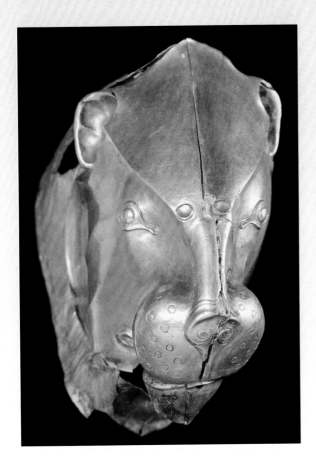

GOLDEN LION'S HEAD RHYTON
Shaft grave IV, south of Lion gate, Mycenae, sixteenth century BCE.
National Archaeological Museum, Athens.

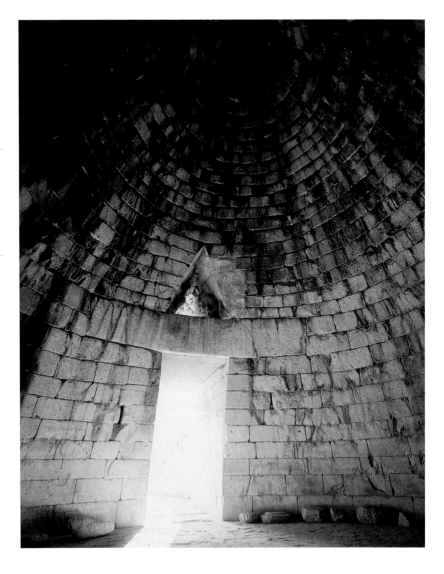

4–23 | CORBELED VAULT, INTERIOR OF THOLOS Limestone vault, height approx. 43′ (13 m), diameter 47′6″ (14.48 m).

This great beehive tomb was half buried until it was excavated by Christos Stamatakis in 1878. For more than a thousand years, this Mycenaean tomb remained the largest uninterrupted interior space built in Europe. The first European structure to exceed it in size was the Pantheon in Rome (Chapter 6), built in the first century BCE.

that were carved of green serpentine porphyry found near Sparta and incised with geometric bands and **chevrons**—inverted Vs—filled with **running spirals**, a favorite Aegean motif. The section above the lintel had smaller engaged columns on each side, and the relieving triangle was disguised behind a red-and-green engraved marble panel. The main tomb chamber (**FIG. 4–23**) is a circular room 47½ feet in diameter and 43 feet high. It is roofed with a **corbel vault** built up in regular **courses**, or layers, of **ashlar**—squared stones—smoothly leaning inward and carefully calculated to meet in a single capstone at the peak. Covered with earth, the tomb became a conical hill. It was a remarkable engineering feat.

Metalwork

The *tholos* tombs at Mycenae had been looted long before archaeologist Heinrich Schliemann began to search for Homeric Greece, but he did excavate the contents of shaft graves (vertical pits 20 to 25 feet deep) at the site. Magnificent gold and bronze swords, daggers, masks, jewelry, and drinking cups were found buried with members of the elite.

Schliemann believed the citadel at Mycenae to be the home of Agamemnon, the commander-in-chief of the Greek

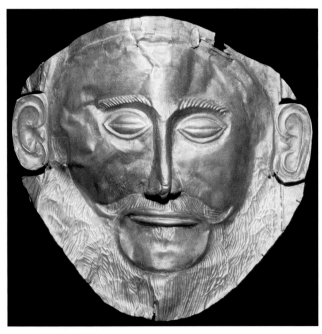

4–24 | "MASK OF AGAMEMNON"
Funerary mask, from the royal tombs, Grave Circle A, Mycenae, Greece. c. 1600–1550 BCE. Gold, height approx. 12″ (35 cm). National Archaeological Museum, Athens.

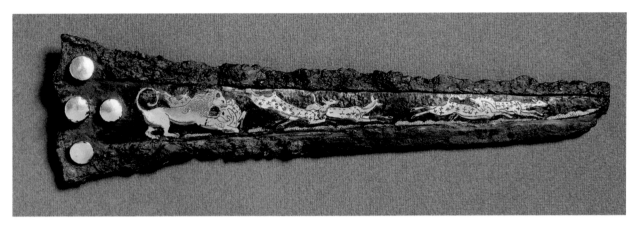

4–25 | **DAGGER BLADE WITH LION HUNT**
Shaft Grave IV, Grave Circle A, Mycenae, Greece. c. 1550–1500 BCE. Bronze inlaid with gold, silver, and niello, length 9⅜″ (23.8 cm). National Archaeological Museum, Athens.

forces against Troy. Among the 30 pounds of gold objects he found in the royal graves were five death masks, and one of these golden treasures (FIG. 4–24) seemed to him to be the face of Homer's hero. We now know this golden mask has nothing to do with the heroes of the Trojan War. Research shows the Mycenae graves are about 300 years older than Schliemann believed, and the burial practices they display were different from those described by Homer. Still, the mask image is so commanding that we sense it is a hero's face. But the characteristics that make it seem so gallant—such as the handlebar moustache and large ears—have caused some scholars to question its authenticity. This mask is significantly different from the others found at the site, and some scholars contend that Schliemann added features to make the mask appear more heroic to viewers of his day.

Among the other objects found in the graves, the gold lion head rhyton (see "The Lion Gate," page 101) and bronze dagger blade (FIG. 4–25), decorated with inlaid scenes, attest to the wealth of a ruling elite. To form the decoration of the dagger, the Mycenaean artist cut shapes out of different-colored metals—copper, silver, and gold—inlaid them in the bronze blade, and then added the fine details in niello (see "Aegean Metalwork," page 93). In the *Iliad*, Homer's epic poem about the Trojan War, the poet describes similar decoration on Agamemnon's armor and Achilles' shield. The decoration on the blade shown here depicts a lion attacking a deer, with four more terrified animals in full flight. Like the bull in the Minoan fresco (FIG. 4–11), the animals spring forward in the "flying-gallop" pose to indicate speed and energy.

Sculpture

Mainland artists saw Minoan art as it was acquired through trade. Perhaps they even worked side by side with Minoan artists brought back by the conquerors of Crete. They adopted Minoan art with such enthusiasm that sometimes experts disagree over the identity of the artists—were they Minoans working for Mycenaeans or Mycenaeans taught by, or copying, Minoans?

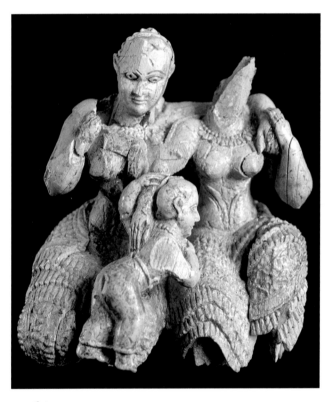

4–26 | **TWO WOMEN WITH A CHILD**
Found in the palace at Mycenae, Greece, c. 1400–1200 BCE. Ivory, height 2¾″ (7.5 cm). National Archaeological Museum, Athens.

A carved ivory group of two women and a child (FIG. 4–26), less than 3 inches high and found in the palace shrine at Mycenae, appears to be a product of Minoan-Mycenaean artistic exchange. Dating from about 1400–1200 BCE, the miniature exhibits carefully observed natural forms, an intricately interlocked composition, and finely detailed rendering. The group is carved entirely in the round—top and bottom as well as back and front. It is an object to be held in the hand. Because there are no clues to the identity or the significance of the group, we might easily interpret it as generational—with grandmother, mother, and child. But the figures could just as

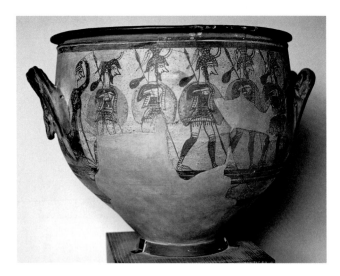

4–27 | WARRIOR VASE
Mycenae, Greece. c. 1300–1100 BCE. Ceramic, height 16″ (41 cm). National Archaelogical Museum, Athens

well represent two nymphs or devotees attending a child god. In either case, the mood of affection and tenderness among the three is unmistakable, and, tiny as it is, the sculpture gives an insight into a gentler aspect of Mycenaean art.

Ceramic Arts

In the final phase of the Helladic period, Mycenaean potters created highly refined ceramics. A large **krater**, a bowl for mixing water and wine, used both in feasts and as grave markers, is an example of the technically superior wares being produced between 1300 and 1100 BCE. Decorations could be highly stylized, like the scene of marching men on the **WARRIOR VASE** (FIG. 4–27). On the side shown here, a woman at the far left bids farewell to a group of helmeted men marching off to the right with lances and large shields. The vibrant energy of the *Harvester Vase* or the *Vapheio Cup* has changed to the regular rhythm inspired by the tramping feet of disciplined warriors. The only indication of the woman's emotions is the gesture of an arm raised to her head, a symbol of mourning. The men are seemingly interchangeable parts in a rigidly disciplined war machine.

The succeeding centuries, between about 1100 and 900 BCE, were a "dark age" in the Aegean, marked by political, economic, and artistic instability and upheaval. But a new culture was forming, one that looked back to the exploits of the Helladic warrior-kings as the glories of a heroic age, while setting the stage for a new Greek civilization.

IN PERSPECTIVE

The study of the eastern Mediterranean—the Aegean Sea—is, in some senses, the newest of archeological studies. The culture of Mycenae, home of Agamemnon and the setting of the great Homeric tragedies, was discovered only at the end of the nineteenth century, and Knossos on Crete, the home of the Minotaur as well as King Minos, only at the beginning of the twentieth century.

The legends and myths of the Greeks and the epics of Homer—long part of the Western literary tradition—were at last given material form. The architectural complex of Knossos, with its open courts and sweeping stairs, also included living quarters, workrooms, storehouses, and a large performance area, but no grandiose tombs or temples. Relatively secure in its island location, the palace had few outer walls and watchtowers. Minoan art as reconstructed seems open, colorful, and filled with images of nature.

Three parallel geographical groups existed simultaneously, and the groups flourished at different times. Cycladic civilization peaked first in a Bronze Age culture beginning in 3000 BCE and characterized, as far as monuments in the history of art are concerned, by marble figures of women and musicians. On Crete, the Minoan culture had existed since Neolithic times but flourished in the Old and New Palace periods from about 1900 to about 1450 BCE. Minoan art is characterized by elaborate and lightly fortified architectural complexes (which we call palaces), wall painting, and work in precious and semiprecious materials—gold, ivory, bronze, steatite, ceramics, and textiles. On the mainland of Greece, the Mycenaeans rose to dominance about 1600 BCE with fortified citadels, princely burials, and magnificent gold and bronze equipment. The culture continued until about 1100 BCE, but by the year 1000 BCE this Aegean Age comes to an end.

SEATED HARP PLAYER
c. 2700–2500 BCE

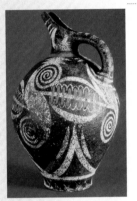

KAMARES WARE JUG
c. 2000–1900 BCE

VAPHEIO CUP
c. 1650–1450 BCE

BULL LEAPING
c. 1550–1450 BCE

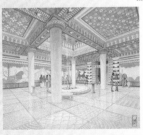

**MEGARON IN THE PALACE
OF PYLOS**
c. 1300–1200 BCE

3000
BCE

2500

2000

1500

1000
BCE

AEGEAN ART

◄ **Aegean Bronze Age**
c. 3000–2000 BCE

◄ **Cycladic Culture**
c. 3000–1600 BCE

◄ **Bronze Age Culture on Crete**
c. 3000 BCE

◄ **Helladic Culture** 3000–1000 BCE

◄ **Minoan Old Palace**
c. 1900–1700 BCE

◄ **Minoan New Palace**
c. 1700–1450 BCE

◄ **Mycenaean Culture**
c. 1600–1100 BCE

◄ **Late Minoan** c. 1450–1100 BCE

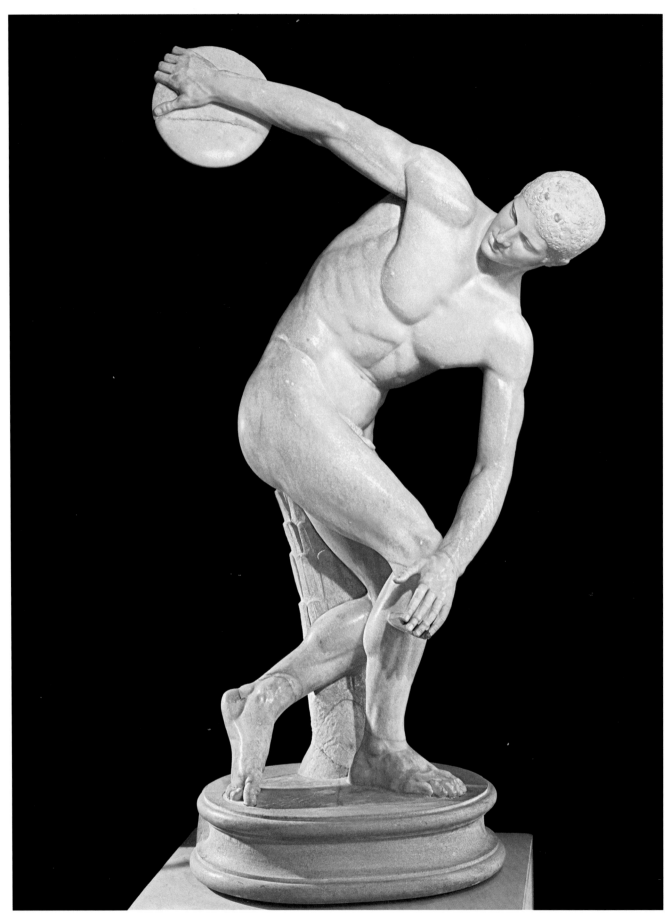

5-1 | Myron **DISCUS THROWER (DISKOBOLOS)** Roman copy after the original bronze of c. 450 BCE. Marble, height 5′11″ (1.55 m). National Museum, Rome.

ART OF ANCIENT GREECE

A sense of awe fills the stadium when the athletes recognized as the best in the world enter. With the opening ceremonies behind them, each has only one goal: to win—to earn recognition as the best, to take home the championship. This competition began more than 2,500 years ago, but the scene seems familiar. Every four years, then as now, the best athletes came together. Attention would focus on physical competition, on the individual human beings who seemed able to surpass even their own abilities—in such feats as running, wrestling, riding, discus throwing, long jumping, boxing, and javelin hurling—in the glorious pursuit of an ideal. Yet beyond those common elements lie striking differences between the Olympian Games of the past and the Olympic Games of the present.

At those first Olympian Games, the contests had a strong religious aspect. The athletes gathered on sacred ground (near Olympia, in present-day Greece) to pay tribute to the supreme god, Zeus. The first day's ceremonies were religious rituals, and the awards were crowns of wild olive leaves from the Sacred Grove of the gods. The winners' deeds were celebrated by poets long after their victories, and the greatest athletes were idealized for centuries in extraordinary Greek sculpture, such as the **DISCUS THROWER (DISKOBOLOS)**, originally created in bronze by Myron about 450 BCE **(FIG. 5–1)**.

The hero Herakles was believed to be the founder of the Olympian Games. According to the ancients, Herakles drew up the rules and decided the size of the stadium. The Olympian Games came to be so highly regarded that the city-states suspended all political activities while the Games were in progress. The Games may have begun in the ninth century BCE; a list of winners survives from 776 BCE. Games were held every four years until they were banned in 393 CE by the Christian Roman emperor Theodosius I. They did not resume for centuries: The first modern Olympic Games were held in Athens in 1896. The modern Olympics too begin with the lighting of a flame from a torch ignited by the sun at Olympia and carried by relay to the chosen site for a particular year—an appropriate metaphor for the way the light of inspiration was carried from ancient Greece throughout the Western world. But Olympic Games were not the only contribution the Greeks made to world civilization.

"Man is the measure of all things," concluded Greek sages. Supremely self-aware and self-confident, the Greeks developed a concept of human supremacy and responsibility into a worldview that demanded a new visual expression in art. Artists studied the human figure intensely, then distilled their newfound knowledge to capture the essence of *humanity*—a term that, by the Greeks' definition, applied only to those who spoke Greek; they considered those who could not speak Greek "barbarians."

Greek customs, institutions, and ideas have had an enduring influence in many parts of the world. Countries

that esteem athletic prowess reflect an ancient Greek ideal. Systems of higher education in the United States and Europe also owe much to ancient Greek models. Many important Western philosophies have conceptual roots in ancient Greece. And representative governments throughout the world today owe a debt to ancient Greek experiments in democracy.

CHAPTER-AT-A-GLANCE

THE EMERGENCE OF GREEK CIVILIZATION

Ancient Greece was a mountainous land of spectacular natural beauty. Olive trees and grapevines grew on the steep hillsides, producing oil and wine. But with little good farmland, the Greeks turned to commerce to supply their needs. In towns, skilled artisans provided metal and ceramic wares to exchange abroad for grain and raw materials. Greek merchant ships carried pots, olive oil, and bronzes from Athens, Corinth, and Aegina around the Mediterranean Sea. The Greek cultural orbit included mainland Greece with the Peloponnesus in the south and Macedonia in the north, the Aegean Islands, and the western coast of Asia Minor (MAP 5–1). Greek colonies in Italy, Sicily, and Asia Minor rapidly became powerful independent commercial and cultural centers themselves, but they remained tied to the homeland by common language, traditions, religion, and history.

More than 2,000 years have passed since the artists and architects of ancient Greece worked, yet their achievements continue to have a profound influence. Their legacy is especially remarkable given their relatively small numbers, the almost constant warfare that beset them, and the often harsh economic conditions of the time. Greek artists sought a level of perfection that led them continually to improve upon their past accomplishments through changes in style and technique. The history of Greek art contrasts dramatically with that of Egyptian art, where the desire for permanence and continuity induced artists to maintain artistic conventions for

nearly 3,000 years. In the comparatively short time span from around 900 BCE to about 100 BCE, Greek artists explored a succession of new ideas to produce a body of work in every medium—from painting and mosaics to ceramics and sculpture—that exhibits a clear stylistic and technical direction toward representing the visual world as we see it. The periods into which ancient Greek art is traditionally divided reflect the definable stages in this stylistic progression.

Historical Background

Following the collapse of Mycenaean dominance about 1100–1025 BCE, the Aegean region experienced a period of disorganization during which most prior cultural developments, including writing, were destroyed or forgotten. Greeks in the ninth and eighth centuries BCE developed the city-state (*polis*), an autonomous region having a city—Athens, Corinth, Sparta—as its political, economic, religious, and cultural center. Each was independent, deciding its own form of government, securing its own economic support, and managing its own domestic and foreign affairs. The power of these city-states initially depended at least as much on their manufacturing and commercial skills as on their military might. In the seventh century BCE, the Greeks adopted two sophisticated new tools, coinage from Asia Minor and alphabetic writing from the Phoenicians, opening the way for success in commerce and literature.

Among the emerging city-states, Corinth, located on major land and sea trade routes, was one of the oldest and

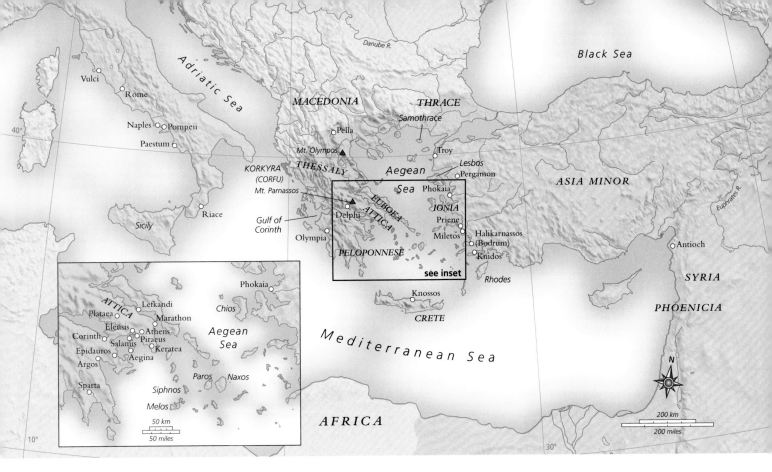

MAP 5-1 ANCIENT GREECE

During the Hellenistic period, Greek influence extended beyond mainland Greece to Macedonia, Egypt, and Asia Minor.

most powerful. By the sixth century BCE, Athens, located in Attica on the east coast of the mainland, began to assume both commercial and cultural preeminence. By the end of the sixth century, Athens had a representative government in which every community had its own assembly and magistrates. All citizens participated in the assembly and all had an equal right to own private property, to exercise freedom of speech, to vote and hold public office, and to serve in the army or navy. Citizenship, however, remained an elite male prerogative. The census of 309 BCE in Athens listed 21,000 citizens, 10,000 foreign residents, and 400,000 others—that is, women, children, and slaves. In spite of the exclusive and intensely patriarchal nature of citizenship, the idea of citizens with rights and responsibilities was an important new concept in governance.

Religious Beliefs and Sacred Places

Knowledge of Greek history is important to understanding its arts; knowledge of its religious beliefs is indispensable. According to ancient Greek legend, the creation of the world involved a battle between the earth gods, called Titans, and

the sky gods. The victors were the sky gods, whose home was believed to be atop Mount Olympus in the northeast corner of the Greek mainland. The Greeks saw their gods as immortal and endowed with supernatural powers, but more than peoples of the ancient Near East and the Egyptians, they also visualized them in human form and attributed to them human weaknesses and emotions. Among the most important deities were the ruling god and goddess, Zeus and Hera; Apollo, god of healing, arts, and the sun; Poseidon, god of the sea; Ares, god of war; Aphrodite, goddess of love; Artemis, goddess of hunting and the moon; and Athena, the powerful goddess of wisdom who governed several other important aspects of human life (see "Greek and Roman Deities," page 110).

SANCTUARIES. Many sites throughout Greece, called **sanctuaries**, were thought to be sacred to one or more gods. Local people enclosed the sanctuaries and designated them as sacred ground. The earliest sanctuaries had one or more outdoor altars or shrines and a sacred natural element such as a tree, a rock, or a spring. As more buildings were added, a

Art and Its Context

GREEK AND ROMAN DEITIES

According to legend, twelve major sky gods and goddesses established themselves on Mount Olympos in northeastern Greece after defeating the earth deities (the Titans) for control of the earth and sky. (The Roman form of the name is given after the Greek name.)

THE FIVE CHILDREN OF EARTH AND SKY

Zeus (Jupiter), supreme deity. Mature, bearded man; holds scepter or lightning bolt; eagle and oak tree are sacred to him.

Hera (Juno), goddess of marriage. Sister/wife of Zeus. Mature woman; cow and peacock are sacred to her.

Hestia (Vesta), goddess of the hearth. Sister of Zeus. Her sacred flame burned in communal hearths.

Poseidon (Neptune), god of the sea. Holds a three-pronged spear; horse is sacred to him.

Hades (Pluto), god of the underworld, the dead, and wealth. His helmet makes the wearer invisible.

THE SEVEN SKY GODS, OFFSPRING OF THE FIRST FIVE

Ares (Mars), god of war. Son of Zeus and Hera. Wears armor; vulture and dog are sacred to him.

Hephaistos (Vulcan), god of the forge, fire, and metal handicrafts. Son of Hera (in some myths, also of Zeus); husband of Aphrodite. Lame, sometimes ugly; wears blacksmith's apron, carries hammer.

Apollo (Phoebus), god of the sun, light, truth, music, archery, and healing. Sometimes identified with Helios (the Sun), who rides a chariot across the daytime sky. Son of Zeus and Leto (a descendant of Earth); brother of Artemis. Carries bow and arrows or sometimes lyre; dolphin and laurel are sacred to him.

Artemis (Diana), goddess of the hunt, wild animals, and the moon. Sometimes identified with Selene (the Moon), who rides a chariot or oxcart across the night sky. Daughter of Zeus and Leto; sister of Apollo. Carries bow and arrows, is accompanied by hunting dogs; deer and cypress are sacred to her. Also the goddess of childbirth and unwed young women.

Athena (Minerva), goddess of wisdom, war, victory, and the city. Also goddess of handcrafts and other artistic skills. Daughter of Zeus; sprang fully grown from his head. Wears helmet and carries shield and spear; owl and olive trees are sacred to her.

Aphrodite (Venus), goddess of love. Daughter of Zeus and the water nymph Dione; alternatively, born of sea foam; wife of Hephaistos. Myrtle, dove, sparrow, and swan are sacred to her.

Hermes (Mercury), messenger of the gods, god of fertility and luck, guide of the dead to the underworld, and god of thieves and commerce. Son of Zeus and Maia, the daughter of Atlas, a Titan who supports the sky on his shoulders. Wears winged sandals and hat; carries caduceus, a wand with two snakes entwined around it.

OTHER IMPORTANT DEITIES

Demeter (Ceres), goddess of grain and agriculture. Daughter of Kronos and Rhea, Sister of Zeus and Hera.

Persephone (Proserpina), goddess of fertility and queen of the underworld. Wife of Hades; daughter of Demeter.

Dionysos (Bacchus), god of wine, the grape harvest, and inspiration. Shown surrounded by grapevines and grape clusters; carries a wine cup. His female followers are called maenads (Bacchantes).

Eros (Cupid), god of love. In some myths, the son of Aphrodite. Shown as an infant or young boy, sometimes winged; carries bow and arrows.

Pan (Faunus), protector of shepherds, god of the wilderness and of music. Half-man, half-goat, he carries panpipes.

Nike (Victory), goddess of victory. Often shown winged and flying.

sanctuary might become a palatial home for the gods, with one or more temples, several treasuries for storing valuable offerings, various monuments and statues, housing for priests and visitors, an outdoor dance floor or permanent theater for ritual performances and literary competitions, and a stadium for athletic events. The Sanctuary of Zeus near Olympia, in the western Peloponnese, housed an extensive athletic facility with training rooms and arenas for track-and-field events. It was here that athletic competitions, prototypes of today's Olympic Games, were held.

Greek sanctuaries are quite different from the religious complexes of the ancient Egyptians (see, for example, the Temple of Karnak, figs. 3–22, 3–23). Egyptian builders dramatized the power of gods or god-rulers by organizing their temples along straight, processional ways. The Greeks, in contrast, treated each building and monument as an independent element to be integrated with the natural features of the site. It is tempting to draw a parallel between this manner of organizing space and the way Greeks organized themselves politically. Every structure, like every Greek citizen, was a unique entity meant to be encountered separately within its own environment while being closely allied with other entities in a larger scheme of common purpose.

DELPHI. The temple at Delphi, the sacred home of the Greek god Apollo, was built about 530 BCE on the site of an earlier temple (FIG. 5–2). In this rugged mountain site, according to Greek myth, Zeus was said to have released two

eagles from opposite ends of the earth and they met exactly at the site of Apollo's sanctuary. Here too, it was said, Apollo fought and killed Python, the serpent son of the earth goddess Ge, who guarded his mother's nearby shrine. From very early times, the sanctuary at Delphi was renowned as an *oracle*, a place where the god was believed to communicate with humans by means of cryptic messages delivered through a human intermediary, or *medium* (the Pythia). The Greeks and their leaders routinely sought advice at oracles, and attributed many twists of fate to misinterpretations of the Pythia's statements. Even foreign rulers requested help at Delphi.

Delphi was the site of the Pythian Games which, like the Olympian Games, attracted participants from all over Greece. The principal events were the athletic contests and the music, dance, and poetry competitions in honor of Apollo. As at Olympia, hundreds of statues dedicated to the victors of the competitions, as well as mythological figures, filled the sanctuary grounds. The sanctuary of Apollo included the main temple, performance and athletic areas, treasuries, and other buildings and monuments, which made full use of limited space on the hillside.

After visitors climbed the steep path up the lower slopes of Mount Parnassos, they entered the sanctuary by a ceremonial gate in the southeast corner. From there they zigzagged up the Sacred Way, so named because it was the route of religious processions during festivals. Moving past the numerous treasuries and memorials built by the city-states, they arrived at the long colonnade of the Temple of Apollo. Below the temple was a **stoa**, a columned pavilion open on three sides, built by the people of Athens. There visitors rested, talked, or watched ceremonial dancing. At the top of the sanctuary hill was a stadium area for athletic contests.

Historical Divisions of Greek Art

The names of major periods of Greek art have remained in use, even though changing interpretations have led some art historians to question their appropriateness. The primary source of information about Greek art before the seventh century BCE is pottery, and the Geometric period (c. 900–700 BCE) owes its name to the geometric, or rectilinear, forms with which artists of the time decorated ceramic vessels. The Orientalizing period (c. 700–600 BCE) is named for the apparent influence of Egyptian and Near Eastern art on Greek pottery of that time, spread through trading contacts as well as the travels of artists themselves. The name of the third period, *Archaic*, meaning "old" or "old-fashioned," stresses a presumed contrast between the art of that time (c. 600–480 BCE) and the art of the following Classical period, once thought to be the most admirable and highly developed. It is a view that no longer prevails among art historians.

The Classical period has been subdivided into three phases: the Early Classical period or transitional style from about 480 to 450 BCE; the High Classical period, from about 450 to the end of the fifth century BCE; and the Late

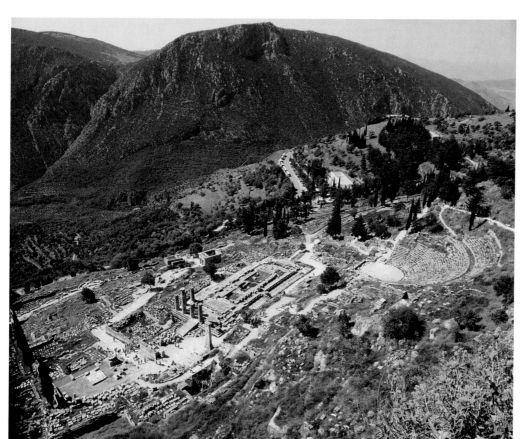

5–2 | **SANCTUARY OF APOLLO, DELPHI**
6th–3rd century BCE.

Classical, from about 400 to about 323 BCE. High Classical art was once known as the "Golden Age" of Greece. The name of the final period of Greek art, *Hellenistic*, means "Greek-like." Hellenistic art was produced throughout the eastern Mediterranean world as non-Greek people gradually became imbued with Greek culture under Alexander and his successors (323–30 BCE). The history and art of ancient Greece end with the fall of Egypt to the Romans in 31 BCE and the death of Cleopatra one year later.

GREEK ART FROM c. 900 to c. 600 BCE

Around the mid-eleventh century BCE, a new culture began to develop from the ashes of the Mycenaean civilization. A style of ceramic, decorated with organized abstract designs, appeared in Athens and spread to the rest of Greece. This development signaled an awakening that was soon followed by the creation of monumental ceramic vessels embellished with complex geometric designs, the resumption of bronze casting, and perhaps the construction of religious architecture. In this Geometric period, the Greeks, as we now call them, were beginning to create their own architectural forms and were trading actively with their neighbors to the east. By c. 700 BCE, in a phase called the Orientalizing period, they began to incorporate exotic motifs into their native art.

The Geometric Period

The first appearance of a specifically Greek style of vase painting, as opposed to Minoan or Mycenaean, dates to about 1050 BCE. This style—known as Proto-Geometric because it anticipated the Geometric style—was characterized by linear motifs, such as spirals, diamonds, and cross-hatching, rather than the stylized plants, birds, and sea creatures characteristic of Minoan vase painting. The Geometric style proper, an extremely complex form of decoration, became widespread after about 900 BCE in all types of art and endured until about 700 BCE.

CERAMICS. A striking ceramic figure of a half-horse, half-human creature called a centaur dates to the end of the tenth century BCE (FIG. 5–3). This figure exemplifies two aspects of the Proto-Geometric style: the use of geometric forms in painted decoration, and the reduction of human and animal body parts to simple geometric solids, such as cubes, pyramids, cylinders, and spheres. The figure is unusual, however, because of its large size (more than a foot tall) and because its hollow body was formed like a vase on a potter's wheel. The artist added solid legs, arms, and a tail (now missing) and then painted the bold, abstract designs with **slip**, a mixture of water and clay. The slip fired to dark brown, standing out against the lighter color of the unslipped portions of the figure.

Centaurs, prominent in Greek mythology, had both a good and a bad side and may have symbolized the similar

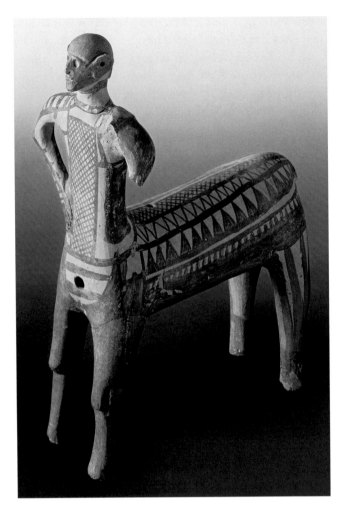

5–3 | CENTAUR
Lefkandi, Euboea. Late 10th century BCE. Ceramic, height 14⅛" (36 cm). Archaeological Museum, Eretria, Greece.

dual nature of humans. This centaur, discovered in a cemetery, had been deliberately broken into two pieces that were buried in adjacent graves. Clearly, the object had special significance for the people buried in the graves or for their mourners.

Large funerary vases were used as grave markers (FIG. 5–4). The ancient cemetery of Athens just outside the Dipylon Gate, once the main western entrance into the city, contained many vases with the complex decoration typical of the Geometric style proper (c. 900–700 BCE). For the first time, human beings are depicted as part of a narrative. The **krater** illustrated here, a grave marker dated about 750 BCE, provides a detailed record of the funerary rituals—including the relatively new Greek practice of cremation—for an important person. The body of the deceased is placed on its side on a funeral bier, about to be cremated, as seen on the center of the top register of the vase. Male and female figures stand on each side of the body, their arms raised and both hands placed on top of their heads in a gesture interpreted as expressing anguish—it suggests that the mourners are literally tearing their hair out with grief. In the bottom register, horse-drawn

chariots and foot soldiers, who look like walking shields with tiny antlike heads and muscular legs, form a procession.

The abstract forms used to represent human figures on this pot—triangles for torsos; more triangles for the heads in profile; round dots for eyes; long, thin rectangles for arms; tiny waists; and long legs with bulging thigh and calf muscles—are typical of the Geometric style. Figures are shown in either full-frontal or full-profile views that emphasize flat patterns and outline shapes. No attempt has been made to create the illusion of three-dimensional forms occupying real space. The artist has nevertheless communicated a deep sense of human loss by exploiting the rigidity, solemnity, and strong rhythmic accents of the carefully arranged elements.

Egyptian funerary art reflected the belief that the dead, in the afterworld, could continue to engage in activities they enjoyed while alive. Greek funerary art, in contrast, focused on the emotional reactions of the survivors. The scene of human mourning on this pot contains no supernatural beings, nor any identifiable reference to an afterlife. According to the Greeks, the deceased entered a place of mystery and obscurity that living humans could not define precisely.

Sequencing Events
KEY PERIODS IN GREEK ART

c. 1050–900 BCE	Proto-Geometric Period
c. 900–700 BCE	Geometric Period
c. 700–600 BCE	Orientalizing Period
c. 600–480 BCE	Archaic Period
c. 480–450 BCE	Early Classical Period
c. 450–400 BCE	High Classical Period
c. 400–323 BCE	Late Classical Period
323–31/30 BCE	Hellenistic Period

METAL SCULPTURE. Greek artists of the Geometric period produced many figurines of wood, ivory, clay, and cast bronze. These small statues of humans and animals are similar to those painted on pots. A tiny bronze of this type, MAN AND CENTAUR, dates to about 750 BCE (FIG. 5–5). (Although there were wise and good centaurs, the theme of battling man and centaur is found throughout Greek art.) The two figures

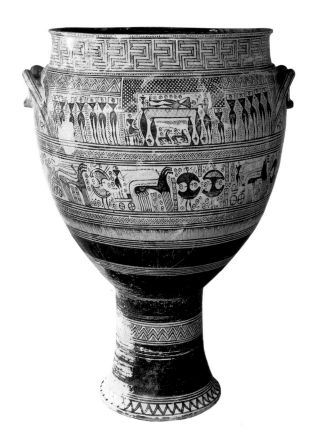

5–4 | **FUNERARY VASE (KRATER)**
Dipylon Cemetery, Athens. c. 750–700 BCE. Attributed to the Hirschfeld Workshop. Ceramic, height 42⅜" (108 cm). The Metropolitan Museum of Art, New York.
Rogers Fund, 1914 (14.130.14)

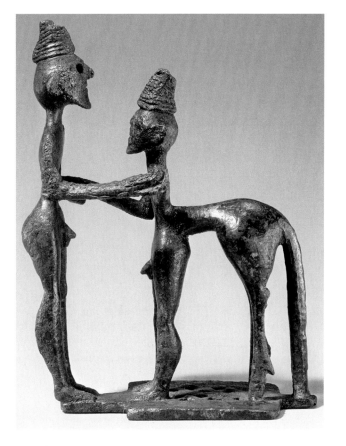

5–5 | **MAN AND CENTAUR**
Perhaps from Olympia. c. 750 BCE. Bronze, height 4⁵⁄₁₆"
(11.1 cm). The Metropolitan Museum of Art, New York.
Gift of J. Pierpont Morgan, 1917 (17.190.2072)

Technique
GREEK PAINTED VASES

The three main techniques for decorating Greek painted vases were **black-figure**, **red-figure**, and **white-ground**. The painters used a complex procedure that involved preparing a **slip** (a mixture of clay and water), applying the slip to the vessel, and carefully manipulating the firing process in a **kiln** (a closed oven) to control the amount of oxygen reaching the ceramics. This firing process involved three stages. In the first stage, oxygen was allowed into the kiln, which "fixed" the whole vessel in one overall shade of red depending on the composition of the clay. Then, in the second (reduction) stage, the oxygen in the kiln was cut back (reduced) to a minimum, turning the vessel black, and the temperature was raised to the point at which the slip partially vitrified (became glasslike). Finally, in the third stage, oxygen was allowed back into the kiln, turning the unslipped areas back to a shade of red. The areas where slip had been applied, which were sealed against the oxygen, remained black. The "reds" varied from dark terra cotta to pale yellow.

In the black-figure technique, artists painted designs—figures, objects, or abstract motifs—with slip in silhouette on the clay vessels. Then using a sharp tool (a **stylus**), they cut through the slip to the body of the vessel, incising linear details within the silhouette. In the red-figure technique, the approach was reversed. Artists painted the background around the figures with the slip and drew details within the figures with the same slip using a brush. In both techniques artists often enhanced their work with touches of white and reddish-purple gloss, pigments mixed with slip. Firing produced the distinctive black (SEE FIG. 5-21) or red (SEE FIG. 5-29) images.

White-ground vases became popular in the Classical period. A highly refined clay slip produced the white ground on which the design elements were painted. After firing the vessel, the artists frequently added details and areas of bright and pastel hues which, because they were added after firing, flaked off easily. Few perfect examples have survived (SEE FIG. 5-46).

confront each other after the man—perhaps Herakles—has stabbed the centaur; the spearhead is visible on the centaur's left side. The centaur must have had a branch or club in his (now missing) right hand. The sculptor reduced the body parts of the figures to simple geometric shapes, arranging them in a composition of solid forms and open, or negative, spaces that makes the piece pleasing from every view. Most such works have been found in sanctuaries, suggesting that they may have been votive offerings to the gods.

THE FIRST GREEK TEMPLES. Greeks worshiped at outdoor altars within sanctuaries where a temple sheltered a statue of a god. Few ancient Greek temples remain standing today. Stone foundations define their rectangular shape, and their appearance has been pieced together largely from fallen columns, broken lintels, and fragments of sculpture lying where they fell centuries ago. Walls and roofs constructed of mud brick and wood have disappeared.

The rectangular building had a door at one end sheltered by a projecting **porch** supported on two sturdy posts. The steeply pitched roof forms a triangular area, or **pediment**, in the **façade**, or front wall that is pierced by an opening directly above the door. The interior followed an enduring basic plan: a large main room called the **cella**, or **naos**, preceded by a small reception area or vestibule, called the **pronaos**.

The Orientalizing Period

By the seventh century BCE, vase painters in major pottery centers in Greece had moved away from the dense linear decoration of the Geometric style. They now created more open compositions built around large motifs that included real and imaginary animals, abstract plant forms, and human figures. The source of these motifs can be traced to the arts of the Near East, Asia Minor, and Egypt. Greek painters did not simply copy the work of Eastern artists, however. Instead, they drew on work in a variety of mediums—including sculpture, metalwork, and textiles—to invent an entirely new approach to vase painting.

The Orientalizing style (c. 700–600 BCE) began in Corinth, a port city where luxury wares from the Near East and Egypt inspired artists. The new style is evident in a Corinthian **olpe**, or wide-mouthed pitcher, dating to about 600 BCE, which shows silhouetted creatures striding in horizontal bands against a light background with stylized flower forms called **rosettes** (FIG. 5–6). An example of the **black-figure pottery** style, it is decorated with dark shapes of lions, a serpent, and composite creatures against a background of very pale buff, the natural color of the Corinthian clay (see "Greek Painted Vases," above). The artist incised fine details inside the silhouetted shapes with a sharp tool and added touches of white and reddish purple **gloss**, or clay slip mixed with metallic color pigments, to enhance the design.

THE ARCHAIC PERIOD,
c. 600–480 BCE

During the Archaic period, from c. 600 to c. 480 BCE, the Greek city-states on the mainland, on the Aegean islands, and in the colonies grew and flourished. Athens, which had lagged behind the others in population and economic devel-

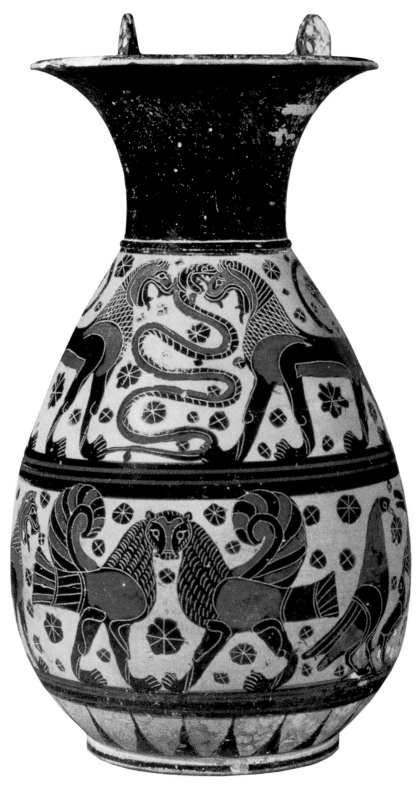

5–6 | PITCHER (OLPE)
Corinth. c. 600 BCE. Ceramic with black-figure decoration, height 11½″ (30 cm).
The British Museum, London.

opment, began moving artistically, commercially, and politically to the forefront.

The Greek arts developed rapidly during the Archaic period. In literature, the poet Sappho on the island of Lesbos was writing poetry that would inspire the geographer Strabo, near the end of the millennium, to write: "Never within human memory has there been a woman to compare with her as a poet." On another island, the semilegendary slave Aesop was relating animal fables that became lasting elements in Western culture. Artists shared in the growing prosperity of

Elements of Architecture
GREEK TEMPLE PLANS

The simplest early temples consist of a single room, the **cella**, or **naos**. Side walls ending in attached **pillars** (**anta**) may project forward to frame two columns **in antis** (literally, "between the pillars"), as seen in plan (a). An **amphiprostyle** temple (b) has a row of columns (**colonnade**) at the front and back ends of the structure, not on the sides, forming **porticos**, or covered entrance porches, at the front and back. If the colonnade runs around all four sides of the building, forming a **peristyle**, the temple is **peripteral** (c and d). Plan (c), the Temple of Hera I at Paestum, Italy, shows a **pronaos** and an **adyton**, an unlit inner chamber. Plan (d), the Parthenon, has an **opithodomos**, enclosed porch, not an adyton, at the back. The **stylobate** is the top step of the **stereobate**, or layered foundation.

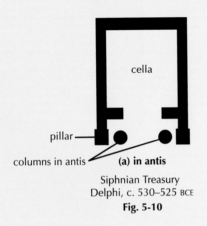

(a) in antis

Siphnian Treasury
Delphi, c. 530–525 BCE
Fig. 5-10

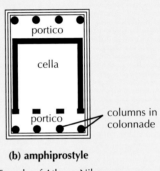

(b) amphiprostyle

Temple of Athena Nike
Athens, c. 425 BCE
Fig. 5-41

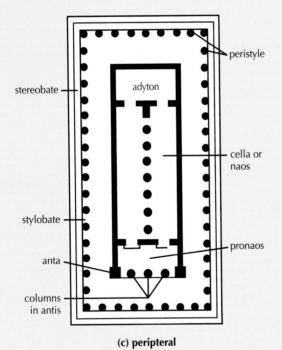

(c) peripteral

Temple of Hera I,
Paestum, Italy, c. 550 BCE
Fig. 5-7

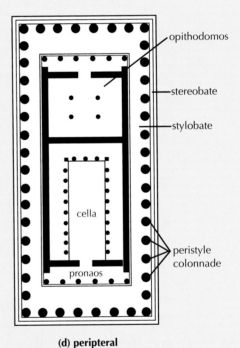

(d) peripteral

Parthenon, Athens,
447–432 BCE
Page 138

the city-states by competing for lucrative commissions from city councils and wealthy individuals, who sponsored the building of temples, shrines, government buildings, monumental sculpture, and fine ceramic wares. During this period, potters and vase painters began to sign their works.

Temple Architecture

As Greek temples grew steadily in size and complexity over the centuries, stone and marble replaced the earlier mud-brick and wood construction. A number of standardized plans evolved, ranging from simple, one-room structures with columned porches to buildings with double porches surrounded by columns (see "Greek Temple Plans," page 116). Builders also experimented with the design of temple elevations—the arrangement, proportions, and appearance of the columns and the lintels, which now grew into elaborate **entablatures**. Two elevation designs emerged during the Archaic period: the **Doric order** and the **Ionic order**. The **Corinthian order**, a variant of the Ionic order, developed later (see "The Greek Architectural Orders," page 118).

Paestum, the Greek colony of Poseidonia established in the seventh century BCE about 50 miles south of the modern city of Naples, Italy, contains some well-preserved early Greek temples. The earliest standing temple there, built about 550–540 BCE, was dedicated to Hera, the wife of Zeus (FIG. 5–7). It is known today as **HERA I** to distinguish it from a second temple to Hera built adjacent to it about a century later.

Hera I illustrates the early form of the Doric order temple. A row of columns called the **peristyle** surrounded the main room, the cella. A Doric column has a fluted **shaft** and a **capital** made up of the cushionlike **echinus** and the square **abacus**. These columns support an entablature distinguished by its **frieze**, where flat areas called **metopes** alternate with projecting blocks with three vertical grooves called **triglyphs**. Usually the metopes were either painted or carved in relief and then painted. Fragments of terra-cotta decorations painted in bright colors have also been found in the rubble of Hera I.

The builders of Hera I created an especially robust column, only about four times as high as its maximum diameter,

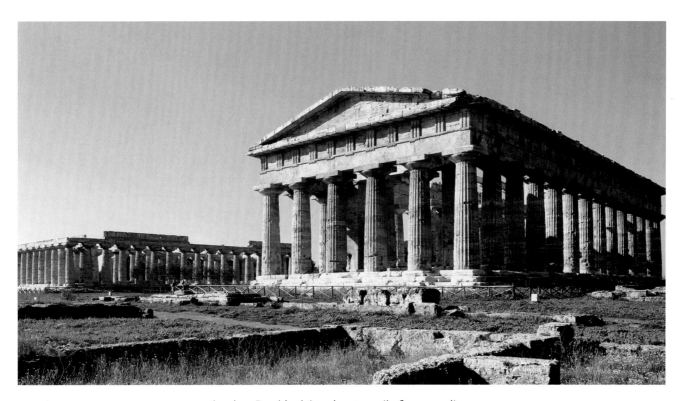

5–7 | **TEMPLE OF HERA I, PAESTUM** (ancient Poseidonia) and **HERA II** (in foreground)
Italy. c. 550–540 BCE (Hera I) and c. 470–460 BCE (Hera II).

Elements of Architecture
THE GREEK ARCHITECTURAL ORDERS

The three Classical Greek architectural orders are the Doric, the Ionic, and the Corinthian. Each order is made up of a system of interdependent parts whose proportions are based on mathematical ratios. No element of an order could be changed without producing a corresponding change in other elements.

The basic components of the Greek orders are the **column** and the **entablature**, which function as post and lintel. All types of columns have a **shaft** and a **capital**; Ionic and Corinthian also have a **base**. The shafts are formed of round sections, or **drums**, which are joined inside by metal pegs. In Greek temple architecture, columns stand on the **stylobate**, the "floor" of the temple.

The **Doric order** shaft rises directly from the stylobate, without a base. The shaft is **fluted**, or channeled, with sharp edges. The height of the column ranges from five-and-a-half to seven times the diameter of the base. At the top of the shaft and part of the capital is the **necking**, which provides a transition to the

capital. The Doric capital itself has three parts: the necking, the rounded **echinus**, and the tabletlike **abacus**. The entablature includes the **architrave**, the distinctive **frieze** of **triglyphs** and **metopes**, and the **cornice**, the topmost, projecting horizontal element. The roofline may have decorative waterspouts and terminal decorative elements called **acroteria**.

The **Ionic order** has more elongated proportions than the Doric, its height being about nine times the diameter of the column at its base. The flutes on the columns are deeper and closer together and are separated by flat surfaces called **fillets**. The **capital** has a distinctive scrolled **volute**; the entablature has a three-panel architrave, continuous sculptured or decorated frieze, and the addition of decorative moldings.

The **Corinthian order** was originally developed by the Greeks for use in interiors but came to be used on temple exteriors as well. Its elaborate capitals are sheathed with stylized **acanthus** leaves that rise from a convex band called the **astragal**.

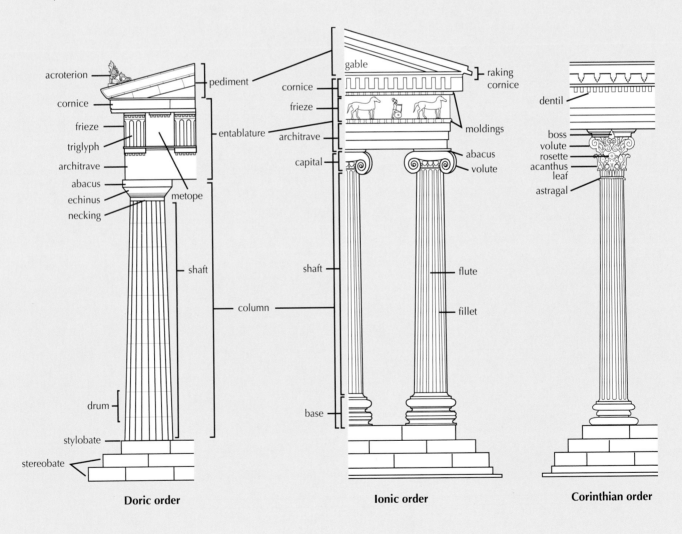

Doric order **Ionic order** **Corinthian order**

topped with a widely flaring capital. This design creates an impression of great stability and permanence, although it is rather ponderous. As the column shafts rise, they swell in the middle and contract again toward the top, a refinement known as **entasis**. This adjustment gives a sense of energy and upward lift. Hera I has an uneven number of columns—nine—across the short ends of the peristyle, with a column instead of a space at the center of the two ends. The entrance to the pronaos has three central columns, and a row of columns runs down the center of the wide cella to help support the ceiling and roof. The unusual two-aisle, two-door arrangement leading to the small room at the end of the cella proper suggests that the temple had two presiding deities: either Hera and Poseidon (patron of the city), or Hera and Zeus (her consort), or perhaps Hera in her two manifestations (as warrior and protector of the city and as mother and protector of children).

Architectural Sculpture

As Greek temples grew larger and more complex, sculptural decoration took on increased importance. Among the earliest surviving examples of Greek pediment sculpture are fragments of the ruined Doric order **TEMPLE OF ARTEMIS** on the island of Korkyra (Corfu) off the northwest coast of the mainland, which date to about 600–580 BCE (**FIG. 5–8**). The figures in this sculpture were carved on separate slabs, then installed in the pediment space. They stand in such high relief from the background plane that they actually break through the architectural frame, which was more than 9 feet tall at the peak.

At the center of the pediment is the rampaging snake-haired **MEDUSA** (**FIG. 5–9**), one of three winged female monsters with wings called Gorgons. Medusa had the power to turn humans to stone if they should look upon her face, and in this sculpture she fixes viewers with huge glaring eyes as if to work her dreadful magic on them. Ancient Greeks would have seen the image of Medusa at the center of this pediment as both menacing and protecting the temple. The Greek hero Perseus, instructed and armed by Athena, beheaded Medusa while looking only at her reflection in his polished shield. The Medusa head became a popular decoration for Greek armor (see **FIG. 5–22**, which shows Achilles' and Ajax's shields.)

The much smaller figures flanking Medusa are the flying horse Pegasus on the left (only part of his rump and tail remain) and the giant Chrysaor on the right. These were Medusa's posthumous children (whose father was Poseidon), born from the blood that gushed from her neck after she was beheaded by Perseus. The felines crouching next to them literally bump their heads against the raking cornices of the roof. Dying human warriors lie at the ends of the pediment,

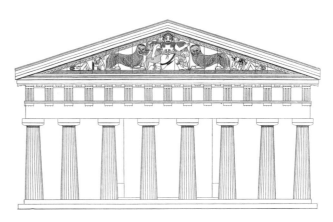

5–8 | **RECONSTRUCTION OF THE WEST FAÇADE OF THE TEMPLE OF ARTEMIS, KORKYRA (CORFU)**
After G. Rodenwaldt and H. Schleif. c. 600–580 BCE.

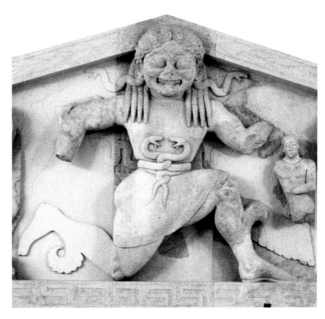

5–9 | **GORGON MEDUSA**
Detail of sculpture from the west pediment of the *Temple of Artemis*, Korkyra. c. 600–580 BCE. Limestone, height of pediment at the center 9′2″ (2.79 m). Archaeological Museum, Korkyra (Corfu).

their heads tucked into its corners and their knees rising with its sloping sides. Such changes of scale and awkward positioning are characteristic of Archaic temple sculpture.

TREASURY OF THE SIPHNIANS. An especially noteworthy collaboration between builder and sculptor can still be seen in the small but luxurious **TREASURY OF THE SIPHNIANS**, built in the sanctuary of Apollo at Delphi between about 530 and 525 BCE and housed today in fragments in the museum at Delphi. Instead of columns, the builders used two **caryatids**—columns carved in the form of clothed

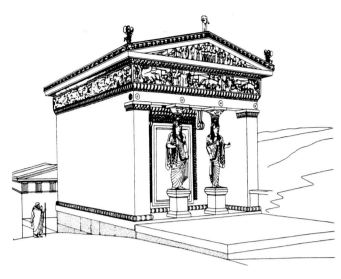

5–10 | RECONSTRUCTION DRAWING OF THE TREASURY OF THE SIPHNIANS, DELPHI
Sanctuary of Apollo, Delphi. c. 530–525 BCE.

This small treasury building at Delphi was originally elegant and richly ornamented. The figure sculpture and decorative moldings were once painted in strong colors, mainly dark blue, bright red, and white, with touches of yellow to resemble gold. The people who commissioned this treasury were from Siphnos, an island in the Aegean Sea just southwest of the Cyclades.

women—(FIG. 5–10). The stately caryatids, with their finely pleated, flowing garments, are raised on pedestals and balance elaborately carved capitals on their heads. The capitals support a tall entablature conforming to the Ionic order, which features a plain, or three-panel, architrave and a continuous carved frieze, set off by richly carved moldings (see "The Greek Architectural Orders," page 118).

Both the continuous frieze and the pediments of the Siphnian Treasury were originally filled with relief sculpture. A surviving section of the frieze from the building's north side, which shows a scene from the legendary battle between the Gods and the Giants, is one of the earliest known examples of a trend in Greek relief sculpture toward a more natural representation of space (FIG. 5–11). To give a sense of three dimensions, the sculptor placed some figures behind others, overlapping as many as three of them and varying the depth of the relief. Countering any sense of deep recession, all the figures were made the same height with their feet on the same groundline.

THE TEMPLE OF APHAIA. The long friezes of Greek temples provided a perfect stage for storytelling, but the triangular pediment created a problem in composition. The sculptor of the east pediment of the Doric **TEMPLE OF APHAIA** at Aegina (FIG. 5–12), dated about 500–490 BCE, provided a creative

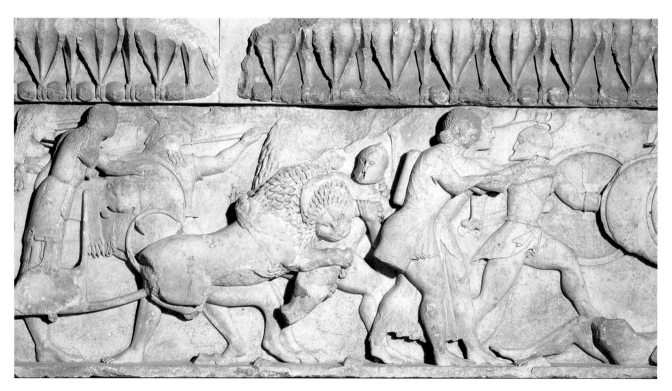

5–11 | BATTLE BETWEEN THE GODS AND THE GIANTS (TITANS)
Fragments of the north frieze of the Treasury of the Siphnians, from the Sanctuary of Apollo, Delphi.
c. 530–525 BCE. Marble, height 26″ (66 cm). Archaeological Museum, Delphi.

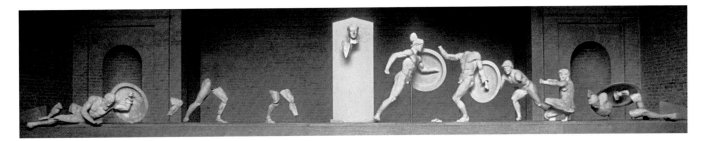

5–12 | EAST PEDIMENT OF THE TEMPLE OF APHAIA, AEGINA

c. 490 BCE. Width about 49′ (15 m). Surviving fragments as assembled in the Staatliche Antikensammlungen, Munich (early restorations removed).

solution that became a design standard, appearing with variations throughout the fifth century BCE. The subject of the pediment, rendered in fully three-dimensional figures, is an early military expedition against Troy led by Herakles (this is not the Troy of Homer's later epic). Fallen warriors fill the angles at both ends of the pediment base, while others crouch and lunge, rising in height toward an image of Athena as warrior goddess under the peak of the roof. The erect goddess, larger than the other figures and flanked by two defenders facing approaching opponents, dominates the center of the scene and stabilizes the entire composition.

Among the best-preserved fragments from this pediment scene is the **DYING WARRIOR** from the far left corner, a tragic but noble figure struggling to rise, pulling an arrow from his side, even as he dies (FIG. 5–13). This figure originally would have been painted and fitted with authentic bronze acces-

sories, heightening the sense of reality. Fully exploiting the difficult framework of the pediment corner, the sculptor portrayed the soldier's uptilted, twisted form turning in space, capturing his agony and vulnerability. The subtle modeling of the body conveys the softness of human flesh, which is contrasted with the hard, metallic geometry of the shield, helmet, and (now lost) bronze arrow.

Freestanding Sculpture

In addition to decorating temple architecture, sculptors of the Archaic period created a new type of large, freestanding statue made of wood, terra cotta, limestone, or white marble from the islands of Paros and Naxos. Frequently life-size or larger, these figures usually were standing or striding. They were brightly painted and sometimes bore inscriptions indicating that they had been commissioned

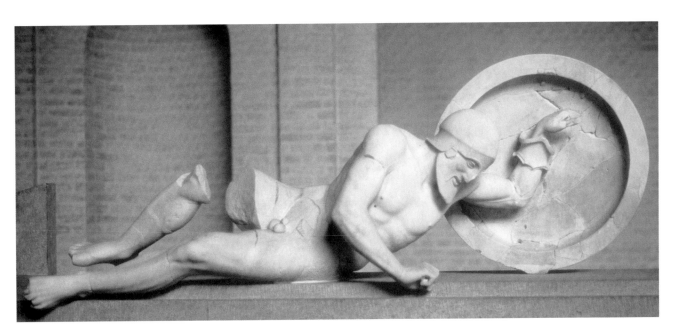

5–13 | DYING WARRIOR

Sculpture from the left corner of the east pediment of the Temple of Aphaia, Aegina. c. 500–490 BCE. Marble, length 6′ (1.83 m). Staatliche Antikensammlungen und Glyptothek, Munich.

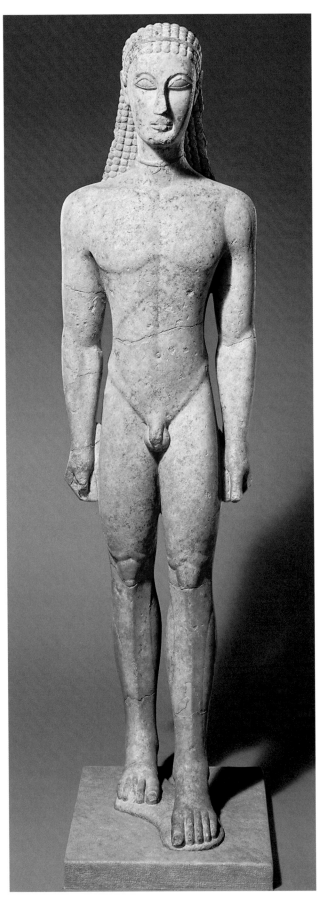

5-14 | **STANDING YOUTH (KOUROS)**
Attica. c. 600 BCE. Marble, height 6' (1.84 m).
The Metropolitan Museum of Art, New York.
Fletcher Fund, 1932 (32.11.1)

by individual men or women for a commemorative purpose. They have been found marking graves and in sanctuaries, where they lined the sacred way from the entrance to the main temple.

A female statue of this type is called a **kore** (plural, *korai*), Greek for "young woman," and a male statue is called a **kouros** (plural, *kouroi*), Greek for "young man." Archaic *korai*, always clothed, probably represented deities, priestesses, and nymphs, young female immortals who served as attendants to gods. *Kouroi*, nearly always nude, have been variously identified as gods, warriors, and victorious athletes. Because the Greeks associated young, athletic males with fertility and family continuity, the *kouroi* figures may have symbolized ancestors.

YOUNG MAN (*KOUROS*). A *kouros* dated about 600 BCE (**FIG. 5-14**) recalls the pose and proportions of Egyptian sculpture. As with Egyptian figures such as the statue of *Menkaure* (SEE FIG. 3-11), this young Greek stands rigidly upright, arms at his sides, fists clenched, and one leg slightly in front of the other. However, Greek artists of the Archaic period did not share the Egyptian obsession with permanence; they cut away all stone from around the body and introduced variations in appearance from figure to figure. Greek statues suggest the marble block from which they were carved, but they have a notable athletic quality quite unlike Egyptian statues.

Here the artist delineated the figure's anatomy with ridges and grooves that form geometric patterns. The head is ovoid, with heavy features and schematized hair evenly knotted into tufts and tied back with a narrow ribbon. The eyes are relatively large and wide open, and the mouth forms a characteristic closed-lip smile known as the **Archaic smile**. In Egyptian sculpture, male figures usually wore clothing associated with their status, such as the headdresses, necklaces, and kilts that identified them as kings. The total nudity of the Greek *kouroi*, in contrast, removes them from a specific time, place, or social class.

The powerful, rounded body of a *kouros* known as the **ANAVYSOS KOUROS**, dated about 530 BCE, clearly shows the increasing interest of artists and their patrons in a more lifelike rendering of the human figure (**FIG. 5-15**). The pose, wiglike hair, and Archaic smile echo the earlier style, but the massive torso and limbs have greater anatomical accuracy suggesting heroic strength. The statue, a grave monument to a fallen war hero, has been associated with a base inscribed: "Stop and grieve at the tomb of the dead Kroisos, slain by wild Ares [god of war] in the front rank of battle." However, there is no evidence that the figure was meant to represent Kroisos.

YOUNG WOMAN (*KORE*). The first Archaic *korai* are as severe and rigid as the male figures. The **BERLIN KORE**, found in a cemetery at Keratea and dated about 570–560 BCE, stands more than 6 feet tall (**FIG. 5-16**). The erect, immobile pose and full-bodied figure—accentuated by a crown and thick-

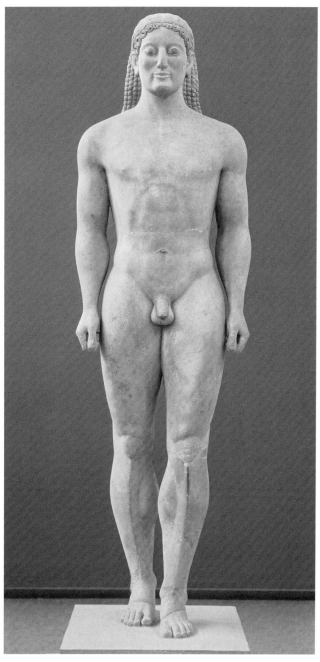

5–15 | **ANAVYSOS KOUROS**
Cemetery at Anavysos, near Athens. c. 530 BCE. Marble with remnants of paint, height 6'4" (1.93 m).
National Archaeological Museum, Athens.

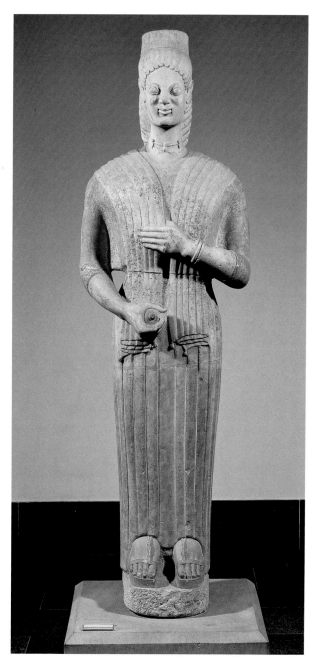

5–16 | **BERLIN KORE**
Cemetery at Keratea, near Athens. c. 570–560 BCE. Marble with remnants of red paint, height 6'3" (1.9 m). Staatliche Museen zu Berlin, Antikensammlung, Preussischer Kulturbesitz, Berlin.

soled clogs—seem appropriate to a goddess, although the statue may represent a priestess or an attendant. The thick robe and tasseled cloak over her shoulders fall in regularly spaced, parallel folds like the fluting on a Greek column, further emphasizing the stately appearance. Traces of red—perhaps the red clay used to make thin sheets of gold adhere—indicate that the robe was once painted or gilded. The figure holds a pomegranate in her right hand, a symbol of Persephone, who was abducted by Hades, the god of the underworld, and whose annual return brought the springtime.

The **PEPLOS KORE** (FIG. 5–17), which dates to about 530 BCE, is named for its distinctive and characteristic garment, called a **peplos**—a draped rectangle of cloth, usually wool, folded over at the top, pinned at the shoulders, and belted to give a bloused effect. The *Peplos Kore* has the same motionless, vertical pose of the earlier *kore,* but is a more rounded, feminine figure. Her bare arms and head convey a greater sense of soft flesh covering a real bone structure, and her smile and hair are somewhat less conventional. The figure once wore a metal crown and earrings and has traces of

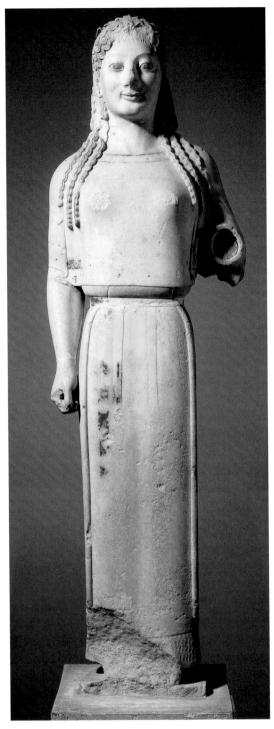

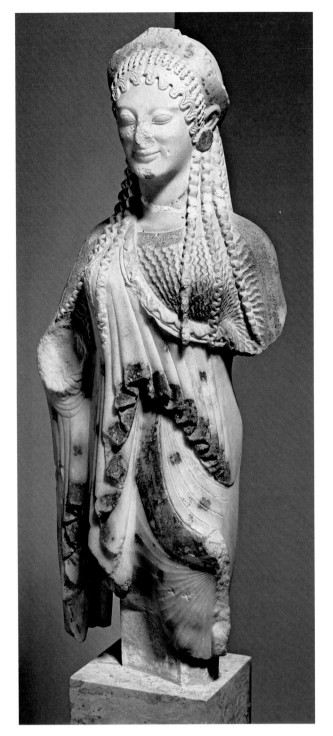

5–17 | **PEPLOS KORE**
Acropolis, Athens. c. 530 BCE. Marble, height 4′ (1.21 m).
Acropolis Museum, Athens.

5–18 | **KORE**
Acropolis, Athens (by a sculptor from Chios?). c. 520 BCE.
Marble, height 22″ (0.55 m). Acropolis Museum, Athens.

encaustic painting, a mixture of pigments and hot wax that left a shiny, hard surface when it cooled. The missing left forearm was made from a separate piece of marble—the socket is still visible—and would have extended forward horizontally. She was probably pouring a libation.

The *Peplos Kore* was recovered from debris on the Acropolis of Athens, where few of the many votive and commemorative statues placed in the sanctuary have survived. After the Persians sacked the city in 480 BCE and destroyed the sculptures there, the fragments were used as fill in the reconstruction of the Acropolis the following year.

Another *kore* (FIG. 5–18), dating to about 520 BCE and found on the Athenian Acropolis, may have been made by a

sculptor from Chios, an island off the coast of Asia Minor. Although the arms and legs of this figure have been lost and its face has been damaged, it is impressive for its rich drapery and the large amount of paint that still adheres to it. Like the *Anavysos Kouros* (SEE FIG. 5–15) and the *Peplos Kore*, it reflects a trend toward increasingly lifelike anatomical depiction that would peak in the fifth century BCE.

The *kore* wears a garment called a **chiton**; like the *peplos* but fuller, it was a relatively lightweight rectangle of cloth pinned along the shoulders. It originated in Ionia on the coast of Asia Minor but became popular throughout Greece. Over it, a cloak called a **himation** was draped diagonally and fastened on one shoulder. The elaborate hairstyle and abundance of jewelry add to the opulent effect. A close look at what remains of the figure's legs reveals a rounded thigh showing clearly through the thin fabric of the *chiton*.

Vase Painting

Greek potters created vessels that combine beauty with a specific utilitarian function (FIG. 5–19). The artists who painted the pots, which were often richly decorated, had to accommodate their work to these fixed shapes. During the Archaic period, Athens became the dominant center for pottery manufacture and trade in Greece.

BLACK-FIGURE VASES. Athenian painters adopted the Corinthian black-figure techniques (see "Greek Painted Vases," page 114), which became the principal mode of decoration throughout Greece in the sixth century BCE. At first, Athenian vase painters retained the horizontal banded composition that was characteristic of the Geometric period. Over time, they decreased the number of bands and increased the size of figures until a single scene covered each side of the vessel. A mid–sixth-century BCE **amphora**—a large, all-purpose storage jar—with bands of decoration above and below a central scene illustrates this development (FIG. 5–20). The decoration on this vessel, a depiction of the wine god Dionysos with **maenads**, his female worshipers, has been attributed to an anonymous artist called the Amasis Painter. Work in this distinctive style was first recognized on vessels signed by a prolific potter named Amasis.

Two maenads, arms around each other's shoulders, skip forward to present their offerings to Dionysos—a long-eared rabbit and a small deer. (Amasis signed his work just above the rabbit.) The maenad holding the deer wears the skin of a spotted panther (or leopard), its head still attached, draped over her shoulders and secured with a belt at her waist. The god, an imposing, richly dressed figure, clasps a large **kantharos** (wine cup). This encounter between humans and a god appears to be a joyful, celebratory occasion rather than one of reverence or fear. The Amasis Painter favored strong shapes and patterns, generally disregarding conventions for making figures appear to occupy real space. He emphasized

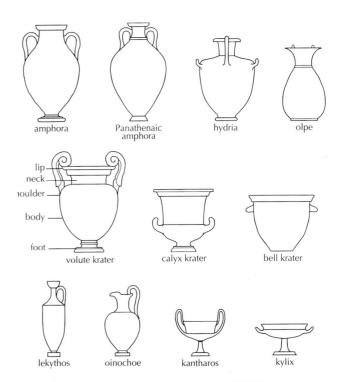

5–19 | **STANDARD SHAPES OF GREEK VESSELS**

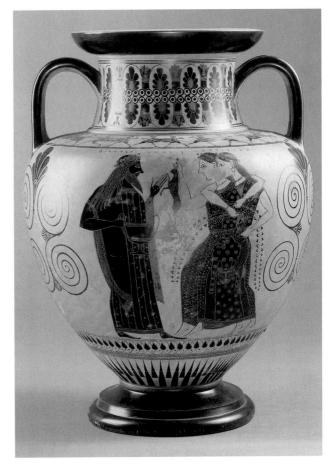

5–20 | Amasis Painter **DIONYSOS WITH MAENADS**
c. 540 BCE. Black-figure decoration on an amphora. Ceramic, height of amphora 13″ (33.3 cm). Bibliothèque Nationale de France, Paris.

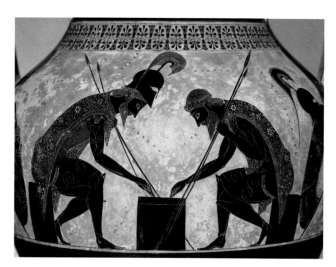

5–21 | Exekias **ACHILLES AND AJAX PLAYING A GAME**
c. 540 BCE. Black-figure decoration on an amphora. Ceramic, height of amphora 2′ (61 cm.). c. 540 BCE. Vatican Museums, Rome.

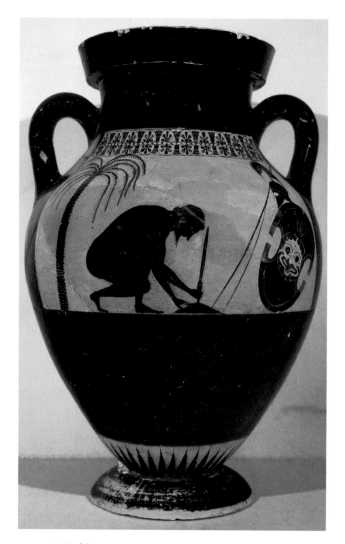

5–22 | Exekias **THE SUICIDE OF AJAX**
c. 540 BCE. Black-figure decoration on an amphora. Ceramic, height of amphora 27″ (69 cm). Château-Musée, Boulogne-sur-Mer, France.

fine details, such as the large, delicate petal and spiral designs below each handle, the figures' meticulously arranged hair, and the bold patterns on their clothing.

EXEKIAS. The finest of all Athenian artists of the Archaic Period, Exekias, signed many of his vessels as both potter and painter. Exekias took his subjects from Greek mythology, which he and his patrons probably considered to be history, such as the hero Achilles and the story of the Trojan War. On the body of an amphora he painted Achilles and his cousin Ajax, a fellow warrior, playing a game of dice (**FIG. 5–21**). The owner of the amphora knew the story—what had happened and what would happen. Achilles, sulking over an insult, has refused to fight, but eventually returns to battle and is killed. The two men bend over the game board in rapt concentration, wearing their body armor and holding their spears but setting aside their shields. At the moment, Achilles is dominant (he wears his helmet) and is winning the game. He calls "four" to Ajax's "three." (After the battle, Ajax will carry Achilles' lifeless body from the field.) Exekias skillfully matches his painting to the shape of the vase. The triangular shape formed by the two men rises to the mouth of the jar, while the handles continue the line of their shields.

This story continues on another amphora depicting the suicide of Ajax (**FIG. 5–22**). Ajax was second only to Achilles in bravery, but after the death of Achilles, the Greeks awarded the fallen hero's armor to Odysseus rather than Ajax. Devastated by this humiliation, and mourning his cousin, Ajax killed himself. Other artists showed the great warrior either dying or already dead, but Exekias has captured the story's most poignant moment, showing Ajax preparing to die. He has set aside his helmet, shield, and spear, and he crouches beneath a tree, planting his sword upright in a mound of dirt so that he can fling himself upon it. Two upright elements— the tree on the left and the shield on the right—frame and balance the figure of Ajax, their in-curving lines echoing the swelling shape of the amphora and the rounding of the hero's powerful back as he bends forward. The composition focuses the viewer's attention on the head of Ajax and his intense concentration as he pats down the earth to secure the sword. He will not fail in his suicide.

Exekias is a skilled draftsman. He captures both form and emotion, balancing areas of black against fine engraved patterns—for example, the heroes' cloaks and silhouetted figures. These two vessels exemplify the quiet beauty and perfect equilibrium for which Exekias's works are so admired today.

RED-FIGURE VASES. In the last third of the sixth century BCE, while many painters were still creating handsome black-figure wares, some vase painters turned away from this meticulous process to a new technique called **red-figure** decoration (see "Greek Painted Vases," page 114). This new method,

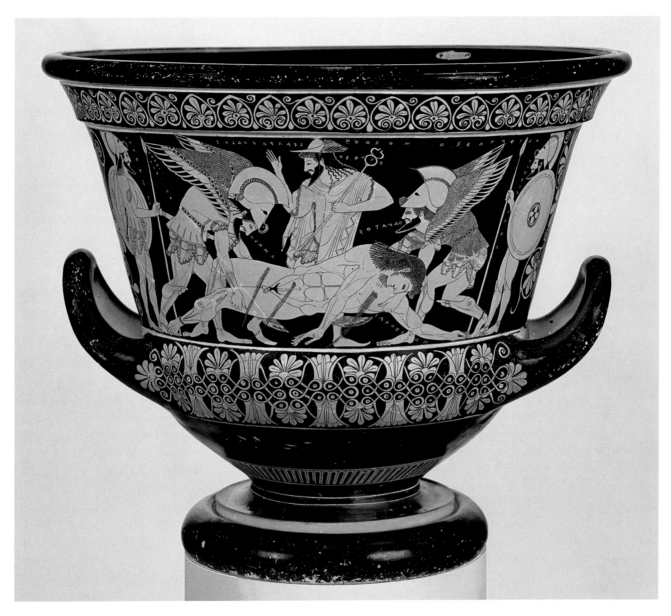

5–23 | Euphronios (painter) and Euxitheos (potter) **DEATH OF SARPEDON**
c. 515 BCE. Red-figure decoration on a calyx krater. Ceramic, height of krater 18″ (45.7 cm).
The Metropolitan Museum of Art, New York, lent by the Republic of Italy (L.2006.10). Photograph © 1999 The
Metropolitan Museum of Art.

The ownership of the Euphronios krater has been the subject of dispute between Italy and the Metropolitan Museum. In 2006
the museum recognized the Italian government's claim.

as its name suggests, resulted in vessels with red figures against a black background, the opposite of black-figure painting. In red-figure wares, the dark slip was painted on as background around the outlined figures, which were left unpainted. Details were drawn on the figures with a fine brush dipped in the slip. The result was a lustrous dark vessel with light-colored figures and dark details. The greater freedom and flexibility of painting rather than engraving the details led artists to adopt it widely in a relatively short time.

One of the best-known artists specializing in the red-figure technique was Euphronios. His rendering of the **DEATH OF SARPEDON**, about 515 BCE, is painted on a **calyx krater**, so called because its handles curve up like a flower calyx (**FIG. 5–23**). According to Homer's *Iliad*, Sarpedon, a son of Zeus and a mortal woman, was killed by the Greek warrior Patroclus while fighting for the Trojans. Euphronios shows the winged figures of Hypnos (Sleep) and Thanatos (Death) carrying the dead warrior from the battlefield, an early use of personification. Watching over the scene is Hermes, the messenger of the gods, identified by his winged hat and *caduceus*, a staff with coiled snakes. Hermes is there in another important role, as the guide who leads the dead to the underworld.

CLASSIC AND CLASSICAL

Our words *classic* and *classical* come from the Latin word *classis*, referring to the division of people into classes based on wealth. Consequently, *classic* has come to mean "first class," "the highest rank," "the standard of excellence." Greek artists in the fifth century BCE tried to create ideal images based on perfect mathematical proportions. Roman artists were inspired by the Greeks, so *Classical* refers to the culture of ancient Greece and Rome. By extension, the word may also mean "in the style of ancient Greece and Rome," whenever or wherever that style is used. In the most general usage, a "classic" is something—perhaps a literary work, a car, or a film—of lasting quality and universal significance.

Euphronios has created a perfectly balanced composition of verticals and horizontals that take the shape of the vessel into account. The bands of decoration above and below the scene echo the long horizontal of the dead fighter's body, which seems to levitate in the gentle grasp of its bearers, and the inward-curving lines of the handles mirror the arching backs of Hypnos and Thanatos. The upright figures of the lance-bearers on each side and Hermes in the center counterbalance the horizontal elements of the composition. The painter, while conveying a sense of the mass and energy of the subjects, also portrayed amazingly fine details of their clothing, musculature, and facial features with the fine tip of a brush. Euphronios created the impression of real space around the figures by **foreshortening** body forms and limbs—Sarpedon's left leg, for example—so that they appear to be coming toward or receding from the viewer.

THE CLASSICAL PERIOD, c. 480–323 BCE

Over the brief span of the next 160 years, the Greeks would establish an ideal of beauty that, remarkably, has endured in the Western world to this day. This period of Greek art, known as the Classical, is framed by two major events: the defeat of the Persians in 480 BCE and the death of Alexander the Great in 323 BCE. Art historians today divide the period into three phases, based on the formal qualities of the art: the Early Classical period or Transitional style (c. 480–450 BCE); the High Classical period (c. 450–400 BCE); and the Late Classical period (c. 400–323 BCE). The speed of change in this short time is among the most extraordinary characteristics of Greek art (see "*Classic* and *Classical*," above).

Scholars have characterized Greek Classical art as being based on three general concepts: humanism, rationalism, and idealism. The ancient Greeks believed the words of their philosophers and followed these injunctions in their art: "Man is the measure of all things," that is, seek an ideal based on the human form; "Know thyself," seek the inner signifi-cance of forms; and "Nothing in excess," reproduce only essential forms. In their embrace of humanism, the Greeks even imagined that their gods looked like perfect human beings. Apollo, for example, exemplifies the Greek ideal: His body and mind in balance, he is athlete and musician, healer and sun god, leader of the Muses.

Yet as reflected in their art, the Greeks valued reason over emotion. Practicing the faith in rationality expressed by the philosophers Sophocles, Plato, and Aristotle, and convinced that logic and reason underlie natural processes, the Greeks saw all aspects of life, including the arts, as having meaning and pattern. Nothing happens by accident. The great Greek artists and architects were not only practitioners but theoreticians as well. In the fifth century BCE, the sculptor Polykleitos (see below) and the architect Iktinos both wrote books on the theory underlying their practice.

Unlike artists in Egypt and the ancient Near East, Greek artists did not rely on memory images. And even more than the artists of Crete, they grounded their art in close observation of nature. Only after meticulous study did they begin to search within each form for its universal ideal, rather than portraying their models in their actual, individual detail. In doing this, they developed a system of perfect mathematical proportions.

Greek artists of the fifth and fourth centuries BCE established a benchmark for art against which succeeding generations of artists and patrons in the Western world have since measured quality.

The Canon of Polykleitos

Just as Greek architects defined and followed a set of standards for ideal temple design, the sculptors of the Classical period selected those human attributes they considered the most desirable, such as regular facial features, smooth skin, and particular body proportions, and combined them into a single ideal of physical perfection.

The best-known theorist of the Classical period was the sculptor Polykleitos of Argos. About 450 BCE he developed a

set of rules for constructing the ideal human figure, which he set down in a treatise called *The Canon* (*kanon* is Greek for "measure," "rule," or "law"). To illustrate his theory, Polykleitos created a larger-than-lifesize bronze statue of a standing man carrying a spear—perhaps the hero Achilles (**FIG. 5–24**). Neither the treatise nor the original statue has survived, but both were widely discussed in the writings of his contemporaries, and later Roman artists made copies in stone and marble of the **SPEAR BEARER (DORYPHOROS).** By studying these copies, scholars have tried to determine the set of measurements that defined the ideal proportions in Polykleitos's canon.

The canon included a system of ratios between a basic unit and the length of various body parts. Some studies suggest that this basic unit may have been the length of the figure's index finger or the width of its hand across the knuckles; others suggest that it was the height of the head from chin to hairline. The canon also included guidelines for *symmetria* ("commensurability"), by which Polykleitos meant the relationship of body parts to one another. In the statue he made to illustrate his treatise, he explored not only proportions, but also the relationship of weight-bearing and relaxed legs and arms in a perfectly balanced figure. The cross-balancing of supporting and free elements in a figure is sometimes referred to as **contrapposto**.

The marble copy of the *Spear Bearer* illustrated here shows a male athlete, perfectly balanced with the whole weight of the upper body supported over the straight (engaged) right leg. The left leg is bent at the knee, with the left foot poised on the ball of the foot, suggesting preceding and succeeding movement. The pattern of tension and relaxation is reversed in the arrangement of the arms, with the right relaxed on the engaged side, and the left bent to support the weight of the (missing) spear. This dynamically balanced body pose—characteristic of High Classical standing figure sculpture—differs somewhat from that of the *Kritian Boy* (SEE FIG. 5–28) of a generation earlier. The tilt of the *Spear Bearer's* hipline is a little more pronounced to accommodate the raising of the left foot onto its ball, and the head is turned toward the same side as the engaged leg.

The Art of the Early Classical Period, 480–450 BCE

In the early decades of the fifth century BCE, the Greek city-states, which for several centuries had developed relatively unimpeded by external powers, faced a formidable threat to their independence from the expanding Persian Empire. Cyrus the Great of Persia had incorporated the Greek cities of Ionia in Asia Minor into his empire in 546 BCE. At the beginning of the fifth century BCE, the Greek cities of Asia Minor, led by Miletos (SEE FIG. 5–47), revolted against Persia, initiating a period of warfare between Greeks and Persians. In 490 BCE, at the Greek mainland town of Marathon, the Athenians drove off the Persian army. (Today's marathon races still

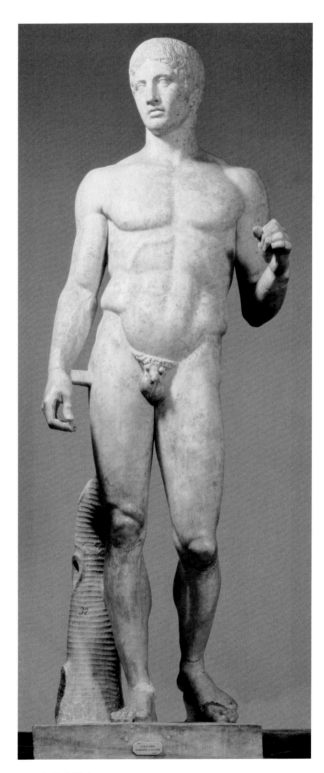

5–24 | Polykleitos **SPEAR BEARER (DORYPHOROS), ALSO KNOWN AS ACHILLES**
Roman copy after the original bronze of c. 450–440 BCE. Marble, height 6′11″ (2.12 m); tree trunk and brace strut are Roman additions. National Archeological Museum, Naples.

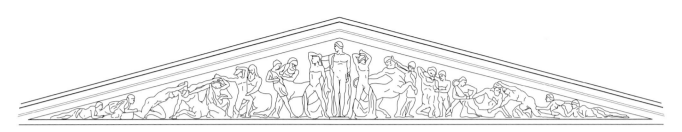

5–25 | **RECONSTRUCTION DRAWING OF THE WEST PEDIMENT OF THE TEMPLE OF ZEUS, OLYMPIA**
c. 470–460 BCE.

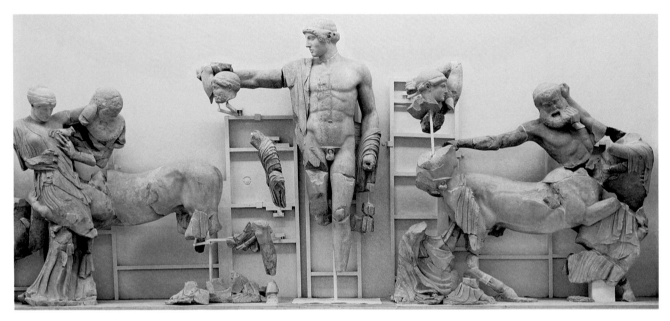

5–26 | **APOLLO WITH BATTLING LAPITHS AND CENTAURS**
Fragments of sculpture from the west pediment of the Temple of Zeus, Olympia. c.470– 460 BCE. Marble,
height of Apollo 10′8″ (3.25 m). Archaeological Museum, Olympia.

recall the feat of the man who ran the 26 miles from Marathon to Athens with news of victory and then dropped dead from exhaustion as he gasped out his words.)

In 480 BCE, the Persians penetrated Greece with a large force and destroyed many cities, including Athens. In a series of encounters—at Plataea on land and in the straits of Salamis at sea—an alliance of Greek city-states led by Athens and Sparta repulsed the invasion. By 480 BCE, the stalwart armies and formidable navies of the Greeks had triumphed over their enemies.

Athens emerged from the Persian wars as the leader of the city-states. Not all Greeks applauded the Athenians, however. In 431 BCE, a war broke out that only ended in 404 with the collapse of Athens and the victory of the militaristic state of Sparta. In the fourth century BCE, a new force appeared in the north—Macedonia.

Some scholars have argued that their success against the Persians gave the Greeks a self-confidence that accelerated the development of their art, inspiring artists to seek new and more effective ways to express their cities' accomplish-

ments. In any case, the period that followed the Persian Wars, extending from about 480 to about 450 BCE and referred to as the Early Classical period, saw the emergence of a new style.

ARCHITECTURAL SCULPTURE. Just a few years after the Persians had been routed, the citizens of Olympia in the northwest Peloponnese began constructing a new Doric temple to Zeus in the Sanctuary of Zeus. The temple was completed between 470 and 456 BCE. Today the massive temple base, fallen columns, and almost all the metope and pediment sculpture remain, impressive even in ruins. Although the temple was of local stone, it was decorated with sculpture of imported marble, and, appropriately for its Olympian setting, the themes of its artwork demonstrated the power of the gods Zeus, Apollo, and Athena, and metaphorically, the power of Athens and Greece over the Persians.

The freestanding sculpture that once adorned the west pediment (FIG. 5–25) shows Apollo helping the Lapiths, a clan from Thessaly, in their battle with the centaurs. This leg-

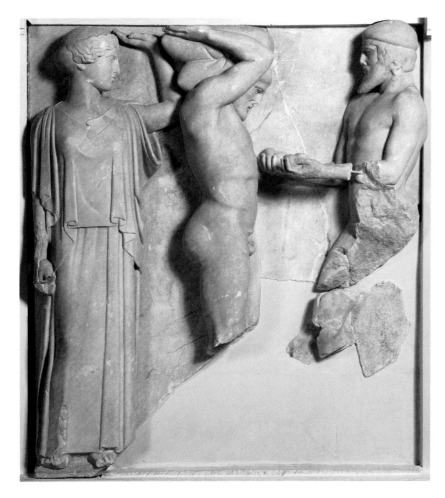

5–27 | ATHENA, HERAKLES, AND ATLAS
Metope relief from the frieze of the Temple of Zeus, Olympia. c. 460 BCE. Marble, height 5′3″ (1.59 m). Archaeological Museum, Olympia.

Herakles is at the center with the heavens on his shoulders. Atlas, on the right, holds out the gold apples to him. As we can see, and Atlas cannot, the human Herakles is backed, literally, by the goddess Athena, who effortlessly supports the sky with one hand.

endary battle erupted after the centaurs drank too much wine at the wedding feast of the Lapith king and tried to carry off the Lapith women. Apollo stands calmly at the center of the scene, quelling the disturbance by simply raising his arm (FIG. 5–26). The rising, falling, triangular composition fills the awkward pediment space. The contrast of angular forms with turning, twisting poses dramatizes the physical struggle. The majestic figure of Apollo celebrates the triumph of reason over passion, civilization over barbarism, Greece over Persia.

The metope reliefs of the temple illustrated the Twelve Labors imposed by King Eurystheus of Tiryns on Herakles. One of the labors was to steal gold apples from the garden of the Hesperides, the nymphs who guarded the apple trees. To do this, Herakles enlisted the aid of the Titan Atlas, whose job was to hold up the heavens. Herakles offered to take on this job himself while Atlas fetched the apples for him. In the episode shown here (FIG. 5–27), the artist has balanced the erect, frontal view of the heavily clothed Athena, at left, with profile views of the two nude male figures. Carved in high relief, the figures reflect a strong interest in realism. Even the rather severe columnlike figure of the goddess suggests the flesh of her body pressing through the graceful fall of heavy drapery.

FREESTANDING SCULPTURE. In the remarkably short time of only a few generations, Greek sculptors had moved far from the rigid, frontal presentation of the human figure embodied in the Archaic *kouroi*. One of the earliest and finest extant freestanding marble figures to exhibit more natural, lifelike qualities is the **KRITIAN BOY** of about 480 BCE (FIG. 5–28). The damaged figure, excavated from the debris on the Athenian Acropolis, was thought by its finders to be by the Greek sculptor Kritios, whose work they knew only from Roman copies. The boy strikes an easy pose quite unlike the rigid, evenly balanced pose of Archaic *kouroi*. His weight rests on his left leg, and his right leg bends slightly at the knee. A noticeable curve in his spine counters the slight shifting of his hips and a subtle drop of one of his shoulders. The slight turn of the head invites the spectator to follow his gaze and move around the figure, admiring the small marble statue from every angle. The boy's solemn expression lacks any trace of the Archaic smile—at last the sculptors have mastered the subtle planes of the face.

BRONZE SCULPTURE. The obvious problem for anyone trying to create a freestanding statue is to ensure that it will not fall over. Solving this problem requires a familiarity with the ability of sculptural materials to maintain equilibrium under

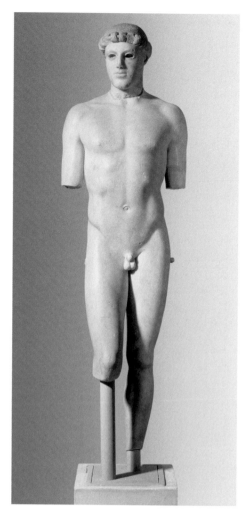

5–28 | **KRITIAN BOY**
From Acropolis, Athens. c. 480 BCE. Marble, height 3′10″ (1.17 m). Acropolis Museum, Athens.

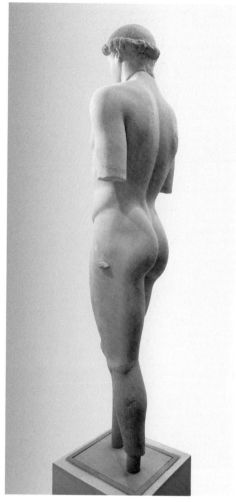

various conditions. The **hollow-casting** technique created a far more flexible medium than solid marble or other stone and became the medium of choice for Greek sculptors. Although it is possible to create freestanding figures with outstretched arms and legs far apart in stone, hollow-cast bronze more easily permits vigorous and even off-balance action poses. Consequently, after the introduction of the new technique, sculptors sought to craft poses that seemed to capture a natural feeling of continuing movement rather than an arbitrary moment frozen in time.

Athens was as famous for its metalwork as it was for ceramics. A painted **kylix**, or drinking cup, illustrates the work in a foundry (FIG. 5–29). The artist, called the Foundry Painter, presents all the workings of a contemporary foundry for casting life-size and monumental bronze figures. The artist organized this scene within the flaring space that extends upward from the foot of the vessel, using the circle that marks the attachment of the foot to the vessel as the groundline for the figures. The walls of the workshop are filled with hanging tools and other foundry paraphernalia and several sketches. The sketches include a horse, human heads, and human figures in different poses.

On the section shown here, a worker wearing what looks like a modern-day construction helmet squats to tend the furnace on the left. The man in the center, perhaps the

supervisor, leans on a staff, while a third worker assembles the parts of a leaping figure that is braced against a molded support. The unattached head lies between his feet. This vase painting provides clear evidence that the Greeks were creating large bronze statues in active poses as early as the first decades of the fifth century BCE.

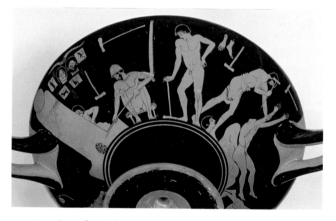

5–29 | Foundry Painter **A BRONZE FOUNDRY**
Red-figure decoration on a kylix from Vulci, Italy. 490–480 BCE. Ceramic, diameter of kylix 12″ (31 cm). Staatliche Museen zu Berlin, Preussischer Kulturbesitz, Antikensammlung, Berlin.

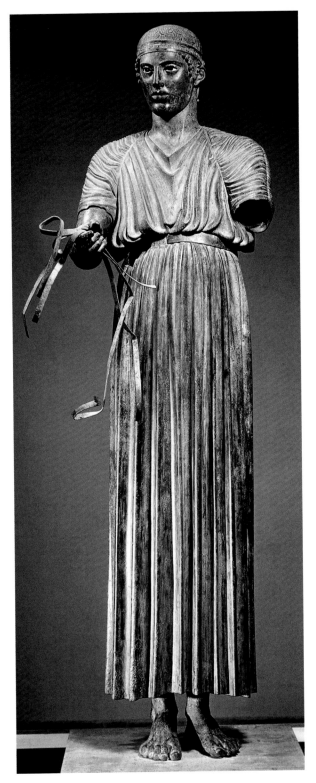

5–30 CHARIOTEER
From the Sanctuary of Apollo, Delphi. c. 470 BCE. Bronze, copper (lips and lashes), silver (hand), onyx (eyes), height 5′11″ (1.8 m). Archaeological Museum, Delphi.

The setting of a work of art affects the impression it makes. Today, the charioteer is exhibited on a low base in the peaceful surroundings of a museum, isolated from other works and spotlighted for close examination. Its effect would have been very different in its original outdoor location, standing in a horse-drawn chariot atop a tall monument. Viewers in ancient times, tired from the steep climb to the sanctuary and jostled by crowds of fellow pilgrims, could have absorbed only its overall effect, not the fine details of the face, robe, and body visible to today's viewers.

THE CHARIOTEER. Unfortunately, foundries began almost immediately to recycle metal from old statues into new works, so few original Greek bronzes have survived. A spectacular life-size bronze, the **CHARIOTEER** (FIG. 5–30), cast about 470 BCE, was saved only because it was buried after an earthquake in 373 BCE. Archaeologists found it in the sanctuary of Apollo at Delphi, along with fragments of a bronze chariot and horses. According to its inscription, it commemorates a victory by a driver in the Pythian Games of 478 or 474 BCE.

If the *Kritian Boy* seems solemn, the *Charioteer* seems to pout. His head turns slightly to one side. His rather intimidating expression is enhanced by glittering, onyx eyes and fine copper eyelashes. The *Charioteer* stands erect; his long robe with its almost columnar fluting is the epitome of elegance. The folds of the robe fall in a natural way, varying in width and depth, and the whole garment seems capable of swaying and rippling with the charioteer's movement. The feet, with their closely observed toes, toenails, and swelled veins over the instep, are so realistic that they seem to have been cast from molds made from the feet of a living person.

WARRIOR A. The sea as well as the earth has protected ancient bronzes. As recently as 1972, divers recovered a pair of larger-than-life–size bronze figures from the seabed off the coast of Riace, Italy (FIG. 5–31). Known as the **RIACE WARRIORS** or **WARRIORS A AND B**, they date to about 460–450 BCE. Just what sent them to the bottom is not known, but conservators have restored them to their original condition (see "The Discovery and Conservation of the Riace Warriors," page 135).

Warrior A reveals a striking balance between idealized anatomical forms and naturalistic details. The supple musculature suggests a youthfulness belied by the maturity of the face. Minutely detailed touches—the navel, the swelling veins in the backs of the hands, and the strand-by-strand rendering of the hair—are also in marked contrast to the idealized, youthful smoothness of the rest of the body. The sculptor heightened these lifelike effects by inserting eyeballs of bone and colored glass, applying eyelashes and eyebrows of separately cast, fine strands of bronze, insetting the lips and nipples with pinkish copper, and plating the teeth that show between the parted lips with silver. The man held a shield (parts are still visible) on his left arm and a spear in his right hand and was probably part of a monument commemorating a military victory, perhaps against the Persians.

At about the same time, the *Discus Thrower*, reproduced at the beginning of this chapter, was created in bronze by the sculptor Myron (SEE FIG. 5–1). The sculpture is known today only from Roman copies in marble, but in its original form it must have been as lifelike in its details as the *Riace Warriors*. Myron caught the athlete at a critical moment, the breathless instant before the concentrated energy of his body will unwind to propel the discus into space. His muscular torso is

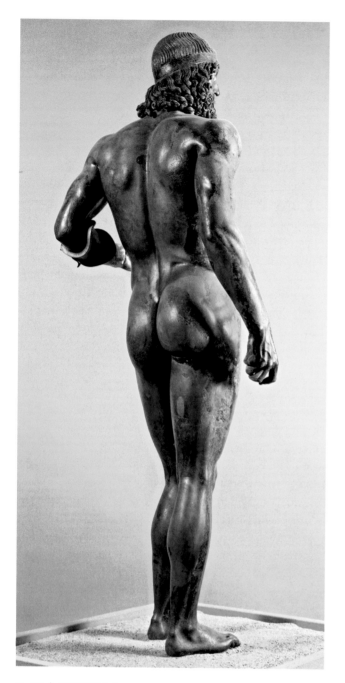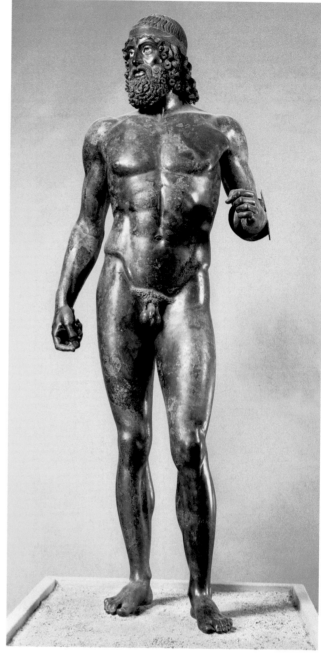

5–31 WARRIOR A
Found in the sea off Riace, Italy. c. 460–450 BCE. Bronze with bone and glass eyes, silver teeth, and copper lips and nipples, height 6'9" (2.05 m). National Archeological Museum, Reggio Calabria, Italy.

coiled tightly into a forward arch, and his powerful throwing arm is poised at the top of his backswing. Myron earned the adulation of his contemporaries: It is interesting that he was most warmly admired for a sculpture that has not survived—a bronze cow!

PAINTING. Vase painters continued to work with the red-figure technique throughout the fifth century BCE, refining their styles and experimenting with new compositions.

Among the outstanding vase painters of the Early Classical period was the prolific Pan Painter, who was inspired by the less heroic myths of the gods to create an admirable body of red-figure works. The artist's name comes from a work involving the god Pan on one side of a bell-shaped krater that dates to about 470 BCE. The other side of this krater shows **ARTEMIS SLAYING ACTAEON (FIG. 5–32).** Actaeon was punished by Artemis for boasting that he was a better hunter than she, or (in another version) for seducing Semele, who was

Technique

THE DISCOVERY AND CONSERVATION OF THE *RIACE WARRIORS*

I n 1972, a scuba diver in the Ionian Sea near the beach resort of Riace, Italy, found what appeared to be a human elbow and upper arm protruding from sand about 25 feet beneath the sea. Taking a closer look, he discovered that the arm was made of metal, not flesh, and was part of a large statue. He soon uncovered a second statue nearby.

Experienced underwater salvagers raised the statues: bronze warriors more than 6 feet tall, complete in every respect, except for swords, shields, and one helmet. But after centuries under-water, the *Warriors* were corroded and covered with accretions. The clay cores from the casting process were still inside the bronzes, adding to the deterioration by absorbing lime and sea salts. To restore the *Warriors*, conservators first removed all the exterior corrosion and lime encrustations using surgeon's

scalpels, pneumatic drills with 3-millimeter heads, and high-technology equipment such as sonar (sound-wave) probes and micro-sanders. Then they painstakingly removed the clay core through existing holes in the heads and feet using hooks, scoops, jets of distilled water, and concentrated solutions of peroxide. Finally, they cleaned the figures thoroughly by soaking them in solvents, and they sealed them with a fixative specially designed for use on metals.

Since the *Warriors* were put on view in 1980, conservators have taken additional steps to ensure their preservation. In 1993, for example, a sonar probe mounted with two miniature video cameras found and blasted loose with sound waves the clay remaining inside the statues, which was then flushed out with water.

being courted by Zeus. The enraged goddess caused Actaeon's own dogs to mistake him for a stag and attack him. The Pan Painter shows Artemis herself about to shoot the unlucky hunter with an arrow from her bow. The angry god-dess and the fallen Actaeon each form roughly triangular shapes that conform to the flaring shape of the vessel.

THE HIGH CLASSICAL PERIOD, c. 450–400 BCE

The High Classical period of Greek art, from about 450 to 400 BCE, corresponds roughly to the domination of Sparta and Athens. The two had emerged as the leading city-states in the Greek world in the wake of the Persian Wars. Sparta dominated the Peloponnesus and much of the rest of main-land Greece. Athens dominated the Aegean and became the wealthy and influential center of a maritime empire.

Except for a few brief interludes, Perikles, a dynamic, charismatic leader, dominated Athenian politics and culture from 462 BCE until his death in 429 BCE. Although comedy writers of the time sometimes mocked him, calling him "Zeus" and "The Olympian" because of his haughty person-ality, he led Athens to a period of great wealth and influence seen later as a "Golden Age." He was a great patron of the arts, supporting the use of Athenian wealth for the adorn-ment of the city and encouraging artists to promote a public image of peace, prosperity, and power.

He brought new splendor to the sanctuaries of the gods who protected Athens and turned the citadel of Athens, the Acropolis, into a center of civic and religious life. Perikles said of his city and its accomplishments: "Future generations will marvel at us, as the present age marvels at us now." It was a prophecy he himself helped fulfill.

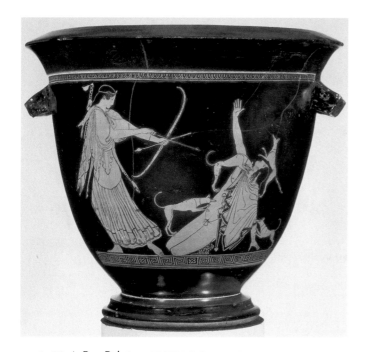

5–32 | Pan Painter **ARTEMIS SLAYING ACTAEON**
c. 470 BCE. Red-figure decoration on a bell krater. Ceramic, height of krater 14⅞″ (37 cm). Museum of Fine Arts, Boston.
James Fund and by Special Contribution (10.185).

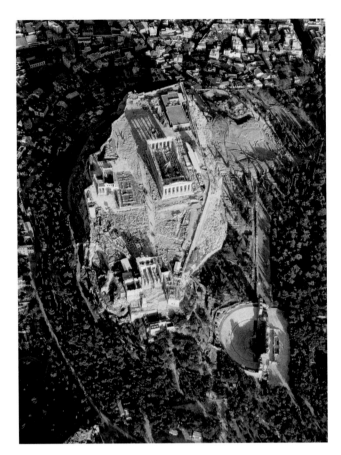

5–33 | ATHENS; ACROPOLIS FROM THE AIR

Athens originated as a Neolithic **acropolis**, or "part of the city on top of a hill" (*akro* means "high" and *polis* means "city"). The flat-topped hill that was the original site of the city later served as a fortress and religious sanctuary. As the city grew, the Acropolis became the religious and ceremonial center devoted primarily to the goddess Athena, the city's patron and protector.

The Acropolis

After Persian troops destroyed the Acropolis in 480 BCE, the Athenians vowed to keep it in ruins as a memorial. Later Perikles convinced them to rebuild it (FIG. 5–33). He argued that this project honored the gods, especially Athena, who had helped the Greeks defeat the Persians. But Perikles also hoped to create a visual expression of Athenian values and civic pride that would glorify his city and bolster its status as the capital of the empire he was instrumental in building. He placed his close friend Pheidias, a renowned sculptor, in charge of the rebuilding and assembled under him the most talented artists and artisans in Athens.

The cost and labor involved in this undertaking were staggering. Large quantities of gold, ivory, and exotic woods had to be imported. Some 22,000 tons of marble had to be transported 10 miles from mountain quarries to city workshops. Perikles was severely criticized by his political opponents for this extravagance, but it never cost him popular support. In fact, many working-class Athenians—laborers, carpenters, masons, sculptors, and the carters and merchants who kept them supplied and fed—benefited from his expenditures.

Work on the Acropolis continued after Perikles' death and was completed by the end of the fifth century BCE (FIG. 5–34). Visitors to the Acropolis in 400 BCE would have climbed a steep ramp on the west side of the hill to the sanctuary entrance, perhaps pausing to admire the small marble temple dedicated to Athena Nike (Athena as the goddess of victory in war), poised on a projection of rock above the ramp. After passing through an impressive porticoed gatehouse called the Propylaia, they would have seen a huge bronze figure of Athena Promachos (the Defender). This statue, designed and executed by Pheidias between about 465 and 455 BCE, showed the goddess bearing a spear. Sailors entering the Athenian port of Piraeus, about 10 miles away, could see the sun reflected off the helmet and spear tip. Behind this statue was a walled precinct that enclosed the Erechtheion, a temple dedicated to several deities.

Religious buildings and votive statues filled the hilltop. A large stoa with projecting wings was dedicated to Artemis Brauronia (the Protector of Wild Animals). Beyond this stoa on the right stood the largest building on the Acropolis, looming above the precinct wall that enclosed it. This was the Parthenon, a temple dedicated to Athena Parthenos (the Virgin). Visitors approached the temple from its northwest corner. The cella of the Parthenon faced east. With permission from the priests, they would have climbed the east steps to look into the cella, seeing a colossal gold and ivory statue of Athena, created by Pheidias and installed and dedicated in the temple in 438 BCE. However, the building was not yet complete and further work on the ornamental sculpture continued until 433/432 BCE.

The Parthenon

Sometime around 490 BCE, Athenians began work on a temple to Athena Parthenos that was still unfinished when the Persians sacked the Acropolis a decade later. Work was resumed in 447 BCE by Perikles, who commissioned the architect Iktinos to design a larger temple using the existing foundation and stone elements. The finest white marble was used throughout, even on the roof, in place of the more usual terra-cotta tiles.

One key to the Parthenon's sense of harmony and balance is an aesthetics of number that was used to determine the perfect proportions—especially the ratio of 4:9, expressing the relationship of breadth to length and also the relationship of column diameter to space between columns. Just as important to the overall effect are subtle refinements of design, including the slightly arched base and entablature, the very subtle swelling of the soaring columns, and the

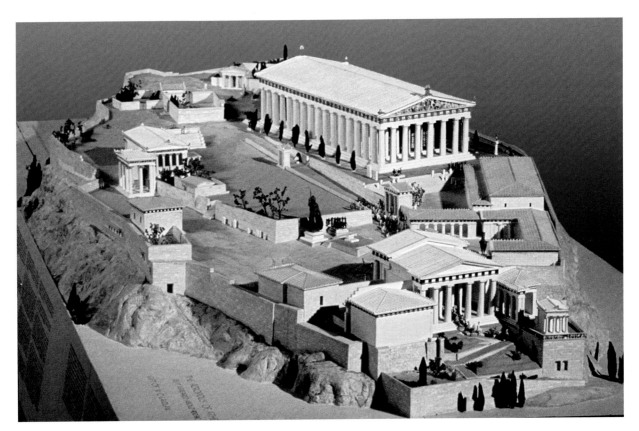

5-34 | **MODEL OF THE ACROPOLIS, ATHENS**
c. 447-432 BCE. Royal Ontario Museum, Toronto.

narrowing of the space between the corner columns and the others in the colonnade. This aesthetic control of space is the essence of architecture, as opposed to mere building. The significance of their achievement was clear to its builders—Iktinos even wrote a book on the proportions of his masterpiece.

The planning and execution of the Parthenon required extraordinary mathematical and mechanical skills and would have been impossible without a large contingent of distinguished architects and builders, as well as talented sculptors and painters. The result is as much a testament to the administrative skills as to the artistic vision of Phidias, who supervised the entire project (see plan (d) of "Greek Temple Plans," page 116). The building and statue of Athena Parthenos were dedicated in 438 BCE. Pheidias designed the ivory and gold sculpture, which was executed in his workshop and finished about 432 .

The decoration of the Parthenon strongly reflects Pheidias's unifying vision. A coherent, stylistic whole, the sculptural decoration conveys a number of political and ideological themes: the triumph of the democratic Greek city-states over imperial Persia, the preeminence of Athens thanks to the favor of Athena, and the triumph of an enlightened Greek civilization over despotism and barbarism (see "The Parthenon," page 138).

THE PEDIMENTS. Like the pediments of most temples, those of the Parthenon were filled with sculpture in the round, set on the deep shelf of the cornice and secured to the wall with metal pins. Unfortunately, much has been damaged or lost over the centuries. Using the locations of the pinholes and weathering marks on the cornice, scholars have been able to determine the placement of surviving statues and infer the poses of missing ones. The west pediment sculpture, facing the entrance to the Acropolis, illustrated the contest Athena won over the sea god Poseidon for rule over the Athenians. The east pediment figures, above the entrance to the cella, illustrated the birth of Athena, fully grown and clad in armor, from the brow of her father, Zeus.

The statues from the east pediment are the best preserved of the two groups (FIG. 5-35). Flanking the missing central figures—probably Zeus seated on a throne with the new-born adult Athena standing at his side—were groups of three goddesses followed by single reclining male figures. In the left corner was the sun god Helios in his horse-drawn chariot rising from the sea. In the right corner was the moon goddess Selene descending in her chariot to the sea. The head of her tired horse hangs over the cornice. The reclining male nude, who fits so easily into the left pediment, has been identified as both Herakles with his lion's skin, or Dionysos (god

THE ◉BJECT SPEAKS

THE PARTHENON

The Parthenon, a symbol of Athenian aspirations and creativity, rises triumphantly above the Acropolis. This temple of the goddess of wisdom spoke eloquently to fifth-century BCE Greeks of independence, self-confidence, and justifiable pride—through the excellence of its materials and craftwork, the rationality of its simple and elegant post-and-lintel structure, and the subtle yet ennobling messages of its sculpture. Today, we continue to be captivated by the gleaming marble ruin of the Parthenon, the building that has shaped our ideas about Greek civilization, about the importance of architecture as a human endeavor, and also about the very notion of the possibility of perfectibility. Its form, even when regarded abstractly, is an icon for democratic values and independent thought.

When the Parthenon was built, Athens was the capital of a powerful, independent city-state. For Perikles, Athens was the model of all Greek cities; the Parthenon was the perfected, ideal Doric temple.

Isolated like a work of sculpture, with the rock of the Acropolis as its base, the Parthenon is both an abstract form—a block of columns—and at the same time the essence of shelter: an earthly home for Athena, the patron goddess. For the ancient Greeks, the Parthenon symbolized Athens, its power and wealth, its glorious victory over foreign invaders, and its position of leadership at home.

Over the centuries, very different people reacting to very different circumstances found that the temple could also express their ideals. They imbued it with meaning and messages that might have shocked the original builders. Over its long life, the Parthenon has been a Christian church dedicated to the Virgin Mary, an Islamic mosque, a Turkish munitions storage facility, an archaeological site, and a major tourist attraction.

To many people through the ages, it remained silent, but in the eighteenth century CE, in the period known as the Enlightenment, the Parthenon found its

voice again. British architects James Stuart and Nicholas Revett made the first careful drawings of the building in the mid-eighteenth century, which they published as *The Antiquities of Athens*, in 1789. People reacted to the Parthenon's harmonious proportions, subtle details, and rational relationship of part to part, even in drawings. The building came to exemplify, in architectural terms, human and humane values. In the nineteenth century, the Parthenon became a symbol of honesty, heroism, and civic virtue, of the highest ideals in art and politics, a model for national monuments, government buildings, and even homes.

Architectural messages, like any communications, may be subject to surprising interpretations. On a bluff overlooking the Danube River near Regensburg in Germany, a nineteenth-century Parthenon commemorates the defeat of Napoleon, and in Edinburgh, Scotland ("the Athens of the North") the unfinished façade of Doric columns and entablature (the

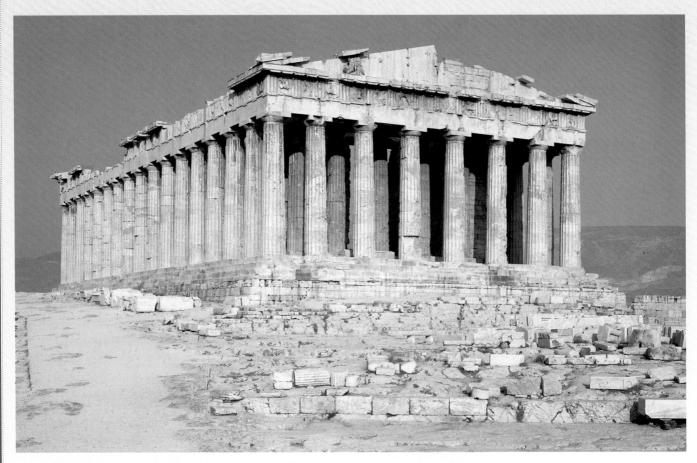

Kallikrates and Iktinos **PARTHENON, ACROPOLIS**
Athens. 447–432 BCE. View from the northwest. Pantelic marble.

builders ran out of money in 1829) confront the Medieval castle on the opposite hill. Nineteenth century Americans dignified their democratic, mercantile culture by adapting the Parthenon's form to government, business, and even domestic buildings. Not only was the simplicity of the Doric order considered appropriate but it also was the cheapest order to build. In the 1830s and 40s the Greek Revival style spread across the United States, adding a touch of elegance to simple farm houses.

One of the most remarkable reincarnations of the Parthenon can be admired in Nashville, Tennessee, "the Athens of the South." Here a replica of the Parthenon was built for the Centenial exhibition of 1897. So popular was the building that when the structure with its plaster sculpture deteriorated dangerously, the city replaced the building in permanent materials. They rebuilt the Parthenon in concrete on a steel frame. The sculptured pediments were created by the local sculptor Belle Kinney of Nashville, assisted by her husband Leopold Schulz. In 1982 Alan LeQuire created a statue of Athena for the interior. The gigantic figure standing nearly 42 feet tall, made of a compound of gypsum cement and chopped fiberglass supported by a structural steel framework, was unveiled May 20, 1990. In the summer of 2002 the figure was painted to simulate marble and gilded—a sight to behold.

The Athenian Parthenon continues to speak to viewers today. Its columns and pediment have become a universal image, like the Great Pyramids of Egypt, used and reused in popular culture. The Parthenon even has an intriguing half-life in postmodern buildings and decorative arts.

When the notable architect Le Corbusier sought to create an architecture for the twentieth century, he turned for inspiration to the still-vibrant temple of the goddess of wisdom's clean lines, simple forms, and mathematical ratios. Le Corbusier called the Parthenon "ruthless, flawless," and wrote, "There is nothing to equal it in the architecture of the entire world and all the ages . . ." (Le Corbusier, *Vers une architecture*, 1923).

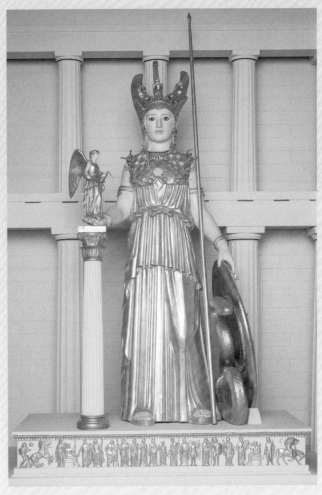

Alan LeQuire **ATHENA, THE PARTHENON, NASHVILLE, TENNESSEE**
Recreation of Pheidias's huge gold and ivory figure. 1982–1990. Gypsum concrete and chopped fiberglass on structural steel, height 41′ 10″. Painted to simulate marble with lapis lazuli eyes by Alan LeQuire and gilded under the direction of master gilder Lou Reed, June 3–Sept. 3, 2002. The ancient sculpture was of ivory and gold.

William Pars **THE PARTHENON WHEN IT CONTAINED A MOSQUE**
Drawing by Nicholas Revett (1765) and published in James Stuart and Nicholas Revett, *The Antiquities of Athens* (London, 1789).

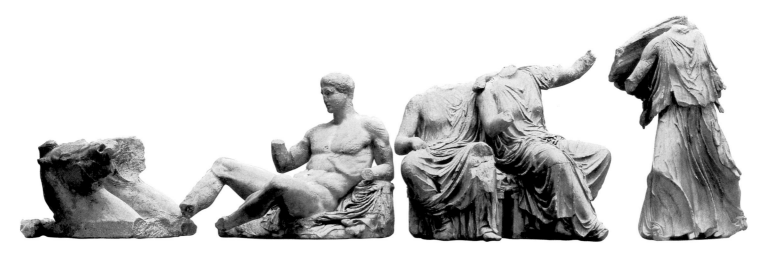

5-35 | **PHOTOGRAPHIC MOCK-UP OF THE EAST PEDIMENT OF THE PARTHENON**
(Using photographs of the extant marble sculpture) c. 447-432 BCE. The gap in the center represents the space that would have been occupied by the missing sculpture. The pediment is over 90 feet (27.45 m) long; the central space of about 40 feet (12.2 m) is missing.

At the beginning of the nineteenth century, Thomas Bruce, the British Earl of Elgin and ambassador to Constantinople, acquired much of the surviving sculpture from the Parthenon, which was being used for military purposes. He shipped it back to London in 1801 to decorate a lavish mansion for himself and his wife. By the time he returned to England a few years later, his wife had left him and the ancient treasures were at the center of a financial dispute. Finally, he sold the sculpture for a very low price. Referred to as the *Elgin Marbles*, most of the sculpture is now in the British Museum, including all the elements seen here. The Greek government has tried unsuccessfully in recent times to have the *Elgin Marbles* returned.

of wine) lying on a panther skin. His easy pose conforms to the slope of the pediment without a hint of awkwardness. The two seated women may be the earth and grain goddesses Demeter and Persephone. The running female figure just to the left of center is Iris, messenger of the gods, already spreading the news of Athena's birth.

The three female figures on the right side, two sitting upright and one reclining, were once thought to be the Three Fates, whom the Greeks believed appeared at the birth of a child and determined its destiny. Most art historians now think that they are goddesses, perhaps Hestia (a sister of Zeus and the goddess of the hearth), Dione (one of Zeus's many consorts), and her daughter, Aphrodite. These monumental interlocked figures seem to be awakening from a deep sleep. The sculptor, whether Pheidias or someone working in his style, expertly rendered the female form beneath the fall of draperies. The clinging fabric both covers and reveals, creating circular patterns rippling with a life of their own over torsos, breasts, and knees and uniting the three figures into a single mass.

THE DORIC FRIEZE. The Athenians intended their temple to surpass the Temple of Zeus at Olympia, and they succeeded. The all-marble Parthenon was large in every dimension. It held a spectacular standing statue of Athena, about 40 feet high. It also had two sculptured friezes, one above the outer peristyle and another atop the cella wall inside (Introduction, see Fig. 20). The Doric frieze on the exterior had ninety-two

metope reliefs, fourteen on each end and thirty-two along each side. These reliefs depicted legendary battles, symbolized by combat between two representative figures: a Lapith against a centaur; a god against a Titan; a Greek against a Tro-

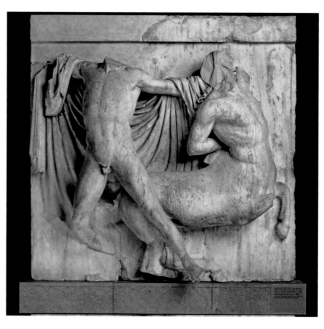

5-36 | **LAPITH FIGHTING A CENTAUR**
Metope relief from the Doric frieze on the south side of the Parthenon. c. 447-432 BCE. Marble, height 56″ (1.42 m). The British Museum, London.

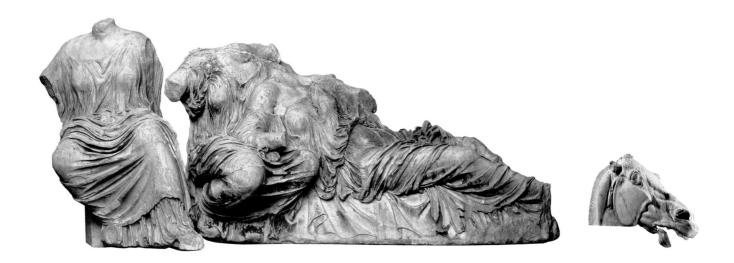

jan; a Greek against an Amazon (Amazons were members of the mythical tribe of female warriors sometimes said to be the daughters of the war god Ares).

Among the best-preserved metope reliefs are those from the south side, including several depicting the battle between the Lapiths and the centaurs. The panel shown here (FIG. 5–36)—with its choice of a perfect moment of pause within a fluid action, its reduction of forms to their most characteristic essentials, and its choice of a single, timeless image to stand for an entire historical episode—captures the essence of High Classical art. So dramatic is the X-shaped composition that we easily accept its visual contradictions.

Like the *Discus Thrower* (SEE FIG. 5–1), the Lapith is caught at an instant of total equilibrium. What should be a grueling tug-of-war between a man and a man-beast appears instead as an athletic ballet choreographed to show off the Lapith warrior's muscles and graceful movements against the implausible backdrop of his carefully draped cloak. Like Greek sculptors of earlier periods, those of the High Classical style were masters of representing hard muscles but soft flesh.

THE PROCESSIONAL FRIEZE. Enclosed within the Parthenon's Doric peristyle, the body of the temple consists of a cella, opening to the east, and an unconnected auxiliary space opening to the west. Short colonnades in front of each entrance support an entablature with an Ionic order frieze in relief that extends along the four sides of the cella, for a total frieze length of 525 feet. The subject of this frieze is a procession celebrating the festival that took place in Athens every four years, when the women of the city wove a new wool *peplos* and carried it to the Acropolis to clothe an ancient wooden cult statue of Athena.

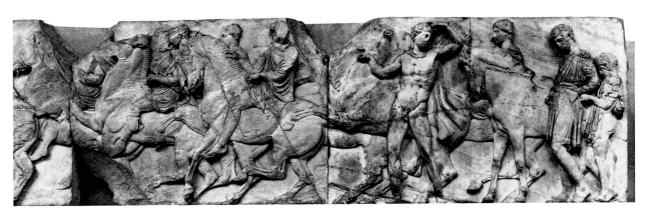

5–37 | **HORSEMEN**
Detail of the *Procession*, from the Ionic frieze on the north side of the Parthenon. c. 447–432 BCE. Marble, height 41¾" (106 cm). The British Museum, London.

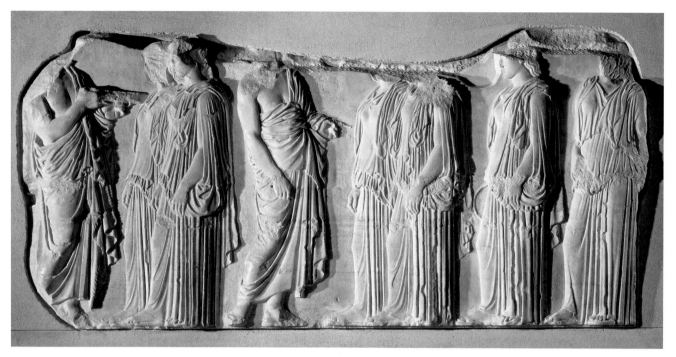

5–38 | **MARSHALS AND YOUNG WOMEN**
Detail of the *Procession*, from the Ionic frieze on the east side of the Parthenon. c. 447–432 BCE. Marble, height 3′6″ (1.08 m). Musée du Louvre, Paris.

The east façade presents a totally integrated program of images—the birth of the goddess in the pediment, her honoring by the citizens who present her with the newly woven *peplos*, and—seen through the doors—the glorious figure of Athena herself.

In Pheidias's portrayal of this major event, the figures—skilled riders managing powerful steeds, for example (FIG. 5–37), or graceful but physically sturdy young walkers (FIG. 5–38)—seem to be representative types, ideal inhabitants of a successful city-state. The underlying message of the frieze as a whole is that the Athenians are a healthy, vigorous people, united in a democratic civic body looked upon with favor by the gods. The people are inseparable from and symbolic of the city itself.

As with the metope relief of the *Lapith Fighting a Centaur*, (SEE FIG. 5–36) viewers of the processional frieze easily accept its disproportions, spatial incongruities, and such implausible compositional features as all the animal and human figures standing on the same groundline, and men and women standing as tall as rearing horses. Carefully planned rhythmic variations—changes in the speed of the participants in the procession as it winds around the walls—contribute to the effectiveness of the frieze: Horses plunge ahead at full gallop; women proceed with a slow, stately step; parade marshals pause to look back at the progress of those behind them; and human-looking deities rest on conveniently placed benches as they await the arrival of the marchers.

In executing the frieze, the sculptors took into account the spectators' low viewpoint and the dim lighting inside the peristyle. They carved the top of the frieze band in higher relief than the lower part, thus tilting the figures out to catch the reflected light from the pavement, permitting a clearer reading of the action. The subtleties in the sculpture may not have been as evident to Athenians in the fifth century BCE as they are now, because the frieze, seen at the top of a high wall and between columns, originally was completely painted (Introduction, See Fig. 23). The background was dark blue and the figures were in contrasting red and ocher, accented with glittering gold and real metal details such as bronze bridles and bits on the horses.

The Propylaia and the Erechtheion

Upon completion of the Parthenon, Perikles commissioned an architect named Mnesikles to design a monumental gatehouse, the Propylaia (SEE FIG. 5–34). Work began on it in 437 and then stopped in 432 BCE, with the structure still incomplete. The Propylaia had no sculptural decoration, but its north wing was originally a dining hall and later it became the earliest known *museum* (meaning "home of the Muses"), the "Pinakotheke" mentioned by Pausanius, which became a gallery built specifically to house a collection of paintings for public view.

The designer of the **ERECHTHEION** (FIG. 5–39), the second important temple erected on the Acropolis under Perikles' building program, is unknown. Work began on the building in 421 BCE and ended in 405 BCE, just before the fall of

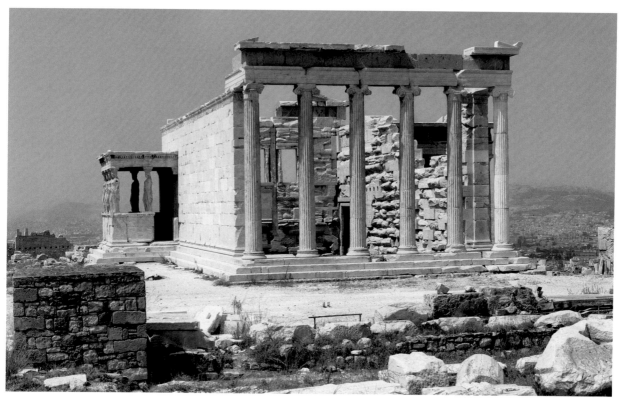

5–39 | **ERECHTHEION**
Acropolis, Athens. 421–406 BCE. View from the east. Porch of the Maidens at left; north porch can be seen through the columns of the east wall.

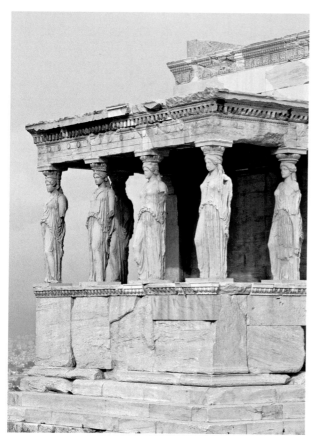

5–40 | **PORCH OF THE MAIDENS (SOUTH PORCH), ERECHTHEION**
Acropolis, Athens. Temple 430s–406 BCE; porch c. 420–410 BCE.

Athens to Sparta. The asymmetrical plan on several levels reflects the building's multiple functions, for it housed many different shrines, and it also conformed to the sharply sloping terrain on which it was located. The building stands on the site of the mythical contest between the sea god Poseidon and Athena for patronage over Athens. During this contest, Poseidon struck a rock with his trident (three-pronged harpoon), bringing forth a spout of water, but Athena gave the olive tree to Athens and won the contest for the city. The Athenians enclosed what they believed to be this sacred rock, bearing the marks of the trident, in the Erechtheion's north porch. The Erechtheion also housed the venerable wooden cult statue of Athena that was the center of the Panathenic festival.

The Erechtheion had porches on the north, east, and south sides. Later architects agreed that the north porch was the most perfect interpretation of the Ionic order, and they have copied the columns and capitals, the carved moldings, and the proportions and details of the door ever since the eighteenth century. The **PORCH OF THE MAIDENS** (FIG. 5–40), on the south side facing the Parthenon, is even more famous. Raised on a high base, its six stately caryatids support simple Doric capitals and an Ionic entablature made up of bands of carved molding. In a pose characteristic of Classical figures, each caryatid's weight is supported on one engaged leg, while the free leg, bent at the knee, rests on the ball of the foot. The three caryatids on the left have their right legs engaged, and

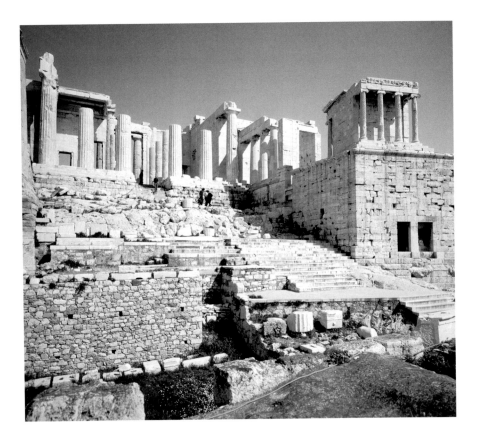

5-41 | **THE MONUMENTAL ENTRANCE TO THE ACROPOLIS**

The Propylaia (Mnesikles) with the Temple of Athena Nike (Kallikrates) on the bastion at the right. c. 437-423 BCE.

the three on the right have their left legs engaged, creating a sense of closure, symmetry, and rhythm. The vertical fall of the drapery on the engaged side resembles the fluting of a column shaft and provides a sense of stability, whereas the bent leg gives an impression of relaxed grace and effortless support. The hair of each caryatid falls in a loose but massive knot behind its neck, a device that strengthens the weakest point in the sculpture while appearing entirely natural.

The Temple of Athena Nike

The Temple of Athena Nike (victory in war), located south of the Propylaia, was designed and built about 425 BCE, probably by Kallikrates (**FIG. 5-41**). It is an Ionic temple built on an **amphiprostyle** plan, that is, with a porch at each end (see plan (c) of "Greek Temple Plans," page 116). Reduced to rubble during the Turkish occupation of Greece in the seventeenth century CE, the temple has since been rebuilt. Its diminutive size, about 27 by 19 feet, and refined Ionic decoration are in marked contrast to the massive Doric Propylaia adjacent to it.

5-42 | **NIKE (VICTORY) ADJUSTING HER SANDAL**
Fragment of relief decoration from the parapet (now destroyed), Temple of Athena Nike, Acropolis, Athens. Last quarter of the 5th century (perhaps 410–405) BCE. Marble, height 3′6″ (1.06 m). Acropolis Museum, Athens.

Art and Its Context

WHO OWNS THE ART?
THE ELGIN MARBLES AND THE EUPHRONIOS VASE

At the beginning of the nineteenth century, Thomas Bruce, the British earl of Elgin and ambassador to Constantinople, acquired much of the surviving sculpture from the Parthenon, which was being used for military purposes. He shipped it back to London in 1801 to decorate a lavish mansion for himself and his wife. By the time he returned to England a few years later, his wife had left him and the ancient treasures were at the center of a financial dispute. Finally, he sold the sculpture for a very low price. Referred to as the *Elgin Marbles*, most of the sculpture is now in the British Museum, including all the elements seen in figure 5–35 except the torso of *Selene*, which is in the Acropolis Museum, Athens. The Greek government has tried unsuccessfully in recent times to have the *Elgin Marbles* returned.

Recently, another Greek treasure has been in the news. In 1972, a krater (a bowl for mixing water and wine), painted by the master Euphronios and depicting the death of the warrior Sarpedon during the Trojan War, had been purchased by the Metropolitan Museum of Art in New York (FIG. 5-23). Museum officials were told that the krater had come from a private collection, and they made it the centerpiece of the Museum's galleries of Greek vases. But in 1995, Italian and Swiss investigators raided a warehouse in Geneva, Switzerland, where they found documents showing that the vase had been stolen from an Etruscan tomb near Rome. The Italian government wanted the masterpiece back. The controversy—who owns the art—was resolved in 2006. The vase, along with other objects known to have been stolen from other Italian sites, will be returned. Meanwhile, the Metropolitan Museum will display pieces "of equal beauty" on long-term loan agreements with Italy.

Between 410 and 405 BCE, the temple was surrounded by a **parapet**, or low wall, faced with sculptured panels depicting Athena presiding over her winged attendants, called *nike* (victory) figures, as they prepared for a celebration. The parapet no longer exists, but some of the panels from it have survived. One of the most admired is of **NIKE (VICTORY) ADJUSTING HER SANDAL** (FIG. 5–42). The figure bends forward gracefully, causing her *chiton* to slip off one shoulder. Her large wings, one open and one closed, effectively balance this unstable pose. Unlike the decorative swirls of heavy fabric covering the Parthenon goddesses or the weighty pleats of the robes of the Erechtheion caryatids, the textile covering this *Nike* appears delicate and light, clinging to her body like wet silk, one of the most discreetly erotic images in ancient art.

The Athenian Agora

In Athens, as in most cities of ancient Greece, commercial, civic, and social life revolved around the marketplace, or **agora**. The Athenian Agora, at the foot of the Acropolis, began as an open space where farmers and artisans displayed their wares. Over time, public and private structures were erected on both sides of the Panathenaic Way, a ceremonial road used during an important festival in honor of Athena (FIG. 5–43). A stone drainage system was installed to prevent flooding, and a large fountain house was built to provide water for surrounding homes, administrative buildings, and shops. By 400 BCE, the Agora contained several religious and administrative structures and even a small racetrack. The Agora also had the city mint, its military headquarters, and two buildings devoted to court business.

In design, the *stoa*, a distinctively Greek structure found nearly everywhere people gathered, ranged from a simple roof held up by columns to a substantial, sometimes architecturally impressive, building with two stories and shops along one side. Stoas offered protection from the sun and rain, and provided a place for strolling and talking business, politics, or philosophy. While city business could be, and often was, conducted in the stoas, agora districts also came to include buildings with specific administrative functions.

In the Athenian Agora, the 500-member *boule*, or council, met in a building called the *bouleuterion*. This structure, built before 450 BCE but probably after the Persian destruction of Athens in 480 BCE, was laid out on a simple rectangular plan with a vestibule and large meeting room. Near the end of the fifth century BCE, a new *bouleuterion* was constructed to the west of the old one. This too had a rectangular plan. The interior, however, may have had permanent tiered seating arranged in an ascending semicircle around a ground-level **podium**, or raised platform. Such an arrangement was typical of the outdoor theaters of the time.

Nearby was a small, round building with six columns supporting a conical roof, a type of structure known as a **tholos**. Built about 465 BCE, this *tholos* was the meeting place of the fifty-member executive committee of the *boule*. The committee members dined there at the city's expense, and a few of them always spent the night there in order to be available for any pressing business that might arise.

The Priam Painter has given us an insight into Greek city life as well as a view of an important public building. A water jug (*hydria*) attributed to him depicts a Greek fountain

5-43 | **PLAN OF THE AGORA (MARKETPLACE)**
Athens. c. 400 BCE.

house in use **(FIG. 5–44)**. The fountains were truly a public amenity, appreciated by the women and slaves who otherwise would have had to pull up heavy containers from a well. The daily trip to collect water was an important event, since most women in ancient Greece were confined to their homes. At a fountain house, in the shade of a Doric-columned porch, three women fill jugs like the one on which they are painted. A fourth balances her empty jug on her head as she waits, while a fifth woman seems to be waving a greeting to someone. The building is designed like a stoa, open on one side, but having animal-head spigots on three walls. The Doric columns support a Doric entablature with an architrave above the colonnade and a colorful frieze—here black and white blocks replace carved metopes. The circular **palmettes** (fan-shaped petal designs) framing the main scenes suggest a rich and colorful civic center.

5-44 | Priam Painter **WOMEN AT A FOUNTAIN HOUSE**
520–510 BCE. Black-figure decoration on a hydria. Ceramic, height of hydria 20⅞" (53 cm). Museum of Fine Arts, Boston.
William Francis Warden Fund (61.195)

Private houses surrounded the Agora. Compared with the often grand public buildings, houses of the fifth century BCE in Athens were rarely more than simple rectangular structures of stucco-faced mud brick with wooden posts and lintels supporting roofs of terra-cotta tiles. Rooms were small and included a dayroom in which women could sew, weave, and do other chores, a dining room with couches for reclining around a table, a kitchen, bedrooms, and occasionally an indoor bathroom. Where space was not at a premium, houses sometimes opened onto small courtyards or porches.

Stele Sculpture

A freestanding monument that was used in the cemeteries in Greece is an upright stone slab, or **stele** (plural, **stelai**), carved in low relief with the image of the person to be remembered. Instead of images of warriors or athletes used in earlier times, however, the Classical stelai represent departures or domestic scenes that very often feature women. Although respectable women played no role in politics or civic life, the presence of many fine tombstones of women indicate that they held a respected position in the family.

The **GRAVE STELE OF HEGESO** depicts a beautifully dressed woman seated in an elegant chair, her feet on a footstool (FIG. 5–45). She selects jewels (a necklace indicated in paint) from a box presented by her maid. The composition is entirely inward turning, not only in the gaze and gestures focused on the jewels, but also in the way the vertical fall of the maid's drapery and the curve of Hegeso's chair seem to enclose and frame the figures. Although their faces and bodies are idealized, the two women take on some individuality through details of costume and hairstyle. The simplicity of the maid's tunic and hair, caught in a net, contrasts with the luxurious dress and partially veiled, flowing hair of Hegeso. The sculptor has carved both women as part of the living spectators, space in front of a simple temple-fronted gravestone. The artist does not invade the private world of women: Hegeso's

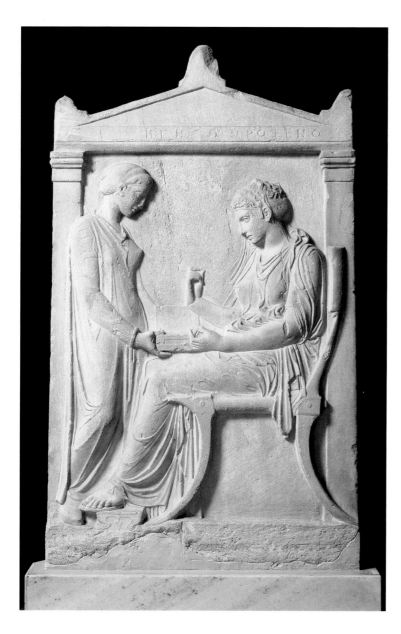

5–45 | **GRAVE STELE OF HEGESO**
c. 410–400 BCE. Marble, height 5′2″ (1.58 m). National Archaeological Museum, Athens.

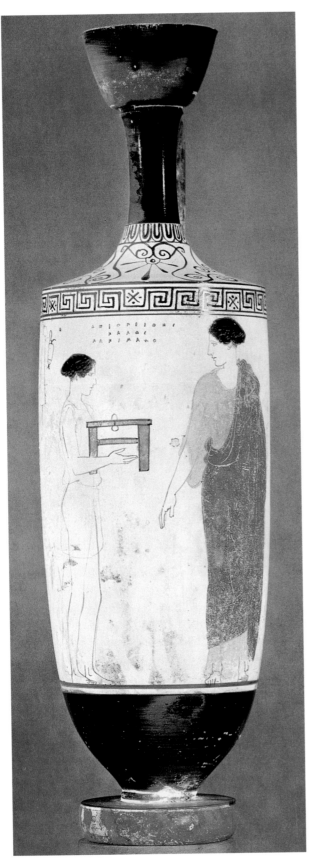

5–46 | Style of the Achilles Painter **WOMAN AND MAID**
c. 450–440 BCE. White-ground lekythos. Ceramic, with
additional painting in tempera, height of lekythos 15⅛"
(38.4 cm). Museum of Fine Arts, Boston.

Francis Bartlett Donation of 1912 (13.201)

stele and many others like it could be set up in the public
cemetery with no loss of privacy or dignity to its subjects.

Painting: Murals and Vases

The Painted Stoa built on the north side of the Athenian
Agora about 460 BCE is known to have been decorated with
paintings (hence its name) by the most famous artists of the
time, including Polygnotos of Thasos (active c. 475–450 BCE).
His contemporaries praised his talent for creating the illusion
of spatial recession in landscapes, rendering female figures
clothed in transparent draperies, and conveying through facial
expressions the full range of human emotions. Ancient writ-
ers described his painting, as well as other famous works,
enthusiastically, but nothing survives for us to see.

Without mural painting, we turn again to ceramics for
information. White-ground vase painting must have echoed
the style of contemporary paintings on walls and panels.
White ground had been used as early as the seventh century
BCE, but white-ground vase painting in the High Classical
period was far more complex than earlier efforts (SEE "Greek
Painted Vases," page 114). Characterized by outlined or drawn
imagery, this style was a specialty of Athenian potters. Artists
enhanced the fired vessel with a full range of colors using
paints made by mixing tints with white clay and also using
tempera, an opaque, water-based medium mixed with glue
or egg white. This fragile decoration deteriorated easily and
for that reason seems to have been favored for funerary,
votive, and other nonutilitarian vessels.

A tall, slender, one-handled white-ground **lekythos** was
used to pour liquids during religious rituals. Some convey
grief and loss with a scene of a departing figure bidding
farewell. Others depict a grave stele draped with garlands. Still
others show scenes of the dead person once again in the
prime of life and engaged in a seemingly everyday activity, but
the images are imbued with signs of separation and loss. A
white-ground lekythos, dated about 450–440 BCE and in the
style of the Achilles Painter (an anonymous artist known from
his painting of Achilles), shows a young servant girl carrying a
stool for a small chest of valuables to a well-dressed woman of
regal bearing, the dead person whom the vessel memorializes
(FIG. 5–46). Like the *Grave Stele of Hegeso*, the scene contains
no overt signs of grief, but a quiet sadness pervades it. The two
figures seem to inhabit different worlds, and their glances just
fail to meet.

THE LATE CLASSICAL PERIOD,
c. 400–323 BCE

After the Spartans defeated Athens in 404 BCE, they set up a
pro-Spartan government so oppressive that within a year
the Athenians rebelled against it, killed its leader, Kritias, and
restored democracy. Athens recovered its independence and

5–47 | **PLAN OF MILETOS**
Ionia (present-day Turkey), with original coastline.

its economy revived, but it never regained its dominant political and military status. Although Athens had lost its empire, it retained its reputation as a center of artistic and intellectual life. In 387 BCE, the great philosopher-teacher Plato founded a school just outside Athens, as Plato's student Aristotle did later. Among Aristotle's students was young Alexander of Macedon, known to history as Alexander the Great.

In 359 BCE, a crafty and energetic warrior, Philip II, had come to the throne of Macedonia. In 338, he defeated Athens and rapidly conquered the other Greek cities. When he was assassinated two years later, his kingdom passed to his 20-year-old son, Alexander. Alexander rapidly consolidated his power and then led a united Greece in a war of revenge and conquest against the Persians. In 334 BCE, he crushed the Persian army and conquered Syria and Phoenicia. By 331, he had occupied Egypt and founded the seaport he named Alexandria. The Egyptian priests of Amun recognized him as the son of a god, an idea he readily adopted.

That same year, Alexander reached the Persian capital of Persepolis, where his troops accidentally burned down the

palace. He continued east until 326 BCE, when he reached the western part of India—now present-day Pakistan. Finally his troops refused to go any farther. On the way home, Alexander died of fever in 323 BCE. He was only 33 years old.

The work of Greek artists during the fourth century BCE exhibits a high level of creativity and technical accomplishment. Changing political conditions never seriously dampened the Greek creative spirit. Indeed, the artists of the second half of the century in particular experimented widely with new subjects and styles. Although they observed the basic Classical approach to composition and form, they no longer followed its conventions. Their innovations were supported by a sophisticated new group of patrons, including the Macedonian courts of Philip and Alexander, wealthy aristocrats in Asia Minor, and foreign rulers eager to import Greek wares and, sometimes, Greek artists.

Architecture and Architectural Sculpture

Despite the political instability, fourth-century Greek cities undertook innovative architectural projects. Architects developed variations on the Classical ideal in urban planning, temple design, and the design of two increasingly popular structures, the *tholos* and the monumental tomb. In contrast to the previous century, much of this activity took place outside of Athens and even in areas beyond mainland Greece, notably in Asia Minor.

CITY PLANS. In older Greek cities such as Athens, buildings and streets developed according to the needs of their inhabitants and the requirements of the terrain. As early as the eighth century BCE, however, builders in some western Greek settlements began to use a rigid, mathematical concept of urban development based on the **orthogonal** (or **grid**) **plan**. New cities or rebuilt sections in old cities were laid out on straight, evenly spaced parallel streets that intersected at right angles to create rectangular blocks. These blocks were then subdivided into identical building plots.

During the Classical period, Greek architects promoted this system as the ideal city plan (FIG. 5–47). Hippodamos of Miletos, a major urban planner of the fifth century BCE, had views on the city akin to those of the Athenian philosophers (such as Socrates) and artists (such as Polykleitos). He believed that humans could arrive at a model of perfection through reason. According to Hippodamos, the ideal city should be limited to 10,000 citizens divided into three classes—artists, farmers, and soldiers—and divided into three zones—sacred, public, and private. The basic Hippodamian plot was a square 600 feet on each side, divided into quarters. Each quarter was subdivided into six rectangular building plots measuring 100 by 150 feet on a side. (This scheme is still widely used in American and European cities and suburbs today.)

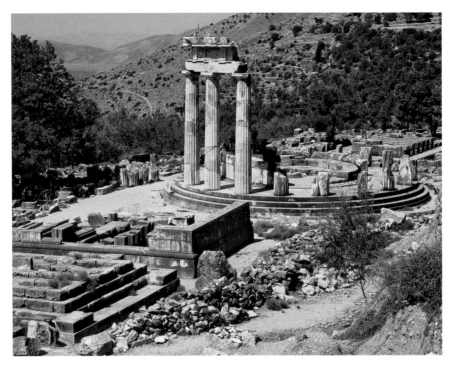

5–48 | **THOLOS, SANCTUARY OF ATHENA PRONAIA, DELPHI**
c. 380–370 BCE.

The term *Pronaia* in this sanctuary name simply means "in front of the temples," referring to
the sanctuary's location preceding the Temple of Apollo higher up on the mountainside.

Many Greek cities with orthogonal plans were laid out on relatively flat land. Miletos, an Ionian city in Asia Minor, for example, was redesigned by Hippodamos after its partial destruction by the Persians. Later the orthogonal plan was applied on less hospitable terrain, such as that of Priene, another Ionian city, which lies on a rugged hillside across the plain from Miletos. In this case, the city's planners made no attempt to accommodate their grid to the irregular mountainside, so some streets are in fact stairs.

THOLOI AND TOMBS. While most buildings followed a rectilinear plan, buildings with a circular plan also had a long history in Greece, going back to Mycenaean *tholos* tombs (SEE FIG. 4–21). In later times, various types of *tholoi* were erected. Some were shrines or monuments and some, like the fifth-century BCE *tholos* in the Athens Agora, were administrative buildings. However, the function of many, such as a *tholos* built from about 388 to 370 BCE in the Sanctuary of Athena Pronaia at Delphi, is unknown (FIGS. 5–48, 5–49). Theodoros, the presumed archi-

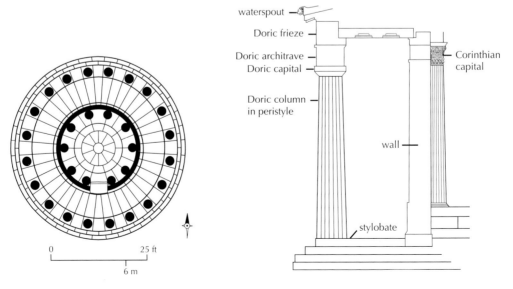

5–49 | **PLAN AND SECTION OF THE *THOLOS*, SANCTUARY OF ATHENA PRONAIA, DELPHI.**

tect, came from Phokaia in Asia Minor. The exterior was of the Doric order, as seen from the three columns and a piece of the entablature that have been restored. Other remnants suggest that the interior featured a ring of columns with capitals carved to resemble the curling leaves of the acanthus plant (see Introduction, Fig. 3). This type of capital came to be called Corinthian in Roman times (see "The Greek Architectural Orders," page 118). It had been used on roof-supporting columns in temple interiors since the last quarter of the fifth century BCE, but was not used on building exteriors until the Hellenistic period, more than a hundred years later.

Monumental tombs—showy memorials to their wealthy owners—often had circular or square plans. One such tomb was built for Mausolos at Halikarnassos in Asia Minor. Mausolos, whose name has given us the term **mausoleum** (a large tomb), was the Persian governor of the region. He admired Greek culture and brought the greatest sculptors from Greece to decorate his tomb. The structure was completed after his death in 353 BCE under the direction of his wife, Artemisia, who was rumored to have drunk her dead husband's ashes mixed with wine. The foundation, many scattered stones, and fragments of sculpture are all that remain of Mausolos's tomb.

Sculpture

Throughout the fifth century BCE, sculptors carefully maintained the equilibrium between simplicity and ornament that is fundamental to Greek Classical art. Standards established by Pheidias and Polykleitos in the mid-fifth century BCE for the ideal proportions and idealized forms of the human figure had generally been accepted by the next generation of artists. Fourth-century BCE artists, on the other hand, challenged and modified those standards. The artists of mainland Greece, in particular, developed a new canon of proportions for male figures—now eight or more "heads" tall rather than the six-and-a-half-or seven-head height of earlier works. The calm, noble detachment characteristic of earlier figures gave way to more sensitively rendered images of men and women with expressions of wistful introspection, dreaminess, or even fleeting anxiety. Patrons lost some of their interest in images of mighty Olympian gods and legendary heroes and acquired a taste for minor deities in lighthearted moments. This period also saw the earliest depictions of fully nude women in major works of art. The fourth century BCE was dominated by three sculptors—Praxiteles, Skopas, and Lysippos.

PRAXITELES. Praxiteles was active in Athens from about 370 to 335 BCE or later. According to the Greek traveler Pausanias, writing in the second century CE, Praxiteles carved a "Hermes of stone who carries the infant Dionysos." The sculpture stood in the Temple of Hera at Olympia. Just such a sculpture in marble, depicting the messenger god Hermes teasing the baby Dionysos with a bunch of grapes, was discovered in the ruins of the ancient Temple of Hera in the Sanctuary at Olympia (FIG. 5–50). Archaeologists accepted **HERMES AND**

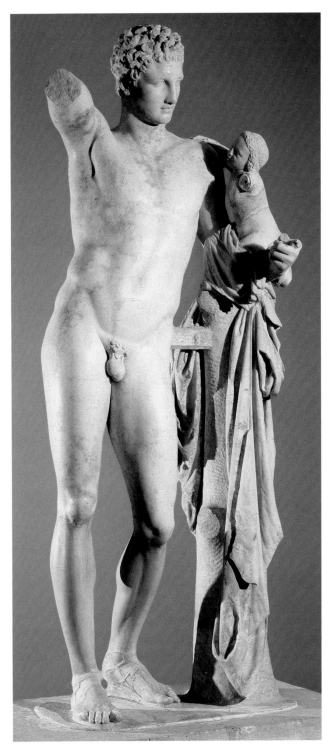

5–50 | Praxiteles or his followers **HERMES AND THE INFANT DIONYSOS**
Probably a Hellenistic or Roman copy after a Late Classical 4th-century BCE original. Marble, with remnants of red paint on the lips and hair, height 7'1" (2.15 m). Archaeological Museum, Olympia.

Discovered in the rubble of the ruined Temple of Hera at Olympia in 1875, this statue is now widely accepted as a very good Roman or Hellenistic copy. Support for this conclusion comes from certain elements typical of Roman sculpture: Hermes' sandals, which recent studies suggest, are fourth-century BCE in style; the supporting element of crumpled fabric covering a tree stump; and the use of a reinforcing strut, or brace, between Hermes' hip and the tree stump. Some scholars still attribute the sculpture to Praxiteles.

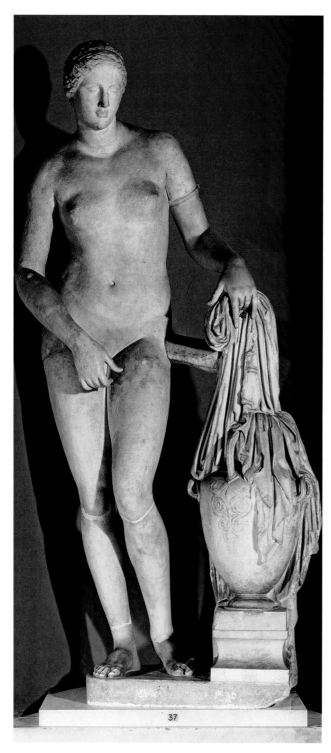

5–51 | Praxiteles **APHRODITE OF KNIDOS**
Composite of two similar Roman copies after the original
marble of c. 350 BCE. Marble, height 6'8" (2.04 m). Vatican
Museums, Museo Pio Clementino, Gabinetto delle Maschere,
Rome.

The head of this figure is from one Roman copy, the body from
another. Seventeenth- and eighteenth-century CE restorers added the
nose, the neck, the right forearm and hand, most of the left arm,
and the feet and parts of the legs. This kind of restoration would
rarely be undertaken today, but it was frequently done and consid-
ered quite acceptable in the past, when archaeologists were trying
to put together a body of work documenting the appearances of
lost Greek statues.

THE INFANT DIONYSOS as an authentic work by Praxiteles
until recent studies indicated that it is probably a very good
Roman or Hellenistic copy.

The sculpture represents the differences between the
fourth and fifth century styles. *Hermes* has a smaller head
and a more youthful body than Polykleitos's *Doryphoros
(Spear Bearer)*, his off-balance, S-curve pose, requiring the
figure to lean on a post, contrasts clearly with the balance
of the earlier work. The sculptor also created a sensuous
play of light over the figure's surface. The gleam of the
smoothly finished flesh contrasts with the textured quality
of the crumpled draperies and the rough locks of hair, even
on the baby's head. Praxiteles is also responsible for the
humanized treatment of the subject—two gods, one a lov-
ing adult and the other a playful child, caught in a moment
of absorbed companionship. The interaction of the two
across real space through gestures and glances creates an
overall effect far different from that of the austere
Olympian deities of the fifth century BCE on the pediments
and metopes of the Temple of Zeus (SEE FIG. 5–25), near
where the work was found.

Around 350 BCE, Praxiteles created a statue of
Aphrodite for the city of Knidos in Asia Minor. Although
artists of the fifth century BCE had begun to hint boldly at
the naked female body beneath tissue-thin drapery, as in
Nike Adjusting Her Sandal (SEE FIG. 5–42), this **APHRODITE**
was apparently the first statue by a well-known Greek sculp-
tor to depict a fully nude woman, and it set a new standard
(**FIG. 5–51**). Although nudity among athletic young men was
admired in Greek society, among women it had been consid-
ered a sign of low character. The eventual wide acceptance of
female nudes in large statuary may be related to the gradual
merging of the Greeks' concept of their goddess Aphrodite
with some of the characteristics of the Phoenician goddess
Astarte (the Babylonian Ishtar), who was nearly always shown
nude in Near Eastern art.

In the version of the statue seen here (actually a compos-
ite of two Roman copies), the goddess is preparing to take a
bath, with a water jug and her discarded clothing at her side.
Her right arm and hand extend in what appears at first glance
to be a gesture of modesty but in fact only emphasizes her
nudity. The bracelet on her left arm has a similar effect. Her
well-toned body, with its square shoulders, thick waist, and
slim hips, conveys a sense of athletic strength. She leans for-
ward slightly with one knee in front of the other in a seduc-
tive pose that emphasizes the swelling forms of her thighs and
abdomen. According to an old legend, the sculpture was so
realistic that Aphrodite herself made a journey to Knidos to
see it and cried out in shock, "Where did Praxiteles see me
naked?" The Knidians were so proud of their *Aphrodite* that
they placed it in an open shrine where people could view it
from every side. Hellenistic and Roman copies probably

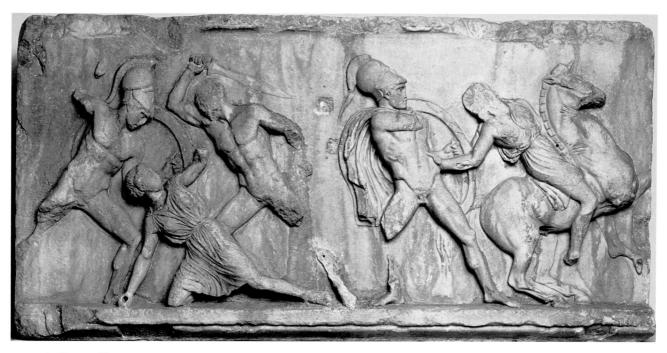

5–52 | Skopas (?) **PANEL FROM THE AMAZON FRIEZE, SOUTH SIDE OF THE MAUSOLEUM AT HALIKARNASSOS**
Mid-4th century BCE. Marble, height 35″ (89 cm). The British Museum, London.

numbered in the hundreds, and nearly fifty survive in various collections today (see Introduction Fig. 7).

SKOPAS. According to Pliny, Skopas was one of the sculptors who worked at the mausoleum at Halikarnassos, carving part of the frieze (FIG. 5–52). Skopas was greatly admired in ancient times. He had a brilliant career as both sculptor and architect that took him around the Greek world. Unfortunately, little survives—originals or copies—that can be reliably attributed to him. If literary accounts are accurate, Skopas introduced a new style of sculpture admired in its time and influential in the Hellenistic period. In relief compositions, he favored very active, dramatic poses over balanced, harmonious ones, and he was especially noted for the expression of emotion in the faces and gestures of his figures. The typical Skopas head conveys intensity with its deep-set eyes, heavy brow, slightly parted lips, and a gaze that seems to look far into the future. The squarish heads with deep set eyes, the energetic figures, and the repeated diagonals of the composition all suggest Skopas as the sculptor of the battle scenes of Lapiths against centaurs and Greeks against Amazons.

LYSIPPOS. In contrast to Praxiteles and Skopas, many details of Lysippos's life are known and many copies of his sculpture survive. He claimed to be entirely self-taught and asserted that "nature" was his only model, but he must have received some technical training in the vicinity of his home, near Corinth. He worked from c. 350 to c. 310 BCE. Although he expressed

great admiration for Polykleitos, his own figures reflect a different ideal and different proportions from those of the fifth-century BCE master. For his famous work **THE MAN SCRAPING HIMSELF (APOXYOMENOS)**, known today only from Roman copies (FIG. 5–53), he chose a typical Classical subject, a nude male athlete, but he treated it in an unusual way. Instead of a figure actively engaged in a sport, striding, or standing at ease, Lysippos depicted a young man methodically removing oil and dirt from his body with a scraping tool called a strigil. Judging from the athlete's expression, his thoughts are far from his mundane task. His deep-set eyes, dreamy stare, heavy forehead, and tousled hair may reflect the influence of Skopas.

The Man Scraping Himself, tall and slender with a relatively small head, like Praxiteles' work, makes a telling comparison with Polykleitos's *Spear Bearer* (SEE FIG. 5–24). Not only does it reflect a different canon of proportions, but the figure's weight is also more evenly distributed between the engaged leg and the free one, with the free foot almost flat on the ground. The legs are also in a wider stance to counterbalance the outstretched arms. The *Spear Bearer* is contained within fairly simple, compact contours and oriented toward a center front viewer. In contrast, the arms of *The Man Scraping Himself* break free into the surrounding space, requiring the viewer to move around the statue to absorb its full aspect. Roman authors, who may have been describing the bronze original rather than a marble copy, remarked on the subtle modeling of the statue's elongated body and the spatial extension of its pose.

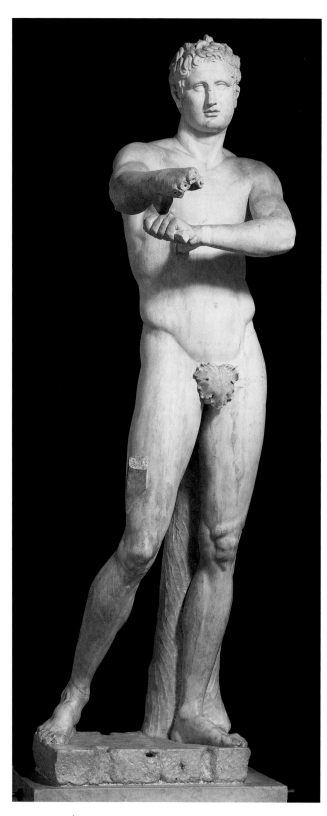

5-53 | Lysippos **THE MAN SCRAPING HIMSELF (APOXYOMENOS)**
Roman copy after the original bronze of c. 350-325 BCE. Marble, height 6′9″ (2.06 m). Vatican Museums, Museo Pio Clementino,
Gabinetto dell'Apoxyomenos, Rome.

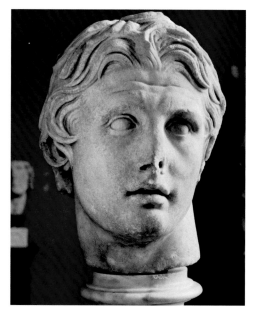

5-54 | Lysippos (?) **ALEXANDER THE GREAT**
Head from a Hellenistic copy (c. 200 BCE) of a statue, possibly after a 4th-century BCE original. Marble fragment, height 16⅛″ (41 cm). Archaeological Museum, Istanbul, Turkey.

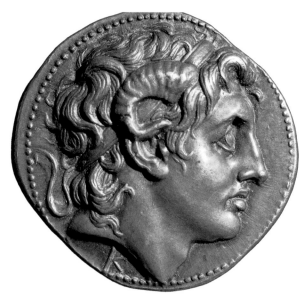

5-55 | **ALEXANDER THE GREAT**
Four drachma coin issued by Lysimachos of Thrace. 306-281 BCE. Silver, diameter 1⅛″ (30 mm). The British Museum, London.

Lysippos was widely known and admired for his monumental statues of Herakles (see Introduction, Fig. 23) and Zeus. The sculpture of Zeus is lost, but the weary Herakles (Hercules), leaning on his club (resting after the last of his Twelve Labors) and holding the apples of the Hesperides, comes down to us in the imposing Hellenistic sculpture known as the Farnese Hercules, a copy in marble, signed by Glykon, of a bronze by Lysippos. Not surprisingly, the Romans admired this heroic figure; the marble copy stood in the Baths of Caracalla. In the Renaissance the sculpture was part of the Farnese collection in

Rome, where it stood in the courtyard of their palace and was studied by artists from all over Europe.

When Lysippos was summoned to do a portrait of Alexander the Great (ruled 336–323 BCE), he portrayed Alexander as a full-length standing figure with an upraised arm holding a scepter, just as he is believed to have posed Zeus. A head found at Pergamon (located in present-day Turkey) that was once part of a standing figure is believed to be from one of several copies of Lysippos's original of Alexander (FIG. 5–54). It depicts a ruggedly handsome, heavy-featured young man with a large Adam's apple and short, tousled hair. The treatment of the hair may be a visual reference to the mythical hero Herakles, who killed the Nemean Lion as his First Labor and is often portrayed wearing its head and pelt as a hooded cloak. Alexander would have felt great kinship with Herakles, whose acts of bravery and strength earned him immortality.

The Pergamon head was not meant to be entirely true to life, although we see here elements of an individual's distinctive appearance. The artist rendered certain features in an idealized manner to convey a specific message about the subject. The deep-set eyes are unfocused and meditative, and the low forehead is heavily lined, as though the figure were contemplating decisions of great consequence and waiting to receive divine advice.

According to the Roman-era historian Plutarch, Lysippos depicted Alexander in a characteristic meditative pose, "with his face turned upward toward the sky, just as Alexander himself was accustomed to gaze, turning his neck gently to one side" (cited in Pollitt, page 20). Because this description fits the marble head from Pergamon and others like it so well, they have been thought to be copies of the Alexander statue. On the other hand, the heads could also be viewed as conventional, idealized "types" created by Lyssipos. A reasonably reliable image of Alexander is found on a coin issued by Lysimachos, who ruled Thrace from 306 to 281 BCE (FIG. 5–55). It shows Alexander in profile wearing the curled ram's-horn headdress that identifies him as the Greek-Egyptian god Zeus-Amun. The portrait has the same low forehead, high-bridged nose, large lips, and thick neck as the Pergamon head.

The Art of the Goldsmith

The work of Greek goldsmiths, which gained international popularity in the Classical period, followed the same stylistic trends and achieved the same high standards of technique and execution found in the other arts. A specialty of Greek goldsmiths was the design of earrings in the form of tiny works of sculpture. They were often placed on the ears of marble statues of goddesses, but they adorned the ears of living women as well. Earrings designed as the youth Ganymede in the grasp of an eagle (Zeus) (FIG. 5–56), dated about 330—300 BCE, are both a charming decoration and a technical tour de force. Slightly more than 2 inches high, they were hollow-cast

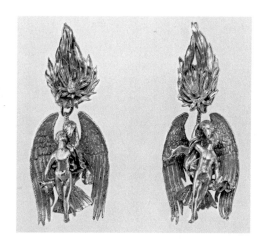

5–56 EARRINGS
c. 330–300 BCE. Hollow-cast gold, height 2⅜" (6 cm).
The Metropolitan Museum of Art, New York.
Harris Brisbane Dick Fund, 1937 (37.11.9-10).

using the **lost-wax process**, no doubt to make them light on the ear. Despite their small size, the earrings convey all the drama of their subject. Action subjects like this, with the depiction of swift movement through space, were to become a hallmark of Hellenistic art.

Wall Painting and Mosaics

Roman observers such as Pliny the Elder claimed that Greek painters were skilled in capturing the appearance of the real world. Roman patrons admired Greek murals and commissioned copies, in paintings or **mosaic**, to decorate their homes. (Mosaics are created from **tesserae**, small cubes of colored stone or marble. They provide a permanent waterproof surface that the Romans used for floors in important rooms.) Mosaics and red-figure vases are the best evidence for fourth-century BCE painting. They indicate a growing taste for dramatic narrative subjects. A first-century CE mosaic, **ALEXANDER THE GREAT CONFRONTS DARIUS III AT THE BATTLE OF ISSOS** (FIG. 5–57), for example, copies a painting of about 310 BCE.

Pliny the Elder mentions a painting of Alexander and Darius by Philoxenos of Eretria; but a new theory claims it was by Helen of Egypt (see "Women Artists in Ancient Greece," page 157). Certainly the scene is one of violent action where radical foreshortening draws the viewer into the scene and elicits an emotional response to a dramatic situation. Astride a horse at the left, his hair blowing free and his neck bare, Alexander challenges the helmeted and armored Persian leader, who stretches out his arm in a gesture of defeat and apprehension as his charioteer whisks him back toward safety in the Persian ranks. The mosaicist has created an illusion of solid figures through modeling, mimicking the play of light on three-dimensional surfaces by highlights and shading.

The interest of fourth-century BCE artists in creating a believable illusion of the real world was the subject of anecdotes repeated by later writers. One popular legend

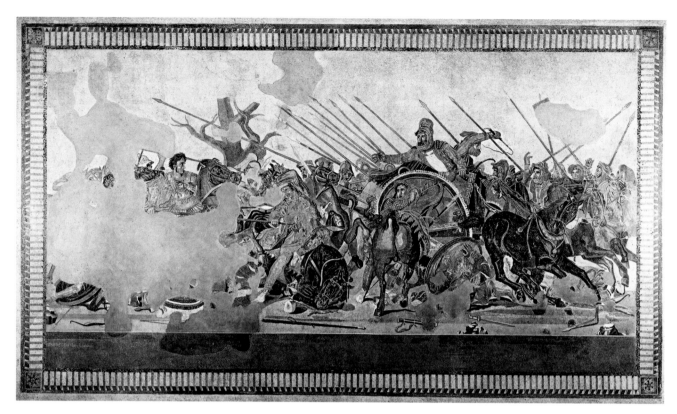

5–57 | **ALEXANDER THE GREAT CONFRONTS DARIUS III AT THE BATTLE OF ISSOS**
Floor mosaic, Pompeii, Italy. 1st-century CE Roman copy of a Greek wall painting of c. 310 BCE, perhaps by Philoxenos of Eretria or Helen of Egypt. Entire panel 8'10" × 17' (2.7 × 5.2 m). National Archeological Museum, Naples.

involved a floral designer, a woman named Glykera—widely praised for the artistry with which she wove blossoms and greenery into wreaths, swags, and garlands for religious processions and festivals—and Pausias, the foremost painter of the day. Pausias challenged Glykera to a contest, claiming that he could paint a picture of one of her complex works that would appear as lifelike to the spectator as her real one. According to the legend, he succeeded. It is not surprising, although perhaps unfair, that the opulent floral borders so popular in later Greek painting and mosaics are described as "Pausian" rather than "Glykeran."

A mosaic floor from a palace at Pella (Macedonia) provides an example of a Pausian design. Dated about 300 BCE, the floor features a series of framed hunting scenes, such as the **STAG HUNT** (FIG. 5–58), prominently signed by an artist named Gnosis. Blossoms, leaves, spiraling tendrils, and twisting, undulating stems frame this scene, echoing the linear patterns formed by the hunters, the dog, and the struggling stag.

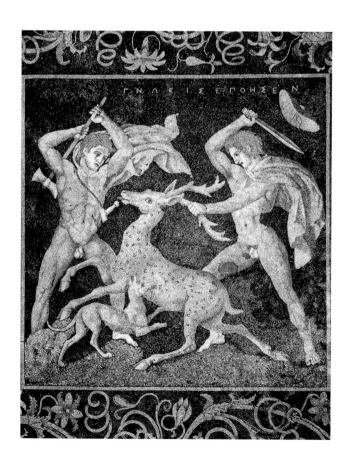

5–58 | Gnosis **STAG HUNT**
Detail of mosaic floor decoration from Pella (Macedonia), (present-day Greece). 300 BCE. Pebbles, height 10'2" (3.1 m). Archaeological Museum, Pella. Signed at top: "Gnosis made it."

The over-life-size human and animal figures are accurately drawn and modeled in light and shade. The dog's front legs are expertly foreshortened to create the illusion that the animal is turning at a sharp angle into the picture. The work is all the more impressive because it was not made with uniformly cut marble in different colors, but with a carefully selected assortment of natural pebbles.

THE HELLENISTIC PERIOD, 323–31/30 BCE

When Alexander died unexpectedly in 323 BCE, he left a vast empire with no administrative structure and no accepted successor. Almost at once his generals turned against one another, local leaders tried to regain their lost autonomy, and the empire began to break apart. The Greek city-states formed a new mutual-protection league but never again achieved significant power. Democracy survived in form but not substance in governments dominated by local rulers.

By the early third century BCE, three of Alexander's generals—Antigonus, Ptolemy, and Seleucus—had carved out kingdoms. The Antigonids controlled Macedonia and mainland Greece; the Ptolemies ruled Egypt; and the Seleucids controlled Asia Minor, Mesopotamia, and Persia. Over the course of the second and first centuries BCE, these kingdoms succumbed to the growing empire centered in Rome. Ptolemaic Egypt endured the longest, almost two and a half centuries. The Ptolemaic capital, Alexandria in Egypt, a prosperous seaport known for its lighthouse (another of the Seven Wonders of the World, according to ancient writers), emerged as a great Hellenistic center of learning and the arts. Its library is estimated to have contained 700,000 papyrus and parchment scrolls. The Battle of Actium in 31 BCE and the death in 30 BCE of Egypt's last ruler, the remarkable Cleopatra, marks the end of the Hellenistic period.

Alexander's lasting legacy was the spread of Greek culture far beyond its original borders, but artists of the Hellenistic period had a vision noticeably different from that of their predecessors. Where earlier artists sought the ideal and the general, Hellenistic artists sought the individual and the specific. They turned increasingly away from the heroic to the everyday, from gods to mortals, from aloof serenity to individual emotion, and from drama to melodramatic pathos. A trend introduced in the fourth century BCE—the appeal to the senses through lustrous or glittering surface treatments and to the emotions with dramatic subjects and poses—became more pronounced. Even the architecture of the Hellenistic period largely reflected the contemporary taste for high drama. Building types continued with few changes, but their size and the amount of decoration increased. Greek art continued to influence the art of the Romans, and the Hellenistic style lasted until the Augustan period in the first century CE.

Art and Its Context
WOMEN ARTISTS IN ANCIENT GREECE

Although comparatively few artists in ancient Greece were women, there is evidence that women artists worked in many mediums. Ancient writers noted women painters—Pliny the Elder, for example, listed Aristarete, Eirene, Iaia, Kalypso, Olympias, and Timarete. Helen, a painter from Egypt who had been taught by her father, is known to have worked in the fourth century BCE and may have been responsible for the original Greek wall painting of c. 310 BCE of *Alexander the Great Confronts Darius III at the Battle of Issos* (SEE FIG. 5-57).

Greek women were known to create narrative or pictorial tapestries. They also worked in pottery workshops. The hydria here, dating from about 450 BCE, shows a woman artist in such a workshop, but her status is ambiguous. The composition focuses on the male painters, who are being approached by Nikes (Victories) bearing wreaths symbolizing victory in an artistic competition. A well-dressed woman sits on a raised dais, painting the largest vase in the workshop. She is isolated from the other artists and is not part of the awards ceremony. Perhaps women were excluded from public artistic competitions, as they were from athletics. Another interpretation, however, is that the woman is the head of this workshop. Secure in her own status, she may have encouraged her assistants to enter contests to further their careers and bring glory to the workshop as a whole.

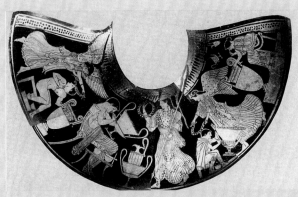

A VASE PAINTER AND ASSISTANTS CROWNED BY ATHENA AND VICTORIES
Composite photograph of the red-figure decoration on a hydria from Athens. c. 450 BCE. Private Collection.

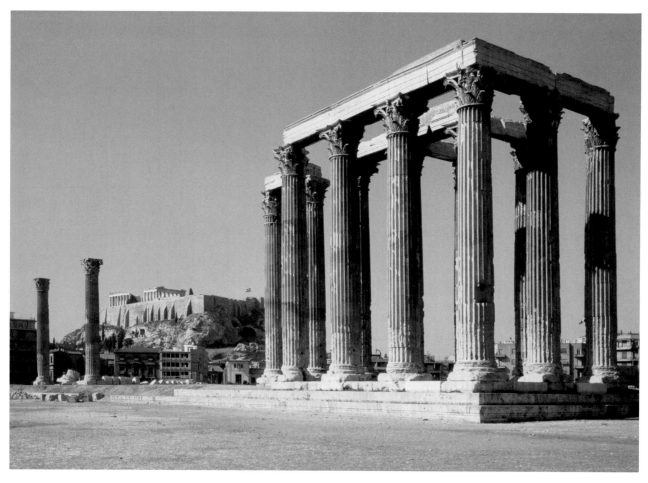

5–59 | **TEMPLE OF THE OLYMPIAN ZEUS, ATHENS, ACROPOLIS IN DISTANCE**
Building and rebuilding phases: foundation c. 520–510 BCE using the Doric order; temple designed by Cossutius, begun 175 BCE, left unfinished 164 BCE, completed 132 CE using Cossutius's design and the Corinthian order (see FIG. 3, Introduction). Height of columns 55'5" (16.89 m).

The Corinthian Order in Hellenistic Architecture

During the Hellenistic period, a variant of the Ionic order featuring tall, slender columns with elaborate foliate capitals challenged the dominant Doric and Ionic orders. Invented in the late fifth century BCE and called Corinthian by the Romans, this highly decorative column had previously been used only indoors, as in the *tholos* at Epidaurus (see Introduction, Fig. 2). Today, the Corinthian variant is routinely treated as a third Greek order (see "The Greek Architectural Orders," page 118). In the Corinthian capital, curly acanthus leaves and coiled flower spikes surround a basket-shaped core. Unlike Doric and Ionic capitals, the Corinthian capital has many possible variations; only the foliage is required. Above the capitals, the Corinthian entablature, like the Ionic, has a stepped-out architrave and a continuous frieze. It also has more bands of carved moldings. The Corinthian design became a symbol of elegance and refinement, and it is still used on banks, churches, and court buildings today.

The Corinthian **TEMPLE OF THE OLYMPIAN ZEUS**, located in the lower city of Athens at the foot of the Acropolis, was designed by the Roman architect Cossutius in the second century BCE (**FIG. 5–59**) on the foundations of an ear-

lier Doric temple. Work on the Cossutius design halted in 164 BCE and was not completed until three centuries later under the patronage of the Roman emperor Hadrian (see Chapter 6). The temple's great Corinthian columns, 55 feet 5 inches tall, may be the second-century BCE Greek originals or Roman replicas. Viewed through these columns, the Parthenon seems modest in comparison. But in spite of its size and luxurious decoration, the new temple followed long-established conventions. It was an enclosed rectangular building surrounded by a screen of columns standing on a three-stepped base. Its proportions and details followed traditional standards. It is, quite simply, a Greek temple grown very large.

Hellenistic Architecture: The Theater at Epidauros

In ancient Greece, the theater was more than mere entertainment; it was a vehicle for the communal expression of religious belief through music, poetry, and dance. In very early times, theater performances took place on the hard-packed dirt or stone-surfaced pavement of an outdoor threshing floor—the same type of floor later incorporated into religious sanctuaries. Whenever feasible, dramas were also presented

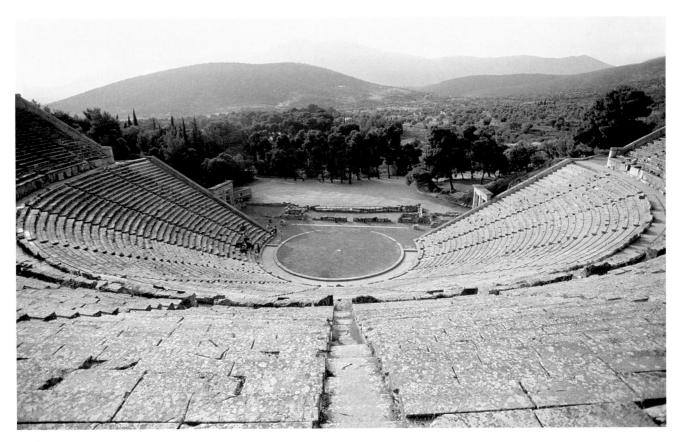

5–60 THEATER, EPIDAUROS
4th century BCE and later.

facing a steep hill that served as elevated seating for the audience. Eventually such sites were made into permanent open-air auditoriums. At first, tiers of seats were simply cut into the side of the hill. Later, builders improved them with stone.

During the fifth century BCE, the plays were usually tragedies in verse based on popular myths and were per-

formed at a festival dedicated to Dionysos. At this time, the three great Greek tragedians—Aeschylus, Sophocles, and Euripides—were creating the dramas that would define tragedy for centuries. Many theaters were built in the fourth century BCE, including those on the side of the Athenian Acropolis and in the sanctuary at Delphi. Because they were

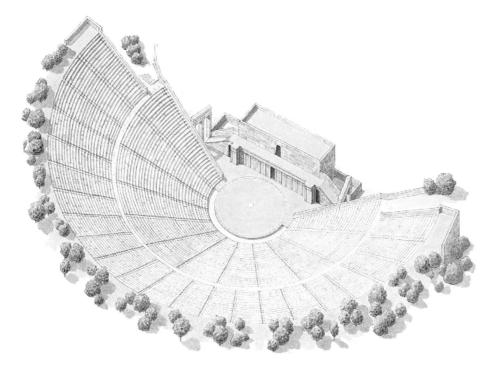

5–61 RECONSTRUCTION DRAWING OF THE THEATER AT EPIDAUROS

used continuously and frequently modified over many centuries, early theaters have not survived in their original form.

The theater at Epidauros, built in the second half of the fourth century, is characteristic (FIGS. 5–60, 5–61). A semicircle of tiered seats built into the hillside overlooked the circular performance area, called the **orchestra**, at the center of which was an altar to Dionysos. Rising behind the orchestra was a two-tiered stage structure made up of the vertical *skene* (scene)—an architectural backdrop for performances that also screened the backstage area from view—and the *proskenion* (**proscenium**), a raised platform in front of the *skene* that was increasingly used over time as an extension of the orchestra. Ramps connecting the *proskenion* with lateral passageways provided access for performers. Steps gave the audience access to the fifty-five rows of seats and divided the seating area into uniform wedge-shaped sections. The tiers of seats above the wide corridor, or gangway, were added at a much later date. This design provided uninterrupted sight lines and good acoustics and allowed for efficient entrance and exit of the 12,000 spectators. No better design has ever been created.

Sculpture

Hellenistic sculptors produced an enormous variety of work in a wide range of materials, techniques, and styles. The period was marked by two broad and conflicting trends. One (sometimes called anti-Classical) led away from Classical models and toward experimentation with new forms and subjects; the other led back to Classical models, with artists selecting aspects of certain favored works by fourth-century BCE sculptors and incorporating them into their own work. The radical anti-Classical style was especially strong in Pergamon and other eastern centers of Greek culture.

PERGAMON. The kingdom of Pergamon, a breakaway state within the Seleucid realm, established itself in the early third century BCE in western Asia Minor. The capital, Pergamon, quickly became a leading center of the arts and the hub of a new sculptural style that had far-reaching influence throughout the Hellenistic period. This new style is illustrated by sculpture from a monument commemorating the victory in 230 BCE of Attalos I (ruled 241–197 BCE) over the Gauls, a Celtic people. The monument extols the dignity and heroism of the defeated enemies and by extension the power and virtue of the Pergamenes.

These figures of Gauls, originally in bronze but known today only from Roman copies in marble, were mounted on a large pedestal. One group depicts the murder-suicide of the Gallic chieftain and his wife (FIG. 5–62) and the slow demise of a wounded soldier-trumpeter (FIG. 5–63). Their wiry, unkempt hair and the trumpeter's twisted neck ring (the Celtic battle dress), identify them as "barbarians." The artist has sought to arouse admiration and pity for his subjects. The chieftain, for example, still supports his dead wife as he plunges the sword

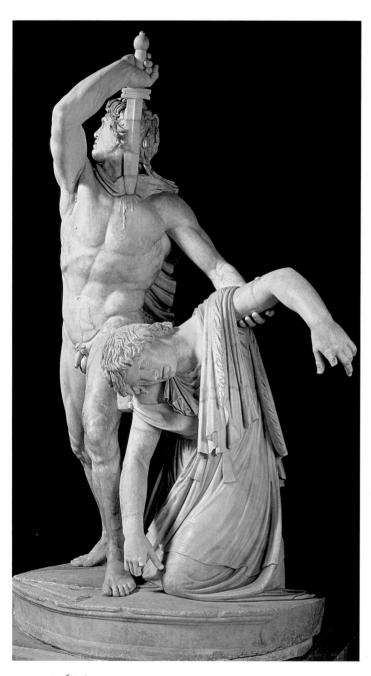

5–62 | **GALLIC CHIEFTAIN KILLING HIS WIFE AND HIMSELF**
Roman copy after the original bronze of c. 220 BCE. Marble, height 6'11" (2.1 m). National Museum, Rome.

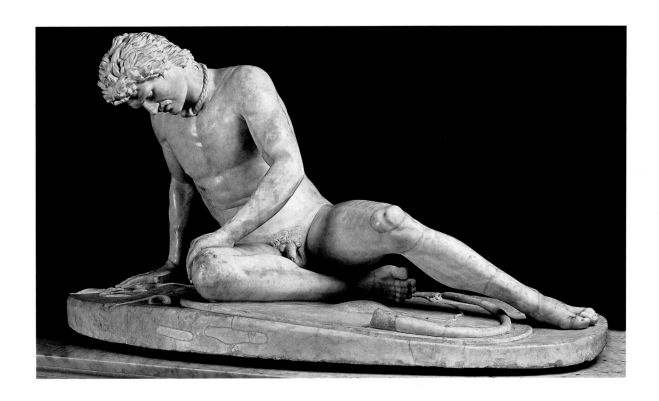

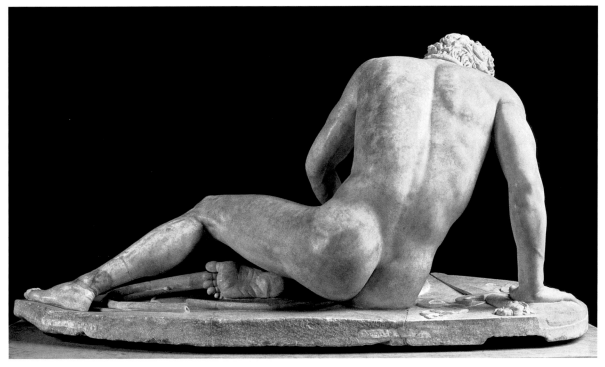

5–63 | Epigonos (?) **DYING GALLIC TRUMPETER**
Roman copy after the original bronze of c. 220 BCE. Marble, height, 36½" (93 cm). Capitoline Museum, Rome.

The marble sculpture was found in Julius Caesar's garden in Rome. The bronze originals were made for the Sanctuary of Athena in Pergamon. Pliny wrote that Epigonos "surpassed others with his Trumpeter."

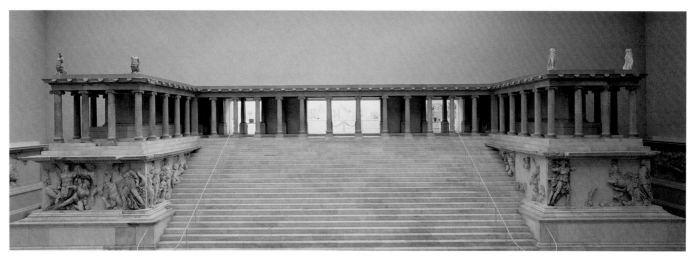

5–64 | **RECONSTRUCTED WEST FRONT OF THE ALTAR FROM PERGAMON, TURKEY**
c. 175–150 BCE. Height of figure 7'7" (2.3 m). Marble. Staatliche Museen zu Berlin, Pergamonmuseum, Preussischer Kutturbesitz, Berlin.

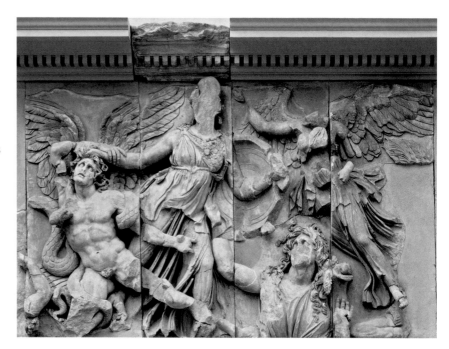

5–65 | **ATHENA ATTACKING THE GIANTS**
Detail of the frieze from the east front of the altar from Pergamon, c. 175–150 BCE. Marble, frieze height 7'7" (2.3 m). Staatliche Museen zu Berlin, Antiken-sammlung, Pergamonmuseum, Berlin.

into his own breast. The trumpeter, fatally injured, struggles to rise, but the slight bowing of his supporting right arm and his unseeing downcast gaze indicate that he is on the point of death. This kind of deliberate attempt to elicit a specific emotional response in the viewer is known as **expressionism**, and it was to become a characteristic of Hellenistic art.

The marble copies of these works are now separated, but originally they formed part of an interlocked, multifigured group on a raised base that could have been viewed and appreciated from every angle. Pliny the Elder described a work like the *Dying Gallic Trumpeter*, attributing it to an artist named Epigonos. Recent research indicates that Epigonos

probably knew the early fifth-century BCE sculpture of the Temple of Aphaia at Aegina, which included the *Dying Warrior* (SEE FIG. 5–13), and could have had it in mind when he created his own works.

The style and approach of the work in the monument became more pronounced and dramatic in later works, culminating in the sculptured frieze on the base of the Great Altar at Pergamon (FIG. 5–64). The wings and staircase to the entrance of the courtyard in which the altar stood have been reconstructed inside a Berlin museum. The original altar complex was a single-story structure with an Ionic colonnade raised on a high podium reached by a monumental

staircase 68 feet wide and nearly 30 feet deep. The running frieze decoration, probably executed during the reign of Eumenes II (197–159 BCE), depicts the battle between the gods and the Giants (Titans), a mythical struggle that the Greeks are thought to have used as a metaphor for Pergamon's victory over the Gauls.

The frieze was more than 7 feet high, tapering along the steps to just a few inches. The Greek gods fight not only human-looking Giants, but also hybrids with snakes for legs emerging from the bowels of the earth. In a detail of the frieze (FIG. 5–65), the goddess Athena at the left has grabbed the hair of a winged male monster and forced him to his knees. Inscriptions along the base of the sculpture identify him as Alkyoneos, a son of the earth goddess Ge, who rises from the ground on the right in fear as she reaches toward Athena, pleading for her son's life. At the far right, a winged Nike rushes to Athena's assistance to crown her with a victor's wreath.

The figures in the Pergamon frieze not only fill the sculptural space, they break out of their architectural boundaries and invade the spectators' space. They crawl out of the frieze onto the steps, where visitors had to pass them on their way up to the shrine. Many consider this theatrical and complex interaction of space and form to be a benchmark of the Hellenistic style, just as they consider the balanced restraint of the Parthenon sculpture to be the epitome of the High Classical style. Where fifth-century BCE artists sought horizontal and vertical equilibrium and control, the Pergamene artists sought to balance opposing forces in three-dimensional space along diagonal lines.

The Classical preference for smooth surfaces reflecting a clear, even light has been replaced by a preference for dramatic contrasts of light and shade playing over complex forms carved with deeply undercut high relief. The composure and stability admired in the Classical style have given way to extreme expressions of pain, stress, wild anger, fear, and despair. In the fifth century, figures stood remote in their own space. In the fourth century BCE, they reached out into their immediate environment, imposing themselves, often forcefully, on the spectator. Whereas the Classical artist asked only for an intellectual commitment, the Hellenistic artist demanded that the viewer empathize.

THE PERGAMENE STYLE: LAOCOÖN AND NIKE. Pergamene artists may have inspired the work of Hagesandros, Polydoros, and Athenedoros, three sculptors on the island of Rhodes named by Pliny the Elder as the creators of the famed *Laocoön and His Sons* (see Introduction, Fig. 10). This work has been assumed by many art historians to be the original version from the second century BCE, although others argue that it is a brilliant copy commissioned by an admiring Roman patron in the first century CE.

The complex sculptural composition illustrates an episode from the Trojan War. The priest Laocoön warned the Trojans not to take the giant wooden horse left by the Greeks

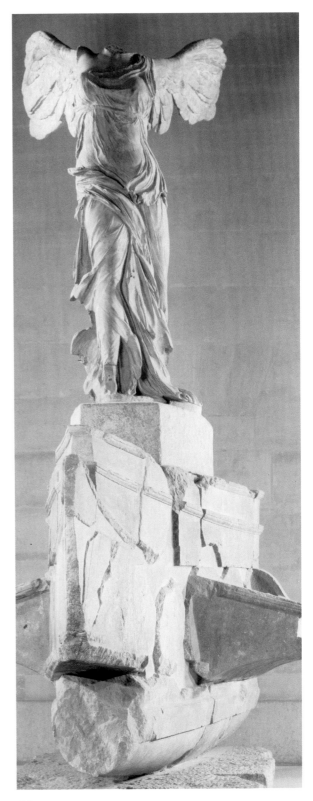

5–66 | **NIKE (VICTORY) OF SAMOTHRACE**
Sanctuary of the Great Gods, Samothrace. c. 180 BCE (?). Marble, height 8′1″ (2.45 m). Musée du Louvre, Paris.

The wind-whipped costume and raised wings of this Victory indicate that she has just alighted on the prow of the stone ship that formed the original base of the statue. The work probably commemorated an important naval victory, perhaps the Rhodian triumph over the Seleucid king Antiochus III in 190 BCE. The Nike (lacking its head and arms) and a fragment of its stone ship base were discovered in the ruins of the Sanctuary of the Great Gods by a French explorer in 1863 (additional fragments were discovered later). Soon after, the sculpture entered the collection of the Louvre Museum in Paris.

5–67 | **VEILED AND MASKED DANCER**
Late 3rd or 2nd century BCE. Bronze, height 8⅛″ (20.7 cm).
The Metropolitan Museum of Art, New York.
Bequest of Walter C. Baker, 1971 (1972.118.95)

inside their walls. The gods who supported the Greeks in the war retaliated by sending serpents from the sea to destroy Laocoön and his sons as they walked along the shore. The struggling figures, anguished faces, intricate diagonal movements, and skillful unification of diverse forces in a complex composition all suggest a strong relationship between Rhodian and Pergamene sculptors. Unlike the monument to the conquered Gauls, the *Laocoön* was composed to be seen from the front, within a short distance. As a result, although sculpted in the round, the three figures resemble the relief sculpture on the altar from Pergamon.

The **NIKE (VICTORY) OF SAMOTHRACE** (FIG. 5–66) is even more theatrical than the *Laocoön*. In its original setting—in a hillside niche high above the sanctuary of the Greek gods at Samothrace and perhaps drenched with spray from a fountain—this huge goddess of victory must have reminded visitors of the god in Greek plays who descends from heaven to determine the outcome of the drama. The fact that victory in real life does often seem miraculous makes this image of a goddess alighting suddenly on a ship breathtakingly appropriate for a war memorial. The forward momentum of the Nike's heavy body is balanced by the powerful backward thrust of her enormous wings. The large, open movements of the figure, the strong contrasts of light and dark on the deeply sculpted forms, and the contrasting textures of feathers, fabric, and skin typify the finest Hellenistic art.

Although "huge," "enormous," and "larger-than-life" are terms correctly applied to much Hellenistic sculpture, artists of the time also created fine works on a small scale. The grace, dignity, and energy of the 8-foot-tall *Nike of Samothrace* can also be found in a bronze about 8 inches tall (FIG. 5–67). This figure of a heavily veiled and masked dancing woman twists sensually under the gauzy, layered fabric in a complex spiral movement. The dancer is clearly a professional performer. This bronze would have been costly, but many such graceful figurines were produced in inexpensive terra cotta from molds.

The Multicultural Hellenistic World

In contrast to the Classical world, which was characterized by relative cultural unity and social homogeneity, the Hellenistic world was varied and multicultural. In this environment, artists turned from idealism, the quest for perfect form, to realism, the attempt to portray the world as they saw it. Portraiture, for example, became popular during the Hellenistic period, as did the representation of people from every level of society. Patrons were fascinated by depictions of unusual physical types as well as of ordinary individuals.

An old peasant woman on her way to the agora with three chickens and a basket of vegetables may seem to be an unlikely subject for sculpture (FIG. 5–68). Despite the bunched and untidy way the figure's dress hangs, it appears to be of an elegant design and made of fine fabric. Her hair, too,

bears some semblance of a once-careful arrangement. These characteristics, along with the woman's sagging lower jaw, unfocused stare, and lack of concern for her exposed breasts, have led some to speculate that she represents an aging, dissolute follower of the wine god Dionysos on her way to make an offering. Whether an aging peasant, or a Dionysian celebrant, the woman is the antithesis of the *Nike of Samothrace*. Yet in formal terms, both sculptures stretch out assertively into the space around them, both demand an emotional response from the viewer, and both display technical virtuosity in the rendering of forms and textures. They are closer to each other than either is to the *Nike Adjusting Her Sandal* (SEE FIG. 5–42) or the *Aphrodite of Knidos* (SEE FIG. 5–51).

But not all Hellenistic artists followed the trend toward realism and expressionism that characterized the artists of Pergamon and Rhodes. Some turned to the past, creating an eclectic style by reexamining and borrowing elements from earlier Classical styles and combining them in new ways. Certain popular sculptors looked back especially to Praxiteles and Lysippos for their models. This renewed interest in the style of the fourth century BCE is exemplified by the **APHRODITE OF MELOS** (better known as the *Venus de Milo*) **(FIG. 5–69),** found on the island of Melos by French excavators in the early nineteenth century CE. The sculpture was intended by its maker to recall the *Aphrodite* of Praxiteles (SEE FIG. 5–51), and indeed the head with its dreamy gaze is very like Praxiteles' work. The figure has the heavier proportions of High Classical sculpture, but the twisting stance and the strong projection of the knee are typical of Hellenistic art. The drapery around the lower part of the body also has the rich, three-dimensional quality associated with the Hellenistic sculpture of Rhodes and Pergamon. The juxtaposition of flesh and drapery, which seems about to slip off the figure entirely, adds a note of erotic tension.

By the end of the first century BCE, the influence of Greek painting, sculpture, and architecture had spread to the artistic communities of the emerging Roman civilization. Roman patrons and artists maintained their enthusiasm for Greek art into Early Christian and Byzantine times. Indeed, so strong was the urge to emulate the great Greek artists that, as we have seen throughout this chapter, much of our knowledge of Greek achievements comes from Roman replicas of Greek artworks and descriptions of Greek art by Roman-era writers.

IN PERSPECTIVE

Greek art between the sixth and the fourth centuries BCE reveals that the Greeks had been studying every detail of their surroundings, from an acanthus leaf to the folds of their own clothing. By then, too, builders had evolved standardized temple plans. They had also experimented with the arrangement, proportions, and appearance of their temples until they

5–68 | **OLD WOMAN**
Roman copy, 1st century CE. Marble, height 49½″ (1.25 m).
The Metropolitan Museum of Art, New York.
Rogers Fund, 1909 (09.39)

perfected two distinct designs—the Doric order and the Ionic order. The Corinthian order became so popular later that today it too is treated as a standard Greek order.

In the fifth century, the Athenians built the Parthenon, a new temple to the goddess Athena in which architectural design and sculptural decoration established a Classical ideal. The Parthenon's extensive program of decoration strongly reflects the ancient Greek vision of unity and beauty.

Studying human appearances closely, the sculptors of the Classical period selected those attributes they considered most desirable and combined them into a single ideal of perfection. These figures also expressed profound political and ideological themes and ideas: the preeminence of Athens and the triumph of an enlightened Greek civilization over despotism and barbarism.

Although later artists continued to observe the basic Classical approach to composition and form, they no longer adhered rigidly to its conventions. Despite the instability of the fourth century BCE, Greek city-states undertook innovative architectural projects. Architects developed variations on Classical ideals in urban planning, temple design, and the construction of monumental tombs and altars. In contrast to the fifth century, much of this activity took place outside of Athens, notably in Asia Minor.

Earlier Greek artists had sought to capture the ideal and often focused on the heroic. Hellenistic artists sought to represent the specific and turned increasingly to the everyday. Since the fourth century BCE, the appeal to the senses through surface treatments and to the emotions through drama had also become more pronounced. Even the architecture of the Hellenistic period largely reflected the contemporary taste for high drama.

5–69 | **APHRODITE OF MELOS (ALSO CALLED VENUS DE MILO)**
c. 150–100 BCE. Marble, height 6'8" (2.04 m). Musée du Louvre, Paris.

The original appearance of this famous statue's missing arms has been much debated. When it was dug up in a field in 1820, some broken pieces (now lost) found with it indicated that the figure was holding out an apple in its right hand. Many judged these fragments to be part of a later restoration, not part of the original statue. Another theory is that Aphrodite was admiring herself in the highly polished shield of the war god Ares, an image that was popular in the second century BCE. This theoretical "restoration" would explain the pronounced S-curve of the pose and the otherwise unnatural forward projection of the knee.

CENTAUR,
LATE 10TH CENTURY BCE

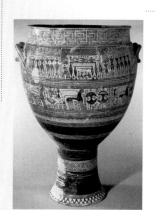

FUNERARY VASE,
C. 750–700 BCE

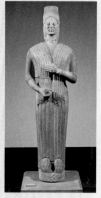

BERLIN CORE,
C. 570–560 BCE

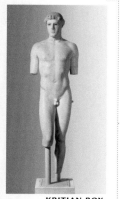

KRITIAN BOY,
C. 480 BCE

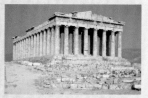

PARTHENON
C. 447–432 BCE

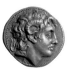

ALEXANDER THE GREAT,
C. 306–281 BCE

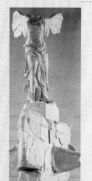

NIKE (VICTORY) OF
SAMOTHRACE
C. 180

1000 BCE

750

500

250

I CE

ART OF ANCIENT GREECE

◀ **Proto-Geometric**
c. 1050–900 BCE

◀ **Geometric**
c. 900–700 BCE

◀ **Earliest Surviving List of Olympic Game Winners** c. 776 BCE

◀ **Orientalizing** c. 700–600 BCE

◀ **Archaic** c. 600–480 BCE

◀ **Early Classical** c. 480–450 BCE

◀ **High Classical** c. 450–400 BCE

◀ **Late Classical** c. 400–323 BCE

◀ **Hellenistic** c. 323–31 BCE

◀ **Roman Empire** 27 BCE–395 CE

167

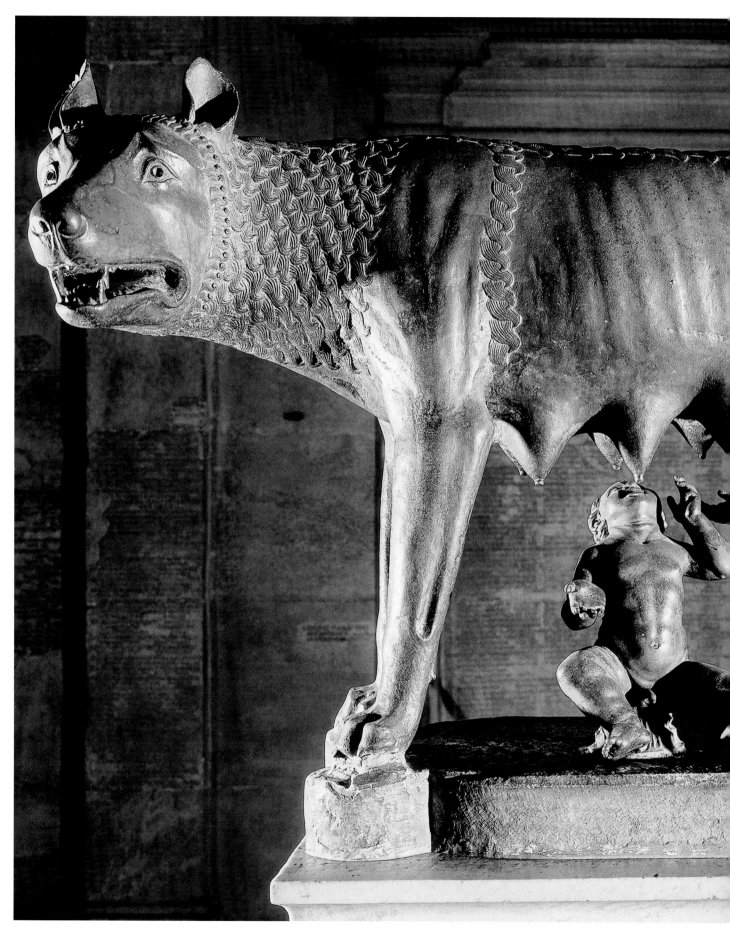

6–1 **SHE-WOLF** c. 500 BCE, or 450–430 BCE with 15th or 16th century additions (the twins). Bronze, glass-paste
eyes, height 33½″ (85 cm). Museo Capitolino, Rome.

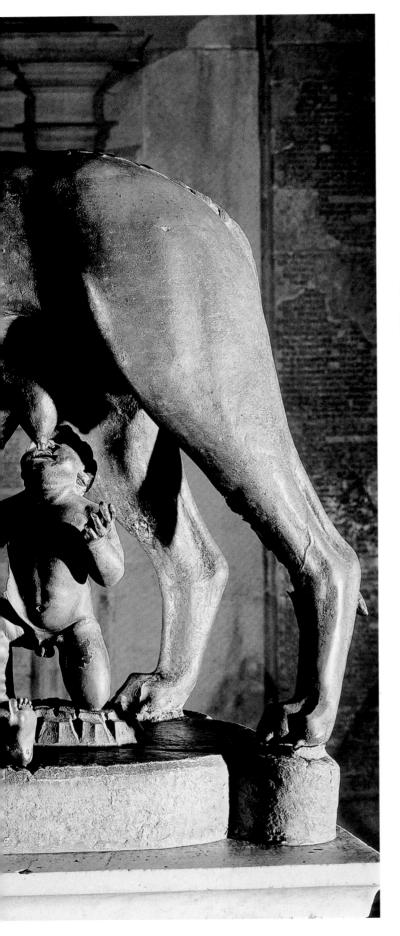

CHAPTER SIX

ETRUSCAN AND ROMAN ART

6

A ferocious she-wolf turns toward us with a vicious snarl. Her tense body, thin flanks, and protruding ribs contrast with her heavy, milk-filled teats. She suckles two active, chubby little human boys. We are looking at the most famous symbol of Rome, the legendary wolf who nourished and saved the city's founder, Romulus, and his twin brother, Remus (FIG. 6–1). According to a Roman legend, the twin sons, fathered by the god Mars and born of a mortal woman, were left to die on the banks of the Tiber River by their wicked great-uncle. A she-wolf discovered the infants and nursed them in place of her own pups; the twins were later raised by a shepherd. When they reached adulthood, the twins decided to build a city near the spot where the wolf had rescued them, in the year 753 BCE.

This composite sculptural group of wolf and boys suggests the complexity of art history on the Italian peninsula. An early people called Etruscans created the bronze wolf in the fifth century BCE. Later Romans added the sculpture of two children in the late fifteenth or early sixteenth century CE.

We know that a statue of a wolf—and sometimes even a live wolf in a cage—stood on the Capitoline Hill, the governmental and religious center of ancient Rome. But whether the wolf in FIGURE 6–1 is the same sculpture that Romans saw millennia ago is far from certain. According to tradition, the original bronze wolf was struck by lightning

and the damaged figure was buried. The documented history of this statue begins in the tenth century CE, when it was discovered and placed outside the Lateran Palace, the home of the pope. The naturalistic rendering of the wolf's body suggests a mid–fifth-century date and contrasts with the decorative, stylized rendering of the tightly curled, molded, and incised ruff of fur around her neck and along her spine. The glass-paste eyes that add so much to the dynamism of the figure were inserted after the sculpture was finished. At that time, statues of two small men stood under the wolf, personifying the alliance between the Romans and their former enemies from central Italy, the Sabines. In the later Middle Ages, people mistook the figures for children and identified the sculpture with the founding of Rome. During the Renaissance, the Florentine sculptor Antonio del Pollaiuolo (see Chapter 19) added the twins we see here. Pope Sixtus IV (papacy 1471–84 CE) had the sculpture moved from his palace to the Capitoline Hill. Today, the wolf maintains her wary pose in a museum there.

THE ETRUSCANS

The boot-shaped Italian peninsula, shielded on the north by the Alps, juts into the Mediterranean Sea. At the end of the Bronze Age (about 1000 BCE), a central European people known as the Villanovans occupied the northern and western regions of the peninsula, and the central area was home to a variety of people who spoke a closely related group of Italic languages, Latin among them. Beginning about 750 BCE, Greeks established colonies on the mainland and in Sicily. Between the seventh and sixth centuries BCE, people known as Etruscans, probably related to the Villanovans, gained control of the north and much of today's central Italy, an area known as Etruria.

Etruscan wealth came from fertile soil and an abundance of metal ore. Both farmers and metalworkers, the Etruscans were also sailors and merchants, and they exploited their resources in trade with the Greeks and with other people of the eastern Mediterranean. Etruscan artists knew and drew inspiration from Greek and Near Eastern sources. They assimilated these influences to create a distinctive Etruscan style. Organized into a loose federation of a dozen cities, the Etruscans reached the height of their power in the sixth century BCE, when they expanded into the Po River valley to the north and the Campania region to the south (MAP 6-1).

Etruscan Architecture

In architecture, the Etruscans used the plans and post-and-lintel structure seen in Greece and elsewhere. Their pattern of building was later adopted by the Romans. The Etruscan city was laid out on a grid plan, like cities in Egypt and Greece, but with a difference: Two main streets—one usually running north-south and the other east-west—divided the city into quarters. The intersection of these streets was the town's business center. We know something about their domestic architecture within these quarters, because the Etruscans created house-shaped funerary urns and also decorated the interiors of tombs to resemble houses. They built their houses around a central courtyard (or **atrium**) open to the sky, with a pool or cistern fed by rainwater.

Walls with protective gates and towers surrounded the cities. As a city's population grew, its boundaries expanded and building lots were added outside the walls. The third- to

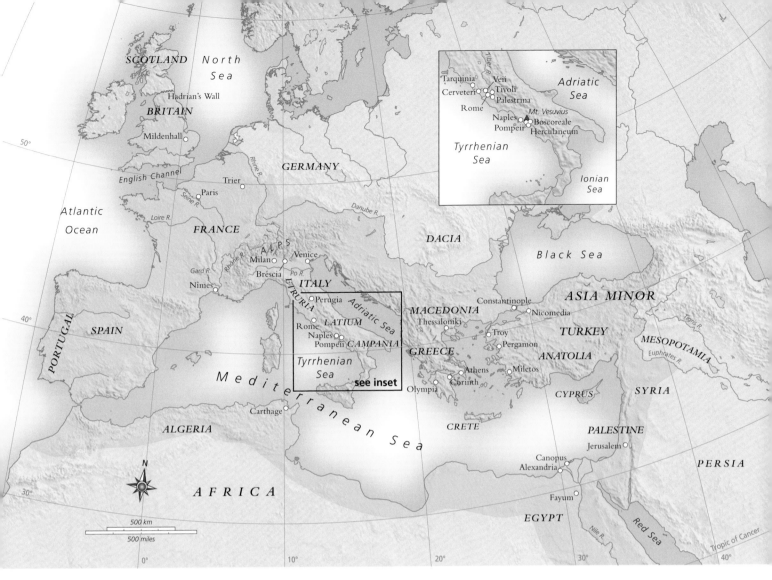

MAP 6–1 THE ROMAN REPUBLIC AND EMPIRE

After expelling their Etruscan kings in 509 BCE, Rome became a republic. The Roman Empire, which began in 27 BCE, extended its borders from the Euphrates River to Scotland under Trajan in 106 CE, but was permanently split into the Eastern and Western empires in 395 CE.

second-century BCE city gate of Perugia, called the Porta Augusta, is one of the few surviving examples of Etruscan monumental architecture (FIG. 6–2). A tunnel-like passageway between two huge towers, this gate is significant for anticipating the Roman use of the round arch, which is here extended to create a semicircular barrel vault over the passageway.

The round arch was not an Etruscan or Roman invention, but the Etruscans and Romans were the first to make widespread use of arches and vaults (see "Arch, Vault, and Dome," page 6-6). Unlike the corbel arch, in which overhanging courses of masonry meet at the top, the round arch is formed by precisely cut, wedge-shaped stone blocks called **voussoirs**. In the Porta Augusta, a square frame surmounted by a horizontal decorative element resembling an entablature sets off the arch, which consists of a double row of *voussoirs*

and a molding. The decorative section is filled with a row of circular panels, or **roundels**, alternating with rectangular, columnlike uprights called **pilasters**. The effect is reminiscent of the Greek Doric frieze.

Etruscan Temples and Their Decoration

The Etruscans incorporated Greek deities and heroes into their pantheon. They may also have adapted the use of divination to predict future events from the ancient Mesopotamians. Beyond this and their burial practices (revealed by the findings in their tombs, discussed later), we know little about their religious beliefs. Our knowledge of the temples' appearance comes from the few remaining foundations of Etruscan temples, from ceramic votive models, and from the writings of the Roman architect Vitruvius.

Elements of Architecture
ARCH, VAULT, AND DOME

The first true arch used in Western architecture is the round arch. When extended, the round arch becomes a barrel vault.

The **round arch** displaces most of the weight, or downward thrust (see arrows on diagrams) of the masonry above it to its curving sides. It transmits that weight to the supporting uprights (door or window jambs, columns, or piers), and from there the thrust goes to the ground. Brick or cut-stone arches are formed by fitting together wedge-shaped pieces, called **voussoirs,** until they meet and are locked together at the top center by the final piece, called the **keystone**. These voussoirs exert an outward thrust so arches may require added support, called **buttressing,** from adjacent masonry elements. Until the keystone is in place and the mortar between the bricks or stones dries, an arch is held in place by wooden scaffolding called **centering**. The points from which the curves of the arch rise, called **springings**, are often reinforced by masonry imposts. The wall areas adjacent to the curves of the arch are **spandrels**. In a succession of arches, called an **arcade**, the space encompassed by each arch and its supports is called a **bay**.

The **barrel vault** is constructed in the same manner as the round arch. The outward pressure exerted by the curving sides of the barrel vault requires buttressing within or outside the supporting walls. When two barrel-vaulted spaces intersect each other at the same level, the result is a **groin vault**. Both the weight and outward thrust of the groin vault are concentrated on the four piers, so only the piers require buttressing. The Romans used the groin vault to construct some of their grandest interior spaces.

A third type of vault brought to technical perfection by the Romans is the **hemispheric dome**. The rim of the dome is supported on a circular wall, as in the Pantheon (SEE FIGS. 6–53, 6–55). This wall is called a **drum** when it is raised on top of a main structure. Sometimes a circular opening, called an **oculus**, is left at the top.

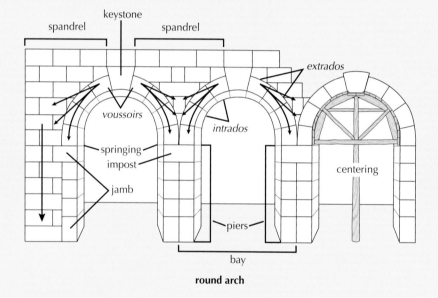

round arch

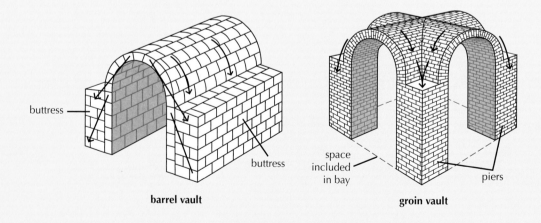

barrel vault **groin vault**

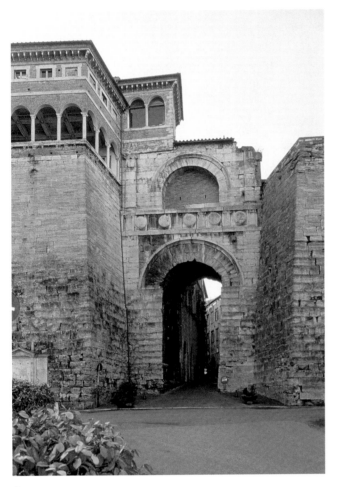

Sometime between 33 and 23 CE, Vitruvius compiled descriptions of Etruscan and Roman architecture (see "Roman Writers on Art," page 179). His account indicates that Etruscan temples (FIG. 6–3) were built on a platform called a **podium**, and had, starting from a courtyard or open city square, a single flight of steps leading up to a front porch. This new focus and orientation constitutes an important difference from Greek temples. Columns and an entablature supported the section of

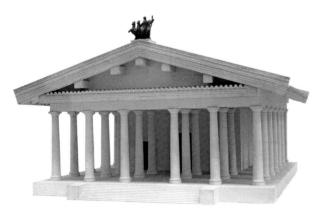

6–3 **RECONSTRUCTION OF AN ETRUSCAN TEMPLE**
Based on archaeological evidence and descriptions by Vitruvius. University of Rome, Istituto di Etruscologia e Antichità Italiche.

roof that projected over the porch. The ground plan was almost square and was divided equally between porch and interior space (FIG. 6–4). Often this interior space was separated into three rooms that probably housed cult statues.

Etruscans built their temples with mud-brick walls. The columns and entablatures were made of wood or a quarried volcanic rock called *tufa*, which hardens upon exposure to air. The column bases, shafts (which were sometimes plain), and capitals could resemble those of the Greek Doric or the Greek Ionic orders, and the entablature might include a frieze resembling that of the Doric order (not seen in the model). Vitruvius used the term **Tuscan order** for the variation that resembled the Doric order, with an unfluted shaft and a simplified base, capital, and entablature (see "Roman Architectural Orders," page 174). Although Etruscan temples were simple in form, they were embellished with dazzling displays of painting and terra-cotta sculpture. The temple roof, rather than the pediment, served as a base for large statue groups.

Etruscan artists excelled at making huge terra-cotta figures, a task of great technical difficulty. A splendid example is a life-size figure of **APOLLO** (FIG. 6–5). To make a large clay sculpture such as this one, the artist must know how to construct the figure so that it does not collapse under its own weight while the clay is still wet. The artist must know how to regulate the temperature in a large kiln for a long period of time. Some of the names of Etruscan terra-cotta artists have come down to us, including that of a sculptor from Veii (near Rome) called Vulca, in whose workshop this Apollo may have been created.

Dating from about 510–500 BCE and originally part of a four-figure scene depicting one of the labors of Hercules (the Greek god Herakles), this *Apollo* comes from the temple dedicated to Minerva and other gods in the sanctuary of Portonaccio at Veii. Four figures on the temple's ridgepole depicted Apollo and Hercules fighting for possession of a deer sacred to Diana,

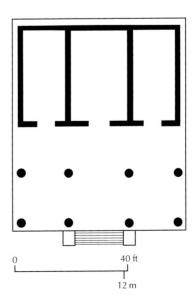

0 40 ft

12 m

6–4 **PLAN OF AN ETRUSCAN TEMPLE**
Based on descriptions by Vitruvius.

Elements of Architecture
ROMAN ARCHITECTURAL ORDERS

The Etruscans and Romans adapted Greek architectural orders to their own tastes and uses (see Chapter 5, "The Greek Architectural Orders," page 118). The Etruscans modified the Greek Doric order by adding a base to the column. In this diagram, the two Roman orders are shown on **pedestals**, which consist of a **plinth**, a **dado**, and a **cornice**. The Romans also created the **Tuscan order** by adding a base to the Doric column and often leaving the shaft unfluted. They elaborated on the Corinthian order with additional moldings and **composite** capitals that were a combination of Ionic volutes placed on the diagonal of all four corners and Corinthian acanthus foliage. Both the Tuscan and the Composite orders were widely used by later architects.

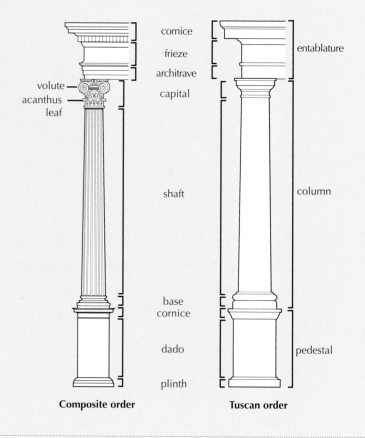

Composite order **Tuscan order**

while she and Mercury looked on. Apollo is shown striding forward (to our eyes he seems to have just stepped over the decorative scrolled element that helps support the sculpture). The representation of the god confronting Hercules in vigorous action on the ridgepole of the temple roof defies the logical relationship of sculpture to architecture seen in Greek pediment and frieze sculpture. The Etruscans seemed willing to sacrifice structural logic for lively action in their art.

Apollo's well-developed body and the "Archaic smile" clearly demonstrate that Etruscan sculptors were familiar with contemporary Greek kouroi. Despite those similarities, a comparison of the Apollo and a figure such as the Greek *Anavysos Kouros* (SEE FIG. 5–15) reveals telling differences. Unlike the Greek figure, the body of the Etruscan Apollo is partially concealed by a robe that cascades in knife-edged pleats to his knees. The forward-moving pose of the Etruscan statue also has a vigor that is only hinted at in the balanced stance of the Greek figure. This realistically portrayed energy expressed in purposeful movement is characteristic of Etruscan sculpture and painting.

Tomb Chambers

Like the Egyptians, the Etruscans thought of tombs as homes for the dead. (They did not try to preserve the body but preferred cremation.) The Etruscan cemetery of La Banditaccia at Cerveteri was laid out like a small town, with "streets" running between the grave mounds. The tomb chambers were partially or entirely excavated below the ground, and some were hewn out of bedrock. They were roofed over, sometimes with corbel vaulting, and covered with dirt and stones.

The Etruscan painters had a remarkable ability to suggest that their subjects inhabit a bright, tangible world just beyond the tomb walls. Brightly colored paintings of scenes of feasting, dancing, musical performances, athletic contests, hunting, fishing, and other pleasures decorated the tomb walls. Many of these murals are faded and flaking, but those in the tombs at Tarquinia are well preserved. In a detail of a painted frieze in the **TOMB OF THE TRICLINIUM**, from about 480–470 BCE, young men and women dance to the music of the lyre and double flute (**FIG. 6–6**). The dancers line the side walls within

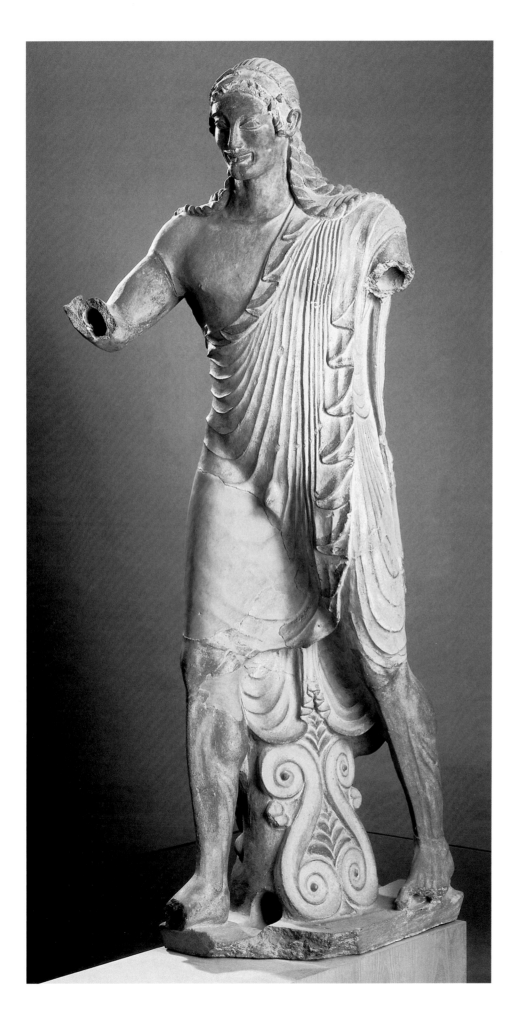

6–5 **APOLLO**
Temple of Minerva, Portenaccio, Veii. Master sculptor Vulca (?). c. 510–500 BCE. Painted terra cotta, height 5′10″ (1.8 m). Museo Nazionale di Villa Giulia, Rome.

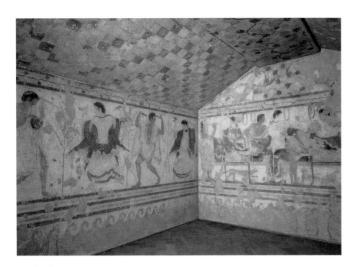

6–6 BURIAL CHAMBER, TOMB OF THE TRICLINIUM, TARQUINIA
c. 480–470 BCE.

a carefully arranged setting of stylized trees and birds, while at the end of the room couples recline on couches as they participate in a funeral banquet. Women are portrayed as active participants in the festivities and ceremonies.

Some tombs were carved out of the rock to resemble rooms in a house. The **TOMB OF THE RELIEFS**, for example, seems to have a flat ceiling supported by square stone posts **(FIG. 6–7)**. Its walls were plastered and painted, and it was fully furnished. Couches were carved from stone, and other furnishings were simulated in **stucco**, a slow-drying type of plaster that can be easily molded and carved. Pots, jugs, robes, axes, and other items were molded and carved to look like real objects hanging on hooks. Rendered in low relief at the bottom of the post just left of center is the family dog.

The deceased were placed in urns or **sarcophagi** (coffins) made of terra cotta. On the **SARCOPHAGUS FROM CERVETERI**, from about 520 BCE **(FIG. 6–8)**, a husband and wife are shown reclining comfortably on a dining couch. Their upper bodies are vertical and square shouldered, but their hips and legs seem to sink into the couch. Portrait sar-

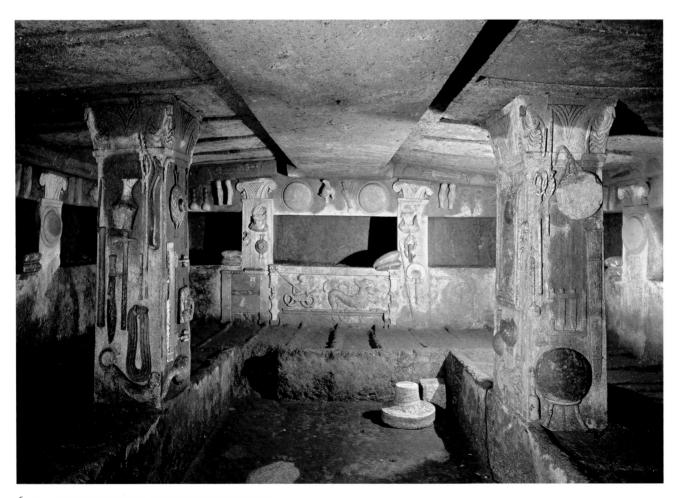

6–7 BURIAL CHAMBER, TOMB OF THE RELIEFS
Cerveteri. 3rd century BCE.

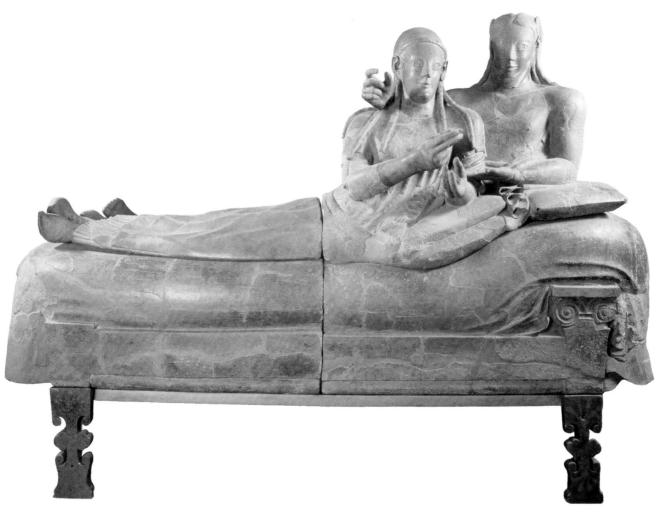

6–8 **SARCOPHAGUS FROM CERVETERI**
c. 520 BCE. Terra cotta, length 6'7" (2.06 m). Museo Nazionale di Villa Giulia, Rome.

cophagi like this one evolved from earlier terra-cotta cinerary urns with sculpted heads of the dead person whose ashes they held. Rather than seeing a somber memorial to the dead, we find two lively individuals—the man once raised a drinking vessel—rendered in sufficient detail to convey hair and clothing styles. These genial hosts, with their smooth, conventionalized body forms and faces, their uptilted, almond-shaped eyes, and their benign smiles, gesture as if to communicate something important to the living viewer—perhaps an invitation to dine with them for eternity.

As these details suggest, the Etruscans made every effort to provide earthly comforts for their dead, but tomb decorations also sometimes included frightening creatures from Etruscan mythology. On the back wall of the *Tomb of the Reliefs* is another kind of dog—a beast with many heads—that probably represents Cerberus, the guardian of the gates of the underworld, an appropriate funerary image.

Bronze Work

The most impressive Etruscan metal works are large-scale sculptures in the round like the she-wolf in Figure 6–1.

Etruscan bronze workers created items for both funerary and domestic use, such as a bronze mirror from the early to mid-fourth century BCE (FIG. 6–9). A mirror had the power to capture an image, hence it was almost magical. Engraved on the back of the mirror is a winged man, identified by the inscription as the Greek priest Calchas, who accompanied the Greek army under Agamemnon to Troy. Here Calchas is shown bending over a table, studying the liver of a sacrificed animal. Greeks, Etruscans, and Romans all believed that the appearance of animal entrails could reveal the future. Perhaps alluding to the legend that Calchas died laughing in his vineyard, the artist has shown him surrounded by grapevines and with a jug at his feet. The complex pose, the naturalistic suggestions of a rocky setting, and the pull and twist of drapery that emphasize the figure's three-dimensionality convey a sense of realism.

Etruscan artists continued to be held in high regard by Roman patrons after the Etruscan cities fell to Rome. Bronze workers and other artists went to work for the Romans, making the distinction between Etruscan and early Roman art difficult. A head that was once part of a bronze statue of a

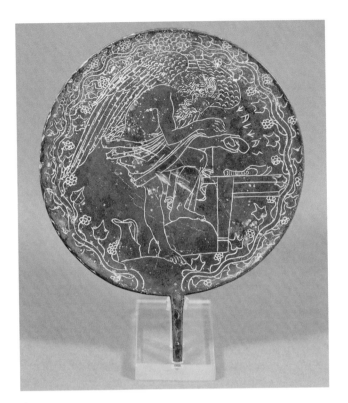

6–9 MIRROR
c. 400–350 BCE. Engraved bronze, diameter 6″ (15.3 cm).
Musei Vaticani, Museo Gregoriano Etrusco, Rome.

One side of the disc was engraved; the other, highly polished to provide a reflecting surface.

them, but in 509 BCE the Romans overthrew the kings and formed a republic centered in Rome. Etruscan power was in decline by the fifth century BCE, and they were absorbed by the Roman Republic at the end of the third century, by which time Rome had steadily expanded its territory in many directions. The Romans unified what is now Italy and, after defeating the North African city-state of Carthage, their rival in the western Mediterranean, established an empire that included the entire Mediterranean region (MAP 6–1).

At its greatest extent, in the early second century CE, the Roman Empire reached from the Euphrates River in southwest Asia to Scotland. It ringed the Mediterranean Sea—*mare nostrum*, or "our sea," the Romans called it. As the Romans absorbed the peoples they conquered, they imposed on them a legal, administrative, and cultural structure that endured for some five centuries—and in the eastern Mediterranean until the fifteenth century CE—and left a lasting mark on the civilizations that emerged in Europe.

man may be an example of an important Roman commission (FIG. 6–10). Often alleged to be a portrait of Lucius Junius Brutus, a founder and first consul of the Roman Republic, the head traditionally has been dated about 300 BCE (and may even be a more recent work from the first century BCE), long after Brutus's death. Although it may represent an unknown Roman dignitary of the day, it could also be an imaginary portrait of the ancient hero. The rendering of the strong, broad face with its heavy brows, hawk nose, firmly set lips, and wide-open eyes (made of painted ivory) is scrupulously detailed. The sculptor seems also to have sought to convey the psychological complexity of the subject, showing him as a somewhat world-weary man who nevertheless projects strong character and great strength of purpose.

Etruscan art and architectural forms left an indelible stamp on the art and architecture of early Rome that was second only to the influence of Greece. By 88 BCE, when the Etruscans had been granted Roman citizenship, their art had already been absorbed into that of Rome.

THE ROMANS

At the same time as the Etruscan civilization was flourishing, the Latin-speaking inhabitants of Rome began to develop into a formidable power. For a time, kings of Etruscan lineage ruled

6–10 HEAD OF A MAN (KNOWN AS BRUTUS)
c. mid-3rd century BCE. Bronze, eyes of painted ivory, height 12½″ (31.8 cm). Palazzo dei Conservatori, Rome.

ROMAN WRITERS ON ART

Only one book specifically on architecture and the arts survives from antiquity. All our other written sources consist of digressions and insertions in works on other subjects. That one book, Vitruvius's *Ten Books on Architecture*, written for Augustus in the first century CE, is a practical handbook for builders that discusses such things as laying out cities, siting buildings, and using the Greek architectural orders. His definition of Greek architectural terms is invaluable. Vitruvius argued for appropriateness and rationality in architecture, and he also made significant contributions to art theory, including studies on proportion.

Pliny the Elder (c. 23-79 CE) wrote a vast encyclopedia of "facts, histories, and observations," known as *Naturalis Historia (The Natural History)*. He often included discussions of art and architecture, and he used works of art to make his points—for example, sculpture to illustrate essays on stones and metals. Pliny's scientific turn of mind led to his death, for he was overcome while observing the eruption of Mount Vesuvius that buried Pompeii. His nephew Pliny the Younger (c. 61-113 CE), a voluminous letter writer, added to our knowledge of Roman domestic architecture with his meticulous description of villas and gardens.

Valuable bits of information can also be found in books by travelers and historians. Pausanias, a second-century CE Greek traveler, wrote descriptions of Greece that are basic sources on Greek art and artists. Flavius Josephus (c. 37-100 CE), a historian of the Flavians, wrote in his *Jewish Wars* a description of the triumph of Titus that includes the treasures looted from the Temple of Solomon in Jerusalem (see Fig. 6-39).

As an iconographical resource, *Metamorphoses* by the poet Ovid (43 BCE-17 CE) provided themes for artists in Ovid's own time, and has done so ever since. Ovid recorded Greek and Roman myths, stories of interactions between gods and mortals, and amazing transformations (metamorphoses)—for example, Daphne turning into a laurel tree to escape Apollo.

Perhaps the best-known—and most pungent—comments on art and artists remain those of the Greek writer Plutarch (c. 46-after 119 CE), who opined that one may admire the art but not the artist, and the Roman poet Virgil (70-19 BCE), who in the *Aeneid* wrote that the Greeks practice the arts, but it is the role of Romans to rule, for their skill lies in government, not art.

Origins of Rome

The Romans saw themselves, not surprisingly, in heroic terms and attributed heroic origins to their ancestors. Two popular legends told the story of Rome's founding: one by Romulus and Remus, twin sons of Mars, the god of war (see the beginning of this chapter); the other, rendered in epic verse by the poet Virgil (70–19 BCE) in the *Aeneid*. In the latter, the Roman people were understood to be the offspring of Aeneas, a Trojan who was the mortal son of Venus. Aeneas and some companions escaped from Troy and made their way to the Italian peninsula. Their sons were the Romans, the people who in fulfillment of a promise by Jupiter to Venus were destined to rule the world.

Archaeologists and historians present a more mundane picture of Rome's origins. In Neolithic times, people settled in permanent villages on the plains of Latium, south of the Tiber River, and on the Palatine, one of the seven hills that would eventually become the city of Rome. The settlements were just clusters of small, round huts, but by the sixth century BCE, they had become a major transportation hub and trading center.

Roman Religion

The Romans adopted the Greek gods and myths as well as Greek art and temple forms. (This chapter uses the Roman form of Greek names.) They assimilated Greek religious beliefs and practices into their state religion. To the Greek pantheon they later added their own deified emperors. Worship of ancient gods mingled with homage to past rulers, and oaths of allegiance to the living ruler made the official religion a political duty. As an official religion, it became increasingly ritualized, perfunctory, and distant from the everyday life of the average person.

Many Romans adopted the more personal religious beliefs of the people they had conquered, the so-called mystery religions. Worship of Isis and Osiris from Egypt, Cybele (the Great Mother) from Anatolia, the hero-god Mithras from Persia, and the single, all-powerful God of Judaism and Christianity from Palestine challenged the Roman establishment. These unauthorized religions flourished alongside the state religion, with its Olympian deities and deified emperors, despite occasional government efforts to suppress them.

THE REPUBLIC, 509–27 BCE

Early Rome was governed by kings and an advisory body of leading citizens called the Senate. The population was divided into two classes: a wealthy and powerful upper class, the *patricians*, and a lower class, the *plebeians*. In 509 BCE, Romans overthrew the last Etruscan king. They established the Roman Republic as an *oligarchy*, a government by the aristocrats. It was to last about 450 years.

By 275 BCE Rome controlled the entire Italian peninsula. By 146 BCE, Rome had defeated its great rival, Carthage, on the north coast of Africa, and taken control of the western

6–11 AULUS METELLUS
Found near Perugia. c. 80 BCE. Bronze, height
5'11" (1.8 m). Museo Archeològico Nazionale,
Florence.

Mediterranean. By the mid-second century BCE, Rome had taken Macedonia and Greece, and by 44 BCE, it had conquered most of Gaul (present-day France) as well as the eastern Mediterranean (SEE MAP 6–1). Egypt remained independent until Octavian defeated Marc Anthony and Cleopatra in the Battle of Actium in 31 BCE.

During the centuries of the Republic, Roman art reflected Etruscan influence, but territorial expansion brought wider exposure to the arts of other cultures. Like the Etruscans, the Romans admired Greek art. As Horace wrote (*Epistulae II, 1*): "Captive Greece conquered her savage conquerors and brought the arts to rustic Latium." The Romans used Greek designs and Greek orders in their architecture, imported Greek art, and employed Greek artists. In 146 BCE,

for example, they stripped the Greek city of Corinth of its art treasures and shipped them back to Rome. Ironically, this love of Greek art was not accompanied by admiration for its artists. In Rome, as in Greece, professional artists were generally considered to be simply skilled laborers.

Sculpture during the Republic

Sculptors of the Republican period sought to create believable images based on careful observation of their surroundings. The desire to render accurate and faithful portraits of individuals may be derived from Roman ancestor veneration and the practice of making death masks of deceased relatives. Roman patrons in the Republican period clearly admired realistic portraits, and it is not sur-

6–12　PORTRAIT OF POMPEY THE GREAT
30 CE. Copy of sculpture of c. 50 BCE. Marble, height 9¾"
(24.8 cm). Ny Carlsberg Glyptotek, Copenhagen.

prising that for bronze sculpture they often turned to skilled Etruscan artists.

THE ORATOR. The life-size bronze portrait of **AULUS METELLUS**—the Roman official's name is inscribed on the hem of his garment in Etruscan letters **(FIG. 6–11)**—dates to about 80 BCE. The statue, known from early times as *The Orator*, depicts a man addressing a gathering, his arm outstretched and slightly raised, a pose expressive of authority and persuasiveness. The orator wears sturdy laced leather boots and the folded and draped garment called a *toga*, dress characteristic of a Roman official. According to Pliny the Elder, large statues like this were often placed atop columns as memorials.

PORTRAIT OF POMPEY. The **PORTRAIT OF POMPEY THE GREAT** (106–48 BCE), a general and one of the three-man team—along with Caesar and Crassus—who ruled Rome from 60 to 53 BCE, illustrates the realism demanded by Romans **(FIG. 6–12)**. Pompey's fleshy face, too-small eyes, and warts are recorded for posterity. Such meticulous realism, called **verism**, combines underlying bone structure with surface detail. In the portrait, however, the elegantly tossed hair suggests a more idealized image. The original sculpture was made during Pompey's lifetime (c. 50 BCE), but about 30 CE

his family commissioned the copy seen here. (A statue, perhaps looking like this one, stood in the Theater of Pompey in Rome. When Caesar was assassinated in 44 BCE, he is supposed to have died at the foot of the statue.)

THE DENARIUS OF JULIUS CAESAR. The propaganda value of portraits was not lost on Roman leaders. In 44 BCE, Julius Caesar issued a denarius (a widely circulated coin) bearing his portrait **(FIG. 6–13)**. Like the monumental images of Etruscan and Roman Republican art, this tiny relief sculpture accurately reproduced Caesar's careworn features and growing baldness. This idea of placing the living ruler's portrait on one side of a coin and a symbol of the country or an image that recalls some important action or event on the other was adopted by Caesar's successors. In the case of this denarius, Venus was placed on the reverse, a reference to the Julian family's claim that they were descended from Venus through her mortal son, Aeneas. Consequently, Roman coins give us an unprecedented and personal view of Roman history.

Architecture and Engineering

Roman architects had to satisfy the wishes of wealthy and politically powerful patrons who ordered buildings for the public as well as themselves. They also had to satisfy the needs of ordinary people. To do this, they created new building types and construction techniques that permitted them to erect buildings efficiently and inexpensively.

CONSTRUCTION TECHNIQUES. Among the techniques Roman architects relied on were the round arch and vault, and during the empire, concrete. For example, an ample water supply was essential for a city, and the Roman invention to supply water was the aqueduct, built with arches and

6–13　DENARIUS WITH PORTRAIT OF JULIUS CAESAR
44 BCE. Silver, diameter approximately ¾" (1.9 cm).
American Numismatic Society, New York.

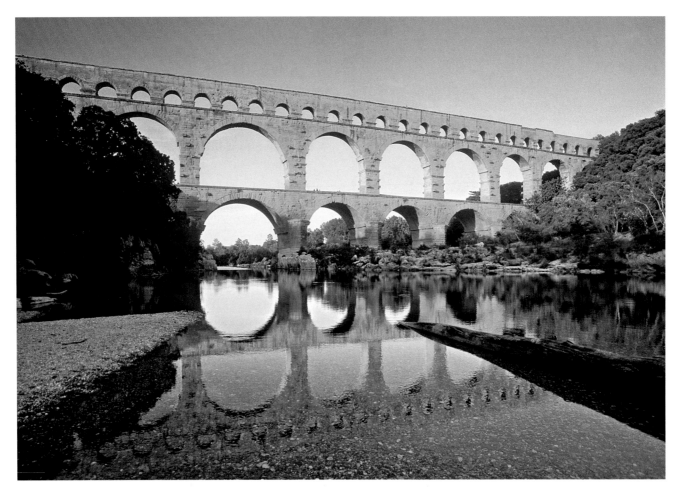

6–14 **PONT DU GARD**
Nîmes, France. Late 1st century BCE.

The aqueduct's three arcades rise 160 feet (49 m) above the river. The thick base arcade supports a roadbed approximately 20 feet (6 m) wide. The arches of the second arcade are narrower than the first and are set at one side of the roadbed. The narrow third arcade supports the water trough, 900 feet (274.5 m) long on 35 arches, each of which is 23 feet (7 m) high.

using concrete. The Pont du Gard, near Nîmes, in southern France, carried the water channel of an aqueduct across the river on a bridge of arches **(FIG. 6–14)** (See "Arch, Vault, and Dome," page 172). It brought water from springs 30 miles to the north using a simple gravity flow, and it provided 100 gallons of water a day for every person in Nîmes. Entirely functional, each arch buttresses its neighbors and the huge arcade ends solidly in the hillsides. The structure conveys the balance, proportions, and rhythmic harmony of a great work of art, and fits naturally into the landscape.

THE USE OF CONCRETE. The Romans were pragmatic, and their practicality extended from recognizing and exploiting undeveloped potential in construction methods and physical materials to organizing large-scale building works. Their exploitation of the arch and the vault is typical of their adapt-and-improve approach. Their innovative use of concrete, beginning in the first century BCE, was a technological breakthrough of the greatest importance.

In contrast to stone—which was expensive and difficult to quarry and transport—the components of concrete were cheap, relatively light, and easily transported. Building stone structures required highly skilled masons, but a large, semi-skilled work force directed by a few experienced supervisors could construct brick-faced concrete buildings.

Roman concrete consisted of powdered lime, sand (in particular, a volcanic sand called *pozzolana* found in abundance near Pompeii), and various types of rubble, such as small rocks and broken pottery. Mixing in water caused a chemical reaction that blended the materials, which hardened as they dried into a strong, solid mass. At first, concrete was used mainly for poured foundations, but with technical advances it became indispensable for the construction of walls, arches, and vaults for ever-larger buildings. In the earliest concrete wall construction, workers filled a framework of rough stones with concrete. Soon they developed a technique known as *opus reticulatum*, in which the framework is a diagonal web of smallish bricks set in a cross pattern. Concrete-based construction

freed the Romans from the limits of right-angle forms and comparatively short spans. With this freedom, Roman builders pushed the established limits of architecture, creating some very large and highly original spaces, many based on the curve.

Concrete's one weakness was that it absorbed moisture, so builders covered exposed surfaces with a **veneer**, or facing, of finer materials, such as marble, stone, stucco, or painted plaster. An essential difference between Greek and Roman architecture is that Greek buildings reveal the building material itself, whereas Roman buildings show only the externally applied surface.

The remains of the **SANCTUARY OF FORTUNA PRIMIGE-NIA**, the goddess of fate and chance, were discovered after World War II by teams clearing the rubble from bombings of Palestrina (ancient Praeneste), about 16 miles southeast of Rome. The sanctuary, an example of Roman Republican architectural planning and concrete construction at its most creative **(FIG. 6–15),** was begun early in the second century BCE and was grander than any building in Rome in its time. Its design and size show the clear influence of Hellenistic architecture, especially the colossal scale of buildings in cities such as Pergamon (SEE FIG. 5–64).

Built of concrete covered with a veneer of stucco and finely cut limestone, the seven vaulted platforms or terraces of the Sanctuary of Fortuna covered a steep hillside. Worshipers ascended long ramps, then staircases to successively higher levels. Enclosed ramps open onto the fourth terrace, which has a central stair with flanking colonnades and symmetrically placed **exedrae**, or semicircular niches. On the sixth level, **arcades** (series of arches) and **colonnades** (rows of columns) form three sides of a large square, which is open on the fourth side to the distant view. Finally, from the seventh level, a huge, theaterlike, semicircular colonnaded pavilion is reached by a broad semicircular staircase. Behind this pavilion was a small tholos—the actual temple to Fortuna—hiding the ancient rock-cut cave where acts of divination took place. The overall axial plan—directing the movement of people from the terraces up the semicircular staircase, through the portico, to the tiny tholos temple, to the cave—brings to mind great Egyptian temples, such as that of Hatshepsut at Deir el-Bahri (SEE FIG. 3–28).

THE ROMAN TEMPLE. Roman temples followed the pattern of Etruscan and Greek buildings. The Romans built urban temples in commercial centers as well as in special sanctuaries. In Rome, a small rectangular temple stands on its raised platform, or podium, beside the Tiber River **(FIG. 6–16).** It is either a second-century temple or a replacement of 80–70 BCE and may have been dedicated to Portunus, the god of harbors and ports. With a rectangular cella and a porch at one end reached by a single flight of steps, the temple combines the Greek idea of a colonnade across the entrance with the Etruscan podium and single flight of steps leading to a front porch entrance. The Ionic columns are freestanding on the porch and **engaged** (set into the wall) around the cella

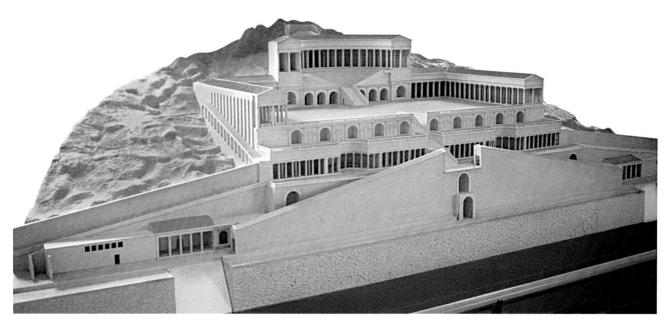

6–15 **MODEL OF THE SANCTUARY OF FORTUNA PRIMIGENIA**
Palestrina, Italy. Late 2nd century BCE. Museo Archeològico Nazionale, Italy.

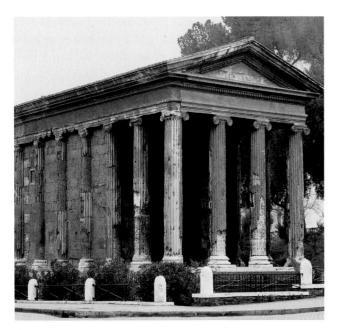

6–16　**TEMPLE, PERHAPS DEDICATED TO PORTUNUS**
Forum Boarium (Cattle Market), Rome. Late 2nd century BCE.

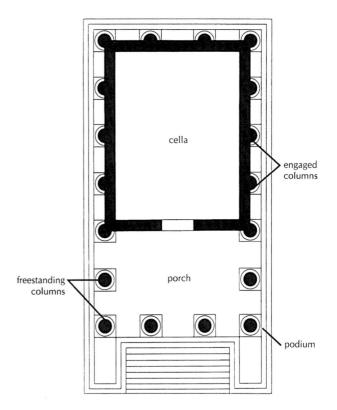

6–17　**PLAN OF TEMPLE**
Forum Boarium (Cattle Market), Rome.

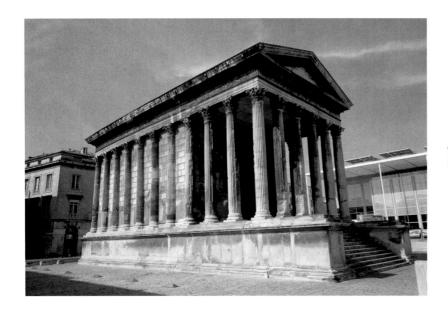

6–18　**MAISON CARRÉE**
Nîmes, France. c. 20 BCE.

(FIG. 6–17). The entablature above the columns on the porch continues around the cella as a decorative frieze. The encircling columns resemble a Greek peripteral temple, but because the columns are engaged, the plan is called pseudo-peripteral. This design, with variations in the orders used with it, is typical of Roman temples.

Early imperial temples, such as the one known as the Maison Carrée (Square House), are simply larger and much more richly decorated versions of the so-called Temple of Portunus. Built in the forum at Nîmes, France, about 20 BCE

and later dedicated to Gaius and Lucius, the adopted heirs of Augustus who died young, the temple was built by their biological father, Marcus Vipsanius Agrippa. The **MAISON CARRÉE** differs from its prototype only in its size and its use of the opulent Corinthian order (FIG. 6–18). The temple summarizes the character of Roman religious architecture: technologically advanced but conservative in design, perfectly proportioned and elegant in sculptural detail. (These qualities appealed to the future American president and amateur architect Thomas Jefferson, who visited Nîmes and was said

to have found inspiration in the Maison Carrée for his own buildings in the new state of Virginia.)

Although by the first century BCE nearly a million people lived in Rome, the Romans thought of themselves as farmers. In fact, Rome had changed from an essentially agricultural society to a commercial and political power. In 46 BCE, the Roman general Julius Caesar emerged victorious over his rivals, assumed autocratic powers, and ruled Rome until his assassination two years later. The conflicts that followed Caesar's death ended within a few years with the unquestioned control of his grandnephew and heir, Octavian, over Rome and all its possessions. Rome was now an empire.

THE EARLY EMPIRE, 27 BCE–96 CE

The first Roman emperor was born Octavius (Octavian) in 63 BCE. When he was only 18 years old, Octavian was adopted as son and heir by his brilliant great-uncle, Julius Caesar, who recognized qualities in him that would make him a worthy successor. Shortly after Julius Caesar refused the Roman Senate's offer of the imperial crown, early in 44 BCE, he was murdered by a group of conspirators, and the nineteen-year-old Octavian stepped up. Over the next seventeen spectacular years, as general, politician, statesman, and public relations genius, Octavian vanquished warring internal factions and brought peace to fractious provinces. By 27 BCE, the Senate had conferred on him the title of Augustus (meaning "exalted, sacred"). In 12 CE, he was given the title Pontifex Maximus ("High Priest") and so became the empire's highest religious official as well as its political leader.

Assisted by his astute and pragmatic second wife, Livia, Augustus led the state and the empire for nearly sixty years. He proved to be an incomparable administrator who established efficient rule throughout the empire, and he laid the foundation for an extended period of stability, internal peace, and economic prosperity known as the Pax Romana ("Roman Peace"), which lasted over 200 years (27 BCE to 180 CE). When he died in 14 CE, Augustus left a legacy that defined the concept of empire and imperial rule for later Western rulers.

Conquering and maintaining a vast empire required not only the inspired leadership and tactics of Augustus, but also careful planning, massive logistical support, and great administrative skill. Some of Rome's most enduring contributions to Western civilization reflect these qualities—its system of law, its governmental and administrative structures, and its sophisticated civil engineering and architecture.

To facilitate the development and administration of the empire, as well as to make city life comfortable and attractive to its citizens, the Roman government undertook building programs of unprecedented scale and complexity (FIG. 6–19), mandating the construction of central administrative and legal centers (forums and basilicas), recreational facilities (racetracks, stadiums), theaters, public baths, roads, bridges, aqueducts, middle-class housing, and even entire new towns. To accomplish these tasks without sacrificing beauty, efficiency, and human well-being, Roman builders and architects developed rational plans using easily worked but durable materials and highly sophisticated engineering methods. The architect Vitruvius described these accomplishments in his *Ten Books of Architecture* (see "Roman Writers on Art," page 179).

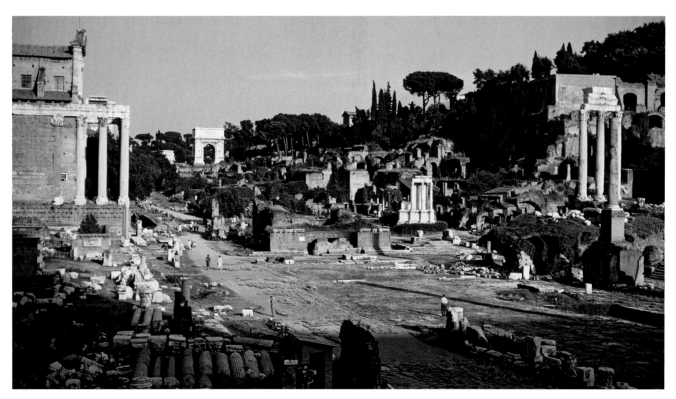

6–19 **VIEW OF THE ROMAN FORUM**

Art and Its Context

COLOR IN ROMAN SCULPTURE: A COLORIZED AUGUSTUS

Ancient sculpture was accentuated by the use of color. A colored reproduction of the Augustus of Primaporta was made based on the research of scholars in the Ny Carlsburg Glyptotek of Copenhagen, Denmark, and the Munich Glyptothek, Germany. In the 1980s, Vincenz Brinkmann of Munich researched the traces of remaining color on ancient sculpture using ultraviolet rays. In addition to aiding the viewer in reading the detailed imagery on Augustus's armor, color also heightens the overall effect of the statue. This painted reproduction may seem shocking to today's viewer, long accustomed to ancient art that has been stripped and scrubbed.

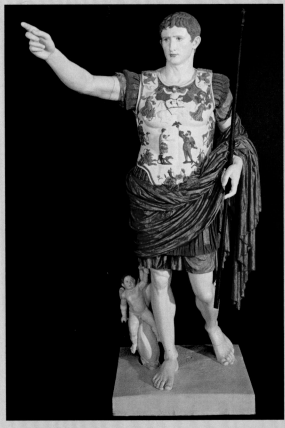

AUGUSTUS OF PRIMAPORTA
A copy with color restored. Vatican Museum, Rome.

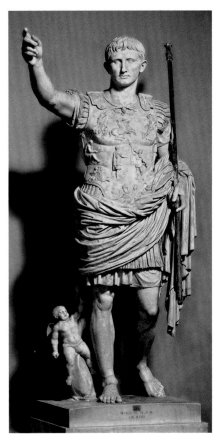

6–20 AUGUSTUS OF PRIMAPORTA
Early 1st century CE. Perhaps a copy of a bronze statue of c. 20 BCE. Marble, originally colored, height 6′8″ (2.03 m). Musei Vaticani, Braccio Nuovo, Rome.

To move their armies about efficiently, to speed communications between Rome and the farthest reaches of the empire, and to promote commerce, the Romans built a vast and complex network of roads and bridges. Many modern European highways still follow the lines laid down by Roman engineers, and Roman-era foundations underlie the streets of many cities. Roman bridges are still in use, and remnants of Roman aqueducts need only repairs and connecting links to enable them to function again.

Augustan Art

Drawing inspiration from Etruscan and Greek art as well as Republican traditions, Roman artists of the Augustan age created a new style—a Roman form of idealism that is grounded in the appearance of the everyday world. They enriched the art of portraiture in both official images and representations of private individuals; they recorded contemporary historical events on arches, columns, and mausoleums erected in public places; and they contributed unabashedly to Roman imperial propaganda.

AUGUSTUS OF PRIMAPORTA. The sculpture known as **AUGUSTUS OF PRIMAPORTA** (FIG. 6–20), discovered in Livia's villa at Primaporta, near Rome, demonstrates the creative assimilation of earlier sculptural traditions into a new context. In its idealization of a specific ruler and his prowess, the sculpture also illustrates the use of imperial portraiture for propaganda. The sculptor of this larger-than-life marble statue adapted the orator's gesture of

186

Aulus Metellus (SEE FIG. 6–11) and combined it with the pose and ideal proportions developed by the Greek Polykleitos and exemplified by the *Spear Bearer* (SEE FIG. 5–24). To this combination the Roman sculptor added mythological imagery that exalts Augustus's family. Cupid, son of the goddess Venus, rides a dolphin next to the emperor's right leg, a reference to the claim of the emperor's family, the Julians, to descent from the goddess Venus through her human son Aeneas. Although Augustus wears a cuirass (torso armor) and may have held a commander's baton or the Parthian standard, his feet are bare, suggesting to some scholars his elevation to divine status after death.

This imposing statue creates a recognizable image of Augustus, yet it is far removed from the intensely individualized portrait style that was popular during the Republican period. Augustus was in his late seventies when he died, but in his portrait sculpture he is always a vigorous young ruler. Whether depicting Augustus as a general praising his troops or as a peacetime leader speaking words of encouragement to his people, the sculpture projects the image of a benign ruler, touched by the gods, who governs by reason and persuasion, not autocratic power.

THE ARA PACIS. The **ARA PACIS AUGUSTAE, OR ALTAR OF AUGUSTAN PEACE** (FIG. **6–21**), begun in 13 BCE and dedicated in 9 BCE, commemorates Augustus's triumphal return to Rome after establishing Roman rule in Gaul and Hispania. In its original location, in the Campus Martius (Plain of Mars), the Ara Pacis was aligned with a giant sundial that had an Egyptian obelisk as its pointer, suggesting that Augustus controlled time itself. A walled rectangular enclosure surrounded the altar. Its decoration is a thoughtful union of portraiture and allegory, religion and politics, the private and the public. On the inner walls, garlands of flowers are suspended in swags, or loops, from ox skulls. The ox skulls symbolize sacrificial offerings, and the garlands, which unrealistically include flowering plants from every season, signify continuous peace.

Decorative allegory gives way to Roman realism on the exterior side walls, where sculptors depicted the just-completed procession with its double lines of senators and magistrates (on the north) and Augustus, priests, and imperial family members (on the south). Here recognizable people wait for

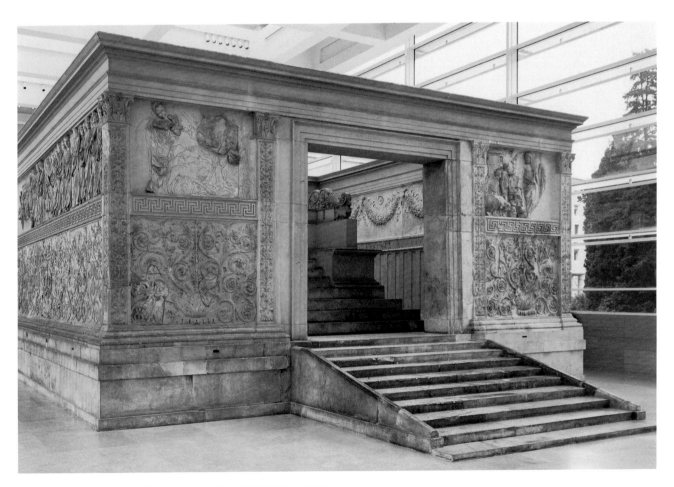

6–21 ARA PACIS AUGUSTAE (ALTAR OF AUGUSTAN PEACE)
Rome. 13–9 BCE. Marble, approx. 34′5″ (10.5 m) × 38′ (11.6 m). View of west side.

At the time of the fall equinox (the time of Augustus's conception), the shadow of the obelisk pointed to the open door of the altar's enclosure wall, on which sculptured panels depicted the first rulers of Rome—the warrior-king Romulus and Numa Pompilius. Consequently, the Ara Pacis celebrates Augustus as both a warrior and a peacemaker. The monument was begun when Augustus was 50 (in 13 BCE) and was dedicated on Livia's 50th birthday (9 BCE).

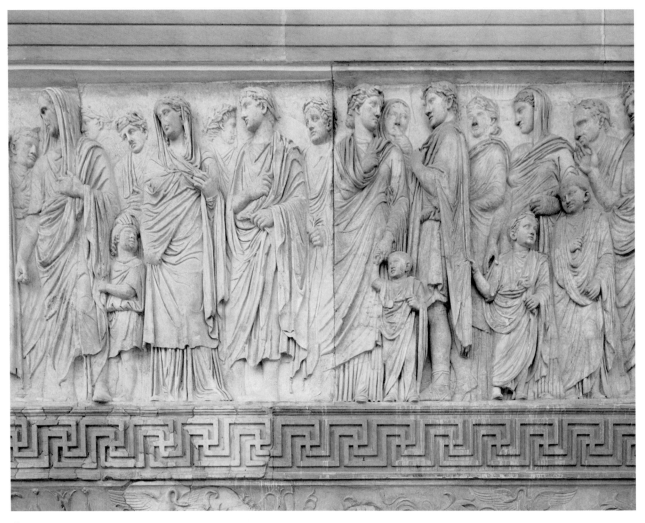

6–22 IMPERIAL PROCESSION
Detail of a relief on the south side of the Ara Pacis. Height 5′2″ (1.6 m).

The middle-aged man with the shrouded head at the far left is Marcus Agrippa, who would have been Augustus's successor had he not died in 12 CE. The bored but well-behaved youngster pulling at Agrippa's robe—and being restrained gently by the hand of the man behind him—is probably Agrippa's son Gaius Caesar. The heavily swathed woman next to Agrippa on the right may be Augustus's wife, Livia, followed by Tiberius, who would become the next emperor. Behind Tiberius is Antonia, the niece of Augustus, looking back at her husband, Drusus, Livia's younger son. She grasps the hand of Germanicus, one of her younger children. Behind their uncle Drusus are Gnaeus and Domitia, children of Antonia's older sister, who can be seen beside them. The depiction of children in an official relief was new to the Augustan period and reflects Augustus's desire to promote private family life as well as his potential heirs.

other ceremonies to begin. At the head of the line on the south side of the altar is Augustus (not shown), with members of his family waiting behind him (FIG. 6–22). Unlike the Greek sculptors who created an ideal procession for the Parthenon frieze (SEE FIG. 5–38), the Roman sculptors of the *Ara Pacis* depicted actual individuals participating in a specific event at a known time. To suggest a double line of marchers in space, they varied the height of the relief, with the closest elements in high relief and those farther back in increasingly lower relief. They draw spectators into the event by making the feet of the nearest figures project from the architectural groundline into the viewers' space.

Moving from this procession, with its immediacy and naturalness, to the east and west ends of the enclosure wall, we find panels of quite a different character, an allegory of Peace and War in two complementary pairs of images. On the west front

6–23 ALLEGORY OF PEACE
Relief on the east side of the Ara Pacis. Height 5′2″ (1.6 m).

(SEE FIG. 6–21) are Romulus and (probably) Aeneas. On the east side are personifications (symbols in human form) of Roma (the triumphant empire) and Pax (the goddess of peace).

In the best-preserved panel, the **ALLEGORY OF PEACE** (FIG. 6–23), the goddess Pax, who is also understood to be Tellus Mater, or Mother Earth, nurtures the Roman people, represented by the two chubby babies in her arms. She is accompanied by two young women with billowing veils, one seated on the back of a flying swan (the land wind), the other reclining on a sea monster (the sea wind). The sea wind, symbolized by the sea monster and waves, would have reminded Augustus's contemporaries of Rome's dominion over the Mediterranean; the land wind, symbolized by the swan, the jug of fresh water, and the vegetation, would have suggested the fertility of Roman farms. The underlying theme of a peaceful, abundant Earth is reinforced by the flowers and foliage in the background and the domesticated animals in the foreground.

Although the inclusion in this panel of features from the natural world—sky, water, rocks, and foliage—represents a Roman contribution to monumental sculpture, the idealized figures themselves are clearly drawn from Greek sources. The artists have conveyed a sense of three-dimensionality and volume by turning the figures in space and wrapping them in revealing draperies. The scene is framed by Corinthian pilasters supporting a simple entablature. A wide molding with a Greek key pattern (**meander**) joins the pilasters and divides the wall into two horizontal segments. Stylized vine and flower forms cover the lower panels. More foliage overlays the pilasters, culminating in the acanthus-covered capitals. The delicacy and the minute detail with which even the ornamental forms are rendered are characteristic of Roman decorative sculpture.

The Julio-Claudians

After his death in 14 CE, the Senate ordered Augustus to be venerated as a god. Augustus's successor was his stepson Tiberius (ruled 14–37 CE), and in acknowledgment of the lineage of both—Augustus from Julius Caesar and Tiberius from his father, Tiberius Claudius Nero, Livia's first husband—the dynasty is known as the Julio-Claudian (14–68 CE). Although the family produced some capable administrators, its rule was marked by suspicion, intrigue, and terror. The dynasty ended with the reign of the despotic, capricious Nero. A brief period of civil war followed Nero's death in 68 CE, until an astute general, Vespasian, seized control of the government in 69 CE.

Exquisite skill characterizes the arts of the first century. A large onyx cameo (a gemstone carved in low relief) known as the **GEMMA AUGUSTEA** glorifies Augustus as triumphant over barbarians and as the deified emperor (FIG. 6–24).

6–24 **GEMMA AUGUSTEA**
Early 1st century CE.
Onyx, 7½ × 9″
(19 × 23 cm).
Kunsthistorisches Museum, Vienna.

The emperor, crowned with a victor's wreath, sits at the center right of the upper register. He has assumed the identity of Jupiter, the king of the gods; an eagle, sacred to Jupiter, stands at his feet. Sitting next to him is a personification of Rome that has Livia's features. The sea goat in the roundel between them may represent Capricorn, the emperor's zodiac sign.

Tiberius, as the adopted son of Augustus, steps out of a chariot at the left. Returning victorious from the German front, he assumes the imperial throne. Below this realm of godly rulers, Roman soldiers are raising a post or standard on which armor captured from the defeated enemy is displayed. The cowering, shackled barbarians on the bottom right wait to be tied to this post. The artist of the *Gemma Augustea* brilliantly combines idealized, heroic figures characteristic of Classical Greek art with recognizable Roman portraits, the dramatic action of Hellenistic art with Roman realism.

The Roman City and the Roman Home

In good times and bad, individual Romans—like people everywhere at any time—tried to live a decent or even comfortable life with adequate shelter, food, and clothing. Despite their urbanity, as we have noted, Romans liked to portray themselves as simple country folk who had never

lost their love of nature. The middle classes enjoyed their gardens, wealthy city-dwellers maintained rural estates, and Roman emperors had country villas that were both functioning farms and places of recreation. Wealthy Romans even brought nature indoors by commissioning artists to paint landscapes on the interior walls of their homes. Through the efforts of the modern archaeologists who have excavated them, Roman cities and towns, houses, apartments, and country villas evoke the ancient Roman way of life with amazing clarity.

ROMAN CITIES. Roman architects who designed new cities or who expanded and rebuilt existing ones based the urban plan on the layout of the army camp. These camps were laid out in a grid, but unlike Greek cities such as Miletos, two main streets crossed at right angles dividing the camp—or the city—into quarters. The commander's headquarters, or in a city, the forum and other public buildings, were located at this intersection.

Much of the housing in a Roman city consisted of brick apartment blocks called *insulae*. These apartment buildings had internal courtyards, multiple floors joined by narrow staircases, and occasionally overhanging balconies. City-

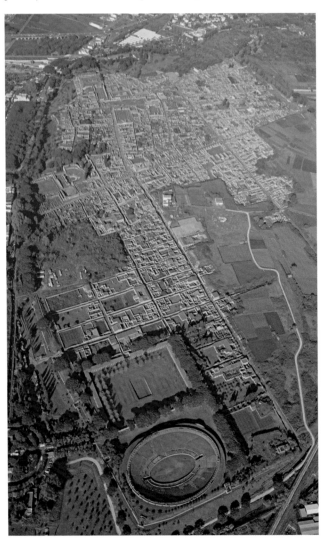

6-25 **AERIAL VIEW OF THE CITY OF POMPEII**
79 CE.

dwellers—then as now—were social creatures who lived much of their lives in public markets, squares, theaters, baths, and neighborhood bars. The city-dweller returned to the insulae to sleep, perhaps to eat. Even women enjoyed a public life outside the home—a marked contrast to the circumscribed lives of Greek women.

The affluent southern Italian city of Pompeii, a thriving center of between 10,000 and 20,000 inhabitants, gives a vivid picture of Roman city life. In 79 CE Mount Vesuvius erupted, burying the city under more than 20 feet of volcanic ash and preserving it until its recovery began in the seventeenth century and rediscovery in the eighteenth century. An ancient village that had grown and spread over many centuries, Pompeii lacked the gridlike regularity of newer, planned Roman cities, but its layout is typical of cities that grew over time (FIG. 6–25). Temples and government buildings surrounded a main square, or forum; shops and houses lined straight paved streets; and a protective wall enclosed the heart of the city. The forum was the center of civic life in Roman towns and cities, as the agora was in Greek cities. Business was conducted in its basilicas and porticoes, religious duties performed in its temples, and speeches presented in its

open square. For recreation, people went to the nearby baths or to events in the theater or amphitheater.

The people of Pompeii lived in houses behind or above rows of shops (FIG. 6–26). Even the gracious private residences with gardens often had street-level shops. If there was no shop, the wall facing the street was usually broken only by a door, for the Romans emphasized the interior rather than the exterior in their domestic architecture.

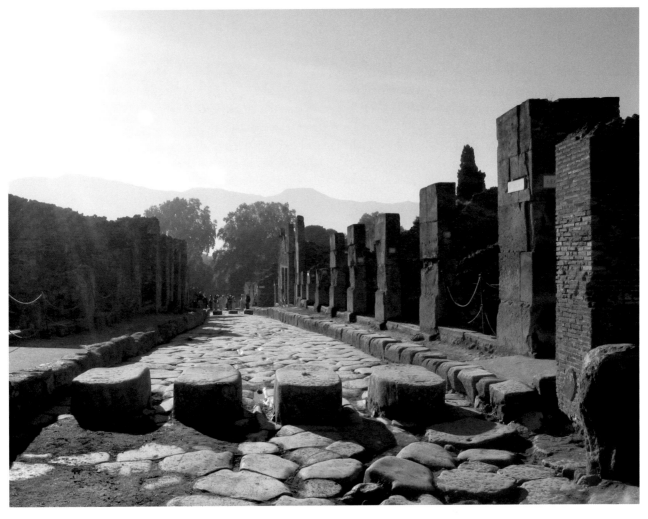

6–26 **STREET IN POMPEII**

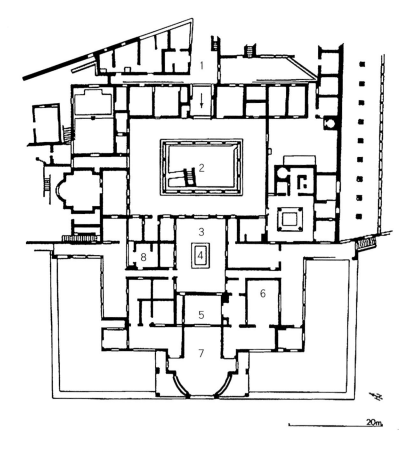

6–27 PLAN OF THE VILLA OF THE MYSTERIES
Pompeii, early second century BCE.
1) entrance foyer, 2) peristyle,
3) atrium, 4) pool (water basin),
5) tablinium (office, official reception room), 6) room with paintings of mysteries, 7) terrace,
8) bedroom

THE ROMAN HOUSE. A Roman house usually consisted of small rooms laid out around one or two open courts, the atrium and the peristyle (FIG. 6–27). The **atrium** was a large space with a pool or cistern for catching rainwater. The **peristyle** was a planted interior court enclosed by columns. The formal reception room or office was called the *tablinum,* and here the head of the household conferred with clients. Portrait busts of the family's ancestors might be displayed there or in the atrium. Rooms were arranged symmetrically. The private areas—such as the family sitting room and bedrooms and the service areas such as the kitchen and servants' quarters—usually were entered from the peristyle. In Pompeii, where the mild southern climate permitted gardens to flourish year-round, the peristyle was often turned into an outdoor living room with painted walls, fountains, and sculpture, as in the mid–first-century CE remodeling of the second-century BCE **HOUSE OF THE VETTII** (FIG. 6–28). The Villa (a country house) combined family living with facilities required by the farm.

THE URBAN GARDEN. The nature-loving Romans softened the regularity of their homes with beautifully designed and planted gardens. Fruit- and nut-bearing trees and occasionally olive trees were arranged in irregular rows. Some houses had both peristyle gardens and separate vegetable gardens. Only the great luxury villas had the formal landscaping and topiery work (fanciful clipped shrubbery) praised by ancient writers.

Little was known about these gardens until the archaeologist Wilhelmina Jashemski began the excavation of the peristyle in the House of G. Polybius in Pompeii in 1973. Earlier archaeologists had usually destroyed evidence of gardens, but Jashemski developed a new way to find and analyze the layout and the plants cultivated in them. Workers first removed layers of debris and volcanic material to expose the level of the soil as it was before the eruption in 79 CE. They then collected samples of pollen, seeds, and other organic material and carefully injected plaster into underground root cavities. When the surrounding earth was removed, the roots, now in plaster, enabled botanists to identify the types of plants and trees cultivated in the garden and to estimate their size.

The garden in the house of Polybius was surrounded on three sides by a portico, which protected a large cistern on one side that supplied the house and garden with water. Young lemon trees in pots lined the fourth side of the garden, and nail holes in the wall above the pots indicated that the trees had been espaliered—pruned and trained to grow flat against a support—a practice still in use today. Fig, cherry, and pear trees filled the garden space, and traces of a fruit-picking ladder, wide at the bottom and narrow at the top to fit among the branches, was found on the site. This evidence suggests that the garden was a densely planted orchard similar to the one painted on the dining-room walls of the villa of Empress Livia in Primaporta (SEE FIG. 6–31).

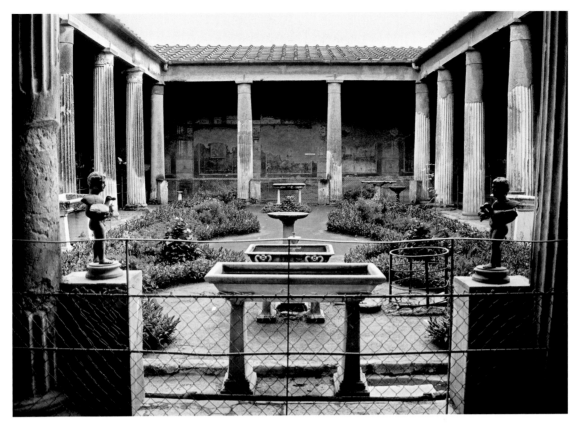

6–28 PERISTYLE GARDEN, HOUSE OF THE VETTII
Pompeii. Rebuilt 62–79 CE.

An aqueduct built during the reign of Augustus elimi-
nated Pompeii's dependence on wells and rainwater basins
and allowed residents to add pools, fountains, and flowering
plants that needed heavy watering to their gardens. In con-
trast to earlier, unordered plantings, formal gardens with low,
clipped borders and plantings of ivy, ornamental boxwood,
laurel, myrtle, acanthus, and rosemary—all mentioned by
writers of the time—became fashionable. There is also evi-
dence of topiary work, the clipping of shrubs and hedges into
fanciful shapes. Sculpture and purely decorative fountains
became popular. The peristyle garden of the House of the
Vettii, for example, had more than a dozen fountain statues
jetting water into marble basins (SEE FIG. 6–28). In the most
elegant peristyles, mosaic decorations covered the floors,
walls, and even the fountains. Some of the earliest wall
mosaics, such as the one from a wall niche in a Pompeian gar-
den, were created as backdrops for fountains (FIG. 6–29).

Wall Painting

The interior walls of Roman houses were plain, smooth plas-
ter surfaces with few architectural features. On these invit-
ingly empty spaces, artists painted decorations using pigment
in a solution of lime and soap, sometimes with a little wax.
After the painting was finished, they polished it with a special
metal, glass, or stone burnisher and then buffed the surface
with a cloth. Many fine wall paintings have come to light

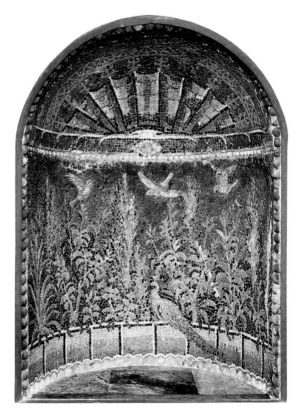

6–29 FOUNTAIN MOSAIC
Wall niche, from a garden in Pompeii. Mid-1st century CE.
Mosaic, 43¾ × 31½″ (111 × 80 cm). Fitzwilliam Museum,
University of Cambridge, England.

through excavations, first in Pompeii and other communities surrounding Mount Vesuvius, near Naples, and more recently in and around Rome.

In the earliest paintings (200–80 BCE), artists attempted to produce the illusion of thin slabs of colored marble covering the walls, which were set off by actual architectural moldings and columns. By about 80 BCE, they began to extend the space of a room visually with painted scenes of figures on a shallow "stage" or with a landscape or cityscape. Architectural details such as columns were painted rather than made of molded plaster.

ROMAN REALISM: CREATING AN ILLUSION OF THE WORLD. One of the most famous painted rooms in Roman art is in the so-called **VILLA OF THE MYSTERIES** just outside the city walls of Pompeii (**FIG. 6–30**; SEE PLAN IN FIG. 6–27). The rites of mystery religions were often performed in private homes as well as in special buildings or temples, and this room, at the corner of a suburban villa, must have been a shrine or meeting place for such a cult. The murals depict initiation rites—probably into the cult of Bacchus, who was the god of vegetation and fertility as well as wine. Bacchus (or Dionysus) was one of the most important deities in Pompeii.

The entirely painted architectural setting consists of a "marble" **dado** (the lower part of a wall) and, around the top of the wall, an elegant frieze supported by pilasters. The action takes place on a shallow "stage" along the top of the dado, with a background of brilliant, deep red—now known as Pompeian red. This red was very popular with Roman

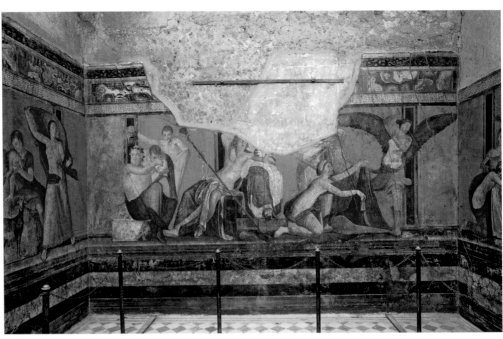

6–30 **INITIATION RITES OF THE CULT OF BACCHUS (?) IN THE VILLA OF THE MYSTERIES**
Pompeii. Wall painting. c. 60-50 BCE.

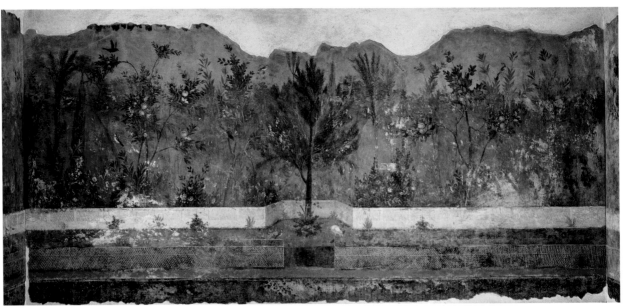

6–31 **GARDEN SCENE**
Detail of a wall painting from the dining room of the Villa of Livia at Primaporta, near Rome. Late 1st century BCE.
Museo Nazionale Romano, Rome.

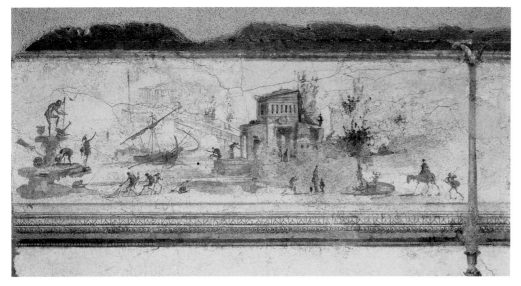

6–32 **SEASCAPE AND COASTAL TOWNS**
Detail of a wall painting from Villa Farnesina, Rome. Late 1st century CE.

painters. The scene unfolds around the entire room, perhaps depicting a succession of events that culminate in the acceptance of an initiate into the cult.

The dining-room walls of Livia's Villa at Primaporta exemplify yet another approach to creating a sense of expanded space (FIG. 6–31). Instead of rendering a stage set, the artist "painted away" the wall surfaces to create the illusion of being on a porch or pavilion looking out over a low wall into an orchard of heavily laden fruit trees. These and the flowering shrubs are filled with a variety of wonderfully observed birds.

In such paintings, the overall effect is one of an idealized view of the world, rendered with free, fluid brushwork and delicate color. A painting from the Villa Farnesina, found in excavations in Rome (FIG. 6–32), depicts the *locus amoenus*, the "lovely place" extolled by Roman poets, where people lived effortlessly in union with the land. Here two conventions create the illusion of space: Distant objects are rendered proportionally smaller than near objects, and the colors become slightly grayer near the horizon, an effect called *atmospheric perspective*—that is, the tendency of distant objects to appear hazy and lighter in color.

ELEGANT FANTASIES: BOSCOREALE AND POMPEII. The walls of a room from a villa at Boscoreale near Pompeii (reconstructed in the Metropolitan Museum of Art in New York) open onto a fantastic urban panorama (FIG. 6–33). The wall

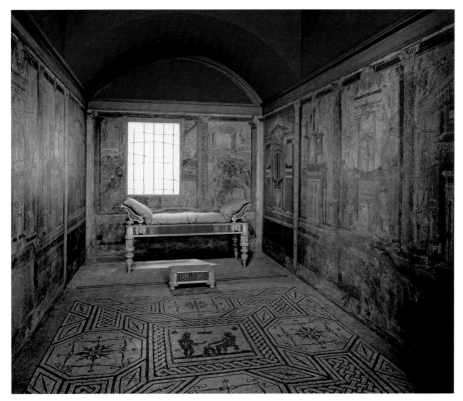

6–33 **RECONSTRUCTED BEDROOM**
House of Publius Fannius Synistor, Boscoreale, near Pompeii. Late 1st century BCE, with later furnishings. The Metropolitan Museum of Art, New York.

Rogers Fund, 1903 (03.14.13)

Although the elements in the room are from a variety of places and dates, they give a sense of how the original furnished room might have looked. The wall paintings, original to the Boscoreale villa, may have been inspired by theater scene painting. The floor mosaic, found near Rome, dates to the second century CE. At its center is an image of a priest offering a basket with a snake to a cult image of Isis. The luxurious couch and footstool, inlaid with bone and glass, date from the first century CE.

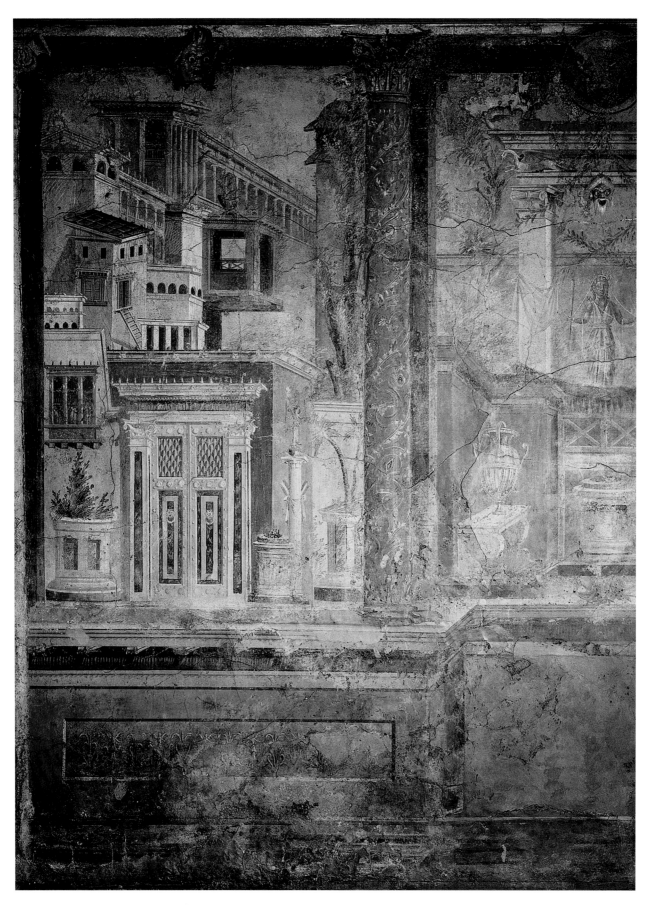

6–34 **CITYSCAPE**
Detail of a wall painting from a bedroom in the House of Publius Fannius Synistor, Boscoreale.
Late 1st century CE. The Metropolitan Museum of Art, New York.
Rogers Fund, 1903 (03.14.13)

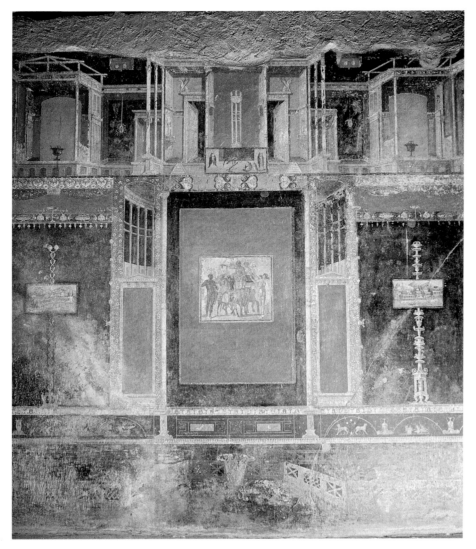

6–35 **DETAIL OF A WALL PAINTING IN THE HOUSE OF M. LUCRETIUS FRONTO**
Pompeii. Mid-1st century CE.

surfaces seem to dissolve behind columns and lintels, which frame a maze of floating architectural forms creating purely visual effects, like the backdrops of a stage. Indeed, the theater may have inspired this kind of decoration, as details in the room suggest. For example, on the rear wall, next to the window, is a painting of a grotto, the traditional setting for satyr plays, dramatic interludes about the half-man, half-goat followers of Bacchus. On the side walls, paintings of theatrical masks hang from the lintels.

As one looks more closely, the architecture becomes a complex jumble of buildings with balconies, windows, arcades, and roofs at different levels, as well as a magnificent colonnade (FIG. 6–34). By using an intuitive perspective, the artist has created a general impression of real space. In **intuitive perspective**, the architectural details follow diagonal lines that the eye interprets as parallel lines receding into the distance, and objects meant to be perceived as far away from the surface plane of the wall are shown slightly smaller than those intended to appear nearby. The orderly focus of a single point of view, however, is lacking.

As time passed, this painted architecture became increasingly fanciful. Solid-colored walls were decorated with slender, whimsical architectural and floral details and small, delicate vignettes. In the **HOUSE OF M. LUCRETIUS FRONTO** in Pompeii, from the mid-first century CE (FIG. 6–35), the artist painted a room with panels of black and red, bordered with architectural moldings. These architectural elements have no logic, and for all their playing with space, they fail to create any significant illusion of depth. Rectangular pictures seem to be mounted on the black and red panels.

The scene with figures in the center is flanked by two small simulated window openings protected by grilles. The two pictures of villas in landscapes appear to float in front of intricate bronze easels.

ROMAN REALISM IN DETAILS: STILL LIFES AND PORTRAITS. In addition to landscapes and city views, other subjects that appeared in Roman art included historical and mythological scenes, exquisitely rendered **still lifes** (compositions of inanimate objects), and portraits. A still-life panel from Herculaneum, a community in the vicinity of Mount Vesuvius near Pompeii, depicts everyday domestic objects—still-green peaches just picked from the tree and a glass jar half filled with water (FIG. 6–36). The items have been carefully arranged on two shelves to give the composition clarity and balance. A strong, clear light floods the picture from right to left, casting shadows, picking up highlights, and enhancing the illusion of real objects in real space.

Portraits, sometimes imaginary ones, also became popular. A first-century **tondo** (circular panel) from Pompeii contains the portrait **YOUNG WOMAN WRITING** (FIG. 6–37). The sitter has regular features and curly hair caught in a golden net. As in a modern studio portrait photograph, with its careful lighting and retouching, the young woman may be somewhat idealized. Following a popular convention, she nibbles on the tip of her stylus. Her sweet expression and clear-eyed but unfocused and contemplative gaze suggest that she is in the throes of composition.

The paintings in Pompeii reveal much about the lives of women during this period (see "The Position of Roman

6–36 STILL LIFE
Detail of a wall painting from House of the Stags (Cervi), Herculaneum. Before 79 CE. Approx. 1′2″ × 1′½″ (35.5 × 31.7 cm). Museo Nazionale, Naples.

Women," above). Some, like Julia Felix, were the owners of houses where paintings were found. Others were the subjects of the paintings. They are shown as rich and poor, young and old, employed as business managers and domestic workers.

The Flavians

The Julio-Claudian dynasty ended with the suicide of Nero in 68 CE, to be replaced by the Flavians, practical military men who restored confidence and ruled for the rest of the first century. They restored the imperial finances and stabilized the frontiers, but during the autocratic reign of the last Flavian, Domitian, intrigue and terror returned to the capital.

THE ARCH OF TITUS. Among the most admirable official commissions during the Flavian dynasty is a distinctive Roman structure, the triumphal arch. Part architecture, part sculpture, the freestanding arch commemorates a triumph, or formal victory celebration, during which a victorious general or emperor paraded through the city with his troops, captives, and booty. When Domitian assumed the throne in 81 CE, for example, he immediately commissioned a triumphal arch to honor the capture of Jerusalem in 70 CE by his brother and deified predecessor, Titus (FIG. 6–38). THE ARCH OF TITUS, constructed of concrete and faced with marble, is essentially a freestanding gateway whose passage is covered by a barrel vault. The arch served as a giant base, 50 feet tall, for a statue of a four-horse chariot and driver, a typical triumphal symbol. Applied to the faces of the arch are columns in the Composite order supporting an entablature. The inscription on the attic story declares that the Senate and the Roman people erected the monument to honor Titus.

Titus's capture of Jerusalem ended a fierce campaign to crush a revolt of the Jews in Palestine. The Romans sacked and

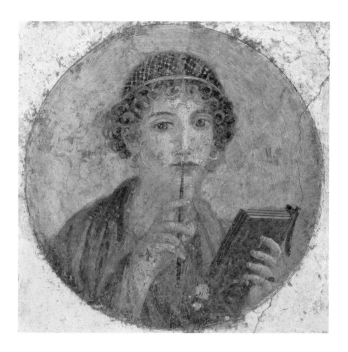

6–37 **YOUNG WOMAN WRITING**
Detail of a wall painting, from Pompeii. Before 79 CE. Diameter 14⅝" (37 cm). Museo Archeològico Nazionale, Naples.

The fashionable young woman seems to be pondering what she will write about with her stylus on the beribboned writing tablet that she holds in her other hand. Romans used pointed styluses to engrave letters on thin, wax-coated ivory or wood tablets in much the way we might use a hand-held computer. Errors could be easily smoothed over. When a text or letter was considered ready, it was copied onto expensive papyrus or parchment. Tablets like these were also used by schoolchildren for their homework.

Sequencing Events
REIGNS OF NOTABLE ROMAN EMPERORS

The Early Empire	**27 BCE–96 CE**
Augustus	27 BCE–14 CE
The Julio-Claudians	**14–69 CE**
Tiberius	14–37 CE
Caligula	37–41 CE
Claudius	41–54 CE
Nero	54–68 CE
The Flavians	**69–96 CE**
Vespasian	69–79 CE
Titus	79–81 CE
Domitian	81–96 CE
The High Empire	**96–192 CE**
Nerva	96–98 CE
Trajan	98–117 CE
Hadrian	117–138 CE
The Antonines	**138–192 CE**
Antoninus Pius	138–161 CE
Marcus Aurelius	161–180 CE
Commodus	180–192 CE
The Late Empire	**192–476 CE**
Septimius Severus	193–211 CE
Caracalla	211–217 CE
Alexander Severus	222–235 CE
Diocletian	284–305 CE
The Tetrarchy (Rule of Four)	293–305/312 CE
Constantine I	312–337 CE
Death of Romulus Augustus (last emperor in the West)	476 CE

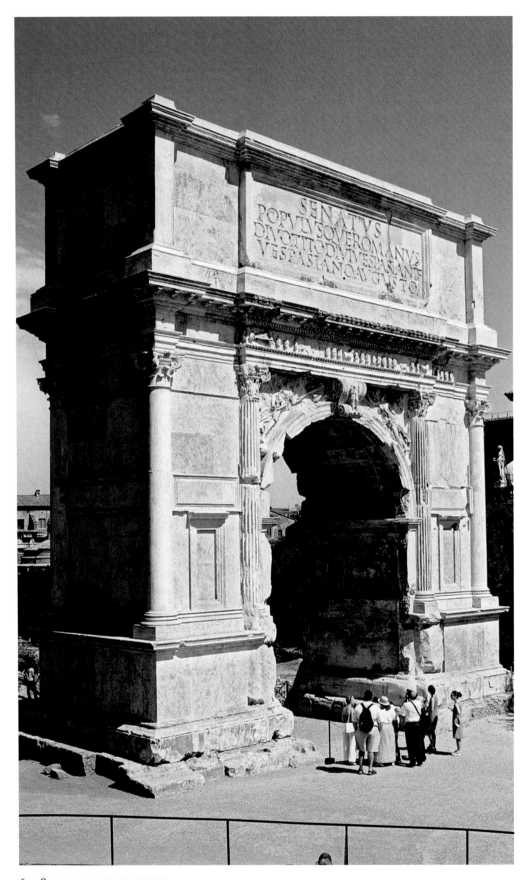

6–38 **THE ARCH OF TITUS**
Rome. c. 81 CE (Restored 1822–24). Concrete and white marble, height 50′ (15 m).

The dedication inscribed across the tall attic story above the arch opening reads: "The Senate and the Roman People to the Deified Titus Vespasian Augustus, son of the Deified Vespasian." The perfectly sized and spaced Roman capital letters meant to be read from a distance and cut with sharp terminals (serifs) to catch the light established a standard that calligraphers and alphabet designers still follow.

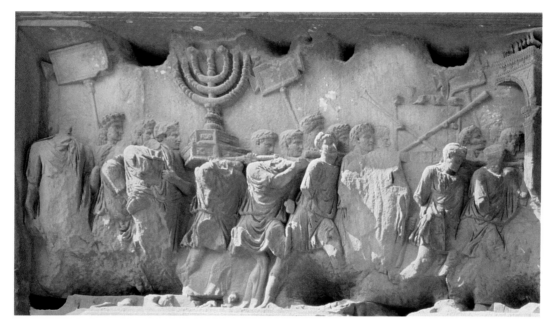

6–39 **SPOILS FROM THE TEMPLE OF SOLOMON**
Relief in the passageway of the Arch of Titus. Marble, height 6′8″ (2.03 m).

destroyed the Second Temple in Jerusalem, carried off its sacred treasures (FIG. 6–39), then displayed them in a triumphal procession in Rome (FIG. 6–40). The reliefs on the inside walls of the arch, capturing the drama of the occasion, depict Titus's soldiers flaunting this booty as they carry it through the streets of Rome. The viewer can sense the press of that boisterous, disorderly crowd and might expect at any moment to hear soldiers and onlookers shouting and chanting.

The mood of the procession depicted in these reliefs contrasts with the relaxed but formal solemnity of the procession portrayed on the Ara Pacis (SEE FIG. 6–21). Like the sculptors of the Ara Pacis, the sculptors of the Arch of Titus showed the spatial relationships among figures, varying the height of the relief by rendering nearer elements in higher relief than those more distant. A **menorah**, or seven-branched lampholder from the Temple of Jerusalem, dominates one scene; Titus riding in his chariot as a participant in the ceremonies, the other. Reflecting their concern for representing objects as well as people in a believable manner, the sculptors rendered this menorah as if seen from the low point of view of a spectator at the event, and they have positioned the arch on the right through which the procession is about to pass on a diagonal. On the vaulted ceiling, an eagle carries Titus skyward to join the gods.

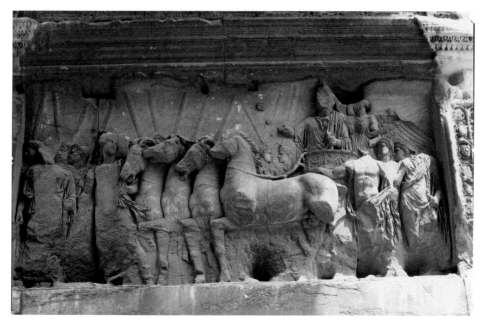

6–40 **TRIUMPHAL PROCESSION, TITUS IN CHARIOT**
Relief in the passageway of the Arch of Titus. Marble, height 6′8″ (2.03 m).

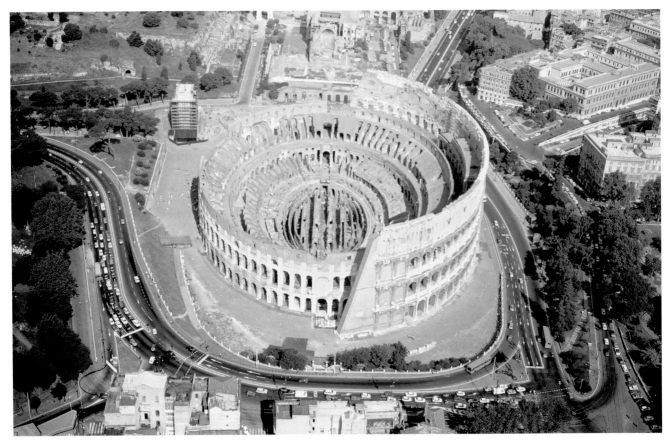

6–41　FLAVIAN AMPHITHEATER (COLOSSEUM)
From the air. Rome. 70–80 CE.

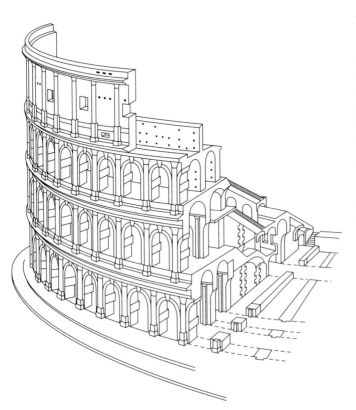

6–42　FLAVIAN AMPHITHEATER
Drawing showing vaulted construction.

THE FLAVIAN AMPHITHEATER. In a way, Romans were as sports-mad as modern Americans, and the Flavian emperors catered to their tastes by building splendid facilities. Construction of the **FLAVIAN AMPHITHEATER**, Rome's greatest arena (FIG. 6–41), began under Vespasian in 70 CE and was completed under Titus, who dedicated it in 80 CE. The Flavian Amphitheater came to be known as the "Colosseum," because a gigantic statue of Nero called the Colossus stood next to it. But "Colosseum" is a most appropriate description of this enormous entertainment center. It is an oval, measuring 615 by 510 feet, with a floor 280 by 175 feet. Its outer wall stands 159 feet high. Roman audiences watched a variety of athletic events and spectacles, including animal hunts, fights to the death between gladiators or between gladiators and wild animals, performances of trained animals and acrobats, and even mock sea battles, for which the arena would be flooded. The opening performances in 80 CE lasted 100 days, during which time it was claimed that 9,000 wild animals and 2,000 gladiators died for the amusement of the spectators.

The floor of the Colosseum was laid over a foundation of service rooms and tunnels that provided an area for the athletes, performers, animals, and equipment. This floor was covered by sand, *arena* in Latin, hence the English term

"arena" for a building of this type. Some 50,000 spectators could move easily through the seventy-six entrance doors to the three levels of seats and the standing area at the top. Each had an uninterrupted view of the spectacle below. Stadiums today are still based on this efficient plan.

The Romans took the form of the Greek theater and enlarged upon it (see Chapter 5, page 159). They constructed freestanding amphitheaters by placing two theaters facing each other to create a central oval-shaped performance area. The amphitheater is a remarkable piece of planning with easy access, perfect sight lines for everyone, and effective crowd control. Ascending tiers of seats were laid over barrel-vaulted access corridors and entrance tunnels that connect the rings of corridors to the ramps and seats on each level (FIG. 6–42). The intersection of the barrel-vaulted entrance tunnels and the ring corridors created groin vaults (see "Arch, Vault, and Dome," page 172). The walls on the top level of the arena supported a huge awning that could shade the seating areas. Sailors who had experience in handling ropes, pulleys, and large expanses of canvas worked the apparatus that extended the awning.

The curving, outer wall of the Colosseum consists of three levels of arcades surmounted by a wall-like attic (top) story. Each arch in the arcades is framed by engaged columns. Entablature-like friezes mark the divisions between levels (FIG. 6–43). Each level also uses a different architectural order, increasing in complexity from bottom to top: the plain **Tuscan order** on the ground level, Ionic on the second level, Corinthian on the third, and Corinthian pilasters on the fourth. The attic story is broken by small, square windows, which originally alternated with gilded bronze shield-shaped ornaments called **cartouches**, supported on brackets that are still in place and can be seen in the illustration. Engaged Corinthian pilasters above the Corinthian columns of the third level support another row of corbels beneath the projecting cornice.

All these elements are purely decorative. As we saw in the Etruscan Porta Augusta (SEE FIG. 6–2), the addition of post-and-lintel decoration to arched structures was an Etruscan innovation. The systematic use of the orders in a logical succession from sturdy Tuscan to lighter Ionic to decorative Corinthian follows a tradition inherited from

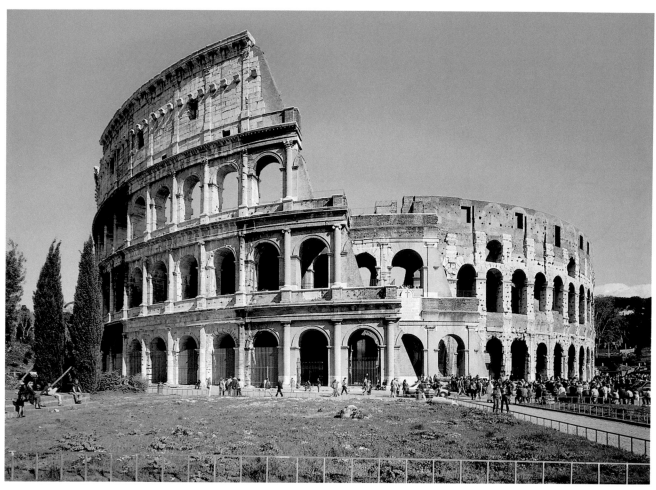

6–43 **FLAVIAN AMPHITHEATER, OUTER WALL**
Rome. 70–80 CE.

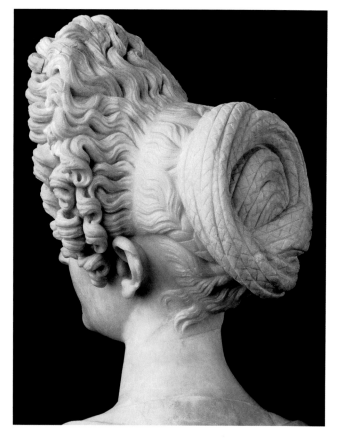

6–44 **A YOUNG FLAVIAN WOMAN**
c. 90 CE. Marble, height 25″ (65.5 cm). Museo Capitolino, Rome.

Hellenistic architecture. This orderly, dignified, and visually satisfying way of organizing the façades of large buildings is still popular. Unfortunately, much of the Colosseum was dismantled in the Middle Ages as a source of marble, metal fittings, and materials for buildings such as churches.

PORTRAIT SCULPTURE. Roman patrons continued to demand likenesses in their portraits, but the portrait, **A YOUNG FLAVIAN WOMAN** (FIG. 6–44), exemplifies the current Roman ideal. Her well-observed, recognizable features—a strong nose and jaw, heavy brows, deep-set eyes, and a long neck—contrast with the smoothly rendered flesh and soft, full lips. (The portrait suggests the retouched fashion photos of today.) Her hair is piled high in an extraordinary mass of ringlets in the latest court fashion. Executing the head required skillful chiseling and drillwork, a technique for rapidly cutting deep grooves with straight sides, as was done here to render the holes in the center of the curls. The overall effect, from a distance, seems very lifelike. The play of natural light over the more subtly sculpted surfaces gives the illusion of being reflected off real skin and hair, yet closer inspection reveals a portrayal too perfect to be real.

A bust of an older woman (FIG. 6–45), reflects a revival of the veristic portraiture popular in the Republican period. The subject of this portrait, though she too wore her hair in the latest style, was apparently not preoccupied with her appearance. The work she commissioned shows her just as she appeared in her own mirror, with all the signs of age recorded on her face.

THE HIGH IMPERIAL ART OF TRAJAN AND HADRIAN

Domitian was assassinated in 96 CE and succeeded by a senator, Nerva (96–98), who designated as his successor Trajan, a general born in Spain and commander of troops in Germany. For nearly a century, the empire was under the control of brilliant administrators. Instead of depending on the vagaries of fate (or genetics) to produce intelligent heirs, the emperors Nerva (96–98), Trajan (98–117), Hadrian (117–138), and Antoninus Pius (138–161) (but not Marcus Aurelius [161–180]) each selected an able administrator to follow him and each thereby "adopted" his successor. Italy and the provinces flourished, and official and private patronage of the arts increased.

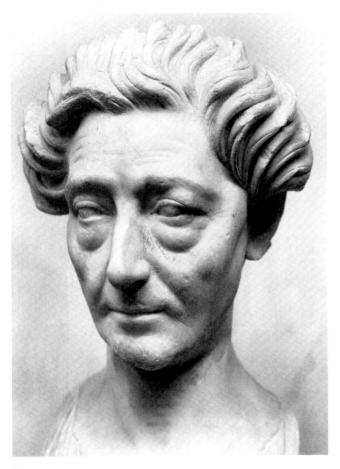
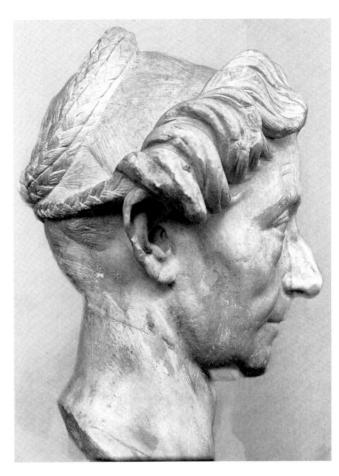

6–45 **MIDDLE-AGED FLAVIAN WOMAN**
Late 1st century CE. Marble, height 9½″ (24.1 cm). Musei Vaticani, Museo Gregoriano
Profano, ex-Lateranese, Rome.

Under Trajan, the empire reached its greatest extent. By 106 CE Romans had conquered Dacia, roughly present-day Romania (SEE MAP 6–1). The next emperor, Hadrian, then consolidated the empire's borders and imposed far-reaching social, governmental, and military reforms. Hadrian was well educated and widely traveled, and his admiration for Greek culture spurred new building programs and art patronage throughout the empire. Unfortunately, Marcus Aurelius broke the tradition of adoption and left his son, Commodus, to inherit the throne. Within twelve years, Commodus (180–192) destroyed the government his predecessors had so carefully built.

Imperial Architecture

The Romans believed their rule extended to the ends of the Western world, but the city of Rome remained the nerve center of the empire. During his long and peaceful reign, Augustus had paved the city's old Republican Forum, restored its temples and basilicas, and followed Julius Caesar's example by building an Imperial Forum. These projects marked the beginning of a continuing effort to transform the capital itself into a magnificent monument to imperial rule. While Augustus's claim of having turned Rome into a city of marble is exaggerated (like most politicians he was speaking metaphorically, not literally), he certainly began the process of creating a monumental civic center. Such grand structures as the Imperial Forums, the Colosseum, the Circus Maximus (a track for chariot races), the Pantheon, and aqueducts stood amid the temples, baths, warehouses, and homes in the city center.

THE FORUM OF TRAJAN. A model of Rome's city center makes apparent the dense building plan (FIG. 6–46). The last and largest Imperial Forum was built by Trajan about 107–113 and finished under Hadrian about 117 CE on a large piece of property next to the earlier forums of Augustus and Julius Caesar (FIG. 6–47). For this major undertaking, Trajan chose a Greek architect, Apollodorus of Damascus, a military engineer. A straight, central axis leads from the Forum of Augustus through a triple-arched gate, surmounted by a bronze chariot group, into a large, colonnaded square with a statue of Trajan on horseback at its center. Closing off the courtyard at the north end was the Basilica Ulpia, dedicated in c. 112 CE, and named for the family to which Trajan belonged.

A **basilica** was a large, rectangular building with a rounded extension, called an **apse**, at each end. A general-purpose administrative structure, it could be adapted to

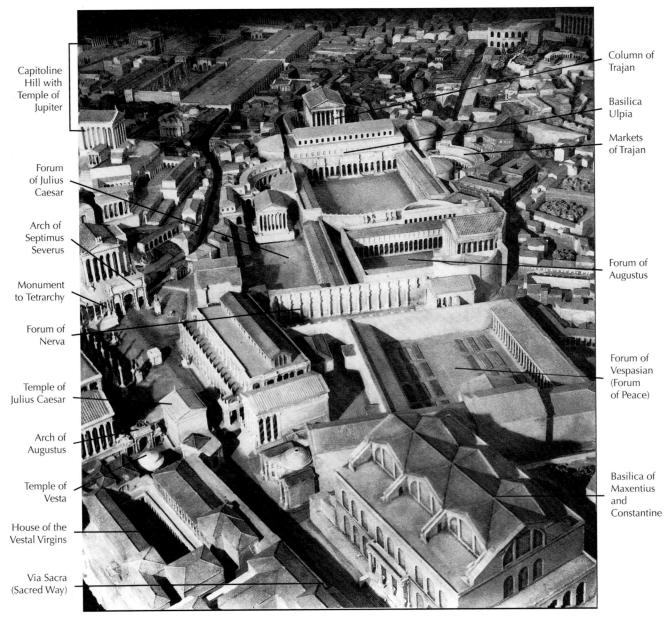

Capitoline
Hill with
Temple of
Jupiter

Forum
of Julius
Caesar

Arch of
Septimus
Severus

Monument
to Tetrarchy

Forum of
Nerva

Temple of
Julius Caesar

Arch of
Augustus

Temple of
Vesta

House of the
Vestal Virgins

Via Sacra
(Sacred Way)

Column of
Trajan

Basilica
Ulpia

Markets
of Trajan

Forum of
Augustus

Forum of
Vespasian
(Forum
of Peace)

Basilica of
Maxentius
and
Constantine

6–46 MODEL OF THE FORUM ROMANUM AND IMPERIAL FORUMS
Rome. c. 325 CE.

many uses. The Basilica Ulpia was a court of law, but other basilicas served as imperial audience chambers, army drill halls, and schools. The basilica design provided a large interior space whose many doors on the long sides provided easy access (FIG. 6–48). The Basilica Ulpia was 385 feet long (not including the apses) and 182 feet wide. The interior space consisted of a large central area (the **nave**) flanked by double colonnaded aisles surmounted by open galleries or by a **clerestory**, an upper nave wall with windows. The cen-

tral space was taller than the surrounding galleries and was lit directly by an open gallery or clerestory windows. The timber truss roof had a span of about 80 feet. The two apses, one at each end of the building, provided imposing settings for judges when the court was in session.

During the site preparation for the forum, part of a commercial district had to be razed and excavated. To make up for the loss, Trajan ordered the construction of a handsome public market (FIG. 6–49). The market, comparable in size to a large

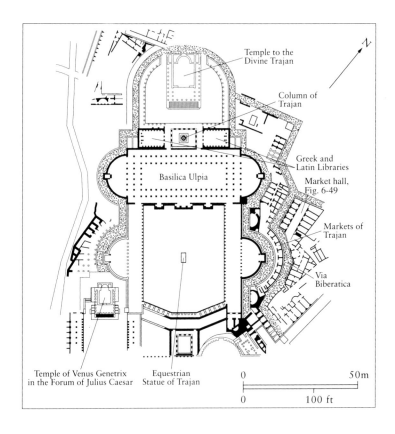

6-47 **PLAN OF TRAJAN'S FORUM**
c. 110–113 CE.

6-48 **RESTORED PERSPECTIVE VIEW OF THE CENTRAL HALL**
Basilica Ulpia, Rome. c. 112 CE. Drawn by Gilbert Gorski. Trajan's architect was Apollodorus of Damascus.

The building may have had clerestory windows instead of the gallery shown in this drawing. The column of Trajan can be seen at the right.

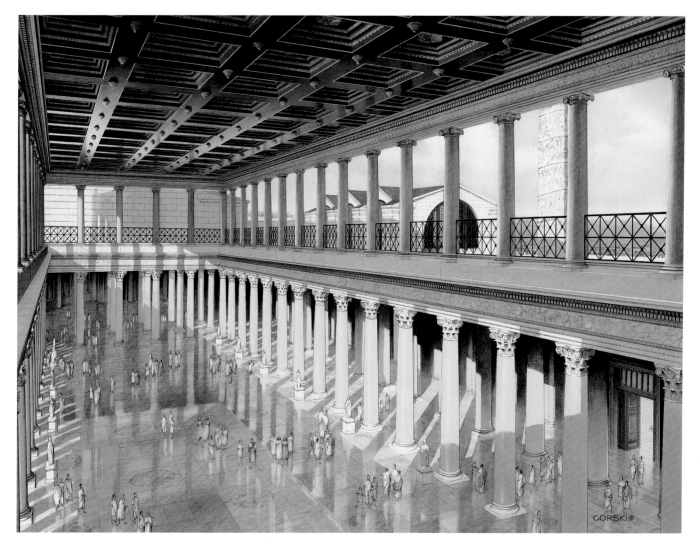

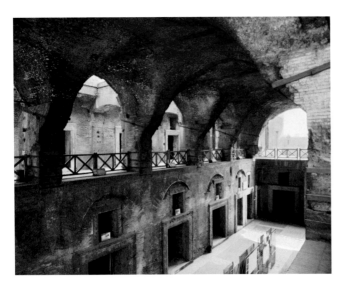

6–49 MAIN HALL, MARKETS OF TRAJAN
Rome. 100–12 CE.

modern shopping mall, had more than 150 individual shops on several levels and included a large groin-vaulted main hall. In compliance with a building code that was put into effect after a disastrous fire in 64 CE, the market, like all Roman buildings of the time, had masonry construction—brick-faced concrete, with only some detailing in stone and wood.

Behind the Basilica Ulpia stood twin libraries built to house the emperor's collections of Latin and Greek manuscripts. These buildings flanked an open court and the great spiral column that became Trajan's tomb (Hadrian placed his predecessor's ashes in the base). The column commemorated Trajan's victory over the Dacians and was erected either with the Basilica Ulpia about 113 CE or by Hadrian after Trajan's death in 117 CE. The Temple of the Divine Trajan stands opposite the Basilica Ulpia, forming the fourth side of the court and closing off the end of the forum. Hadrian ordered the temple built after Trajan's death.

THE COLUMN OF TRAJAN. The relief decoration on the **COLUMN OF TRAJAN** spirals upward in a band that would stretch almost 625 feet if unfurled. Like a giant version of the scrolls housed in the libraries next to it, the column is a continuous pictorial narrative of the Dacian campaigns of 102–103 and 105–106 CE (FIG. 6–50). The remarkable sculpture includes more than 2,500 individual figures linked by landscape, architecture, and the recurring figure of Trajan. The artist took care to make the scroll legible. The narrative band slowly expands from about 3 feet in height at the bottom, near the viewer, to 4 feet at the top of the column, where it is farther from view.

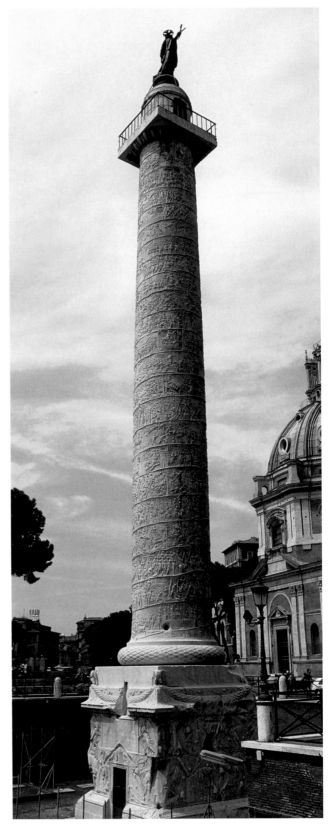

6–50 COLUMN OF TRAJAN
Rome. 113–16 or after 117 CE. Marble, overall height with base 125′ (38 m), column alone 97′8″ (29.77 m); relief 625′ (190.5 m) long.

The height of the column, 100 Roman feet (97′8″, 30 m) may have recorded the depth of the excavation required to build the Forum of Trajan. The column had been topped by a gilded bronze statue of Trajan that was replaced in 1588 CE by order of Pope Sixtus V with the statue of Saint Peter seen today. Trajan's ashes were interred in the base in a golden urn.

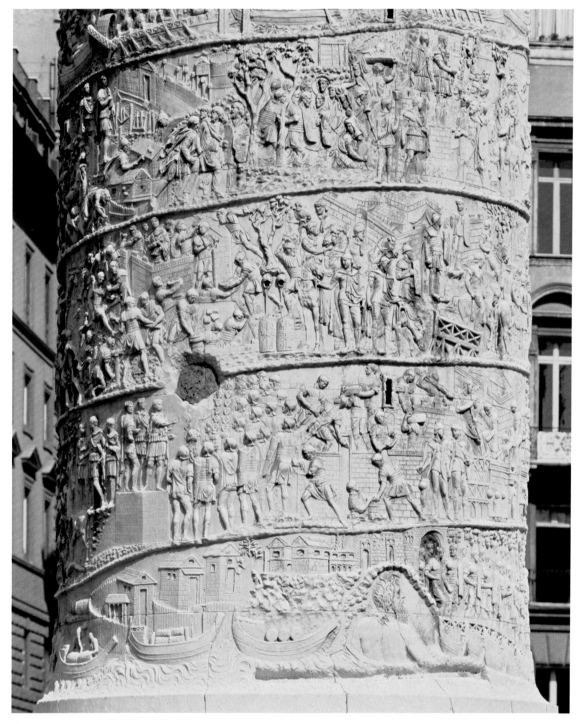

6–51 ROMANS CROSSING THE DANUBE AND BUILDING A FORT
Detail of the lowest part of the Column of Trajan. 113–16 CE, or after 117. Marble, height of the spiral band approx. 36″ (91 cm).

The natural and architectural elements in the scenes have been kept small to emphasize the important figures.

On the Column of Trajan, sculptors refined the art of pictorial narrative seen on the Arch of Titus (SEE FIGS. 6–39, 6–40). The scene at the beginning of the spiral, at the bottom of the column, shows Trajan's army crossing the Danube River on a pontoon bridge as the first Dacian campaign of 101 gets under way (FIG. 6–51). Soldiers construct a battle-field headquarters in Dacia from which the men on the frontiers will receive orders, food, and weapons. In this spectacular piece of imperial propaganda, Trajan is portrayed as a strong, stable, and efficient commander of a well-run army, and his barbarian enemies are shown as worthy opponents of Rome.

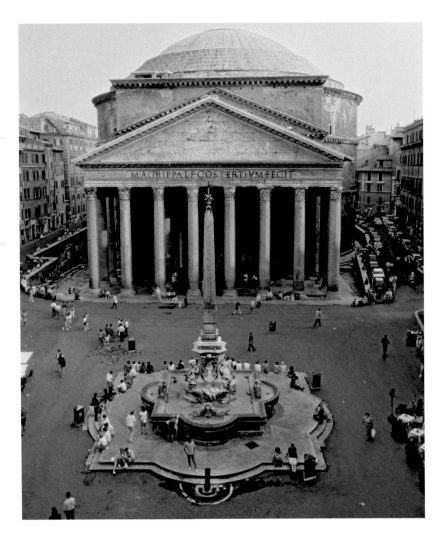

6–52 PANTHEON
Rome c. 118–128 CE.

The approach to the Pantheon is very different today. A huge fountain dominates the square in front of the building. Built in 1578 by Giacomo della Porta, today it supports an Egyptian obelisk placed there in 1711 by Pope Clement XI.

THE PANTHEON. Perhaps the most remarkable ancient building surviving in Rome—and one of the marvels of architecture in any age—is a temple to the Olympian gods called the **PANTHEON** (literally, "all the gods") (FIG. 6–52). Originally the Pantheon stood on a podium and was approached by stairs from a colonnaded square. (The difference in height of the street levels of ancient and modern Rome can be seen at the left side of the photograph.) Although this magnificent monument was designed and constructed entirely during the reign of the emperor Hadrian, the long inscription on the architrave states that it was built by "Marcus Agrippa, son of Lucius, who was consul three times." Agrippa, the son-in-law and valued adviser of Augustus, was responsible for building on this site in 27–25 BCE. After a fire in 80 CE, Domitian built a new temple, which Hadrian then replaced in 118–128 CE with the Pantheon.

Hadrian, who must have had a strong sense of history, placed Agrippa's name on the façade in a grand gesture to the memory of the illustrious consul, rather than using the new building to memorialize himself. Septimius Severus (see page 218) restored the Pantheon in 202 CE.

The approach to the temple gives little suggestion of its original appearance. Centuries of dirt and street construction hide its podium and stairs. Attachment holes in the pediment indicate the placement of sculpture, perhaps an eagle within a wreath, the imperial Jupiter. Nor is there any hint of what lies beyond the entrance porch, which resembles the façade of a typical Roman temple. Behind this porch is a giant rotunda with 20-foot-thick walls that rise nearly 75 feet. The walls support a bowl-shaped dome that is 143 feet in diameter and 143 feet from the floor at its summit (FIG. 6–53). Standing at the center of this hemispherical temple (FIG. 6–54), the visitor feels isolated from the outside world and intensely aware of the shape and tangibility of the space itself. The eye is drawn upward over the circular patterns made by the sunken panels, or **coffers**, in the dome's ceiling to the light entering the 29-foot-wide **oculus**, or central opening. The sun pours through this opening on clear days; rain falls on wet ones, then drains off as planned by the original engineer; and the occasional bird flies in. The empty, luminous space gives the feeling that one could rise buoyantly upward and escape the spherical hollow of the building to commune with the gods.

The simple shape of the Pantheon's dome belies its sophisticated design and engineering (FIG. 6–55). Marble veneer disguises the internal brick arches and concrete structure. The interior walls, which form the drum that both

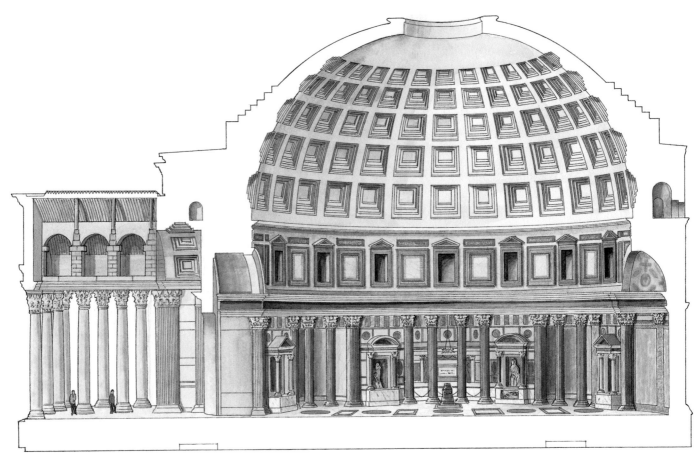

6–53 RECONSTRUCTION DRAWING OF THE PANTHEON

Ammianus Marcellinus described the Pantheon in 357 CE as being "rounded like the boundary of the horizon, and vaulted with a beautiful loftiness." Although the Pantheon has inspired hundreds—perhaps thousands—of faithful copies, inventive variants, and eclectic borrowings over the centuries, only recently have the true complexity and the innovative engineering of its construction been fully understood.

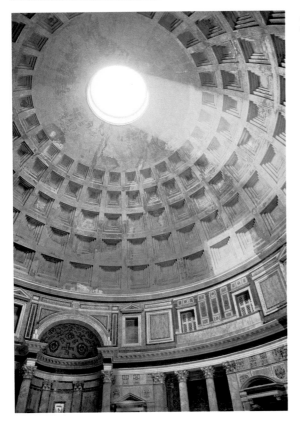

6–54 DOME OF THE PANTHEON
With light from the oculus on its coffered ceiling. 125–128 CE.
Brick, concrete, marble, veneer, diameter of dome 143′ (43.5 m).

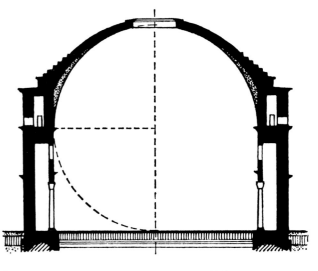

6–55 CIRCLE SECTION OF THE PANTHEON

supports and buttresses the dome, are disguised by two tiers of architectural detail and richly colored marble. More than half of the original decoration—a wealth of columns, pilasters, and entablatures—survives. The wall is punctuated by seven *exedrae* (niches)—rectangular alternating with semicircular—that originally held statues of gods. This simple repetition of square against circle is found throughout the building. The square, boxlike coffers inside the dome, which help lighten the weight of the masonry, may once have contained gilded bronze rosettes or stars suggesting the heavens. In 609 CE, Pope Boniface IV dedicated the Pantheon as the Christian church of Saint Mary of the Martyrs, thus ensuring its survival through the Middle ages.

HADRIAN'S VILLA AT TIVOLI. To imagine Roman life at its most luxurious, one must go to Tivoli, a little more than 20 miles from Rome. Hadrian's Villa was not a single building but an architectural complex of many buildings, lakes, and gardens spread over half a square mile. Each section had its own inner logic, and each took advantage of natural land formations and attractive views. Hadrian instructed his architects to re-create his favorite places throughout the empire. In his splendid villa, he could pretend to enjoy the Athenian Grove of Academe, the Painted Stoa from the Athenian Agora, and buildings of the Ptolemaic capital of Alexandria, Egypt.

Landscapes with pools, fountains, and gardens turned the villa into a place of sensuous delight. An area with a long reflecting pool, called the **CANOPUS** after a site near Alexandria, was framed by a colonnade with alternating semicircular and straight entablatures (FIG. 6–56). It led to an outdoor dining room with concrete couches facing the pool. Copies of famous Greek statues, and sometimes even the originals, filled the spaces between the columns. So great was Hadrian's

love of Greek sculpture that he even had the caryatids of the Erechtheion (SEE FIG. 5–40) replicated for his pleasure palace.

The individual buildings were not large, but they were extremely complex. Roman builders and engineers exploited to the fullest the flexibility offered by concrete and vaulted construction. Walls and floors had veneers of marble and travertine or exquisite mosaics and paintings.

ARCHITECTURE THROUGHOUT THE EMPIRE. Hadrian traveled widely, since the emperor's appearance in distant lands reinforced his authority there. Hadrian also seemed to be genuinely interested in people and places. The emperor did more than copy his favorite cities at his villa; he also added to them. In Athens, for example, he finished the Temple of the Olympian Zeus and dedicated it in 131/132 CE (SEE FIG. 5–59). He also built a library, a stoa, and an aqueduct for the Athenians, and according to Pausanias, placed a statue of himself inside the Parthenon.

At the other end of the empire he engaged in the construction of functional architecture. During a visit to Britain in 122 CE as part of a review of the western provinces, Hadrian ordered the building of a defensive wall (FIG. 6–57) across the northernmost boundary of the empire.

Hadrian's Wall was built of stone and turf by legionaries and garrisoned by as many as 24,000 auxiliaries from conquered territories. Forts, and fortified towers at mile intervals, were built along its 73-mile length. It was defended by natural sharp drop-offs in the terrain and by a ditch on the north side and a wide open space that allowed easy movement of the troops on the south. Seventeen large camps housed forces ready to respond to any trouble. The wall created a symbolic as well as a physical boundary between Roman territory and that of the "barbarian" Picts and Scots to the north.

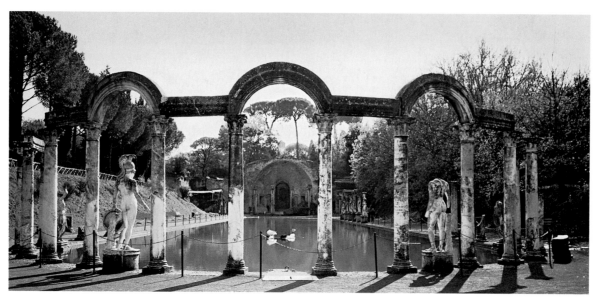

6–56 **CANOPUS, HADRIAN'S VILLA**
Tivoli. c. 130–35 CE.

6–57 **HADRIAN'S WALL**
Great Britain. 2nd century CE.
View from near Housesteads,
England.

Mosaics

Pictorial mosaics covered the floors of fine houses, villas, and public buildings throughout the empire. Working with very small *tesserae* (cubes of glass or stone) and a wide range of colors, mosaicists achieved remarkable effects (see "Roman Mosaics," page 215). The panels from a floor mosaic from Hadrian's Villa at Tivoli illustrate extraordinary artistry (FIG. 6–58). In a rocky landscape with only a few bits of greenery, a desperate male centaur raises a large boulder over his head to crush a tiger that has attacked and severely wounded a female centaur. Two other felines apparently took part in the attack—the white leopard on the rocks to the left

6–58 **BATTLE OF CENTAURS AND WILD BEASTS**
Hadrian's Villa, Tivoli. c. 118–28 CE. Mosaic, 23 × 36″ (58.4 × 91.4 cm).
Staatliche Museen zu Berlin, Preussischer Kulturbesitz, Antikensammlung, Berlin.

This floor mosaic may be a copy of a much-admired painting of a fight between centaurs and wild animals done by the late fifth-century BCE Greek artist Zeuxis.

THE OBJECT SPEAKS

THE UNSWEPT FLOOR

In his first-century CE work *Satyricon*, the comic genius and satirist Petronius created one of the all-time wild dinner parties. In *Trimalchio's Feast* (*Cena Trimalchionis*, Book 15), the newly rich Trimalchio entertains his friends at a lavish banquet. He shows off his extraordinary wealth, but also exposes his boorish ignorance and bad manners. Unlike the Greeks, whose banquets were private affairs, Romans such as Trimalchio used such occasions to display their possessions. When dishes are broken, Trimalchio orders his servants to sweep them away with the rubbish on the floor.

In *The Unswept Floor* mosaic, the remains of fine food from a party such as Trimalchio's—from lobster claws to cherry pits—seem to litter the floor. In the dining room where this segment was found, mosaics cover almost the entire floor.

Because Romans arranged their dining rooms with three-person couches on three sides of a square table, the family and guests would have seen these fictive remains of past gourmet pleasures under their couches. Such a festive Roman dinner might have had as many as seven courses, including a whole roasted pig (or ostrich, crane, or peacock), veal, and several kinds of fish; the final course may have been snails, nuts, shellfish, and fruit.

If art speaks to and of the ideals of a society, what does it mean that wealthy Romans commemorated their table scraps in mosaics of the greatest subtlety and skill? Is this a form of conspicuous consumption, proof that the owner of this house gave lavish banquets and hosted guests who had the kind of sophisticated humor that could appreciate satires like *Trimalchio's Feast*?

The Romans did in fact place a high value on displaying their wealth and taste in the semipublic rooms and gardens of their houses and villas, and they did so through their possessions, especially their art collections. *The Unswept Floor* is but one of a very large number of Roman copies of Greek mosaics and paintings, such as *Alexander the Great Confronts Darius III* (SEE FIG. 5–57).

In the case of *The Unswept Floor*, Herakleitos, a second-century CE Greek mosaicist living in Rome, made this copy of an original work by the renowned second-century BCE artist Sosos. Pliny the Elder, in his *Natural History*, mentions a mosaic of an unswept floor and another of doves that Sosos made in Pergamon. The guests reclining on their banquet couches could have displayed their knowledge of the notable precedents for the mosaic on the floor.

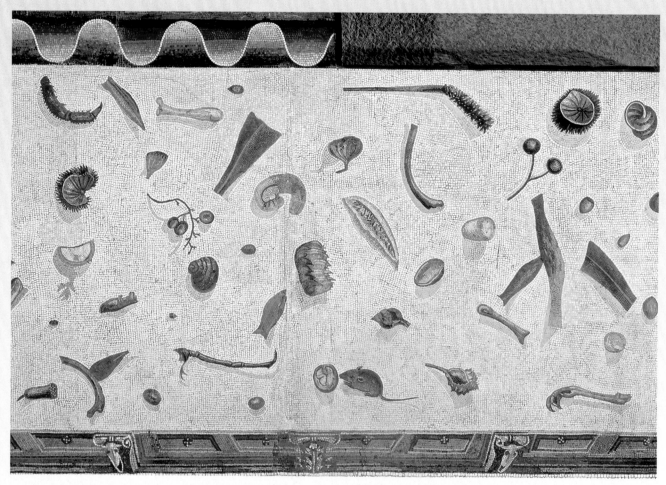

THE UNSWEPT FLOOR Mosaic variant of a 2nd-century BCE painting by Sosos of Pergamon. 2nd century CE. Signed by Herakleitos. Musei Vaticani, Museo Gregoriano Profano, Rome.

Technique
ROMAN MOSAICS

Mosaics were used widely in Hellenistic times and became enormously popular for decorating homes in the Roman period. **Mosaic** designs were created with pebbles (see Fig. 5-58), or with small, regularly shaped pieces of colored stone and marble, called **tesserae**. The stones were pressed into a kind of soft cement called *grout*. When the stones were firmly set, the spaces between them were also filled with grout. After the surface dried, it was cleaned and polished. At first, mosaics were used mainly as durable, water-resistant coverings on floors. They were done in a narrow range of colors depending on the natural color of the stone—often earth tones or black or some other dark color on a light background. When mosaics began to be used on walls (see Fig. 6–29), a wide range of colors—and sometimes colored glass—was employed. Some skilled mosaicists even copied well-known paintings. Employing a technique in which very small tesserae, in a wide range of colors, were laid down in irregular, curving lines, they effectively imitated painted brushstrokes.

Mosaic production was made more efficient by the use of **emblemata** (the plural of *emblema*, "central design"). These small, intricate mosaic compositions were created in the artist's workshop in square or rectangular trays. They could be made in advance, carried to a work site, and inserted into a floor decorated with an easily produced geometric pattern.

and the dead lion at the feet of the male centaur. The mosaicist rendered the figures with three-dimensional shading, foreshortening, and a great sensitivity to a range of figure types, including human torsos and powerful animals in a variety of poses.

Artists created these fine mosaic image panels, called **emblemata**, in their workshops. The emblemata were then set into a larger area already bordered by geometric patterns in mosaic. The mosaic floor in the reconstructed room in the Metropolitan Museum of Art in New York (SEE FIG. 6–33) shows a typical floor with a small image panel and many abstract designs in black and white. Image panels in floors usually reflected the purpose of the room. A dining room, for example, might have an Unswept Floor (see "The Unswept Floor," page 214), with table scraps re-created in meticulous detail, even to the shadows they cast, and a mouse foraging among them.

Sculpture

Hadrian also used monumental sculpture to publicize his accomplishments. Several large, circular reliefs, or **roundels** (originally part of a monument that no longer exists and now reused in the Arch of Constantine) contain images designed to affirm his imperial stature and right to rule (FIG. 6–59). In the

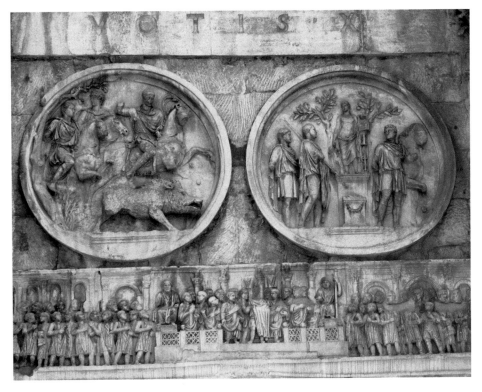

6–59 HADRIAN HUNTING BOAR AND SACRIFICING TO APOLLO
Roundels made for a monument to Hadrian and reused on the Arch of Constantine. Sculpture c. 130–38 CE. Marble, roundel diameter 40″ (102 cm). Horizontal panel by Constantinian sculptors 312–315 CE.

In the fourth century CE, Emperor Constantine had the roundels removed from a Hadrianic monument, had Hadrian's head recarved with his own or his father's features, and placed them on his own triumphal arch (SEE FIG. 6-74).

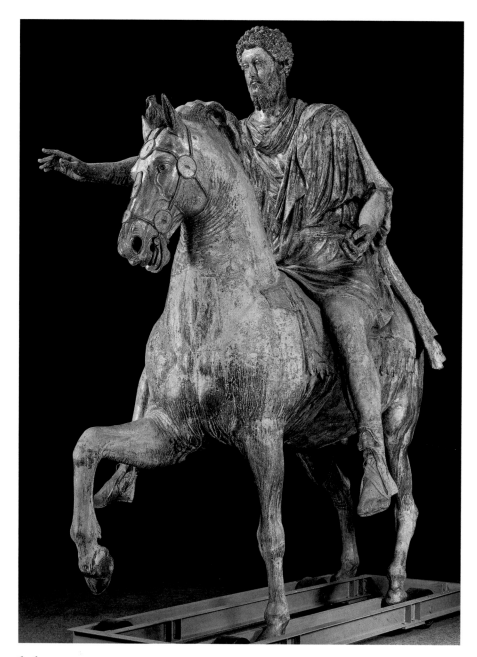

6–60 EQUESTRIAN STATUE OF MARCUS AURELIUS
c. 176 CE. Bronze, originally gilded, height of statue 11'6" (3.5 m).
Museo Capitolino, Rome.

Between 1187 and 1538, this statue stood in the piazza fronting the palace and church of Saint John Lateran in Rome. In January 1538, Pope Paul III had it moved to the Capitoline Hill. After being removed from its base for cleaning and restoration in recent times, it was taken inside the Capitoline Museum to protect it from air pollution, and a copy has replaced it in the piazza.

scene on the left, he demonstrates his courage and physical prowess in a boar hunt. Other roundels, not included here, show him confronting a bear and a lion. At the right, in a show of piety and appreciation to the gods for their support for his endeavors, Hadrian makes a sacrificial offering to Apollo at an outdoor altar.

Like the sculptors of the Column of Trajan, the sculptors of these roundels included elements of a natural landscape setting but kept them relatively small, using them to frame the proportionally larger figures. The idealized heads, form-enhancing drapery, and graceful yet energetic move-

ment of the figures owe a distant debt to the works of Praxiteles and Lysippos (Chapter 5). The well-observed details of the features and the bits of landscape are characteristically Roman. Much of the sculpture of the mid-second century CE shows the influence of Hadrian's love of Greek art, and for a time Roman artists achieved a level of idealized figural depiction close to that of Classical Greece.

Imperial Portraits

Imperial portraits contained an element of propaganda. Marcus Aurelius, like Hadrian, was a successful military commander

who was equally proud of his intellectual attainments. In a lucky error—or twist of fortune—a gilded bronze equestrian statue of the emperor (FIG. 6–60) came mistakenly to be revered as a statue of Constantine, known in the Middle Ages as the first Christian emperor, and consequently the sculpture escaped being melted down. The emperor is dressed as a military commander in a tunic and short, heavy cloak. The raised foreleg of his horse once trampled a crouching barbarian.

Marcus Aurelius's head, with its thick, curly hair and full beard (a style that was begun by Hadrian) resembles the traditional "philosopher" portraits of the Republican period. The emperor wears no armor and carries no weapons; like Egyptian kings, he conquers effortlessly by the will of the gods. And like his illustrious predecessor Augustus, he reaches out to the people in a persuasive, beneficent gesture. It is difficult to create an equestrian portrait in which the rider stands out as the dominant figure without making the horse look too small. The sculptor of this statue found a balance acceptable to viewers of the time and, in doing so, created a model for later artists.

Marcus Aurelius was succeeded as emperor by his son Commodus, a man without political skill, adminis-

trative competence, or intellectual distinction. The emperor Commodus was not just decadent—he was probably insane. During his unfortunate reign (180–92 CE), he devoted himself to luxury and frivolous pursuits. He claimed at various times to be the reincarnation of Hercules and the incarnation of the god Jupiter. When he proposed to assume the consulship dressed and armed as a gladiator, his associates, including his mistress, arranged to have him strangled in his bath by a wrestling partner. Commodus did, however, attract some of the finest artists of the day for his commissions. A marble bust of the emperor posing as Hercules reflects his character (FIG. 6–61). In this portrait, the emperor is shown adorned with references to the hero's legendary labors: Hercules's club, the skin and head of the Nemean Lion, and the golden apples from the garden of the Hesperides.

The sculptor's sensitive modeling and expert drillwork exploit the play of light and shadow on the figure and bring out the textures of the hair, beard, facial features, and drapery. The portrait conveys the illusion of life and movement, but it

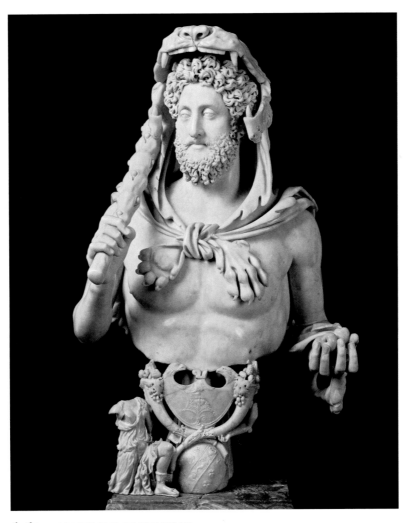

6–61 **COMMODUS AS HERCULES**
Esquiline Hill, Rome. c. 191–92 CE. Marble, height 46½" (118 cm).
Palazzo dei Conservatori, Rome.

also captures its subject's weakness. The foolishness of the man comes through in his pretentious assumption of the attributes of Hercules.

THE LATE EMPIRE, THIRD AND FOURTH CENTURIES

The comfortable life suggested by the wall paintings in Roman villas was, within a century, to be challenged by hard times. The reign of Commodus marked the beginning of a period of political and economic decline. Barbarian groups had already begun moving into the empire in the time of Marcus Aurelius. Now they pressed on Rome's frontiers. Many crossed the borders and settled within them, disrupting provincial governments. As perceived threats spread throughout the empire, imperial rule became increasingly authoritarian. Eventually the army controlled the government, and the Imperial Guards set up and deposed rulers almost at will, often selecting candidates from among poorly educated, power-hungry provincial leaders in their own ranks.

The Severan Dynasty

Despite the pressures of political and economic change, at least the arts continued to flourish under the Severan emperors (193–235 CE) who succeeded Commodus. Septimius Severus (ruled 193–211 CE), who was born in Africa, and his Syrian wife, Julia Domna, restored public buildings, commissioned official portraits, and made some splendid additions to the old Republican Forum, including the transformation of the House of the Vestal Virgins, who served the Temple of Vesta, goddess of hearth and home, into a large, luxurious residence. Their sons, Geta and Caracalla, succeeded Septimus Severus as co-emperors in 211 CE. In 212 CE, Caracalla murdered Geta, and then ruled alone until he in turn was murdered in 217 CE.

THE FAMILY OF SEPTIMIUS SEVERUS. A portrait of the family of Septimius Severus provides insight into both the history of the Severan dynasty and early third-century CE painting (FIG. 6–62). The work is in the highly formal style of the Fayum region in northwestern Egypt (SEE FIG. 3–36), and it may be a souvenir of an imperial visit to Egypt. The emperor, clearly identified by his distinctive divided beard and curled moustache, wears an enormous crown. Next to him is the empress Julia Domna, portrayed with similarly recognizable features—full face, large nose, and masses of waving hair. Their two sons, Geta (whose face has been scratched out) and Caracalla, stand in front of them. Perhaps because we know that he grew up to be a ruthless dictator, little Caracalla looks like a disagreeable child.

After murdering his brother, perhaps with Julia Domna's help, Caracalla issued a decree to abolish every reference to Geta. Clearly the owners of this painting complied. The work emphasized the trappings of imperial wealth and power—crowns, jewels, and direct, forceful expressions—rather than

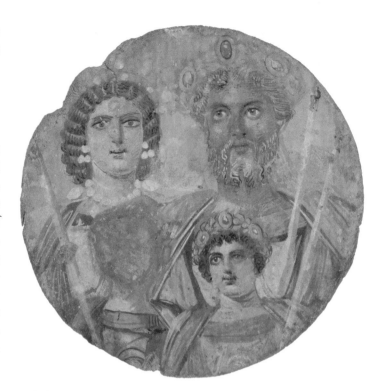

6–62 **SEPTIMIUS SEVERUS, JULIA DOMNA, AND THEIR CHILDREN, GETA AND CARACALLA**
Fayum, Egypt. c. 200 CE. Painted wood, diameter 14″ (35.6 cm). The face of Geta has been obliterated. Staatliche Museen zu Berlin, Preussischer Kulturbesitz, Antikensammlung.

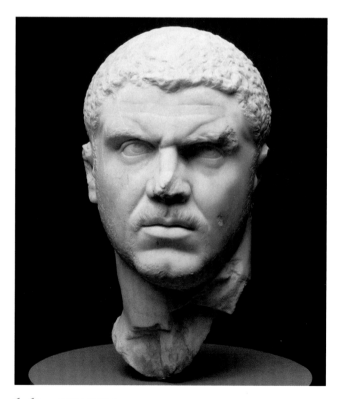

6–63 **CARACALLA**
Early 3rd century CE. Marble, height 14½″ (36.2 cm). The Metropolitan Museum of Art, New York.
Samuel D. Lee Fund, 1940 (40.11.1A)

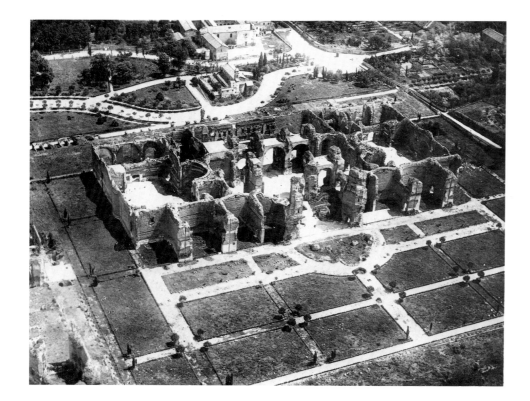

6–64 **BATHS OF CARACALLA**
Rome. c. 211–17 CE.

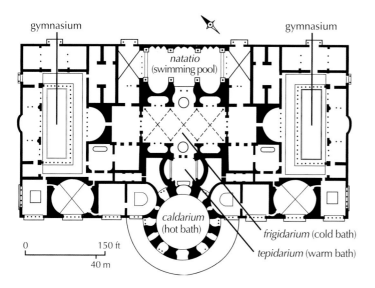

gymnasium gymnasium

natatio
(swimming pool)

caldarium
(hot bath)

frigidarium (cold bath)

tepidarium (warm bath)

0 150 ft

40 m

6–65 **PLAN OF THE BATHS OF CARACALLA**

attempting any psychological study. The rather hard drawing style, with its broadly brushed-in colors, contrasts markedly with the subtlety of earlier portraits, such as the *Young Woman Writing* (SEE FIG. 6–37).

Emperor Caracalla emerges from his adult portraits as a man of chilling and calculating ruthlessness. In the example shown here (FIG. 6–63), the sculptor has enhanced the intensity of the emperor's expression by producing strong contrasts of light and dark with careful chiseling and drillwork. Even the marble eyes have been drilled and engraved to catch the light in a way that makes them glitter. The contrast between this style and that of the portraits of Augustus is a telling

reflection of the changing character of imperial rule. Augustus presented himself as the first among equals: Caracalla revealed himself as a no-nonsense ruler of iron-fisted determination.

THE BATHS OF CARACALLA. The year before his death in 211 CE, Septimius Severus had begun a popular public works project: the construction of magnificent new public baths on the southeast side of Rome. Caracalla completed and inaugurated the baths in 216–17 CE, and they are known by his name. For the Romans, baths were recreational and educational centers in which the brick and concrete structure was hidden under a sheath of colorful marble and mosaic. Even in ruins the great halls soar over the heads of the visitors. The builders covered the space with groin and barrel vaults, which allow the maximum space with the fewest possible supports. (In the early years of the twentieth century, the halls provided architects with the models for major train stations in American cities.) The groin vaults also made possible large windows in every bay. Windows were important, since the baths depended on natural light and could only be open during daylight hours.

The **BATHS OF CARACALLA** (FIG. 6–64) were laid out on a strictly symmetrical plan. The bathing facilities were grouped in the center of the main building to make efficient use of the below-ground furnaces that heated them and to allow bathers to move comfortably from hot to cold pools and then finish with a swim (FIG. 6–65). Many other facilities—exercise rooms, shops, latrines, and dressing rooms—were housed on each side of the bathing block. The bath buildings alone covered five acres. The entire complex, which included gardens, a stadium, libraries, a painting gallery, auditoriums, and huge water reservoirs, covered an area of 50 acres.

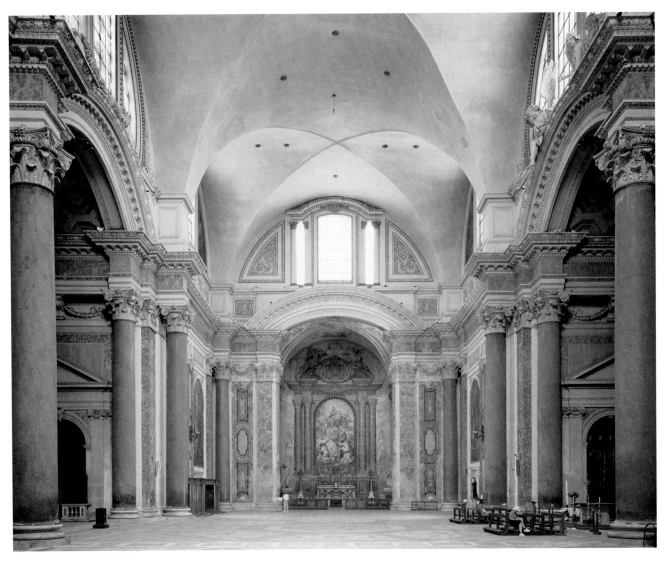

6–66 CHURCH OF SANTA MARIA DEGLI ANGELI (BATHS OF DIOCLETIAN, c. 298–306)
Converted into a church by Michelangelo in 1563.

The luxury of these imperial establishments can still be seen in the **CHURCH OF SANTA MARIA DEGLI ANGELI** in Rome **(FIG. 6–66)**, where Michelangelo converted the *frigidarium* of the Baths of Diocletian into a church, thus preserving it. Marble veneers and huge Corinthian columns and pilasters disguise the structural concrete of the building, although the vaults have lost their decoration.

The Third Century: The Soldier Emperors

The successors of the Severan emperors—the more than two dozen so-called soldier-emperors who attempted to rule the empire for the next seventy years—continued to favor the style of Caracalla's portraits. The sculptor of a bust of **PHILIP THE ARAB** (ruled 244–49 CE), for example, only modeled the broad structure of the emperor's head, then used both chisel and drill to deepen shadows and heighten the effects of light in the furrows of the face and the stiff folds of the drapery

(FIG. 6–67). Tiny flicks of the chisel suggest the texture of hair and beard. The overall impact of the work depends on the effects of light and the imagination of the spectator as much as on the carved stone itself.

This portrait does not convey the same malevolent energy as Caracalla's portraits. Philip seems tense and worried, suggesting that this is the portrait of a troubled man in troubled times. What comes through from Philip's twisted brow, sidelong upward glance, quizzical lips, and tightened jaw muscles is a sense of guile, deceit, and fear. Philip had been the head of the Imperial Guard, but he murdered his predecessor and was murdered himself after only five years.

ENGRAVED GOLD-GLASS. During the turmoil of the third century CE, Roman artists emphasized the symbolic or general qualities of their subjects and expressed them in increasingly simplified, geometric forms. Despite this trend toward

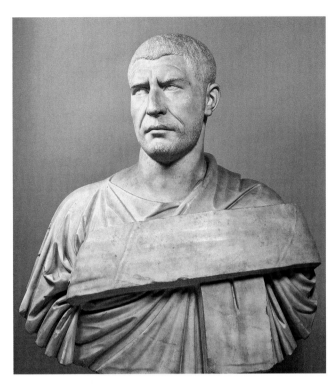

6-67 PHILIP THE ARAB
Ruled 244-49 CE. Marble, height 26″ (71.1 cm).
Musei Vaticani, Braccio Nuovo, Rome.

abstraction, the earlier tradition of slightly idealized but realistic portraiture was slow to die out, probably because it showed patrons as they wanted to be remembered. In the engraved gold-glass image of a woman with her son and daughter, the so-called **FAMILY OF VUNNERIUS KERAMUS** (**FIG. 6-68**), the subjects are rendered as individuals, although the artist has emphasized their great almond-shaped eyes. The work seems to reflect the advice of Philostratus who, writing in the late third century CE, commented:

> The person who would properly master this art [of painting] must also be a keen observer of human nature and must be capable of discerning the signs of people's characters even though they are silent; he should be able to discern what is revealed in the expression of the eyes, what is found in the character of the brows, and, to state the point briefly, whatever indicates the condition of the mind. (Quoted in Pollitt, pages 224-25)

The Family Group portrait was engraved and stippled on a sheet of gold leaf sealed between two layers of glass. This fragile, delicate medium, often used for the bottoms of glass bowls or cups, seems appropriate for an age of material insecurity and emotional intensity. The portrait was inserted by a later Christian owner as the central jewel in a Lombard cross (SEE FIG. 14-3).

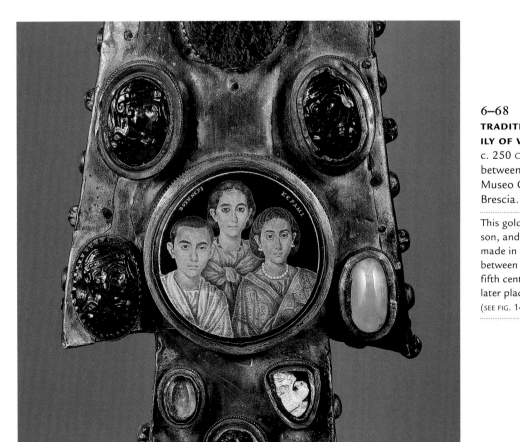

6-68 FAMILY GROUP, TRADITIONALLY CALLED THE FAMILY OF VUNNERIUS KERAMUS
c. 250 CE. Engraved gold leaf sealed between glass, diameter 2⅜″ (6 cm). Museo Civico dell'Età Cristiana, Brescia.

This gold-glass medallion of a mother, son, and daughter could have been made in Alexandria, Egypt, at any time between the early third and the mid-fifth centuries CE. The medallion was later placed in a Lombard cross (SEE FIG. 14-3).

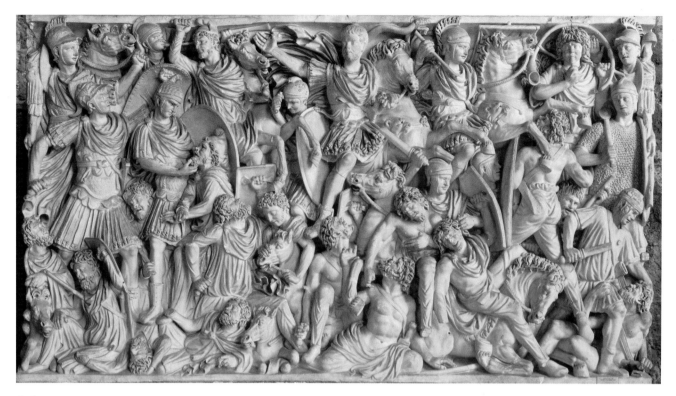

6–69 **BATTLE BETWEEN THE ROMANS AND THE BARBARIANS, DETAIL OF THE LUDOVISI BATTLE SARCOPHAGUS**
Found near Rome. c. 250 CE. Marble, height approx. 5′ (1.52 m). Museo Nazionale Romano, Rome.

FUNERARY SCULPTURE. Although portraits and narrative reliefs were the major forms of public sculpture during the second and third centuries CE, a shift from cremation to burial led to a growing demand for funerary sculpture. Wealthy Romans commissioned elegant marble sarcophagi. Workshops throughout the empire produced thousands of them, carved with reliefs that ranged in complexity from simple geometric or floral ornaments to scenes involving large numbers of figures.

A figured sarcophagus known as the **LUDOVISI BATTLE SARCOPHAGUS** (after a seventeenth-century owner) dates to about 250 CE (**FIG. 6–69**) and depicts Romans triumphing over barbarians. The imagery and style has roots in the sculptural traditions of Hellenistic Pergamon (Chapter 5). In contrast to the carefully crafted illusion of earlier Roman reliefs like the Arch of Titus, where figures move in and through naturalistic surroundings, the artist of the Ludovisi squeezed his figures into the allotted space with no attempt to create a realistic environment. The Romans, packed together in orderly rows at the top of the panel, efficiently dispatch the barbarians—clearly identifiable by their heavy, twisted locks of hair and scraggly beards—who fall, dying, or beaten into an unorganized heap at the bottom. The bareheaded young Roman commander with his gesture of victory, who occupies the center top of the composition, recalls the *Equestrian Statue of Marcus Aurelius* (SEE FIG. 6–60).

The Tetrarchy

The half century of anarchy, power struggles, and inept rule by the soldier-emperors that had begun with the death of Alexander Severus (ruled 222–235 CE), the last in the Severan line, ended with the rise to power of Diocletian (ruled 284–305 CE). This brilliant politician and general reversed the empire's declining fortunes, but he also began an increasingly autocratic form of rule, and the social structure of the empire became increasingly rigid.

To divide up the task of defending and administering the empire and to assure an orderly succession, in 286 CE Diocletian divided the empire in two parts. According to his plan, with the title of "Augustus" he would rule in the East, while another Augustus, Maximian, would rule in the West. Then, in 293 CE, he devised a form of government called a **tetrarchy**, or "rule of four," in which each Augustus designated a subordinate and heir, who held the title of "Caesar."

PORTRAIT OF THE TETRARCHS. Sculpture depicting the tetrarchs, about 300 CE, documents a turn in art toward abstraction and symbolic representation (**FIG. 6–70**). The four figures—two with beards, probably the senior Augusti, and two clean-shaven, probably the Caesars—are nearly identical. Dressed in military garb and clasping swords at their sides, they embrace each other in a show of imperial unity, proclaiming a kind of peace through concerted strength and

vigilance. As a piece of propaganda and a summary of the state of affairs at the time, it is unsurpassed.

The sculpture is made of porphyry, a purple stone from Egypt reserved for imperial use. The hardness of the stone, which makes it difficult to carve, may have contributed to the extremely abstract style of the work. The most striking features of **THE TETRARCHS**—the simplification of natural forms to geometric shapes, the disregard for normal human proportions, and the emphasis on a message or idea—appear often in Roman art by the end of the third century. The sculpture may have been made in Egypt and moved to Constantinople after 330 CE. Christian Crusaders who looted Constantinople in 1204 CE took the statue to Venice and placed it on the Cathedral of Saint Mark, where it can still be seen.

THE BASILICA AT TRIER. The tetrarchs had ruled the empire from administrative headquarters in Milan, Italy; Trier, Germany; Thessaloniki, in Greece; and Nicomedia, in present-day Turkey. These four capital cities all had imposing buildings. In Trier, for example, Constantius Chlorus (Augustus, 293–306 CE) and his son Constantine fortified the city with walls and a monumental gate which still stand. They built public amenities, such as baths, and a palace with a huge audience hall, later used as a Christian church (**FIGS. 6–71, 6–72**). This early fourth-century CE basilica's large size and simple plan and structure exemplify the architecture of the tetrarchs: imposing buildings that would impress their subjects.

The audience hall is a large rectangular building, 190 by 95 feet (200 by 100 Roman feet), with a strong directional focus given by a single apse opposite the door. Brick walls, originally stuccoed on the outside and covered with marble veneer inside, are pierced by two rows of arched windows. The flat roof, nearly 100 feet above the floor, covers both the nave and the apse. In a

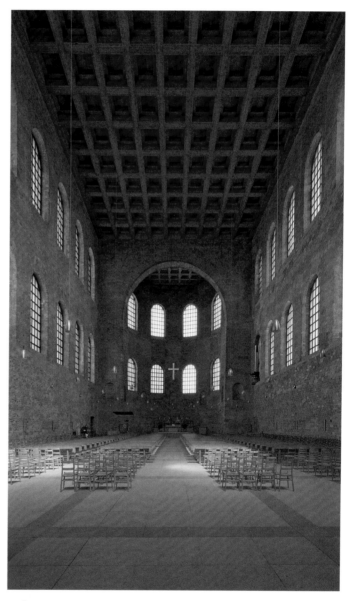

6–70 THE TETRARCHS
c. 300 CE. Porphyry, height of figures 51″ (129 cm). Brought from Constantinople in 1204, installed at the corner of the façade of the Cathedral of Saint Mark, Venice.

6–71 AUDIENCE HALL OF CONSTANTINE CHLORUS (NOW KNOWN AS THE BASILICA)
Interior. Trier, Germany. Early 4th century. View of the nave. Height of room 100′ (30.5 m).

Only the left wall and apse survive from the original Roman building. The hall became part of the bishop's palace during the medieval period.

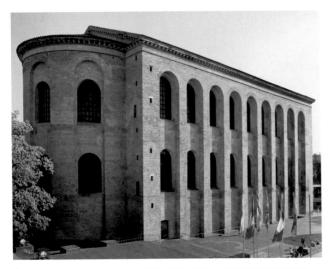

6–72 AUDIENCE HALL (NOW KNOWN AS THE BASILICA)
Exterior. Trier, Germany. Early 4th century.

concession to the northern climate, the building was centrally heated with hot air flowing under the floor (a technique used in Roman baths). The windows of the apse create an interesting optical effect. Slightly smaller and set higher than the windows in the hall, they create the illusion of greater distance, so that the tetrarch enthroned in the apse would appear larger than life.

Constantine the Great and His Legacy

In 305 CE, Diocletian abdicated and forced his fellow Augustus, Maximian, to do so too. The orderly succession he had hoped for failed to occur, and a struggle for position and advantage followed almost immediately. Two main contenders emerged in the western empire: Maximian's son Maxentius and Constantine I, son of Tetrarch Constantius Chlorus. Constantine was victorious in 312, defeating Maxentius at the Battle of the Milvian Bridge at the entrance to Rome.

According to tradition, Constantine had a vision the night before the battle in which he saw a flaming cross in the sky and heard these words: "In this sign you shall conquer."

The next morning he ordered that his army's shields and standards be inscribed with the monogram XP (the Greek letters *chi* and *rho*, standing for *Christos*; see "Christian Symbols," page 238). The victorious Constantine then showed his gratitude by ending the persecution of Christians and recognizing Christianity as a lawful religion. (He may also have been influenced in that decision by his mother, Helen, a devout Christian—later canonized.) Whatever his motivation, in 313 CE, together with Licinius, who ruled the East, Constantine issued the Edict of Milan, a model of religious toleration.

The Edict granted freedom to all religious groups, not just Christians. Constantine, however, remained the Pontifex Maximus of Rome's state religion and also reaffirmed his devotion during his reign to the military's favorite god, Mithras, and to the Invincible Sun, Sol Invictus, a manifestation of Helios Apollo, the sun god. In 324 CE Constantine defeated Licinius, his last rival; he ruled as sole emperor until his death in 337. He made the port city of Byzantium the new Rome and renamed it Constantinople (present-day Istanbul, in Turkey). After Constantinople was dedicated in 330, Rome, which had already ceased to be the seat of government in the West, further declined in importance.

PORTRAITURE. Portraiture continued to be an important aspect of imperial propaganda. Constantine commissioned a colossal, 30-foot statue of himself for his new basilica (FIG. 6–73). To create the colossal figure, the sculptor used white marble for the head, chest, arms, and legs, and sheets of bronze for the drapery, all supported on a wooden frame. This statue became a permanent stand-in for the emperor, representing him whenever the conduct of business legally required his presence. The head combines features of traditional Roman portraiture with the abstract qualities evident in *The Tetrarchs* (SEE FIG. 6–70). The defining characteristics of Constantine's face—his heavy jaw, hooked nose, and jutting chin—have been incorporated into a rigid, symmetrical pattern in which other features, such as his eyes, eyebrows, and hair, have been simplified into repeated geometric arcs. The

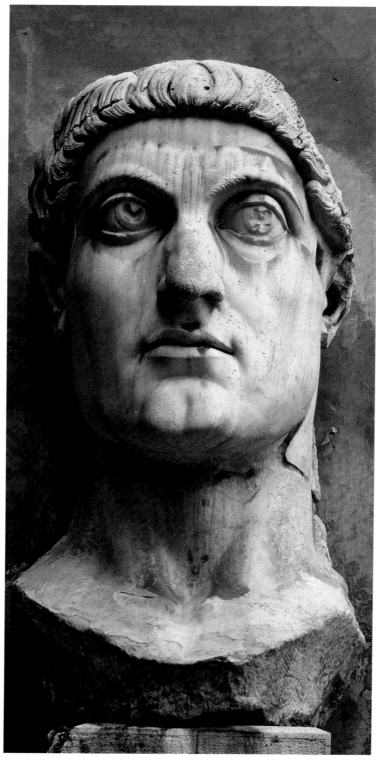

6–73 **CONSTANTINE THE GREAT**
Basilica of Maxentius and Constantine, Rome. 325–26 CE. Marble, height of head 8'6" (2.6 m). Palazzo dei Conservatori, Rome.

result is a work that projects imperial power and dignity with no hint of human frailty or imperfection. Similar portraits appear in relief sculpture on Constantine's triumphal arch.

THE ARCH OF CONSTANTINE. In Rome, next to the Colosseum, the Senate erected a memorial to Constantine's victory over Maxentius (FIG. 6–74), a huge, triple arch that dwarfs the

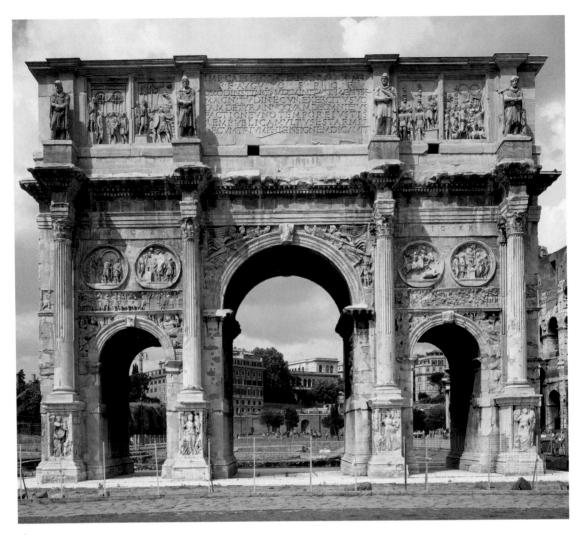

6–74 **ARCH OF CONSTANTINE**
Rome. 312–15 CE (dedicated July 25, 315).

This massive, triple-arched monument to Emperor Constantine's victory over Maxentius in 312 CE is a wonder of recycled sculpture. On the attic story, flanking the inscription over the central arch, are relief panels taken from a monument celebrating the victory of Marcus Aurelius over the Germans in 174 CE. On the attached piers framing these panels are large statues of prisoners made to celebrate Trajan's victory over the Dacians in the early second century CE. On the inner walls of the central arch (not seen here) are reliefs commemorating Trajan's conquest of Dacia. Over each of the side arches are pairs of large roundels taken from a monument to Hadrian (SEE FIG. 6-59). The rest of the decoration is 4th century, contemporary with the arch.

nearby Arch of Titus (SEE FIG. 6–38). Its three barrel-vaulted passageways are flanked by columns on high pedestals and surmounted by a large attic story with elaborate sculptural decoration and a traditional laudatory inscription: "To the Emperor Constantine from the Senate and the Roman People. Since through divine inspiration and great wisdom he has delivered the state from the tyrant and his party by his army and noble arms, [we] dedicate this arch, decorated with triumphal insignia." The "triumphal insignia" were in part looted from earlier monuments made for Constantine's illustrious predecessors, Trajan, Hadrian (SEE FIG. 6–59), and Marcus Aurelius. The reused items visually transferred the old Roman virtues of strength, courage, and piety associated with

these earlier "good" emperors to Constantine. New reliefs made for the arch recount the story of Constantine's victory and symbolize his power and generosity.

Although these new reliefs reflect the long-standing Roman affection for depicting important events with realistic detail, they nevertheless represent a significant change in style, approach, and subject matter. They are easily distinguished from the reused elements in the arch. The stocky, frontal, look-alike figures are compressed by the buildings of the forum into the foreground plane. The arrangement and appearance of the uniform participants below the enthroned Constantine clearly isolate the new emperor and connect him visually with his illustrious predecessors on each side.

This two-dimensional, hierarchical approach and abstract style are far removed from the realism of earlier imperial reliefs. This style, with its emphasis on authority, ritual, and symbolic meaning, was adopted by the emerging Christian Church. Constantinian art thus bridges the art of the Classical world and the art of the Middle Ages (approximately from 476 to 1453 CE).

THE BASILICA NOVA. Constantine's rival Maxentius, who controlled Rome throughout his short reign (ruled 306–12), ordered the repair of many buildings there and had others built. His most impressive undertaking was a huge new basilica, just southeast of the Imperial Forums, called the Basilica Nova, or New Basilica. Now known as the Basilica of Maxentius and Constantine, this was the last important imperial government building erected in Rome. Like all basilicas, it functioned as an administrative center and provided a magnificent setting for the emperor when he appeared as supreme judge.

Earlier basilicas, such as Trajan's Basilica Ulpia (SEE FIG. 6–48), had been columnar halls, but Maxentius ordered

his engineers to create the kind of large, unbroken, vaulted space found in public baths. Such solid masonry construction was less vulnerable to fire, an important consideration in troubled times. The central hall was covered with groin vaults, and the side aisles were covered with lower barrel vaults. These vaults acted as buttresses, or projecting supports, for the central vault and allowed generous window openings in the clerestory areas over the side walls.

Three of these brick-and-concrete barrel vaults still loom over the streets of present-day Rome (FIG. 6–75). The basilica originally measured 300 by 215 feet and the vaults of the central nave rose to a height of 114 feet. A groin-vaulted porch extended across the short side and sheltered a triple entrance to the central hall. At the opposite end of the long axis of the hall was an apse of the same width, which acted as a focal point for the building (FIGS. 6–76, 6–77). The directional focus along a central axis from entrance to apse was adopted by Christians for use in churches.

Constantine, seeking to impress the people of Rome with visible symbols of his authority, put his own stamp on projects Maxentius had started. He may have changed the orientation

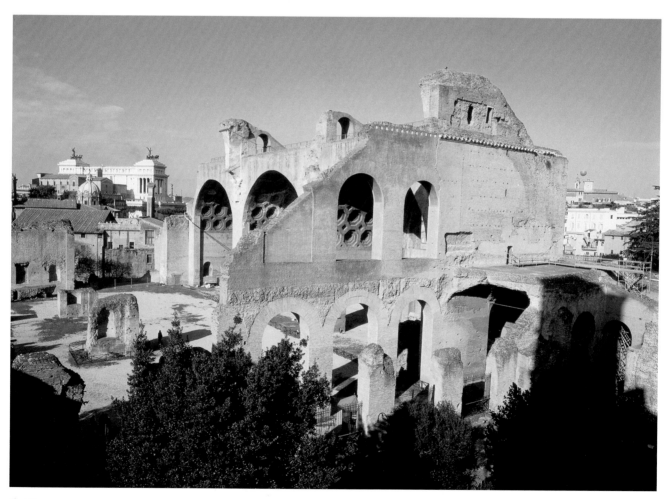

6–75 **BASILICA OF MAXENTIUS AND CONSTANTINE (BASILICA NOVA)**
Rome. 306–13 CE.

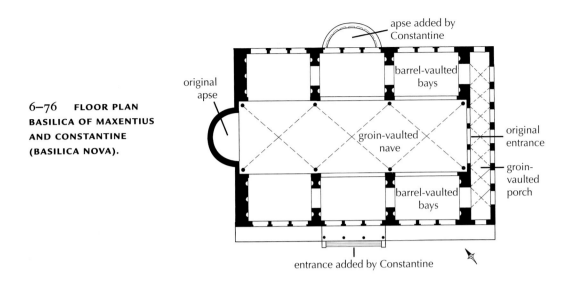

6–76 **FLOOR PLAN BASILICA OF MAXENTIUS AND CONSTANTINE (BASILICA NOVA).**

apse added by Constantine

original apse

barrel-vaulted bays

groin-vaulted nave

original entrance

groin-vaulted porch

barrel-vaulted bays

entrance added by Constantine

of the Basilica Nova by adding an imposing new entrance in the center of the long side facing the Via Sacra and a giant apse facing it across the three aisles. (A new theory suggests that the building was designed and built as a single project.)

ROMAN ART AFTER CONSTANTINE. Although Constantine was baptized only on his deathbed in 337, Christianity had become the official religion of the empire by the end of the fourth century CE, and non-Christians had become tar-

gets of persecution. Many people resisted this shift and tried to revive Classical culture. A large silver platter dating from the mid-fourth century CE shows how themes involving Bacchus continued to provide artists with the opportunity to create elaborate figural compositions displaying the nude or lightly draped human body in complex, dynamic poses (FIG. 6–78).

The Bacchic revelers whirl, leap, and sway in a dance to the piping of satyrs around a circular central medallion. In the

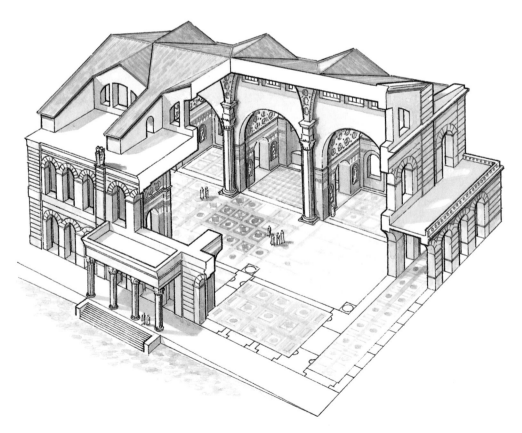

6–77 **RECONSTRUCTION OF THE BASILICA OF MAXENTIUS AND CONSTANTINE (BASILICA NOVA).**

6–78 DISH

From Mildenhall, England. Mid-4th century CE. Silver, diameter approx. 24″ (61 cm).
The British Museum, London.

centerpiece, the head of the sea god Oceanus is ringed by nude females frolicking in the waves with fantastic sea creatures. In the outer circle, Bacchus is the one stable element. With a bunch of grapes in his right hand, a krater at his feet, and one foot on the haunches of his panther, he listens to a male follower begging for another drink. Only a few figures away, the pitifully drunken hero Hercules has lost his lion-skin mantle and collapsed in a stupor into the supporting arms of two satyrs. The detail, clarity, and liveliness of this platter reflect the work of a skillful artist. Deeply engraved lines emphasize the contours of the subtly modeled bodies, echoing the technique of undercutting used to add depth to figures in stone and marble reliefs and suggesting a connection between silver working and relief sculpture. The platter was found in a cache of silver near Mildenhall, England. (Such opulent items were often hidden or buried to protect them from theft and looting, a sign of the breakdown of the long Roman peace.)

Among the champions of paganism were the Roman patricians Quintus Aurelius Symmachus and Virius Nicomachus Flavianus. A famous ivory **diptych**—a pair of panels attached with hinges—attests to the close relationship between their families, perhaps through marriage, as well as to their firmly held beliefs. One family's name is inscribed at the top of each panel. On the panel inscribed *Symmachorum* (FIG. 6–79), a stately, elegantly attired priestess burns incense at a beautifully decorated altar. On her head is a wreath of ivy, sacred to Bacchus. She is assisted by a small child, and the event takes place out of doors under an oak tree, sacred to Jupiter. The Roman ivory carvers of the fourth century were extremely skillful, and their wares were widely admired. For conservative patrons like the Nicomachus and Symmachus families, they imitated the Augustan style effortlessly. The exquisite rendering of the drapery and foliage recalls the reliefs of the Ara Pacis (SEE FIG. 6–21).

Classical subject matter remained attractive to artists and patrons, and imperial repression could not immediately extinguish it. Even such great Christian thinkers as the fourth-century CE bishop Gregory of Nazianzus (a saint and father of the Orthodox church) spoke out in support of the right of the people to appreciate and enjoy their classical heritage, so long as they were not seduced by it to return to

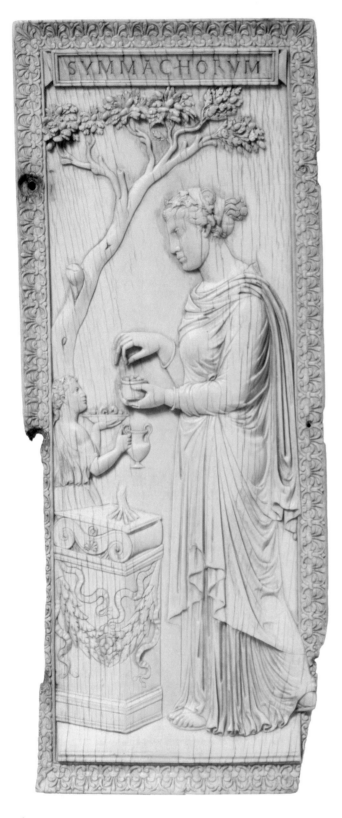

6–79 PRIESTESS OF BACCHUS (?)
Right panel of the diptych of Symmachus. c. 390–401 CE.
Ivory, 11¾ × 4¾″ (29.9 × 12 cm). Victoria & Albert Museum,
London.

pagan practices. As a result, stories of the ancient gods and heroes entered the secular realm as lively, visually delightful, and even erotic decorative elements.

The style and subject matter of the art reflect a society in transition, for even as Roman authority gave way to local rule by powerful "barbarian" tribes in much of the West, many people continued to appreciate classical learning and to treasure Greek and Roman art. In the East, classical traditions and styles endured to become an important element of Byzantine art.

IN PERSPECTIVE

The Romans, who supplanted the Etruscans and the Greeks, appreciated the earlier art of these peoples and adapted it to their own uses, but they also had their own strengths, such as efficiency and a practical genius for organization. As sophisticated visual propaganda, Roman art served the state and the empire. Creating both official images and representations of private individuals, Roman sculptors enriched and developed the art of portraiture. They also recorded contemporary historical events on commemorative arches, columns, and mausoleums.

Roman artists covered the walls of private homes with paintings, too. Sometimes fantastic urban panoramas surround a room, or painted columns and cornices, swinging garlands, and niches make a wall seem to dissolve. Some artists created the illusion of being on a porch or in a pavilion looking out into an extensive landscape. Such painted surfaces are often like backdrops for a theatrical set.

Roman architects relied heavily on the round arch and masonry vaulting. Beginning in the second century BCE, they also relied increasingly on a new building material: concrete. In contrast to stone, the components of concrete are cheap, light, and easily transported. Imposing and lasting concrete structures could be built by a large, semiskilled work force directed by one or two trained and experienced supervisors.

Drawing artistic inspiration from their Etruscan and Greek predecessors and combining this with their own traditions, Roman artists made a distinctive contribution to the history of art, creating works that formed an enduring ideal of excellence in the West. And as Roman authority gave way to local rule, the newly powerful "barbarian" tribes continued to appreciate and even treasure the Classical learning and art the Romans left behind.

SARCOPHAGUS FROM CERVETERI
C. 520 BCE

MIRROR
C. 400–350 BCE

PONT DU GARD
LATE 1ST CENTURY BCE

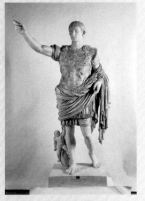

AUGUSTUS OF PRIMAPORTA
EARLY 1ST CENTURY CE

**FLAVIAN AMPHITHEATER
(COLOSSEUM)**
70–80 CE

ARCH OF CONSTANTINE
C. 312–15 CE

700 BCE

◄ **Etruscan Supremacy**
c. 700–509 BCE

◄ **Persian Empire**
c. 559–331 BCE

◄ **Roman Republic**
c. 509–27 BCE

500

◄ **Classical Greek Culture**
c. 450–323 BCE

300

100

◄ **Julius Caesar Assassinated**
44 BCE

◄ **Roman Empire** 27 BCE–395 CE

100 CE

◄ **Conquest of Dacia** 106 CE

300

◄ **Battle of Milvian Bridge** 312 CE

◄ **Costantinople Becomes Capital**
330 CE

◄ **Division of Empire** 395 CE

400

231

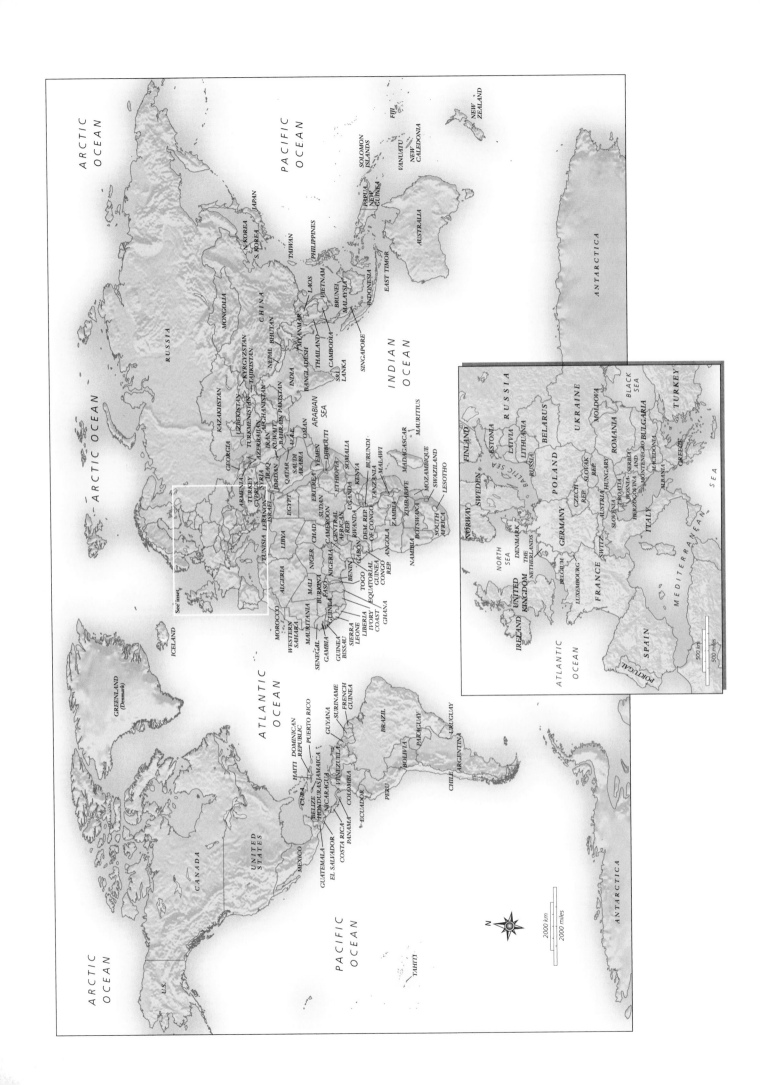

GLOSSARY

abacus The flat slab at the top of a **capital**, directly under the **entablature**.

absolute dating A method of assigning a precise historical date to periods and objects based on known and recorded events in the region as well as technically extracted physical evidence (such as carbon-14 disintegration). See also **radiometric dating, relative dating**.

abstract, abstraction Any art that does not represent observable aspects of nature or transforms visible forms into a stylized image. Also: the formal qualities of this process.

acropolis The **citadel** of an ancient Greek city, located at its highest point and housing temples, a treasury, and sometimes a royal palace. The most famous is the Acropolis in Athens.

acroterion (acroteria) An ornament at the corner or peak of a roof.

adobe Sun-baked blocks made of clay mixed with straw. Also: the buildings made with this material.

adyton The back room of a Greek temple. At Delphi, the place where the **oracles** were delivered. More generally, a very private space or room.

aedicula (aediculae) A decorative architectural frame, usually found around a niche, door, or window. An aedicula is made up of a **pediment** and **entablature** supported by **columns** or **pilasters**.

agora An open space in a Greek town used as a central gathering place or market. See also forum.

aisle Passage or open corridor of a church, hall, or other building that parallels the main space, usually on both sides, and is delineated by a row, or **arcade**, of **columns** or piers. Called side aisles when they flank the **nave** of a church.

album A book consisting of a series of painting or prints (album leaves) mounted into book form.

all'antica Meaning, "in the ancient manner."

allegory In a work of art, an image (or images) that symbolically illustrates an idea, concept, or principle, often moral or religious.

alloy A mixture of metals; different metals melted together.

amalaka In Hindu architecture, the circular or square-shaped element on top of a spire (*shikhara*), often crowned with a **finial**, symbolizing the cosmos.

ambulatory The passage (walkway) around the **apse** in a basilican church or around the **central space in a central-plan building**.

amphiprostyle Term describing a building, usually a temple, with **porticoes** at each end but without **columns** along the other two sides.

amphora An ancient Greek jar for storing oil or wine, with an egg-shaped body and two curved handles.

aniconic A symbolic representation without images of human figures, very often found in Islamic art.

animal interlace Decoration made of interwoven animals or serpents, often found in Celtic and early medieval Northern European art.

ankh A looped cross signifying life, used by ancient Egyptians.

appropriation Term used to describe an artist's practice of borrowing from another source for a new work of art. While in previous centuries artists often copied one another's figures, motifs, or compositions, in modern times the sources for appropriation extend from material culture to works of art.

apse, apsidal A large semicircular or polygonal (and usually vaulted) niche protruding from the end wall of a building. In the Christian church, it contains the altar. Apsidal is an adjective describing the condition of having such a space.

arabesque A type of linear surface decoration based on foliage and **calligraphic** forms, usually characterized by flowing lines and swirling shapes.

arcade A series of **arches**, carried by **columns** or **piers** and supporting a common wall or lintel. In a blind arcade, the arches and supports are engaged (attached to the wall) and have a decorative function.

arch In architecture, a curved structural element that spans an open space. Built from wedge-shaped stone blocks called **voussoirs**, which, when placed together and held at the top by a trapezoidal **keystone**, form an effective space-spanning and weight-bearing unit. Requires buttresses at each side to contain the outward thrust caused by the weight of the structure. **Corbel** arch: arch or **vault** formed by **courses** of stones, each of which projects beyond the lower course until the space is enclosed; usually finished with a **capstone**. Horseshoe arch: an arch of more than a half-circle; typical of western Islamic architecture. Ogival arch: a pointed arch created by S curves. Relieving arch: an arch built into a heavy wall just above a post-and-lintel structure (such as a gate, door, or window) to help support the wall above by transferring the load to the side walls.

archaic smile The curved lips of an ancient Greek statue, usually interpreted as an attempt to animate the features.

architrave The bottom element in an **entablature**, beneath the **frieze** and the **cornice**.

art brut French for "raw art." Term introduced by Jean Dubuffet to denote the often vividly **expressionistic** art of children and the insane, which he considered uncontaminated by culture.

articulated Joined; divided into units; in architecture, divided into parts to make spatial organization intelligible.

ashlar A highly finished, precisely cut block of stone. When laid in even **courses**, ashlar masonry creates a uniform face with fine joints. Often used as a facing on the visible exterior of a building, especially as a veneer for the **façade**. Also called **dressed stone**.

assemblage Artwork created by gathering and manipulating two and/or three-dimensional found objects.

astragal A thin convex decorative **molding**, often found on classical **entablatures**, and usually decorated with a continuous row of beadlike circles.

atelier The studio or workshop of a master artist or craftsperson, often including junior associates and apprentices.

atmospheric perspective See **perspective**.

atrial cross The cross placed in the atrium of a church. In Colonial America, used to mark a gathering and teaching place.

atrium An unroofed interior courtyard or room in a Roman house, sometimes having a pool or garden, sometimes surrounded by columns. Also: the open courtyard in front of a Christian church; or an entrance area in modern architecture.

automatism A technique whereby the usual intellectual control of the artist over his or her brush or pencil is foregone. The artist's aim is to allow the subconscious to create the artwork without rational interference.

avant-garde Term derived from the French military word meaning "before the group," or "vanguard." Avant-garde denotes those artists or concepts of a strikingly new, experimental, or radical nature for the time.

axis mundi A concept of an "axis of the world," which marks sacred sites and denotes a link between the human and celestial realms. For example, in Buddhist art, the axis mundi can be marked by monumental freestanding decorative pillars.

baldachin A canopy (whether suspended from the ceiling, projecting from a wall, or supported by columns) placed over an honorific or sacred space such as a throne or church altar.

bargeboards Boards covering the rafters at the gable end of a building; bargeboards are often carved or painted.

barrel vault See **vault**.

bar tracery See **tracery**.

bas-de-page French: bottom of the page; a term used in manuscript studies to indicate pictures below the text, literally at the bottom of the page.

base Any support. Also: masonry supporting a statue or the **shaft** of a **column**.

basilica A large rectangular building. Often built with a **clerestory**, side **aisles** separated from the center **nave** by **colonnades**, and an **apse** at one or both ends. Roman centers for administration, later adapted to Christian church use. Constantine's architects added a transverse aisle at the end of the nave called a **transept**.

bay A unit of space defined by architectural elements such as **columns**, **piers**, and walls.

beehive tomb A **corbel-vaulted** tomb, conical in shape like a beehive, and covered by an earthen mound.

Benday dots In modern printing and typesetting, the individual dots that, together with many others, make up lettering and images. Often machine- or computer-generated, the dots are very small and closely spaced to give the effect of density and richness of tone.

bestiary A book describing characteristics, uses, and meaning illustrated by moralizing tales about real and imaginary animals, especially popular during the Middle Ages in western Europe.

bi A jade disk with a hole in the center.

biomorphic Adjective used to describe forms that resemble or suggest shapes found in nature.

black-figure A style or technique of ancient Greek pottery in which black figures are painted on a red clay ground. See also **red-figure**.

bodhisattva In Buddhism, a being who has attained enlightenment but chooses to remain in this world in order to help others advance spiritually. Also defined as a potential Buddha.

boss A decorative knoblike element. Bosses can be found in many places, such as at the intersection of a Gothic vault rib. Also buttonlike projections in decorations and metalwork.

bracket, bracketing An architectural element that projects from a wall to support a horizontal part of a building, such as beams or the eaves of a roof.

brandea An object, such as a linen strip, having contact with a relic and taking on the power of the relic.

buon fresco *See* **fresco**.

cairn A pile of stones or earth and stones that served both as a prehistoric burial site and as a marker of underground tombs.

calligraphy Handwriting as an art form.

calyx krater *See* **krater**.

came (cames) A lead strip used in the making of leaded or **stained-glass** windows. Cames have an indented vertical groove on the sides into which the separate pieces of glass are fitted to hold the design together.

cameo Gemstone, clay, glass, or shell having layers of color, carved in **low relief** to create an image and ground of different colors.

camera obscura An early cameralike device used in the Renaissance and later for recording images of nature. Made from a dark box (or room) with a hole in one side (sometimes fitted with a lens), the camera obscura operates when bright light shines through the hole, casting an upside-down image of an object outside onto the inside wall of the box.

canon of proportions A set of ideal mathematical ratios in art based on measurements of the human body.

capital The sculpted block that tops a **column**. According to the conventions of the orders, capitals include different decorative elements. See **order**. Also: a historiated capital is one displaying a narrative.

capriccio A painting or print of a fantastic, imaginary landscape, usually with architecture.

capstone The final, topmost stone in a **corbel arch** or vault, which joins the sides and completes the structure.

cartoon A full-scale drawing used to transfer the outline of a design onto a surface (such as a wall, canvas, panel, or tapestry) to be painted, carved, or woven.

cartouche A frame for a **hieroglyphic** inscription formed by a rope design surrounding an oval space. Used to signify a sacred or honored name. Also: in architecture, a decorative device or plaque, usually with a plain center used for inscriptions or epitaphs.

caryatid A sculpture of a draped female figure acting as a column supporting an **entablature**.

catacomb A subterranean burial ground consisting of tunnels on different levels, having niches for urns and **sarcophagi** and often incorporating rooms (cubiculae).

celadon A high-fired, transparent **glaze** of pale bluish-green hue whose principal coloring agent is an oxide of iron. In China and Korea, such glazes typically were applied over a pale gray **stoneware** body, though Chinese potters some-

times applied them over **porcelain** bodies during the Ming (1368-1644) and Qing (1644-1911) dynasties. Chinese potters invented celadon glazes and initiated the continuous production of celadon-glazed wares as early as the third century CE.

cella The principal interior room at the center of a Greek or Roman temple within which the cult statue was usually housed. Also called the **naos**.

cenotaph A funerary monument commemorating an individual or group buried elsewhere.

centering A temporary structure that supports a masonry **arch** and **vault** or **dome** during construction until the mortar is fully dried and the masonry is self-sustaining.

centrally planned building Any structure designed with a primary central space surrounded by symmetrical areas on each side. For example, **Greek-cross plan** (equal-armed cross).

ceramics A general term covering all types of wares made from fired clay, including **porcelain** and **terra cotta**.

chaitya A type of Buddhist temple found in India. Built in the form of a hall or **basilica**, a chaitya hall is highly decorated with sculpture and usually is carved from a cave or natural rock location. It houses a sacred shrine or stupa for worship.

chamfer The slanted surface produced when an angle is trimmed or beveled, common in building and metalwork.

chasing Ornamentation made on metal by incising or hammering the surface.

chattri (chattris) A decorative pavilion with an umbrella-shaped **dome** in Indian architecture.

chevron A decorative or heraldic motif of repeated Vs; a zigzag pattern.

chiaroscuro An Italian word designating the contrast of dark and light in a painting, drawing, or print. Chiaroscuro creates spatial depth and volumetric forms through gradations in the intensity of light and shadow.

chiton A thin sleeveless garment, fastened at waist and shoulders, worn by men and women in ancient Greece.

citadel A fortress or defended city, if possible placed in a high, commanding location.

clapboard Horizontal overlapping planks used as protective siding for buildings, particularly houses in North America.

clerestory The topmost zone of a wall with windows in a **basilica** extending above the **aisle** roofs. Provides direct light into the central interior space (the **nave**).

cloisonné An enamel technique in which metal wire or strips are affixed to the surface to form the design. The resulting areas (cloisons) are filled with enamel (colored glass).

cloister An open space, part of a monastery, surrounded by an **arcaded** or **colonnaded** walkway, often having a fountain and garden, and dedicated to nonliturgical activities and the secular life of the religious. Members of a cloistered order do not leave the monastery or interact with outsiders.

codex (codices) A book, or a group of **manuscript** pages (folios), held together by stitching or other binding on one side.

coffer A recessed decorative panel that is used to reduce the weight of and to decorate ceilings or **vaults**. The use of coffers is called coffering.

colonnade A row of **columns**, supporting a straight lintel (as in a **porch** or **portico**) or a series of arches (an **arcade**).

colophon The data placed at the end of a book listing the book's author, publisher, illuminator, and other information related to its production. Also, in East Asian handscrolls, the inscriptions which follow the painting are called colophons.

column An architectural element used for support and/or decoration. Consists of a rounded or polygonal vertical **shaft** placed on a **base** and topped by a decorative **capital**. In classical architecture, built in accordance with the rules of one of the architectural **orders**. Columns can be free-standing or attached to a background wall (**engaged**).

complementary color The primary and secondary colors across from each other on the color wheel (red and green, blue and orange, yellow and purple). When juxtaposed, the intensity of both colors increases. When mixed together, they negate each other to make a neutral gray-brown.

Composite order *See* **order**.

cong A square or octagonal jade tube with a cylindrical hole in the center. A symbol of the earth, it was used for ritual worship and astronomical observations in ancient China.

connoisseurship A term derived from the French word connoisseur, meaning "an expert," and signifying the study and evaluation of art based primarily on formal, visual, and stylistic analysis. A connoisseur studies the style and technique of an object to deduce its relative quality and possible maker. This is done through visual association with other, similar objects and styles. See also **contextualism**; **formalism**.

contextualism An interpretive approach in art history that focuses on the culture surrounding an art object. Unlike **connoisseurship**, contextualism utilizes the literature, history, economics, and social developments (among other things) of a period, as well as the object itself, to explain the meaning of an artwork. See *also* **connoisseurship**.

contrapposto An Italian term mearing "set against," used to describe the twisted pose resulting from parts of the body set in opposition to each other around a central axis.

corbel, corbeling An early roofing and **arching** technique in which each course of stone projects slightly beyond the previous layer (a corbel) until the uppermost corbels meet. Results in a high, almost pointed **arch** or **vault**. A corbel table is a ledge supported by corbels.

corbeled vault *See* **vault**.

Corinthian order *See* **order**.

cornice The uppermost section of a Classical **entablature**. More generally, a horizontally projecting element found at the top of a building wall or **pedestal**. A raking cornice is formed by the junction of two slanted cornices, most often found in **pediments**.

course A horizontal layer of stone used in building.

crenellation Alternating high and low sections of a wall, giving a notched appearance and creating permanent defensive shields in the walls of fortified buildings.

crockets A stylized leaf used as decoration along the outer angle of spins, pinnacles, gables, and around **capitals** in Gothic architecture.

cuneiform An early form of writing with wedge-shaped marks impressed into wet clay with a stylus, primarily used by ancient Mesopotamians.

curtain wall A wall in a building that does not support any of the weight of the structure. Also: the freestanding outer wall of a castle, usually encircling the inner bailey (yard) and keep (primary defensive tower).

cyclopean construction or **masonry** A method of building using huge blocks of rough-hewn stone. Any large-scale, monumental building project that impresses by sheer size. Named after the Cyclopes (sing. Cyclops) one-eyed giants of legendary strength in Greek myths.

cylinder seal A small cylindrical stone decorated with incised patterns. When rolled across soft clay or wax, the resulting raised pattern or design (**relief**) served in Mesopotamian and Indus Valley cultures as an identifying signature.

dado (dadoes) The lower part of a wall, differentiated in some way (by a **molding** or different coloring or paneling) from the upper section.

daguerreotype An early photographic process that makes a positive print on a light-sensitized copperplate; invented and marketed in 1839 by Louis-Jacques-Mandé Daguerre.

demotic writing The simplified form of ancient Egyptian hieratic writing, used primarily for administrative and private texts.

dharmachakra Sanskrit for "wheel" (*chakra*) and "law" or "doctrine" (*dharma*); often used in Buddhist iconography to signify the "wheel of the law."

diptych Two panels of equal size (usually decorated with paintings or reliefs) hinged together.

dogu Small human figurines made in Japan during the Jomon period. Shaped from clay, the figures have exaggerated expressions and are in contorted poses. They were probably used in religious rituals.

dolmen A prehistoric structure made up of two or more large upright stones supporting a large, flat, horizontal slab or slabs.

dome A round **vault**, usually over a circular space. Consists of a curved masonry vault of shapes and cross sections that can vary from hemispherical to bulbous to ovoidal. May use a supporting vertical wall (**drum**), from which the vault springs, and may be crowned by an open space (**oculus**) and/or an exterior **lantern**. When a dome is built over a square space, an intermediate element is required to make the transition to a circular drum. There are two types: A dome on **pendentives** (spherical triangles) incorporates **arched**, sloping intermediate sections of wall that carry the weight and thrust of the dome to heavily buttressed supporting **piers**. A dome on **squinches** uses an arch built into the wall (squinch) in the upper corners of the space to carry the weight of the dome across the corners of the square space below. A half-dome or conch may cover a semicircular space.

domino construction System of building construction introduced by the architect Le Corbusier in which reinforced concrete floor slabs are floated on six freestanding posts placed as if at the positions of the six dots on a domino playing piece.

Doric order See **order**.

dressed stone See **ashlar**.

drum The wall that supports a **dome**. Also: a segment of the circular **shaft** of a **column**.

drypoint An **intaglio** printmaking process by which a metal (usually copper) plate is directly inscribed with a pointed instrument (**stylus**). The resulting design of scratched lines is inked, wiped, and printed. Also: the print made by this process.

earthenware A low-fired, opaque **ceramic** ware that is fired in the range of 800 to 900 degrees Celsius. Earthenware employs humble clays that are naturally heat resistant; the finished wares remain porous after firing unless **glazed**. Earthenware occurs in a range of earth-toned colors, from white and tan to gray and black, with tan predominating.

echinus A cushionlike circular element found below the **abacus** of a Doric **capital**. Also: a similarly shaped **molding** (usually with egg-and-dart motifs) underneath the **volutes** of an Ionic **capital**.

electron spin resonance techniques Method that uses magnetic field and microwave irradiation to date material such as tooth enamel and its surrounding soil.

emblema (emblemata) In a mosaic, the elaborate central motif on a floor, usually a self-contained unit done in a more refined manner, with smaller **tesserae** of both marble and semiprecious stones.

encaustic A painting technique using pigments mixed with hot wax as a medium.

engaged column A **column** attached to a wall. See also column.

engraving An intaglio printmaking process of inscribing an image, design, or letters onto a metal or wood surface from which a print is made. An engraving is usually drawn with a sharp implement (burin) directly onto the surface of the plate. Also: the print made from this process.

entablature In the **Classical orders**, the horizontal elements above the **columns** and **capitals**. The entablature consists of, from bottom to top, an **architrave**, a **frieze**, and a **cornice**.

entasis A slight swelling of the **shaft** of a Greek column. The optical illusion of entasis makes the column appear from afar to be straight.

exedra (exedrae) In architecture, a semicircular niche. On a small scale, often used as decoration, whereas larger exedrae can form interior spaces (such as an **apse**).

expressionism, expressionistic Terms describing a work of art in which forms are created primarily to evoke subjective emotions rather than to portray objective reality.

façade The face or front wall of a building.

faience Type of **ceramic** covered with colorful, opaque glazes that form a smooth, impermeable surface. First developed in ancient Egypt.

fang ding A square or rectangular bronze vessel with four legs. The fang ding was used for ritual offerings in ancient China during the Shang dynasty.

fête galante A subject in painting depicting well-dressed people at leisure in a park or country setting. It is most often associated with eighteenth-century French Rococo painting.

filigree Delicate, lacelike ornamental work.

fillet The flat ridge between the carved out flutes of a **column shaft**. See also **fluting**.

finial A knoblike architectural decoration usually found at the top point of a spire, pinnacle, canopy, or gable. Also found on furniture; also the ornamental top of a staff.

fluting In architecture, evenly spaced, rounded parallel vertical grooves **incised** on **shafts** of **columns** or columnar elements (such as **pilasters**).

foreshortening The illusion created on a flat surface in which figures and objects appear to recede or project sharply into space. Accomplished according to the rules of **perspective**.

formal analysis See **formalism**.

formalism, formalist An approach to the understanding, appreciation, and valuation of art based almost solely on considerations of form. This approach tends to regard an artwork as independent of its time and place of making. See also **connoisseurship**.

four-iwan mosque See **iwan** and **mosque**.

fresco A painting technique in which waterbased pigments are applied to a surface of wet plaster (called **buon fresco**). The color is absorbed by the plaster, becoming a permanent part of the wall. **Fresco secco** is created by painting on dried plaster, and the color may flake off. Murals made by both these techniques are called frescoes.

fresco secco See **fresco**.

frieze The middle element of an **entablature**, between the **architrave** and the **cornice**. Usually decorated with sculpture, painting, or **moldings**. Also: any continuous flat band with **relief sculpture** or painted decorations.

frottage A design produced by laying a piece of paper over a textured surface and rubbing with charcoal or other soft medium.

fusuma Sliding doors covered with paper, used in traditional Japanese construction. Fusuma are often highly decorated with paintings and colored backgrounds.

galleria See **gallery**.

gallery In church architecture, the story found above the side **aisles** of a church, usually open to and overlooking the nave. Also: in secular architecture, a long room, usually above the ground floor in a private house or a public building used for entertaining, exhibiting pictures, or promenading. *Also*: a building or hall in which art is displayed or sold. Also: *galleria*.

garbhagriha From the Sanskrit word meaning "womb chamber," a small room or shrine in a Hindu temple containing a holy image.

genre A type or category of artistic form, subject, technique, style, or medium. See also genre painting.

gesso A ground made from glue, gypsum, and/or chalk forming the ground of a wood panel or the priming layer of a canvas. Provides a smooth surface for painting.

gilding The application of paper-thin **gold leaf** or gold pigment to an object made from another medium (for example, a sculpture or painting). Usually used as a decorative finishing detail.

giornata (giornate) Adopted from the Italian term meaning "a day's work," a giornata is the section of a **fresco** plastered and painted in a single day.

glaze See **glazing**.

glazing An outermost layer of vitreous liquid (**glaze**) that, upon firing, renders **ceramics** waterproof and forms a decorative surface. In painting, a technique particularly used with oil mediums in which a transparent layer of paint (**glaze**) is laid over another, usually lighter, painted or glazed area.

gloss A type of clay **slip** used in **ceramics** by ancient Greeks and Romans that, when fired, imparts a colorful sheen to the surface.

golf foil A thin sheet of gold.

gold leaf Paper-thin sheets of hammered gold that are used in **gilding**. In some cases (such as Byzantine **icons**), also used as a ground for paintings.

gopura The towering gateway to an Indian Hindu temple complex. A temple complex can have several different gopuras.

Grand Manner An elevated style of painting popular in the eighteenth century in which the artist looked to the ancients and to the Renaissance for inspiration; for portraits as well as history painting, the artist would adopt the poses, compositions, and attitudes of Renaissance and antique models.

Grand Tour Popular during the eighteenth and nineteenth centuries, an extended tour of cultural sites in southern Europe intended to finish the education of a young upper-class person from Britain or North America.

grattage A pattern created by scraping off layers of paint from a canvas laid over a textured surface. See also *frottage*.

Greek-cross plan See **centrally planned building**.

Greek-key pattern A continuous rectangular scroll often used as a decorative border. Also called a **meander pattern**.

grid A system of regularly spaced horizontally and vertically crossed lines that gives regularity to an architectural plan. Also: in painting, a grid enables designs to be enlarged or transferred easily.

grisaille A style of monochromatic painting in shades of gray. Also: a painting made in this style.

groin vault See **vault**.

guild An association of craftspeople. The medieval guild had great economic power, as it set standards and controlled the selling and marketing of its members' products, and as it provided economic protection, group solidarity, and training in the craft to its members.

hall church A church with a **nave** and **aisles** of the same height, giving the impression of a large, open hall.

handscroll A long, narrow, horizontal painting or text (or combination thereof) common in Chinese and Japanese art and of a size intended for individual use. A handscroll is stored wrapped tightly around a wooden pin and is unrolled for viewing or reading.

hanging scroll In Chinese and Japanese art, a vertical painting or text mounted within sections of silk. At the top is a semicircular rod; at the bottom is a round dowel. Hanging scrolls are kept rolled and tied except for special occasions, when they are hung for display, contemplation, or commemoration.

haniwa Pottery forms, including cylinders, buildings, and human figures, that were placed on top of Japanese tombs or burial mounds.

hemicycle A semicircular interior space or structure.

henge A circular area enclosed by stones or wood posts set up by Neolithic peoples. It is usually bounded by a ditch and raised embankment.

hieratic In painting and sculpture, a formalized style for representing rulers or sacred or priestly figures.

hieratic scale The use of different sizes for significant or holy figures and those of the everyday world to indicate importance. The larger the figure, the greater the importance.

high relief Relief sculpture in which the image projects strongly from the background. See also **relief sculpture**.

himation In ancient Greece, a long loose outer garment.

historicism The strong consciousness of and attention to the institutions, themes, styles, and forms of the past, made accessible by historical research, textual study, and archaeology.

history painting Paintings based on historical, mythological, or biblical narratives. Once considered the noblest form of art, history paintings generally convey a high moral or intellectual idea and are often painted in a grand pictorial style.

hollow-casting See **lost-wax casting**.

hypostyle hall A large interior room characterized by many closely spaced **columns** that support its roof.

icon An image in any material representing a sacred figure or event in the Byzantine, and later in the Orthodox, Church. Icons were venerated by the faithful, who believed them to have miraculous powers to transmit messages to God.

iconoclasm The banning or destruction of images, especially icons and religious art. Iconoclasm in eighth- and ninth-century Byzantium and sixteenth- and seventeenth-century Protestant territories arose from differing beliefs about the power, meaning, function, and purpose of imagery in religion.

iconographic See **iconography**.

iconography The study of the significance and interpretation of the subject matter of art.

iconostasis The partition screen in a Byzantine or Orthodox church between the **sanctuary** (where the Mass is performed) and the body of the church (where the congregation assembles). The iconostasis displays **icons**.

idealism *See* idealization.

idealization A process in art through which artists strive to make their forms and figures attain perfection, based on pervading cultural values and/or their own mental image of beauty.

ideograph A written character or symbol representing an idea or object. Many Chinese characters are ideographs.

ignudi Heroic figures of nude young men.

illumination A painting on paper or **parchment** used as illustration and/or decoration for **manuscripts** or **albums**. Usually done in rich colors, often supplemented by gold and other precious materials. The illustrators are referred to as illuminators. Also: the technique of decorating manuscripts with such paintings.

impasto Thick applications of pigment that give a painting a palpable surface texture.

impost, impost block A block, serving to concentrate the weight above, imposed between the **capital** of a **column** and the springing of an arch above.

in antis Term used to describe the position of columns set between two walls, as in a **portico** or a **cella**.

incising A technique in which a design or inscription is cut into a hard surface with a sharp instrument. Such a surface is said to be incised.

ink painting A monochromatic style of painting developed in China using black ink with gray **washes**.

inlay To set pieces of a material or materials into a surface to form a design. *Also:* material used in or decoration formed by this technique.

installation art Artworks created for a specific site, especially a gallery or outdoor area, that create a total environment.

intaglio Term used for a technique in which the design is carved out of the surface of an object, such as an engraved seal stone. In the graphic arts, intaglio includes **engraving**, etching, and **drypoint**—all processes in which ink transfers to paper from incised, ink-filled lines cut into a metal plate.

intarsia Decoration formed through wood **inlay**.

intuitive perspective See **perspective**.

Ionic order See **order**.

iwan A large, **vaulted** chamber in a **mosque** with a monumental arched opening on one side.

jamb In architecture, the vertical element found on both sides of an opening in a wall, and supporting an **arch** or lintel.

japonisme A style in French and American nineteenth-century art that was highly influenced by Japanese art, especially prints.

jasperware A fine-grained, unglazed, white **ceramic** developed by Josiah Wedgwood, often colored by metallic oxides with the raised designs ramaining white.

jataka **tales** In Buddhism, stories associated with the previous lives of Shakyamuni, the historical Buddha.

joined-wood sculpture A method of constructing large-scale wooden sculpture developed in Japan. The entire work is constructed from smaller hollow blocks, each individually carved, and assembled when complete. The joined-wood technique allowed the production of larger sculpture, as the multiple joints alleviate the problems of drying and cracking found with sculpture carved from a single block.

joggled voussoirs Interlocking voussoirs in an arch or lintel, often of contrasting materials for colorful effect.

kantharos A type of Greek vase or goblet with two large handles and a wide mouth.

key block A key block is the master block in the production of a colored **woodblock print**, which requires different blocks for each color. The key block is a flat piece of wood with the entire design carved or drawn on its surface. From this, other blocks with partial drawings are made for printing the areas of different colors.

keystone The topmost **voussoir** at the center of an **arch**, and the last block to be placed. The pressure of this block holds the arch together. Often of a larger size and/or decorated.

kiln An oven designed to produce enough heat for the baking, or firing, of clay.

kinetic art Artwork that contains parts that can be moved either by hand, air, or motor.

kondo The main hall inside a Japanese Buddhist temple where the images of Buddha are housed.

kore (korai) **An Archaic** Greek statue of a young woman.

kouros (kouroi) An Archaic Greek statue of a young man or boy.

krater An ancient Greek vessel for mixing wine and water, with many subtypes that each have a distinctive shape. **Calyx krater:** a bell-shaped vessel with handles near the base that resemble a flower calyx. Volute krater: a type of krater with handles shaped like scrolls.

kufic An ornamental, angular Arabic script.

kylix A shallow Greek vessel or cup, used for drinking, with a wide mouth and small handles near the rim.

lacquer A type of hard, glossy surface varnish used on objects in East Asian cultures, made from the sap of the Asian sumac or from shellac, a resinous secretion from the lac insect. Lacquer can be layered and manipulated or combined with pigments and other materials for various decorative effects.

lakshana Term used to designate the thirtytwo marks of the historical Buddha. The lakshana include, among others, the Buddha's golden body, his long arms, the wheel impressed on his palms and the soles of his feet, and his elongated earlobes.

lamassu Supernatural guardian-protector of ancient Near Eastern palaces and throne rooms, often represented sculpturally as a combination of the bearded head of a man, powerful body of a lion or bull, wings of an eagle, and the horned headdress of a god, and usually possessing five legs.

lancet A tall narrow window crowned by a sharply pointed **arch**, typically found in Gothic architecture.

lantern A turretlike structure situated on a roof, **vault**, or **dome**, with windows that allow light into the space below.

lekythos (lekythoi) A slim Greek oil vase with one handle and a narrow mouth.

limner An artist, particularly a portrait painter, in England during the sixteenth and seventeenth centuries and in New England during the seventeenth and eighteenth centuries.

lingam **shrine** A place of worship centered on an object or representation in the form of a phallus (the lingam), which symbolizes the power of the Hindu god Shiva.

literati The English word used for the Chinese wenren or the Japanese bunjin, referring to well-educated artists who enjoyed literature, **calligraphy**, and painting as a pastime. Their painting are termed **literati painting**.

literati painting A style of painting that reflects the taste of the educated class of East Asian intellectuals and scholars. Aspects include an appreciation for the antique, small scale, and an intimate connection between maker and audience.

lithograph See **lithography**.

lithography Process of making a print (**lithograph**) from a design drawn on a flat stone block with greasy crayon. Ink is applied to the wet stone and adheres only to the greasy areas of the design.

loggia Italian term for a covered open-air. **gallery**. Often used as a corridor between buildings or around a courtyard, loggias usually have **arcades** or **colonnades**.

lost-wax casting A method of casting metal, such as bronze, by a process in which a wax mold is covered with clay and plaster, then fired, melting the wax and leaving a hollow form. Molten metal is then poured into the hollow space and slowly cooled. When the hardened clay and plaster exterior shell is removed, a solid metal form remains to be smoothed and polished.

low relief Relief sculpture whose figures project slightly from the background. See also **relief sculpture**.

lunette A semicircular wall area, framed by an arch over a door or window. Can be either plain or decorated.

lusterware Ceramic pottery decorated with metallic **glazes**.

madrasa An Islamic institution of higher learning, where teaching is focused on theology and law.

maenad In ancient Greece, a female devotee of the wine god Dionysos who participated in orgiastic rituals. She is often depicted with swirling drapery to indicate wild movement or dance. (Also called a Bacchante, after Bacchus, the Roman name of Dionysos.)

majolica Pottery painted with a tin glaze that, when fired, gives a lustrous and colorful surface.

mandala An image of the cosmos represented by an arrangement of circles or concentric geometric shapes containing diagrams or images. Used for meditation and contemplation by Buddhists.

mandapa In a Hindu temple, an open hall dedicated to ritual worship.

mandorla Light encircling, or emanating from, the entire figure of a sacred person.

manuscript A handwritten book or document.

maqsura An enclosure in a Muslim mosque, near the mihrab, designated for dignitaries.

martyrium (martyria) In Christian architecture, a church, chapel, or shrine built over the grave of a martyr or the site of a great miracle.

mastaba A flat-topped, one-story structure with slanted walls over an ancient Egyptian underground tomb.

matte Term describing a smooth surface that is without shine or luster.

mausoleum A monumental building used as a tomb. Named after the tomb of Mausolos erected at Halikarnassos around 350 BCE.

meander See **Greek-key pattern**.

medallion Any round ornament or decoration. Also: a large medal.

megalith A large stone used in prehistoric building. Megalithic architecture employs such stones.

megaron The main hall of a Mycenaean palace or grand house, having a columnar **porch** and a room with a central fireplace surrounded by four **columns**.

memento mori From Latin for "remember that you must die." An object, such as a skull or extinguished candle, typically found in a *vanitas* image, symbolizing the transience of life.

memory image An image that relies on the generic shapes and relationships that readily spring to mind at the mention of an object.

menorah A Jewish lamp-stand with seven or nine branches; the nine-branched menorah is used during the celebration of Hanukkah. Representations of the seven-branched menorah, once used in the Temple of Jerusalem, became a symbol of Judaism.

metope The carved or painted rectangular panel between the **triglyphs** of a **Doric frieze**.

mihrab A recess or niche that distinguishes the wall oriented toward Mecca (*qibla*) in a **mosque**.

minaret A tall slender tower on the exterior of a mosque from which believers are called to prayer.

minbar A high platform or pulpit in a **mosque**.

miniature Anything small. In painting, miniatures may be illustrations within **albums** or **manuscripts** or intimate portraits.

mirador In Spanish and Islamic palace architecture, a very large window or room with windows, and sometimes balconies, providing views to interior courtyards or the exterior landscape.

mithuna The amorous male and female couples in Buddhist sculpture, usually found at the entrance to a sacred building. The mithuna symbolize the harmony and fertility of life.

moat A large ditch or canal dug around a castle or fortress for military defense. When filled with water, the moat protects the walls of the building from direct attack.

mobile A sculpture made with parts suspended in such a way that they move in a current of air.

modeling In painting, the process of creating the illusion of three-dimensionality on a two-dimensional surface by use of light and shade. In sculpture, the process of molding a three-dimensional form out of a malleable substance.

module A segment or portion of a repeated design. Also: a basic building block.

molding A shaped or sculpted strip with varying contours and patterns. Used as decoration on architecture, furniture, frames, and other objects.

monolith A single stone, often very large.

mortise-and-tenon joint A method of joining two elements. A projecting pin (tenon) on one element fits snugly into a hole designed for it (mortise) on the other. Such joints are very strong and flexible.

mosaic Images formed by small colored stone or glass pieces (tesserae), affixed to a hard, stable surface.

mosque An edifice used for communal Muslim worship.

mudra A symbolic hand gesture in Buddhist art that denotes certain behaviors, actions, or feelings.

mullion A slender vertical element or **colonnette** that divides a window into subsidiary sections.

muqarnas Small nichelike components stacked in tiers to fill the transition between differing vertical and horizontal planes.

naos The principal room in a temple or church. In ancient architecture, the **cella**. In a Byzantine church, the **nave** and **sanctuary**.

narthex The vestibule or entrance porch of a church.

naturalism, naturalistic A style of depiction that seeks to imitate the appearance of nature. A naturalistic work appears to record the visible world.

nave The central space of a **basilica**, two or three stories high and usually flanked by **aisles**.

necking The molding at the top of the **shaft** of the **column**.

necropolis A large cemetery or burial area; literally a "city of the dead."

nemes headdress The royal headdress of Egypt.

niello A metal technique in which a black sulfur alloy is rubbed into fine lines engraved into a metal (usually gold or silver). When heated, the alloy becomes fused with the surrounding metal and provides contrasting detail.

nishiki-e A multicolored and ornate Japanese print.

nocturne A night scene in painting, usually lit by artificial illumination.

nonrepresentational art An **abstract** art that does not attempt to reproduce the appearance of objects, figures, or scenes in the natural world. Also called nonobjective art.

oculus (oculi) In architecture, a circular opening. Oculi are usually found either as windows or at the apex of a **dome**. When at the top of a dome, an oculus is either open to the sky or covered by a decorative exterior lantern.

ogee An S-shaped curve. See **arch**.

olpe Any Greek vase or jug without a spout.

one-point perspective See **perspective**.

opithodomos In greek temples, the entrance porch or room at the back.

oracle A person, usually a priest or priestess, who acts as a conduit for divine information. Also: the information itself or the place at which this information is communicated.

orant The representation of a standing figure praying with outstretched and upraised arms.

orchestra The circular performance area of an ancient Greek theater. In later architecture, the section of seats nearest the stage or the entire main floor of the theater.

order A system of proportions in Classical architecture that includes every aspect of the building's plan, elevation, and decorative system. Composite: a combination of the Ionic and the Corinthian orders. The **capital** combines acanthus leaves with **volute** scrolls. **Corinthian:** the most ornate of the orders, the Corinthian includes a **base**, a fluted **column shaft** with a capital elaborately decorated with acanthus leaf carvings. Its **entablature** consists of an **architrave** decorated with **moldings**, a **frieze** often containing **sculptured reliefs**, and a **cornice** with dentils. Doric: the column shaft of the Doric order can be fluted or smooth-surfaced and has no base. The Doric capital consists of an undecorated **echinus** and **abacus**. The Doric entablature has a plain architrave, a frieze with **metopes** and **triglyphs**, and a simple cornice. Ionic: the column of the Ionic order has a base, a fluted shaft, and a capital decorated with volutes. The Ionic entablature consists of an architrave of three panels and moldings, a frieze usually containing sculpted relief ornament, and a cornice with dentils. **Tuscan:** a variation of Doric characterized by a smooth-surfaced column shaft with a base, a plain architrave, and an undecorated frieze. A colossal order is any of the above built on a large scale, rising through several stories in height and often raised from the ground by a **pedestal**.

orthogonal Any line running back into the represented space of a picture perpendicular to the imagined picture plane. In linear perspective, all orthogonals converge at a single **vanishing point** in the picture and are the basis for a **grid** that maps out the internal space of the image. An orthogonal plan is any plan for a building or city that is based exclusively on right angles, such as the grid plan of many modern cities.

pagoda An East Asian **reliquary** tower built with successively smaller, repeated stories. Each story is usually marked by an elaborate projecting roof.

palace complex A group of buildings used for living and governing by a ruler and his or her supporters, usually fortified.

palmette A fan-shaped ornament with radiating leaves.

parapet A low wall at the edge of a balcony, bridge, roof, or other place from which there is a steep drop, built for safety. A parapet walk is the passageway, usually open, immediately behind the uppermost exterior wall or battlement of a fortified building.

parchment A writing surface made from treated skins of animals. Very fine parchment is known as **vellum**.

parterre An ornamental, highly regimented flowerbed. An element of the ornate gardens of seventeenth-century palaces and châteaux.

pastel Dry pigment, chalk, and gum in stick or crayon form. Also: a work of art made with pastels.

pedestal A platform or **base** supporting a sculpture or other monument. Also: the block found below the base of a Classical **column** (or **colonnade**), serving to raise the entire element off the ground.

pediment A triangular gable found over major architectural elements such as Classical Greek **porticoes**, windows, or doors. Formed by an **entablature** and the ends of a sloping roof or a raking **cornice**. A similar architectural element is often used decoratively above a door or window, sometimes with a curved upper **molding**. A broken pediment is a variation on the traditional pediment, with an open space at the center of the topmost angle and/or the horizontal cornice.

pendentive The concave triangular section of a **vault** that forms the transition between a square or polygonal space and the circular base of a **dome**.

peplos A loose outer garment worn by women of ancient Greece. A cloth rectangle fastened on the shoulders and belted below the bust or at the waist.

peripteral A term used to describe any building (or room) that is surrounded by a single row of columns. When such **columns** are engaged instead of freestanding, called pseudo-peripteral.

peristyle A surrounding **colonnade** in Greek architecture. A peristyle building is surrounded on the exterior by a colonnade. Also: a peristyle court is an open colonnaded courtyard, often having a pool and garden.

perspective A system for representing three-dimensional space on a two-dimensional surface. **Atmospheric** perspective: A method of rendering the effect of spatial distance by subtle variations in color and clarity of representation. **Intuitive perspective:** A method of giving the impression of recession by visual instinct, not by the use of an overall system or program. Oblique perspective: An intuitive spatial system in which a building or room is placed with one corner in the picture plane, and the other parts of the structure recede to an imaginary vanishing point on its other side. Oblique perspective is not a comprehensive, mathematical system. **One-point** and multiple-point **perspective** (also called linear, scientific or mathematical perspective): A method of creating the illusion of three-dimensional space on a two-dimensional surface by delineating a horizon line and multiple orthogonal lines. These recede to meet at one or more points on the horizon (called **vanishing** points), giving the appearance of spatial depth. Called scientific or mathematical because its use requires some

knowledge of geometry and mathematics, as well as optics. **Reverse perspective:** A Byzantine perspective theory in which the orthogonals or rays of sight do not converge on a vanishing point in the picture, but are thought to originate in the viewer's eye in front of the picture. Thus, in reverse perspective the image is constructed with orthogonals that diverge, giving a slightly tipped aspect to objects.

photomontage A photographic work created from many smaller photographs arranged (and often overlapping) in a composition.

picture plane The theoretical spatial plane corresponding with the actual surface of a painting.

picture stone A medieval northern European memorial stone covered with figural decoration. See also **rune stone**.

picturesque A term describing the taste for the familiar, the pleasant, and the pretty, popular in the eighteenth and nineteenth centuries in Europe. When contrasted with the sublime, the picturesque stood for all that was ordinary but pleasant.

piece-mold casting A casting technique in which the mold consists of several sections that are connected during the pouring of molten metal, usually bronze. After the cast form has hardened, the pieces of the mold are disassembled, leaving the completed object.

pier A masonry support made up of many stones, or rubble and concrete (in contrast to a **column shaft** which is formed from a single stone or a series of **drums**), often square or rectangular in plan, and capable of carrying very heavy architectural loads.

pietra dura Italian for "hard stone." Semi-precious stones selected for color variation and cut in shapes to form ornamental designs such as flowers or fruit.

pietra serena A gray Tuscan limestone used in Florence.

pilaster An **engaged** columnar element that is rectangular in format and used for decoration in architecture.

pillar In architecture, any large, freestanding vertical element. Usually functions as an important weight-bearing unit in buildings.

plate tracery See **tracery**.

plinth The slablike **base** or **pedestal** of a **column**, statue, wall, building, or piece of furniture.

pluralism A social structure or goal that allows members of diverse ethnic, racial, or other groups to exist peacefully within the society while continuing to practice the customs of their own divergent cultures. Also: an adjective describing the state of having many valid contemporary styles available at the same time to artists.

podium A raised platform that acts as the foundation for a building, or as a platform for a speaker.

polychrome See **polychromy**.

polychromy The multicolored painted decoration applied to any part of a building, sculpture, or piece of furniture.

polyptych An altarpiece constructed from multiple panels, sometimes with hinges to allow for movable wings.

porcelain A high-fired, vitrified, translucent, white **ceramic** ware that employs two specific clays—kaolin and petuntse—and that is fired in the range of 1,300 to 1,400 degrees Celsius. The

relatively high proportion of silica in the body clays renders the finished porcelains translucent. Like **stonewares**, porcelains are glazed to enhance their aesthetic appeal and to aid in keeping them clean. By definition, porcelain is white, though it may be covered with a **glaze** of bright color or subtle hue. Chinese potters were the first in the world to produce porcelain, which they were able to make as early as the eighth century.

porch The covered entrance on the exterior of a building. With a row of **columns** or **colonnade**, also called a **portico**.

portal A grand entrance, door, or gate, usually to an important public building, and often decorated with sculpture.

portico In architecture, a projecting roof or porch supported by columns, often marking an entrance. See also porch.

post-and-lintel construction An architectural system of construction with two or more vertical elements (posts) supporting a horizontal element (lintel).

potassium-argon dating Technique used to measure the decay of a radioactive potassium isotope into a stable isotope of argon, an inert gas.

potsherd A broken piece of ceramic ware.

Prairie Style A style of architecture initiated by the American Frank Lloyd Wright (1867-1959), in which he sought to integrate his structures in an "organic" way into the surrounding natural landscape, often having the lines of the building follow the horizontal contours of the land. Since Wright's early buildings were built in the Prairie States of the Midwest, this type of architecture became known as the Prairie Style.

primitivism The borrowing of subjects or forms usually from non-Western or prehistoric sources by Western artists. Originally practiced by Western artists as an attempt to infuse their work with the naturalistic and expressive qualities attributed to other cultures, especially colonized cultures, primitivism also borrowed from the art of children and the insane.

pronaos The enclosed vestibule of a Greek or Roman temple, found in front of the **cella** and marked by a row of **columns** at the entrance.

proscenium The stage of an ancient Greek or Roman theater. In modern theater, the area of the stage in front of the curtain. Also: the framing **arch** that separates a stage from the audience.

psalter In Jewish and Christian scripture, a book containing the psalms, or songs, attributed to King David.

punchwork Decorative designs that are stamped onto a surface, such as metal or leather, using a punch (a handheld metal implement).

putto (putti) A plump, naked little boy, often winged. In classical art, called a cupid; in Christian art, a cherub.

pylon A massive gateway formed by a pair of tapering walls of oblong shape. Erected by ancient Egyptians to mark the entrance to a temple complex.

qibla The mosque wall oriented toward Mecca indicated by the mihrab.

quatrefoil A four-lobed decorative pattern common in Gothic art and architecture.

quincunx A building in which five **domed** bays are arranged within a square, with a central unit and four corner units. (When the central unit has similar units extending from each side, the form becomes a **Greek cross**.)

quoin A stone, often extra large or decorated for emphasis, forming the corner of two walls. A vertical row of such stones is called quoining.

radiometric dating A method of dating prehistoric works of art made from organic materials, based on the rate of degeneration of radiocarbons in these materials. *See also* **relative dating, absolute dating**.

raigo A painted image that depicts the Amida Buddha and other Buddhist deities welcoming the soul of a dying worshiper to paradise.

raku A type of **ceramic** pottery made by hand, coated with a thick, dark **glaze**, and fired at a low heat. The resulting vessels are irregularly shaped and glazed, and are highly prized for use in the Japanese tea ceremony.

readymade An object from popular or material culture presented without further manipulation as an artwork by the artist.

realism In art, a term first used in Europe around 1850 to designate a kind of **naturalism** with a social or political message, which soon lost its didactic import and became synonymous with naturalism.

red-figure A style and technique of ancient Greek vase painting characterized by red clay-colored figures on a black background. (The figures are reversed against a painted ground and details are drawn, not engraved, as in black-figure style.) See also **black-figure**.

register A device used in systems of spatial definition. In painting, a register indicates the use of differing **groundlines** to differentiate layers of space within an image. In sculpture, the placement of self-contained bands of **reliefs** in a vertical arrangement. In printmaking, the marks at the edges used to align the print correctly on the page, especially in multiple-block color printing.

registration marks In Japanese **woodblock** printing, these were two marks carved on the blocks to indicate proper alignment of the paper during the printing process. In multicolor printing, which used a separate block for each color, these marks were essential for achieving the proper position or registration of the colors.

relative dating See also **radiometric dating**.

relief sculpture A three-dimensional image or design whose flat background surface is carved away to a certain depth, setting off the figure. Called high or **low (bas) relief** depending upon the extent of projection of the image from the background. Called **sunken relief** when the image is carved below the original surface of the background, which is not cut away.

reliquary A container, often made of precious materials, used as a repository to protect and display sacred relics.

repoussé A technique of hammering metal from the back to create a protruding image. Elaborate reliefs are created with wooden armatures against which the metal sheets are pressed and hammered.

reverse perspective See **perspective**.

rhyton A vessel in the shape of a figure or an animal, used for drinking or pouring liquids on special occasions.

rib vault See **vault**.

ridgepole A longitudinal timber at the apex of a roof that supports the upper ends of the rafters.

rosette A round or oval ornament resembling a rose.

rotunda Any building (or part thereof) constructed in a circular (or sometimes polygonal) shape, usually producing a large open space crowned by a **dome**.

round arch See **arch**.

roundel Any element with a circular format, often placed as a decoration on the exterior of architecture.

rune stone A stone used in early medieval northern Europe as a commemorative monument, which is carved or inscribed with runes, a writing system used by early Germanic peoples.

running spirals A decorative motif based on the shape formed by a line making a continuous spiral.

rustication In building, the rough, irregular, and unfinished effect deliberately given to the exterior facing of a stone edifice. Rusticated stones are often large and used for decorative emphasis around doors or windows, or across the entire lower floors of a building. Also, masonry construction with conspicuous, often beveled joints.

salon A large room for entertaining guests; a periodic social or intellectual gathering, often of prominent people; a hall or **gallery** for exhibiting works of art.

sanctuary A sacred or holy enclosure used for worship. In ancient Greece and Rome, consisted of one or more temples and an altar. In Christian architecture, the space around the altar in a church called the chancel or presbytery.

sarcophagus (sarcophagi) A stone coffin. Often rectangular and decorated with **relief sculpture**.

scarab In Egypt, a stylized dung beetle associated with the sun and the god Amun.

scarification Ornamental decoration applied to the surface of the body by cutting the skin for cultural and/or aesthetic reasons.

school of artists An art historical term describing a group of artists, usually working at the same time and sharing similar styles, influences, and ideals. The artists in a particular school may not necessarily be directly associated with one another, unlike those in a workshop or **atelier**.

scribe A writer; a person who copies texts.

scriptorium (scriptoria) A room in a monastery for writing or copying manuscripts.

scroll painting A painting executed on a rolled support. Rollers at each end permit the horizontal scroll to be unrolled as it is studied or the vertical scroll to be hung for contemplation or decoration.

seals Personal emblems usually carved of stone in **intaglio** or **relief** and used to stamp a name or legend onto paper or silk. They traditionally employ the archaic characters appropriately known as "seal script," of the Zhou or Qin. Cut in stone, a seal may state a formal givem name, or it may state any of the numerous personal names that China's painters and writers adopted throughout their lives. A treasured work of art often bears not only the seal of its maker but also those of collectors and admirers through the centuries. In the Chinese view, these do not disfigure the work but add another layer of interest.

seraph (seraphim) An angel of the highest rank in the Christian hierarchy.

serdab In Egyptian tombs, the small room in which the ka statue was placed.

sfumato Italian term meaning "smoky," soft, and mellow. In painting, the effect of haze in an image. Resembling the color of the atmosphere at dusk, sfumato gives a smoky effect.

sgraffito Decoration made by incising or cutting away a surface layer of material to reveal a different color beneath.

shaft The main vertical section of a column between the capital and the base, usually circular in cross section.

shaftgrave A deep pit used for burial.

shikhara In the architecture of northern India, a conical (or pyramidal) spire found atop a Hindu temple and often crowned with an *amalaka*.

shoji A standing Japanese screen covered in translucent rice paper and used in interiors.

sinopia The preparatory design or underdrawing of a **fresco**. Also: a reddish chalklike earth pigment.

site-specific sculpture A sculpture commissioned and/or designed for a particular spot.

slip A mixture of clay and water applied to a **ceramic** object as a final decorative coat. Also: a solution that binds different parts of a vessel together, such as the handle and the main body.

spandrel The area of wall adjoining the exterior curve of an arch between its **springing** and the **keystone**, or the area between two arches, as in an **arcade**.

springing The point at which the curve of an arch or vault meets with and rises from its support.

squinch An **arch** or lintel built across the upper corners of a square space, allowing a circular or polygonal **dome** to be more securely set above the walls.

stained glass Molten glass is given a color that becomes intrinsic to the material. Additional colors may be fused to the surface (flashing). Stained glass is most often used in windows, for which small pieces of differently colored glass are precisely cut and assembled into a design, held together by **cames**. Additional painted details may be added to create images.

stele (stelae) A stone slab placed vertically and decorated with inscriptions or reliefs. Used as a grave marker or memorial.

stereobate A foundation upon which a Classical temple stands.

still life A type of painting that has as its subject inanimate objects (such as food, dishes, fruit, or flowers).

stoa In Greek architecture, a long roofed walkway, usually having columns on one long side and a wall on the other.

stoneware A high-fired, vitrified, but opaque **ceramic** ware that is fired in the range of 1,100 to 1,200 degrees Celsius. At that temperature, particles of silica in the clay bodies fuse together so that the finished vessels are impervious to liquids, even without **glaze**. Stoneware pieces are glazed to enhance their aesthetic appeal and to aid in keeping them clean (since unglazed ceramics are easily soiled). Stoneware occurs in a range of earth-toned colors, from white and tan to gray and black, with light gray predominating. Chinese potters were the first in the world to produce stoneware, which they were able to make as early as the Shang dynasty.

stucco A mixture of lime, sand, and other ingredients into a material that can be easily molded or modeled. When dry, produces a very durable surface used for covering walls or for architectural sculpture and decoration.

stupa In Buddhist architecture, a bell-shaped or pyramidal religious monument, made of piled earth or stone, and containing sacred relics.

stylobate In Classical architecture, the stone foundation on which a temple **colonnade** stands.

stylus An instrument with a pointed end (used for writing and printmaking), which makes a delicate line or scratch. Also: a special writing tool for **cuneiform** writing with one pointed end and one triangular wedge end.

sublime Adjective describing a concept, thing, or state of high spiritual, moral, or intellectual value; or something awe-inspiring. The sublime was a goal to which many nineteenth-century artists aspired in their artworks.

sunken relief See **relief sculpture**.

syncretism In religion or philosophy, the union of different ideas or principles.

taotie A mask with a dragon or animal-like face common as a decorative motif in Chinese art.

tapestry Multicolored pictorial or decorative weaving meant to be hung on a wall or placed on furniture.

tatami Mats of woven straw used in Japanese houses as a floor covering.

tempera A painting medium made by blending egg yolks with water, pigments, and occasionally other materials, such as glue.

tenebrism The use of strong **chiaroscuro** and artificially illuminated areas to create a dramatic contrast of light and dark in a painting.

terra cotta A medium made from clay fired over a low heat and sometimes left unglazed. Also: the orange-brown color typical of this medium.

tessera (tesserae) The small piece of stone, glass, or other object that is pieced together with many others to create a mosaic.

tetrarchy Four-man rule, as in the late Roman Empire, when four emperors shared power.

thatch A roof made of plant materials.

thermo-luminescence dating A technique that measures the irradiation of the crystal structure of material such as flint or pottery and the soil in which it is found, determined by luminescence produced when a sample is heated.

tholos A small, round building. Sometimes built underground, as in a Mycenaean tomb.

thrust The outward pressure caused by the weight of a vault and supported by buttressing. See **arch**.

tierceron In **vault** construction, a secondary rib that arcs from a **springing** point to the rib that runs lengthwise through the vault, called the ridge rib.

tokonoma A niche for the display of an art object (such as a screen, scroll, or flower arrangement) in a Japanese hall or tearoom.

tondo A painting or **relief sculpture** of circular shape.

torana In Indian architecture, an ornamented gateway arch in a temple, usually leading to the stupa.

toron In West African **mosque** architecture, the wooden beams that project from the walls. Torons are used as support for the scaffolding erected annually for the replastering of the building.

tracery Stonework or woodwork applied to wall surfaces or filling the open space of windows. In **plate tracery**, opening are cut through the wall. In **bar tracery**, **mullions** divide the space into vertical segments and form decorative patterns at the top of the opening or panel.

transept The arm of a cruciform church, perpendicular to the **nave**. The point where the nave and transept cross is called the crossing. Beyond the crossing lies the **sanctuary**, whether **apse**, choir, or chevet.

travertine A mineral building material similar to limestone, typically found in central Italy.

trefoil An ornamental design made up of three rounded lobes placed adjacent to one another.

triglyph Rectangular block between the **metopes** of a **Doric frieze**. Identified by the three carved vertical grooves, which approximate the appearance of the end of a wooden beam.

triptych An artwork made up of three panels. The panels may be hinged together so the side segments (**wings**) fold over the central area.

trompe l'oeil A manner of representation in which the appearance of natural space and objects is re-created with the express intention of fooling the eye of the viewer, who may be convinced that the subject actually exists as three-dimensional reality.

trumeau A column, pier, or post found at the center of a large portal or doorway, supporting the lintel.

tugra A calligraphic imperial monogram used in Ottoman courts.

Tuscan order See **order**.

twisted perspective A convention in art in which every aspect of a body or object is represented from its most characteristic viewpoint.

ukiyo-e A Japanese term for a type of popular art that was favored from the sixteenth century, particularly in the form of color **woodblock prints**. Ukiyo-e prints often depicted the world of the common people in Japan, such as courtesans and actors, as well as landscapes and myths.

urna In Buddhist art, the curl of hair on the forehead that is a characteristic mark of a buddha. The urna is a symbol of divine wisdom.

ushnisha In Asian art, a round turban or tiara symbolizing royalty and, when worn by a buddha, enlightenment.

vanishing point In a **perspective** system, the point on the horizon line at which **orthogonals** meet. A complex system can have multiple vanishing points.

vanitas An image, especially popular in Europe during the seventeenth century, in which all the objects symbolize the transience of life. Vanitas paintings are usually of **still lifes** or **genre** subjects.

vault An **arched** masonry structure that spans an interior space. Barrel or tunnel vault: an elongated or continuous semicircular vault, shaped like a half-cylinder. **Corbeled** vault: a vault made by projecting courses of stone. **Groin** or cross vault: a vault created by the intersection of two barrel vaults of equal size which creates four side compartments of identical size and shape. Quadrant or half-barrel vault: as the name suggests, a half-barrel vault. Rib vault: ribs (extra masonry) demarcate the junctions of a groin vault. Ribs may function to reinforce the groins or may be purely decorative. See also **corbeling**.

veduta (vedute) Italian for "vista" or "view."

Paintings, drawings, or prints often of expansive city scenes or of harbors.

vellum A fine animal skin prepared for writing and painting. See also parchment.

veneer In architecture, the exterior facing of a building, often in decorative patterns of fine stone or brick. In decorative arts, a thin exterior layer of finer material (such as rare wood, ivory, metal, and semiprecious stones) laid over the form.

verism A style in which artists concern themselves with capturing the exterior likeness of an object or person, usually by rendering its visible details in a finely executed, meticulous manner.

vihara From the Sanskrit term meaning "for wanderers." A vihara is, in general, a Buddhist monastery in India. It also signifies monks' cells and gathering places in such a monastery.

vimana The main element of a Southern Indian Hindu temple, usually in the shape of a pyramidal or tapering tower raised on a **plinth**.

volute A spiral scroll, as seen on an Ionic **capital**.

votive figure An image created as a devotional offering to a god or other deity.

voussoirs The oblong, wedge-shaped stone blocks used to build an **arch**. The topmost voussoir is called a **keystone**.

warp The vertical threads in a weaver's loom. Warp threads make up a fixed framework that provides the structure for the entire piece of cloth, and are thus often thicker than **weft** threads. See also **weft**.

wash A diluted watercolor or ink. Often washes are applied to drawings or prints to add tone or touches of color.

wattle and daub A wall construction method combining upright branches, woven with twigs (wattles) and plastered or filled with clay or mud (daub).

weft The horizontal threads in a woven piece of cloth. Weft threads are woven at right angles to and through the **warp** threads to make up the bulk of the decorative pattern. In carpets, the weft is often completely covered or formed by the rows of trimmed knots that form the carpet's soft surface. See also **warp**.

white-ground A type of ancient Greek pottery in which the background color of the object is painted with a slip that turns white in the firing process. Figures and details were added by painting on or **incising** into this **slip**. White-ground wares were popular in the Classical period as funerary objects.

wing A side panel of a **triptych** or **polyptych** (usually found in pairs), which was hinged to fold over the central panel. Wings often held the depiction of the donors and/or subsidiary scenes relating to the central image.

woodblock print A print made from one or more carved wooden blocks. In Japan, woodblock prints were made using multiple blocks carved in relief, usually with a block for each color in the finished print. See also **woodcut**.

woodcut A type of print made by carving a design into a wooden block. The ink is applied to the block with a roller. As the ink remains only on the raised areas between the carved-away lines, these carved-away areas and lines provide the white areas of the print. Also: the process by which the woodcut is made.

x-ray style In Aboriginal art, a manner of representation in which the artist depicts a figure or animal by illustrating its outline as well as essential internal organs and bones.

yaksha, yakshi The male (yaksha) and female (yakshi) nature spirits that act as agents of the Hindu gods. Their sculpted images are often found on Hindu temples and other sacred places, particularly at the entrances.

ziggurat In Mesopotamia, a tall stepped tower of earthen materials, often supporting a shrine.

BIBLIOGRAPHY

Susan V. Craig

This bibliography is composed of books in English that are appropriate "further reading" titles. Most items on this list are available in good libraries, whether college, university, or public institutions. I have emphasized recently published works so that the research information would be current. There are three classifications of listings: general surveys and art history reference tools, including journals and Internet directories; surveys of large periods that encompass multiple chapters (ancient art in the Western tradition, European medieval art, European Renaissance through eighteenth-century art, modern art in the West, Asian art, and African and Oceanic art and art of the Americas); and books for individual chapters 1 through 32.

General Art History Surveys and Reference Tools

Adams, Laurie Schneider. *Art across Time.* 2nd ed. New York: McGraw-Hill, 2002.

Barnet, Sylvan. *A Short Guide to Writing about Art.* 8th ed. New York: Pearson/Longman, 2005.

Boströöm, Antonia. *Encyclopedia of Sculpture.* 3 vols. New York: FitzroyDearborn, 2004.

Broude, Norma, and Garrard, Mary D., eds. *Feminism and Art History: Questioning the Litany.* Icon Editions. New York: Harper & Row, 1982.

Chadwick, Whitney. *Women, Art, and Society.* 3rd ed. New York: Thames and Hudson, 2002.

Chilvers, Ian, ed. The *Oxford Dictionary of Art.* 3rd ed. New York: Oxford Univ. Press, 2004.

Curl, James Stevens. *A Dictionary of Architecture and Landscape Architecture.* 2nd ed. Oxford: Oxford Univ. Press, 2006.

Davies, Penelope J.E., et al. *Janson's History of Art: The Western Tradition.* 7th ed. Upper Saddle River, NJ: Prentice Hall, 2006.

Dictionary of Art, The. 34 vols. New York: Grove's Dictionaries, 1996.

Encyclopedia of World Art. 16 vols. New York: McGraw-Hill, 1972–83.

Frank, Patrick, Duane Preble, and Sarah Preble. *Preble's Artforms.* 8th ed. Upper Saddle River, NJ: Prentice Hall, 2006.

Gardner, Helen. *Gardner's Art through the Ages.* 12th ed. Ed. Fred S. Kleiner & Christin J. Mamiya. Belmont, CA: Thomson/Wadsworth, 2005.

Gaze, Delia, ed. *Dictionary of Women Artists.* 2 vols. London: Fitzroy Dearborn Publishers, 1997.

Griffiths, Antony. *Prints and Printmaking: An Introduction to the History and Techniques.* 2nd ed. London: British Museum Press, 1996.

Hadden, Peggy. *The Quotable Artist.* New York: Allworth Press, 2002.

Hall, James. *Illustrated Dictionary of Symbols in Eastern and Western Art.* New York: Icon Editions, 1994.

Holt, Elizabeth Gilmore, ed. *A Documentary History of Art.* 3 vols. New Haven: Yale Univ. Press, 1986.

Honour, Hugh, and John Fleming. *The Visual Arts: A History.* 7th ed. Upper Saddle River, NJ: Prentice Hall, 2005.

Hults, Linda C. *The Print in the Western World: An Introductory History.* Madison: Univ. of Wisconsin Press, 1996.

Johnson, Paul. *Art: A New History.* New York: HarperCollins, 2003.

Kaltenbach. G. E. *Pronunciation Dictionary of Artists' Names.* 3rd ed. Rev. Debra Edelstein. Boston: Little, Brown, and Co., 1993.

Kemp, Martin. *The Oxford History of Western Art.* Oxford: Oxford Univ. Press, 2000.

Kostof, Spiro. *A History of Architecture: Settings and Rituals.* 2nd ed. Rev. Greg Castillo. New York: Oxford Univ. Press, 1995.

Mackenzie, Lynn. *Non-Western Art: A Brief Guide.* 2nd ed. Upper Saddle River, NJ: Prentice Hall, 2001.

Marmor, Max, and Alex Ross, eds. *Guide to the Literature of Art History 2.* Chicago: American Library Association, 2005.

Onians, John, ed. *Atlas of World Art.* New York: Oxford Univ. Press, 2004.

Roberts, Helene, ed. *Encyclopedia of Comparative Iconography: Themes Depicted in Works of Art.* 2 vols. Chicago: Fitzroy Dearborn, 1998.

Rogers, Elizabeth Barlow. *Landscape Design: A Cultural and Architectural History.* New York: Harry N. Abrams, 2001.

Sayre, Henry M. *Writing about Art.* 5th ed. Upper Saddle River, NJ: Pearson/Prentice Hall, 2006.

Sed-Rajna, Gabrielle. *Jewish Art.* Trans. Sara Friedman and Mira Reich. New York: Abrams, 1997.

Slatkin, Wendy. *Women Artists in History: From Antiquity to the Present.* 4th ed. Upper Saddle River, NJ: Prentice Hall, 2000.

Sutton, Ian. *Western Architecture: From Ancient Greece to the Present.* World of Art. New York: Thames and Hudson, 1999.

Trachtenberg, Marvin, and Isabelle Hyman. *Architecture: From Prehistory to Postmodernity.* 2nd ed. Upper Saddle River, NJ: Prentice Hall, 2001.

Tufts, Eleanor. *Our Hidden Heritage: Five Centuries of Women Artists.* New York: Paddington Press, 1974.

West, Shearer. *Portraiture.* Oxford History of Art. Oxford: Oxford Univ. Press, 2004.

Wilkins, David G., Bernard Schultz, and Katheryn M. Linduff. *Art Past, Art Present.* 5th ed. Upper Saddle River, NJ: Prentice Hall, 2005.

Watkin, David. *A History of Western Architecture.* 4th ed. New York: Watson-Guptill Publications, 2005.

Art History Journals: A Select List of Current Titles

African Arts. Quarterly. Los Angeles: Univ. of California at Los Angeles, James S. Coleman African Studies Center, 1967-

American Art: The Journal of the Smithsonian American Art Museum. 3/year. Chicago: Univ. of Chicago Press, 1987-

American Indian Art Magazine, Quarterly. Scottsdale, AZ: American Indian Art Inc, 1975-

American Journal of Archaeology. Quarterly. Boston: Archaeological Institute of America, 1885-

Antiquity: A Periodical of Archaeology. Quarterly. Cambridge, UK: Antiquity Publications Ltd, 1927-

Apollo: The International Magazine of the Arts. Monthly. London: Apollo Magazine Ltd, 1925-

Architectural History. Annually. Farnham, UK: Society of Architectural Historians of Great Britain, 1958-

Archives of American Art Journal. Quarterly. Washington, D.C.: Archives of American Art, Smithsonian Institution, 1960-

Archives of Asian Art. Annually. New York: Asia Society, 1945-

Ars Orientalis: The Arts of Asia, Southeast Asia, and Islam. Annually. Ann Arbor: Univ. of Michigan Dept. of Art History, 1954–

Art Bulletin. Quarterly. New York: College Art Association, 1913-

Art History: Journal of the Association of Art Historians. 5/year. Oxford: Blackwell Publishing Ltd, 1978-

Art in America. Monthly. New York: Brant Publications Inc, 1913-

Art Journal. Quarterly. New York: College Art Association, 1960-

Art Nexus. Quarterly. Bogata, Colombia: Arte en Colombia Ltda, 1976-

Art Papers Magazine. Bi-monthly. Atlanta: Atlanta Art Papers Inc, 1976-

Artforum International. 10/year. New York: Artforum International Magazine Inc, 1962-

Artnews. 11/year. New York: Artnews LLC, 1902-

Bulletin of the Metropolitan Museum of Art. Quarterly. New York: Metropolitan Museum of Art, 1905-.

Burlington Magazine. Monthly. London: Burlington Magazine Publications Ltd, 1903-

Dumbarton Oaks Papers. Annually. Locust Valley, NY: J. J. Augustin Inc, 1940-

Flash Art International. Bimonthly. Trevi, Italy: Giancarlo Politi Editore, 1980-

Gesta. Semiannually. New York: International Center of Medieval Art, 1963-

History of Photography. Quarterly. Abingdon, UK: Taylor & Francis Ltd, 1976-

International Review of African American Art. Quarterly. Hampton, VA: International Review of African American Art, 1976-

Journal of Design History. Quarterly. Oxford: Oxford Univ. Press, 1988-

Journal of Egyptian Archaeology. Annually. London: Egypt Exploration Society, 1914-

Journal of Hellenic Studies. Annually. London: Society for the Promotion of Hellenic Studies, 1880-

Journal of Roman Archaeology. Annually. Portsmouth, RI: Journal of Roman Archaeology LLC, 1988-

Journal of the Society of Architectural Historians. Quarterly. Chicago: Society of Architectural Historians, 1940-

Journal of the Warburg and Courtauld Institutes. Annually. London: Warburg Institute, 1937-

Leonardo: Art, Science and Technology. 6/year. Cambridge, MA: MIT Press, 1968-

Marg. Quarterly. Mumbai, India: Scientific Publishers, 1946-

Master Drawings. Quarterly. New York: Master Drawings Association, 1963–

October. Cambridge, MA: MIT Press, 1976-

Oxford Art Journal. 3/year. Oxford: Oxford Univ. Press, 1978-

Parkett. 3/year. Züürich, Switzerland: Parkett Verlag AG, 1984-

Print Quarterly. Quarterly. London: Print Quarterly Publications, 1984-

Simiolus: Netherlands Quarterly for the History of Art. Quarterly. Apeldoorn, Netherlands: Stichting voor Nederlandse Kunsthistorische Publicaties, 1966-

Woman's Art Journal. Semiannually. Philadelphia: Old City Publishing Inc, 1980-

Internet Directories for Art History Information

ARCHITECTURE AND BUILDING

http://library.nevada.edu/arch/rsrce/webrsrce/contents.html

A directory of architecture websites collected by Jeanne Brown at the Univ. of Nevada at Las Vegas. Topical lists include architecture, building and construction, design, history, housing, planning, preservation, and landscape architecture. Most entries include a brief annotation and the last date the link was accessed by the compiler.

ART HISTORY RESOURCES ON THE WEB

http://witcombe.sbc.edu/ARTHLinks.html

Authored by Christopher L. C. E. Witcombe of Sweet Briar College in Virginia since 1995, the site includes an impressive number of links for various art historical eras as well as links to research resources, museums, and galleries. The content is frequently updated.

ART IN FLUX: A DIRECTORY OF RESOURCES FOR RESEARCH IN CONTEMPORARY ART

http://www.boisestate.edu/art/artinflux/intro.html

Cheryl K. Shutleff of Boise State Univ. in Idaho has authored this directory, which includes sites selected according to their relevance to the study of national or international contemporary art and artists. The subsections include artists, museums, theory, reference, and links.

ARTCYCLOPEDIA: THE FINE ARTS SEARCH ENGINE

With over 2,100 art sites and 75,000 links, this is one of the most comprehensive web directories for artists and art topics.

The primary searching is by artist's name but access is also available by artistic movement, nation, timeline and medium.

MOTHER OF ALL ART HISTORY LINKS PAGES

http://www.art-design.umich.edu/mother/

Maintained by the Dept. of the History of Art at the Univ. of Michigan, this directory covers art history departments, art museums, fine arts schools and departments as well as links to research resources. Each entry includes annotations.

VOICE OF THE SHUTTLE

http://vos.ucsb.edu

Sponsored by Univ. of California, Santa Barbara, this directory includes over 70 pages of links to humanities

and humanities-related resources on the Internet. The structured guide includes specific sub-sections on architecture, on art (modern & contemporary), and on art history. Links usually include a one sentence explanation and the resource is frequently updated with new information.

YAHOO! ARTS>ART HISTORY
http://dir.yahoo.com/Arts/Art_History/
Another extensive directory of art links organized into subdivisions with one of the most extensive being "Periods and Movements." Links include the name of the site as well as a few words of explanation.

Ancient Art in the Western Tradition, General

Amiet, Pierre. *Art in the Ancient World: A Handbook of Styles and Forms.* New York: Rizzoli, 1981.

Beard, Mary, and John Henderson. *Classical Art: From Greece to Rome.* Oxford History of Art. Oxford: Oxford Univ. Press, 2001.

Boardman, John. *Oxford History of Classical Art.* New York: Oxford Univ. Press, 2001.

Chitham, Robert. *The Classical Orders of Architecture.* 2nd ed. Boston: Elsevier/Architectural Press, 2005.

Ehrich, Robert W., ed. *Chronologies in Old World Archaeology.* 3rd ed. 2 vols. Chicago: Univ. of Chicago Press, 1992.

Gerster, Georg. *The Past from Above: Aerial Photographs of Archaeological Sites.* Ed. Charlotte Trüümpler. Trans. Stewart Spencer. Los Angeles: The J. Paul Getty Museum, 2005.

Groenewegen-Frankfort, H. A., and Bernard Ashmole. *Art of the Ancient World: Painting, Pottery, Sculpture, Architecture from Egypt, Mesopotamia, Crete, Greece, and Rome.* Library of Art History. Upper Saddle River, NJ: Prentice Hall, 1972.

Haywood, John. *The Penguin Historical Atlas of Ancient Civilizations.* New York: Penguin, 2005.

Lloyd, Seton, and Hans Wolfgang Muller. *Ancient Architecture.* New York: Rizzoli, 1986.

Milleker, Elizabeth J., ed. *The Year One: Art of the Ancient World East and West.* New York: Metropolitan Museum of Art, 2000.

Nagle, D. Brendan. *The Ancient World: A Social and Cultural History.* 6th ed. Upper Saddle River, NJ: Pearson Prentice Hall, 2006.

Romer, John, and Elizabeth Romer. *The Seven Wonders of the World: A History of the Modern Imagination.* New York: Henry Holt, 1995.

Saggs, H. W. F. *Civilization before Greece and Rome.* New Haven: Yale Univ. Press, 1989.

Smith, William Stevenson. *Interconnections in the Ancient Near East: A Study of the Relationships between the Arts of Egypt, the Aegean, and Western Asia.* New Haven: Yale Univ. Press, 1965.

Tadgell, Christopher. *Imperial Form: From Achaemenid Iran to Augustan Rome.* New York: Whitney Library of Design, 1998.

———. *Origins: Egypt, West Asia and the Aegean.* New York: Whitney Library of Design, 1998.

Trigger, Bruce G. *Understanding Early Civilizations: A Comparative Study.* New York: Cambridge Univ. Press, 2003.

Winckelmann, Johann Joachim. *History of the Art of Antiquity.* Trans. Harry Francis Mallgrave. Texts & Documents. Los Angeles: Getty Research Institute, 2006.

Woodford, Susan. *The Art of Greece and Rome.* 2nd ed. New York: Cambridge Univ. Press, 2004.

CHAPTER 1
Prehistoric Art in Europe

Aujoulat, Norbert. *Lascaux: Movement, Space, and Time.* New York: H. N. Abrams, 2005.

Bahn Paul G. *The Cambridge Illustrated History of Prehistoric Art.* Cambridge Illustrated History. Cambridge, U.K.: Cambridge Univ. Press, 1998.

Bataille, Georges. *The Cradle of Humanity: Prehistoric Art and Culture.* Ed. and intro. Stuart Kendall. Trans. Michelle Kendall & Stuart Kendall. New York: Zone Books, 2005.

Berghaus, Gunter. *New Perspectives on Prehistoric Art.* Westport, CT: Praeger, 2004

Chippindale, Christopher. *Stonehenge Complete.* 3rd ed. New York: Thames and Hudson, 2004.

Clottes, Jean. *Chauvet Cave: The Art of Earliest Times.* Salt Lake City: Univ. of Utah Press, 2003.

———. *World Rock Art.* Trans. Guy Bennett. Los Angeles: Getty Conservation Institute, 2002.

———, and J. David Lewis-Williams. *The Shamans of Prehistory: Trance and Magic in the Painted Caves.* Trans. Sophie Hawkes. New York: Harry N. Abrams, 1998.

Cunliffe, Barry W., ed. *The Oxford Illustrated History of Prehistoric Europe.* New York: Oxford Univ. Press, 2001.

Forte, Maurizio, and Alberto Siliotti. *Virtual Archaeology: Re-Creating Ancient Worlds.* New York: Abrams, 1997.

Freeman, Leslie G. *Altamira Revisited and Other Essays on Early Art.* Chicago: Institute for Prehistoric Investigation, 1987.

Gowlett, John A. J. *Ascent to Civilization: The Archaeology of Early Humans.* 2nd ed. New York: McGraw-Hill, 1993.

Guthrie, R. Dale. *The Nature of Paleolithic Art.* Chicago: Univ. of Chicago Press, 2005.

Jope, E. M. *Early Celtic art in the British Isles.* 2 vols. New York: Oxford Univ. Press, 2000.

Leakey, Richard E. and Roger Lewin. *Origins Reconsidered: In Search of What Makes Us Human.* New York: Doubleday, 1992.

Leroi-Gourhan, Andrée. *The Dawn of European Art: An Introduction to Paleolithic Cave Painting.* Trans. Sara Champion. Cambridge, U.K.: Cambridge Univ. Press, 1982.

Lewis-Williams, J. David. *The Mind in the Cave: Consciousness and the Origins of Art.* New York: Thames & Hudson, 2002.

Marshack, Alexander. *The Roots of Civilization: The Cognitive Beginnings of Man's First Art, Symbol, and Notation.* New York: McGraw-Hill, 1972.

Megaw, Ruth, and Vincent Megaw. *Celtic Art: From Its Beginnings to the Book of Kells.* Rev. and exp. ed. New York: Thames and Hudson, 2001.

O'Kelly, Michael J. *Newgrange: Archaeology, Art, and Legend. New Aspects of Antiquity.* London: Thames and Hudson, 1982.

Price, T. Douglas, and Gray M. Feinman. *Images of the Past.* 3rd ed. Mountain View, CA: Mayfield, 2000.

Renfrew, Colin, ed. *The Megalithic Monuments of Western Europe.* London: Thames and Hudson, 1983.

Ruspoli, Mario. *The Cave of Lascaux: The Final Photographs.* New York: Abrams, 1987.

Sandars, N. K. *Prehistoric Art in Europe.* 2nd ed. Pelican History of Art. New Haven: Yale Univ. Press, 1992.

Sura Ramos, Pedro A. *The Cave of Altamira.* Gen. Ed. Antonio Beltran. New York: Abrams, 1999.

Sieveking, Ann. *The Cave Artists.* Ancient People and Places, vol. 93. London: Thames and Hudson, 1979.

White, Randall. *Prehistoric Art: The Symbolic Journey of Humankind.* New York: Harry N. Abrams, 2003.

CHAPTER 2
Art of the Ancient Near East

Akurgal, Ekrem. *Ancient Civilizations and Ruins of Turkey: From Prehistoric Times until the End of the Roman Empire.* 5th ed. London: Kegan Paul, 2002.

Aruz, Joan, ed. *Art of the First Cities: The Third Millennium B.C. from the Mediterranean to the Indus.* New York: Metropolitan Museum of Art, 2003.

Bahrani, Zainab. *The Graven Image: Representation in Babylonia and Assyria.* Archaeology, Culture, and Society Series. Philadelphia: Univ. of Pennsylvania Press, 2003.

Boardman, John. *Persia and the West: An Archaeological Investigation of the Genesis of Achaemenid Art.* New York: Thames & Hudson, 2000.

Bottero, Jean. *Everyday Life in Ancient Mesopotamia.* Trans. Antonia Nevill. Baltimore, MD.: Johns Hopkins Univ. Press, 2001.

Charvat, Petr. *Mesopotamia before History.* Rev. & updated ed. New York: Routledge, 2002.

Collon, Dominique. *Ancient Near Eastern Art.* Berkeley: Univ. of California Press, 1995.

Crawford, Harriet. *Sumer and the Sumerians.* 2nd ed. New York: Cambridge Univ. Press, 2004.

Curtis, J.E., and J. E. Reade, eds. *Art and Empire: Treasures from Assyria in the British Museum.* New York: Metropolitan Museum of Art, 1995.

Curtis, John, and Nigel Tallis, eds. *Forgotten Empire: The World of Ancient Persia.* Berkeley: Univ. of California Press, 2005.

Downey, Susan B. *Mesopotamian Religious Architecture: Alexander through the Parthians.* Princeton: Princeton Univ. Press, 1988. Ferrier, R. W., ed. Arts of Persia. New Haven: Yale Univ. Press, 1989.

Frankfort, Henri. *The Art and Architecture of the Ancient Orient.* 5th ed. Pelican History of Art. New Haven: Yale Univ. Press, 1996.

Haywood, John. *Ancient Civilizations of the Near East and Mediterranean.* London: Cassell, 1997.

Lloyd, Seton. *Ancient Turkey: A Traveller's History of Anatolia.* Berkeley: Univ. of California Press, 1989.

Meyers, Eric M., ed. *The Oxford Encyclopedia of Archaeology in the Near East.* 5 vols. New York: Oxford Univ. Press, 1997.

Moorey, P. R. S. *Idols of the People: Miniature Images of Clay in the Ancient Near East.* The Schweich Lectures of the British Academy; 2001. New York: Oxford Univ. Press, 2003.

Polk, Milbry, and Angela M. H. Schuster. *The Looting of the Iraq Museum, Baghdad: The Lost Legacy of Ancient Mesopotamia.* New York: Harry N. Abrams, 2005.

Reade, Julian. *Assyrian Sculpture.* Cambridge, MA: Harvard Univ. Press, 1999.

Roaf, Michael. *Cultural Atlas of Mesopotamia and the Ancient Near East.* New York: Facts on File, 1990.

Roux, Georges. *Ancient Iraq.* 3rd ed. London: Penguin, 1992.

Zettler, Richard L., and Lee Horne, ed. *Treasures from the Royal Tombs of Ur.* Philadelphia: Univ. of Pennsylvania, Museum of Archaeology and Anthropology, 1998.

CHAPTER 3
Art of Ancient Egypt

Arnold, Dieter. *Temples of the Last Pharaohs.* New York: Oxford Univ. Press, 1999.

Arnold, Dorothea. *When the Pyramids Were Built: Egyptian Art of the Old Kingdom.* New York: Metropolitan Museum of Art, 1999.

Baines, John, and Jaromiír Máálek. *Cultural Atlas of Ancient Egypt.* Rev. ed. New York: Facts on File, 2000.

Brier, Bob. *Egyptian Mummies: Unraveling the Secrets of an Ancient Art.* New York: Morrow, 1994.

Casson, Lionel. *Everyday Life in Ancient Egypt.* Rev. & exp. ed. Baltimore, Md.: Johns Hopkins Univ. Press, 2001.

Egyptian Art in the Age of the Pyramids. New York: Metropolitan Museum of Art, 1999.

The Egyptian Book of the Dead: The Book of Going Forth by Day: Being the Papyrus of Ani (Royal Scribe of the Divine Offerings). Trans. Raymond O. Faulkner. 2nd rev. ed. San Francisco: Chronicle, 1998.

Freed, Rita E. Sue D'Auria, and Yvonne J Markowitz. *Pharaohs of the Sun: Akhenaten, Nefertiti, Tutankhamen.* Boston: Museum of Fine Arts in assoc. with Bulfinch Press/Little, Brown and Co., 1999.

Hawass, Zahi A. *Tutankhamun and the Golden Age of the Pharaohs.* Washington, D.C.: National Geographic, 2005.

Johnson, Paul. *The Civilization of Ancient Egypt.* Updated ed. New York: HarperCollins, 1999.

Kozloff, Arielle P., and Betsy M. Bryan. *Egypt's Dazzling Sun: Amenhotep III and His World.* Cleveland: Cleveland Museum of Art, 1992.

Lehner, Mark. *The Complete Pyramids: Solving the Ancient Mysteries.* New York: Thames and Hudson, 1997.

Máálek, Jaromir. *Egypt: 4000 Years of Art.* London: Phaidon, 2003.

Pemberton, Delia. *Ancient Egypt.* Architectural Guides for Travelers. San Francisco: Chronicle, 1992.

Robins, Gay. *The Art of Ancient Egypt.* Cambridge, MA: Harvard Univ. Press, 1997.

Roehrig, Catharine H., Renee Dreyfus, and Cathleen A. Keller. *Hatshepsut, from Queen to Pharaoh.* New York: The Metropolitan Museum of Art, 2005.

Russmann, Edna R. *Egyptian Sculpture: Cairo and Luxor.* Austin: Univ. of Texas Press, 1989.

Smith, Craig B. *How the Great Pyramid Was Built.* Washington, D.C.: Smithsonian Books, 2004.

Smith, W. Stevenson. *The Art and Architecture of Ancient Egypt.* 3rd ed. Rev. William Kelly Simpson. Pelican History of Art. New Haven: Yale Univ. Press, 1999.

Strudwick, Nigel, and Helen Studwick. *Thebes in Egypt: A Guide to the Tombs and Temples of Ancient Luxor.* Ithaca, NY: Cornell Univ. Press, 1999.

Thomas, Thelma K. *Late Antique Egyptian Funerary Sculpture: Images for this World and for the Next.* Princeton: Princeton Univ. Press, 2000.

Tiradritti, Francesco. *Ancient Egypt: Art, Architecture and History.* Trans. Phil Goddard. London: British Museum, 2002.

The Treasures of Ancient Egypt: From the Egyptian Museum in Cairo. New York: Rizzoli, 2003.

Wilkinson, Richard H. *The Complete Temples of Ancient Egypt.* New York: Thames & Hudson, 2000.

———. *Reading Egyptian Art: A Hieroglyphic Guide to Ancient Egyptian Painting and Sculpture.* London: Thames and Hudson, 1992.

Ziegler, Cristiane, ed. *The Pharaohs.* New York: Rizzoli, 2002.

Zivie-Coche, Christiane. *Sphinx: History of a Monument.* Trans. David Lorton. Ithaca, NY: Cornell Univ. Press, 2002.

CHAPTER 4
Aegean Art

Barber, R. L. N. *The Cyclades in the Bronze Age.* Iowa City: Univ. of Iowa Press, 1987.

Castleden, Rodney. *The Knossos Labyrinth: A New View of the "Palace of Minos" at Knossos.* London: Routledge, 1990.

———. *Mycenaeans.* New York: Routledge, 2005.

Demargne, Pierre. *The Birth of Greek Art.* Trans. Stuart Gilbert & James Emmons. Arts of Mankind. New York: Golden, 1964.

Dickinson. Oliver. *The Aegean Bronze Age.* Cambridge World Archaeology. Cambridge, U.K.: Cambridge Univ. Press, 1994.

Doumas, Christos. *The Wall-Paintings of Thera.* 2nd ed. Trans. Alex Doumas. Athens: Kapon Editions, 1999.

Fitton, J. Lesley. *Cycladic Art.* 2nd ed. London: British Museum, 1999.

Getz-Gentle, Pat. *Personal Styles in Early Cycladic Sculpture.* Madison: Univ. of Wisconsin Press, 2001.

Hamilakis, Yannis. ed. *Labyrinth Revisited: Rethinking 'Minoan' Archaeology.* Oxford: Oxbow, 2002.

Higgins, Reynold. *Minoan and Mycenean Art.* Rev. ed. World of Art. New York: Thames and Hudson, 1997.

Hitchcock, Louise. *Minoan architecture: A Contextual Analysis.* Studies in Mediterranean Archaeology and Literature, Pocket-Book, 155. Jonsered: P. Ååströöms Föörlag, 2000.

Immerwahr, Sara Anderson. *Aegean Painting in the Bronze Age.* University Park: Pennsylvania State Univ. Press, 1990.

Preziosi, Donald, and Louise Hitchcock. *Aegean Art and Architecture.* Oxford History of Art. Oxford: Oxford Univ. Press, 1999.

CHAPTER 5
Art of Ancient Greece

Barletta, Barbara A. *The Origins of the Greek Architectural Orders.* New York: Cambridge Univ. Press, 2001.

Beard, Mary. *The Parthenon.* Cambridge, MA: Harvard Univ. Press, 2003.

Belozerskaya, Marina, and Kenneth Lapatin. *Ancient Greece: Art, Architecture, and History.* Los Angeles: J. Paul Getty Museum, 2004.

Boardman, John. *Early Greek Vase Painting: 11th–6th Centuries B.C.: A Handbook.* World of Art. London: Thames and Hudson, 1998.

——. *Greek Sculpture: The Archaic Period: A Handbook.* World of Art. New York: Thames and Hudson, 1991.

——. *Greek Sculpture: The Classical Period: A Handbook.* London: Thames and Hudson, 1985.

——. *Greek Sculpture: The Late Classical Period and Sculpture in Colonies and Overseas.* World of Art. New York: Thames and Hudson, 1995.

———. *The History of Greek Vases: Potters, Painters, and Pictures.* New York: Thames & Hudson, 2001.

Burn, Lucilla. *Hellenistic Art: From Alexander the Great to Augustus.* London: British Museum Press, 2004.

Camp, John M. *The Athenian Agora: Excavations in the Heart of Classical Athens.* New York: Thames and Hudson, 1986.

Carpenter, Thomas H. *Art and Myth in Ancient Greece: A Handbook.* World of Art. London: Thames and Hudson, 1991.

Clark, Andrew J., Maya Elston, Mary Louise Hart. *Understanding Greek Vases: A Guide to Terms, Styles, and Techniques.* Los Angeles: J. Paul Getty Museum, 2002.

De Grummond, Nancy T. and Brunilde S. Ridgway. *From Pergamon to Sperlonga: Sculpture in Context.* Berkeley: Univ. of California Press, 2000.

Donohue, A. A. *Greek Sculpture and the Problem of Description.* New York: Cambridge Univ. Press, 2005.

Fullerton, Mark D. *Greek Art.* Cambridge, U.K.: Cambridge Univ. Press, 2000.

Hurwit, Jeffrey M. *The Art and Culture of Early Greece 1100–480 B.C.* Ithaca, NY: Cornell Univ. Press, 1985.

———, and Adam D. Newton. *The Acropolis in the Age of Pericles.* 1 v. & CD-ROM. New York: Cambridge Univ. Press, 2004.

Karakasi, Katerina. *Archaic Korai.* Los Angeles: The J. Paul Getty Museum, 2003.

Lagerlof, Margaretha Rossholm. *The Sculptures of the Parthenon: Aesthetics and Interpretation.* New Haven: Yale Univ. Press, 2000.

Lawrence, A. W. *Greek Architecture.* 5th ed. Rev. R. A. Tomlinson. Pelican History of Art. New Haven: Yale Univ. Press, 1996.

Martin, Roland. *Greek Architecture: Architecture of Crete, Greece, and the Greek World.* History of World Architecture. New York: Electa/Rizzoli, 1988.

Osborne, Robin. *Archaic and Classical Greek Art.* Oxford History of Art. Oxford: Oxford Univ. Press, 1998.

Palagia, Olga. ed. *Greek Sculpture: Function, Materials, and Techniques in the Archaic and Classical Periods.* New York: Cambridge Univ. Press, 2006.

———, and J.J. Pollitt., eds. *Personal Styles in Greek Sculpture.* Yale Classical Studies, v. 30. New York: Cambridge Univ. Press, 1996.

Pedley, John Griffiths. *Greek Art and Archaeology.* 3rd ed. Upper Saddle River: Prentice-Hall, 2002.

Pollitt, J. J. *The Art of Ancient Greece: Sources and Documents.* 2nd ed. Cambridge, U.K.: Cambridge Univ. Press, 1990.

Ridgway, Brunilde Sismondo. *The Archaic Style in Greek Sculpture.* 2nd ed. Chicago: Ares, 1993.

——. *Fifth Century Styles in Greek Sculpture.* Princeton: Princeton Univ. Press, 1981.

——. *Fourth Century Styles in Greek Sculpture.* Wisconsin Studies in Classics. Madison: Univ. of Wisconsin Press, 1997.

——. *Hellenistic Sculpture 1: The Styles of ca. 331–200 B.C.* Wisconsin Studies in Classics. Madison: Univ. of Wisconsin Press, 1990.

Stafford, Emma J. *Life, Myth, and Art in Ancient Greece.* Los Angeles: J. Paul Getty Museum, 2004.

Stewart, Andrew F. *Greek Sculpture: An Exploration.* 2 vols. New Haven: Yale Univ. Press, 1990.

Whitley, James. *The Archaeology of Ancient Greece.* New York: Cambridge Univ. Press, 2001.

CHAPTER 6
Etruscan and Roman Art

Bianchi Bandinelli, Ranuccio. *Rome: The Centre of Power: Roman Art to A.D. 200.* Trans. Peter Green. Arts of Mankind. London: Thames and Hudson, 1970.

——. *Rome: The Late Empire: Roman Art A.D. 200–400.* Trans. Peter Green. Arts of Mankind. New York: Braziller, 1971.

Borrelli, Federica. *The Etruscans: Art, Architecture, and History.* Ed. Stefano Peccatori & Stefano Zuffi. Trans. Thomas Michael Hartmann. Los Angeles: J. Paul Getty Museum, 2004.

Breeze, David John. *Hadrian's Wall.* 4th ed. London: Penguin, 2000.

Brendel, Otto J. *Etruscan Art.* 2nd ed. Yale Univ. Press Pelican History Series. New Haven: Yale Univ. Press, 1995.

Ciarallo, Annamaria, and Ernesto De Carolis, eds. *Pompeii: Life in a Roman Town.* Milan: Electa, 1999.

Conlin, Diane Atnally. *The Artists of the Ara Pacis: The Process of Hellenization in Roman Relief Sculpture.* Studies in the History of Greece & Rome. Chapel Hill: Univ. of North Carolina Press, 1997.

Cornell, Tim, and John Matthews. *Atlas of the Roman World.* New York: Facts on File, 1982.

D'Ambra, Eve. *Roman Art.* Cambridge, U.K.: Cambridge Univ. Press, 1998.

Elsner, Ja. *Imperial Rome and Christian Triumph: The Art of the Roman Empire A.D. 100–450.* Oxford History of Art. Oxford: Oxford Univ. Press, 1998.

Gabucci, Ada. *Ancient Rome: Art, Architecture, and History.* Eds. Stefano Peccatori & Stephano Zuffi. Trans. T. M. Hartman. Los Angeles, CA: J. Paul Getty Museum, 2002.

——. ed. *The Colosseum.* Los Angeles, CA: J. Paul Getty Museum, 2002.

Grant, Michael. *Art in the Roman Empire.* London: Routledge, 1995.

Guillaud, Jacqueline, and Maurice Guillaud. *Frescoes in the Time of Pompeii.* New York: Potter, 1990.

Haynes, Sybille. *Etruscan Civilization: A Cultural History.* Los Angeles: J. Paul Getty Museum, 2000.

Holloway, R. Ross. *Constantine & Rome.* New Haven: Yale Univ. Press, 2004.

L'Orange, Hans Peter. *The Roman Empire: Art Forms and Civic Life.* New York: Rizzoli, 1985.

MacDonald, William L. *The Architecture of the Roman Empire: An Introductory Study.* Rev. ed. Yale Publications in the History of Art. New Haven: Yale Univ. Press, 1982.

——. *The Pantheon: Design, Meaning, and Progeny.* Cambridge, MA: Harvard Univ. Press, 1976.

——, and John A. Pinto. *Hadrian's Villa and Its Legacy.* New Haven: Yale Univ. Press, 1995.

Mazzoleni, Donatella. *Domus: Wall Painting in the Roman House.* Los Angeles: J. Paul Getty Museum, 2004.

Packer, James E., and Kevin Lee Sarring. *The Forum of Trajan in Rome: A Study of the Monuments.* California Studies in the History of Art, 31. 2 vols., portfolio and microfiche. Berkeley: Univ. of California Press, 1997.

Pollitt, J. J. *The Art of Rome, c. 753 B.C.–337 A.D.: Sources and Documents.* Upper Saddle River, NJ: Prentice Hall, 1966.

Ramage, Nancy H., and Andrew Ramage. *Roman Art: Romulus to Constantine.* 4th ed. Upper Saddle River, NJ: Prentice Hall, 2004.

Spivey, Nigel. *Etruscan Art.* World of Art. New York: Thames and Hudson, 1997.

Stamper, John W. *The Architecture of Roman Temples: The Republic to the Middle Empire.* New York: Cambridge Univ. Press, 2005.

Stewart, Peter. *Roman Art.* New York: Oxford Univ. Press, 2004.

———. *Statues in Roman Society: Representation and Response.* Oxford Studies in Ancient Culture and Representation. New York: Oxford Univ., 2003.

Strong, Donald. *Roman Art.* 2nd ed. rev. & annotated. Ed. Roger Ling. Pelican History of Art. New Haven: Yale Univ. Press, 1995.

Ward-Perkins, J. B. *Roman Architecture.* History of World Architecture. New York: Electa/Rizzoli, 1988.

——. *Roman Imperial Architecture.* Pelican History of Art. New Haven: Yale Univ. Press, 1981.

Wilson Jones, Mark. *Principles of Roman Architecture.* New Haven: Yale Univ. Press, 2000.

CREDITS

INDEX

Notes

Notes

Notes

Notes

Notes